Monumentality in Early Chinese Art and Architecture

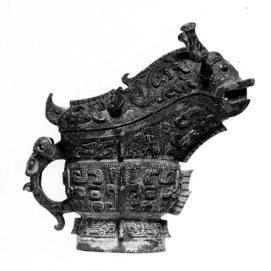

Stanford University Press
Stanford, California 1995

MONUMENTALITY

in Early Chinese Art
and Architecture

WU HUNG

Stanford University Press
Stanford, California

© 1995 by the Board of Trustees
of the Leland Stanford Junior University

Printed in the United States of America

CIP data appear at the end of the book

Published with the assistance of the National Endowment for the
Humanities, the Getty Grant Program, and the Chiang Ching-kuo
Foundation for International Scholarly Exchange

Stanford University Press publications are distributed exclusively
by Stanford University Press within the United States, Canada,
Mexico, and Central America; they are distributed exclusively by
Cambridge University Press throughout the rest of the world.

To K. C. Chang

9

Acknowledgments

CLEARLY, A STUDY such as this must rely on previous scholarship on early Chinese art and architecture and must address many questions posed by that scholarship. Indeed, this book grew from six years of dialogues, lectures, and seminars with scholars and students, and it is meant to continue this process of communication. The project began to take shape in conversations with my colleagues at Harvard, in particular John Czaplicka, a scholar learned in the history and theory of monuments. But it was my teaching on both graduate and undergraduate levels that offered me the chance to pursue a systematic reinterpretation of early Chinese art. My lecture notes gradually grew into writings, conceptualized as sections in this volume but presented as individual papers in more than twenty symposia, conferences, and colloquia. On all these occasions I benefited from many inspiring comments and suggestions. A number of scholars read the first draft of this book, among whom Martin Powers offered detailed comments important to my revision. John R. Ziemer and Helen Tartar, editors at Stanford University Press, have been two major supporters of this project from its beginning; they are also responsible for the book's fine form. Finally and most of all, my wife, Judith Zeitlin, has always been the first reader of every section and chapter, and her critical reading contributed not only to the book's arguments but also to its conceptualization.

W.H.

Contents

Figures and Maps

MAPS

Chronologies

Hemudu culture	ca. 5000–3300 B.C.
Dawenkou culture	ca. 4300–2500
Liangzhu culture	ca. 3300–2200
Longshan culture	ca. 2500–2000
Xia dynasty (unconfirmed)	ca. 2100–1600
Shang dynasty	ca. 1600–1050
Western Zhou	ca. 1050–721
Eastern Zhou	721–256
Spring and Autumn period	721–481
Warring States period	480–256
Qin dynasty	221–206
Western Han dynasty	206 B.C.–A.D. 9
Xin dynasty	A.D. 9–23
Eastern Han dynasty	25–220
Three Kingdoms period	220–65
Western Jin dynasty	265–317
Southern dynasties	317–589
Eastern Jin	317–420
Song	420–79
Qi	479–502
Liang	502–57
Chen	557–89

APPROXIMATE DATES OF THE LATE SHANG KINGS

Wu Ding	1200–1180 B.C.
Zu Geng	1180–1170
Zu Jia	1170–1150
Lin Xin and/or Keng Ding	1150–1130
Wu Yi	1130–1115
Wen Wu Ding	1115–1100
Ti Yi	1100–1080
Ti Xin	1080–1050

PERIODIZATION OF THE WESTERN ZHOU AND APPROXIMATE DATES OF DYNASTIC RULERS

Early Western Zhou	1050–973 B.C.
Wu	1050–1047
Cheng	1047–1017

Kang	1017–992
Zhao	992–973
Middle Western Zhou	973–893
Mu	973–918
Gong	918–903
Yi	903–901
Xiao	901–893
Late Western Zhou	893–771
Yi	893–861
Li	861–841
Gonghe (regency)	841–827
Xuan	827–781
You	781–771

EMPERORS OF THE WESTERN HAN, XIN, AND EASTERN HAN DYNASTIES

Western Han	206 B.C.–A.D. 9
Gaozu	206–195 B.C.
Hui	194–188
Empress Dowager Lü	187–180
Wen	179–157
Jing	156–141
Wu	140–87
Zhao	86–74
Xuan	73–48
Yuan	48–33
Cheng	32–7
Ai	6–1
Ping	A.D. 1–5
Ruzi Ying	6–9
Xin	9–23
Wang Mang	9–23
Eastern Han	25–220
Guangwu	25–57
Ming	58–75
Zhang	76–88
He	89–106
Shang	106
An	107–25
Shao	125
Shun	126–44
Chong	145
Zhi	146
Huan	147–67
Ling	168–89
Xian	189–220

EMPERORS OF THE LIANG DYNASTY

Wu	502–49
Jianwen	550–55
Yuan	555
Jing	555–57
King Yongjia	557–58

Monumentality in Early Chinese Art
and Architecture

The Nine Tripods and Traditional Chinese Concepts of Monumentality

MY USE OF *monumentality* as the organizing concept of this study calls for some explanation. I chose it, rather than the more common word *monument*, because its relative abstractness offers flexibility for interpretation and because it is not overburdened with preexisting connotations. The word *monument*, as so often encountered in tourist guides and other writings, is frequently associated with giant, durable, solemn structures in public places—the Arc de Triomphe, the Lincoln Memorial, the Statue of Liberty, the Mount Rushmore National Memorial, and the Monument to the People's Heroes in Tiananmen Square (Figs. I.1a–d). Such associations imply a conventional understanding of the monument based on size, material, topology, and location—anyone passing a granite obelisk or a bronze statue would call it a "monument" without knowing anything about it. This common wisdom is shared by artists and art historians. Many scholars, for example, consider the art of monuments synonymous with "monumental architecture" or "public sculpture," an unspecified equivalence underlying their discussion of monu-

ments.[1] Some avant-garde artists who attack traditional "official" art also focus on conventional monumental images. Claes Oldenburg thus designed a series of "anti-monuments," including a pair of scissors that parodies the Washington Monument (Fig. I.2): "The scissors are an obvious morphological equivalent to the obelisk, with interesting differences—metal for stone, humble and modern for ancient, movement for monumentality."[2] The quintessential official monument is once again defined in terms of permanence, grandiosity, and stillness.

It remains questionable, however, whether this seemingly universal understanding sums up every sort of "monument" from every time and place, or whether it is itself a historical construct conditioned by its cultural origin. Indeed, it has been challenged by some writers even in the West. For example, in "The Modern Cult of Monuments: Its Character and Its Origin" (1902), the Austrian art historian and theoretician Alois Riegl attributed monumentality not only to "intentional" commemorative monuments, but also to those "unintentional" ones (such as

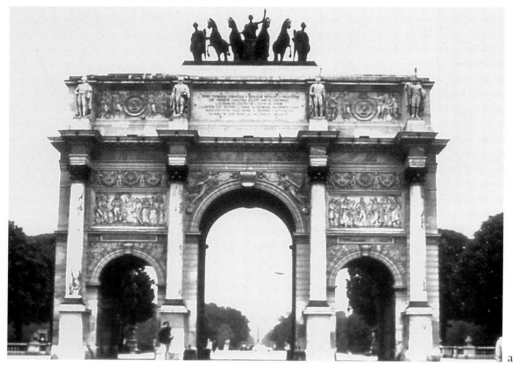

a

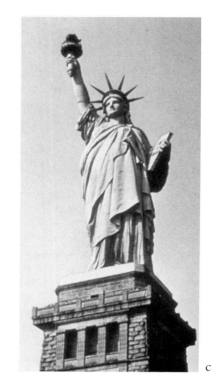

c

*Fig. I.1. (a) Arc de Tri-
omphe du Carrousel,
Paris. (b) Mount Rush-
more National Memorial,
South Dakota. (c) Statue
of Liberty, New York.
(d) Monument to the
People's Heroes, Beijing.*

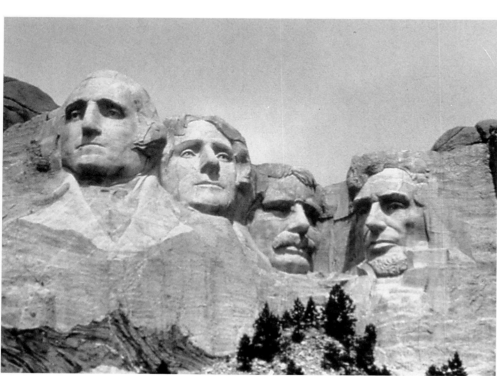

b

d

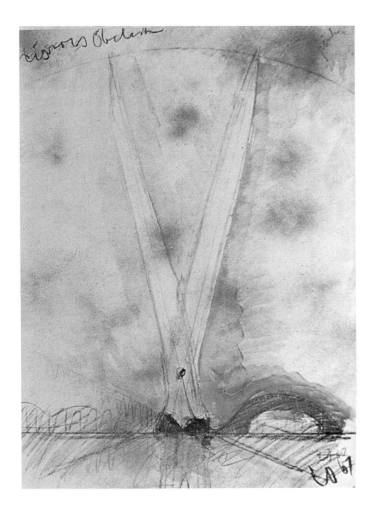

Fig. I.2. Claes Olden-
burg, "Giant Scissors,"
1965–69. Watercolor on
paper.

Riegl's and Jackson's views oppose the conventional understanding of the monument. To them, topology and physical appearance count little in identifying a monument; what makes a thing a monument is its essential ability to memorialize and commemorate. As thought-provoking as this assertion is, it fails to account fully for individual monuments, especially their tangible forms. It lends itself to abstract discourses on memory and history but contributes only indirectly to analyses of art and architecture. Historians who deal with concrete forms (these would include art, architectural, and cultural historians) have to find a third position between empiricism and metaphysics. Their observation of a monument must take into account its function as well as its visual properties. Thus the following questions were posed at a 1992 conference at the University of Washington, entitled straightforwardly "The Monument": "What is a monument? What are the common denominators that constitute monumentality? Is it inherent in size, in power, in mood, in specific temporality, in perdurability, in place, in immortalization? Are concepts of the monumental transhistorical, or have they evolved or radically shifted in the modern period?"[5]

The organizers of the conference felt it necessary to raise these questions because, according to them, "no common ground has been established to account for the phenomenon of the monument in a cross-disciplinary and broadly theoretical way."[6] But if one believes (as this author does) that the phenomenon of the monument (or the phenomenon of anything) is never "transhistorical" and "transcultural," then one must describe and interpret such phenomena historically and culturally. Rather than attempting to find another universal "common ground" that accounts for various kinds of monuments in a "broadly theoretical way," a more urgent and plausible goal is to historicize the phenomenon of the monument—to explore indigenous concepts and forms within well-defined cultural and political traditions, to contextualize these concepts and forms, and to observe conflicting notions and manifestations of the monumental in specific situations. Such case studies, not general abstractions or syntheses, will broaden our knowledge of the monument and will prevent cul-

ruins) and any object possessing "age value."[3] A yellowed historical document would readily fall into this last category. Following a different line, the American scholar John Brinckerhoff Jackson noticed the widespread desire after the Civil War to declare the Gettysburg battlefield a "monument": "This was something unheard of: an immense, populated landscape of thousands of acres of fields and roads and farmhouses becoming a monument to an event which had taken place there." Such reflections led him to conclude that a monument can take any form. It certainly does not have to be an intimidating structure and does not even have to be a manufactured object—"A monument can be nothing more than a rough stone, a fragment of ruined wall as at Jerusalem, a tree, or a cross."[4]

turally biased theoretical formulations. This is why I propose to treat the monument strictly as a historical issue, and why I need first to define the geographical, chronological, and cultural scope of my study: in the following pages, I examine the concepts of monumentality and the forms of monuments in the specific context of ancient China from prehistorical times to the period known as the Northern and Southern Dynasties.

Here I use the two concepts—*monumentality* and *monument*—to indicate two interrelated levels in my discussion. Both terms derive from the Latin word *monumentum*, meaning to remind and to admonish. But in my usage, *monumentality* (defined in *Webster's New International Dictionary* as a "monumental state and quality")[7] sustains such functions of a "monument"; a physical monument can survive even after it has lost its commemorative and instructive significance. The relationship of monumentality to monument is thus close to that of *content* and *form*. This explains why only an object possessing a definite monumentality is a functional monument. *Monumentality* thus denotes memory, continuity, and political, ethical, or religious obligations to a tradition. This primary meaning underlies a monument's manifold social, political, and ideological significance. As scholars have repeatedly stated, a monument, no matter what shape or material, serves to preserve memory, to structure history, to immortalize a figure, event, or institution, to consolidate a community or a public, to define a center for political gatherings or ritual communication, to relate the living to the dead, and to connect the present with the future. All these concepts are obviously important for any understanding of art and architecture as social and cultural products. But these are nevertheless empty words until they are historically defined. Moreover, even when a particular type of monumentality is defined, it remains an isolated phenomenon until it is linked with other kinds of monumentality into a dynamic historical sequence. I call this sequence a "history of monumentality"; it reflects the changing notion of memory and history.

This transformation in meaning is reflected and expressed by the development of monuments—physical entities that embody and realize historical monumentality. Like the concepts and notions they signify, the tangible properties of a monument—shape, structure, medium, decoration, inscription, and location—constantly change; there is absolutely nothing we can categorically label a standard "Chinese monument." In other words, my identification of various forms of ancient Chinese monuments and their historical relationship is supported by my discussion of different conceptions of monumentality and their historical relationship. These forms may or may not agree with our conventional idea of monumental images. In either case, their qualification as monuments must be justified by their function and symbolism in ancient Chinese society. More important, they must not be viewed as isolated types of monuments but as products of a continuous development of symbolic forms, which I call a "history of monuments."

By combining the history of monumentality and the history of monuments into a single narrative, I hope in this book to discover the essential developmental logic of ancient Chinese art and architecture up to the appearance of educated artists and private works of art. Before this moment, all three major traditions of Chinese art and architecture—the ancestral temple and ritual vessels, the capital city and palaces, the tomb and funerary paraphernalia—resulted from large religious or political projects. Instead of pleasing a sensitive viewer, they reminded the public of what it should believe and how it should act. All can be qualified as monuments or components of monumental complexes. By identifying their monumentality, we may find a new way to interpret these traditions and thereby to reconstruct early Chinese art history. To demonstrate this, let us begin by exploring perhaps the oldest Chinese concept of monumentality, a concept revealed most clearly in an ancient myth about a set of legendary bronze tripods.

In the year 605 B.C., an ambitious lord of the southern state of Chu went on an expedition near the Zhou capital at Luoyang. The campaign was not aimed to show his loyalty toward the Zhou royal house, which had been reduced to puppet status and was constantly threatened by the feudal princes' increasing demands for political power. In this case, the lord's disloyalty was first shown by his holding

military maneuvers near the capital. The submissive Zhou king sent a minister named Wangsun Man to bring "greetings" and gifts to the troops. The lord of Chu immediately questioned the minister: "Could you tell me how large and heavy are the Nine Tripods?" This seemingly innocent question aroused Wangsun Man's famous speech recorded in *Master Zuo's Commentaries on the Spring and Autumn Annals* (*Chunqiu Zuo zhuan*):

> The Tripods do not matter; virtue does. In the past when the Xia dynasty was distinguished for its virtue, the distant regions put their *things* [*wu*] into pictures and the nine provinces sent in copper as tribute. The Tripods were cast to present those *things*. One hundred different *things* were presented, so that the people could distinguish divine from evil. . . . Hereby a harmony was secured between the high and the low, and all enjoyed the blessing of Heaven.
>
> When the virtue of Jie [the last king of the Xia] was all-obscured, the Tripods were transferred to the Shang dynasty, and for six hundred years the Shang enjoyed its ruling status. Finally King Zhou of the Shang proved cruel and oppressive, and the Tripods were transferred to the Zhou dynasty.
>
> When virtue is commendable and brilliant, those which are small will be heavy; when things come to be crafty and decrepit, those which are large will be light. Heaven blessed intelligent virtue, and on this its favor rests. King Cheng [of the Zhou] fixed the Tripods in the Zhou capital[8] and divined that the Zhou dynasty should last for thirty reigns, over seven hundred years. This is the Zhou's mandate from Heaven. Though now the Zhou has lost its past glory, the decree of Heaven is not yet changed. The weight of the tripods cannot yet be inquired about![9]

This passage has been frequently quoted as a valuable source for the "meaning" of ancient Chinese bronze art. Scholars have often focused their attention on the term *things* and have interpreted and translated it as "totems," "emblems," "symbols," "decoration," or "animal sacrifices" to suit their various arguments, but I suggest that the significance of this record goes far beyond an iconographic reference. What this passage implies is, above all, an ancient *monumentality* in Chinese culture, and the essence of an entire artistic genre called *liqi* or "ritual art."

The implications of the Tripods exist on three different levels corresponding to the three paragraphs of this passage. First, the Nine Tripods as a collective monument were made to commemorate the most important political event in ancient China: the establishment of the Xia, which initiated a series of "dynasties" and separated traditional Chinese history into two broad periods. Before this moment, it was thought, various regional groups fought for political dominance; after this moment, a centralized power appeared and assumed a position to give orders to subsidiary authorities. The Nine Tripods thus fall into Riegl's general category of an *intentional monument*, which is commemorative in nature. On the other hand, the Nine Tripods not only commemorated a past event but also legitimated and consolidated the consequence of the event—the implementation of a centralized political power over the whole country. Wangsun Man expressed this idea symbolically. According to him, the tripods bore the *things* of various regions. These regions were Xia's allies. The act of sending their *things* to the Xia demonstrated their submission to Xia authority. The engraving of their *things* on the tripods meant that they had entered into a single political entity. Wangsun Man stated this idea even more clearly when he said that after the Tripods were made, "people could distinguish divine from evil": all the tribes and kingdoms belonging to the Xia alliance were identified (by the Tripods) as "divine," whereas all enemy tribes and kingdoms (whose *things* were absent from the Tripods) were considered "evil."

This may have been the original impulse behind the creation of the Tripods. But as soon as these ritual objects came into being, their significance, or monumentality, changed. They became something that could be possessed, and indeed this new theme dominates the next part of Wangsun Man's political rhetoric. Here we find the second symbolism of the Tripods: these objects had become a symbol not only of a particular political power (the Xia) but of Power itself. It was thought that any dynasty would inevitably perish (as Wangsun Man asserted, the Zhou was mandated to last no longer than thirty reigns), but the centralization of political power—hence the Tripods—would persist. Correspondingly, the changing possession

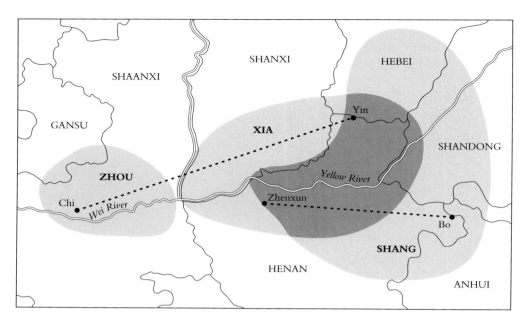

SHANXI

SHAANXI

HEBEI

GANSU

XIA

Yin

SHANDONG

ZHOU

Yellow River

Chi

Wei River

Zhenxun

Bo

SHANG

HENAN

ANHUI

Map I.1. The approximate spheres and the succession of the Xia, Shang, and Zhou dynasties (based on K. C. Chang 1981: fig. 6)

and location of the Tripods indicated the transmission of political power from one dynasty to another. (Thus, Wangsun Man said: "When the virtue of Jie was all-obscured, the Tripods were transferred to the Shang dynasty, and for six hundred years the Shang enjoyed its ruling status. Finally King Zhou of the Shang proved cruel and oppressive, and the Tripods were transferred to the Zhou dynasty.") From the Xia to the Shang and then to the Zhou, possession of the Nine Tripods coincided exactly with the succession of the Three Dynasties (Map I.1). The transmission of the Tripods thus became synonymous with the progression of History.

The broadening symbolism of the Tripods leads finally to the third significance of these objects: they and their transmission were not so much the *consequence* of historical events as the *prerequisite* for historical events. Theoretically, the distinguished virtue of a dynasty led to its mandate, which was then demonstrated by its creation or possession of the Tripods. In actuality, however, this logic was reversed: because a ruler possessed the Tripods, he was certainly virtuous and ought to enjoy Heaven's favor. This is why the ambitious lord asked about (in fact, asked *for*) the Tripods, and this is also why Wangsun Man answered: "Though now the Zhou has lost its past glory, the decree

of Heaven is not yet changed. The weight of the Tripods cannot yet be inquired about!" His argument may be summarized this way: although the Zhou is declining, it is still the possessor of the Nine Tripods; hence it is still the legitimate ruler of China, hence it still retains Heaven's mandate, and hence it is virtuous and morally unshakable. The Zhou's control of the Tripods had become the sole prop for its survival; for the ambitious lord, obtaining the Tripods would be the first step toward dynastic power.

As a collective political monument, the physical properties of the Nine Tripods both agree with and differ from those of a monument in a conventional, modern understanding. As mentioned earlier, a monument, or more precisely an "intentional" monument, is usually considered a manufactured form of durable materials that bears signs "to preserve a moment in the consciousness of later generations, and therefore to remain alive and present in perpetuity."[10] The legendary Nine Tripods conform to this basic definition: they were made of the most durable material available at the time, and their engraved signs registered the establishment of the First Chinese dynasty. But beyond this, the Nine Tripods were perhaps unique. First, the material of the Tripods was not only the most durable but was also the most prized. During the Three Dynasties, only the ruling classes possessed bronze. Moreover, Wangsun Man especially emphasized that people from China's nine provinces had presented the bronze used to make the Tripods. This implies that the symbolism of bronze lay not only in its solidity, durability, and preciousness but also in its origins and in the process of the Tripods' manufacture. When bronze from various places was mixed and cast into a single set of ritual vessels, it was understood that those who presented the material were assimilated into a single unity. As we have noted, the same logic also underlay the practice of engraving the *things* of these places on the Tripods.

Second, the word *monument* is often associated with colossal constructions whose giant size dominates public view. But as bronze vessels, the Nine Tripods could not possibly have been taller than two meters, and they were transportable from one location to another to correspond with a change in the dynastic succession (Fig. I.3).[11] We

may say that their condensed form and their portability made the Tripods important; it was not their imposing size that made the ideas they represented grandiose. As Wangsun Man attested, "When virtue is commendable and brilliant, those which are small will be heavy; when things come to be crafty and decrepit, those which are large will be light." This is also why in ancient China all ritual bronzes were called "heavy vessels" (*zhongqi*), a term referring to their political and psychological importance, not to their physical size and weight. We read in the *Book of Rites* (*Li ji*) that "when one is holding a ritual article belonging to his lord, though it may be light, he should seem unable to sustain it."[12]

Third, the form of a monument is often related to the characteristics of permanence and stillness. The Nine Tripods, however, were believed to have an "animate" nature.

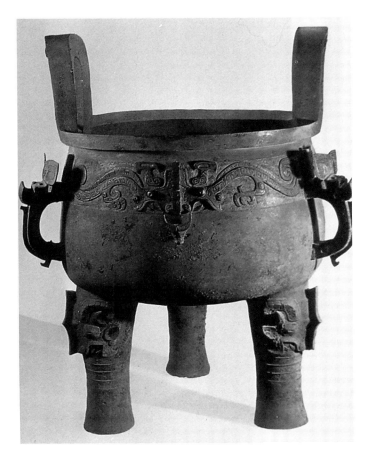

The last part of Wangsun Man's speech has been translated: "When the virtue of Jie was all-obscured, the Tripods were transferred to the Shang. . . . Finally King Zhou of the Shang proved cruel and oppressive, and the Tripods were transferred to the Zhou." But the meaning of the original text is by no means so definite. In particular, the verb *qian* can be interpreted both as "to be transferred" and "to transfer itself"; and in fact the syntax of the sentences seems to encourage the second reading (a word-by-word translation of the two sentences, *ding qian yu Shang* and *ding qian yu Zhou* would be "the tripods move to Shang/Zhou").

Another version of the Tripod legend makes this even more explicit: it is recorded in the *Mozi* that a divination was made before casting the Tripods and a divine message appeared on the tortoise shell: "Let the Tripods, when completed, have a square body and four legs. Let them be able to boil without kindling, to hide themselves without being lifted, and to move themselves without being carried so that they will be used for the sacrifice at the field of Kunwu." The diviner, whose name was Weng-nan Yi, then interpreted the oracle: "Oh! like those luxuriant clouds that float to the four directions, after their completion the Nine Tripods will move to three kingdoms: when the Xia clan loses them, the people of Yin [i.e., Shang] will possess them, and when the people of Yin lose them, the people of Zhou will have them."[13] Comparing the Nine Tripods to drifting clouds, Yi's metaphor clearly suggests that these divine objects generated their own movement (or transmission)—that the various dynasties could possess them only because the Tripods were willing to be possessed by these legitimate owners.

This "animate" quality of the Nine Tripods was even further mystified during the Han dynasty: people began to think that they could not only generate their own movement but also possessed consciousness (Figs. I.4, 5): "The Tripods are the essence of both substance [*zhi*] and refinement [*wen*]. They know the auspicious and the inauspicious and what continues and what perishes. They can be heavy or light; they can be at rest or in motion. Without fire they cook, and without drawing water they are naturally full. . . . The divine tripods appear when a ruler rises

Fig. I.3. Ding *tripod. Bronze. Early Western Zhou. 10th century B.C. H. 122 cm. Excavated in 1979 at Chunhua, Shaanxi province. Chunhua County Cultural House.*

Fig. I.4. Divine tripod. Carving on the ceiling of the Wu Liang Shrine. A.D. 151. Jiaxiang, Shandong province. Woodblock reconstruction.

and disappear when a ruler falls."[14] As I discuss later in this book, this "animate" quality was not a metaphysical conception but a visual one. This quality is directly related, on the one hand, to the general idea of "metamorphosis" in early Chinese ritual art, and on the other hand, to actual decoration on bronzes, which favors protean images.

Fourth, it seems surprising that the Nine Tripods, the most important political monument in ancient China, were actually a set of vessels. Unlike a conventional monument, which often fulfills no practical function, the Nine Tripods were used for cooking in sacrifices. They were therefore functional objects in religious communication with certain divine beings, most likely the spirits of deceased ancestors.[15] The Tripods commemorated not only the ancestors who originally created and acquired these ritual objects (i.e., their establishment of the Three Dynasties) but also all previous kings who had successfully maintained the Tripods in the royal temple (and had thus proved a dynasty's continuing mandate from Heaven). The political symbolism of the Tripods could be sustained over the several hundred years of a dynasty precisely because the *memory* of these ancestral kings was constantly renewed through ancestral sacrifices. Since only royal descendents could hold such sacrifices, any *user* of the Tripods was self-evidently the inheritor of political power.

Finally, unlike a conventional monument, whose grandeur is often displayed on public occasions, the Nine Tri-

pods were concealed in darkness. In fact, many ancient writings, including Wangsun Man's statement, suggest that only because the Tripods were hidden and unseen could they maintain their power. We know that during the Shang and Zhou, ritual bronzes were kept in ancestral temples at the center of cities where the ruling clan held all important ceremonies. As I discuss in Chapter 2 of this book, such a temple, described in ancient texts as "deep" and "dark," functioned to structure a ritual process leading toward the ritual bronzes concealed deep inside, where only the male members of the ruling clan were allowed to enter. Outsiders were firmly forbidden to approach these vessels because this would have implied access to political power. This is why the Nine Tripods remained silent symbols of authority during the Xia, Shang, and Western Zhou, and why they suddenly became the focus of public interest during the Spring and Autumn and the Warring States periods after the Zhou royal house had declined and local kingdoms were competing for political dominance. The Chu lord's inquiry about the Tripods' "weight" in 605 B.C. initiated a series of similar events.[16] In 290 B.C., for example, Zhang Yi, the prime minister of Qin, proposed an attack on two towns in central China: "Once this is done, our troops will reach the outskirts of the Zhou capital. . . . The Zhou's only way to survive would be to submit its secret Nine Tripods and other precious symbols. With the Nine Tripods in our control, official

Fig. I.5. Divine tripod. Stone carving. Eastern Han. 2d century A.D. Excavated in 1954 at Suining, Jiangsu province. Xuzhou Museum. Ink rubbing.

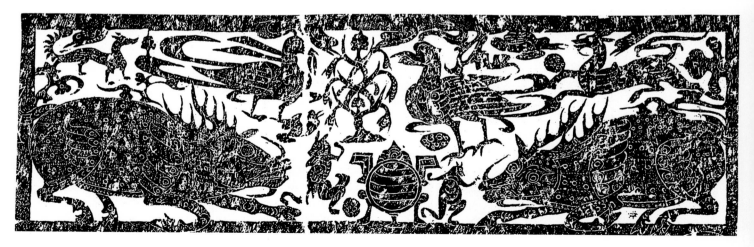

maps and documents in our possession, and the Zhou King himself as hostage, the Qin can thereby give orders to all under Heaven and no one would dare disobey."[17]

But according to the *Intrigues of the Warring States* (*Zhanguo ce*), the Zhou did manage to survive without losing its treasures. This was again accomplished through a clever minister's eloquence on the mysterious Tripods. It is said that not only the Qin but other powerful kingdoms such as the Qi, the Chu, and the Liang cast covetous eyes on the Tripods. The Zhou minister Yan Shuai first made use of Qi's desire for the vessels to upset Qin's plan. He then traveled to the east, persuading the king of Qi to believe that even if he could have the Tripods (as the Zhou had promised him), it would be impossible for him to move these monumental objects to his kingdom in Shandong:

> The Tripods are not something like a vinegar bottle or a bean-paste jar, which you can bring home in your hand. . . . In the past, when the Zhou king conquered the Shang and obtained the Nine Tripods, he ordered 90,000 people to draw each of them [to the Zhou capital]. Altogether 810,000 people, including officials, soldiers, master workers, and apprentices, were involved, and all kinds of tools and instruments were employed. People thus take this event as a most thoughtful and well-prepared undertaking. Now, even assuming that Your Majesty could gather enough men to pull the Tripods, which route could you take to bring them home? [The country is divided and all the kingdoms located between the Zhou and the Qi are eager to possess the Tripods; their lords would certainly not allow you to ship the Tripods through their land.] I worry that your desire will only bring trouble.[18]

In retrospect, we realize that in his defense of the Zhou's possession of the Tripods, Wangsun Man of the late seventh century B.C. was still relying on the Zhou's mandate and moral authority; Yan Shuai of the early third century B.C., however, resorted to a physical exaggeration of the size of the secret Tripods. His words remind us of other instances in which the lack of empirical experience with an object helps confound any real sense of its size and proportions. For example, Barbara Rose has observed in her study of modern Western artworks:

> Our idea of the monumentality of Picasso's works is not dependent on actual scale; in fact, in my case an appreciation of their monumentality was largely a result of never having seen the originals, but of having experienced them as slides or photographs. In this way, the comparison with the human body never came up, so that the epoch-making 1928–29 *Construction in Wire*, although a scant twenty inches high in actuality, was as large as the imagination cared to make it.[19]

Unlike Picasso's masterpiece, only verbal descriptions of the Tripods were available, allowing even freer exaggeration of these mysterious objects in imagination and expression. Also unlike the modern case, access to the Tripods was tightly controlled by law; an insider's knowledge of these secret objects thus became his means of possessing and exercising power. This is perhaps why Yan Shuai's account, though obviously fictional, still helped stop the king of Qi's plan to obtain the Tripods. On the other hand, Yan's emphasis on the Tripods' physicality was something new and alien to the traditional concept of the vessels' monumentality: he no longer described them as self-animated divine beings but as immobile, stupendous physical entities, each of which had to be drawn by an army of 90,000 people. The Tripods were now literally "heavy vessels," an expression originally denoting their extraordinary political significance invested in a limited material form. Likewise, whereas Wangsun Man was still confident enough to refuse the Chu lord's inquiry about the "weight" of the Tripods ("The weight of the Tripods cannot yet be inquired about"), Yan Shuai volunteered information about the Tripods' "weight" and based his whole rhetoric on exaggerating it. As we will see, such differences reflect a crucial change in the concept of monumentality during the Eastern Zhou, when China was undergoing a transition from the archaic Three Dynasties to the imperial era. In fact, Yan Shuai's account represented a final effort to save the Tripods by supplying these old political symbols with the symbolism and forms of new types of monuments. In this sense, the original monumentality of the Nine Tripods had been rejected, and they, as material monuments, would soon disappear: when the Zhou dynasty finally fell, they also vanished into a river.[20]

•

The story of the Nine Tripods is probably sheer legend: although many ancient writers recorded and discussed the Tripods, no one ever claimed to have seen them and could thus describe them in detail. Nothing seems more unsuitable for an art-historical inquiry than such elusive objects. But to me, their value as historical evidence lies not in their physical form, not even in their existence, but in the myth surrounding them. Instead of informing us what the Nine Tripods were, the ancient authors told us what they were supposed to be. They were supposed to commemorate an important historical event and to symbolize political unity and its public. Concealed in the royal temple, their location defined the center of the capital and the country; the common knowledge of their location made them a focus of social attention. They could change hands, and their possession by different owners, or their "movement" from one place to another, indicated the course of history. They took the form of a cooking utensil but exceeded the utilitarian usage and productive requirements of any ordinary vessel. Most important to an art-historical inquiry, they demonstrated their unique status through physical attributes including material, shape, and surface patterns. Since all these implications of the Nine Tripods are crucial to our understanding of extant ancient bronzes and other ritual objects, these legendary objects help us discover not only a forgotten concept of monumentality in ancient China, but also a new perspective in interpreting the whole tradition of *liqi* (ritual paraphernalia) or *zhongqi* ("heavy" vessels), which dominated Chinese art from late Neolithic times to the end of the Three Dynasties.

This interpretation is pursued in Chapter 1 of this book, "The Age of Ritual Art." As the earliest artistic tradition in China, ritual art divorced itself from the principle of "least effort" associated with crafts and introduced the concept of "conspicuous consumption."[21] Thorstein Veblen's idea, that wasteful spending can enhance social prestige and power,[22] has enabled anthropologists to find an essential feature of monumental architecture: its vast scale requires an extraordinarily large amount of human energy.[23] But to the ancient Chinese, who did not pursue colossal buildings until the end of the Three Dynasties, conspicuous

ritual objects signified the power to control and "squander" human labor. The earliest works of ritual art were therefore "expensive" imitations and variations of ordinary tools and utensils: an axe made of extremely hard jade or a clay jar with paper-thin walls. The distinction between *liqi* and *yongqi* (practical utensil) began to emerge through conscious choices of *material* and *shape*; surface patterns then appeared as additional signifiers of *liqi* and developed into *decoration* and *inscription*.

The conspicuous principle of ritual art also implies that during this early period, whenever a new medium was discovered or a new technology invented, it would be absorbed into the *liqi* tradition to become its exclusive properties. The amazing development of bronze art in ancient China best demonstrates this theory. The concept of a Bronze Age is conventionally understood as a period in human history characterized by the intensive production and utilization of bronze implements; the Chinese Bronze Age, however, must be defined as a specific stage of ritual art. Bronze vessels and other ceremonial paraphernalia became the major representatives of this art tradition; practical tools were rarely, if at all, made of this "precious" material. The course of ritual art thus conforms to a traditional Chinese evolutionary theory that places the Bronze Age after a Jade Age. In this scheme, jade is distinguished from stone just as bronze is differentiated from iron: stone and iron are "ugly" materials for practical tools, whereas jade and bronze are "fine" media for ritual art.

This and other observations lead me to depart from two standard methods of studying early Chinese art. First, instead of classifying ancient objects into individual material categories (such as jade, pottery, and bronze) and observing their relatively independent evolution, I pay special attention to the historical and conceptual relationship between works in different media. Second, rather than taking "shape" and "decor" as the major criteria for an artistic or semiotic analysis, I assume that the four basic attributes of ritual art—*material, shape, decoration,* and *inscription*—all possessed meaning and could separately play the leading role in developing a new stage of this art. Although these two approaches are by no means entirely new, I hope not

only to *propose* but also to *practice* them in a reconstruction of the history of ritual art, which will integrate and further develop many important discoveries and ingenious observations by individual scholars in art history, architectural history, archaeology, anthropology, metallurgy, religion, and history.

If we take the course of bronze art as an example, the late Xia plain cups from Erlitou (see Fig. 1.34)—the earliest known Chinese bronze vessels—have been considered "primitive" because they lack surface decoration. But in my view they represented a major advance in ritual symbols by transforming ceremonial pottery into metal; their meaning, or monumentality, was conveyed primarily by the newly discovered art medium. Decoration appeared during the early and middle Shang and soon became the locomotive of bronze art (see Figs. 1.37–46). The study of decoration usually falls into the domains of iconography and formal analysis; the former classifies and identifies motifs, and the latter focuses on the evolution of style. My investigation, however, shows that Shang bronze decoration is deliberately "metamorphic" in both style and motif. This fundamental characteristic challenges the premises of iconography and stylistic analysis and demands a new interpretation of the development of bronze art. Scholars have frequently noticed that Western Zhou bronze decor developed in the direction of abstraction and simplification. This process, in my view, did not necessarily reflect a formal evolution. Rather, the decline in decoration resulted from the increasing dominance of inscription: now that it bore a long commemorative text, a bronze became an object of "reading," not of "viewing" (see Fig. 1.65).

Interestingly, Wangsun Man seems to have encapsulated this dynamic process of bronze art into the single set of Nine Tripods. His emphasis on the symbolism of the bronze material could have been shared by the maker of the Erlitou cups (Fig. 1.34). He said that the Tripods bore *things*, most likely emblems of local regions, and such emblems only appeared on bronzes after the early Shang (see Fig. 1.47). His belief in the supernatural qualities of the Tripods—their "intelligence" and ability to generate their own movement—seems to have been related to late Shang bronze decoration, whose metamorphic imagery gave

a vessel an air of animation (see Figs. 1.45–46). The number of the Tripods, however, must have reflected a Western Zhou convention that a set of "nine tripods" symbolized the Son of Heaven (Fig. I.6). As mentioned earlier, ancient writers recorded that the Tripods disappeared into a river some time after the Western Zhou. When the fierce Qin First Emperor unified the country in the third century B.C., the Tripods exposed themselves in the river. The emperor was overjoyed and immediately ordered several thousand men to seek these divine objects. The men had secured the Tripods with ropes and were about to haul them out when a dragon suddenly appeared and bit the ropes to pieces. The Tripods vanished, never to appear again (Fig. I.7).[24] Significantly, the "life" of the Tripods coincided exactly with the duration of the pre-imperial Three Dynasties.

With the disappearance of the Nine Tripods, the age of ritual art ended. The monuments of the new historical era were no longer secret "heavy vessels" but enormous palaces and funerary buildings, whose imposing images dazzled the eye. This historical transformation is the topic of Chapter 2, which also tackles the unanswered questions of why murals and bas-relief carvings became the main forms of Han art and why pictorial images came to dominate the artist's imagination. My survey again begins from the Three Dynasties, but with a new focus on architectural forms that housed *liqi*. These were ancestral temples established at the center of large and small cities

Fig. I.6. Five ding *tripods and four* gui *vessels from Yu Bo's tomb. Mid–Western Zhou dynasty. Ca. 9th century B.C. Excavated at Rujiazhuang, Baoji, Shaanxi province. Drawing.*

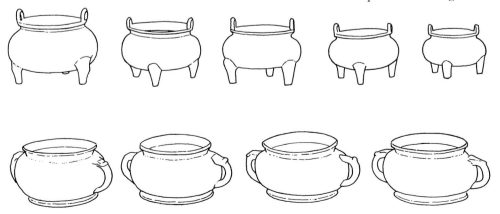

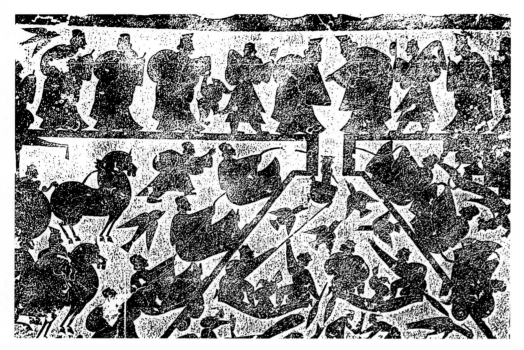

Fig. I.7. The First Emperor's unsuccessful search for the divine tripod. Carving on the Left Wu Family Shrine. Late Eastern Han. 2d half of 2d century A.D. Jiaxiang, Shandong. Ink rubbing.

(see Figs. 2.4, 6). Never pursuing the third dimension, the evolution of this architectural type was characterized by extending the central axis and by adding more layers of gates and walls—the two principal features of a temple that punctuated a ritual journey. This journey began with the worship of recent ancestors in the shrines near a temple's entrance, and ended at the last shrine, which honored the Original Ancestor or the founder of a lineage. What we find here is the essence of ancestral worship during the Three Dynasties: "to go back to the Origin, maintain the ancient, and not forget those to whom the living owe their being." [26]

The royal temple in the capital—the temple with the highest status—housed both sacrifices to former kings and all important state ceremonies. In this sense, it combined the functions of a religious center and a political center. But when the archaic social system based on a lineage hierarchy fell apart after the Western Zhou, the palace gained independence and became the chief political symbol of powerful feudal lords. Tall *tai* platforms and terrace-buildings—new types of palatial architecture— emerged to suit the needs of the new social elite (see Fig. 2.18). We are told that some of these structures, more than a hundred meters high, helped their owners intimidate and even terrorize political opponents. These palatial buildings contradicted the old ancestral temple in every respect: no longer a deep, walled compound concealing secrecy, an Eastern Zhou and Qin palatial platform soared into the sky. It did not guide people back to the Origin through a temporal ritual sequence but displayed the immediate power of the current ruler.

The appearance of terrace-buildings in graveyards indicated another aspect of the Eastern Zhou social transformation: in the religious sphere, the center of ancestral worship gradually shifted from temple to tomb (see Fig. 2.27). This development originated in the divergent symbolism of these two kinds of architecture: even during the Shang and the Western Zhou, a temple honored generations of ancestors, among whom the founder of a lineage was the most venerated; a tomb, on the other hand, was built for one's late father or close relatives. As the ambition of individuals skyrocketed during the Eastern Zhou, the

and towns. Their name, *zongmiao* or "lineage temple," most clearly points to their social and political significance: as K. C. Chang and other scholars have convincingly demonstrated, the society of the Three Dynasties was fundamentally a hierarchy of patrilineages, and the temples (or, more precisely, the ancestors worshipped in them) identified these lineages' status and interrelationship in the overall sociopolitical network.[25] Ancient hymns, documents, and ritual canons reveal the overwhelming importance of a temple: a "noble man" was supposed to erect this building before he made any structure for the living, just as ritual vessels were supposed to be made before any cooking or eating utensil. Such statements identify *liqi* and the temple as the two basic components of a Three Dynasties monumental complex: the former defined the locus of power, and the latter provided a ritual site.

Excavated Three Dynasties temples further enable us to understand how a temple embodied social and political values in its architectural form. A flat courtyard structure surrounded by walls, a temple created an enclosed space, separating itself from the surrounding mundane world

grandeur of funerary structures rapidly increased. Feudal lords considered an enormous mausoleum a personal monument; they constructed their "funerary parks" and issued laws to guarantee their completion. This architectural movement gained additional momentum during the Han: nuclear families replaced large lineages as the basic social unit; popular religions supported by the Liu imperial family prevailed, and irregular royal successions caused difficulties in maintaining traditional temple worship. This last factor led Emperor Ming, the second ruler of the Eastern Han, to abolish all temple services and to transfer them to graveyards. The next two centuries emerged as the golden age of funerary art in Chinese history. This instance also teaches us that the development of monuments was not a teleologic process but was affected by chance accidents. Sometimes the needs of a particular group of patrons could dramatically change the form and function of monuments and could reorient the direction of artistic creation. An art-historical study should not only describe a general evolution but also explore such accidents and determine their impact on the general development of art and architecture.

Unlike wooden-framed palaces, many Eastern Han funerary monuments were made of stone—a material the ancient Chinese had never favored (see Figs. 4.2–5). I investigate this sudden "discovery" of stone and conclude that the Han Chinese learned this medium from the ancient Indians, who had been building stone monuments for centuries. My principal goal, however, is not simply to suggest *what* happened but to show *how* and *why* this cultural exchange took place. The alien material became "meaningful" to the Chinese only because it became associated with intrinsic Chinese concepts. Three interrelated concepts in the Han immortality cult and funerary art—death, immortality, and the West—became associated with stone. Such conceptual correlations enable me to explain many puzzling phenomena. Why, for example, did Prince Liu Sheng's tomb have a wooden house built in his underground "audience hall" but a stone house in his burial chamber? Why did Emperor Wu construct his mausoleum due west of the capital Chang'an? Why was a temple of the Queen Mother of the West a stone

structure? Why did Emperor Ming, the first Chinese ruler to send envoys to seek Buddhism in India, build the first imperial stone funerary shrine for himself? Finally, why did stone become the proper medium for funerary monuments that also bore many "Buddhist" motifs?

Chapter 2, therefore, describes and explains the transition from Shang-Zhou ritual art to Qin-Han palatial and funerary monuments. In this way, it introduces the next two chapters, which focus on the palace and the tomb, respectively. The topic of Chapter 3 is the Western Han capital Chang'an. Although scholars have tried repeatedly to reconstruct this important historical city, they tend to offer a static image reduced to a two-dimensional plan: a Chang'an with city walls, twelve gates, thirteen imperial mausoleums, and a certain number of palaces (see Figs. 3.1–4). My reconstruction of the city takes a different route: instead of synthesizing all literary and archaeological evidence into a single, timeless image, I try to use this evidence to illustrate crucial changes in Chang'an's history. We find that Emperor Gaozu, the founder of the Han, built an individual palace as the supreme symbol of the new regime. The city walls came into being only under his son, and their construction, guided by an old city plan, reveals the power of tradition in early Han politics. The fifth Han emperor, Wu, turned his eyes to the city's outskirts, where he built a fantastic garden and a replica of the Heavenly Palace. Finally, Wang Mang, who took over the Han throne and founded the short-lived Xin dynasty, destroyed Emperor Wu's garden and reused its material to build a group of Confucian monuments to legitimate his mandate from Heaven. What I hope to show is Chang'an as a dynamic historical process, shaped by a series of changes that reflected divergent concepts of monumentality (see Maps 3.1–2, 6–7).

A different strategy is employed in my discussion of Han funerary monuments in Chapter 4. Instead of tracing the general evolution of this art, I limit my observation to a single region in present-day western Shandong and to the two decades from A.D. 150 to 170. This narrow scope helps me uncover different intentions behind establishing and decorating funerary monuments. I thus share the basic approach of Martin Powers and other scholars

that a Han funerary complex represented a cross section of society: it was not only a center of ancestral worship within the family but was also a focus of social relationships; its monuments not only were the property of the dead but also bore witness to the various concerns of the living.[27] Instead of dividing patrons of funerary monuments into different social groups or classes, however, my discussion shows that the construction of an Eastern Han funerary site often combined the efforts of four groups of people: the deceased, his family, his former friends and colleagues, and the builders. I try to uncover their different concerns—the "voices" of Han funerary monuments—by reconstructing a number of historical scenarios based on existing funerary inscriptions and carvings.

Chapter 5 ends this book by discussing what may be the most important event in Chinese art history: the appearance of individual artists during the post-Han era who transformed public monumental art into their private idiom. Before this moment, what we call works of art, whether a bronze vessel or a stone shrine, served a direct function in religious and political life; their creation was generally mobilized by the desire to make religious and political concepts concrete. They were made by anonymous craftsmen through collective efforts, and major changes in subject matter and style were determined, first of all, by broad social and religious movements. Unlike later scroll paintings that can be appreciated individually, the various forms of early Chinese art were integral parts of larger monumental complexes; an individual form gained significance both through its intrinsic attributes and in conjunction with other forms. These essential features of early Chinese art determine the scope of this book.

This study, therefore, is essentially a historical inquiry rather than a theoretical abstraction. The theme of monumentality enables me to pursue a systematical reconstruction and reinterpretation of early Chinese art history. Instead of a single Chinese concept of the monumental, we find multiple ones, whose divergent ideals highlight different art traditions and whose historical relationship reveals a major thread running through the course of early Chinese art and architecture. We find this thread

in the shifting focus of artistic creation from ritual paraphernalia to palatial and funerary structures. Decorative, pictorial, and architectural forms, often approached and described as separate histories, appear to be interrelated and subordinated to a broad artistic movement. It is my hope that a reconstruction of this movement will lead to a better understanding of how art and architecture evolved and functioned in a changing society—how forms were selected and employed in ritual and religious contexts, how they oriented people both physically and mentally, how they exemplified common moral or value systems, how they supported and affected the constitution of collective identities and specific political discourses, and how they suited individual ambitions and needs.

In terms of methodology, the theme of monumentality helps me bring some current scholarly concerns in early Chinese art history into a single focus. The first of these concerns is to "revolutionize" traditional formal analysis by broadening the scope of observation, by studying the relationship and interaction between different types of signs, and by investigating the technological determinants of styles. The second concern emphasizes the interaction between the viewer and objects; it is argued that such interaction—rather than the "objective" attributes of a work of art—determines the work's value and meaning in the observer's perceptual system. The third concern focuses on various "contexts": by placing and observing a work of art in its physical, ritual, religious, ideological, and political environment, scholars hope to determine more accurately its position, significance, and function in a given society. Related to such contextual research is a fourth trend often termed "patronage studies," which concentrate on the sociological aspect of art and explore the direct impact of patrons upon subject matter and style. Finally, a fifth trend called "cultural history" focuses neither on individual objects nor on their contexts but utilizes all sorts of visual and textual materials to reconstruct the past in all its vividness.

I believe that these methods are not contradictory but can be used complementarily either to show various aspects of early Chinese art or to conform to the available data. The five chapters of this book deliberately employ these

different methods. Chapter 1 on *liqi* tries to reconstruct the history of ritual art based primarily on its intrinsic visual properties. I select the mode of a broad historical narrative partly because of the lack of detailed information about artisans, workshops, and patrons, and about the design and manufacture of specific objects. Chapter 2 locates ritual paraphernalia in their architectural, ritual, and political contexts; the decline of *liqi* and the independence of architectural monuments signifies, then, an important historical transformation. Chapters 3 and 4 share the goal of cultural history in portraying a broad social and historical spectrum, but my reconstruction of Chang'an follows a chronological order whereas my discussion of funerary monuments explores a cross section of society. Both chap-

ters consider patrons' roles but with different focuses: I relate Chang'an's changes directly to the ambitions and political agenda of individual rulers; the patrons of funerary monuments, on the other hand, included petty officials, local scholars, and commoners, whose concerns often reflected prevailing social and moral values. Chapter 5 describes the transition from early Chinese art to later Chinese art. Instead of reconstructing specific historical situations, I hope to employ various kinds of evidence to illustrate a "revolution" in visual perception and representation: when educated artists and writers began to dominate the art scene, they viewed public monuments in a new light and transformed them into a private art.

The Age of Ritual Art

When Heaven gave birth to the multitudes of
 people,
There came images and words.
Holding up ritual vessels [that bore them],
People could appreciate fundamental virtue.

THESE LINES OPEN a famous Zhou dynasty ode in
the *Book of Songs*. But I doubt that readers, even learned
sinologists, could immediately identify the original Chinese source. This is because this English translation rejects
the ode's orthodox exegesis and follows a reinterpretation
proposed by Liu Jie fifty years ago. Although largely unknown or forgotten, this reinterpretation, in my opinion,
"rediscovered" the poem, which had been buried underneath thick layers of Confucian commentaries.[1] To appreciate the freshness of Liu's reading we need only compare
it with James Legge's 1871 translation of the same stanza:

> Heaven, in giving birth to the multitudes of the
> people,
> To every faculty and relationship annexed its law.
> The people possess this normal nature,
> And they [consequently] love its normal virtue.[2]

Here Legge closely followed a Confucian exegetical
tradition, first established by Mencius and then elaborated
by two Han Confucian masters, Mao Heng (2d c. B.C.)
and Zheng Xuan (A.D. 127–200).[3] Mencius cited the

lines to support his view of human nature. Mao and Zheng
focused on individual terms; in itself the need for annotation implies that the original meaning of these lines had
become obscure by Han times. Without citing philological
or textual evidence, they defined three characters in the
verse as three key concepts in Confucian ideology: *wu*, as
general human faculties and relations; *ze*, as common laws
and principles that govern or guide these faculties and relations; and *yi*, as the "constancy" (*chang*) in human nature. They thus followed Mencius in viewing the ode as
an abstract Confucian philosophical discourse, and their
commentaries transformed the lines into such a discourse.

This Confucian exegesis remained the basis for all discussions of the ode until it was challenged when China
entered the modern era. Liu Jie, an advocate of New Historical Studies (*xin shixue*) in the May Fourth tradition,
wrote an article in 1941 redefining the three terms. Citing
evidence from a comparative textual analysis, he argued
that *ze* means "inscription" or "to inscribe" instead of
"laws" or "principles." His identification of *wu* as "totem"
is less successful (largely because of the vagueness of the

Western concept "totem").[4] But his basic assumption, that *wu* are images symbolizing groups of people, threw much light on this and other ancient passages, including the one about "distant regions" sending the pictures of their *wu* to the Xia and having them represented on the Nine Tripods. Finally, he pointed out that *yi* is a collective term for ritual vessels; this definition was still well remembered during the Han. With this explanation, Liu Jie allowed students of Classical literature to read the lines from the *Book of Songs* anew. The ode seems to present an idea much older than that of Mencius, Mao Heng, or Zheng Xuan. It teaches that when Chinese civilization had just appeared, what supported it were not abstract laws but concrete ritual vessels engraved with images and words; only by treasuring these ritual objects could people "appreciate fundamental virtue."

These lines thus convey to us an authentic voice from the Age of Ritual Art, the subject of this chapter. Equally important to my discussion, the rediscovery of these lines in modern scholarship attests to the power of interpretation. It sets an excellent example for my study of archaic monumentality in China, a study that also aims to restore to their original cultural context some well-known examples of early Chinese art and architecture.

The Concept of 'Liqi'

At the bottom of each branch of human knowledge rests a classification. Before the world can be explained, it must be ordered; a mass of undifferentiated phenomena must be divided into manageable groups or classes. Members of a single group are considered to share certain common characteristics, either physical or conceptual. Since criteria essential for a classification are selected (though not always consciously) from the myriad features of the objects being classified, a classification is always determined by the position of the classifier and thus always appears as a historical phenomenon, temporal and purposeful.

Generally speaking, there are two basic ways in which social phenomena are classified: the "internal classification" or "natural order position," made by contemporary members of the society, and the "external classification"

or "artificial order position," pursued by people outside the society, either from alien cultures or from later periods.[5] These two systems both reflect and index the cognitive and cultural structures of the classifiers, but the latter is often viewed as an objective system and is often imposed on the original society.

The classification at the bottom of the study of early Chinese art is a typical external classification. It displaces ancient works of art and transfers them from their original contexts into the structure of a later social science. When antiquarians first cast their eyes on ancient artifacts, they were dealing with random assemblages of old objects whose natural orders had largely been forgotten. It is these antiquarians—collectors and cataloguers—who first overcame this chaos by re-establishing a new order.[6] Even the Chinese term for antiquarianism, *jinshi xue*, suggests a basic classification. *Jin* and *shi* mean, respectively, "metal" and "stone," and *xue* means "discipline." The term can properly be translated into English as "the study of [ancient] metal and stone works."[7] This system, established during the Song, has been continuously refined ever since. The number of medium-oriented categories has constantly increased; Zhao Ruzhen's early twentieth-century *Guide to Antiques* (*Guwan zhinan*) alone introduces 30 kinds of ancient artifacts of different materials.[8]

The classification of research materials further led to the classification of the researchers themselves. As data proliferated and scholarship became increasingly sophisticated, no one individual could deal with the vast array of ancient works in an encyclopedic manner. Collectors and researchers began to concentrate on one particular class of objects, and their expertise in their own field made them acknowledged scholars and connoisseurs. The medium-oriented division of professionals thus rests firmly on a medium-oriented classification of materials. Consequently, the belief emerged that each medium-based branch was an independent artistic "genre" with its own life. True, there have been efforts to reunite these separated branches into a coherent narrative, but until recently the boundaries separating categories were rarely crossed.

Thus, when at the beginning of the twentieth century the British Board of Education commissioned Stephen W.

Bushell to write the first comprehensive English-language introduction to Chinese art, one of his major tasks was the organization of his material (and hence the structure of his book). A learned sinologist who had lived in Beijing for some thirty years, Bushell described himself as "a diligent collector of Chinese books relating to antiquities and art industries [who has] tried to gain a desultory knowledge of their scope."[9] In establishing the basic descriptive categories for his book, he combined the Chinese antiquarian tradition with a Western classification of "collectible objects" popular in his day. The twelve chapters of the book survey the histories of twelve branches of Chinese art, including bronzes, carved jades, pottery and ceramics, and lacquer wares, with "typical" examples selected from the Victoria and Albert Museum. As Bushell wrote in his preface, "These have been the lines followed here as far as the brief space assigned to each branch of art has allowed."[10] Many other scholars of early Chinese art and archaeology shared Bushell's strategy for studying the whole span of Chinese art history, though their "material categories" were often fewer. When the prominent historian Liang Qichao delivered a talk entitled "Archaeology in China" before the crown prince of Sweden in 1926, he began: "If we classify the objects that have been treated by the archaeologists [a term also referring to traditional antiquarians and art historians] of the last 150 years, we get four kinds: (1) Stone, (2) Bronze, (3) Pottery, and (4) Bones and tortoise shells."[11]

Although such a classification has the obvious advantage of arranging the vast and often chaotic collection of ancient objects into comprehensible units, it has disadvantages. As Stephen Owen points out in a discussion of Chinese poetry:

> There are dimensions of the poetic art, often those of the "greatest force," which lie beyond the reach of our usual discourse on literature. When that "greatest force" is felt to move in poems, there is no reason to meddle with it or to seek to expose its workings. But when an art is displaced—by transfer to another civilization, by time's long spans, or by the disruption of its continuity—then we must discover a way to give voice to those very dimensions of the poetic art which are usually left in tactful silence.[12]

The question confronting a student of early Chinese art is, therefore, where and how to "discover a way to give voice" to the silent force that once governed the original working of this art but has largely been neglected in later "external classifications." More specifically, how can we explore the ancient Chinese concept of monumentality if it is conveyed by unfamiliar forms? To pursue this goal, I suggest that we try to discover the "internal classification" of early artworks or, more practically, to find ancient classification systems closer to the original classification than our own.[13] This proposal has led me to the *Three Ritual Canons* (*San li*—*Li ji*; *Yi li*, or *Ceremonies and Rites*; *Zhou li*, or *Rites of Zhou*). Compiled at the end of the Bronze Age, these records were written by ritual specialists who attempted to revitalize (by systematization and idealization) earlier ritual procedures and institutions. These are not art-historical or historical studies, and their authors treated bronzes or carved jades as contemporary, functional objects rather than as relics of the remote past. Differing from later medium-oriented scholarship, which often isolates works of art from their contexts, these books always situate manufactured objects in groups and in specific ritual occasions. In terms of both chronology and ideology, therefore, these records are close to the period during which ancient bronzes and jades were produced and used, and they preserve important clues for a proper understanding of early Chinese art.

The most fundamental classification of manufactured forms proposed by the authors of these books is that between "ritual paraphernalia" and "daily utensils." This distinction, which is closely related to the ancient Chinese conceptualization of art, craft, and monumentality, is clearly stated in the following passages:

> When a nobleman is about to prepare things for his lineage, the vessels of sacrifice should have the first place; the offerings, the next; and the vessels for use at meals, the last.[14]

> Not until [a Grand Officer] has made sacrificial vessels is he permitted to make vessels for his own private use.[15]

> The [jade] *gui* tablets, *bi* disks, and the gilt libation cups are not allowed to be sold in the marketplace [where

utensils are sold]; nor are the official robes and chariots, the gifts of the king, or vessels of an ancestral temple.[16]

The last passage suggests more detailed categorizations based on material, form, and precise usage within the general class of "ritual paraphernalia." In fact, large portions of the ritual books are devoted to regulating the combinations of such objects to be used on different ritual occasions. Thus, we read in the *Rites of Zhou* that the senior and junior *zongbo*, the two chief ceremonial officials of the royal lineage (*zong*), are responsible for "the rituals for the heavenly deities, human ghosts, and earthly spirits of the state." All the articles they administer are ritual objects and include "six types of ritual jades," "six types of bronze vessels for presenting sacrificial food," "six types of bronze vessels for presenting sacrificial wine," and many others.[17] The production of daily utensils is not their business.

The standard Chinese term for "ritual paraphernalia" is *liqi* (*jiqi*, or "vessels for ancestral sacrifices," is sometimes used interchangeably). The meaning of *li* is close to "ritual" or "rite," and *qi*, to "vessel" or "implement." Although this composite term itself draws a rough boundary for the genre, it is far from adequate for defining its actual content, since the two characters of the term—*li* and *qi*—refer to innumerable things and concepts. The nineteenth-century French sinologist Joseph Marie Callery summarized the usages of the character *li* in Classical Chinese writings:

> As far as possible, I have translated *li* by the word "rite," whose meaning has the greatest range; but it must be acknowledged that according to the circumstances in which it is employed it can signify ceremonial, ceremonies, ceremonial practices, etiquette, politeness, urbanity, courtesy, honesty, good manners, respect, good education, good breeding, the proprieties, convention, *savoir-vivre*, decorum, decency, personal dignity, moral conduct, social order, social duties, social laws, duties, rights, morality, laws of hierarchy, sacrifice, mores, and customs.[18]

Callery's list is by no means a compact definition, but it does make clear two major aspects of human lives to which the concept of *li* is applied: ceremonies and related practices, and the social conventions—primarily those of law, morality, and propriety—that govern the working of society at large. These two aspects overlap: in the ritualized society of the Three Dynasties, ceremonies both reflected and regulated human relationships and thus determined legal and moral standards; correct "ritual behavior" could hardly be distinguished from "propriety" or "good manners."[19] If we must explain *li* in a short formulation, we may say that it means the principles and forms of both secular and sacred relations and communications.[20]

Li, therefore, seems to have embodied general social principles shared by everyone, and indeed many writings on ancient Chinese ideology have created an impression that *li* was universally applicable to all members of society.[21] This may have been the dream of later philosophers, but it was certainly not a reality, for the whole system of *li* depended on and also guaranteed social stratifications and distinctions. It is stated plainly in the *Book of Rites*: "*Li* does not extend down to the commoners, nor does *xing* [punishment] extend to the noble."[22] *Li* became meaningful and functional only within this polar structure. It provided reasons for the king to be a king, a lord to be a lord, and so on down to the lowest level of the aristocratic hierarchy. It forced an individual of the aristocratic class to behave according to his inherited and assigned status; otherwise he would be accused of being *feili* ("against *li*"), a severe denunciation implying "unlawful" and "immoral." *Li*, therefore, was the manus of the ruling machine, and both its fundamental premise and its primary function were "to distinguish." This role of *li* was explained explicitly by the ancient Chinese themselves: "It is *li* that clarifies the dubious and distinguishes [things] to the minute, and thus it can serve as dykes for the people. Because of *li*, there are the grades of the noble and the mean; there are the distinctions of dresses [as symbols of social ranks]; the court has its proper position; and people all yield their places."[23] A more elaborate paean glorifies *li* to almost godlike proportions:

> Of all things by which men live, *li* is the greatest. Without *li*, there would be no means of regulating the services paid to the spirits of heaven and earth; without *li*, there would be no means of distinguishing the positions of ruler and subject, superior and inferior, old and young;

without *li*, there would be no means of maintaining the separate relations between men and women, father and son, elder and younger brothers, and of conducting the intercourse between families related in marriage, and the frequency and infrequency [of the reciprocities between friends].[24]

This quotation provides an explanation for the origins of *li*. Here, two hierarchical systems, one political and the other genealogical, become entangled as the result of *li*'s operation. These systems were two dimensions of a single network that unified the aristocratic society of the Three Dynasties. Among modern scholars, K. C. Chang has argued most forcefully that the basic elements of pre-Qin society were patrilineages fragmented from a number of clans.[25] Theoretically, all members of the ruling group, from the king down to the lowest-ranking official, were related by blood or marriage. A person's social and political status was primarily determined by seniority in the overall genealogical structure. For instance, a king had the right to be a king because he was a direct descendent of the founder of the clan that dominated the country; his younger brothers could only be lords of principalities. Following this pattern of fragmentation, direct descendents of a lord carried on their ancestor's duty under the same official title; other branches of the lineage were set up with descending ranks and fiefs.

This is, of course, much too simplistic a summary of the social and political structure of archaic China and the Zhou system, but it may help us understand the most important component and expression of *li*—*ji*, or ancestral sacrifices. The *Book of Rites* states: "Of all the methods for the good ordering of men, there is none more urgent than the use of *li*. *Li* are of five kinds [i.e., sacrificial, mourning, greeting, military, and festive], and there is none of them more important than *ji*."[26] We may add another layer to this statement: of the many ways available to the living to show their respect to their ancestors, none was more important than offering food and drink. Year after year, members of a lineage gathered in the ancestral temple and placed food and wine before the symbols of the dead. As I discuss in Chapter 2, the design of the temple reflected the lineage's genealogy, with its founder worshipped at

the innermost location in the compound and more recent ancestors worshipped nearer the entrance.[27] This architectural form thus became a metaphor for the social structure, and the ancestral ritual held in it defined the social hierarchy. As the ritual of ancestral sacrifice identified a person's status in the clan-lineage framework was identified with clarity and repetition, his position in the political framework was regulated. Any attempt to break these bonds was "against *li*."

To Shang and Zhou people, ancestors were not abstract concepts but concrete beings. Although believing the departed kin had become spirits with whom one could communicate only through secret means, they also insisted that these invisible beings retained all human desires, especially that for food. This mortal attachment divulges a kind of intimacy beyond political calculation. Descendents kept recalling the hardships their remote ancestors had experienced; the accuracy of their reminiscences often surprises a modern anthropologist.

> In the past, our former kings had no palaces and houses. In winter they excavated caves and lived in them, and in summer they framed nests and stayed in them. They knew nothing about fire and cooking; they ate the fruits of plants and trees, as well as the flesh of birds and beasts. They drank the blood of animals and swallowed their hair. They were ignorant of flax and silk and clothed themselves with feathers and skins.
>
> Later, sages arose and invented and utilized fire. They moulded the metals and fashioned clay, and they built towered pavilions and houses with windows and doors. They toasted, grilled, boiled, and roasted. They produced must and sauces, and they made linen and silken fabric from flax and silk. They were thus able to nourish the living, to carry out mourning for the dead, and to serve the spirits of the departed and the Lord on High; in all these things we must follow their examples.[28]

The history of Chinese civilization is thus viewed as the creation and elaboration of *li* or *ji*; the later generations must follow *li* and *ji* diligently because these are the foundation of the whole civilization:

> Thus, [in our sacrifices] the dark liquor is offered in the inner chamber [of the temple]; the vessels containing

must are placed near its entrance; the reddish liquor is offered in the main hall; and the clear, in a place below. Animal victims are displayed, and the tripods and stands are prepared. The lutes and citherns are arranged in rows, with the flutes, sonorous stones, bells, and drums. The prayers and the benedictions are framed. All of these aim to bring down the Lord on High, as well as ancestral deities, from above.

The relation between the ruler and ministers is then rectified; generous feeling between father and son is maintained; elder and younger brothers are harmonized; the high and low find their own positions; and the proper relationship between husband and wife is established. This is what is called "securing the blessing of Heaven."[29]

As suggested by this passage, in the course of history the quality of offerings was gradually refined and newly discovered materials and techniques were employed to make ritual paraphernalia. But the function of *ji* or ancestral sacrifices remained without change: they maintained the social structure by drawing distinctions, because proper distinctions meant a good order. The same logic can be reversed: although the ancestral sacrifices supported social organizations throughout ancient Chinese history, their paraphernalia was subject to constant change, and from these changes emerged a history of ritual art centered on sacrificial vessels.

An idea repeatedly emphasized in the ritual books is that "*li* began from meat and drink [of sacrifices]."[30] To students of art, this means that *li* began with the use of vessels and other ritual implements. In fact, this implication of *li* is suggested by the character itself, which consists of two pictograms; one (see character *a* to left) represents an ancestral tablet, and the other (*b*) shows a bowl containing offerings, perhaps two strings of jades.[31] This image, therefore, defines *li* by presenting its most tangible form—offerings presented to spirits. But the same image can also be understood as a representation of a ritual action—*to place* offerings before spirits, as explained in the earliest Chinese dictionary, the *Shuo wen*: "The character *li* means 'one step in an act'; whereby we serve spiritual beings and obtain happiness."[32] This twofold meaning of the character corresponds to two visual aspects of a

a

b

rite: on the one hand, a ritual employs numerous individual symbols—vessels, musical instruments, banners, insignia, ornaments—that we call *liqi*, or ritual paraphernalia, whose functions and meanings are signified by their material, shape, decoration, and inscription. On the other hand, a ritual is always a sequence of actions, and an individual symbol is always an integral element of a larger ritual complex and realizes its function and meaning in the ritual sequence. Such sequences may be discovered from ancient texts, but to art historians a ritual sequence must be defined according to the spatial conjunctions of individual symbols.[33] These two aspects of a ritual presentation thus determine the two levels of our investigation of ritual art: on the first level we study *liqi* as individual symbols, and on the second level we observe their spatio-temporal structure in relation to their architectural context.

The present chapter focuses on the first aspect, and its central question is What are *liqi*? The most convenient answer to this question is that *liqi* are objects *used* in ritual practices; thus the Qing scholar Gong Zizhen enumerated as many as nineteen different usages of *liqi* in a learned article entitled "On Temple Vessels" ("Shuo zongyi").[34] This understanding of *liqi* is still dominant in scholarly writings, largely because it fits well with a functional classification of ancient objects: the *ding* tripod is a type of ritual bronze because it was *used* to cook sacrificial meat, and the *gui* bowl is another type because it was *used* to contain sacrificial rice. These interpretations or identifications are important but not sufficient for our understanding of *liqi*, because they do not answer the question What is the *art* of ritual paraphernalia? By using the word *art*, we assume that these ancient ritual objects, in addition to their use as cooking pots or food containers in religious ceremonies, possess other kinds of values. What are these values, and how can we explore and identify these values? These much neglected questions are of crucial importance to early Chinese art history.

I explore these values and see how they change over time in the next section. But before throwing readers into an ocean of works of art, I need to examine the concept of *liqi* more closely and to relate it to the concepts of monuments and monumentality. As a conceptual entity, *liqi* are

characterized by a deliberate ambiguity that results from the multiple meanings of the term *qi*. The standard and narrowest dictionary definition of *qi* is "vessel," as in the *Shuo wen* dictionary: "*qi* means containers."[35] But the character was often employed in a broader sense, referring to all kinds of artifacts, including vessels, implements, and insignia; thus Duan Yucai, a Qing dynasty authority on ancient ritual books, argued that "*qi* is the general term for all manmade objects."[36] The concept *qi* was sometimes further broadened; *The Yellow Emperor's Inner Classic* (*Huangdi neijing*), an ancient medical book, defines it as "all forms that are empty inside and thus able to contain things."[37] In accord with this definition, the term is used in the book not for pottery or bronze jars but for the human body, which "contains" vital energy. This generalization finally leads to the broadest usage of the term, in the *Book of Changes* (*Yi jing*): "Form is called *qi*."[38]

The character *qi* was thus used and understood by the ancient Chinese both literally and metaphysically. As the former, a *qi* is a physical object distinctive in its function; as the latter, it is close to an "embodiment" or "prosopopeia"—a physical entity "containing" meaning and typifying an abstraction. The range of the changing concept of *qi* is demonstrated by the following quotations from the Chinese Classics, which are extremely important to a final definition of *liqi*:

1. *Qi* are [things] that can be handled and used.[39]

2. The round and square food containers *fu* and *gui*, the stand *zu*, and the tall dish *dou*, with their regulated [forms] and surface decoration, are the *qi* embodying *li*.[40]

3. The grand ceremonial bells and *ding* tripods, these are beautiful *qi* of extraordinary importance.[41]

4. It is only the *qi* and the title of a ruler that cannot be granted to others, because these are what enable him to govern. It is by his title that he secures the confidence [of the people]; it is by that confidence that he preserves the *qi*; it is these *qi* that conceal *li*; it is *li* that is essential to the practice of righteousness; it is righteousness that contributes to the advantage [of his state]; and it is that advantage which secures the quiet of the people. These are the principles of politics.[42]

5. What is above Form is called Principle; what is

within Form is called *qi*; what transforms things and fits them together is called Change; what stimulates them and sets them in motion is called Continuity; what raises them up and sets them forth before all people on earth is called Action. Therefore, with respect to Symbols: the sages were able to see those hidden in all the things under heaven; they provided them with forms to present their manifestations. These are called Symbols.[43]

6. [The sages] made *qi* to present Symbols.[44]

Thus, *qi* are vessels and objects in general, and *liqi* are ceremonial paraphernalia for specific ritual purposes. Utensils—*yongqi* or *yangqi*—are used in daily life and could be sold in the marketplace, whereas *liqi*—which embody essential ritual codes and political power—cannot be sold or granted to others. This understanding, in turn, leads us to another paradox of *liqi*: on the one hand, as a symbol, a *liqi* must be physically distinguishable from a utensil (also called a *qi*) in material, shape, decoration, and inscription so the concepts that it typifies can be clearly recognized and conceived. On the other hand, it is still a *qi*—a vessel or an implement comparable with a utensil in typology. In other words, a *liqi* is an axe, a pot, or a bowl, but it should not be an "ordinary" axe, pot, or bowl. This seemingly paradoxical feature of *liqi*, in fact, lies at the heart of the artistic genre, and its importance was clearly recognized by the ancient Chinese themselves:

The offerings to ancestral kings serve as food but do not minister to the pleasures of the palate. The ceremonial cap and the grand carriage serve for display but do not awaken a fondness for their use. The ceremonial Wu dance is characterized by its gravity but does not awaken the emotion of delight. The ancestral temple is majestic but does not dispose one to rest in it. The ritual vessels may be of use but are never made for people's convenience. The idea is that those used to communicate with spirits should not be identical with those for rest and pleasure.[45]

Significantly, the author of this passage speaks about the appearance and perception of *liqi*: the *forms* of the ceremonial cap, the chariot, the dance, the ancestral temple, and the temple vessels should not be "identical" with their counterparts as utensils, and the *feeling* and *thoughts* they

arouse should be distinguished from those aroused by ordinary utensils. There are interesting parallels between such ancient Chinese writings and modern discussions of monuments. According to these discussions, a monument, though taking the basic shape of a hall, gate, or tower, distinguishes itself from an "ordinary" hall, gate, or tower in material, form, and implication. In other words, broadly speaking, these modern monuments are also *liqi*—physical embodiments (*qi*) of principles or monumentality (*li*). I have cited ancient Chinese descriptions of *li*, which "clarifies the dubious and distinguishes [things] to the minute, and thus it can serve as dykes for the people." Similar admonitions abound in official rhetoric on modern monuments, which, without exception, identify a marble memorial hall or a stone obelisk as an embodiment of fundamental social codes and moral value: "Thus monuments are lasting incentives, to those who view them, to imitate the virtues they commemorate, and attain, by their life and spirit, glory and honor."[46] In Georges Bataille's critical view, "[Monumental] architecture, formerly the image of social order, now guarantees and even imposes this order. From being a simple symbol it has now become master."[47] The same words can be said of the ancient Chinese tradition of *liqi*.

Not every modern monument commemorates a definite figure or event. In fact, the numerous statues of anonymous figures in the United States, starting from the statue of the Minute Man erected on Lexington Green in 1876, has led Jackson to propose an interesting theory: "This kind of monument is celebrating a different past, not the past which history books describe, but a vernacular past, a golden age where there are no dates or names, simply a sense of the way it *used to be*, history as the chronicle of everyday existence."[48] We can approach many *liqi* from ancient China in a similar light: without inscriptions identifying their specific causes and purposes, these objects commemorated a nameless past through rituals rather than through records. They realized their monumentality in constantly refreshing the memories of bygone ages ("in the past, our former kings had no palaces and houses") and in transferring these memories into the ritual behavior of the living generation ("in all these things we

must follow their examples"). On this level, all *liqi*, from a tiny ritual jade to a grand bronze sacrificial vessel, can be identified as commemorative objects in a specific ritual context. Some *liqi* did refer to a specific figure and event, however. In addition to their basic function as ritual paraphernalia, they were reminders of such figures and events, and contributed to the formation of a written history. The Nine Tripods were the epitome of this type of *liqi* and could thus be singled out as the most important monument in archaic China.

In the discussion that follows, I shift to a more concrete level to examine the physical features of *liqi*: most important, their specific materials, shapes, decorations, and inscriptions as signifiers of *li* or monumentality. These features were gradually invented, enriched, and formulated over the course of a long process. Having attempted to define the concept of *liqi* based on textual sources, I therefore hope to reconstruct the history of *liqi*—as Arnold Isenberg has said, "those which have no simple names, are revealed, if at all, in acquaintance."[49]

The Legacy of Ritual Art

"COSTLY" ART

In Chinese art history, the notion of distinguishing *liqi* from *yongqi* (or ritual paraphernalia from utilitarian objects) emerged during the fourth millennium B.C. in the East Coast cultural tradition (Map 1.1).[50] The first clear sign of this movement was the appearance of "costly" imitations of "cheap" tools, daily wares, and ornaments. I use the word *costly* to describe an object that is made of precious material and/or requires specialized craftsmanship and an unusual amount of human labor. Two early types of such work are jade axes and rings from the Dawenkou culture in present-day Shandong.[51] Like a stone axe, a jade axe is roughly rectangular in shape, with a sharpened edge and a perforation at one end (Figs. 1.1a, b). Similarly, jade rings (Fig. 1.2) appear to be faithful copies of pottery ornaments. At first sight, the lack of originality in these carvings seems almost astonishing: no decoration, no surface engraving, no innovation in shape. What is unusual is the medium: jade.

The Age of Ritual Art

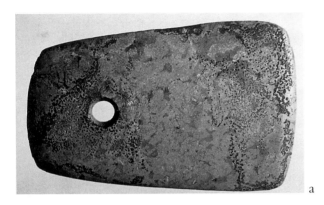

a

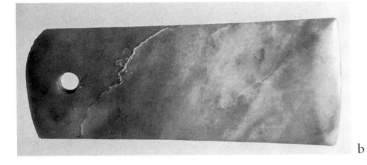

b

Fig. 1.1. (a) Stone axe. Dawenkou culture. 5th–4th millennia B.C. L. 16.8 cm. Excavated in 1959 from Tomb no. 59 at Dawenkou, Shandong. Shandong Provincial Museum. (b) Jade axe. Dawenkou culture. 4th–3d millennia B.C. L. 17.8 cm. Excavated in 1957 from Tomb no. 117 at Dawenkou. Shandong Provincial Museum.

Ancient Chinese used the term *yu*, or "jade," for a hard stone noted for its fine texture and rich color.[52] Jade is difficult to work because of its extraordinary hardness. It is so tough that steel makes no impression on it, and it can be cut and polished only by using semiliquid abrasives mixed with a powdered material harder than jade itself. Ethnologists report that the Maori of New Zealand, who until recently lived at a neolithic level of material culture, cut jade with a piece of sandstone or slate, while constantly applying an abrasive made from powdered quartz and water to the edge of the "saw." It took a month of ceaseless work for a Maori craftsman to cut a piece of raw jade measuring less than 1.5 inches thick and the size of an octavo book into a roughly triangular slab.[53] Though simple in shape, a Dawenkou jade axe or ring required a more complex manufacturing process that must have consisted of at least five steps: (1) splitting the jade boulder and wearing away the rough surface, (2) cutting the raw material roughly into the desired shape, (3) elaborating the shape and sharpening the edge, (4) boring the hole, and (5) polishing the surface to make it smooth and shiny. Judging from the Maori example, one can imagine that the whole process must have been extremely slow and tedious. On the other hand, working jade does not require advanced technology. In fact, to carve a piece of jade, a metal knife is no more useful than a block of stone, a piece of bamboo, or a linen string. Generally speaking, in jade carving the tool is less important than human hands and patience.

What the Dawenkou jade axes and rings pose, therefore, is a puzzling question. A stone axe or a pottery ring could be produced with far less time and energy than the months or even years it took to carve and polish a piece of hard jade. What led the Dawenkou people to create jade axes and rings that resembled stone and pottery objects but involved over a thousand times the cost in human labor?

The secret of these jade artifacts is that they imitated stone and pottery objects but were not intended to be the same. Although similar in shape, the differences between a jade axe and its humble stone prototype are obvious (Figs. 1.1a, b). Rich in color, the surface of a polished jade glistens with changing reflections. There is a physical delight in it, for it is simultaneously smooth, moist, and unyielding. A jade's formal or typological resemblance to a stone or pottery work, therefore, became symbolic and rhetorical: it looked like an ordinary thing, but it was not. To people familiar with the difficulty of carving a jade work, it meant a prodigious amount of human energy frozen in a small object. Consequently, the jades signified the ability of their owner to control and "squander" such a huge amount of human energy. The same rhetoric underlies a modern advertisement for a wine goblet: "At Waterford we take 1,120 times longer than necessary to create a glass." The goblet is expensive and thus precious not because of its shape or function (which are no different from those of "cheap" glass goblets) but because of its crystal material and the excessive labor involved in its manufacture. The advertisement is aimed not at people who want to buy a glass for drinking but at potential customers eager to prove and parade their wealth to their honored guests. In both the ancient and modern cases, the objects, with their "conventional" shape and huge investment of labor, become concrete symbols of power.

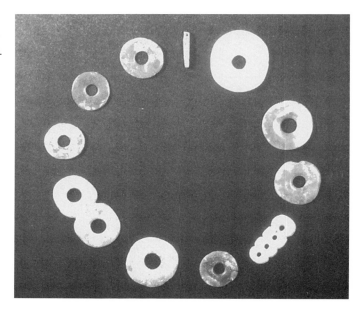

Fig. 1.2. near right
Jade rings and other orna-
ments. Dawenkou culture.
4th–3d millennia B.C.
L. 3–6.8 cm. Excavated
in 1971 at Zouxian,
Shandong. Shandong
Provincial Museum.

Fig. 1.3. far right
(a) Dawenkou Tomb no.
128. 4th–3d millennia
B.C. (b) Dawenkou
Tomb no. 10. 4th–3d
millennia B.C.

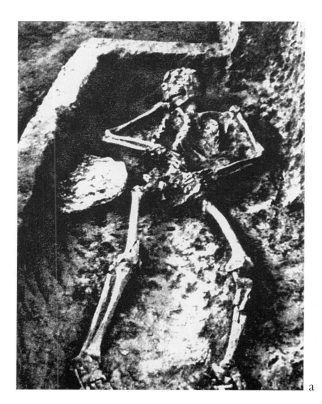

a

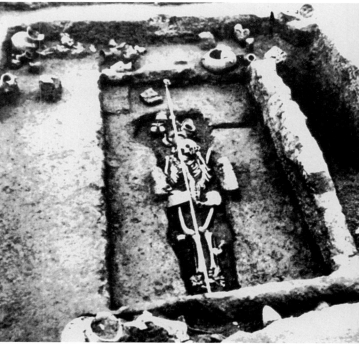

b

It is no accident that the appearance of the Dawenkou jade carvings coincided with a profound social transformation. It was during this period that the differentiation of the wealthy and the poor, as well as concepts of privilege and power, emerged. This social stratification and polarization are most clearly reflected in Dawenkou burials: the majority of tombs were unfurnished or poorly furnished (Fig. 1.3a), but a few graves contained hundreds of fine objects (Fig. 1.3b). Without exception, jade carvings were found only in the largest tombs that were also richly furnished with other objects of value.[54] What these objects demonstrate is a historical stage of seeking a political symbol, which in this case found expression in the medium of jade.[55]

In *What Is Art For?*, Ellen Dissanayake argues that one of the major ingredients of artistic creativity is the desire to "make things special":

> From an ethnological perspective, art, like making things special, will embrace a domain extending from the greatest to the most prosaic results. Still, mere making or creating is neither making special nor art. A chipped stone tool is simply that, unless it is somehow made special in some way, worked longer than necessary, or worked so that an embedded fossil is displayed to advantage. A

purely functional bowl may be beautiful, to our eyes, but not having been made special it is not the product of a behavior of art. As soon as the bowl is fluted, or painted, or otherwise handled using considerations apart from its utility, its maker is displaying artistic behavior.[56]

Here Dissanayake is speaking about a general characteristic of art. The Dawenkou jade carvings, however, emerged from a specific stage in Chinese art history. In particular, they signify the beginning of the tradition of *liqi* or ritual paraphernalia, which, as I argue in the preceding section, both resemble and distinguish themselves from ordinary implements. It is the visual properties of jade—its unusual color and texture—that define the specific status of a *liqi*. In this way, "forms" could "conceal ritual codes" and become political symbols.

The divorce of *liqi* from *yongqi*, or "art" from "crafts," also occurred in pottery production. The problem faced by the Dawenkou potter was the same as that faced by the jadesmith: how to transform a utilitarian object into a symbol? Vessels of special colors (mostly white or black) were made, but the key was found in altering shape. A small group of pottery wares began to exhibit a delicacy of style. The legs or the stem of a vessel were gradually elongated, and openwork patterns were added. A complex silhouette became the point of departure in design. Deliberately rejected were the functional aspects of the vessel as a food or water container and the sense of volume.[57] An early example of this type of pottery is a cup dated to the fourth millennium B.C. (Fig. 1.4). The cup is slender and angular, with an extremely elongated foot, but the bowl of the cup is comparatively insignificant—it is disproportionally small and shallow. One wonders how someone could drink from its much attenuated and flaring mouth without the liquid pouring out, or whether the vessel would stand firmly when it was full.

The impression of delicacy and fragility was also emphasized by reducing a vessel's thickness. A white pottery *gui* (Fig. 1.5), whose shape is the most complicated among all discovered Dawenkou wares, has three sharply pointed legs, an arched handle, and a superfluous complex built above the mouth. With such a complex shape and an extreme thinness, the vessel resembles a paper construction

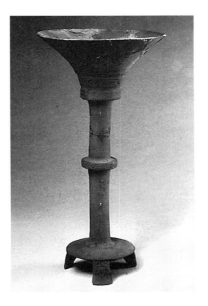

rather than a clay product. I have been informed that it would be impossible to raise the *gui* by holding its handle: the paper-thin handle would break if the vessel were even half full of water. The particular aesthetics exemplified by this *gui* culminated in the pottery industry of the succeeding Longshan culture in the Shandong peninsula. A group of extremely thin black vessels "represented the highest achievement of pottery-making at the time."[58] A number of special features of these vessels have led the Chinese archaeologist Wu Ruzuo to identify them as *liqi*: (1) they have been found only in tombs, not in residential sites; (2) they have only appeared in the richest tombs, not in small- or even medium-sized burials; (3) in such tombs they have been found beside the arms of the dead, separated from "ordinary pottery vessels" but grouped together with other "ceremonial insignia" such as jade axes; and (4) they cannot have been used in daily life due to their peculiar shapes and extreme thinness.[59] We are thus again reminded of the passage in the ritual books: "The ritual vessels may be of use but are never made for people's convenience. The idea is that those which serve to communicate with spirits should not be identical with those for rest and pleasure."[60]

Map 1.1. *Distribution of East Coast prehistoric cultures*

"DECORATION" AND "EMBLEM"

The *gui* mentioned above was made close to the end of the Dawenkou period in the early third millennium B.C. Around the same time, jade art was flourishing in the Liangzhu culture, another regional variant of the East Coast cultural tradition centered on the lower Yangzi River valley (Map 1.1). Liangzhu jades were known even before modern archaeology began in China: the *Illustrated Examination of Ancient Jades* (*Guyu tukao*) by the Qing antiquarian Wu Dacheng (1835–1902) contains at least six examples identifiable as Liangzhu products (Fig. 1.6).[61] The earliest excavation of a Liangzhu site took place in 1936, and the report came out two years later.[62] But until the publication of the first group of radiocarbon dates for Liangzhu remains in 1977, carved jades from this prehistorical coastal culture had generally been considered Zhou or even Han works.[63] An archaeological boom followed the new dating and attribution of Liangzhu jades: in the next decade, an amazing number of rich Liangzhu burials were found in the three adjacent provinces of Zhejiang, Jiangsu, and Anhui (Map 1.1).[64] The special term *jade-furnished burial* (*yulianzang*) was invented for tombs with an extraordinary number of jades. One such burial is Tomb no. M3 at Sidun in Jiangsu. Excavated in 1982, this small rectangular grave contained more than a hundred jade carvings, including 33 short or long tubular *cong* encircling the corpse of a young male (Fig. 1.7).[65] Entire Liangzhu cemeteries were subsequently discovered in 1986 and 1987: the eleven tombs in the Fanshan cemetery in Zhejiang yielded some 1,200 jades or groups of jades, and more than 700 jades or groups of jades came from the twelve tombs in a nearby cemetery at Yaoshan (Figs. 1.8a, b).[66] More discoveries followed the Yaoshan excavation: 21 jade-furnished tombs at Fuquanshan near Shanghai included human sacrifices; large Liangzhu tombs are distributed not only in the Yangzi Delta and around the Hangzhou Bay but also along the Jiangsu-Shandong border in the north; a survey in Changming village near Yuhang in Zhejiang has located Liangzhu cemeteries that are "even larger than those at Fanshan and Yaoshan."[67] Finally a large architectural site, 450 meters north–south and 670

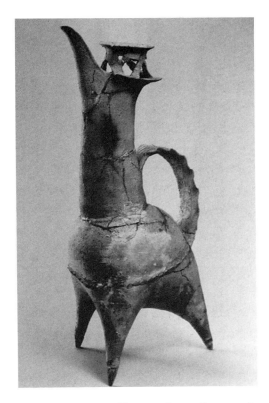

Fig. 1.5. above *Pottery gui
tripod. Dawenkou culture.
4th millennium B.C.
H. 37.2 cm. Excavated in
1977 at Linyi, Shandong
province. Linyi Museum.*

a

Fig. 1.6. below *Liangzhu
cong, as recorded by Wu
Dacheng*

Fig. 1.7. top *Sidun Tomb
no. 3. Liangzhu culture.
3d millenium B.C. Excavated
in 1979 at Sidun, Wujin,
Jiangsu province.*

Fig. 1.8. above *(a) Yaoshan
cemetery. Liangzhu culture.
3d millennium B.C. Exca-
vated in 1987 at Yaoshan,
Yuhang, Zhejiang province.
(b) Plan of the cemetery.*

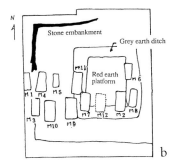

b

Fig. 1.9. *Classification of Yaoshan jades*

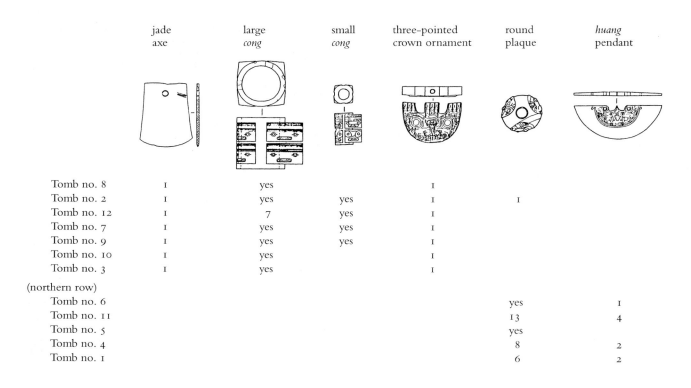

	jade axe	large *cong*	small *cong*	three-pointed crown ornament	round plaque	*huang* pendant
Tomb no. 8	1	yes		1		
Tomb no. 2	1	yes	yes	1	1	
Tomb no. 12	1	7	yes	1		
Tomb no. 7	1	yes	yes	1		
Tomb no. 9	1	yes	yes	1		
Tomb no. 10	1	yes		1		
Tomb no. 3	1	yes		1		
(northern row)						
Tomb no. 6					yes	1
Tomb no. 11					13	4
Tomb no. 5					yes	
Tomb no. 4					8	2
Tomb no. 1					6	2

meters east–west, was found in 1992 at Loujiaoshan near Hangzhou. Surrounded by Fanshan, Yaoshan, and other Liangzhu cemeteries and sacrificial sites, it may have been the center of a large religious network.[68]

Serious research on Liangzhu culture must be postponed until the publication and analyses of this rich archaeological data. Indeed, although the available "preliminary" excavation reports reveal important and sometimes unexpected features of this prehistorical culture, they often pose more questions than we are able to answer. For example, it was extremely exciting to learn that the graves in two separate tiers in the Yaoshan cemetery belonged to males and females, respectively.[69] But who were these deceased? Were they priests and priestesses, shamans and shamanesses, or chieftains and their wives—as some writers have suggested?[70] The excavators of this site noted that jades buried with males and females also differ: axes, *cong*, and three-pronged objects only accompanied men, whereas women possessed arched *huang* pendants, round plaques, and "spinning wheels" (Fig. 1.9).[71] What, however, were the exact sym-

bolism and uses of these jade objects? Were they purely religious and social symbols or paraphernalia for certain rituals? The differences between the Yaoshan and Fanshan cemeteries are puzzling. Merely five kilometers apart, they seem to reflect quite different burial customs: the furnishings of the Fanshan tombs included 125 large *bi* disks (41 from Tomb no. M20 alone), but none of the Yaoshan graves contained this type of object. What do such differences imply?

A recognition of our inability to answer these questions, however, should caution us against making premature generalizations but should not prevent all discussion. Certain aspects of Liangzhu culture are better known, and at certain levels interpretation can be pursued with greater confidence. Hundreds of published Liangzhu jade carvings, including both previously known and recently excavated examples, constitute a large enough corpus of research material. Although these tell us little about the patrons, makers, and precise use of individual types, and although reconstruction of a developmental pattern and symbolic

system of Liangzhu jades is still beyond our reach,[72] known Liangzhu jade works do allow us to observe their basic formal and semiotic features. These features, in turn, indicate the position of this art in the general development of ancient Chinese *liqi*.

Unlike earlier Dawenkou jades, Liangzhu jades are not direct copies of stone and pottery objects. The *bi* disk may have developed from ornamental rings, but the Liangzhu *bi* are so large and heavy that they could not function as personal ornaments. Similarly, the axes are so thin that it would have been impossible to use them in any practical way. These two types of Liangzhu jades, therefore, may be considered a second generation of imitated forms; their form still attests to their connection with earlier implements and ornaments, but dysfunctional aspects have been accentuated by formal characteristics. A more important development in Liangzhu jade art (in fact, the most important Liangzhu contribution to ancient Chinese ritual art), however, is the invention and proliferation of surface engravings: all Dawenkou jade works are plain, but the Liangzhu jades are richly decorated with zoomorphic patterns and other signs.

In a paper on the semiotics of visual art, Meyer Schapiro argues that the appearance of manufactured objects and architectural forms was preceded by a period during which people had no idea of a well-defined picture surface and no sense of regularity in design. Paleolithic cave paintings appear on an unprepared and unlimited ground, and the primitive artist worked on a field with no set boundaries and thought very little of the "surface" as a distinct pictorial plane.

The smooth prepared field of the surface is an invention of a later stage of humanity. It accompanies the development of polished tools in the Neolithic and Bronze Ages and the creation of pottery and an architecture with regular courses of jointed masonry. It might have come about through the use of these artifacts as sign-bearing objects. The inventive imagination recognized their value as grounds, and in time gave to pictures and writing on smoothed and symmetrical supports a corresponding regularity of direction, spacing and grouping, in harmony

a

b

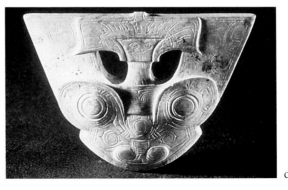

c

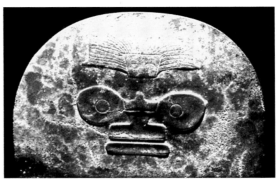

d

Fig. 1.10. Jade ornaments. Liangzhu culture. 3d millennium B.C. (a) H. 5.6 cm. Excavated in 1986 from Fanshan Tomb no. 23 at Yuhang, Zhejiang province. Zhejiang Provincial Institute of Archaeology. (b) H. 5.2 cm. Excavated in 1986 from Fanshan Tomb no. 16. Zhejiang Provincial Institute of Archaeology. (c) H. 6.2 cm. Excavated in 1987 from Yaoshan Tomb no. 10. Zhejiang Provincial Institute of Archaeology. (d) H. 5.4 cm. Minneapolis Institute of Art.

with the form of the object like the associated ornament of the neighboring parts.[73]

Although thought-provoking, Schapiro's statement implies the predominance of a "picture ground" over the images it bears. Applied to decorative art, this theory means that decoration "fills" a visual field defined by shape, a basic assumption shared by many scholars who interpret the function of ornamentation as framing, filling, and linking.[74] It may be argued, however, that the relationship between shape and decoration is dialectical: surface patterns not only embellish a shape but also redefine it. A particular formation of patterns can reorient viewing, blur or reinforce the silhouette of an object, or provide a geometric shape with symbolic or mimetic meaning. As Oleg Grabar has observed: "It is possible for an ornament to be *the* subject of the design. . . . There is a difference between 'filling' a space with a design and transforming an object by covering all or parts of its surfaces with that design. In the first instance, the filling design has no other purpose than to partake of whatever uses its carrier has; in the second one, it can transform the very purpose of its carrier."[75]

This argument about the function of ornamentation provides a basis for analyzing Liangzhu jade carvings. Many Liangzhu jades are flat, thin plaques (Figs. 1.10a–d); holes drilled along the edges or on the backs allowed them to be attached to clothing or stands, or to be used as pen-

dents. The mask motifs embellishing these flat objects may have developed from a local tradition, which can be traced back to the Hemudu period of the fourth millennium B.C. A mask engraved on a Hemudu black pottery basin consists of a pair of round eyes and a curved headdress with a trapezoid ornament in the center and is further flanked by two crudely depicted birds (Figs. 1.11a, b). All these pictorial elements, as well as their symmetrical arrangement, survived in Liangzhu jade decoration. The relationship between mask and the objects that bear them, however, changed markedly. Unlike the Hemudu mask, which forms part of a continuous decorative band on the exterior of the basin, a Liangzhu mask at the center of a two-dimensional plaque defines a fixed visual focus. The silhouette of the object—either semicircular, three-pronged, or trapezoidal—then becomes the boundary of the image and sometimes even appears as the "face" of a zoomorph. In other words, the mask has become "the subject of design" and supplements the meaning of an otherwise geometric or abstract shape.

Such a centralized mask motif seems to reflect a desire to forge a nonrepresentational icon. A Liangzhu mask does not portray a real animal or human figure. It is an artificial image whose most prominent feature is a pair of large eyes formed by concentric circles. Perfectly frontal and symmetrical, this mask on a flat plaque directly faces the viewer, demanding his visual and mental concentra-

Fig. 1.11. (a) Pottery basin with incised decoration. Hemudu culture. 4th millennium B.C. H. 16.2 cm. Excavated in 1973 at Hemudu, Zhejiang province. Museum of Chinese History, Beijing. (b) Decoration. Ink rubbing.

a

b

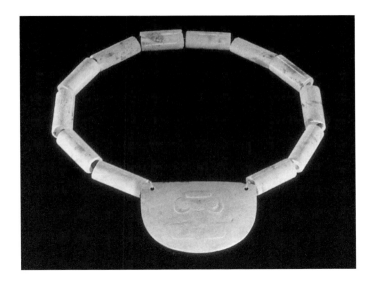

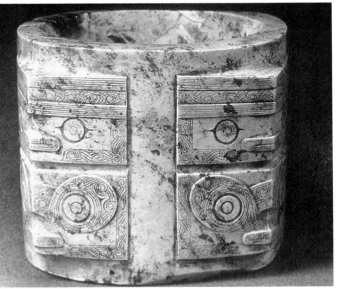

spectator of the picture. (Renaissance painting, on the contrary, was understood as 'a window on the world' and hence was oriented towards an EXTERNAL viewer's position, that is, towards the position of the spectator of the picture who is, in principle, a non-participant in this world.)[76]

He suggests that similar iconic representations existed in many different religious arts from antiquity to the Middle Ages. Such an image always embodies an "internal observer" who is "looking out" at the viewer from an imaginary world.[77] These features on a two-dimensional Liangzhu mask establish a direct conjunction between the mask and the spectator and between this world and the supernatural. The modern Chinese scholar Zhang Minghua has proposed that some of these flat jades were originally fixed on stands as cult objects.[78] His reconstruction of these objects helps explain their "iconic" decoration—as commonly understood, establishing a direct conjunction between a deity and a devotee is essential to religious worship. Similar masks on pendants and headdresses may have also functioned to identify the person wearing them. Interestingly, a Fanshan *huang*-pendant bears an upside-down mask (Fig. 1.12). Its unique

Fig. 1.12. Jade necklace. Liangzhu culture. 3d millennium B.C. H. 7.6 cm (huang pendant only). Excavated in 1986 from Fanshan Tomb no. 22. Zhejiang Provincial Institute of Archaeology.

tion. The implication of this form can be understood in the light of other religious iconic representations, as B. A. Uspensky has observed:

> Medieval painting, and in particular icon painting, was oriented primarily toward an INTERNAL viewer's position, that is, towards the point of view of an observer imagined to be within the depicted reality and to be facing the

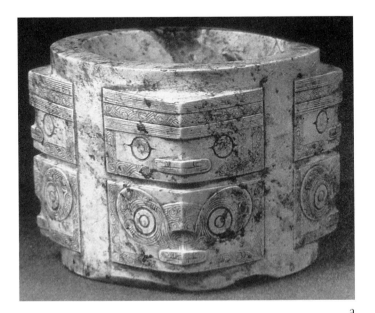

Fig. 1.13. (a, b) Two views of a jade cong. Liangzhu culture. 3d millennium B.C. H. 7.2 cm. Excavated in 1982 from Sidun Tomb no. 4 at Wujin, Jiangsu province. Nanjing Museum.

a

b

Fig. 1.14. Developmental stages of Liangzhu cong.

Fig. 1.15. Jade cong. Liangzhu culture. 3d millennium B.C. H. 16.2 cm (two sections). Excavated in 1984 from Fuquanshan Tomb no. 40 at Qingpu, Shanghai. Shanghai Cultural Relics Administration.

decorative position implies that the expected viewer was none other than the owner and bearer of the jade. Looking down at the mask hanging on her chest, she would find herself confronting a "mirror image," which, however, distorted and mystified reality.[79]

These two-dimensional jades differ from the tubular *cong* not only in shape but also in decor. Although similar mask motifs appear on both kinds of jades, their application follows divergent principles. The exterior of a typical *cong* is modified into a truncated, square prism, on which masks are placed along the four corners (Figs. 1.13a, b). This design thus completely destroys the concept of a two-dimensional visual field: each flat side of a *cong* is both terminated with two half-masks and open-ended. In order to comprehend a whole image, the viewer must shift his gaze to an adjacent side to find the other half of the face. This peculiar decorative scheme of a *cong*, most likely a Liangzhu invention, signifies the second orientation of Liangzhu art: "decomposing" a static icon. The essence of this design, that an image has to consist of two identical halves, identifies it as an important early example of the "dualistic phenomena" that, according to K. C. Chang, characterized early Chinese civilization.[80] Separated on two adjacent sides of a square *cong*, a mask appears as a perfect profile when viewed from the side, and as a whole face when seen from a corner. This pattern thus represents an abrupt change in image making: a single image could

and ought to be viewed in two ways—both frontally and in profile—and an artificial image could and ought to represent various dimensions of a single subject.[81] Unlike a two-dimensional mask that stresses the confrontation between the image and the viewer, this new decorative formula emphasizes the interplay between the individual parts of an image.

Rudolf Arnheim has observed in his study of visual psychology that "as soon as we split the compositional space down the middle, its structure changes. It now consists of two halves, each organized around its own center. The pattern represents the two symmetrical partners in dialogue, balanced along the interface."[82] This theoretical formulation can be historicized in the development of the *cong*; the Chinese scholar Liu Bin proposes that the Liangzhu mask motif "developed in parallel with the trans-

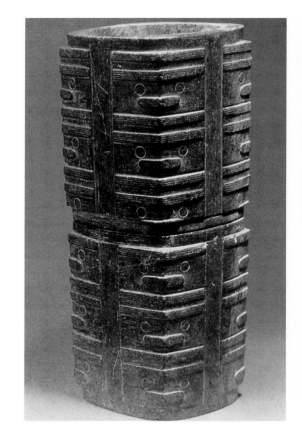

formation of the shape of the *cong*": "A mask originally on a curved surface [on a bracelet] was later divided into two halves on two flat surfaces along the raised vertical axis."[83] According to archaeologist Wang Wei, the three major stages in this evolution are exemplified by the examples in Fig. 1.14: (1) four rectangular picture fields containing identical masks were defined on tall rings; (2) slight angles then emerged along the vertical axis of each mask; and (3) these angles became increasingly sharper, finally transforming a circular ring into a square prism, with masks centered on its corners.[84] These observations point to two fundamental impulses in Liangzhu artistic creation—the multiplication of a motif (Fig. 1.15) and the formation of composite and dual motifs (Fig. 1.13); the former creates visual repetitions resembling a verbal charm, and the latter leads to metamorphosis and dynamism.

As defined earlier, a composite mask has its two identical halves placed on two picture planes left and right. Dual masks, on the other hand, consist of two varying zoomorphs one above the other. The surface of a *cong* is frequently separated into upper and lower registers, each containing a mask (Fig. 1.13). The similarity between these two masks is evident: they both have circular eyes, and their mouths or noses are both represented by a short bar. But the divergences between them are also unmistaken: the upper mask is relatively simple and topped with a tripartite horizontal band, which may stand for a crown; the lower one has a sunken nose, and its oval eyes are connected by a "bridge." The upper one is plain, while the lower one is embellished with fine spiral incisions. Significantly, each of dual masks is also a composite mask. When these two compositions are combined, they attest to a single underlying dualistic structure in Liangzhu decorative art. Varieties of dual images are found on Liangzhu jade, not only on the corners of a *cong* but also on plaques (Figs. 1.18a–b). On some jades from Fanshan and Yaoshan, a frontal anthropomorphic image with a huge feathered headdress replaces the upper, simplified mask in a more conventional design (Figs. 1.16–18). On other jades from the same sites, this image is represented by its profiles flanking a large, frontal mask (Fig. 1.10c).

Although the multiplication of a single motif and the

formation of composite and dual masks are based on different principles, they are by no means contradictory. Most important, both types of decoration negate a single dominant icon. Moreover, as soon as a composite mask or a dual-mask motif was invented, it immediately became the subject of repetition (Fig. 1.16). Although these complex decorative patterns developed from the earlier iconic image, they never replaced it. In fact, the most striking feature of Liangzhu jade art is the coexistence of many kinds of imagery and the increasing richness of the visual vocabulary. I would argue that the Liangzhu jade mask, like later bronze decoration, is characterized by its protean shapes and incessant permutations, not by a "standard" iconography. As an example, no two of the 700 jades from the Yaoshan cemetery bear identical masks. It is unlikely that all these variations were subject to stylistic or icono-

Fig. 1.16. Jade cong. Liangzhu culture. 3d millennium B.C. H. 9.6 cm. Excavated in 1986 from Fanshan Tomb no. 20. Zhejiang Provincial Institute of Archaeology.

*Fig. 1.17. (a) Jade axe.
Liangzhu culture. 3d mil-
lennium B.C. H. 17.9 cm.
Excavated in 1986 from
Fanshan Tomb no. 12.
Zhejiang Provincial Insti-
tute of Archaeology.
(b) Emblem on the axe.*

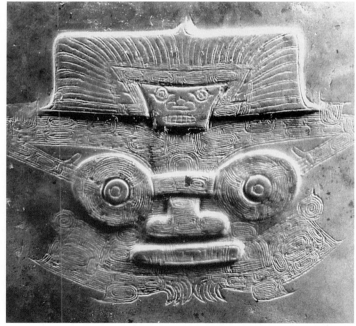

a

*Fig. 1.18. (a) Jade cong.
Liangzhu culture. 3d mil-
lennium B.C. H. 8.8 cm.
Excavated in 1986 from
Fanshan Tomb no. 12.
Zhejiang Provincial Insti-
tute of Archaeology.
(b) Emblem on the cong.*

b

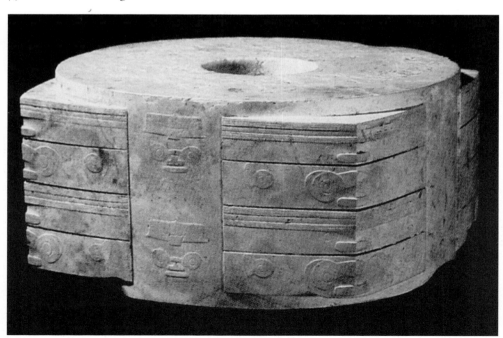

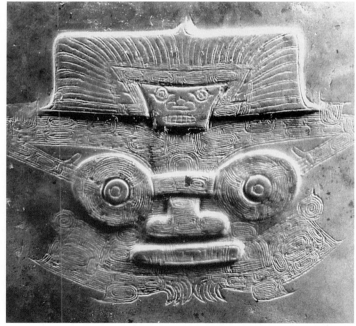

a

b

graphic evolution. A more plausible assumption is that the divergences are deliberate and that the "metamorphosis" of styles and images, a concept which I explore more deeply in my discussion of bronze decoration, was itself a fundamental goal of Liangzhu ritual art.

Liangzhu art, however, also demonstrates another tendency opposed to metamorphosis and even to decoration. To define this tendency, let us return to a dual-mask motif consisting of an anthropomorphic figure and a large mask (Figs. 1.10a, c, 12, 17–19). Following the general decorative principle of Liangzhu art, this motif appears in various forms and styles: it is rendered in either relief, sunken lines, or openwork patterns, and its anthropomorphic figure shows either frontal or profile images. All these variations, however, correspond closely to the shape of a given object: they fit the shapes and also provide these shapes with meaning. In this sense, we call such designs "decoration."

One of these variations on a large axe from Tomb no. M12 at Fanshan, however, violates this principle (Figs. 1.17a, b). Although still consisting of the anthropomorphic figure and the front mask, it is a tiny image against a plain background at an upper corner of the axe. Its small size greatly limits its decorative role, and its design and placement have little to do with the overall shape of the object. Moreover, unlike the metamorphic decoration on most Liangzhu jades, this particular image is duplicated on other objects with minute precision. It recurs on a *cong* and a round column, both from Tomb no. M12 (Figs. 1.18–19), and can also be observed on a *huang* pendant from M22 at the same site (Fig. 1.12). The objects bearing this "standardized" twin image are themselves extraordinary: the axe, 16.8 centimeters across the blade, is the largest ever discovered in Liangzhu burials; the *cong*, 17.6 centimeters wide and 6.5 kilograms in weight, is the largest and heaviest Liangzhu *cong*; and the column has not been seen in any other place. Not coincidentally, Tomb no. M12, where these three objects were found, was the most prominent Fanshan grave, located at the center of the cemetery and furnished with 511 carved jades. M22, which yielded the *huang* pendant, was next to M20. It has been suggested that axes and *cong* were buried with

Fig. 1.19. Jade column. Liangzhu culture. 3d millennium B.C. H. 10.5 cm. Excavated in 1986 from Fanshan Tomb no. 12. Zhejiang Provincial Institute of Archaeology.

Fig. 1.20. (a–c) Bird emblems on three Liangzhu bi *disks. 3d millennium B.C. Freer Gallery of Art, Washington, D.C.*

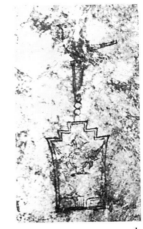
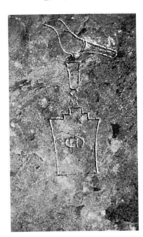

a b c

The Age of Ritual Art 37

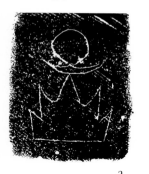

Fig. 1.21. Pottery jar. Dawenkou culture. 4th–3d millennia B.C. H. 59.5 cm. Excavated at Lingyanghe, Juxian, Shandong province. Museum of Chinese History, Beijing.

Fig. 1.22. Emblems on pottery vessels. Dawenkou culture. 4th–3d millennia B.C. (a, c, e–f) Excavated at Lingyanhe, Juxian, Shandong province.

(b) Excavated at Qian-zhai, Zhucheng, Shandong province. (d) Excavated at Dazhucun, Lü-xian. Ink rubbings.

a

b

c

d

e

f

Liangzhu noblemen and *huang* with Liangzhu noble-women. Jean James thus concludes that "the use of a very similar image on jades from both M20 (male) and M12 (female) could indicate a close relationship between the two occupants."[85] In other words, this "very similar image"—the highly formulated and duplicated dual-mask motif—now functioned to identify the status and relationship of their owners. It is not simply a decorative motif that could be manipulated at will, but a fixed symbol for identification.

To date, this particular dual-mask image has been found only in these two tombs at Fanshan. But bird signs rendered in similar fashion are distributed in a broad area along the eastern coast and may shed more light on the meaning of this type of prehistoric jade engraving. In 1963, Alfred Salmony reported on incisions on three *bi* disks in the Freer collection.[86] These pictorial marks share a number of elements (Figs. 1.20a–c, 29a–c): an altar or a "mountain" whose top arches in steps toward the center, a bird standing on the top of this altar, and a circle—most likely representing the sun—on the front side of the altar. On the other hand, the visible minor compositional and stylistic differences may indicate different dates for these engravings. The incisions shown in Figs. 1.20a and 1.29a are the most complete and "picture-like": the bird is almost realistically drawn, with a round spot on its shoulder. An additional crescent halved by a median line and placed below the sun represents the new moon.[87] In the next design (Figs. 1.20b, 29b), the altar has duplicated contours. A bird's tail is added to the sun motif along with, in Salmony's words, "two flanking birds' heads, which have hooked beaks and long pointing crests,"[88] thus transforming the circle motif into a sun-bird combination. The crescent moon, however, disappears. This incision becomes somewhat simplified and abstracted in the third image (Figs. 1.20c, 29c) drawn in coherent and fluent lines. An oval formation replaces the earlier sun motif; a vertical band in the middle further transforms this shape into the pictograph of the sun in Chinese writing.

Lacking reliable comparative data, Salmony dated these three images, as well as the disks bearing them, to the Shang dynasty.[89] But in the 1970's, Chinese archaeologists found

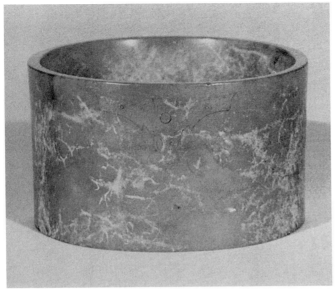

b

a

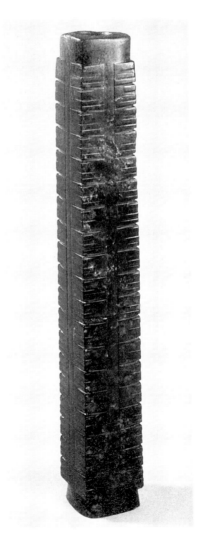

three similar incisions on large pottery jars of ceremonial use from Dawenkou sites in Shandong (Fig. 1.21).[90] One vessel bears sun and moon images (Fig. 1.22c); the incisions on the other two vessels (Figs. 1.22a, d) are more complicated—a five-peaked "mountain," akin to the "altar" motif on the three Freer *bi*, is added to support the sun-moon cluster.[91] More Dawenkou engravings of both kinds have been reported (Figs. 1.22b, e, f),[92] and similar marks have increasingly been found on carved jades. Among these jade objects, a tall ring in the Freer Gallery has the sun-moon combination on one side and an "abstract" bird on the opposite side (Figs. 1.23a−b, 29h);[93] a large *cong* in the Museum of Chinese History in Beijing also bears the sun-moon motif (Figs. 1.24, 29i);[94] a *cong* in the Museé Guimet is engraved with a sign combining a sun-altar and a crescent moon (Fig. 1.29f); another *cong* in the Capital Museum in Beijing (Figs. 1.25a−b, 29d) and a *bi* disk in the National Palace Museum in Taipei (Figs. 1.26a−b, 29e) are engraved with images identical in both form and style with the incisions on the Freer *bi*.[95] Deng Shuping has recently discussed all these pieces in a learned article and, based on a newly excavated example from Anqi (Figs. 1.27a−b, 29d),[96] has identified them as Liangzhu products.[97]

A number of significant features of these engravings reject any attempt to identify them as "decoration." First, these engravings are small, sometimes so tiny that they can hardly be seen, and thus their decorative function is deliberately negated (Fig. 1.28). Second, these images are formed by thin, incised lines; this means that they were added after the completion of the works. Third, these and other bird images are always shown in silhouette. George Rowley has called such a simple pro-file "ideational," that is, an image representing a concept, reduced to its essence.[98] Call to mind the abstract idea of "bird"; instantly it will appear in profile in the mind's eye. Finally, the incisions appear in isolation, without obvious relationship with the shapes of the objects. These isolated, tiny images call for the viewer's concentration, but the more attention one pays to them, the less attention one pays to the object as a whole.

On the other hand, all these features suggest interesting parallels between these engravings and certain *pictographs* in early Chinese writing. We can even find direct evidence for this relationship. The circular motif on the first Freer *bi* (Fig. 1.20a), for example, is filled with spirals and thus resembles the character shown in the margin, meaning "sun-brightness" in Shang oracle bone inscriptions. When this motif is further simplified on the third Freer *bi*, it resembles the Chinese character *ri*, or sun (Fig. 1.20c). This form also appears independently on another *bi* disk, and this confirms its use as a graph.[99] Significantly, incisions belonging to this group have been observed in a broad area along China's east coast from the lower Yellow River valley to the lower Yangzi River region. Although the various cultures in this region developed distinctive decorative art motifs and styles, they seem to have shared these "picto-graphs" for a considerable period.[100] Moreover, we find that some bronze ritual vessels of the Shang dynasty bear similar "bird-altar" signs (Fig. 1.30), which scholars have considered symbols of a certain clan.

This last observation leads us to identify these incisions not only as "pictographs" but also as "pictorial emblems" (Fig. 1.29), which Paul Ekman and Wallace V. Friesen define as follows: "Emblems are those nonverbal acts which have a direct verbal translation, or dictionary definition.

b

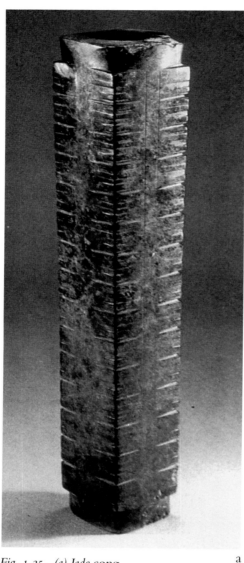

a

Fig. 1.25. (a) Jade cong. *Liangzhu culture. 3d millennium* B.C. *H. 38.2 cm. Capital Museum, Beijing. (b) Emblem on the* cong.

The Age of Ritual Art

Fig. 1.26. (a) Jade bi disk. Liangzhu culture. 3d millennium B.C. Diameter 13.17–13.44 cm. National Palace Museum, Taipei. (b) Emblem on the bi.

Fig. 1.27. (a) Jade bi disk. Liangzhu culture. 3d millennium B.C. Diameter 26.2 cm. Excavated in 1989 at Anqi in Yuhang, Zhejiang province. Zhejiang Provincial Examination Committee of Cultural Relics. (b) Emblems on the bi.

Fig. 1.28. Jade bi disk. Liangzhu culture. 3d millennium B.C. Diameter 20.7 cm. Freer Gallery of Art, Washington, D.C.

Fig. 1.29. Incised emblems on Liangzhu ritual jades

This verbal definition or translation of the emblem is well known by all members of a group, class or culture. . . . People are almost aware of their use of emblems; that is, they know when they are using an emblem, can repeat it if asked to do so, and will take communicational responsibility for it."[101] The identification of the bird motifs as emblems is supported by ancient legends and myths.[102] It was a widespread belief in ancient China that the God of the East named Jun had a bird's head with a sharp beak. Jun lived in Heaven, but two altars were dedicated to him on earth and were administered by his "earthly friends," who were multicolored birds. Lord Jun supervised Four Birds, and one of his two wives gave birth to ten sun-birds, the other to twelve moons.[103] Many versions of this legend exist, but no matter how elaborated or abridged, all versions share four basic elements—the bird, the sun, the moon, and the east. The *Classic of Mountains and Seas* (*Shanhai jing*) mentions yet another element—a great mountain: "In the Eastern Wilderness there is a mountain known as Huoming. It is the origin of Jun's clan and the place whence the sun and moon emerge."[104]

This last reference seems less "legendary" in nature. It neither offers a creation myth nor glorifies Jun as a supreme god, but simply identifies the origin of Jun's clan. In the earliest Chinese geographic text, "The Tribute of Yu" ("Yu gong"), various groups of people on the east coast are given the designation Yi or Bird Yi, and their "precious things" include "beautiful stones" or jades.[105] Even more fascinating, this text contains the following passage concerning the area between the Yellow and Yangzi rivers: "The Huai and the sea formed the boundaries of Yangzhou. The lake of Pengli was confined to its proper limits; and the 'Sun Birds' [*yangniao*] had a place to settle in. . . . [The area's] articles of tribute were . . . elephants' teeth, hides, feathers, fur, and timber. The wild bird-men brought garments of grass."[106]

Here the term *Sun Birds* is clearly the name of a group of people who settled in the region. These people, also called "wild bird-men," treasured certain goods including bird feathers. Not incidentally, the ritual jades from the places where they lived are engraved with the emblem "Sun Bird."[107] The modern Chinese scholar Xu Xusheng

has suggested that the myth about Jun's giving birth to the ten suns and twelve moons and his employment of groups of "birds" reflect the structure and fragmentation of an eastern cultural complex during prehistoric times. He also compared this legend with an episode in ancient Egyptian history in which Menes integrated the symbols of the tribes that he had conquered into his own royal emblem.[108] His discussion prompts a reexamination of the composition of various Dawenkou-Liangzhu emblems (Figs. 1.22, 29). The main element of the Dawenkou incisions is the sun-moon unit, sometimes combined with the five-peaked mountain. The Liangzhu emblems, on the other hand, emphasize a bird standing on the

Fig. 1.30. Bird inscriptions on late Shang dynasty ritual bronze vessels

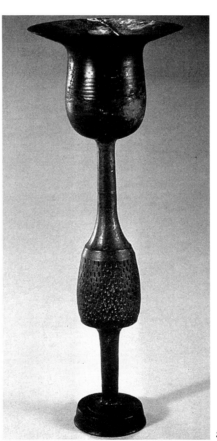

Fig. 1.31. Pottery cups. Shandong Longshan culture. 3d millennium B.C. Excavated in 1960 at Yaoguanzhuang, Weifang, Shandong province. Shandong Provincial Museum, Ji'nan. (a) H. 17.5 cm. (b) H. 17.5 cm.

a

b

mountain embellished with the sun; a crescent moon is sometimes present. Possibly these various signs identified different branches of a pan-eastern cultural complex, as Xu Xusheng has argued based on textual sources.[109]

The identification of these Dawenkou-Liangzhu incisions as emblems suggests that during this early stage, engravings on ritual objects were of two kinds: *decoration* favoring protean imagery, and *emblems* identifying the ownership of objects. Decoration is primarily a visual expression, and an emblem is fundamentally a verbal expression. These two types of signs, however, could be transformed into one another, as we have observed in a variety of examples. The properties and determinants of *liqi* thus not only consisted of *material* and *shape* but now also included *decoration* and *inscription*. As we shall see, the interplay of these four elements determined the course of ritual art during the following Bronze Age.

FROM IMITATION TO SYNTHESIS

By the beginning of the Bronze Age around 2000 B.C., a set of formal characteristics defining a symbolic art had emerged. These characteristics reveal a conscious effort to separate ritual paraphernalia from ordinary utensils and reflect a tendency to supply visual forms with written expressions, exemplified in the beginning by emblems. This artistic tradition culminated in the Shandong Longshan culture: the wall of a pottery vessel (Figs. 1.31a, b) was reduced to a critical point, 2 to 3 millimeters in thickness; the subtle curves of its contours were meticulously calculated; and its monochrome color exaggerates the sharpness of its silhouette. Some jade works are ground so thin that they become literally semitransparent (Fig. 1.32); fragility seems to have been the highest artistic goal. On other jades, pairs of masks and birds are executed in fine fillets in various forms (Fig. 1.33).[110] It is against this background that the Chinese Bronze Age began.

Like painting, bronze art is not a single artistic genre. When bronze first appeared as a "precious" art medium, it was employed to express values of ritual art previously conveyed by clay and jade. Our earliest Chinese bronze vessels—seven *jue* cups excavated at the late Xia capital site in Erlitou[111]—can be studied from precisely this per-

spective. The best Erlitou *jue* (Figs. 1.34a, b) has been described as showing "an exaggerated fragility: the waist is sharply constricted; spout and tail are drawn out to an extreme slenderness; and the top-heavy superstructure is delicately balanced on three long and elegant legs, faintly curved to continue the profile of the skirt. These graceful, mannered proportions, in a vessel type already curiously contrived, bear witness to the Erlitou founder's conscious concern for formal, aesthetic matters."[112] The "graceful" shape of this *jue*, however, cannot be attributed entirely to its maker. It represents, in fact, the apex of a long development that extended back to prehistorical times. Dawenkou or Longshan pottery wares (Figs. 1.4–5, 31) may have different shapes, but they display the same emphasis on thinness, slenderness, and delicacy, and the same pursuit of a complex silhouette by vitiating volume and usefulness. One can hardly believe that the Longshan cup was made of soft clay or that the Erlitou bronze emerged from fitted molds. In both cases the materials have been "conquered" and the normal production of a thick, durable utensil has been replaced by a painstaking process aimed at "fragility"—a traditional quality of ritual art.

Evidence for a genealogy stretching from Longshan pottery to Erlitou bronzes can be derived from other sources. First, both the Erlitou bronze vessels and Longshan black pottery neglect decoration: six of the seven Erlitou *jue* have no embellishment, and the decorated one bears only six faint dots on its waist. The Erlitou artisan seems to have shared the Longshan approach that excessive surface pattern would increase the impression of volume and thus was uncalled for.[113] Second, the dualism of Erlitou art seems to continue a prehistorical convention: decoration is reduced to a minimum on bronze vessels, but jades and inlaid works from the same site bear elaborate mask designs.[114] One of the Erlitou jades (Figs. 1.35a, b) is covered with masks on parallel registers, and each mask is centered on a corner; the decorative formula is apparently derived from the Liangzhu *cong* design (Figs. 1.13–16).

This dualism, however, diminished during the mid-Shang period (ca. 1500–1300 B.C.).[115] Mid-Shang bronze

The Age of Ritual Art

Fig. 1.32. Jade blade. Longshan culture. Late 3d millennium B.C.

Fig. 1.33. Ceremonial jade adz. Shandong Longshan culture. Late 3d millennium B.C. L. 18 cm. Found in 1963 at Liangchengzhen, Rizhao, Shandong province. Shandong Provincial Museum, Ji'nan.

Fig. 1.34. (a) Bronze jue vessel. Late Xia dynasty. 2d millennium B.C. H. 22.5 cm. Excavated in 1975 at Erlitou, Yanshi, Henan province. Yanshi County Cultural House. (b) Drawing.

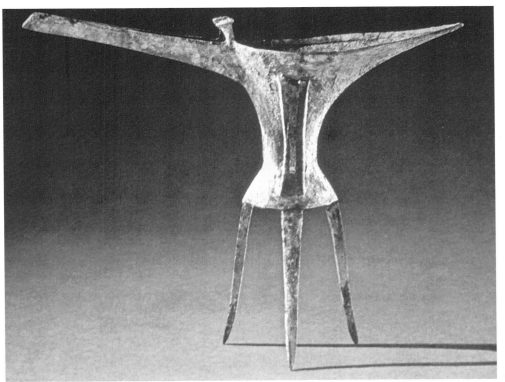

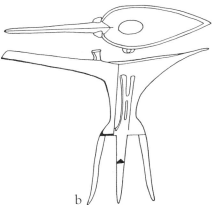

a b

Fig. 1.35. (a) Jade "han-
dle." Late Xia dynasty.
2d millennium B.C. L.
17.1 cm. Excavated in
1975 at Erlitou, Yanshi,
Henan province. Institute
of Archaeology, CASS.
(b) Drawing.

Fig. 1.36. Typological rela-
tionship between prehistoric
pottery vessels and Shang
bronze vessels

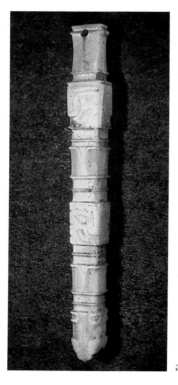

a b

art appears to have synthesized the two most powerful preceding art traditions—pottery and jade. Almost all mid-Shang bronze vessels derived their shapes from pottery types (Fig. 1.36), but the masks that had been previously monopolized by jade art were now transplanted onto them. In this respect, mid-Shang bronzes differ fundamentally from the earlier *jue* from Erlitou, which are aesthetically homogeneous with Longshan black ritual pottery. Rather than following any one tradition, mid-Shang bronze art utilized the available artistic vocabulary from divergent sources to create new conventions. In this way, these works announced the independence of bronze art, which then dominated Chinese art for a thousand years. The transformation in bronze art from the early Shang to mid-Shang thus supports Susanne K. Langer's assertion that "almost every technical advance is first felt to be the discovery of a better means of imitation, and only later is recognized as a new form, a stylistic convention."[116] Earlier I proposed that the first jade *liqi* faithfully imitated stone and pottery objects (Fig. 1.1). Only during the following period did the gradual formulation

| WINE | | | | | | | | | | WATER |
|------|------|------|------|------|------|------------|-------------|---------|------|
| jia | he | gu | zun | lei | hu | you (type I) | you (type II) | fang yi | pan |

(Table of vessel typology drawings: three rows illustrating jia, he, gu, zun, lei, hu, you type I, you type II, fang yi, and pan forms.)

of the distinctive formal characteristics of jade carvings establish jade art as an independent artistic genre (Figs. 1.10, 12–20). The evolution of bronze art during the Shang followed the same path.

The most popular decorative motif on middle and late Shang bronzes is the zoomorphic mask traditionally called the *taotie* (Fig. 1.38). In Eleanor von Erdberg Consten's words:

> The term *taotie* denotes mask-like animal faces in frontal view, which lie flat on the surface of the vessel . . . with legs, tails, and the intimation of a body added to the sides of the face. Except for inconspicuous variation in the linear pattern fillings, the two halves of the face are symmetrical to both sides of a line—either imaginary or stressed by flange or ridge—that runs down from the forehead to the nose.[117]

Consten points out a distinctive feature of a *taotie*: the zoomorph is often composed as a pair of profile "dragons" standing nose to nose to form a frontal mask. This iconography long puzzled scholars; as Jordan Paper wrote in

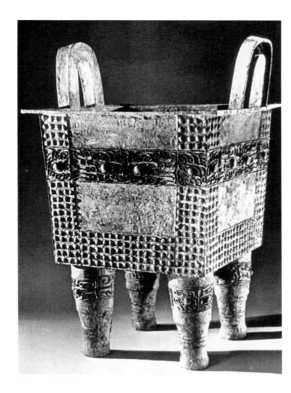

Fig. 1.37. *Bronze square ding. Mid-Shang dynasty. Mid-2d millennium* B.C. *H. 100 cm. Excavated in 1974 at Zhangzhai, Zhengzhou, Henan province. Museum of Chinese History, Beijing.*

FUNCTION	FOOD								
NAME OF VESSEL TYPE STAGE OF DEVELOPMENT	ding	fang ding	li	xian or yan	gui	yu	dou	fu	jue
POTTERY PROTOTYPE									
EARLY SHANG									
LATE SHANG									

1978: "The origin of the *t'ao-t'ie* [*taotie*] is still a mystery. It has not been found on extant objects from the neolithic culture."[118] But recent archaeological discoveries help clarify both the *taotie*'s origin and its peculiar imagery.[119] On Liangzhu *cong* (Figs. 1.13a, b) and the Erlitou jade (Figs. 1.35a, b), a mask is centered on a corner so that it appears as a perfect profile viewed from the side, and as a whole face viewed frontally. The mid-Shang people inherited this convention and pursued it further: they not only applied a mask to a corner of a bronze but also stretched it open to fill a frieze (Fig. 1.37). As the three-dimensional mask became two-dimensional, it still combined both frontal and profile aspects.[120] We should not overlook the importance of this transformation: it represents an abrupt advance in image-making. A mask on Liangzhu and Erlitou jades exhibits its full face and profile only when viewed from different angles. The depiction, therefore, is still conditioned by ordinary visual experience in viewing a three-dimensional entity. The two-dimensional and "split" *taotie* on Shang bronzes, however, is an entirely artificial image since it shows its full face and two sides at the same time. William Watson once commented: "It is impossible to see the *t'ao-t'ieh* simultaneously as a single mask *and* as two dragons standing nose to nose. An awareness of these two possible readings of the shapes disturbs a viewer as soon as they are pointed out to him."[121] But achieving such visual ambiguity and departing radically from naturalism may have been the aims of early Chinese art.

METAMORPHOSIS OF DECORATION

Shang *taotie* imagery suggests that important prehistorical decorative codes—*multiplication*, *dualism*, and *metamorphosis*—continued to play fundamental roles in Shang bronze art. This contention both requires and leads to a reexamination of the most widely used theory in analyzing Shang bronzes in the West—the Five Styles sequence that Max Loehr proposed in 1953.[122] Various scholars have summarized and interpreted this sequence;[123] here is Loehr's own abstraction (see Fig. 1.38):

Style I: Thin relief lines; simple forms; light, airy effect.

Style II: Relief ribbons; harsh, heavy forms; incised appearance.

Style III: Dense, fluent, more curvilinear figurations developed from the preceding style.

Style IV: First separation of motifs proper from spirals, which now become small and function as ground pattern. Motifs and spirals are flush.

Style V: First appearance of motifs in relief: the motifs rise above the ground spirals, which may be eliminated altogether.[124]

Loehr's identification of Styles I and II as early types of Shang decoration has been proved by subsequent archaeological discoveries. His characterizations of the five indi-

Fig. 1.38. Five bronze decorative bands representing the Five Styles of Max Loehr (Styles I–V, top to bottom). Ink rubbing.

The Age of Ritual Art

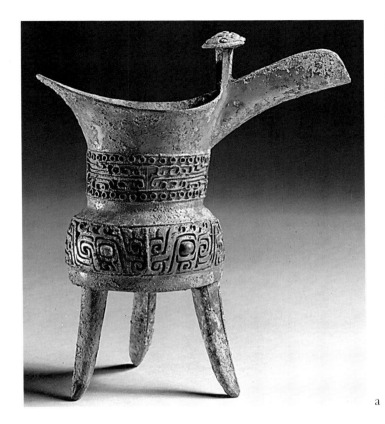

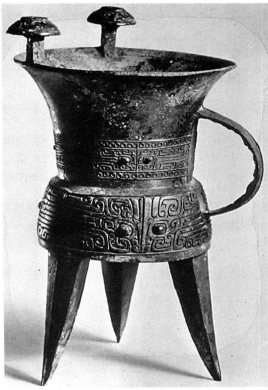

Fig. 1.39. Mid-Shang bronzes with Styles I and II decoration. (a) Jue vessel. H. 17.2 cm. Said to be from Huixian, Henan province. Royal Ontario Museum, Toronto. (b) Jia vessel. H. 26.7 cm. Shanghai Museum.

a

b

vidual styles have provided scholars, including this writer, with standards in categorizing and describing the forms of Shang bronze decor. But his basic theoretical assumption, that the five styles constituted a consecutive sequence and each dominated a particular period in the course of Shang bronze art, is based on an evolutionary pattern that is not supported by excavated materials.[125] New archaeological evidence reveals that the development of Shang bronze art was far more complex: the five styles did not occupy equal segments of time during the Shang dynasty, nor did they replace one another in a linear progression. Rather, all five styles were invented during a relatively short period from approximately 1400 to 1300 B.C.[126] Many instances indicate the wide coexistence of divergent styles in a given period. There are mid-Shang vessels decorated with both Style I and II patterns (Figs. 1.39a, b);[127] some even have Style III designs and a cast-on handle

(Fig. 1.40). A set of bronzes from a mid-Shang tomb or hoard often consists of vessels bearing designs of various styles (Figs. 1.41a, b).[128] There are late Shang bronzes covered with both Style IV and V patterns,[129] and vessels with Style IV or Style V patterns appear together in a single tomb.[130] Moreover, after the invention of Style V, Shang bronze art continued to develop, and earlier styles remained in use. Louisa G. Fitzgerald Huber has identified a number of new styles that emerged toward the end of the Shang, including an "archaic" style reminiscent of Styles I and II of the mid-Shang period (Fig. 1.58).[131]

From a strict evolutionary approach, these situations must be viewed as "exceptions," and the coexistence of different styles must be interpreted as the survival (or revival) of older ones after new ones had come into being.[132] But the frequency of such "exceptions" may in fact indicate important "norms" in Shang artistic creation.[133] The

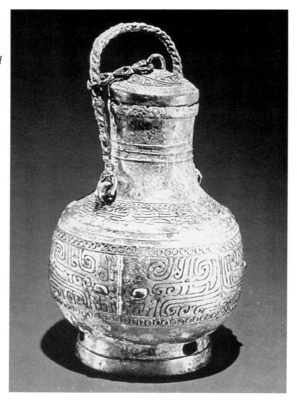

imbues the shapes with life and therefore with movement and expression."[134] Interestingly, a second century B.C. Chinese author appreciated ancient bronze *liqi* exactly for their seemingly puzzling ability to evoke a sense of life and movement.

> The grand ceremonial bells and *ding* tripods, these are beautiful *qi* of extraordinary importance. They are engraved with elaborate birds of intertwining bodies, crouching rhinoceros, stealthy tigers, and coiling dragons whose interlocking forms resemble a textile design. Their shining color dazzles people's eyes; ablaze with lights, they radiate even more brilliantly. Flexible and intricate, their spiral decoration comprises complex patterns. Further inlaid with tin and iron, they change their appearance as if the sky were now darkened, now brightened.[135]

Since metamorphosis does not reject the concepts of "style" and "iconography" but creates and integrates stylistic and iconographic variations, the study of Shang bronze art can utilize the result of previous formal analyses. In other words, Loehr's basic identifications of the five styles may still be valid, but the intent behind the creation of these styles and the relationships among them must be reconsidered. Such a reconsideration reveals that two essential modes—a *metamorphosis* in "style," or the way of presentation, and a *metamorphosis* in "image," or the subject of presentation—characterize mid-Shang and late Shang bronze decoration, respectively.

The deliberate stylistic variation during the mid-Shang is most apparent in the wide coexistence of Style I and II patterns, designs that are contradictory and complementary in visual effect. The main motif executed in thin threads in Style I is expressed by thick ribbons in Style II; correspondingly, the ground left empty in the former becomes thin sunken "lines" in the latter. In fact, the "mirroring" effects[136] of these two styles was best described by Loehr himself: the first style is light, airy, and in relief; the second is harsh and heavy and has an incised appearance.[137] The depiction of the *taotie* in these two styles on a single vessel (Figs. 1.39a, b) or on different vessels in a single set (Figs. 1.41a, b) must, therefore, signify the Shang people's fascination with the possibility of rendering a single image in various ways.[138] The same fascination is apparent

key to understanding these norms, I suggest, is not a straight stylistic sequence or a revision of such a sequence, but the concept of *metamorphosis*, which helps explain a series of problems unsolved by an evolutionary interpretation and allows us to discover the dynamic nature of Shang ritual art. The term *metamorphosis* is used here in its dictionary meaning to refer to deliberate alteration, transformation, or transmutation of form, structure, or substance. In art, the effort toward metamorphosis rejects monotony and invites variation and permutation. Instead of a "standard" or "dominant" style or iconography, it favors protean styles and motifs. The combining of complementary or even contradictory styles and motifs in the decoration of a single object creates visual ambiguity and dynamism that contribute to the sense of *animation*. E. H. Gombrich has contrasted the principle of "animation" in design with that of "stylization": "The latter imposes order and approximates the living form to geometric shapes, the former

in the decoration of Liangzhu ritual jades: the two masks in a pair are sometimes distinguished not only in iconography but also in carving style (Figs. 1.17b, 18b).

Bagley rightly suggests that "it is important to note that they [i.e., Style I and II designs] retain precisely the same non-pictorial character. The raised areas of Style II do not outline or embody a creature any more than did the thread-relief designs of Style I."[139] The mid-Shang *taotie* imitated and, to some extent, distorted earlier mask motifs on jades. In many cases the *taotie* consists of little more than a pair of eyes, surrounded by abstract linear patterns that can hardly be conceived as the "body" of any real or imaginary creature. Even though details were gradually added, the *taotie* generally remained an elusive image with an ambiguous contour. The tendency toward visual complexity rather than organic imagery is especially evident in Style III, which is characterized by repetitions of abstract elements. The fine, slender, feather-like extensions projecting from various parts of a *taotie*—the trademark of this style—create a disciplined rhythm but at the same time further blur the *taotie*'s outline.

The best examples of mid-Shang stylistic *metamorphosis* are the thirteen bronze vessels unearthed in 1982 from a Zhengzhou hoard (H1; Fig. 1.42).[140] The largest bronzes in this group are two imposing square *ding* (Figs. 1.43a, b). These apparently formed a pair, to judge from their identical decorative scheme and measurements (both 81 cm high and 53 cm wide), but they differ in using Styles I and II, respectively. Significantly, these two vessels were placed in the hoard side by side but in opposite directions (Fig. 1.42). In other words, they seem to "invert" each other in both decoration and placement. The same dualistic convention may also underlie the decoration of two other vessels in the group—a *lei* and a *you* (Figs. 1.44a, b). Although the *lei* has an angular shoulder and the *you* is equipped with a lid and a handle, they are similar in size and their bodies are covered with large *taotie* of similar shapes. The dense "quill" motifs surrounding the *taotie* identify the masks as Style III designs, but the pattern on the *lei* is "positive"—the *taotie* is represented by thick ribbons above the ground—whereas the pattern on the *you* is "negative"—the *taotie* is a "hollowed" image defined

Fig. 1.42. Zhengzhou Hoard no. 1. Mid-Shang dynasty. Mid-2d millennium B.C. Excavated in 1982 at Zhengzhou, Henan province. Drawing.

various *taotie* rendered in a uniform style. The precise date of the change is uncertain, but available evidence places it close to or around 1200 B.C.[142] The strong interest in images, first revealed by the conscious effort to distinguish organic *taotie* (and other animals and birds) from the ground covered with geometric spirals (i.e., Style IV), was furthered by the overwhelming popularity of relief *taotie* (Style V). Loehr has described such phenomena as the "'growth' from rudimentary and vaguely suggested, semi-geometric forms to neatly defined, fully zoomorphic forms."[143] Bagley has interpreted the invention of Style IV as "a major innovation, and one that makes an abrupt break with the earlier trend toward ever more complex designs."[144] Although these statements still reflect an evolutionary theory, the two authors imply that the five styles are not equal phases in a smooth evolution but that the first three styles and the last two differ fundamentally in intention and visual quality and that they should be redefined as representing two essential decorative "modes."[145]

The problem of dating Styles IV and V has been partially resolved by the discovery of Tomb no. 5 at Anyang—the only known Shang royal burial to have escaped robbers. Belonging to Fu Hao, a consort of King Wu Ding (ca. 1200–1181 B.C.),[146] the tomb yielded hundreds of bronze vessels decorated with large *taotie*, many of which are relief images that surface from a densely incised ground with force and vividness (Fig. 1.45).[147] The effort to create tangible plastic images was coupled with the wide application of vertical flanges that protrude from the surfaces of a bronze.[148] The visual psychology behind this device was apparently to create a kind of picture frame. With the help of flanges, even a round vessel appears as an assemblage of rectangular units containing masks and half-masks as the foci of the viewer's concentration (Fig. 1.46).[149] Bronze vessels have became bearers of images and were sometimes even transformed into three-dimensional images (Fig. 1.47).

There has been a persistent scholarly impulse to attempt to define or identify the *taotie*. But in my opinion, late Shang art never recognized a "standard" *taotie*, only endless variations. However forceful and demanding, late Shang zoomorphs are not static symbols. They combine

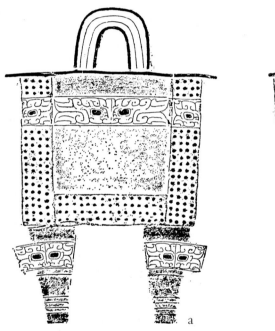
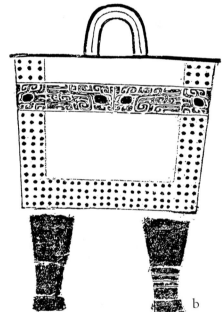

Fig. 1.43. (a, b) Two bronze square ding from Zhengzhou Hoard no. 1. Mid-Shang dynasty. Mid-2d millennium B.C. Both H. 81 cm. Zhengzhou Museum. Ink rubbing.

by the raised ground.[141] The group of bronzes from this hoard not only exhibit the first three of Loehr's five styles, but high-relief taotie also appear on vessels otherwise decorated with more "primitive" patterns.

The movement toward protean and complementary styles, however, was altered during the late Shang. The emphasis was now on *metamorphic images* represented by

The Age of Ritual Art

features from different animal species but never become naturalistic representations or formulated icons. Even on a single vessel, the *taotie* assume different forms and are shown from various angles (Figs. 1.48a, b);[150] and even pairs of vessels never bear identical decoration. In analyzing the bronzes from Fu Hao's tomb, the Chinese archaeologist Zheng Zhenxiang was puzzled by what he considered a peculiar phenomenon: "In the pairs and sets of vessels . . . the overall body of decoration is basically the same, but there are always slight differences of detail in the decor and the background designs. [But] the forms of the characters in the inscriptions on the paired vessels are similar, as if written by one person. . . . The question of why the decorative designs manifest differences still requires further investigation."[151]

The answer to Zheng's question is found in the metamorphic nature of Shang decorative art. What distinguishes late Shang bronze decoration from the previous stage is that the *metamorphosis* now occurs primarily in iconography, not in style. In other words, it is the form of an image that is protean and constantly changing, although all the variations may be rendered in a single style. It is likely that these metamorphic images—not only molded on bronzes but also painted and carved everywhere in a "sacred" place—functioned to "animate" inanimate material—a piece of metal or wood.[152] Similar beliefs existed in many traditions in the ancient world, along with a universal belief in the magic power of eyes or masks.[153] These varying images seem to attest to a painstaking effort to create metaphors for an intermediate state between the supernatural and reality—something that one could depict but not portray.

THE TRIUMPH OF WORDS

We have seen that three basic elements of a monument—material, shape, and decor—in turn played important roles in the development of bronze art. This art again changed orientation from the end of the Shang through the Western Zhou: symbolic imagery gradually declined, and the literary values of ritual bronzes were heightened. The fourth and last signifier of *liqi*, inscription, now became the most important marker of monumentality in bronze art.

Fig. 1.44. Two bronze vessels from Zhengzhou Hoard no. 1. Mid-Shang dynasty. Mid-2d millennium B.C. (a) You vessel. H. 50 cm. (b) Lei vessel. H. 33 cm. Zhengzhou Museum. Drawing and ink rubbing.

Fig. 1.45. near right Bronze square yi vessel. Late Shang dynasty. Late 2d millennium B.C. H. 36.6 cm. Excavated in Yinxu Tomb no. 5 at Anyang, Henan province. Museum of Chinese History, Beijing.

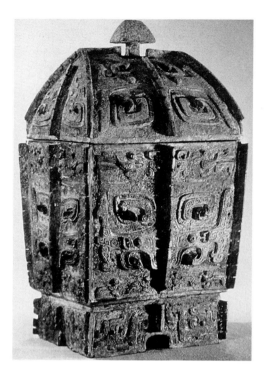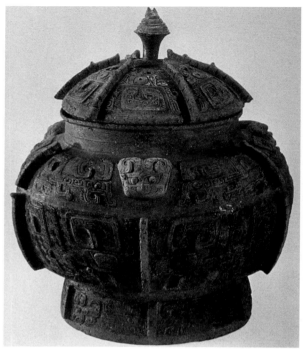

Fig. 1.46. far right Bronze bu vessel. Late Shang dynasty. Late 2d millennium B.C. H. 42.5. Excavated in 1959 at Zhaizishan, Ningxiang, Hunan province. Hunan Provincial Museum.

Fig. 1.47. Bronze gong vessel. Late Shang dynasty. Late 2d millennium B.C. H. 24.8 cm. Harvard University Art Museums, Cambridge, Mass.

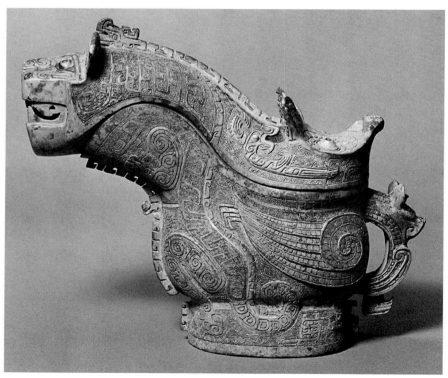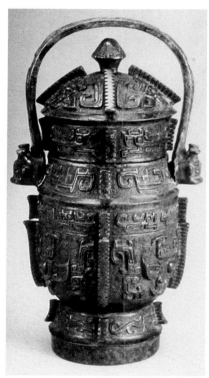

b

Fig. 1.48. (a) Bronze you vessel. Late Shang dynasty. Late 2d millennium B.C. H. 24.6 cm. National Palace Museum, Taipei. (b) Decoration and inscription. Ink rubbing.

a

As mentioned earlier, the "emblem" as a primitive form of inscription had appeared on Liangzhu ritual jades (Fig. 1.29). Inscriptions on mid-Shang bronze vessels are also emblems in animal shapes (Fig. 1.49a, b); as an emblem, such an inscription identifies the clan or lineage that owned the ritual object.[154] By the early thirteenth century B.C., however, a person's name could be added to specify an attribution further.[155] This seemingly minor modification testifies to a major change in the significance of a bronze ritual object: instead of being linked to a group of people (as indicated by a shared emblem), the bronze was now associated with a specific person (as indicated by his or her name). Such an association could be established by an individual, in which case the "living name" of a person would be inscribed on a vessel, or by descendents, in which case the "temple name" of a person would be inscribed instead. (During the Shang, a noble man or woman had a "living name" while alive; after death, his or her spirit received a "temple name" in ancestral worship.) David N. Keightley explains this second practice:

> It is well-known that some late Shang and early Zhou ancestors were given temple names, such as "Father Jia" and "Grandmother Keng," and that these temple names employed the same "heavenly stems" (*tiangan*) given to the ten days of the Shang week, jia, yi, bing, ding, and so forth. Further, we know that Father (Mother, Grandfather, or Grandmother) Jia received cult on a jia day, the first day of the week, Father Yi on an yi day, the second day of the week, and so on. There were ten *gan* stems available for naming ancestors, just as there were ten days to the Shang week.[156]

Inscriptions on bronzes found in Fu Hao's tomb include both types of names: among the 190 inscribed bronzes, 31 bear "temple names"—"Queen Tu Mother" (Si Tu Mu) (Fig. 1.50a) or "Queen Mother Xin" (Si Mu Xin) (Fig. 1.50b); and 109 bear the name Fu Hao (Fig. 1.50c), which is well documented in the oracle-bone inscriptions as the "living name" of a consort of King Wu Ding.[157] The extraordinary number of the Fu Hao bronzes, which include some huge vessels and axes, seems to indicate that around the time of Wu Ding's reign many bronzes were made not for the dead but for living members of

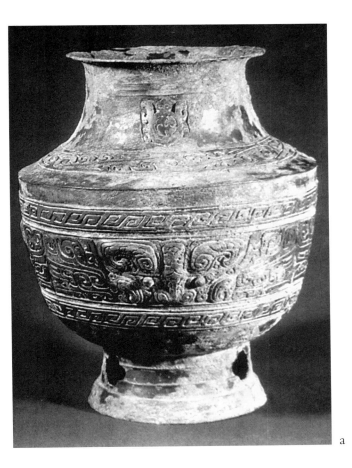

Fig. 1.49. (a) Bronze lei vessel. Mid-Shang dynasty. Mid-2d millennium B.C. H. 25 cm. Excavated at Baijiazhuang, Zhengzhou, Henan province. (b) Emblem on the lei. Ink rubbing.

Fig. 1.50. below Inscriptions on bronzes from Yinxu Tomb no. 5. Late Shang dynasty. Ca. 13th century B.C. (a) "Si Tu Mu." (b) "Si Mu Xin." (c) "Fu Hao." Ink rubbings.

Fig. 1.51. Inscription on
Mu Wu gong. Late
Shang dynasty. 12th–11th
centuries B.C. Excavated
in 1975 at Xiazhuang,
Linxian, Henan province.
Linxian County Museum.
Ink rubbing.

b

Fig. 1.52. (a) Yu yu. Late
Shang dynasty. 11th century
B.C. (b) Inscription. Ink rub-
bing.

the royal house as symbols of their social status and power. Nevertheless, ritual vessels with "temple names" soon became dominant, and this dominance demonstrates that bronzes increasingly served ancestral worship and "commemorative" purposes.[158] The nature of such temple-name inscriptions is unmistakable: the emphasis lies on the person to whom the bronze was dedicated, not on the person who dedicated the bronze.[159] This emphasis is clearly indicated by the omission of the commissioner's name. Even when the verb *zuo* (to make) was added and the inscription became "To make this precious ritual vessel for a certain ancestor (or ancestress)" (Fig. 1.51),[160] the presence of the living person who dedicated the bronze was still implicit.

The inclusion of the dedicator's name in an inscription, therefore, signified another important change in the meaning of the text, the intention behind the commissioning of the ritual object, and the "monumentality" of the bronze. An inscription reading "[I,] X, commissioned this precious ritual bronze for [my deceased] ancestor Y" (Figs. 1.52a, b) not only states the purpose of the dedication but also makes clear that it was X who conducted the dedication. The memory the ritual vessel and its inscription bears thus

became double-edged: when used in ancestral rituals, it would remind future generations of X as well as Y.

This change ushered in a type of "narrative" inscription, a practice that became popular toward the end of the Shang dynasty during the reigns of the last two Shang kings (Di Yi and Di Xin).[161] The emphasis of the inscription shifted further to the *reason* for an ancestral dedication. In most cases this was a courtier's receipt of awards from the king or his superiors. The courtier's worldly achievements thus led to his making the bronze vessel for his ancestors, and the religious event (the ancestral dedication) was the result of a non-religious event (an award to the courtier). A typical example reads: "On the day *guisi* the King awarded [me], *xiaochen* Yi, ten strings of cowries, which [I] then used to make this ritual vessel for [my deceased] mother Gui. It was in the King's sixth *si*, during the *yong* sacrificial cycle, in the fourth month. [Emblem]" (Figs. 1.53a, b).

It is clear that the primary focus of such inscriptions is no longer ancestral dedication, but the commemoration of the worldly glory of its commissioner. This is perhaps why the date of the receipt of the award is always carefully recorded. Moreover, we find that such commemorative bronzes were often related to war and royal sacrifices—the two most important state activities in Bronze Age China.[162] Sometimes awards were conferred on officials during royal sacrifices:[163] "On the day *bingwu* the King awarded [me], Shu Si Zi, twenty strings of cowries at the X Temple, which I then used to make this precious *ding* tripod for [my deceased] father Gui. It was when the King held the X-sacrifice in the Great Hall at the temple in the ninth month. [Emblem]" (Figs. 1.54a, b).[164]

The king mentioned in this inscription is perhaps the last Shang ruler, Di Xin. The same king also frequently conferred awards on his ministers during his unfortunate military expedition to the Ren Fang southeast of the Shang, and these grants consequently led to the casting of commemorative bronzes.[165] But instead of introducing an inscription with a record of the award, these bronze texts often begin by mentioning the military campaign and thus assume a more obvious "archival" quality:[166] "The King came to conquer the Ren Fang. . . . The King awarded [me], archivist Ban, cowries, which I then used to make

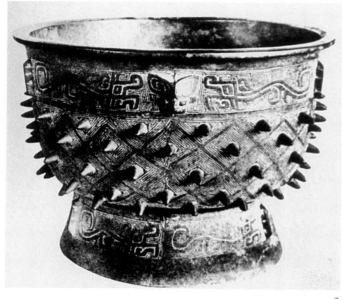

a

this sacrificial vessel for [my deceased] father Ji. [Emblem]"
(Fig. 1.55).

The implication of the inscription thus becomes more complex: in addition to recording the courtier's merit and his consequent dedication of the ritual bronze, the king and his activities become a major focus of the inscribed texts. It is understood that the bronze was made only because its commissioner had received an award and that this award was conferred only because the king had held an important ceremony or military campaign. Bronze inscriptions thus developed toward elaborating the *causes* of the religious dedication. Sometimes these causes even became the sole content of an inscription. The text cast on a rhinoceros-shaped vessel in the Asian Art Museum of San Francisco records only the king's expedition and the

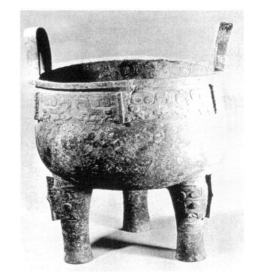

a b

Fig. 1.54. (a) Shu Si Zi ding. Bronze. Late Shang dynasty. 11th century B.C. H. 48 cm. Excavated in 1959 at Hougang, Anyang, Henan province. Institute of Archaeology, CASS. (b) Inscription. Ink rubbing.

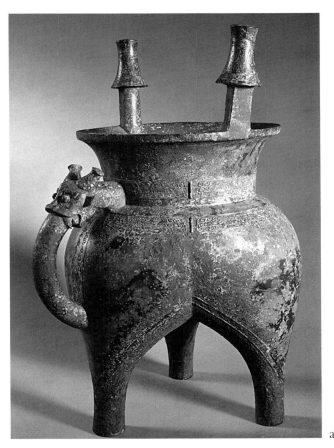

a

Fig. 1.53. left *(a) Yi jia. Bronze. Late Shang dynasty. 11th century B.C. H. 45.9 cm. St. Louis Art Museum. (b) Inscription. Ink rubbing.*

b

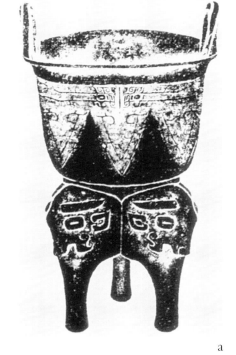

b

a

Fig. 1.55. (a) Zuoce Ban xian. Bronze. Late Shang dynasty. 11th century B.C. Museum of Chinese History, Beijing. (b) Inscription. Ink rubbing.

award received by a courtier named Yu; there is no ancestral dedication, and the vessel is purely commemorative: "On the day *dingzi* the King inspected X-place. The King presented [me], *xiaozi* Yu, cowries from that place. It was during the King's expedition against the Ren Fang. It was in the King's fifteenth *si*, a day in the *yu* sacrificial cycle" (Figs. 1.56a, b).

These late Shang inscriptions reveal a crucial change in the monumentality of ritual bronzes. They also pertain to the development of ritual bronzes in two ways. As Virginia Kane has pointed out, they provided "important late Shang precedents for the many similar features subsequently found in the inscriptions of the Early and Middle Western Chou [Zhou] period."[167] Moreover, the change in inscription was associated with important innovations in late Shang bronze decoration, which again strongly influenced the further development of bronze art during the Zhou. The following discussion thus proceeds from two angles: the development of inscription and the stylistic transformation of bronze decoration.

First, although often much longer, Western Zhou inscriptions grew from their Shang precedents. Many early Zhou (ca. 1050–975 B.C.) examples focus on political events, among which the most important ones are King Wu's conquest of the Shang, King Cheng's construction of the capital Chengzhou and his military campaigns to suppress rebellions in the east, and King Zhao's military expedition against southern uprisings.[168] Other inscriptions, again following the Shang examples, document royal sacrifices.[169] A majority of lengthy Western Zhou bronze texts, however, record "investiture" ceremonies routinely held in the Zhou royal temple, during which officials were given titles, properties, and status symbols by the king.[170] As the Chinese historian Chen Hanping recently demonstrated in an exhaustive study of such documents, this type of inscription became popular during the middle Western Zhou (ca. 975–875 B.C.).[171] The political and ritual events considered important enough to record in earlier inscriptions disappear from such writings, which were now stereotypical in both content and format.

Fig. 1.56. (a) Rhinoceros-shaped zun *vessel. Bronze. Late Shang dynasty. 11th century B.C. H. 22.9 cm. Said to be from Liangshan, Shandong province. Asian Art Museum of San Francisco, The Avery Brundage Collection (B60 B1+). (b) Inscription. Ink rubbing.*

b

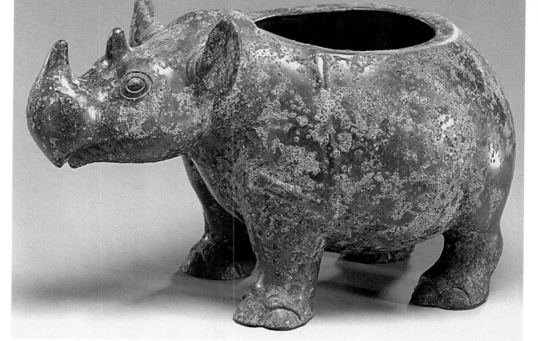

a

The following inscription repeated on three ritual bronzes commissioned by an official named Li (Figs. 1.57a, b) exemplifies the convention:

> In the first quarter of the eighth month, the King arrived at the Temple of Zhou. The Duke of Mu guided me, Li, into the Middle Court, to stand facing north. The King commanded the attendants to present me with scarlet cloth, black jade, and a bridle, saying: "By these tokens, govern the Royal Officers and the Three Ministers—the Seneschal, the Master of Horse, and the Master of Artisans." The King commanded me, saying: "For the time being, take charge of the lieutenants of the Six Regiments [the army of the West] and of the Eight Regiments [the army of the eastern capital, Chengzhou]." I, Li, bowed to the floor and made bold to answer that I would proclaim the King's trust by casting precious vessels for my gentle ancestor Yi Gong. I said, "The Son of Heaven's works defend our empire everlastingly! I prostrate myself before him and vow to be worthy of my forebears' faithful service."[172]

Regulations for such ceremonies can be found in the *Book of Rites*.[173] The author of this text also recorded an exemplary "investiture" inscription and explained the idea behind casting such texts on ritual bronzes: "By casting such a discourse on a ritual vessel, the inscriber makes himself famous and proves that he is entitled to sacrifice to his ancestors. In the celebration of his ancestors he exalts his filial piety. That he himself appears after them is natural. And in the clear showing of all this to future generations, he is giving instruction."[174] This author thus defined "inscription" (*ming*) as *ziming*—"to make oneself known" or "self-identification."[175] As we have seen, this idea of "making oneself known" can be traced back to the personal names in late Shang bronze inscriptions. A major difference in a Zhou "investiture" text, however, is that such a document, with its exhaustive description of the ritual, has become a truly personal record. Shorter inscriptions still existed during the Zhou, but unlike Shang examples of similar length, which emphasize the dedicatee rather than dedicator, they often omit the ancestral dedication and contain only the name of the commissioner of the vessel. Although this may seem to be a return to the ancient practice of inscribing one's "living name" on vessels

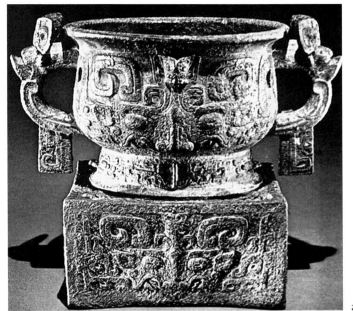

a b

Fig. 1.57. (a) Li gui. Bronze. Late 11th century B.C. H. 28 cm. Excavated in 1976 at Lintong, Shaanxi province. Lintong Museum. (b) Inscription. Ink rubbing.

(as exemplified by the Fu Hao bronzes), short inscriptions during the late Western Zhou resulted from the general decline of ancestor worship.

The development of bronze inscription from the late Shang to the end of the Western Zhou was closely related to, and to a certain extent determined, the appearance of ritual bronzes. Significantly, the innovation of Shang "narrative" inscriptions was coupled with a dramatic change in decorative style: many vessels bearing such texts are not embellished with large, powerful *taotie*. Instead, these vessel are "plain" and "sober," often decorated only with narrow bands reminiscent of mid-Shang designs (Figs. 1.58a, b). The contours of the vessels are smooth and gentle, lacking protruding flanges as image frames. Without ruling out the possibility that this style derived from pottery wares or was associated with a particular group of patrons, I strongly suggest an intimate relationship between inflating inscription and deflating decoration—two phenomena that together attest to the growing importance of words over images. It is perhaps still too early to estimate the absolute importance and far-reaching influence of this change in the history of Chinese art and culture

Fig. 1.58. upper left
(a) Bronze you *vessel.*
Late Shang dynasty. 11th
century B.C. *(b) Inscrip-*
tion. Woodblock recon-
struction.

Fig. 1.59. upper right
Bronze zun *vessel (Hu-*
ber's Style Va). Late
Shang dynasty. 12th–11th
centuries B.C. *H. 36.8 cm.*
Freer Gallery of Art,
Washington, D.C.

Fig. 1.60. lower left
Bronze you *vessel (Hu-*
ber's Classic Style). Late
Shang dynasty. 11th cen-
tury B.C. *H. 36.5 cm.*
Freer Gallery of Art,
Washington, D.C.

Fig. 1.61. lower right
Bronze gong *vessel (Hu-*
ber's Post–Classic Style).
Late Shang dynasty. 11th
century B.C. *H. 22.9 cm.*
Asian Art Museum of San
Francisco, The Avery
Brundage Collection.

a

b

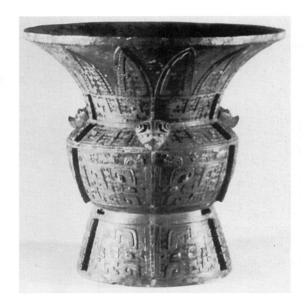

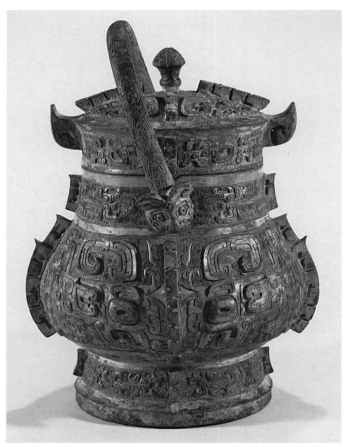

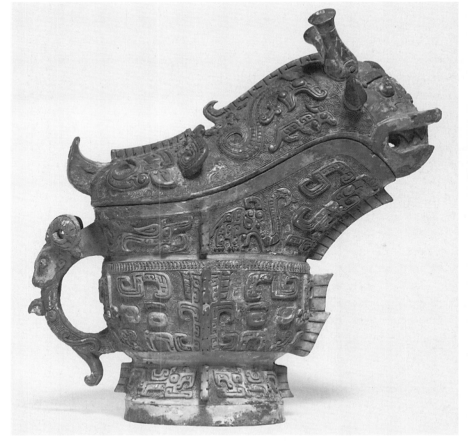

in general, but a number of clues may lead us to see its multiple manifestations in art, religion, and literature.

In an excellent study of late Shang bronze art, Louisa Huber observes that after the "golden age" of this art during the Wu Ding period, "the inventory of motifs ceases to grow . . . and thereafter becomes relatively conventional and standardized."[176] From this conservative movement appeared what she calls Style V(a) and the Classic Style. In Style V(a), uniform spiral patterns cover both the main zoomorphic motifs and the background, and a *taotie*, now disassembled, loses its sculptured image (Fig. 1.59).[177] The Classic Style, on the other hand, continued to employ large, plastic zoomorphs, but "the designs are neither charged with the energy of the Wu Ding pieces nor can they be considered innovative, insofar as the repertory of designs has become quite restricted" (Fig. 1.60).[178] These two styles anticipated the further patternization of bronze decor toward the end of the Shang: the *taotie* became even more conventional and mannered in a Post–Classic Style (Fig. 1.61); a kind of "plain" bronze appeared with only narrow bands of geometric patterns (Fig. 1.58a); and stark high-relief *taotie* protruded above the plain background (Fig. 1.62).

Huber relates this conservative tendency in late Shang art to a contemporary change in ancestor worship summarized by Keightley as follows:

> The whole process of divination has become more artificial, more routine, less spontaneous, less dramatic, less important. . . . The entire scope of Shang divination, in fact, had become constricted remarkably by Period V [i.e., the reigns of the last two Shang kings] so that questions about many problematical matters of Period I [i.e., the Wu Ding period] universe, such as the weather, sickness, dreams, ancestral curses, requests for harvest . . . were rarely divined about, if at all. The bulk of Period V divination was concerned with three topics: the routine execution of the rigid sacrificial schedule, the ten-day period, and the king's hunts. . . . The changes no longer involved specific forecasts about what the ultra human powers might do to man. The inscriptions record, as it were, the whispering of charms and wishes, a constant bureaucratic murmur, forming a routine background of

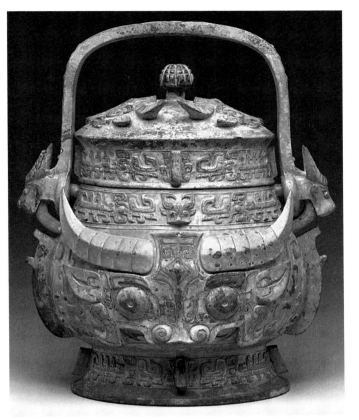

invocation to the daily life of the late Shang kings, now talking, perhaps, more to themselves than to the ultra-human powers. Optimistic ritual formula had replaced belief. . . . Man, rather than Ti and the ancestors, was thought to be increasingly capable of handling his own fate.[179]

Not coincidentally, we have found parallel changes in the monumentality of ritual art. As demonstrated earlier, the focus of some late Shang bronze inscriptions gradually shifted from the deity to the devotee, and narratives of worldly events replaced ancestral dedications. This style of inscription, as well as the late Shang art styles in decoration, continued into the Zhou. This observation is reminiscent of an approach of ancient writers, who persistently placed the Shang and Zhou cultures in opposition: the Shang emphasized *zhi* or "material substance," whereas

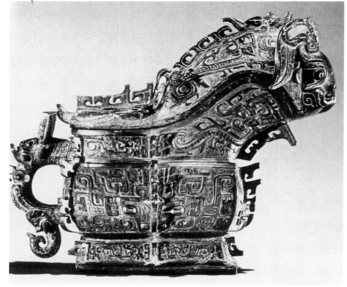

a

b

Fig. 1.63. (a) Zhe gong. Bronze. Early Western Zhou. 11th–10th centuries B.C. H. 28.7 cm. Excavated in 1976 from Zhuangbai Hoard no. 1, Fufeng, Shaanxi province. Fufeng Cultural Relics Administration. (b) Inscription. Ink rubbing.

the Zhou emphasized *wen* or "literary refinement"; the Shang worshipped ancestral ghosts, but the Zhou honored Heaven and people. Sarah Allan recently suggested that the key to understanding the Shang-Zhou transition is that the former's "myth tradition" was replaced by the latter's "historical schemes."[180] In a broader historical scale my discussion agrees with these interpretations and formulations, but this discussion also reveals that the rigid

separation of the Shang and Zhou may be artificial—many elements thought to be characteristic of Zhou art and culture had emerged before the Zhou conquered the Shang.

As many art historians have observed, Western Zhou bronze decoration generally evolved toward patternization.[181] This tendency was visible from the beginning of the dynasty: the late Shang "archaic" style prevailed, and a "flamboyant" style (Fig. 1.63a) began to exaggerate the ornamental features of earlier zoomorphs. Ornate details were intensively produced; feather-like hooks became a universal vocabulary, added to every image and even reshaping flanges. A more important change was the dismissal of the frontal mask. The two dragons became divorced (Figs. 1.64a, b), and the result is a fundamental change in perception: there is no longer a visual center; instead, profile images guide the viewer's gaze around the surface of a vessel. Consequently, flanges as image frames were abolished. This new formula then provided a structure for the bird motifs popular during the mid–Western Zhou (Fig. 1.65). With their reversed heads, elaborate crests, and large and often detached tails, such birds form smooth S-shaped patterns that echo the carved outlines of the vessels. Both the abolition of a visual focus and the emphasis on ornamental details led to the further abstraction and fragmentation of zoomorphs. Finally, during the late Western Zhou, animal motifs were dismembered into

Fig. 1.64. (a) Yanhou yu. Bronze. Early Western Zhou. Early 10th century B.C. H. 24 cm. Excavated in 1955 at Kezuo, Liaoning province. Museum of Chinese History, Beijing. (b) Decoration. Ink rubbing.

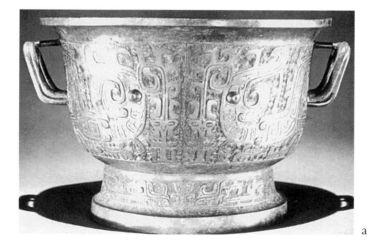

a

b

pure "patterns"—quills, eyes, and scales—often applied on a series of vessels of decreasing sizes (Fig. 1.66). The number of bronzes in such a set denoted the rank of its maker or owner.[182]

Again, the stylistic evolution (or degeneration) sketched here must be understood in relation to the parallel development in inscription. As I have shown, from the end of the Shang the focus of inscription gradually shifted from the ancestral deity to the living devotee. Although most Western Zhou bronzes were still dedicated to deceased ancestors, the dedication appeared as a consequence of an important event in the life of a living descendent. It was these events, mainly court audiences and investitures, that provided the cause for making ritual vessels, and they were elaborately described in a commemorative inscription. Consequently, the meaning and function of a ritual vessel, and hence its monumentality, changed: it was no longer an instrument in a ritual communication with deities, but a proof of glory and achievement in this life.

Fig. 1.66. Some decorative patterns on late Western Zhou bronze vessels. Ink rubbing.

Consequently, the symbolic protean imagery lost its vitality and dominance; lengthy documents were painstakingly cast on a poorly decorated plate or a shallow tripod. As monuments, such bronzes demand "reading," not "seeing" (Figs. 1.67a, b, 2.12a, b).

The Chinese Bronze Age

The concept of a "Bronze Age," frequently employed in modern scholarship on early Chinese history and art history, is borrowed from the Western evolutionary theory called the "three-stage technological sequence."[183] Credit for this theory is usually given to two nineteenth-century Danish scholars, Christian Thomsen and Kens Worsaae, although similar sequences had been proposed by Johann von Eckart in the early eighteenth century and can even be found in the writings of Lucretius of ancient Rome.[184] Thomsen defines the Three Ages in his *Guide to Northern Antiquities*:

> The Age of Stone, or that period when weapons and implements were made of stone, wood or bone, or some such material, and during which very little or nothing at all was known of metals. . . .
> The Age of Bronze, in which weapons and cutting implements were made of copper or bronze, and nothing at all, or but very little was known of iron or silver. . . .
> The Age of Iron is the third and last period of the heathen times, in which iron was used for those artifacts to which that metal is eminently suited, and in the fabrication of which it came to be used as a substitute for bronze.[185]

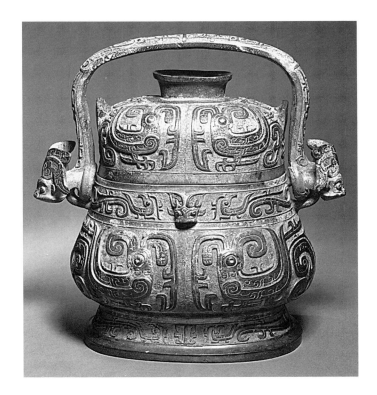

Fig. 1.65. Geng Ying you. Bronze. Mid–Western Zhou. 10th–9th centuries B.C. H. 24.8 cm. Harvard University Art Museums.

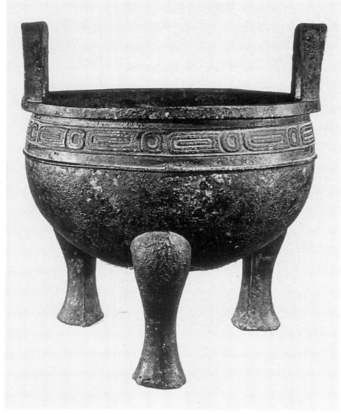

Fig. 1.67. (a) Mao gong ding. Bronze. Late Western Zhou. 9th century B.C. H. 53.8 cm. Said to be from Qishan, Shaanxi province. (b) Ink rubbing of inscription.

a

b

The simplicity of Thomsen's model was not to endure for long; the "three-stage sequence" was greatly elaborated during the second half of the nineteenth century and the beginning of the twentieth century: John Lubbock divided the Stone Age into the Paleolithic and Neolithic periods; the term *Mesolithic* was introduced by Aleen Brown; and Italian archaeologists suggested an Eneolithic period between the Stone Age and the Bronze Age.[186] But it was Gordon Childe who finally integrated these individual discoveries into a coherent theory of cultural evolution consisting of "a series of consecutive stages in technological development." In this general context, the Bronze Age was thought to comprise three subsequent "modes":

> In Mode 1, weapons and ornaments were made from copper and its alloys, but no "mutant" tools and few implements were adapted exclusively for industrial use. Stone tools continued to be made with care. In Mode 2, copper and bronze were regularly used in handicraft, but neither in husbandry nor in rough work. The metal types included knives, saws, and specialized axes, adzes, and chisels. Mode 3 is characterized by the introduction of metal implements in agriculture and for heavy labor, shown in the archaeological record by metal sickles, hoe blades, and even hammerheads.[187]

The evolution of the Bronze Age itself thus attests to (and results from) the basic assumption of the theory in general—the continuous development of "forces of production" brought about by the invention of advanced tools and their widening employment. Moreover, as a general evolutionary theory, this pattern was thought to have been shared by various cultures in the ancient world.[188] Belief in the universality of the "three-stage technological sequence" led to the free borrowing of the term *Bronze Age* in the study of early Chinese history to refer to the period traditionally called the Three Dynasties during which the bronze industry reached its zenith.

The problem, as a number of scholars have pointed out, is that although Chinese bronze works are commonly recognized as products of the most advanced bronze technology developed in the ancient world, the Chinese never made advanced bronze agricultural implements and only produced limited handicraft tools.[189] Among them,

K. C. Chang tried to redefine the concept of the Bronze Age in the Chinese context in an important article published in 1980: "Since bronze was not widely used for agricultural implements, the Bronze Age [of China] was not achieved primarily through a revolution in productive technology. If there was a revolution, it was in the realm of social organization."[190] This general proposition led him to two further observations. First, since the Chinese Bronze Age coincided with factors such as the state form of government, urbanism, and civilization, this concept "could well serve as a criterion for cultural and social definitions." Second, "the characteristic feature of the Chinese Bronze Age is that the use of that metal was inseparable from ritual and from war. In other words, bronze was political power."[191] These observations provide a basis for my discussion in this section on the symbolism of bronze in relation to the concepts of power and monumentality. Before I begin, however, it is necessary to survey the basic uses of bronze in ancient China.

Extant bronze objects allow us to reach three preliminary conclusions regarding the function of bronze. First, after the discovery of bronze in China, this new material was used *primarily* for nonproductive purposes. These nonproductive bronze objects fall into two large categories: (1) vessels and musical instruments used in rituals, and (2) weapons and chariot fittings. Some weapons and chariots could have been used in warfare,[192] but a considerable number are exquisitely inlaid and/or oversized and must have also served a ceremonial purpose (Figs. 1.68a, b).

Second, some bronze drills, knives, chisels, and small spades have been found, but it would be dangerous to identify these as utilitarian tools used in daily life. For example, Shang oracle bones—instruments of royal divination—were drilled with holes in order to produce cracks after burning. It was estimated in the early 1960's that some 460,000 Shang oracle bones existed, including 150,000 inscribed ones, and that each bore five holes on average, so that an astonishing number of 2.3 million holes should be found on these bones.[193] Most holes, if not all, were created by using bronze drills; one such tool was found together with bones and turtle shells in 1952 in Zhengzhou, and another drill found in 1953 in the same area fits the

a

b

Fig. 1.68. (a) Spear. Bronze and jade. Late Shang dynasty. 13th–12th centuries B.C. L. 18.4 cm. Palace Museum, Beijing. (b) Xiong Ya axe. Bronze. Late Shang dynasty. 12th–11th centuries B.C. L. 32.7 cm. W. 34.5 cm. Excavated in 1964 at Yidu, Shandong province. Shandong Provincial Museum.

holes on oracle bones perfectly (Fig. 1.69).[194] Based on this evidence, the Chinese archaeologist Guo Baojun has concluded that a large number of bronze drills must have been made for religious services controlled by the Shang royal house.[195]

A rich tomb discovered in 1989 at Xin'gan in present-day Jiangxi probably belonged to a ruler of a southern kingdom contemporary with the Shang. Although 127 bronzes objects from this tomb have been termed "implements,"[196] many of them are embellished with *taotie* and mystical zoomorphic images (Fig. 1.70). The same feature is shared by some extant bronze "tools" (Figs. 1.71); other extant chisels and axes even bear emblems, titles, and the names of Shang or Zhou aristocratic clans and personages (Figs. 1.72a–d). The appearance of the same inscriptions and patterns on ritual vessels suggests that these so-called tools may have been part of ritual paraphernalia. The Xin'gan tomb provides strong support for this argument: the 127 "tools" were grouped together with ritual vessels, ceremonial weapons, jade carvings, and a half-meter-tall bronze icon. These objects surrounded the dead and were obviously his personal belongings.[197] It is possible that the precious bronze "tools" were *liqi* used in certain agricultural rituals; we read in ritual books that such ceremonies were important duties for a ruler.[198]

In an archaeological discovery in Ningxiang in Hunan

Fig. 1.70. Bronze implements. Late Shang dynasty. Ca. 13th century B.C. Excavated in 1989 at Dayangzhou, Xin'gan, Jiangxi province. Jiangxi Xin'gan County Museum.

predating the excavation of the Xin'gan tomb, bronze "tools" had been found along with other ritual objects: 224 small bronze axes were placed inside a large ceremonial jar.[199] In other finds in the same area, a *you* vessel discovered in 1963 contained more than 1,100 jade tubes and beads, and another *you* unearthed in 1970 held some 320 ritual jades.[200] Most likely, all four cases present original groupings of different kinds of ritual objects; similar groupings are recorded in ancient ritual books but become unrecognizable when bronzes and jades are studied as individual "tools" or "works of art." It is also significant that when the market economy developed during the late Zhou period, bronze coins took the shapes of spades, knives, or rings—objects originally used in ritual and warfare but now invested with commercial value (Figs. 1.73a, b). In fact, scholars have argued that those small and thin "spades" from Shang and Western Zhou burials were in fact "prototypes" of such coins.[201]

Third, excavated Shang and Western Zhou agricultural implements are made of stone. The excavation of the Erlitou site has shown that people continued to employ stone agricultural implements after bronze casting was invented.[202] Among the later Shang examples, 3,640 stone knives or sickles were found between 1928 and 1937 at the last Shang capital, Anyang (Fig. 1.74).[203] This archaeological evidence has led some Chinese scholars to raise questions about the nature of the Chinese Bronze Age. The historian Lei Haizong wrote in 1957: "The [Chinese]

Fig. 1.69. Oracle bone with a bronze drill. Middle to late Shang dynasty. 14th–11th centuries B.C. Excavated in 1952 at Erligang, Zhengzhou.

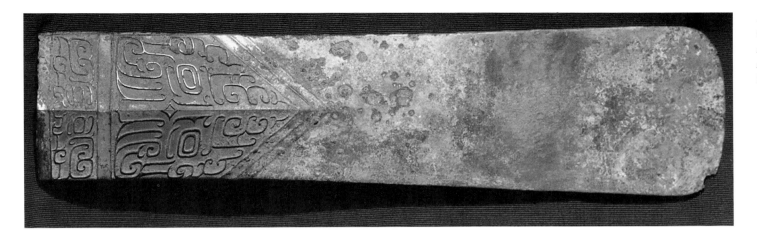

Fig. 1.71. Bronze adz with taotie *decoration. L. 29.2 cm. Harvard University Art Museums, Cambridge, Mass.*

Bronze Age was essentially a Stone Age. Tools of production, especially agricultural implements, were still largely made of stone and wood. Productive forces were still very low, and surplus was considerably limited."[204] His opinion was supported by the prominent archaeologists Chen Mengjia and Yu Xingwu.[205] Chen proposed: "When bronze casting became known, this technique was employed in making implements for royal craftsmen, weapons for royal armies, and vessels for royal sacrifices. Individual farmers were unable to make bronze agricultural implements for themselves, and slaves were certainly not allowed to use precious bronzes in farming."[206]

This discussion in the 1950's, however, was soon forced to stop abruptly: an important component of the Chinese Communist Party's doctrine of "historical materialism" was the "three-stage technological sequence" believed to be fundamental in the social evolution of the human race.[207] Any doubt about the existence of bronze tools in Chinese history was considered heretical. Lei Haizong and Chen Mengjia were condemned, labeled counter-revolutionary "rightists," and forced to stop writing. Tang Lan's 1960 article "A Preliminary Study of Problems Concerning the Use of Bronze Agricultural Implements in Ancient Chinese Society" concluded the debate by announcing the victory of the official line.[208]

A scholar learned in the Chinese Classics and antiquarianism, Tang found written characters for agricultural tools with "metal" radicals in almost all surviving pre-Qin

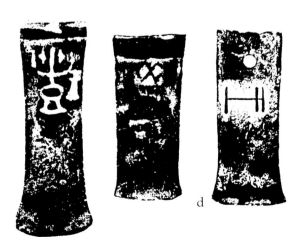

Fig. 1.72. Inscribed bronze implements. (a) Ya Yi adz. Late Shang dynasty. 13th–11th centuries B.C. *H. 11.5 cm. (b) Feng adz. Early Western Zhou. 11th–10th centuries* B.C. *H. 11.5 cm. (c) Gui adz. Western Zhou. 11th–8th centuries* B.C. *(d) Wang adz. Late Western Zhou. 9th–8th centuries* B.C. *Ink rubbings.*

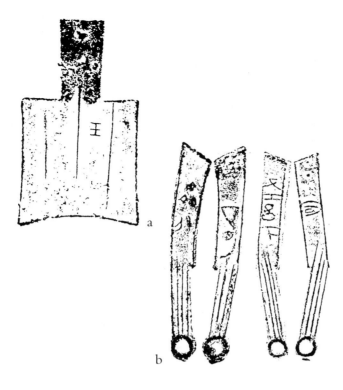

Fig. 1.73. Eastern Zhou coins. (a) Hollow-headed bu *coin with the character* wang. *(b)* Ming *knife coins. Ink rubbings.*

a

b

Fig. 1.74. right Stone agricultural tools. Late Shang dynasty. 13th–11th centuries B.C. Excavated at Xiaotun, Anyang, Henan province.

This last statement leads to a crucial question in studying early Chinese history and art history: Were "precious materials" used to improve production in ancient China? Or, was there a tradition that "precious materials" and advanced technology were persistently employed in non-productive practices? It is interesting in this regard to see a native Chinese tradition of an evolutionary pattern. Yuan Kang of the first century A.D. stated in his *Yuejue shu* (The distinction of the Yue)[212] that "stone weapons" characterized the utopia of the Three Sovereigns, and jade artifacts (which he called "divine objects") were invented by

texts and listed 45 actual bronzes that he claimed were agricultural implements. But ironically, these examples proved the absolute poverty of his evidence: most texts he quoted were written during the Eastern Zhou and their extant versions were compiled even later. The 45 objects were scattered over a broad period of some 1,500 years from Shang to Han. Not only is the limited number of these "tools" incommensurate with the numerous bronze ritual paraphernalia and weapons produced during the same period, but these so-called agricultural implements include small and thin spades, axes and "hoes" with prestigious inscriptions and *taotie* masks, and some weapons.[209] In explaining the poor result of his laborious search, Tang argued—and his argument has been repeated by many scholars who follow the party line—that "precious bronze" had to be reused and that bronze tools must have been melted down to recast other objects.[210] This assumption is, however, self-contradictory: if bronze was "precious," it had to be strictly controlled by the ruling class and had to be used to make "precious" objects.[211]

the Yellow Emperor, a legendary figure responsible for creating statecraft and regulating social ranks.[213] The use of bronze was associated with the first dynasty, Xia, and this was again followed by the Iron Age after the Three Dynasties. In this scheme, jade is distinguished from stone just as bronze is differentiated from iron. Each of the two general material categories—"stone" and "metal"—thus again contains two subcategories ("stone": ordinary stone and jade; "metal": bronze and iron). In ancient texts, ordinary stone and iron were called "ugly" or "crude" materials (*e*) and were used to make tools, whereas jade and bronze were called "beautiful" or "fine" materials (*mei*) and were employed to fashion nonproductive artifacts.[214] Yuan's Four-Age theory—if we may call it this—does not testify to a straightforward evolution of productive forces but implies two separated but interrelated developments of *liqi* (ritual paraphernalia) and *yongqi* (utilitarian implements and utensils). The Jade and Bronze ages in this scheme are correlated with the development of ritual art and with the concept of monumentality during the Shang and Western Zhou outlined in the preceding section.

As I have shown, carved jades were intensively made from the fourth millennium B.C. on and all physical characteristics of jade were understood in social terms. I have proposed that this phenomenon reflected a desire to forge symbols of privilege and power, a desire that appeared only at a certain stage in human history. Some basic characteristics for *liqi*—the major form of archaic Chinese monuments—were gradually formulated: works of ritual art always required the highest technology available at the time; these works were always made of rare materials and/or demanded an extraordinary amount of labor by skilled and specialized craftsmen; and their forms, while maintaining some basic typological features of implements, deliberately neglected functional aspects. The evidence of these early prestigious artifacts leads to the conclusion that once a new technique was invented and a "precious" material was discovered, they would be absorbed into the *liqi* tradition and used for entirely nonutilitarian purposes. It is only logical that bronze casting was employed to produce religious paraphernalia and status symbols. A major difference between these new pres-

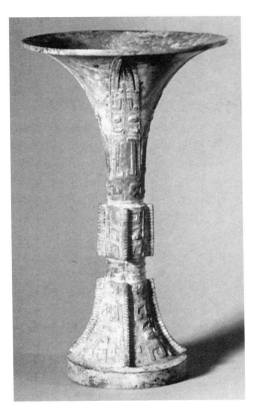

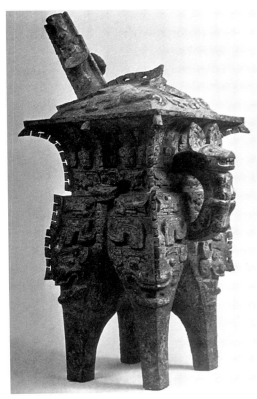

tigious artifacts and the older ones, however, is that they were more effective in legitimating the control of power, as the authors of an excellent study on prehistorical cultures and ideology have observed:

> To those without access to modern scientific explanations, metal working is inherently a magical transformation of aspects of the natural world. By selecting certain stones and heating them in certain conditions a liquid is produced which can be poured into moulds of varying shapes and forms. Left to cool, the liquid becomes a solid which is at the same time bright, shiny and attractive as well as stronger and more durable than the hardest stone. . . . It is hardly surprising in these circumstances that individuals capable of controlling such processes should have acquired considerable prestige.[215]

As *liqi*, bronze ritual vessels had to distinguish themselves from ordinary utensils. A bronze *gu* has a narrow body and a flared mouth (Fig. 1.75)—what was the point

Fig. 1.75. above, left *Bronze* gu *vessel. Late Shang dynasty. 13th–11th centuries B.C. Freer Gallery of Art, Washington, D.C.*

Fig. 1.76. above, right *Square* he *vessel. Late Shang dynasty. Ca. 13th century B.C. H. 71.2 cm. Said to be from Xibeigang Tomb no. 1001 at Anyang, Henan province. Nezu Museum, Tokyo.*

of making a "drinking vessel" into such an unconvenient shape? A *he* became so ornate and heavy (Fig. 1.76)—can one imagine holding it to pour wine from its narrow spout? A *pan* is covered with such a long commemorative inscription (Figs. 2.12a, b)—is it a plate for a meal or a medium for documentation? It is obvious that the material, the shape, the decoration, and the inscription of these bronzes were meant to attest to something entirely beyond the range of ordinary experience, to demonstrate that the vessels, as *liqi* or ritual paraphernalia, were sacred and unworldly.

According to the "three-stage technological sequence," bronze functioned to reinforce production. I would argue, however, that ancient Chinese bronze *liqi*, as well as previous ritual jades and pottery, "squandered" and "absorbed" productive forces. Only because these man-made objects were able to "squander" and "absorb" productive force could they have power and gain monumentality.

But what is "power"? In Marxist historical philosophy the raison d'être and most fundamental determinant of power are located in the economy.[216] Power results from the control of the means and forces of production (tools and labor) and thus appears ultimately "as a concrete possession analogous to a commodity which can be wielded, transferred, seized or alienated."[217] Among the many critics of this theory, Michel Foucault has most effectively attempted to dispel the notion that power is inherently negative or repressive: "Power is not something that is acquired, seized, or shared, something that one holds on to or allows to slip away; power is exercised from innumerable points, in the interplay of nonegalitarian and mobile relations."[218] The first of these two views focuses on the political relationship between antagonistic groups or classes, and the second approaches power as a general force (which is not necessarily "political" in a strict sense) within a single social unity.[219] Since they deal with different situations and interpret power on different levels, these two approaches may not be entirely contradictory, and each may reveal something essential about ancient society.

The strict control of bronze resources and production implies coercion and repression. When an alien tribe or kingdom was conquered, it may have had to surrender its bronze (as the "different regions" sent bronze to the Xia to make the Nine Tripods), and within each of the Three Dynasties such control generated and guaranteed social stratification. It is also clear, however, that in order to bestow raw bronze—the alloy of two natural elements, copper and tin—with social value, this material had to be transformed into a "work." The exercise of power was thus most intimately related to certain bronze forms, and, conversely, these forms reflect different aspects of the exercise of power.

K. C. Chang has pointed out that a famous dictum from ancient China—"The principal affairs of the state are sacrifices and military actions"—explains the exclusive use of bronze in manufacturing ritual paraphernalia and weapons.[220] We may develop this argument even further: the polarity between sacrifices and military actions and between ritual paraphernalia and weapons reflects two kinds of power, which M. Benton has termed as *power to* and *power over*.[221] The first concept, *power to*, refers to power as a "component of all social interaction and as a feature embedded in all social practices. This power draws upon and creates resources. Viewed at perhaps the most abstract level it can be regarded as a dispositional capability, neither possessed nor exercised or controlled by any particular agent or collectivity, but as a structural feature of social systems, which is only manifested through its effects on individuals, groups and institutions."[222] *Power over*, on the other hand, means coercion and control—asymmetrical forms of social domination that involve a "dialectical relationship between the power 'holder' and those upon whom power is exercised."[223] These two aspects of power are thus related, respectively, to the two views offered by Marxists and Foucauldians.

The connection between *power over* and weapons is obvious. The whole history of the Three Dynasties was based on the domination of three clans over other kin and regional groups.[224] The ultimate and most effective form of political domination was military conquest, which was also a major source of wealth and slaves.[225] It is perhaps no coincidence that wars were often directly associated with the rise and decay of a ruling power or

a culture. Among many instances, the sudden flourishing of the Shang civilization during King Wu Ding's reign was coupled with endless military campaigns against alien tribes and kingdoms,[226] and the reasons for the Shang's collapse included King Zhou's failure in such campaigns as well as ethnic slave rebellions. It is recorded that facing attack by the Zhou army, this desperate king was forced to recruit soldiers from among his slaves and to equip them with bronze weapons, which were then turned on him. His fall thus appeared as a direct consequence of his losing the means of political domination.

Liqi or ritual paraphernalia, on the other hand, played a very different role in the same society. As discussed earlier, *liqi* embodied *li*, and *li* encompassed the entire repertoire of rules for all sorts of nonviolent social activities and regulations—ceremonial practices and manners, legal and moral codes, and personal behavior and conduct. No one created *li* or could ever "possess" it, but everyone was obliged to practice it. It was in the omnipresent practices of *li* that a social order was achieved. The power of *li*, therefore, did not derive from antagonism or dominance but emerged from mutual conditions and restrictions that characterized all kinds of ritual practices. In other words, this power was not possessed but exercised. Conversely, all individuals and groups who exercised this power were also subject to its exercise.

Likewise, the power of *liqi* was not located in physical possession. Even though one could seize the ritual vessels of others through violence, without the necessary justification of *li* such acquisition only proved one's violation of basic social codes. Ritual vessels were neither functional in a practical sense nor static symbols of social status; they became "powerful" only when they were made and used properly by proper persons for proper purposes at proper times in proper places and in proper ways. The sum of this endless "propriety" was *li*, and in this way a ritual vessel could conceal principles. To take a Western Zhou investiture bronze as an example, the inscription records the ritual leading to the bronze's creation as well as rituals initiated by its creation. The investiture ceremony was held in the royal ancestral temple in the early morning and was conducted by the king in person. All participants—the king,

the ceremonial officials, and the recipient of the investiture—were dressed in the appropriate ritual costumes, took their appropriate places, moved with the appropriate gestures, and delivered the appropriate speeches. The king praised his own ancestors as well as the ancestors of the recipient. He confirmed the title and privileges previous kings had given to the recipient's family and sometimes conferred additional favors. A set of symbolic gifts was presented to the recipient, who then in his response praised the king, the former kings, and his own ancestors. The bronze that he made after the ceremony not only finalized the investiture, but would be "treasured and used by his sons and grandsons"—a standard expression meaning that the vessel would be installed in his family temple and would be used in sacrifices as long as the family line continued.[227] The significance of this ritual lay in its confirmation of sets of social relationships, including those between the king and his royal ancestors, the minister and his own ancestors, the king's ancestors and the minister's ancestors, the king and the minister, and the minister and his descendents. The monumentality of the ritual bronze, therefore, lay in embodying and consolidating the web of social relationships.

The investiture ceremony was only one of numerous rituals conducted on greater or lesser scales in all spheres of social life. The six general *li* described in ancient ritual books in abundant detail—rituals of capping, marrying, mourning, sacrificing, feasting, and gathering—encompass almost all the activities of a life.[228] *Li* thus became life itself, and its power, masked by reference to the "natural order" of human life, became fundamental, unchangeable, and itself natural. Rather than creating coercive sanctions, *li* in these activities constantly reassured and adjusted social relationships—between senior and junior, husband and wife, the living and the dead, descendent and ancestor, host and guest, and ruler and subject. Although the two parties in each relationship were not equal, no two relationships were overlapping and this means that no single "powerholder" could be in absolute control; even the king had to worship his ancestors and honor his seniors and guests. If there were a single force that dominated this system, it could only be *li* itself, for all individuals and

groups who exercised the power of li were also subject to its exercise.[229]

But these two aspects of power—*power over* and *power to*—were never separated. Connecting them was the concept of monumentality. On the one hand, even before the Three Dynasties, jade "weapons" had appeared as an important type of *liqi*; the wide existence of oversized and inlaid bronze axes, knives, and spears proves the continuation of this tradition in the Bronze Age. On the other hand, many ritual vessels were made during or after military expeditions; I have cited some inscriptions recording such events in this chapter. Such instances guide us back to the Nine Tripods. This set of monumental bronzes reflects not a single function of power but a dialectical relationship between the two; only in this way could the Tripods become a primary symbol of the Chinese Bronze Age. My earlier investigation of the Tripods has shown (1) that the Tripods attested to political domination since the change in their ownership signified alternating rulership, and (2) that the Tripods were structural features of a given society since they generated and sustained the society's internal system. In other words, the Tripods were "objects whose acquisition conferred status on the individual either within a particular group or vis-à-vis other groups," and which also "act[ed] as the concrete confirmation of acquired power."[230]

This twofold function of the Tripods is best revealed by the transition from the Shang to the Zhou. As soon as King Wu of the Zhou conquered the Shang, he ordered the removal of the Nine Tripods and ritual jades from the Shang capital—a gesture signaling the irretrievable destruction of the older dynasty.[231] Afterward the Tripods were sent to the base of the Zhou clan.[232] But interestingly, the physical seizure of the Tripods did not automatically prove the Zhou their legitimate owner. The transaction had to be ritualized through the act of *dingding*, a term meaning both "to settle the *ding* tripods" and "to establish a new political power." In other words, the Zhou's possession of the Tripods had to be converted from negative proof of the Shang's destruction to positive proof of the Zhou's ruling mandate. In demonstrating the Shang's destruction,

the Tripods were still viewed as symbols of the Shang; to legitimate the Zhou's mandate, the Tripods had to become internal elements of the Zhou.

We read in the *Book of Changes*: "*Ke* [overcoming or conquering] means to get rid of the old, and *ding* [settling the Tripods] means to establish the new."[233] Thus, King Wu was given the royal title Wu—"military prowess"—because he had conquered the Shang and captured the Tripods. But it was his son who "established the new" by settling the Tripods in a newly constructed capital; he was thus given the title Cheng or "Accomplishment." Elaborate rituals were conducted: divine oracles were sought to determine the proper location for the Tripods; a city was built to house them; and the Tripods were moved into their new home through a specific entrance called the Tripod Gate.[234] These rituals provided occasions to display the might of the new dynasty, hold court audiences and investitures, and make additional ritual bronzes.[235] In this process, various social and political relationships were established and justified. It can be said that only at that point did the Tripods become a collective monument of the Zhou.

Five hundred years later, the Zhou royal house had degenerated to a puppet government struggling for survival, and the Chu lord held his military maneuvers outside the Zhou capital and impudently inquired about the Tripods. His intention was understood to be the overthrow of the Zhou, and Wangsun Man's speech on the Nine Tripods aimed to demonstrate the Zhou's legitimacy as the central power. This clever minister drew his evidence from King Cheng, who "fixed the Tripods in the Zhou capital and divined that the Zhou dynasty should last for thirty reigns, over seven hundred years." What is omitted from his account is King Wu's seizure of the Tripods from the Shang, a historical episode that the Chu lord could readily use to justify his ambition.

It is impossible to know whether Wangsun Man had ever seen the Tripods, believed to be housed somewhere deep inside the Zhou royal temple. But the set of Tripods that we learn about from his speech are without doubt a historical fabrication. Significantly, this fabrication condenses and abstracts the whole course of ritual art into a

The Age of Ritual Art

single image. As the most important monument of the Three Dynasties, the Tripods apparently had to combine all phases of ritual art and all significant aspects of a dominant concept of monumentality that had developed over a long period of several thousand years.

The history of *liqi* began in at least the fourth millennium B.C. Works of ritual art were created by imitating ordinary objects in "precious" materials. Shapes were then altered, and symbolic decoration and emblems were added. This sequence was replicated in the development of bronze art. Bronze as the new "precious" material was first employed to imitate the fragile imagery of earlier ritual pottery. A new emphasis on metamorphic images then brought about great variations in style and motif. Commemorative inscriptions, in turn, took over, and finally a bronze became a "text" for reading. The changing foci in this

evolution—from material to shape to decoration to inscription—suggest the changing signifiers of ritual art from the most concrete to the most abstract, and from natural elements to artificial signs.

All these layers and aspects of ritual art were woven into Wangsun Man's image of the Nine Tripods. Their material was contributed by various regions so that the Tripods could symbolize a unified political power. The same symbolism was also expressed by casting regional *things*—most likely emblems of local authorities—onto the Tripods; such emblems also characterized ritual jades and early bronzes. The belief in the supernatural qualities of the Tripods—their "intelligence" and their ability to generate their own movement—seems to have been related to late Shang metamorphic imagery, which gives a vessel an animated presence. The number and formation

Fig. 1.77. (a) Bird-shaped bronze zun *vessel, with the gold inlay inscription "The gentlemen commissioned this bird for amusement." Eastern Zhou, ca. 5th century B.C. H. 26.5 cm. Freer Gallery of Art, Washington, D.C. (b) Inscription on the bird's head.*

a

b

of the Tripods, moreover, attests to the Zhou convention that only the Son of Heaven could possess a set of nine tripods.[236]

It has been suggested that political monuments are most often established when a new power is forming or when an old power is collapsing.[237] The Xia forged the Tripods at the dawn of China's dynastic history; toward the end of the Three Dynasties the Tripods again dominated people's thoughts. But as we have seen, the Tripods conceived in the sixth century B.C. were no longer real vessels, but *memories* of the bygone history of *liqi*. It was on these memories, not on the physical Tripods, that the Zhou's fate depended. Wangsun Man's speech on the Tripods was thus also a lamentation, but what he lamented was not only the Zhou's loss of glory but also the decline of an ancient monumentality and the Chinese Bronze Age. By this time, the production of ritual paraphernalia had been largely replaced by the manufacture of luxury goods. Patronized by powerful lords, an extravagant artistic style had come into vogue.[238] Commemorative inscrip-

Fig. 1.78. above *A set of bronze* zun *and* pan *vessels. Eastern Zhou. 5th century B.C. H. 33.1 cm (*zun); *24 cm (*pan). *Excavated in 1978 at Leigudun, Suixian, Hubei province. Hubei Provincial Museum, Wuhan.*

Fig. 1.79. right
(a) Bronze hu *vessel with pictorial decoration. Eastern Zhou. Ca. 5th century B.C. H. 38.3. Palace Museum, Beijing. (b) Drawing of the decoration.*

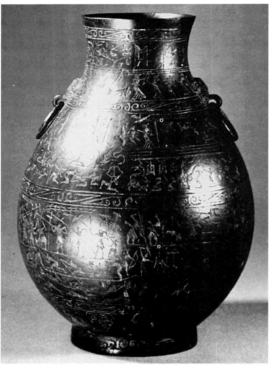

a

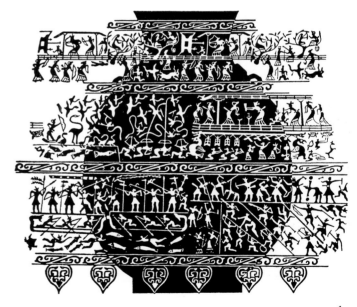

b

The Age of Ritual Art

a

b

Fig. 1.80. (a) Human-shaped lamp. Bronze with gold, silver, and turquoise inlay. Eastern Zhou. 4th century B.C. H. 66.4 cm. Excavated in 1966 at Pingshan, Hebei province. Hebei Provincial Museum. (b) Chamber pot. Bronze with gold and silver inlay. Late Eastern Zhou. Ca. 4th–3d centuries B.C. Palace Museum, Beijing.

tions fell out of fashion; words on bronzes now stated that these were dowries or "playthings" (*nongqi*) (Figs. 1.77a, b). Meaningless decoration conquered substance; intricate designs transformed a solid bronze into a honeycomb (Fig. 1.78). Vessels were also turned into pictures, illustrating banquets, hunting games, and killing (Figs. 1.79a, b).

The important signifiers of the archaic monumentality—commemorative inscription, symbolic decoration, and shape—were thus, one by one, rejected, and this counterdevelopment finally led to the abandonment of bronzes. About a hundred years after Wangsun Man's speech, in 512 B.C., a reformer from the state of Jin named Zhao Yang "published" a legal document. While this act was in itself a rebellion against the old social system based on *li*, his way of doing it seemed also to parody traditional monumentality: he inscribed the document on a *ding* tripod

made of the "ugly and crude" metal iron. When Confucius—an admirer of the traditional Zhou system—heard this, he sighed: "Now that the iron tripod has been made, Order has been abandoned."[239] Iron, however, never became a popular material for vessels. The demands for extravagance were satisfied by inlaid objects of mixed media (Figs. 1.80a, b). These works—sculptures, mirrors, belt hooks, musical instruments, wine and food containers, and even chamber pots—contradicted in every way the solemnity of ritual bronzes. Rich in color, intricate in design, but poor in commemorative content, what they exhibited was the uncontrolled desire for luxury.[240]

This was the end of *liqi* and the Chinese Bronze Age. So the Nine Tripods—the chief monuments of this age—retreated from history: they vanished in 336 B.C. No one was ever able to obtain them again.

Temple, Palace, and Tomb

When he built the Spirit Tower
When he planned it and founded it,
All the people worked at it;
In less than a day they finished it.

—*Book of Songs*

INTRODUCTIONS TO EARLY Chinese art history often show an alarming discontinuity: zoomorphic patterns on bronze vessels dominate the chapters on Shang-Zhou art; discussions of Qin-Han art focus on figurative images and pictorial scenes. Questions such as how these two distinct phases were linked historically in the cultural tradition, why ritual bronzes died out and were replaced by carvings and paintings, and what caused such a dramatic change, obviously among the most crucial problems in the study of early Chinese art, have drawn only limited attention from scholars, however. Two interrelated factors may be responsible for this neglect. First, the foci and interests of art historians are often restricted by their chosen "field" of either Shang-Zhou bronzes or Han bas-reliefs. Second, in the conventional conceptualization of early Chinese art history, bronze art is a "decorative" tradition and pictorial art a "representational" tradition. The transition from the former to the latter is approached either as a revolution in visual forms or as a consequence of foreign influence from a more vivid "barbarian" world.

This conceptualization is fundamentally misleading be-cause it favors surface patterns over objects and privileges isolated objects over their groupings and context. In other words, it reflects the mentality of an art collector influenced by painting connoisseurship who appreciates examples of early art for their individual aesthetic and historical value. But unlike a later scroll painting, a Shang-Zhou bronze vessel or a Han pictorial slab was never created or viewed as an independent "work of art." Such works were always originally a component of a larger assembly, either a set of ritual paraphernalia or a pictorial program. These assemblies in turn always appeared as integral components of special architectural structures—a temple, a palace, or a tomb. Such a structure constituted a monumental complex in society. As the site of administration and important ceremonies, it focused people's attention and defined a political center. It synthesized and organized individual forms of ritual art into a coherent and functional whole, and it provided people with a place and occasions to encounter and utilize these forms—objects and images—in ritual practices. This understanding, first reached by social historians through their study of textual sources,[1]

has profound implications for the methodology of early art history. It demands that art historians shift their focus from individual objects and images to large monumental complexes with all their physical, ritual, and ideological components: only at this level of analysis can we discuss the precise historical relationship among art, ritual, social structure, and politics, and explain important changes in early Chinese art, including the decline of ritual bronzes and the flourishing of pictorial images.

This understanding also determines my first task in this chapter: to contextualize *liqi*'s monumentality in relation to the structure and symbolism of the ancestral temple, the legitimate place for holding both political and religious ceremonies during the Western Zhou and the most important site for storing and displaying commemorative bronzes, including the Nine Tripods. A dialectic relationship existed between *liqi* and their architectural context: sacred bronzes gave meaning and authority to a temple, but these bronzes became functional and meaningful only during temple rituals. The most important ritual, that of metaphorically "returning" to the Origin of a clan or lineage, was oriented and punctuated by the temple's two-dimensional, layered spatial structure. A temple with its *liqi* thus became a collective monument of a clan or lineage, identifying its political status, preserving memories of its past, and linking it into a large social network through a "temple system" (*miaozhi*).

The temple system gained its most sophisticated form during the Western Zhou, but declined from the Eastern Zhou to the Han as palatial and funerary monuments assumed its political and religious roles. The appearance of these new monuments corresponded to essential changes in the country's social and religious structures. First, following the decline of Zhou rule based on the ancient clan-lineage system, powerful principalities gained independence and a unified political state finally emerged. Consequently, the palace became divorced from the lineage temple and became the chief symbol of political power. Second, this social and political transformation was coupled with a religious transformation, most clearly signified by the shift of the center for ancestor worship from the collective lineage temple to tombs of families and individuals.

Both developments contributed to a new conception of authority and a new symbolic presentation of authority, which took the form of "monumental architecture."

A massive Eastern Zhou tower or a giant Qin tumulus differed from a deep, dark Western Zhou temple not only in visual appearance but also in its essential monumentality. Unlike earlier monuments that guided people back to their clan origin, these new monuments were associated with powerful political entities and personages. A traditional temple relied largely upon the sacred *liqi* inside it to proclaim its monumentality, but palatial and funerary monuments realized their significance mainly through their own architectural form. Important signifiers of monumentality thus shifted from within to without—from objects to architecture, depth to surface, concealment to exhibition. If the development of Chinese art up to this point had been centered on *liqi*, architecture now became the locomotive. The desire for powerful architectural symbols stimulated people's fantasies to create high-rise buildings; architectural decoration—murals and wall-carvings—began to dominate the artistic imagination. The sudden popularity of stone funerary monuments further attests to a new consciousness of the symbolism of building material, just as in the old days special media— jade and bronze—had been employed in making *liqi*. Only at this moment in Chinese history does architecture replace *liqi* to become "the expression of the very soul of societies"—to embody social and political power with the authority to command and prohibit.[2] Following this line of argument, the second and third sections of this chapter reconstruct a historical process that occurred during the Eastern Zhou and Qin, when architectural monuments appeared in China and functioned to express and regulate new social, political, and religious orders. This role of architectural monuments reinforced their further alienation from ordinary architecture: they had to be "unique" not only in height and volume but also in material. The last section therefore examines the Chinese "discovery" of stone as a major medium for funerary structures. This chapter links the earlier and later chapters in this book and provides a background for my later discussion of Han palatial and funerary monuments.

The Temple

When Tan Fu led the members of the Ji clan on a westward march along the Wei River, he was looking for a home for the descendents of Hou Ji, who would eventually conquer the Shang and establish the Zhou dynasty. Tan Fu found this home in the Plain of Zhou (Zhouyuan) at the foot of Mount Qi, a fertile land where "celery and sowthistle were sweet as ricecakes." Tortoise shells were consulted for divine confirmation, and an auspicious prognostication was obtained: "Stop and halt, build your home right here." So Tan Fu stopped and began to build the first Zhou capital (Map 2.1).[3] He determined the orientation of the city, drew its boundaries, and entrusted the construction work to the Masters of Works and Multitudes. The first building was an ancestral temple called Jinggong, or the Capital Temple.[4] As recorded in the Zhou ritual hymn "Mian" in the *Book of Songs,*

> Dead straight was the plumb-line,
> The planks were lashed to hold the earth;
> They made the Hall of Ancestors, very venerable.[5]

The poem reveals two principal features of an archaic Chinese capital in terms of its definition and building sequence. First, "a capital [*du*] is a city that has a lineage temple [*zongmiao*] housing ancestral tablets."[6] Second, the construction of Tan Fu's town confirms a regulation later formulated in the *Book of Rites*: "When a nobleman is about to engage in building, the ancestral temple should have his first attention, the stables and arsenal the next, and the residences the last."[7] The function and construction of a town were understood in a hierarchical scheme: ancestor worship first, defense second, living arrangements last. Furthermore, the temple, the heart of a town, provided only a spatial framework for ancestral rites and other ceremonies; its importance lay, to a great extent, in housing ritual vessels dedicated to ancestral spirits. As the same ritual canon continues: "When the head of a lineage is about to prepare things, the vessels of sacrifice should have the first place, the offerings, the next; and the vessels for use at meals, the last."[8] Stated consecutively in the ritual canon, these two passages best demonstrate the intimate relationship between an ancestral temple and its *liqi* as the two basic components of an archaic monumental complex in Shang–Western Zhou society.

Tan Fu's town initiated a series of Zhou capitals established by his descendents. Within the three generations from Tan Fu to his grandson King Wen, the Zhou moved their operational center step by step eastward toward the lower streams of the Wei River.[9] Underlying this movement was a persistent Zhou attempt to gain access to China's heartland and to wrest control of the country from the Shang:

> Descendant of Hou Ji
> Was the Great King [i.e., Tan Fu]
> Who lived on the southern slopes of Mount Qi
> And began to trim the Shang.
> Till at last came King Wen and King Wu,
> And continued the Great King's task,
> Fulfilled the wrath of Heaven
> In the field of Mu:
> "No treachery, no blundering!
> God on high is watching you!"[10]

Although the Zhou defeated the Shang only during King Wu's reign, later Zhou people considered their "dynastic" history to have begun with King Wen and repeatedly praised the merit of this king in their temple hymns:

Map 2.1. Zhou capitals in the Guanzhong area

Renowned was King Wen,
Yes, high was his renown.
He united, he gave peace;
Manifold were his victories.

Among many factors that contributed to this attitude, an important one was that this king built Feng, a new Zhou capital centered on a new ancestral temple, again called Jinggong (Map 2.1). As the same hymn continues:

He built his city within due boundaries,
He made Feng according to the ancient plan.
He did not fulfill his own desires,
But worked in pious obedience to the dead.[11]

King Wen was thus considered loyal to his ancestors and instrumental in carrying out their plan to conquer the Shang. Because of the new Jinggong in Feng, this capital was also called Zongzhou, meaning the seat of the Zhou lineage.[12]

King Wen's son and successor, King Wu, expanded the capital to include Hao across the Feng River, but he maintained the temple in Feng and supervised important religious and political matters there.[13] His role in Zhou history was to realize Wen's plan:

A strong toiler was King Wen;
Well he opened the way for those that followed him.
As heir Wu received it,
Conquered the Yin [i.e., Shang], utterly destroyed them.[14]

After King Wu led an allied army to storm the Shang capital, he immediately abrogated the royal temple and the Land Altar (she) of the Shang, obtained the Nine Tripods, and announced that the Zhou had therefore received the mandate from Heaven.[15] In the following days, he communicated this message to his deceased father, Wen, and "set a foundation for administration" (lizheng).[16] The king held another series of grand ritual events as soon as he returned to the capital. Wearing the most honored ritual costume and holding a ceremonial scepter, King Wu sacrificed to a series of Zhou ancestors while denouncing the Shang's crimes. He again went to the temple the next day to appoint the ministers of eight major districts.[17] All

these rituals functioned to "upgrade" the Zhou lineage to a dynastic level, to establish an administrative system, and to help the king govern the country through this system.

King Wu ended the Shang's political dominance, but the Zhou's final victory over the Shang took place only after his death, when his brother Dan, better known as the Duke of Zhou, helped young King Cheng put down violent disturbances by Shang loyalists. Traditional historiography eulogized this period as that of "accomplishment" (cheng): a feudal system (fengjian) was established with 71 vassal states "shielding" the Zhou royal house in the center.[18] The beginning of this new era was indicated by founding New Capital (Xinyi), or Chengzhou, near present-day Luoyang in Henan (Map 2.1).[19] The city's construction followed the building sequence of Tan Fu's town.[20] The site for the capital was selected by divination, and the city's boundary was then marked out, as recorded in "The Announcement of the Duke of Shao" ("Shao gao"), a Zhou official text now in the Book of Documents:

In the third quarter of the second month, on the sixth day yiwei . . . the Grand Guardian [i.e., the Duke of Shao] preceded the Duke of Zhou to inspect the site. Two days later, on maoshen, the Grand Guardian in the morning arrived at Luo and made a tortoise-shell divination about the site. When he had obtained the oracle, he planned and laid out [the city]. On the [next] third day, gengxu, the Grand Guardian with all the Yin people started work on the [public] emplacements at the nook of the Luo River; and four days later, on jiayin, the emplacements were determined. The next day, yimao, the Duke of Zhou arrived at Luo in the morning and again inspected the position of the new city.[21]

Just as Tan Fu had done in the past, the initial selection of Chengzhou's site was reexamined and confirmed by repeated prognostications, which were conducted by the Duke of Zhou, regent for King Cheng.[22] Again like Tan Fu's capital, the first and most important building in Chengzhou was an ancestral temple—we know this because the Duke of Zhou instructed young King Cheng to hold a winter sacrifice in the temple as the city's inauguration ceremony. During this ritual, the king sacrificed red bulls

to his forebears Kings Wen and Wu. After this, "The king's guests [i.e., the ancestral spirits] all arrived. The king entered Grand Hall [in the temple] and poured out the libation. The king gave investiture to the lineage of the Duke of Zhou, and the archivist Yi made the declaration."[23] The sequence of this ritual seemed to repeat that of King Wu's victory ceremony: sacrifices first and investiture second, both taking place in a royal temple and witnessed by ancestral spirits. A major difference between these two rituals, however, was that at the time of Chengzhou's establishment, King Wu had joined the "former kings" of Zhou; he had become an ancestral spirit worshipped in Chengzhou's temple, a receiver of ritual offerings and a guardian of his son, the living ruler.

Tan Fu's foundation of the Zhou base at Mount Qi, Kings Wen and Wu's conquest of the Shang, and King Cheng's pacification of the country were the three most crucial moments in early Zhou history. All instances were related to the establishment and reestablishment of capitals and royal temples, and all three temples constructed by these Zhou rulers were called Jinggong.[24] But why did new temples have to be built at different stages in Zhou history? What was their internal structure, and who was worshipped in them? What did these subjects of worship signify? There is virtually no evidence for the organization of Tan Fu's temple. Hypothetically, this temple was constructed to worship the Zhou ancestors from Hou Ji down to Tan Fu's father. The temple established by King Wen did not replace this original temple and offered only a place for worshipping a second group of Zhou ancestors. A passage in a document called "The Grand Presentation of Captives" ("Shi fu"), now in the *Leftover Documents from the Zhou* (*Yi Zhou shu*), suggests that during King Wu's reign, those worshipped in the temple at Feng included six ancestors of the four consecutive generations since Tan Fu:[25]

1. Tan Fu
2. Tai Bo (Tan Fu's eldest son, who refused the throne)
3. Yu Zhong (Tan Fu's second son, who refused the throne)
4. Wang Ji (Tan Fu's third son and royal successor)
5. King Wen (Wang Ji's elder son and royal successor)
6. Yi Kao (King Wen's elder son, killed by the Shang)

After King Wu died, his memorial tablet was added to this temple.[26] The temple built by King Cheng, however, differed radically from the previous temples in introducing a new pattern of ancestor worship. It consisted of three ancestral shrines, one for Hou Ji and the other two for King Wen and King Wu.[27] It thus demonstrated three new features that later became crucial for ancestral temples: first, the subjects of worship were restricted to the heads of the royal lineage and did not include indirect ancestors. Second, not all former kings were worshipped in the temple; the chosen ones belonged to two categories: the *yuanzu* (the remote ancestor or the founder of the royal lineage) and the *jinzu* (recent ancestors and direct forebears of the living king). Third, although there was only a single *yuanzu*, the multiple *jinzu* were divided into the *mu* sequence (starting from King Wen) and the *zhao* sequence (starting from King Wu). As time passed and the royal line lengthened, more recent royal ancestors were worshipped in the temple, and Kings Wen and Wu were distinguished from both *yuanzu* and *jinzu*. Because of the extraordinary importance of these two kings in Zhou history, their shrines were kept in the temple and given a special name, *tiao*. This process finally led to a temple consisting of seven shrines to individual ancestors in three groups (Figs. 2.1, 2.2a).[28]

This structure, which must have come into being after King Gong's reign (tenth century B.C.),[29] then became the standard form of the Zhou royal temple. The three shrines of Hou Ji, Wen, and Wu were permanent, but the occupants of the four *zhao* and *mu* shrines changed every generation in order to maintain the fixed number

Group 1:	(1) original ancestor	
Group 2:	(2) tiao 1: King Wen	(3) tiao 2: King Wu
Group 3:	(mu)	(zhao)
	(4) great-great-grandfather	(5) great-grandfather
	(6) grandfather	(7) father

Fig. 2.1. Internal organization of the Zhou royal temple

a b

Fig. 2.2 Two levels of ancestral temples. (a) The Zhou royal ancestral temple, with the temple of the founder at the center and three temples of recent ancestors on each side. (b) The temple of a feudal lord, with only two temples of recent ancestors on each side.

of shrines. When a king died, he would be worshiped in the "father's shrine"; his father, grandfather, and great-grandfather would be moved up; the shrine of his great-great-grandfather would be dismantled, and the tablet of this ancestor would be stored in a *tiao*.

Scholars since the Han dynasty have generally agreed about this process. What they have often neglected, however, are the "meaning" of the ancestral groupings and the symbolism of the temple's structure. In my opinion, these two interrelated aspects most clearly disclose the monumentality of the royal temple complex. The three groups of ancestors, which determined the overall organization of this temple and its *liqi*, provided a basic system for organizing fragmentary memories of the Zhou's past into a coherent narrative. In other words, they presented a periodization of Zhou history from the vantage point of the descendents of the royal lineage. Zheng Xuan, a Han commentator on ancient ritual canons, wrote a highly significant passage: "The memorial tablets of the pre-dynastic ancestors [*xiangong*] were stocked in the shrine of the original ancestor, Hou Ji; the tablets of the dynastic ancestors [*xianwang*] were removed and kept in the shrines of King Wen and King Wu."[30] This implies that the three permanent subjects of worship were viewed not merely as individual ancestors but as symbols of two broad stages in Zhou history: Hou Ji initiated the Ji clan and repre-

sented the Zhou's pre-dynastic period; Wen and Wu founded the Zhou dynasty and symbolized this political unity. The remaining four ancestors worshiped in the temple testified to the direct ancestry of the living king and linked him to the remote ancestors. This temple in Chengzhou thus incorporated and, to some extent, replaced the old temples of Tan Fu and King Wen; its significance lay in both maintaining the royal lineage's internal order and legitimating its political status. This new Jinggong was the "dynastic temple" of the Zhou and Chengzhou, the "dynastic capital" and the new "seat of the Zhou lineage."[31] Based on documents and bronze inscriptions, the modern scholar Wei Tingsheng has speculated that after conquering the Shang, the Zhou royal house formally moved its capital to Chengzhou and held the most important royal activities there.[32] This movement, in fact, was first planned by King Wu when he moved the Nine Tripods—the symbol of central power—from the Shang capital directly to Luoyang.[33] But it is King Cheng who finally realized this plan: traditional texts record that this king "settled the Tripods" in the new capital,[34] and the inscription on a recently discovered bronze begins with the sentence "King [Cheng] first moved the capital to Chengzhou."[35]

This discussion of the temple's internal organization, however, does not answer an important question concerning the temple's architectural design: Why was the shrine of the founding ancestor, Hou Ji, located deep inside the temple, whereas the recent royal ancestors were worshiped in front halls closer to the outside world? The key to this question is found in the relationship between the temple's spatial system and the temporal sequence of temple rituals. The positions of the individual ancestral shrines in the temple compound implied a chronological order from the present back to the remote past, an order helping to structure ritual events that aimed to refresh people's memory and reconstruct their history. In fact, it is fair to say that a Zhou temple was a temple of the Origin (*shi*), and that the ceremonies performed in the temple followed a uniform pattern of seeking, returning to, and communicating with the Origin. It is stressed more than ten times in the *Book of Rites* that temple rituals guided people "to

go back to their Origin, maintain the ancient, and not forget those to whom they owe their being."[36] The temple hymns of Shang and Zhou survive in the "Daya" section of the *Book of Songs*. Without exception, they trace the origins of specific clans to mythological heroes who emerged from the twilight zone between Heaven and the human world.[37] One of the most famous hymns, for example, commemorates the mysterious birth of Hou Chi. One day Hou Chi's mother, Jiang Yuan, trod on the big toe of God's footprint; she subsequently became pregnant and gave birth to a child. The infant, however, was rejected by the mother's family because of his unusual conception:

> Indeed, they put him in a narrow lane;
> But oxen and sheep tenderly cherished him.
> Indeed, they put him a far-off wood;
> But it chanced that woodcutters came to this wood.
> Indeed, they put him on the cold ice;
> But the birds covered him with their wings.
> The birds at last went away,
> And Hou Ji began to wail.[38]

So Hou Chi survived and "brought down many blessings" to his people:

> Millet for wine, millet for cooking, the early planted
> and the late planted,
> The early ripening and the late ripening, beans and
> corn.
> He took possession of all lands below,
> Setting the people to husbandry.[39]

To be sure, the main purpose of such temple hymns was not to glorify individual ancestors; they were composed to specify the common origin of the members of a clan. This is why the poem "Jiang Yuan" begins with the question: "How did she give birth to the *people*?"[40] This is also why it ends with the stanza:

> Hou Ji founded the sacrifices [to the God],
> And without blemish or flaw
> They have gone on till now.[41]

As long as the song was performed in Zhou temples and the sacrifices were offered to the High Ancestor, the people of Zhou knew their origin and identity. In this tradition, "myth" was conceived as history, and history tied the present to the past.

The essence of temple ceremonies taught in the *Book of Rites*—"to go back to the Origin, maintain the ancient, and not forget those to whom they owe their being"— also provides us with a key to understanding the visual form of the ancestral temple and its relationship with an ancient city. Early examples of Three Dynasties cities include the Shang settlements discovered at Erlitou, Zhengzhou, and Panlongcheng (Fig. 2.3a–b).[42] Though located in different regions, all three share a basic architectural plan: all were roughly rectangular and oriented north–south; all were surrounded by tall thick walls, in which large gates opened to the four directions. Inside each town, a cluster of large buildings, possibly the ritual complex, was constructed in a special area. The Zhou people must have followed this basic plan in constructing their cities. One of the most important cities founded at the beginning of the Zhou was Qufu, the capital of the state of Lu, which was the fief of the famous Duke of Zhou. Excavations of Qufu have continued since the early 1940's, and archaeologists have concluded that although the city was constructed and reconstructed many times from the Zhou to the Han, its basic layout remained basically unaltered.[43] As shown in Fig. 2.4, this rectangular city was encircled by a continuous wall. A well-defined area, 500 meters north–south and 550 meters east–west, occupied the center of the city; its ramped foundation still rises ten meters above the ground. Local people called this area Zhougong miao, or the Temple of the Duke of Zhou, a name that suggests the identity of the oldest buildings established there.

Three groups of excavated examples allow us to have a closer look at Three Dynasties temple complexes. These are the late Xia and early Shang structures discovered in Yanshi in present-day Henan and a temple compound found in the Western Zhou capital area, Fengchu, in Shaanxi. Like all timber structures built in ancient China, the aboveground parts of these buildings have long since disappeared. But enough remains are left on their foundations to suggest a consistent plan. Two late Xia structures

Fig. 2.3. (a) Early Shang city at Yanshi in Erlitou, Henan province. Ca. 15th–14th centuries B.C. (b) Mid-Shang city at Zhengzhou, Henan province. Ca. 14th–13th centuries B.C.

Legend
- ▬▬ City wall above-ground
- ▨▨ City wall underground
- === Wall gaps
- ▥▥ Stamped earth foundations

Bone Workshop

Bronze Foundry

Chin-shui River

Pottery Kilns

The People's Park Cemetery Area

Site of the Hoard of Shang Bronzes

Pai-chia-chuang Cemetery Area

Site of the Hoard of Shang Bronzes

Hsiung-erh River

Cheng-chou Tobacco Factory Cemetery Area

Yang-chuang Cemetery Area

Bronze Foundry

Erh-li-kang

discovered in Erlitou appear to have been closed compounds surrounded by roofed corridors (Figs. 2.5a–c).[44] An isolated hall was built inside the compound, and an exit opened close to the northeast corner; both show an amazing resemblance to the structure of a Three Dynasties ancestral temple recorded in the *Book of Documents* and the *Ceremonies and Rites* (Fig. 2.6).[45] From an art-historical view, this structure initiated a major architectural principle for constructing an ancient Chinese temple. The corridors create discontinuity in space by separating the "inner" from the "outer," and the enclosed open courtyard then becomes a relatively independent space

with its focus in the central hall. Rudolf Arnheim calls such an artificial space "extrinsic space," which "controls the relation between independent object systems and provides them with standards of reference for their perceptual features."[46]

The basic layout of the Xia buildings was shared by early Shang temples and palaces discovered in a nearby site,[47] but the Fengchu building, where divinatory documents of the Western Zhou royal house were found, demonstrated a greater effort to create "extrinsic space" (Figs. 2.7a, b).[48] Compared to the floor plans of earlier ritual buildings, those for this structure are far more com-

plex. The inner hall and courtyard were doubled, so that the whole compound consisted of a series of alternating "open" and "closed" sections. The south-facing halls were connected by two rows of side chambers along the east and west walls; the structure of the compound thus resembled that of a Zhou temple recorded in texts (Fig. 2.2a). A central axis, along which doorways and a corridor were built, now became a prominent architectural feature orienting ritual processions. An earthen screen was erected to shield the front gate. The psychology behind this device and the architectural design of the whole compound was apparently to make the enclosure coherent, closed and "deeper"—to make one cross layers of barriers before reaching the center.

What ideology underlay this architectural form? Before answering this question, let us take an imaginary journey to a Three Dynasties temple. First, we enter the town through gates in tall walls that block off the outside. We then walk toward the center where a palace-temple compound stands, again blocked by walls or corridors. The feeling of secrecy gradually increases as we enter the temple yard and penetrate layers of halls leading to the shrine of the founder of the clan, located at the end of the compound. At last, we enter the shrine; in the dim light, numerous shining bronze vessels, decorated with strange images and containing ritual offerings, suddenly loom before us. We find ourselves in a mythical world, the end of our journey where we would encounter the Origin—the *shi*. The ritual vessels hidden deep inside the temple compound provide us with the means to communicate with the invisible spirits of ancestors—to present offerings and to ascertain their will. This final stage is recorded in the *Book of Rites*; following a long list of ritual bronzes (as well as sacrificial food and wine), the passage ends with a crucial statement: "[All of these] aim to bring down the Supreme God, as well as ancestral to

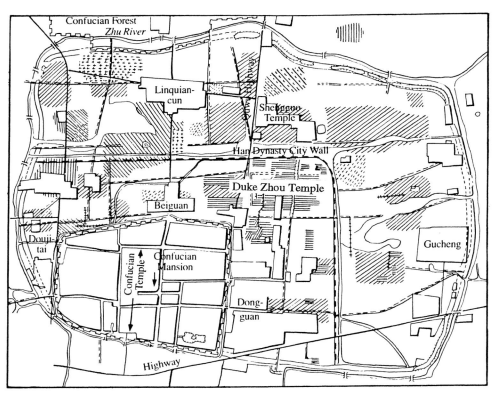

Fig. 2.4. Qufu during the Eastern Zhou. 8th–3d centuries B.C.

City wall on ground

Bronze workshop

Reconstructed, underground

Iron workshop

Ancient burials

Ancient road

Bone workshop

Ancient dwellings

Rammed earth

Pottery workshop

Fig. 2.5. (a, b) Founda-
tions of two late Xia
temple-palace structures.
Ca. 16th century B.C.
Excavated in 1973–74
(Structure no. 1) and
1977–78 (Structure no. 2)
at Erlitou, Yanshi, Henan
province. (c) Reconstruction
of Structure no. 1.

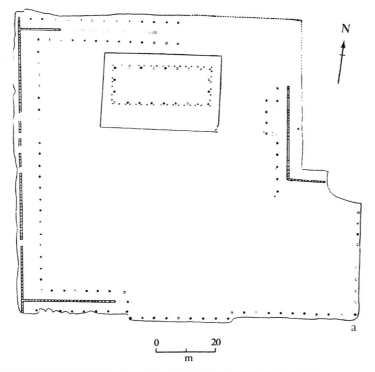

0 20

m

a

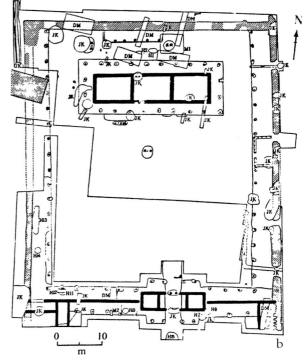

N

0 10

m

b

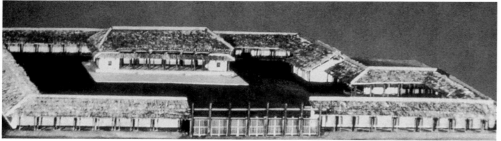

c

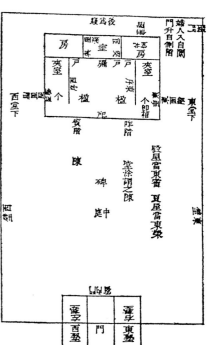

Fig. 2.6. Plan of an an-
cestral temple during the
Three Dynasties as
recorded in ancient texts

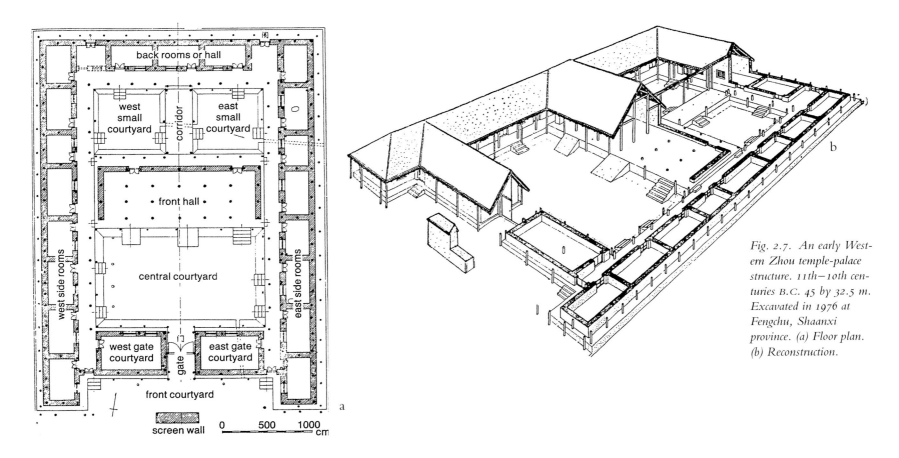

labels in floor plan:
back rooms or hall

west small courtyard · corridor · east small courtyard

front hall

west side rooms · central courtyard · east side rooms

west gate courtyard · gate · east gate courtyard

front courtyard

screen wall 0 500 1000 cm

a

Fig. 2.7. An early Western Zhou temple-palace structure. 11th–10th centuries B.C. 45 by 32.5 m. Excavated in 1976 at Fengchu, Shaanxi province. (a) Floor plan. (b) Reconstruction.

bring down the Supreme God, as well as ancestral deities, from above."[49]

We may assume that such a journey was actually undertaken during the Three Dynasties, since the spatial-temporal structure of the ritual sequence is so clearly disclosed by the visual forms of the architecture and objects we can still observe. In fact, the ancient Chinese characterized their temples in similar terms. In the poem "Mian," for example, the construction of the first Zhou temple is described in the following lines:

> Dead straight was the plumb-line,
> The planks were lashed to hold the earth;
> They made the Hall of Ancestors, very venerable.
>
> They tilted in the earth with a rattling,
> They pounded it with a dull thud,

> They beat the walls with a loud clang,
> They pared and chiseled them with a faint *p'ing p'ing*.
>
> .
>
> They raised the outer gate;
> The outer gate soared high.
> They raised the inner gate;
> The inner gate was very strong.[50]

Instead of focusing on the temple's sacrificial halls, the poet emphasizes its two seemingly less important features: walls and gates. The temple had multiple walls and gates; the result was a layered structure that concealed sacrificial halls and sacred ritual vessels. Such an architectural structure was conceived as "closed," "vast," "hallowed," "solemn," and "mysterious," as we read in two other Zhou hymns:

Holy is the Closed Temple,
Vast and mysterious;
Glorious was Jiang Yuan,
Her power was without flaw.[51]

Solemn the hallowed temple,
Awed and silent the participants of the sacrifice,
Well purified the many knights
That handle their sacred task.
There has been an answer in heaven;
Swiftly the spirits flit through the temple,
Very bright, very glorious,
Showing no distaste towards men.[52]

By manipulating space, a temple created a temporal ritual sequence and heightened religious feeling. Instead of exposing its content to the public, it was a "closed" structure—a walled compound that was "solid" outside but "hollow" inside. Separated from the mundane world, its deep courtyards and dark halls became "solemn," "mysterious," and "holy." All its spatial elements led worshippers closer and closer to the center of the secret, but at the same time they created layers of barriers to resist such an effort. Even at the end of the ritual process, what people found was still not a concrete image of the ancestral deity, but ritual bronzes that served as the means to communicate with this invisible being.[53] The whole monumental complex of a temple, therefore, becomes a metaphor of history and the ancestral religion itself: to return to the Origin, maintain the ancient, and not forget those to whom one owed one's being.

From Temple to Palace

Far from being an architectural complex designed and constructed purely for ancestral services, a Western Zhou temple was both a religious and political center.[54] In this sense, the royal temple combined the functions of a temple and a palace—it was the place of both ancestral sacrifices and civil administration. It is impossible and misleading to separate temple ceremonies into "sacred" and "secular" types: a series of ritual events often proceeded from worshipping ancestral spirits to dealing with mundane issues

of government. Herrlee Glessner Creel summarizes activities of the latter category: "All of the most important activities of the state took place in the ancestral temple of its ruler. Here the new heir assumed his position. Military expeditions set out from the temple, and returned to it to report and celebrate victory upon their return. The business of diplomacy, and state banquets, took place there. Officials were appointed to office and given rewards, and vassals were invested with territories, in the same hall."[55]

Moreover, rather than being a self-contained monument, the royal temple demonstrated and "disseminated" its monumentality through a "temple system" that linked the country into an interrelated network. Scholars have explained this network in terms of the Zhou social and political structure. They have suggested that the basic elements of Zhou society were patrilineages fragmented from a number of clans. Whereas the royal lineage had its seat in Chengzhou, the capital of each vassal state was founded by a lineage sent out by the Zhou king.[56] The establishment of such vassal states is lavishly recorded in inscriptions and ancient texts. A passage from *Zuo's Commentary on the Spring and Autumn Annals* describes King Cheng's *fengjian* (establishing vassal states) at the beginning of the Zhou:

When King Wu had subdued the Shang, King Cheng completed the establishment of the new dynasty, and chose and appointed [the princes of] intelligent virtue to act as bulwarks and screens to the Zhou. Hence it was that the Duke of Zhou gave his aid to the royal house for the adjustment of all the kingdom, he being most dear and closely related to the Zhou. To him there were given— a grand chariot, a grand flag with dragons on it, the *huang* stone of the sovereigns of the Xia, and the [great bow] called Fangruo of Fengfu. [The heads of] six lineages of the people of the Yin—the Tiao, the Xu, the Xiao, the Suo, the Changshao, and the Weishao—were ordered to lead the chiefs of their kindred, to collect their branches, the remote as well as the near, to conduct the multitude of their connections, and repair with them to the Zhou, to receive the instructions and laws of the Duke of Zhou. They were then charged to perform duty in the Lu principality [of the duke], that thus the brilliant virtue of the Duke of Zhou might be made illustrious. Lands [also]

were apportioned [to the duke] on an enlarged scale, with priests, superintendents of the ancestral temple, diviners, archivists, all the appendages of State, the tablets of historical records, the various officers and the ordinary instruments of their offices.[57]

Also during the same ceremony, Prince Kangshu, one of the younger brothers of King Wu, received the order to rule the state of Wei in the former Shang territory, and Prince Tangshu was charged to govern the state of Jin in the old land of the Xia.[58] These two princes, as well as the Duke of Zhou, were among the "sixteen sons of King Wen and four children of King Wu" enfeoffed with subsidiary states. Xunzi also stated that of the 71 vassal states established at the time, 53 were given to members of the royal clan and the rest to relatives by marriage and descendents of old privileged clans.[59]

Once such vassal states were founded, the segmentation of the clan was continued on another level. With his assigned symbols of authority (including special carriages, scepters, ritual vessels, flags, and especially his ancestral temple), the lord of a state could send out branches of his own lineage to establish secondary territories.[60] These subbranches would build towns centered on their ancestral temple. The result of this segmentation process was a tightly interrelated hierarchical structure safeguarded by routine ritual practices (see Figs. 2.8a, b). Cho-yun Hsu has characterized the social and political function of this system: "The institutionalization of rank occurred as a consequence of a political authority that relied only in part on force to maintain control. Social order had to be made routine and acceptable in order to sustain political control. The regularization of ritual and status ranking reflected social stability, for privileges and obligations of individual members were known and regulated. Internal conflicts were minimized because everyone's place was known."[61]

Most important to the present study, this sociopolitical structure was indexed and supported by the temple system. An ancestral temple in a city or town was symbolic on three levels: first, it proved the common ancestry and homogeneity of the lineage that owned it. It was under-

Main Line	Branches	Secondary Branches	Tertiary Branches
King			
King	Dukes		
King	Dukes	Ministers	
King	Dukes	Ministers	Shi
King	Dukes	Ministers	Shi

a

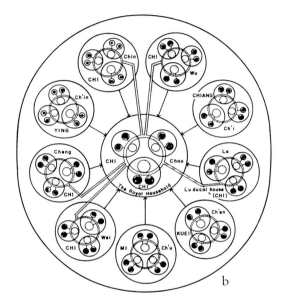

b

Fig. 2.8. Western Zhou social and political structure. (a) The zongfa (lineage-rank) system. (b) The Zhou vassal states.

○ STATE (EITHER ROYAL OR DUCAL)
○ KINSHIP UNITS OF THE RULING FAMILY
● KINSHIP UNITS OF SURNAMES DIFFERENT FROM THE RULING GROUP
⸺ SUBORDINATION TO
→ KINSHIP TIES
YING SURNAMES
Ch'in STATE NAMES

stood that as long as lineage members worshipped their ancestors in the temple, they recognized their blood relationship and were united in a basic social group. The *Book of Rites* thus states: "[A nobleman] maintains his ancestral temple and presents sacrifices reverently at proper seasons. This brings order to his lineage and clan."[62] Second, a temple indicated the position of a lineage in a larger social and political hierarchy. As we have seen, the temple of the royal lineage consisted of seven shrines or chambers for seven individual ancestors; the lineage temple of a feudal lord, on the other hand, had only five chambers; and that of a minister, three chambers (see Figs. 2.2a, b).[63] The numbers of the chambers in a temple compound thus signified the different status of the lineages. Third, the

"founder" worshipped at the focal point in a temple, which symbolized the beginning of a lineage, also served to remind people of a larger historical context: the existence of a "father lineage" that had sent the ancestor to establish his own sub-branch. A lineage's history was thus always part of a larger historical narrative. The key events in this narrative were a series of "investiture" ceremonies, which made a clan's fragmentation and expansion official.

We thus return to the "investiture" ritual, but with a renewed interest. My earlier discussion of this temple ritual focused on its recording in bronze inscriptions and its relation to the commissioning of bronzes, but it is also crucial to our understanding of the construction and organization of the Western Zhou temple system. In particular, this ritual explains how political power was disseminated within this system and transmitted from one social stratum to another. In fact, this significance is already implied in *ceming*, the original term for the ritual, which means literally "to give and record an order."[64] The pictograph *ce* (see character *a* to left) illustrates a document written on a set of bamboo splints; *ming* (*b*) shows a figure (*c*) kneeling under a "roof" (*d*) while receiving an order from a "mouth" (*e*). The "roof" symbolizes the ancestral temple or the temple's audience chamber, which was called the Great Hall (Taishi or Dashi); the "mouth" belongs to the king who issues the order. Bronze inscriptions and traditional texts describe *ceming* or investiture ceremonies in a uniform narrative. After providing the date and place of a ceremony, a text often records that the king "assumed his position" (*jiwei*) in front of the Great Hall, between two stairways ascending from the courtyard. Wearing ritual attire and facing south, he stood before a screen decorated with patterns of ceremonial axes—symbols of royal power. A *bin* ceremonial usher, usually a prominent courtier, then led the receiver of the investiture through the temple gate and positioned him in the courtyard, to the left of the usher and facing the king. When the *ceming* ceremony began, an archivist (*shi*) standing above the east stairway to the Great Hall (i.e., to the king's left or east) presented the king with a *ce* document, which recorded the king's order (*ming*). The king then handed the document to another archivist to his right

Fig. 2.9. right *Chen Mingjia's reconstruction of a Zhou investiture ceremony in the royal ancestral temple*

(or west), who read it in a loud voice. After listening to the order and receiving the king's gifts, the official being invested bowed, thanked the king, declared his loyalty, and proclaimed that he would make ritual bronze(s) for his own ancestor(s) which would bear the king's order.[65] The modern Chinese scholar Chen Mengjia has reconstructed the positioning of various participants in such a ceremony (Fig. 2.9).[66]

Chen's reconstruction fits in well with the architectural layout of the Western Zhou royal temple recorded in texts and exemplified by the Fengchu site (Figs. 2.7a, b). But more important is the symbolism of an investiture ritual that it reveals. First, standing in front of the Great Hall and facing south, the king occupied "the host position" (*zhuwei*); he thus presented himself as the master of the temple/palace, a status derived from his royal ancestors, who were worshipped in the ritual structure. The person being invested, on the other hand, was in "the guest position" (*kewei*); he was invited to the temple/palace to receive the king's order. He maintained this submissive position throughout the ceremony—even when leaving the compound after the ritual, he walked backward, never facing south. Second, during the ritual, the king presented himself as a silent symbol of political and kin authority. He spoke very little, if at all;[67] his order was conveyed by archivists. Two copies were made to record the royal order. One copy was stored in the royal temple/palace as part of the government archive. The other copy was given

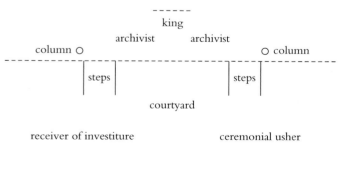

GREATHALL

king

archivist archivist

column ○ ○ column

steps steps

courtyard

receiver of investiture ceremonial usher

| gate |

to the official being invested, who inscribed the order on the ritual bronze(s) that he made after the ceremony and placed the bronze(s) in his ancestral temple (which also functioned as the palace of a feudal lord or the office of a minister). In this way, power was distributed from the central authority to sub-authorities, and the transmission of power was officialized by transmitting ritual symbols from the royal temple/palace to the temples/offices of the nobility.

The investiture of an official was only a single link in a long chain of "giving and receiving orders." The Zhou believed that even the king had to receive his mandate from Heaven and from his royal ancestors, and that only then was he able to assign his ministers and relatives noble status and official posts. The absolute importance of *ceming* rituals in Zhou politics explains why they were abundantly recorded in Western Zhou documents, temple songs, and the inscriptions of bronze *liqi*.[68] Based on this written information, the modern Chinese scholar Chen Hanping has classified royal investiture ceremonies into five major kinds.[69] The first is called *shiming*, or "original investitures," during which a prominent official initially received the order to establish a vassal state, along with a noble title, lands, people, and status symbols. Theoretically, the direct descendents of the founders of these states inherited their forefathers' titles and political status. But such succession was supposed to be confirmed by the king through another kind of investiture known as *ximing* (an order to inherit).[70] The "original investiture" could also be altered through *zengming* (an additional order) or *gaiming* (changing an order).[71] The fifth kind of royal investiture was called *chongming*: after a new king ascended the throne, he might hold investiture ceremonies in the royal temple/palace to reconfirm his deceased father's orders.[72] A number of ancient texts explain why all these five types of investiture had to be held in the royal temple: "To invest nobles in a temple means that this is not a private business; to enfeoff feudal lords in a temple means that the king is not despotic. [The location of these rituals thus] demonstrates that the principles of governing were founded by our ancestors, and that the king must thus report all his activities to his ancestors."[73]

Such royal *ceming* ceremonies were duplicated on multiple local levels. After being invested by the king, a feudal lord could then establish his temple/palace; there he ruled his territory and ordered his ministers and relatives to establish their subsidiary fiefs and temples. The chain of events in an investiture thus functioned to construct the state organization, and the formative process of the state organization was mirrored by the expansion of the "temple system" from the center to the periphery and from above to below.

Unfortunately, no temple or office of Western Zhou lords, ministers, and officials has been found.[74] Our chief archaeological evidence for the past existence of these structures, in my opinion, consists of groups of ritual bronzes excavated from large and small storage pits. In 1988, Luo Xizhang reported that he had personally examined 68 such hoards in the Plain of Zhou, which had yielded nearly a thousand bronze vessels and musical instruments.[75] Guo Moruo and Huang Shengzhang have contended that an important political event must have caused the burial of such a great number of ritual bronzes. The event that Huang Shengzhang identified took place in 841 B.C., when a group of ministers forced King Li and his followers to leave his capital and go into exile.[76] Guo Moruo, on the other hand, believed that a later event provided a better reason: "In the eleventh year of King You of Zhou [771 B.C.], the invading Quanrong nomads flooded into the Zhouyuan area and destroyed the Zhou capital there. The Zhou royal house decided to move its seat eastward, and noble families hurriedly hid their ritual vessels by burying them. But these nobles never gained an opportunity to return to their homes [and reopen the pits]. The buried bronzes have thus survived for us to discover."[77] Luo Xizhang considered both explanations acceptable, but also pointed out that based on stylistic attributes, some bronzes from the excavated hoards must be dated to periods after King Li and even after King You. He thus proposed that although ritual objects may have been buried during periods of political chaos, the storage pits in Zhouyuan could have also been constructed during peaceful times as a means of storing family treasures.[78]

Instead of following this line of argument, my chief

*Fig. 2.10. below
(a) Zhuangbai Hoard
no. 1. Western Zhou.
11th–8th centuries B.C.
Excavated in 1976 at
Fufeng, Shaanxi province.
page 93 (b) Some bronze
vessels from Zhuangbai
Hoard no. 1, commis-
sioned by four generations
of the Wei family: (i) the
Zhe vessels; (ii) the Feng
vessels; (iii) the Qiang ves-
sels; (iv) the Xing vessels.*

question concerns the origin of the bronzes found in the hoards: Where had these *liqi* been used and displayed *before* their burial? We know that during the Western Zhou, ritual vessels and ceremonial musical instruments were normally housed in ancestral temples. Luo Xizhang has shown that bronzes from one or two hoards often belonged to many generations of a lineage or a family.[79] It seems obvious that these buried *liqi* were removed from temples of Zhou nobles and officials. Thus, although these bronzes and their inscriptions have been studied over and over as important works of art and as historical texts, the approach developed in this study, that *liqi* and temple architecture formed two basic components of a single monumental complex, suggests that the *relationship* between a group of buried bronzes also supplies evidence for understanding Western Zhou monumentality. By studying the bronzes from a single hoard, we can gain important information regarding the changing significance of a Western Zhou temple, which functioned as the seat of a subordinate political authority and as a "memory site" preserving its owners' history.

Discovered in 1976, Zhuangbai hoard no. 1 provides an excellent opportunity to conduct such a study (Figs.

2.10a, b). The hoard yielded 103 bronze vessels and musical instruments, 74 of them inscribed. The oldest bronzes are of the late Shang–early Zhou, and the latest are in the style of the late Western Zhou.[80] Scholars recognized at once the extraordinary value of this group in reconstructing the evolution of Western Zhou bronze styles; as Jessica Rawson pointed out, it "has proved especially useful to Western Zhou bronze chronology, enabling us to arrange many early Western Zhou bronzes in a firmly based sequence and to date them approximately to certain reigns."[81] Instead of conducting a stylistic analysis, however, I will approach and interpret the Zhuangbai bronzes as integral and cumulative components of a Western Zhou temple, which, in this case, belonged to a branch of the Wei clan.

The genealogy of this branch can be reconstructed from the texts inscribed on the Zhuangbai bronzes. Its remote forebear arose from Wei, a place probably located not far from the last Shang capital in Henan.[82] Its members were hereditary archivists or court recordkeepers, and so their emblems included the pictograph *ce* (a). When King Wu conquered the Shang, an ancestor of the clan, whom his descendents referred to as their Brilliant Ancestor (Lie Zu), submitted to Zhou rule. He was charged by the new regime to organize court rituals, and he received a fief in the Plain of Zhou. His son, called Ancestor Yi (Yi Zu) in the inscriptions, probably lived during the reigns of Kings Cheng and Kang. His descendents described him as the kings' "henchman" (*fuxin*) but offered no concrete evidence for his achievement. Yi Zu's son Zhe, however, is a very important figure for this study.

In fact, it is possible that the Zhuangbai bronzes were removed from a temple founded by him, since his temple title (*miaohao*), Ya Zu or Subordinate Ancestor, indicates that he initiated a new lineage within the clan's overall organization.[83] This hypothesis explains why Zhe's great-grandson Xing called him the High Ancestor (Gao Zu), and why bronzes commissioned by him are the oldest made by any identifiable Wei clan member found in the Zhuangbai hoard.[84] These Zhe bronzes, as well as those commissioned by his direct descendents, bear the emblem (*b*), which likely identified this sub-lineage

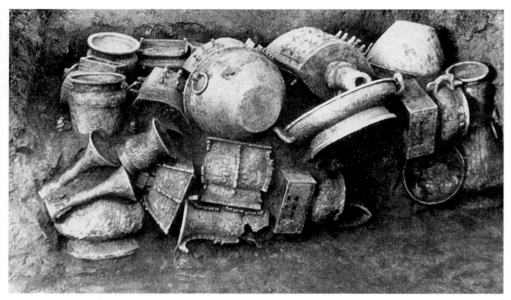

a

Temple, Palace, and Tomb

within a larger kin group whose members shared the emblem *ce*.

Zhe, or Ancestor Xin, was also the first Wei clan member whose personal name we know, and he and his son Feng (also called Yi Gong or Lord Yi) continued to serve Zhou kings as court archivists. One of their duties was to participate in royal investiture ceremonies, during which they recorded and announced royal orders. They described such glorious moments in their lives on sacrificial vessels, in the hope that their descendents would remember this tradition always (Figs. 2.11a, b):[85]

> In the fifth month, the king was at Gan. On the day *maozi*, the king ordered me, Archivist Zhe, to bestow lands on Marquis Xiang; [other gifts from the king included] bronze metal and servitors. I praise the king's beneficence. In the nineteenth year of the king's reign, I make this vessel for [my deceased] Father Yi. May it be treasured forever [by my descendents]. (Lineage emblem.)

Since this and other inscribed bronzes were stored and displayed in the lineage's temple, knowledge about the lineage's ancestors was preserved in the temple and handed down to later generations. Qiang, who followed Feng as head of the lineage and as court archivist, compiled a systematic history of the lineage and recorded it in one of the most important extant Western Zhou bronze inscriptions (Figs. 2.12a, b). The text, inscribed on the vessel known as the Shi Qiang *pan* and roughly rendered into English below, first sets out a chronology of the Zhou royal house from King Wen down to the living ruler, King Gong.[86]

> In antiquity, King Wen first established harmony in government. God on High bestowed on him intelligent virtues. He could thus pacify [the country], hold fast to the whole world, and assemble and receive [tribute delegations] from the ten thousand states. Powerful King Wu campaigned in four directions. He took over the people of the Yin [Shang], consolidated [the achievements of] his ancestors, and forever quelled the troubles with the [nomadic] Di and the [eastern] Yi. The wise sage-king Cheng, assisted by strong helpers, governed the country with systematic rules. The virtuous King Kang divided the country [by enfeoffing feudal lords]. The

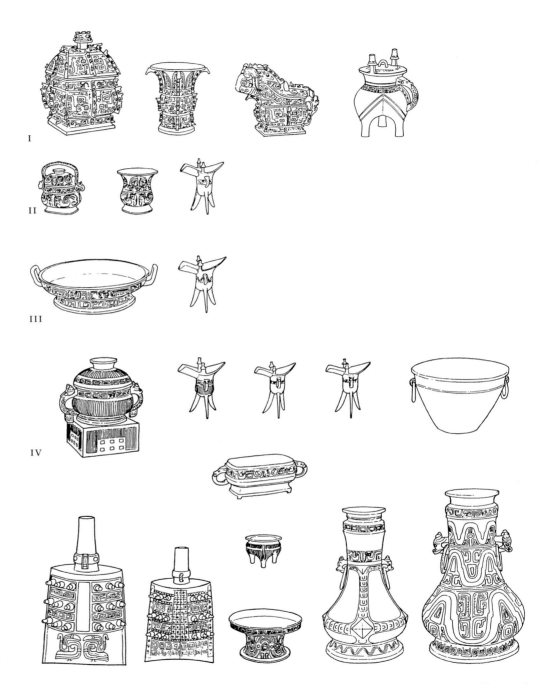

Fig. 2.10b

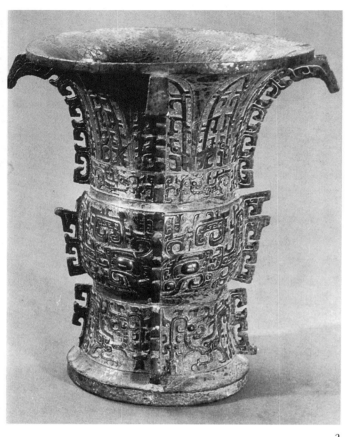

Fig. 2.11. (a) Zhe zun.
Bronze. Early Western
Zhou. 11th—10th cen-
turies B.C. H. 32.5 cm.
Excavated in 1976 from
Zhuangbai Hoard no. 1.
(b) Ink rubbing of inscrip-
tion.

court and was received in audience by King Wu. The king commanded the Duke of Zhou to assign him a residence in the Plain of Zhou. Our great-grandfather, Ancestor Yi [Yi Zu], served his king well and enjoyed the king's confidence. Our grandfather, Ancestor Xin [Zu Xin or Zhe, the Subordinate Ancestor], gave birth to many descendents and brought them blessings and happiness. To him we should offer sincere sacrifices. Our father Lord Yi [Yi Gong or Feng] was wise and virtuous. No one uttered criticism of him. He engaged in farming and managed well, and demonstrated the virtues of loyalty, filial piety, and brotherly love.

The final paragraph of the text describes Qiang's accomplishments.

I, Qiang the Archivist, work hard all day and night. I dare not neglect court ritual affairs. I praise the brilliant mandate of the Son of Heaven, and for this I make this precious and sacred vessel. It will be used in sacrificing to my Brilliant Ancestor and my fine deceased father, who left me the lineage fief with all its income. May good luck and blessings last until my hair turns white and my skin becomes dry. May I serve my king diligently and well. May this vessel be treasured 10,000 years [by my descendents].

This history of a noble lineage is deliberately interwoven with the history of the Zhou royal house: it was this linkage that legitimated the lineage's status within the Zhou bureaucratic network. Thus, the inscription elaborately narrates how the Brilliant Ancestor received the lineage fief in the capital area from King Wu; and the final paragraph emphasizes that the vessel was made to honor both this ancestor and the Son of Heaven. Once displayed on a bronze vessel in the lineage temple, this text provided later generations of the lineage a standard version of their family history. Not coincidentally, this inscription was partially copied on a set of ceremonial bells (Figs. 2.16a, b) commissioned by Qiang's son and the next lineage head, Xing.[87]

Among the members of the lineage who made ritual bronzes for their temple, Xing was perhaps the last but certainly the most illustrious.[88] The Zhuangbai hoard yielded 43 inscribed bronzes made by him, compared with

broad-minded King Zhao campaigned southward to the regions of Chu and Jing. The brilliant King Mu set a model for the current Son of Heaven, carefully educated him, and provided him with a solid dynastic foundation. Our Son of Heaven has received a great mandate to continue the long royal line King Wen and King Wu began. Our Son of Heaven should enjoy long life and good health. He serves the deities well and glorifies the previous kings and royal ancestors. God on High blesses him so that he may enjoy good harvests and have peoples of all places come to pay their respects.

This dynastic chronology sets a framework for Qiang's narrative of his own lineage's history.

Our tranquil High Ancestor [Gao Zu] originally resided in Wei. When King Wu had conquered the Shang, our great-great-grandfather, the Brilliant Ancestor [Lie Zu], who had been the archivist of Wei, came to the Zhou

13 inscribed vessels commissioned by previous generations. These 43 bronzes, however, still represent only part of Xing's donation to the temple: none of his four sets of ceremonial bells from the hoard is complete, and bronzes made by him had been found elsewhere as early as the Song dynasty.[89] Moreover, whereas his close forefathers had served the Zhou kings only as court archivists and attended to investiture rituals in this capacity, Xing was the only lineage member entitled Lord of Wei (Wei Bo) and more than once personally received investiture in the royal temple/palace. The first of these investitures took place in the fourth year of King Xiao's reign.[90] The king gave Xing special chariot fittings as his status symbols, and Xing responded by making a pair of *xu* vessels for his deceased father, Qiang (Figs. 2.13a, b). Nine years later, the same king again invested Xing in the capital Chengzhou. Accompanied by the ceremonial usher Yi Fu, Xing received ritual costumes from the king; he then made a pair of *hu* vessels to commemorate this event (Figs. 2.14a, b). He continued to enjoy favor from the next ruler, King Yi: the inscriptions on two other *hu*, which he made in the third year in the king's reign, record that he twice received bronze vessels from the king during royal rituals and banquets (Figs. 2.15a, b).

In addition to these three groups of bronzes commemorating Xing's investitures, a larger number of bronzes aimed to demonstrate his loyalty and filial piety. This intention is shown most clearly in the following inscriptions, which were cast on two separate sets of ceremonial bells:

In antiquity, King Wen first established harmony in government. God on High bestowed on him intelligent virtues. He could thus pacify [the country], hold fast to the whole world, and assemble and receive [tribute delegations] from the 10,000 states. When King Wu had conquered the Shang, our Brilliant Ancestor [Lie Zu], who had been the archivist of the Wei, came to the Zhou court and was received in audience by King Wu. The king commanded the Duke of Zhou to assign him a

Fig. 2.12. (a) Shi Qiang pan. Bronze. Mid–Western Zhou. 10th–9th centuries B.C. H. 16.2 cm. Diameter 47.3 cm. Excavated in 1976 from Zhuangbai Hoard no. 1. (b) Ink rubbing of inscription.

a

b

a

b

Fig. 2.13. above *(a) 4th year Xing* xu. *Bronze. Middle–late Western Zhou. 10th–9th centuries* B.C. *H. 13.5 cm. Excavated in 1976 from Zhuangbai Hoard no. 1.* right *(b) Ink rubbing of inscription.*

Fig. 2.14. above, right *(a) 13th year Xing* hu. *Bronze. Middle–late Western Zhou. 10th–9th centuries* B.C. *H. 59.6 cm. Excavated in 1976 from Zhuangbai Hoard no. 1.* below, right *(b) Ink rubbing of inscription.*

a

b

Fig. 2.15. (a) 3d year
Xing hu. Bronze.
Middle–late Western
Zhou. 10th–9th centuries
B.C. H. 65.4. Excavated
in 1976 from Zhuangbai
Hoard no. 1. (b) Ink rub-
bing of inscription.

fest my good fortune without limit. Use [this set of bells]
to make me radiate with glory; forever shall I treasure it.
(Figs. 2.16a, b)[91]

I, Xing, am fearful and ceaselessly active from morn-
ing to night, always mindful of not losing [my mandate];
striving to practice filial piety toward my High Ancestor
Lord Xin, my Accomplished Ancestor Lord Yi, and my
august deceased father Lord Ding. I made this set of har-
monically tuned chime bells. Use it so as to please and
exalt those who arrive in splendor, so as to let the ac-
complished men of former generations rejoice. Use it to
pray for long life, to beg for an eternal life-mandate, [so
that I may] extensively command a position of high emol-
ument in respected old age and [enjoy] unadulterated
happiness.

My venerable august ancestors are loftily facing these
illustrious achievements, [looking on] sternly from up on
high. May they let me be rich and prosperous, forever [en-
joying] with ease ever more ample and manifold good
fortune. May they broadly open up my awareness, help-
ing [me to obtain] an eternal life-mandate; may they per-
sonally bestow upon me that abundant good fortune [of
theirs]. May I live for 10,000 years. [My sacrificial bull]
has long horns, he is well-fattened, and [his skin] is glis-
tening; sacrificing to the Accomplished Spirits according
to propriety, may I manifest my good fortune without
limit. Use [this set of bells] to make me radiate with glory,
forever shall I treasure it. (Figs. 2.17a, b)[92]

residence in the Plain of Zhou, and charged him to orga-
nize the 50 kinds of court rituals.

Now I, Xing, work ceaselessly day and night; respect-
ful and reverent, I devote my life [to the royal house].
Thus I make this set of harmonically tuned bells. Use it
[so that I may] forever be at ease, [enjoying] ever more
ample and manifold fortune. May my awareness be broadly
opened up, helping [to obtain] an eternal life-mandate;
may I have caringly bestowed upon me abundant good
fortune and a good end. May I live for 10,000 years. [My
sacrificial bull] has long horns; may I offer them to the
Accomplished Spirits according to propriety; may I mani

b

a

Fig. 2.16. (a) Xing bell. Bronze. Middle–late Western Zhou. 10th–9th centuries B.C. H. 48 cm. Excavated in 1976 from Zhuangbai Hoard no. 1. (b) Ink rubbing of inscription.

These and similar inscriptions on Xing's bronzes reveal a number of changes in the ancestor worship practiced in the Wei lineage temple toward the end of Western Zhou. These changes were related to the attitude toward the deceased ancestors, the intention of preserving past memories, the desire to rewrite history, and the self-esteem of the living generation—all indicative of a new concept of monumentality. First, although the lineage's history recounted in the first inscription was apparently based on the Shi Qiang *pan* inscription, Xing omitted his pre-Zhou High Ancestor and began his narrative from the Brilliant Ancestor, who received the lineage's fief from

King Wu. He thus revised his lineage history; the result was a perfect parallel between the history of his family and that of the dynastic Zhou rule. Second, instead of following his father's example of praising every ancestor, Xing restricted his "ancestral models" to three particular personages: his great-grandfather Zhe, his grandfather Feng, and his father Qiang. Moreover, whereas Qiang used the term "High Ancestor" (Gao Zu) in addressing the remote founder of the Wei clan, Xing used the same term for his great-grandfather Zhe, who, as suggested earlier, may have initiated a new branch of the Wei lineage. What we find here is the internal fragmentation of the lineage

Temple, Palace, and Tomb

and the narrowing of a kinship unit. Correspondingly, the focus of ancestor worship gradually shifted from *yuanzu* (remote ancestors) to *jinzu* (close and direct ancestors).

Third, the inscriptions on Xing's bronzes largely served to glorify the donor himself. The description of his ancestry was significantly reduced, and his own worldly achievements laboriously emphasized. Many formulaic sentences convey his hope for longevity and, more frequently, for "good fortune." In the preceding chapter I interpreted this new emphasis in late Western Zhou bronze inscriptions as evidence for the transformation of ritual objects from *liqi* that one devoted to one's ancestral deities to those that one dedicated to oneself. The present discussion, which views these bronzes as an integral component of an ancestral temple, reveals another aspect of the same transformation: as "self-glorifying" bronzes gradually came to dominate the temple, they inevitably created tension between tradition and reality. On the one hand, since the old ritual paraphernalia were still housed in a temple and traditional rituals were still routinely performed there, the temple continued to preserve the past history of a lineage. On the other hand, the living members of the lineage had gradually lost interest in their past and were eager to demonstrate their power straightforwardly by presenting their personal deeds in the temple. In other words, they were eager to transform the temple from a collective lineage monument to a monument to a few illustrious individuals. This contradiction finally led to the division of the traditional temple into twin centers: a temple, which continued to exist as a religious or sacrificial center, and a palace, which gained its independence as the center of administration. A temple continued to belong to a larger kinship group and worshipped a collective body of ancestors; a palace was the property and symbol of one man and his small family. When the archaic social and political systems based on a large clan-lineage network collapsed after the Western Zhou, princes and lords no longer submitted to the central authority or received their mandate through royal investitures. They had to demonstrate their own worth and strength. Consequently, their palaces became the chief monuments of a new historical era.

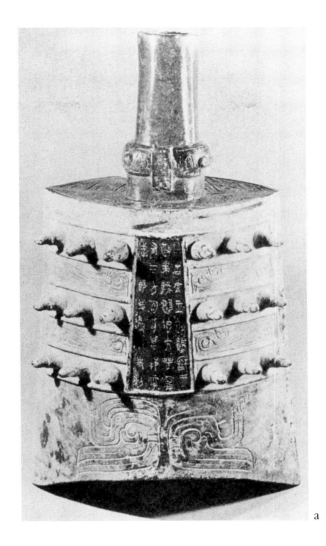

a

b

Fig. 2.17. (a) Xing bell. Bronze. Middle–late Western Zhou. 10th–9th centuries B.C. H. 70 cm. Excavated in 1976 from Zhuangbai Hoard no. 1. (b) Ink rubbing of inscription.

This new era lasted some 500 years, from the early eighth to the late third century B.C. In traditional Chinese chronology, it is divided into two stages—the Eastern Zhou (consisting of the Spring and Autumn and the Warring States periods) and the Qin—which witnessed China's transition from a country united by kinship ties to an empire governed by a central government. Scholars have suggested a number of reasons for the devolution of political power from the Zhou kings to the feudal lords during the Eastern Zhou. These include the rapid growth of regional economies and the increasing control of resources

and military forces by local rulers, the gradual distancing and detachment of the family lines of these rulers from the central royal lineage, and the internal turmoil and foreign invasions that continuously weakened the Zhou royal house. Jacques Gernet summarized the consequences of this social and political transformation:

> It was no longer the religious and military sovereignty of the [Zhou] kings that was the dominant factor, even if it remained customary to refer to them for arbitration and to lean on their moral authority; ritual practices and the knowledge of precedents formed the foundation of a new order. They governed the relations between these allied yet rival cities, united and also divided by war, vendetta, matrimonial alliances, treaties, and the exchange of goods and services. With the development of the principalities and the weakening of the royal power a new society and new manners made their appearance: a nobility jealous of its privileges and attentive to questions of protocol, the ideal of the noble warrior, and ethic of honor and prestige.[93]

Struggles between feudal lords for political and territorial dominance further reduced the number of the principalities established previously by Zhou kings through investitures. A handful of "hegemonies" (*ba*)—large, powerful kingdoms able to enforce their will on the Zhou court and the weaker states—appeared (Maps 2.2a, b); their rulers came to call themselves "kings" (*wang*), a title reflecting their newly gained status and confidence. Political struggles also took place within principalities; often officials of minor lineages and lower positions overpowered their lords. The basic tendency of this historical process, again summarized by Gernet, is that

> political power was trying to free itself from the matrix in which it was imprisoned—that is, from the family and religious context of which it formed an integral part in the ninth to seventh centuries—and that as it gradually broke loose it was conceived more and more clearly as a specific factor. To say that the prince sought to free himself from the weighty tutelage of the families of high dignitaries does not take account of the whole reality: in fact it was power itself that changed its nature during the course of this struggle between tradition and the new demands of the age.[94]

This social transformation is most clearly reflected by the development of Eastern Zhou cities and by the growing importance of the palace, which has now assumed an independent "monumental" status. The divorce of the palace from the lineage temple meant that political power was freeing itself from the "family and religious context" that had imprisoned it; the independence of the palace signified that political power "was conceived more and more clearly as a specific factor"; and the supremacy of the palace over the temple documented the result of "the struggle between tradition and the new demands of the age."

More than twenty Warring States capitals of large and small Eastern Zhou states have been excavated during the past fifty years.[95] Their impressive scale contradicts the traditional building code based on the Western Zhou social hierarchy.[96] We know this code from a statement made by the official Ji Zhong in 722 B.C. In that year, the lord of the state of Zheng gave a large city, Jing, to his younger brother as the latter's fief. Ji Zhong opposed this decision: "According to the rule of the former [Zhou] kings, the larger capital [of a lord?] should be one-third the size of the national capital; the middle capital [of a *qing*-minister?] should be one-fifth the size of the national capital; and the smaller capital [of a *shi*-officer?] should be one-ninth the size of the national capital. Now the scale of Jing does not match [your brother's status]; I am afraid that your order is against the established rule."[97] But his protest went in vain; the lord considered the "established rule" no more than a cliché and persevered in his decision.

If the old Western Zhou code was still murmured at the beginning of the Spring and Autumn period, it was completely ignored during the late Eastern Zhou. None of the excavated Warring States cities followed the regulation quoted by Ji Zhong; some of them even surpassed the Zhou Royal City (Wangcheng) in both size and elaborateness.[98] All these new cities contained a special "palace district" (*gongdianqu*). Although the district occupied different positions in the various princely capitals, its presence is indicated by the large remaining foundations enclosed by walls that originally divided a city into areas for the ruler and for his subjects. In the Lower Capital (Xiadu) of

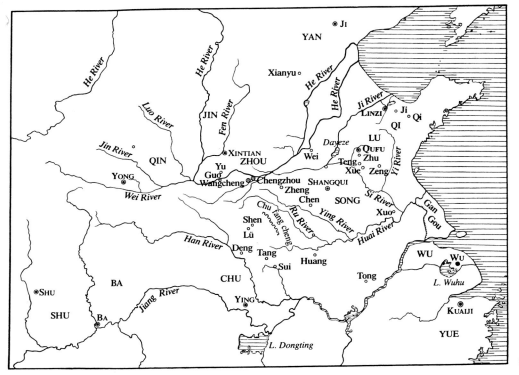

Map 2.2. (a) China during the Spring and Autumn period. (b) China during the Warring States period (Li Xueqin 1985: figs. 1, 2).

the state of Yan (in modern Hebei), this district occupied the city's northern part (Fig. 2.18a). Many large earthen foundations, some still rising 20 meters above the surrounding plain, along with exquisite bronze architectural accessories unearthed there, suggest the splendor of vanished palatial halls and pavilions built on tall terraces (Figs. 2.18b, c).[99] In Linzi, the capital of Qi, in present-day Shandong, the palace district was even more strictly defined: it had become a self-contained "palace town" loosely attached to the city's southwest corner (Fig. 2.19). These and other regional capitals provided the historic basis for an ideal city plan, which emerged during the Warring States period (Fig. 2.20). Recorded in a treatise called "Regulations of Workmanship" ("Kaogong ji"), this plan places the palace in the center of a "state capital" (*guo*), flanked by the ancestral temple and the Land Altar, two prominent components of a traditional capital that have become secondary elements of the new city.[100]

This plan, however, only illustrates the "ideal capital" as a flat image and does not shows an extremely important development of Warring States cities, which is their rapid vertical growth. For example, near the center of Linzi's palace town is a large mound approached by flights of stairs. Archaeologists have identified it as the remains of a famous terrace building called Huangong tai, the Platform of Duke Huan, where many important historical events took place.[101] Even after more than two thousand years, the oval-shaped foundation of Huangong tai is still 86 meters long. It must have also been of a considerable height: a contemporary *tai* platform constructed by a Chu king was said to have measured a 100 *ren* high and reached the floating clouds.[102] A large number of architectural remains surround the Huangong tai, suggesting that it was not an isolated tower but the commanding focus of the palace city. Imposing in appearance, this kind of structure best represents the architectural difference between an Eastern Zhou palace complex and a Western Zhou temple compound. A Western Zhou temple (Figs. 2.2a, b), as discussed earlier, was a walled enclosure that emphasized horizontal expansion; its ritual function lay in gradually guiding visitors to trace their ancestral origin and to re-experience their history. An Eastern Zhou palace,

on the other hand, stood on tall terraces or was built around an earthen pyramid; its powerful three-dimensional image had an immediate visual affect (see Fig. 2.21).

It thus becomes understandable why the *tai* platform became fashionable as a new type of monument among Eastern Zhou kings and lords, and why such constructions were extensively recorded in ancient texts. Duke Jing of Qi built the Great Platform (Da tai), Duke Ling of Wei the Juniper Platform (Chonghua tai), Duke Ling of Jin the Nine-Layered Platform (Jiuceng tai), and the kings of Chu the Platform of Qianxi (Qianxi tai), the Platform of Splendid Display (Zhanghua tai), and the Platform of Gold (Huangjin tai), among others.[103] Although these platforms were in different regions, they shared a single political significance: the taller a *tai*, the stronger its patron felt in the contemporary political arena. In the eastern part of the country, when Duke Jing of Qi climbed onto Boqin tai and surveyed his capital, he sighed with satisfaction: "Wonderful! Who in the future will be able to possess a platform like this!"[104] In the north, King Wuling of Zhao built an extremely tall *tai* that allowed him to overlook the neighboring state of Qi; this structure thus demonstrated his strength and intimidated his enemy.[105] In the south, a Chu king constructed an imposing platform as the site for a meeting with other feudal lords. Struck with awe, his guests agreed to join the Chu alliance and made a vow: "How tall this platform! How deep the mind it shows! If I betray my words, let me be punished by other states in this alliance."[106] In the west, Duke Miu of Qin tried to intimidate foreign envoys by showing them his palaces, which "even spirits could not build without exhausting their strength."[107] In the state of Wei in central China, the minister Xu Wan responded as follows to his sovereign's plan to construct the Middle Heaven Platform (Zhongtian tai):

I have heard that heaven is 15,000 *li* above the earth. Today Your Majesty wishes to build a platform that will reach half this height; so it must be 7,500 *li* tall with a base of 8,000 *li* on each side. Even all Your Majesty's lands are not enough for its foundation. In antiquity, Yao and Shun established vassal states within a territory of 5,000 *li* on each side. If Your Majesty insists on satisfying your fancy,

Temple, Palace, and Tomb

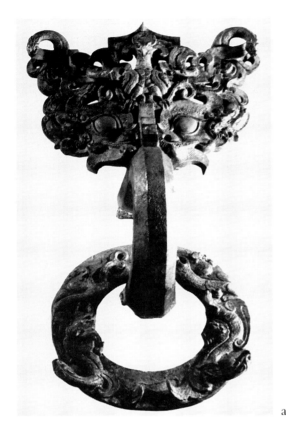

then you certainly must employ military force to conquer other states. But even if you conquer all the other states, the acquired land will still not be enough for the foundation of your platform. Only when you have conquered the foreign countries in the four directions and have gained an area of total 8,000 *li* on each side, can you begin to think about your building. But still, there will be the questions of building materials and manpower. The construction will also have to be supported by a state granary that can supply billions of bushels of grain. Your Majesty therefore will have to seek such resources 8,000 *li* beyond the nearby foreign lands, and will have to devote all cultivated land for your building.[108]

Xu Wan's fascinating rhetoric most clearly reveals the monumentality of an Eastern Zhou platform. He seems to have realized the historical significance of this type of palatial structure: its construction meant the destruction

Fig. 2.18. (a) Bronze door ring. Late Eastern Zhou. 4th–3d centuries B.C. L. 74.5 cm. W. 36.5 cm. Excavated in 1966 at *Laolao tai, Xiadu. Hebei Provincial Institute of Cultural Relics. (b) Plan of Xiadu, capital of the state of Yan. Yixian,* *Hebei province. Eastern Zhou. 8th–3d centuries B.C. (c) The remaining foundation of Laolao tai in Xiadu.*

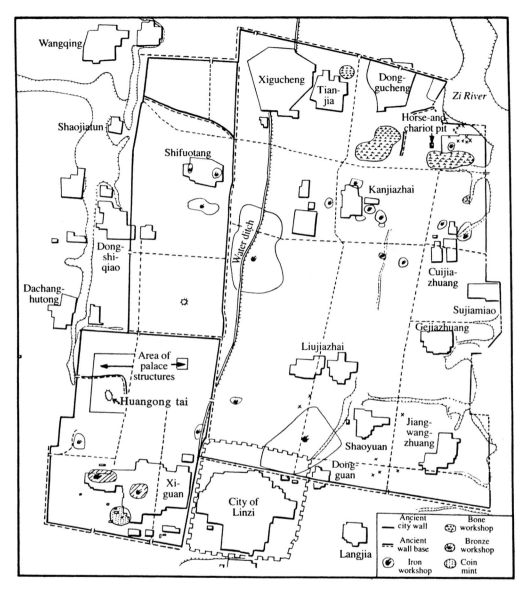

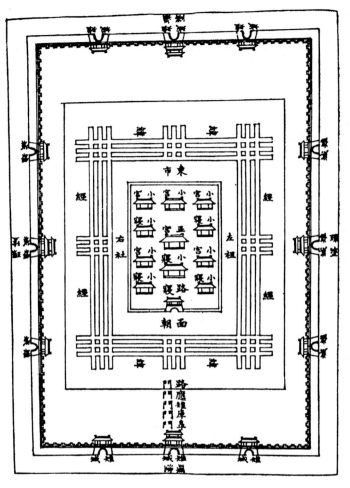

Fig. 2.19. Plan of Linzi, capital of the state of Qi. Shandong province. Eastern Zhou. 8th–3d centuries B.C.

Fig. 2.20. above, right Idealized plan of the Zhou royal capital as recorded in the Eastern Zhou text "Kaogong ji."

of the feudal system established by ancient sages. To him, the desire for such a tall building was equivalent to the ambition for political dominance over the whole nation, even foreign countries—seizing lands from other states, ruling the entire population, and becoming master of the world. In Xu Wan's metaphor, the man who achieved this goal would stand on a giant tower that buried his empire and people underneath. In our modern historical conception, the process leading to such an empire was the state of Qin's unification of China, and the man who finally managed to stand on the tower was Qin Shi Huang, the great First Emperor.

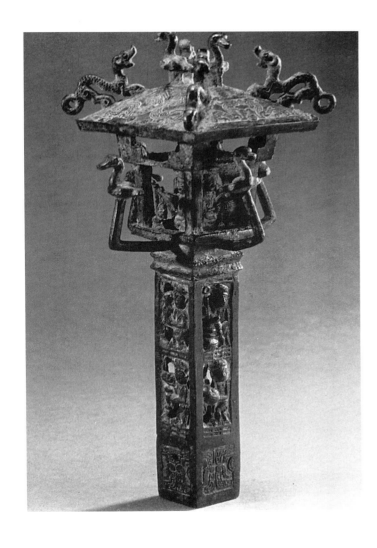

abolished, and their members could receive official titles and posts only after making recognizable contributions to the state. One of Shang Yang's crucial decisions, which also ensured the institutionalization of other new policies, was to move Qin's capital from Yong to Xianyang.[109] Yong, the sacred site of the Qin ancestral temple and the home of many hereditary lineages, represented everything that Shang Yang was trying to abolish. Xianyang, on the other hand, was a new city free from the burden of tradition; its strategic position at the intersection of major rivers and traffic roads allowed the Qin to further influence national politics.

Not coincidentally, when Shang Yang began to construct the new capital, he completely ignored the fundamental precept of traditional architecture that the first building a nobleman erected was his ancestral temple. What he founded first was a pair of palatial halls, which Sima Qian called the Ji que, or the Ji Gate Towers.[110] The modern scholar Wang Xueli interprets Shang Yang's preference for this particular building type as a reflection of the Eastern Zhou custom of posting legal documents and official pronouncements on the *que* gates in front of a palace. The gate-like Qin palace can thus be viewed as an architectural manifestation of Shang Yang's new laws and the imperial authority that he hoped to forge.[111] This interpretation seems convincing, especially because *ji*, the name of the palace, means "to record official orders on a *que* tower."[112] Interestingly, *ji* has a second meaning of "tall and imposing."[113] Indeed, the three-dimensionality of a gate-tower must have inspired the designer of the Qin palace, who wanted to create a new type of monument for his state and ruler.

After years of work, Chinese archaeologists finally published their excavation and reconstruction of Shang Yang's building in 1976 (Figs. 2.22a, b).[114] The reconstruction shows an architectural complex consisting of two identical wings, which, like the twin pillars of a *que* gate, were built around solid "earthen cores."[115] Each wing had three stories; the chambers were connected by intricate passages and balconies and were decorated with patterned tiles (Figs. 2.23a, b) and colorful murals (Figs. 2.24a, b). Patterned eave tiles accentuated the outline of each level,

Fig. 2.21. Miniature tower with figures and musicians inside. Bronze. Late Eastern Zhou. 4th–3d centuries B.C. H. 21.5 cm. W. 9.0 cm. Excavated at Dong-guancheng in Xiadu, Yixian, Hebei province. Hebei Provincial Institute of Cultural Relics.

The Qin was the most aggressive of the states contending for the imperial seat. Chief credit for its rapid rise to power belongs to Shang Yang, who instituted a series of political reforms from 356 to 338 B.C. A radical Legalist, Shang Yang dedicated his life to transforming an old feudal principality into a "modern" political state. He helped establish the absolute power of the king, forged a centralized administration, reorganized large lineages into small mutual-surveillance family units, converted serfs into tax-paying farmers, and imposed harsh measures on those who broke the law. The old lineages lost their power in this new system; their hereditary status and privilege were

Fig. 2.22. (a) Reconstruction of the Jique Palace. (b) The remaining foundation of the Jique Palace. Xianyang, Shaanxi Province. Late Eastern Zhou to Qin. 4th–3d centuries B.C.

a

b

and a row of columns surrounding the first level gave the whole structure a stable appearance.

The new interest in the third dimension, which this group of buildings so clearly demonstrates, explains two important developments in Eastern Zhou art and architecture. First, in the images of multilevel structures that frequently decorate Eastern Zhou "pictorial bronzes" (Figs. 2.25a, b), the rituals associated with these structures are no longer ancestral sacrifices in a temple but, as the modern scholar Yang Kuan has proved, new kinds of ceremonies—greeting honored guests, for example—which were held during the Eastern Zhou in the palaces of a king or the audience hall of a noble.[116] Instead of representing these structures from a bird's-eye view, the artist depicts their vertical elevation. Second, the emphasis on three-dimensionality must have underlaid the invention and intensive use of the "earthen core" in Eastern Zhou architecture. Compared with the low foundations of Shang

a

b

a

Fig. 2.23. far left Deco-
rated tiles from the Jique
Palace. Late Eastern
Zhou to Qin. 4th–3d
century B.C. Excavated
at Xianyang, Shaanxi
province. (a) Floor tile
with geometric patterns.
L. 44 cm. (b) Hollow tile
with incised bird images.

Fig. 2.24. Murals in the
Qin Palace no. 3. Late
Eastern Zhou to Qin.
4th–3d century B.C.
Excavated in 1979 at
Xianyang, Shaanxi
province. Administration
of Cultural Relics from
the Qin Capital. above,
right (a) Horse-drawn
chariot. left (b) Palace
lady.

and Western Zhou temple compounds (which rarely ex-
ceeded 1 meter in height),[117] the "earthen core" employed
by Eastern Zhou architects no longer functioned as the
flat base for an entire courtyard structure; rather, it raised
a palatial hall toward the third dimension. Its role was mainly
visual and symbolic: in an age when techniques for true
multistory structures had not yet fully developed, this de-
vice allowed people to increase the height and visibility

b

Fig. 2.25. (a) Bronze ves-
sel with incised pictorial
scenes. Mid–Eastern
Zhou. Ca. 5th century
B.C. (b) A terrace building
illustrated on the vessel.
Drawing.

a

b

of a building, although the actual living area in the build-
ing remained the same as or even less than that of a single-
level structure. I thus disagree with the theory that the
"earthen core" in Eastern Zhou architecture developed
smoothly from the leveled foundations of Shang and
Western Zhou temple compounds.[118] Although tech-
nically the earlier foundation anticipated the later "earthen
core," the latter was used for entirely different purposes
and, in fact, freed people from the norms of the Shang–
Western Zhou ritual architecture. Like a contemporary
tai platform, Shang Yang's palace derived its meaning from
its volume and height, which allowed its owner to "over-
look" his subjects and strike them with awe. This is why
it was also called a *guan*, a term meaning "to see" or "to
be seen."[119]

Shang Yang's Ji que palace was the first in a series of
palatial buildings at Xianyang (Map 2.3). It is said that King
Huiwen "obtained huge amounts of timber from Qi and

Yong to create new palaces in a broad area south of the
Wei River and beyond the Jing River in the north. The
number of individual palaces finally reached 300."[120]
These buildings were scattered over a broad region along
the Wei River, and no city walls were erected to limit
the capital's development. These two features implied
that from the very beginning, Xianyang was planned and
constructed as an oversized "palace district" that could
expand freely to include surrounding areas. Its expansion
reached its zenith under Ying Zheng, the future First Em-
peror. Many palaces, pavilions, and platforms were added.
Finally, in one ancient author's words, "North to Jiuzong
and Ganquan, south to Changyang and Wuzuo, east to
the Yellow River, and west to the intersection of the Yan
and Wei Rivers, palaces and imperial villas stood side by
side in this region of 800 *li*. There, trees were covered
with embroidered silk and earth was painted with the
imperial colors red and purple. Even a palace attendant
who spent his whole life there could not comprehend
the multitude of scenes."[121]

Still, the most crucial development of Xianyang during
the First Emperor's reign was not its physical expansion.
Rather, under this emperor the palace city Xianyang was
finally transformed into the imperial city Xianyang: no
longer the capital of a regional kingdom, it became the
capital of a unified empire. The definite signs of this de-
velopment included three groups of monuments. In the
Records of the Historian, Sima Qian recorded the founding
of the first group, the Palaces of the Six Former Kingdoms
(Liuguo gongdian):[122]

The empire extended in the east to the ocean and Chaoxian
[present-day Korea], in the west to Lintao and Qiangzhong,
in the south to Beixianghu, in the north to the fortresses by
the Yellow River and along Mount Yinshan to Liaodong.
One hundred and twenty thousand wealthy families were
brought from all over the empire to Xianyang. . . . *Each
time the Qin had conquered a state, a replica of its palace was
built on the northern bank of the Wei River overlooking the river;
while eastward from Yongmen to the Jing and Wei rivers,
in a series of courts, walled-in avenues and pavilions, were
kept the beautiful women and musical instruments cap-
tured from different states.*

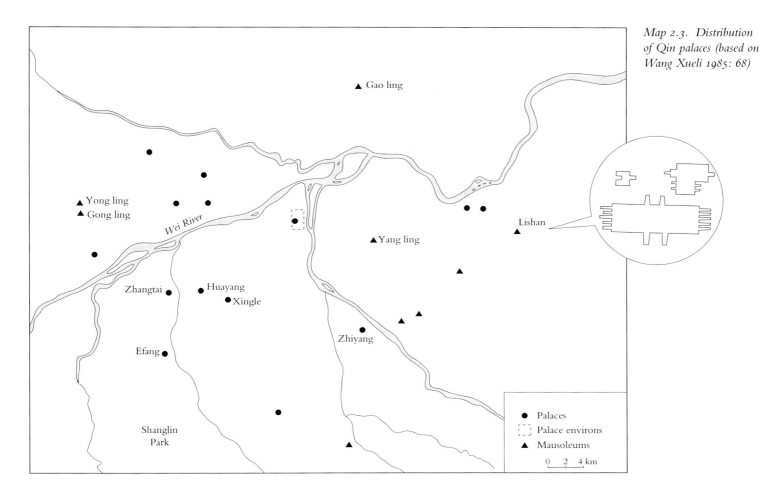

Map 2.3. Distribution of Qin palaces (based on Wang Xueli 1985: 68)

Labels on map:
Gao ling
Yong ling
Gong ling
Wei River
Lishan
Yang ling
Zhangtai
Huayang
Xingle
Zhiyang
Efang
Shanglin Park

Legend:
● Palaces
⬚ Palace environs
▲ Mausoleums

0 2 4 km

Thus, not only were rich families and beautiful women brought from the conquered states, but copies of the palaces of these states were erected in the Qin capital. The most significant aspect of this architectural project was its *timing* and *duration*: whenever a rival state was defeated and its capital razed, its palace was "transplanted" or "relocated" to Xianyang; when the last state disappeared from China's map, the construction of the Palaces of the Six Former Kingdoms was automatically finished. Here we find a fascinating example of monuments that symbolize both the constructive and destructive aspects of a military conquest. First, the monumentality of the duplicated palaces differed radically from that of their models: instead of demonstrating the political power and authority of their original

owners, the duplicated palaces became evidence of their fall. Second, the construction of the duplicated palaces echoed the destruction of their models and therefore documented the Qin campaign to unify China. Third, according to Chinese archaeologists, the foundations of these palaces have been found on either side of Xianyang gong, the First Emperor's audience hall. The layout of the whole monumental complex of the emperor's palace thus mirrored the newly established empire, which brought previously fragmented parts of China into a unity dominated by Qin's power.

The *Records of the Historian* also document a second group of Qin monuments:[123]

The emperor divided his empire into 36 provinces, each with a governor, an army commander, and an inspector. Commoners [*min*] were renamed "blackheads" [*qianshou*]. There were great celebrations. *All the weapons in the country were collected and brought to Xianyang. They were melted down to make bronze bells and the "Twelve Golden Men"* [shier jinren]. *These bronze figures, each of which weighed 240,000 catties, were placed in the palace.* All weights and measures were standardized; all carriages had axles of the same width. The script was also standardized.

If the construction of the Palaces of the Six Former Kingdoms coincided with the Qin's military conquests, the Twelve Golden Men fashioned immediately after the completion of these palaces commemorated a single historical moment: Qin's final victory. Sima Qian listed the construction of the Twelve Golden Men among other unification measures that the First Emperor announced the day he assumed the imperial title. The implication of these statues is unmistakable: the country had been pacified and no further wars were necessary. The Six Kingdoms had been destroyed and assimilated into the new empire. Their weapons had to be "melted down" to make new monuments. Standing along the Imperial Way leading to the First Emperor's throne, the Twelve Golden Men formed *six* pairs of figures that, one may imagine, represented the *six* defeated kingdoms. These works remind us of the Nine Tripods, which were also made of bronze from different regions and which symbolized the Xia's assimilation of these regions into a political unity.[124] But in the Qin case, the bronze figures were not symbols of the new regime but stood for the conquered states and the bygone feudal society. There exists no better example of the decline of the Bronze Age and the change in the Chinese conception of monumentality.

Ten years later, the First Emperor began the construction of the legendary Efang Palace. Sima Qian again recorded the event:[125]

The emperor considered that Xianyang was overcrowded and the palaces of the former kings were too small. [He said:] "I have heard that King Wen of Zhou had his capital at Feng, King Wu at Hao. The region between Feng and Hao is fit to be the capital of a great lord." He thus had

palaces constructed in the Shanglin Garden south of the Wei River. The front palace, Efang, built first, was 500 paces from east to west and 500 feet from north to south. Ten thousand people could be seated on its terraces; below was room for banners 50 feet tall. One causeway around the palace led to the southern mountains, at the top of which a *que* was erected as Efang's gate; another causeway led across the Wei River to Xianyang, just as the Heavenly Corridor in the sky leads from the Apex of Heaven across the Milky Way to the Royal Chamber.

Unlike the Palaces of the Six Former Kingdoms and the Twelve Golden Men, which denoted the First Emperor's subjugation of rival states, the Efang Palace resulted from his dissatisfaction with "the palaces of the former kings" of the Qin itself. These three groups of monuments thus reflect two main targets of his struggle against the past— the former regional powers and the Qin ancestral tradition. We may also call the Palaces of the Six Former Kingdoms and the Twelve Golden Men "negative monuments" and the Efang Palace a "positive monument": the former were related directly to the emperor's destruction of his rivals; the latter symbolized his own supremacy. The Efang Palace thus had to be a structure taller and bigger than any building attempted before in Chinese history and to correspond to the Apex of Heaven surrounded by stars and constellations. As I discuss in the following section, the same ambition also led to the construction of the emperor's enormous Lishan mausoleum. This mausoleum, however, resulted from a separate line of development in ancient Chinese monuments and concluded a historical movement in which the center of ancestor worship gradually shifted from temple to tomb.

From Temple to Tomb

The ancient Chinese worshiped many deities, but their religion was "primarily a cult of the ancestors concerned with the relationships between dead and living kin."[126] The ancient Chinese made artworks for many uses, but the major art forms were always closely associated with ancestor worship. All surviving pictorial bricks, stone carvings, and pottery figurines in Han art derive from tombs

and funerary shrines, the centers of ancestor worship at the time. All ritual bronzes of the Three Dynasties were likewise paraphernalia associated with ancestor worship; however, they were probably first made for the ancestral temple. I say "probably" because we know nothing about the Xia and very little about Shang ritual practices, but abundant Western Zhou bronze inscriptions and related texts seem to lead to this assumption.[127]

In fact, even during the Shang and Western Zhou, tomb and temple coexisted as twin centers of ancestor worship, but their function and architectural principle were entirely different. An ancestral temple, as discussed in the preceding section, was always a lineage temple, not a family temple or a temple of an individual.[128] A tomb, on the other hand, housed only a single deceased person, as demonstrated by Fu Hao's burial. A lineage temple always formed the nucleus of a walled town; tombs, however, were most frequently built outside the town in an open field. The prominent subject worshipped in a temple was the remote ancestor of the lineage (*yuanzu*), but a tomb was dedicated to a newly deceased (*jinqin*). A temple was a "living monument" of a lineage—its religious content (the ancestors being worshipped) and physical components (ritual vessels) were subject to constant renewal; a tomb was a static symbol of an individual. No living descendents of a lineage ever "created" a temple, which was always constructed by the founder of the lineage, but a tomb was built by oneself or one's heirs. Especially important to my investigation of the architectural symbolism of monuments is that a temple was a walled compound in which shrines of individual ancestors were arranged in a two-dimensional genealogical pattern, whereas a tomb, the alternative center of ancestor worship, assumed a very different form.

At Fu Hao's burial site, for example, a small shrine about 5 meters on each side covered the vertical grave pit (Figs. 2.26a, b). Neither walls nor other architectural remains have been observed around this structure; the building seems to have stood in isolation in an open field.[129] The structure of a tomb thus differs essentially from that of a temple: a tomb is "vertical" and a temple is "horizontal"; in a tomb the soul of the deceased traveled along a vertical

a

path to receive offerings, and in a temple the living proceeded along a horizontal axis to worship their ancestors. The only visible part of a tomb—the small shrine—was a landmark, a monument to the deceased individual. Archaeological excavations have revealed that sacrifices, mostly human sacrifices, were made year after year around Shang royal mausoleums (Fig. 2.27).[130] Unlike the temple, the tomb district was the realm of death, not a source from which people derived their knowledge of history and life.

The distinction between temple and tomb is also attested by records in ritual canons. It is recorded that temple sacrifices are "auspicious" in nature (*jili*), since these are dedicated to deities of the country and kingdoms; funerary sacrifices, on the other hand, are "inauspicious rituals" (*xiongli*), which are always associated with death and sorrow.[131] This classification of ancestral sacrifices as well as types of offerings seems to have been related to a unique understanding of the soul. A very significant passage in the *Book of Rites* records a conversation between Confucius and his student Zai Wo. In answering Zai Wo's questions about the nature of *shen* (spirit, divinity) and *gui* (ghost), the master explains that *gui* means the *po* soul that remains underground after one's death, whereas *shen* flies on high and becomes a divine being.

b

Fig. 2.26. Fu Hao tomb. Excavated in 1976 at Xiaotun, Anyang, Henan province. Late Shang. Ca. 13th–12th centuries B.C. (a) Reconstruction of the structure above the tomb. (b) Floor and section.

Fig. 2.27. Plan of the
royal cemetery of the late
Shang dynasty at
Xibeigang, Anyang,
Henan province.
13th–11th centuries B.C.

Once this opposition is established, two kinds of rituals are framed in accordance and [different] sacrifices are regulated. The fat of the innards is burned to bring out its fragrance, which is again mixed with the blaze of dried wood—these serve as a tribute to the spirit [in Heaven], and teach people to go back to their Origin. Millet and rice are presented; the delicacies of the liver, lungs, head, and heart, along with two bowls of liquor and odoriferous wine, are offered—these serve as a tribute to the po [in the earth] and teach the people to love one another and cultivate good feeling between high and low.[132]

The humble scale of Fu Hao's shrine cannot be compared with that of the large temple-palace compound inside the capital. Moreover, although descriptions of and regulations for temple rituals fill Shang and Zhou texts, virtually no written record of sacrifices held routinely in graveyards can be found.[133] This lacuna has sparked an extensive debate over whether grave sacrifices were officially practiced and codified during the Three Dynasties.[134] My discussion suggests that the temple system was the religious form that matched the lineage-oriented Shang-Zhou society; the tomb sacrifice for individuals could only be secondary.

This situation, however, changed dramatically during the Eastern Zhou as people began to pay increasing attention to tombs. The Book of Rites records that "the ancients made graves only and raised no mounds over them."[135] But now tumuli covered with elaborate terrace pavilions appeared in graveyards. It was said that in his travels Confucius saw some large tomb mounds that were "covered by Summer Palaces."[136] A number of such elaborate funerary structures have been found. A mausoleum of the Zhongshan kingdom is representative. This royal cemetery belonging to King Xi of the fourth century B.C. was never completed; the kingdom perished before its completion. But a plan of the mausoleum inlaid on a bronze plate, about a meter long and a half meter wide, was found in the king's tomb (Figs. 2.28a, b). The earliest known architectural drawing from ancient China, it details the placement, dimensions, and measurements of the burial mound and its components. An edict inscribed on the plate warns that anyone not following the design in building the mausoleum will be executed without mercy. The severe tone of this edict, along with the appearance of the architectural plan, signifies important changes in people's psychology: now their central interest was their own tomb, not a temple dedicated to their deceased ancestors. The stern edict issued by the king vividly reflects both his desire to build a great mausoleum for himself and his anxiety that his descendents would not share this desire but would devote their time and energy to their own mausoleums.

Based on the design and archaeological excavations, Chinese scholars have reconstructed the Zhongshan mausoleum on paper (Fig. 2.29).[137] The cemetery was originally planned to contain five tombs; the king's tomb is in the center, flanked by two queens' tombs and then by two concubines' tombs. Each grave is covered by an individual ceremonial hall of the terrace pavilion type. The king's hall, about 200 meters square at the base, is built on a three-storied terrace; galleries surround the earthen core at the lowest level, and a free-standing square hall of considerable size stands on top of the pyramid. The five halls are major components of the central area of the mausoleum, the neigong, or Inner Palace, which is enclosed by double walls. The outer wall is over 410 meters long and 176 meters wide; the inner wall is 340 meters by 105 meters. Between the two walls and behind the five tombs are four square halls with names identifying them as ceremonial

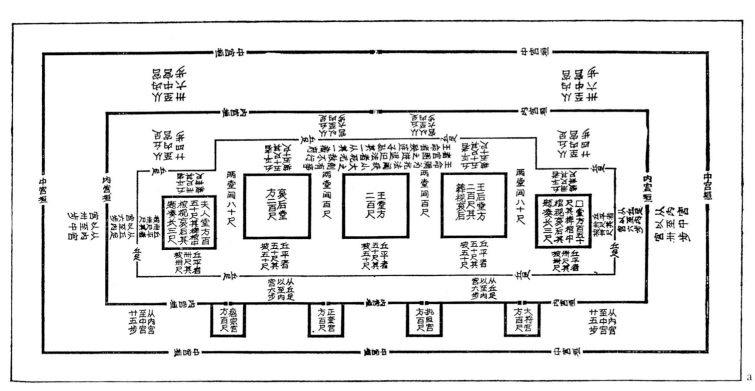

Fig. 2.28. (a) Drawing of the "Design of the Mausoleum District," with the inscriptions transcribed in modern Chinese. (b) "Design of the Mausoleum District" ("Zhaoyu tu"). Bronze with gold inlay. Warring States period. 4th century B.C. L. 94 cm. H. 48 cm. Excavated in 1977 at Pingshan, Hebei province. Hebei Provincial Institute of Cultural Relics.

a

b

offices. This reconstruction shows three basic features of a large mausoleum of the Warring States period: first, each king had an independent "funerary park" containing the tombs of himself and his spouses. Second, a funerary park imitated a palace, with double walls (or ditches) defining the king's private domain and his court. Third, each grave in a funerary park was marked by an elaborate ceremonial structure built either above or beside a huge tumulus.

Like contemporary palaces, this new type of ritual structure in ancestor worship was related to the social and religious transformation taking place during the Eastern Zhou. As mentioned in the earlier discussion, during this period the Zhou royal house gradually declined, and the society was no longer united in a hierarchical genealogical structure. Political struggles were waged by families and individuals who gained power from their control of economic resources and military forces, not from noble ancestry. The old religious institutions and symbols could no longer

convey political messages and were consequently replaced or complemented by new ones. The lineage-temple system declined, and tombs belonging to families and individuals became symbols of the new social elite.

Eastern Zhou texts tell us that during this period an estate system was established to regulate funerary design. The *Rites of Zhou* records that the height of a tomb mound symbolized the rank of the deceased.[138] This system was not an idealized scheme; it was actually practiced in the state of Qin and regulated in the laws of Shang Yang. According to this law, the "rank" of a deceased was determined not by his inherited status but by his achievements in public service.[139] This illustrates the essential difference between a temple and a tomb at that time: a temple represented a person's clan heritage; the tomb demonstrated his personal accomplishments. As individual ambition increased, the size of funerary structures skyrocketed. The following passage from *Master Lü's Spring and Autumn*

Annals (*Lüshi chunqiu*), a miscellany compiled near the end of the Eastern Zhou period, vividly describes the consequence of this development.

> Nowadays when people make burials, they erect tumuli tall and huge as mountains and plant trees dense and luxuriant as a forest. They arrange tower-gates and courtyards and build halls and chambers with flights of steps for visitors. Their cemeteries are like towns and cities! This may be a way of making a display of their wealth to the world, but how could they serve the deceased [with such extravagance]![140]

The culmination of the inflation of tomb building was the great Lishan mausoleum of the First Emperor (Fig. 2.30).[141] The Qin had ancestral temples in both the old capital of Yong and the new capital of Xianyang, but these temples attracted little of the emperor's attention. Instead, he began building his necropolis the day he mounted the throne. The center of the mausoleum was a huge pyra-

Fig. 2.29. A reconstruction of a Zhongshan royal mausoleum based on the "Design of the Mausoleum District."

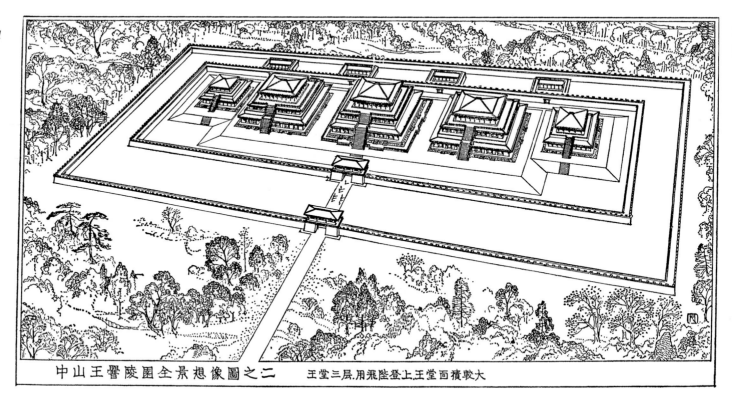

中山王䂮陵園全景想像圖之二　　王堂三層.用飛陛登上王堂面積較大

Temple, Palace, and Tomb

mid. (Only after a long and complex development did the ancient Chinese finally begin to share this monumental architectural design with the ancient Egyptians, who had begun building pyramids thousands of years earlier.) In contrast to the flat, two-dimensional temple compound, an enormous pyramid appears in a vast landscape against an empty sky. No extrinsic space is pursued; the only force with which the structure interacts is nature. The reason for the late appearance of this monumental form in China is that only during this stage in Chinese history did such a form become meaningful. As his royal title "Shi Huang Di" signifies, the First Emperor viewed himself as the *shi*, or Origin (*huang di* means a sovereign-emperor). He cast a position for himself in the social and religious hierarchy unequaled by any other being, even his ancestors. This notion, which broke radically with the archaic concept of religious and political authority, is manifested in the monumental design of his tomb.

The pyramid in the Lishan mausoleum was built as a personal monument of the First Emperor, and the underground tomb chamber was transformed into a physical representation of the universe for him. As Sima Qian recorded in the *Records of the Historian*:

> When the First Emperor first ascended the throne, he ordered workers to excavate and construct Lishan. Having just unified the world, he sent over 700,000 convicts to work there. They dug through three springs, stopped their flow, and assembled the chamber there. They carried in [models of?] palaces, pavilions, and the hundred officials, and strange objects and valuables to fill up the tomb. . . . With mercury they made the myriad rivers and the ocean with a mechanism that made them flow about. Above were all the Heavens and below all the Earth.[142]

To students of Chinese art history, the importance of this passage goes far beyond the factual record. It reveals an artistic goal that would have been entirely alien to the Three Dynasties. Shang and Zhou ritual art did not portray worldly phenomena, but aimed to visualize an intermediate stage between the human world and the world beyond it; it thus linked these two separate realms.[143] In the Lishan tomb, however, art imitated things: there was

Fig. 2.30. Lishan mausoleum of the First Emperor of the Qin. Late 3d century B.C. Lintong, Shaanxi province.

an artificial ocean and flowing rivers, and all images were arranged to create an artificial microcosm of the universe.

Historically speaking, the plan of the Lishan mausoleum combined two major types of mortuary structure current during the Warring States period: one was used in Qin, and the other was popular in certain eastern kingdoms. Two groups of royal burials of pre-dynastic Qin have been found in Fengxiang and Lintong in present-day Shaanxi.[144] According to Chinese archaeologists, the 32 large tombs at Fengxiang may date to the Spring and Autumn and early Warring States period; the three Qin kings buried in Lintong were Zhaoxiang, Xiaowen, and Zhuangxiang, the direct predecessors of the First Emperor.[145] The Lintong tombs share two basic features absent in the mausoleums of the eastern states. First, instead of erecting terrace pavilions over grave pits, wooden-framed architectural complexes were built beside earthen tomb mounds. Second, the Lintong mausoleums, as well as those in Fengxiang, were encircled by two or three rows of ditches, sometimes 7 meters in depth, whereas the royal tombs of the Zhongshan and Wei were surrounded by walls. The Lishan mausoleum appeared to integrate these two designs: it continued the Qin tradition of having a tumulus and a ceremonial structure built separately and adopted the eastern device of replacing ditches with double walls (Fig. 2.31). This combination allowed the First Emperor to develop a well-defined hierarchical structure that distinguished the Lishan mausoleum from its Eastern Zhou

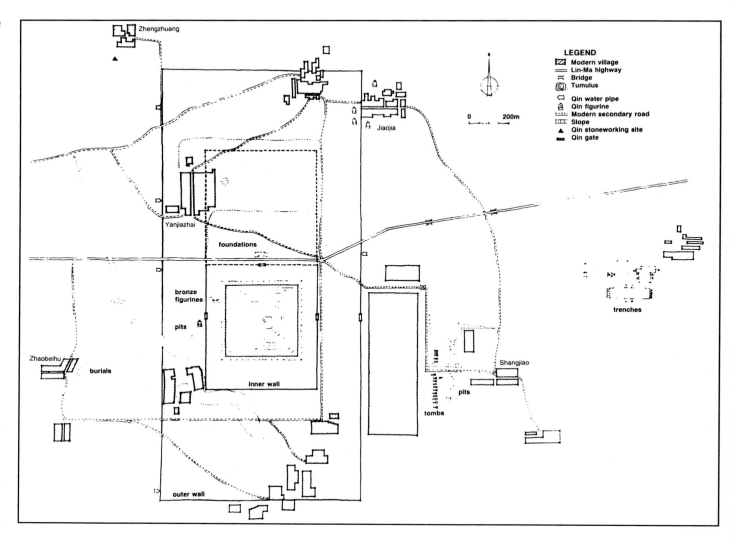

Fig. 2.31. Plan of Lishan mausoleum of the First Emperor of the Qin. Drawing.

LEGEND
- Modern village
- Lin-Ma highway
- Bridge
- Tumulus
- Qin water pipe
- Qin figurine
- Modern secondary road
- Slope
- Qin stoneworking site
- Qin gate

predecessors. Its three sections—the district encircled by the inner wall, the area between the inner and outer walls, and the open space surrounding the funerary park—assumed different functions and symbolism. The heart of the mausoleum was the burial and sacrificial area; the area between the inner and outer walls was occupied by ceremonial officials and their departments.[146] A important feature of the Lishan mausoleum was an architectural complex of considerable size, built beside the tumulus in the exact center of the walled funerary park.[147] The Eastern Han scholar Cai Yong identified the model for this building.

An ancient ancestral temple consisted of a ceremonial hall [*miao*] in front and a retiring hall [*qin*] in the rear, just as a ruler had an audience hall in front and a retiring chamber in the rear. The ancestral tablet was set in the ceremonial hall and was worshipped during the seasonal sacrifices. The retiring hall contained royal gowns, caps, armrests, and staffs, like the paraphernalia of the living king, which were used when presenting offerings. The Qin first removed the retiring hall [from the temple] to occupy a position flanking the tomb.[148]

Based on this passage, scholars have argued that the

Temple, Palace, and Tomb

First Emperor was the first to establish a *qin* hall in a mausoleum. The excavations of the pre-dynastic Qin mausoleums at Lintong, however, have demonstrated that this tradition extended back several generations. Architectural foundations found beside the tomb mounds in the Lintong mausoleums have led excavators to suggest structural similarities between these buildings and the one in the Lishan mausoleum.[149] A record in the *History of the Former Han* confirms this: "In ancient times no sacrifices were held in graveyards; the Qin initiated [the custom of] building the *qin* inside the mausoleum. . . . Beginning with Qin, the *qin* was removed [from the temple] and was constructed beside the tomb."[150] Since the name "Qin" in this passage can be understood as the pre-dynastic Qin kingdom, we may contend that the ritual buildings excavated in both the Lintong mausoleums and the Lishan mausoleum were the *qin* halls that were originally part of the traditional ancestral temple.

Unlike the mausoleums of Eastern Zhou kings, the territory of the Lishan necropolis extended to a large area outside the graveyard.[151] To the east, the underground terra-cotta army duplicated the Qin military forces under the First Emperor's command (Fig. 2.32). In the area between the terra-cotta army and the park, nineteen tombs of high officials and members of the royal family, as well as an enormous underground stable, have been found. West of the funerary park lie the burials of about seventy convicts, some perhaps buried alive. Thus, while the funerary park itself was constructed as the emperor's "forbidden city," the surrounding area mirrored his empire, with its courtiers, soldiers, servants, and perhaps slaves.

Since the First Emperor had assumed the position of Origin of a great tradition, associating himself with an existing lineage temple became impossible.[152] He thus had a temple dedicated to himself even before his death. This temple, called the Ji miao or the Temple of the Absolute, was built somewhere south of the Wei River; a road was constructed to connect it with the Lishan mausoleum.[153] An important passage from the *Records of the Historian* describes a court meeting held after the emperor's death, during which all ministers agreed upon a new policy concerning ancestor worship:

In the past, the ancestral temple complex of the Son of Heaven consisted of seven individual temples [for individual ancestors]; that of a lord, five individual temples, and that of a grand official, three individual temples. Such ancestral temple complexes persisted generation after generation. Now the First Emperor has built the Temple of the Absolute, and people within the four seas have sent tribute and offerings. The ritual has been completed and cannot be further elaborated. . . . The Son of Heaven should hold ancestral ceremonies exclusively in this temple of the First Emperor.[154]

The Qin burial system exemplified by the Lishan mausoleum established a basic framework for Han funerary monuments. All pre-Qin burials were vertical earthen pits containing wooden encasements, coffins, and tomb furnishings (Figs. 2.33a, b). This structure was explained by a certain Guozi Gao of the Eastern Zhou: "Burying means hiding away; and this hiding is from a wish that people should not see it. Hence there are clothes sufficient for an elegant covering; the coffin all-around the clothes; the encasement all-around the coffin; and the earth all-around

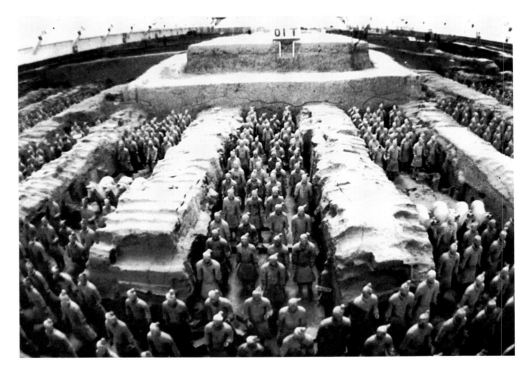

Fig. 2.32. Terra-cotta "underground army." Pit no. 1 of Lishan mausoleum. Late 3d century B.C. L. 210 m. W. 62 m. Found in 1974 at Lintong, Shaanxi province.

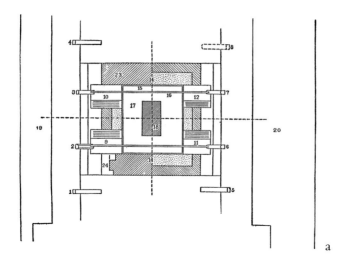

Fig. 2.33. *Vertical pit grave, represented by Guweicun Tomb no. 3. Warring States period. 4th century B.C. Excavated in 1950–51 at Huixian, Henan province. (a) Floor plan. (b) Section.*

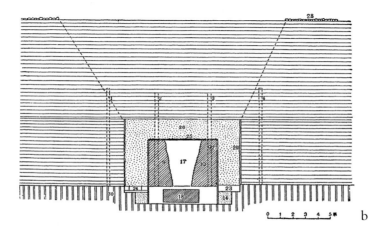

a

b

Fig. 2.34. right *Horizontal pit grave, represented by Luoyang Tomb no. 61. Late Western Han. 1st century B.C. Excavated in 1957 at Shaogou, Luoyang, Henan province.*

tomb in Han ancestor worship: "He [Xiang Wuhuan] and his younger brother worked in the open air in their parents' graveyard, even in the early morning or the heat of summer. They transported soil on their backs to build the tumulus and planted pine and juniper trees in rows. *They erected a stone shrine, hoping that the* hun *souls of their parents would have a place to abide.*" [157]

Likewise, when Kong Dan built a funerary shrine for himself during the second century, he also wrote down his intention: "I realized that even gold and stone would erode and that everything in the world had its beginning and end. I then began to consider the great span of time after this life, and settled on an auspicious shrine that would represent the heavenly kingdom. As I looked at the structure the craftsmen were fashioning, *I rejoiced that I would abide there after this life.*" [158]

The idea implied in these two passages was explained by the Ming writer Qiu Qiong: "When a son's parents die, their bodies and *po* souls return to the ground below,

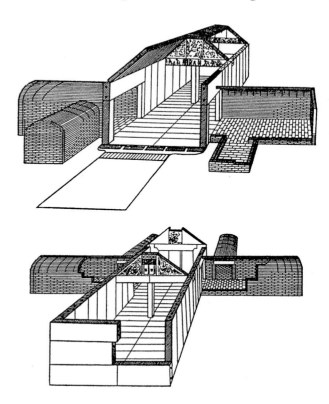

the encasement." [155] From the mid–Western Han, however, an underground tomb, built of hollow bricks or carved inside a rocky hill, appeared to imitate the deceased's household, with a main hall, a bedroom, and side-chambers (Fig. 2.34). [156] Wooden-framed or stone offering shrines were further erected in front of tomb mounds (Fig. 2.35). Later I discuss pictures on the ceiling, gables, and walls of a shrine that transformed the plain stone structure into a concrete universe, with different sections depicting Heaven, an immortal paradise, and the human world. An inscription on an Eastern Han shrine, dedicated by two brothers to their dead parents, sheds light on the significance of the dualism of the aboveground shrine and the underground

Temple, Palace, and Tomb

and thus the son builds tombs to conceal them. Their *hun* souls soar into the sky, and thus the son erects a shrine to house them." [159] In a departure from the ancient idea that the temple was the legitimate place for the *hun* soul's visit, it was now believed that the *hun* soul actually dwelled in the funerary shrine. To invoke ancestral deities through a display of ritual paraphernalia and offerings in the temple became less important; the primary ritual practice was to provide the *hun* with housing in a graveyard.

Moreover, the establishment of the Han dynasty greatly reinforced the political and ritual significance of funerary structures. The founder of the Han and his generals arose from commoners who had never had the privilege of holding temple sacrifices. [160] When the Western Han emperors began to construct mausoleums, they had few scruples about deviating from archaic ritual codes. Various components of the palace, including ceremonial halls, rulers' retiring rooms, concubines' quarters, administrative offices, and huge *que* gates, were faithfully copied in funerary parks. [161] Three-dimensional statues, which had still been buried underground in the Lishan mausoleum, were erected aboveground to flank the Spirit Path (*shendao*). Satellite burials of members of the royal family and statesmen surrounded an emperor's tomb, as if the ministers and generals were still paying respect to their sovereign. [162]

Following the Qin system, from Emperor Hui's reign on, an ancestral temple, called a *miao*, was dedicated to each deceased emperor and built near his mausoleum. [163] Chinese archaeologists have located the temples of Emperors Jing and Yuan about 400 meters to the south and 300 meters north of their respective tombs. [164] Therefore, the traditional temple dedicated to a single lineage disappeared and dissolved into a number of temples belonging to individual emperors. A special road connected a temple with an emperor's *qin* hall inside the funerary park. Every month, a ceremony was held in the ancestral temple of each deceased ruler, and a ritual procession conveyed the royal crown and costume to lead the soul of the deceased emperor from his tomb to his temple to receive offerings. These roads were therefore named "costume and crown road" (*yiguandao*). [165] Interestingly, the *miao* and *qin* halls were originally two integral sections of

Fig. 2.35. Plan and elevation of Zhu Wei's tomb and offering shrine. Late Eastern Han. 2d century A.D. Jinxiang, Shandong province. Drawing.

an ancestral temple. The Qin extracted the *qin* hall from the temple and reset it in royal mausoleums. The rulers of the Western Han went even further: they attached the *miao* to their mausoleums. Although *qin* were built inside funerary parks and *miao* outside, they were once again united—by the crown and costume road.

A Western Han imperial temple, therefore, differed fundamentally from a Three Dynasties royal temple. As the property of an individual ruler, the Western Han temple no longer signified the genealogical and political tradition of the royal house. The traditional ancestral temple had perished during the Qin and Western Han, and the temple had become firmly wedded to the tomb. Until the Eastern Han, however, the temple was still built outside the funerary park and was still the legitimate place to hold major ancestral sacrifices. [166] The next step was the total independence of the tomb as the center of ancestor worship and the promotion of funerary structures as the most important monuments in society. This change, which took place during the mid–first century A.D., greatly stimulated the development of funerary art and gave it new significance. The change may have been caused by a number

of factors, including the firm establishment of the family system in society and the heightening of the Confucian virtue of filial piety, but a direct cause is found in an almost accidental event.

This event took place at the beginning of the Eastern Han. In A.D. 58, Emperor Ming abolished the temple sacrifice and transferred it to the royal mausoleum.[167] Following this incident, the temple's role was reduced to a minimum, and graveyards became the sole center of ancestor worship. This event has been interpreted in terms of the emperor's devout filial piety;[168] an examination of the historical evidence, however, reveals that the motivation behind this ritual reform was political and aimed at resolving a difficulty in the legitimacy of the Eastern Han regime.

Emperor Ming's father, the Guangwu emperor, was one of many rebel leaders. During his long military struggles against his enemies, he had derived great advantage from two sources; one was his surname, Liu, as evidence of his blood relationship to the Former Han royal house, and the other was his declaration that he would restore orthodox Confucian ideology on the model of Western Zhou ritual. These concerns had led him to establish a lineage temple for the Former Han royal house in A.D. 26, in which tablets of the eleven Western Han emperors were worshipped.[169] But as Guangwu himself understood, perhaps more clearly than anyone else, he was not the legitimate successor of the Western Han royal line. He was from a distant branch of the Liu clan, and in the clan genealogy he was actually two generations senior to the last Western Han emperor. Inevitably, Guangwu faced a dilemma: on the one hand, he had to maintain the newly established Liu royal temple; on the other hand, this temple irked him like "a fishbone in his throat" because it disclosed the irregularity in the royal succession. To resolve this dilemma, he first tried to build a new Eastern Han royal temple, but soon failed because of the resistance of some Confucian ministers.[170] He then made a great effort to transfer temple sacrifices to mausoleums. According to the *History of the Former Han*, no Western Han emperor ever attended a mausoleum sacrifice, for all important ancestral rituals were held in temples. The biography of the

Guangwu emperor in the *History of the Latter Han* records that the founder of the Eastern Han held ancestral sacrifices 57 times, but only 6 of these were in the temple; the other 51 were held in graveyards.[171] Therefore, even though Guangwu failed to establish a new temple system, he did succeed in shifting the locus of ancestor worship to tombs and thus prepared a way to resolve the problem his successor would eventually face.

This test appeared immediately after Guangwu's death. The question was where the sacrifice to the founder of the Eastern Han should be held. As we have seen, his son Emperor Ming's solution was to transfer temple ceremonies to the mausoleum. It is said that on the night before an annual ancestral sacrifice, Emperor Ming dreamed of his deceased parents. The emperor was deeply sorrowful and could not fall asleep; the next morning, he led his ministers and courtiers to Guangwu's graveyard and held the sacrifice there. During the ceremony sweet dew fell from Heaven, which the emperor asked his ministers to collect and offer to his deceased father. He became so sad that he crawled forward to the "spirit bed" and began to weep as he examined his mother's dressing articles. "At the time, none of the ministers and attendants present could remain dry-eyed."[172]

We do not know if this story of filial piety is genuine. But the preceding discussion of early Eastern Han politics suggests that Emperor Ming's motives for initiating the "mausoleum sacrifice" (*shanglingli*) were not purely emotional or ethical. Going even further, this emperor ordered in his will that no temple except his funerary shrine be built for him.[173] All later Eastern Han rulers followed this arrangement. Thus, during the next 160 years, the royal temple became nominal. Instead, the graveyard became the focus of ancestor worship. The royal example was in turn imitated by people throughout the country. As the Qing scholar Zhao Yi pointed out: "Taking the imperial 'grave sacrifice' as their model, all officials and scholars erected funerary shrines. Commoners, who could not afford to establish shrines, also customarily held ancestral sacrifices in the family graveyard."[174]

The graveyard was no longer the silent world of the deceased; it became a center of social activities. There

yearly, monthly, and daily sacrifices were offered, and large social gatherings were conducted. The royal mausoleums became the political and religious headquarters of the court, and family graveyards provided the common people with a proper place for banquets, musical performances, and art displays.[175] Pictorial images were not only painted and carved in underground tomb chambers for the deceased, but also in open funerary shrines for the public.[176] Increasing numbers of motifs for educational, memorial, and entertainment purposes entered this art. It is for these reasons that the Eastern Han period appears to have been the golden age of funerary art in Chinese history.

This golden age ended as abruptly as it had begun. In A.D. 222, two years after the fall of the Eastern Han, Emperor Wen of the new dynasty, the Wei, announced that funerary ritual was unorthodox and abolished it. Trying to resume the ancient temple system of the Three Dynasties, he issued an edict to destroy all aboveground funerary structures, including that of his father, the famous warlord Cao Cao.[177] Shrine destruction was apparently not limited to royal mausoleums: Chinese archaeologists have found a number of Wei-Jin tombs in which elaborately engraved stone slabs from destroyed Eastern Han shrines were reused as building materials. In my opinion, these stones, sometimes randomly paved on the floor and sometimes covered with mortar, attest to a nationwide iconoclastic movement and a sweeping shift in the form of ancestor worship.[178] But the advocates of this ritual reform never achieved full success. Rather, from that time until the fall of imperial China, temple and tomb resumed their positions as the twin centers of the ancestor cult. Never again, however, did they attain the political significance they had held during the Three Dynasties and the Eastern Han.

The Chinese Discovery of Stone

In the debate concerning the *materials* of traditional Chinese architecture, some scholars have noticed and tried to explain the monopoly of wood, which they consider an essential feature of Chinese architecture throughout the ages. Gin Djih Su seeks the solution in economic determinism: "Although wooden-structured buildings easily catch fire, because people's livelihood largely depends on agriculture and the country remains economically underdeveloped, this building type is still the most common even after more than twenty centuries of development."[179] Liu Zhiping, on the other hand, attributes the popularity of timber buildings to China's natural resources: "The earliest Chinese civilization originated in the Central Plain and other loess regions, where trees were abundant but stone was rare. This is why very few stone structures have been built in China."[180] Other scholars, represented by Joseph Needham, argue that the Chinese created not only wooden buildings but also large stone structures comparable to their European and Western Asian counterparts. But these stone structures seem to have had distinct religious functions and are mostly "funerary structures, memorial pillars, and monuments."[181]

Although representing a more balanced view, this second observation and explanation is still inadequate for several reasons. First, as we have seen, wood as well as stone was used for funerary structures and other types of monuments in ancient China. Second, timber and stone buildings do not always coexist; the latter appeared far later in Chinese history. Third, rather than purely "natural" materials, wood and stone were given symbolic value and were associated with divergent concepts. Fourth, stone monuments never replaced wooden monuments. As a result, the meaning or monumentality of these two types of structure became interreferential; their coexistence represents a fundamental conceptual opposition or juxtaposition in Chinese culture. These four points imply a methodological proposition, which will direct my discussion in this section. Since the appearance of stone monuments was a specific historical phenomenon, we should try to reconstruct its process and its social, cultural, and religious context. Moreover, since such stone structures marked a distinct stage in the long history of Chinese monuments, we should observe their significance in a larger historical context. In retrospect, we can see that although the ancient Chinese had had a strong interest in the symbolism of art media since prehistorical times, all "special" materials,

especially jade and bronze, had been employed in making portable ritual objects (*liqi*).[182] The "discovery" of stone as a special architectural material thus indicated an essential change in psychology; this, in turn, signified the arrival of an age of monumental architecture after the dominance of ritual art for several millennia.

Erecting a *stone* funerary monument became a common practice during the Eastern Han. All evidence—textual records, extant buildings, and statues, and more than a thousand decorated stone blocks and slabs from abandoned mortuary structures—demonstrates the wide popularity of stone in funerary architecture at the time. A closer examination of the data further indicates that an important change must have taken place some time before the Eastern Han. Prior to the second century B.C., aboveground funerary structures, such as the buildings that once stood above the graves of Fu Hao and the Zhongshan kings, were uniformly timber-framed (Figs. 2.26b, 29). Likewise, no stone stelae or statues have been found in a pre-Han graveyard;[183] even the ambitious First Emperor seemed quite satisfied with his terra-cotta soldiers and bronze chariots. From the first century A.D. on, however, all sorts of funerary monuments—pillar-gates, memorial tablets, offering shrines, and statues in human and animal forms—were customarily made of stone. Inscriptions on these structures often contain a standard statement by the patrons: "We chose excellent stones from south of the southern mountains; we took those of perfect quality with flawless and unyellowed color. In front we established an altar; behind we erected a [stone] offering shrine."[184]

We wonder what caused this dramatic change. The ancient Chinese, who for many centuries had largely ignored stone as an architectural material,[185] suddenly seem to have "discovered" it and bestowed on it fresh meaning. Stone was opposed to wood, and this opposition was understood in symbolic terms. All the natural characteristics of stone—strength, plainness, and especially endurance—became analogous to eternity or immortality; wood, which was relatively fragile and vulnerable to the elements, was associated with temporal, mortal existence. From this dichotomy emerged two kinds of architecture: those of

wood used by the living, and those of stone dedicated to the dead, the gods, and immortals.[186] The double connotation of stone with death on the one hand and with immortality on the other implied a further link between death and immortality. Indeed, we find that this link, which was finally established during the second and first centuries B.C., prepared a new ground for imagining and constructing the afterlife, and was responsible for many changes in funerary art and architecture, including the use of stone.

In an excellent introduction to the Han conception of the afterlife, Michael Loewe makes a distinction between several objectives; the first "was a wish to prolong the life of the flesh on earth as long as possible."[187] Indeed, death always inspires fear, and the recognition that life has its limit leads first to the desire to postpone death and then to avoid it altogether. The incessant pursuit of longevity by pre-Han philosophers, necromancers, and princes aimed not at overcoming death but at infinitely prolonging life. This goal, which represented an early belief in immortality, may be characterized as achieving eternal happiness in this world and this life. It might be pursued by internal or external means: longevity might be realized either by transforming oneself into an immortal or by transporting oneself to an immortal land. As early as the Eastern Zhou, people began to think that through certain physical practices, such as purification, starvation, and the breathing exercise called *daoyin* (Fig. 2.36), the practitioner could gradually eliminate his material substance, leaving only the "essence of life." Simultaneously, there emerged the belief in the lands of deathlessness, the most prominent being the Penglai Islands in the Eastern Sea.[188] It was thought that by discovering and reaching such a place, one would cease to age, and death would never occur.

Happy endings for both pursuits were described in ancient literature. Zhuangzi vividly portrayed those ageless men unaffected by time and other natural rules: "There is a Divine Man living on faraway Ku-she Mountain, with skin like ice or snow, and gentle and shy like a young girl. He doesn't eat the five grains, but sucks the wind and drinks the dew, climbs up on clouds and mists, rides a flying dragon, and wanders beyond the four seas."[189] With

similar vividness, the lore of immortal lands was spread by necromancers, whose chief aim was to convince their audience of the existence of a magic land and to arouse the fantasy of such a place through colorful descriptions.[190]

Zhuangzi focused on *man*, and the necromancers on *place*, but in both their accounts, a *divine man* and a *divine place* appear in similar disguise. Both are still found in this world and assume human and natural forms; only their features—unusual shapes, colors, materials, and habits—make them seem unworldly. These extraordinary attributes are thus signs of immortality or longevity: these men and places are no longer governed by the laws of decay and death. Once we understand this train of thought, we can correct a confusion in modern scholarship on early Chinese religion and art, which often equates "immortality" and the "afterlife" without the necessary qualification. In fact, the pre-Han idea of *xian*, or immortal, rested firmly on the hope of escaping death. The notion of an afterlife, however, was based on another premise: as a predestined event, death marked the beginning of a continuous existence in the other world. Indeed, instead of approaching death as the total elimination of living consciousness, the ancient Chinese insisted that it was caused by, and thus testified to, the separation of the body and soul. Yü Yingshih has demonstrated that this concept appeared long before the desire for immortality: "The notion that the departed soul is as conscious as the living is already implied in Shang-Chou sacrifices."[191] Based on a new archaeological find, we can further date the idea of the autonomous soul to at least the fifth millennium B.C.: a hole was drilled in the wall of a Yangshao pottery coffin to allow the soul to move in and out (Fig. 2.37).

The belief in the posthumous soul naturally led to a simple conception of the afterlife: during pre-Han times, the afterlife in its most ideal form was no more than a mirror image of life.[192] The official hierarchy was projected into the underworld,[193] and the tomb of an aristocrat was arranged as his or her posthumous dwelling, containing luxury goods, food, and drink for a comfortable life. This happy home of the dead was also protected by tomb guardians, first by human sacrifices, then by certain mechanisms as well as sculptured and painted protective deities (Figs.

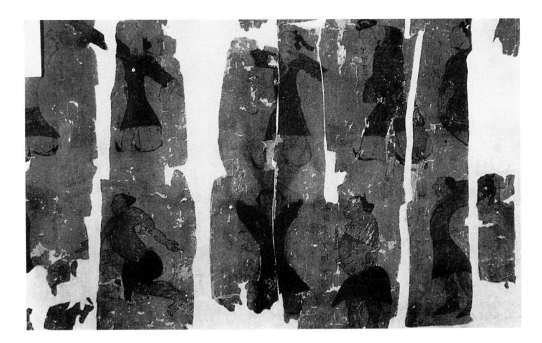

Fig. 2.36. top *A detail of the "Diagram of Daoyin Exercises" ("Daoyin tu"). Ink and color on silk. Early Western Han. 2d century B.C. W. 53 cm. L. 110 cm. Excavated in 1973 from* Tomb no. 3 at Mawangdui, Changsha, Hunan province. Hunan Provincial Museum, Changsha.

Fig. 2.37. Pottery coffin for a child. Yangshao culture. Ca. 3500 B.C. L. 65 cm. Excavated in 1978 at Yancun, Linru, Henan province. Henan Provincial Museum, Zhengzhou.

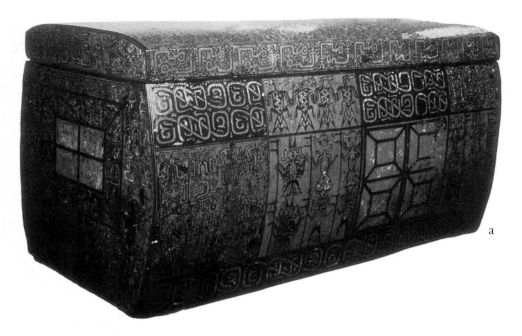

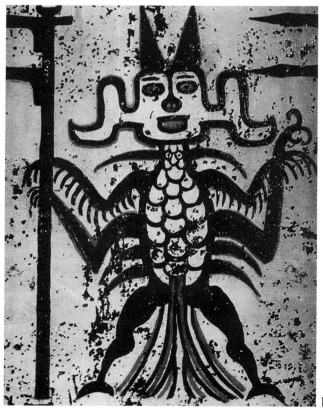

Fig. 2.38. (a) Inner coffin of Marquis Yi of the state of Zeng. Wood and lacquer. Early Warring States period. 5th century B.C. L. 250 cm. H. 132 cm. Excavated in 1978 at Leigudun, Suixian, Hubei province. Hubei Provincial Museum, Wuhan. (b) Protective deity painted on the coffin.

2.38a, b). The great Lishan mausoleum of the First Emperor, though constructed and considered as a monument of a new historical era, was still based on this traditional approach. As mentioned earlier, its underground chamber was modeled upon the whole universe. This universe, however, cannot be equated with a "paradise" (as some writers have proposed), since all its components—miniature rivers and oceans, and other simulations of heavenly and earthly phenomena—were symbols of nature, not of immortality.

The people of the Han inherited and developed both beliefs in a worldly paradise and in an otherworldly happy home. The search for Penglai and other magic lands continued, but now these places were imagined to be occupied by immortals who, having gained the secret of deathlessness, would unselfishly grant mortal beings eternal life.[194] More replicas of immortal mountains were made at this time than at any other time in Chinese history (Figs. 2.39a–c); it was thought that these and other imitations of divine forms would attract immortals with their elixir.[195] At the same time, funerary art also flourished to an unprecedented degree, and it became customary for a person to prepare his or her own tomb.[196] What we find here, therefore, is a heightening inner contradiction in the search for eternal happiness: a tomb would not be necessary if one truly believed that longevity could be achieved, yet the desire to prepare a tomb during one's lifetime must have been based on a certain skepticism toward the search for longevity. This dilemma led to a compromise: the people of the Han increasingly wished to believe that eternal happiness could be realized after death. This idea, which may be called "immortality in the afterlife and the other world," represented a turning point in the ancient Chinese immortality cult and is indicated by both literary and archaeological evidence.

Two instances in the Records of the Historian denote the emergence of this new religious trend. After the necromancer Li Shaojun died, Emperor Wu ordered that his tomb be uncovered. Li's corpse could not be found, and only empty clothes remained in the grave chamber. The emperor was thus convinced that the magician had escaped this world through some posthumous mystical transfor-

a

b

c

Fig. 2.39. Immortal mountains. (a, b) Incense burner. Gilded bronze. Western Han. 2d century B.C. H. 58 cm. Excavated in 1981 at Xingping, Shaanxi province. Mao ling Mausoleum Museum.

(c) Clay stand of a "money tree." Late Eastern Han. 2d century A.D. H. 60.5 cm. Excavated in 1978 near Chengdu, Sichuan province. Chengdu Museum.

mation.[197] The same emperor once traveled to the tomb of the Yellow Emperor at Mount Qiao. While offering a sacrifice to the ancient divine ruler, he posed a question to his religious advisers: "I have heard that the Yellow Emperor never died—how is it that he had a tomb?" The advisers told him that the Yellow Emperor had indeed become an immortal and that only his clothes were buried in his grave.[198] The idea implied in these anecdotes would later be developed into a Taoist concept called *shijie,* meaning "the dissolution of the corpse" or "liberation from the corpse." One kind of *shijie* took the form of the mysterious vanishing of the physical body of the deceased, which was interpreted as the attainment of immortality after death. Integrating various early trends into a coherent theory, the author of the *Canon of Immortality* (*Xian jing*) states: "Gentlemen of the upper rank who can raise their bodies to enter the Great Void are called Heavenly Immortals. Gentlemen of the middle rank who roam among famous mountains are called Earthly Immortals. Gentlemen of the lower rank cannot avoid death, and they have to shed their physical shells like a cicada; they are called Shijie Immortals."[199]

The design of a burial signified such changes in the conception of the afterlife. It was precisely around the same time in the mid-second century B.C. that rock-cut tombs first appeared in China. Instead of passively imitating a wooden-framed dwelling underground, a tomb carved into a living cliff revealed a new desire to make a person's otherworldly home eternal. This architectural form shared the basic premise of *shijie,* that although death was inevitable, it was a necessary stage in one's achievement of eternity. Emperor Wen of the Western Han, for example, began his testamentary edict of 157 B.C. with the philosophical statement: "Death is a part of the abiding order of heaven and earth and the natural end of all creatures."[200] But the same emperor constructed for himself a mausoleum dug into a rocky mountain, with a special stone sarcophagus intended to last forever. He also carefully planned his own funeral in advance, so that at his death he would safely be transported to his stone palace.[201]

Emperor Wen's mausoleum, Ba ling, is one of the earliest known stone funerary structures in China. Sima Qian

recorded that the emperor once led a group of courtiers to this mountain tomb southeast of Chang'an. Confronting his future burial place (and therefore his death), the emperor's heart was full of sorrow, and he began to sing a melancholy song. But his mood soon changed when he began to inspect the arrangement of his otherworldly dwelling: "Oh! Using stone from the Northern Mountains to make my outer coffin, securing it with linen cloth and again gluing the cloth with lacquer, how can the coffin still be shaken!"[202] His desire for an everlasting posthumous home represented a contemporary development in Chinese religious thought, but why did this idea have to be conveyed by stone structures? Until this point the Chinese had rarely, if at all, constructed stone buildings. Were they suddenly able to "discover" this material themselves, or were they, in searching for new symbolic forms to express new ideas, inspired by an outside culture that had a long tradition of stone religious architecture? This question directs attention to the Indian world to the west, where people for centuries had built rock-cut sanctuaries and made stone sculptures. My basic approach to this cultural interaction, however, differs from the old theory of "cultural impact." In my view, instead of passively receiving influences from neighboring countries, the Han Chinese actively sought stimuli from the outside world and, in fact, invented an outside world that provided them with such stimuli.

Wolfgang Bauer has observed that in the ancient Chinese mind, the East and the West were always the places of refuge and immortality.[203] A closer examination reveals that pre-Han searches for immortality were most frequently oriented to the East, as a result of the intense activities of the necromancers from the northeastern states of Qi, Zhao, and Yan (Map 2.2), who traveled throughout the country and spread tales about the Penglai Islands off the east coast.[204] From the early and middle Western Han, however, people began to pay increasing attention to the West. This new focus in the immortality search was intimately related to China's unification and its subsequent western-oriented expansion. This expansion process, which may have begun in the early Han,[205] culminated during

the reign of Emperor Wu, who made use of the strength accumulated in the early years of the dynasty to double the territory of his empire. By defeating the Huns in a series of brilliant campaigns, the Chinese armies pushed ever farther across Central Asia until they finally confronted the Roman empire (Map 2.4). Two great highways were established; the one north of the Heavenly Mountains (Tianshan) ran through the Gobi Desert to Balkhash, and the one south of the mountains led across the Tarim Basin to Kashgar and Khotan. "Over both roads came Western ideas and art motifs to be incorporated into but never to dominate the Chinese aesthetic canon."[206] Of these ideas and art motifs, many came from the Indian world, which had suddenly become a neighbor of Han China.

All these activities—expeditions, conquests, travel, trade, geographical investigations, exchanges of ideas and experiences, and the search for immortality—were part of a broad cultural movement characterized, first of all, by a strong attraction to an unfamiliar space as well as an alienation from it.[207] The mysterious West was conceptualized as a geographic territory that expanded from China proper to the "western limit" of the world, a vast sphere consisting of a number of vaguely divided zones—some actually reached by the Han Chinese, others known only through hearsay. The Near West was occupied by hostile Hun tribes that presented a constant danger. Beyond this barrier were more peaceful states, including Dayuan (Ferghana), Yuzhi (Indo-scythia), Daxia (Bactria), and Kangju (Trans-Oxiana), places that Zhang Qian, Emperor Wu's ambassador to the West, visited during his mission from 138 to 126 B.C.[208] Zhang's report to the emperor, which survives in the *Records of the Historian*, contains amazing factual details;[209] but the farther west the places he describes, the more fantastic his accounts. Tiaozhi (Mesopotamia), for example, is situated several thousand *li* west of Persia; there "great birds lay eggs as large as pots," and one can find the Queen Mother of the West.[210] Gaston Bachelard calls such an imaginary geography a "poetic space," whose objective properties become less important than what it is imagined to be.[211] Edward W. Said further points out that "poetic space" is often associated with

Fig. 2.40. Elephant-tending motif on a bronze chariot ornament. Western Han. Early 1st century B.C. Excavated in 1965 at Sanpanshan, Dingxian, Hebei province. Hebei Provincial Museum, Shijiazhuang. Drawing.

distinctive objects that have only a fictional reality (e.g., "the great birds and their huge eggs" frequently mentioned in Han descriptions of western regions), or is viewed as a place outside time (e.g., the realm of the Queen Mother of the West). The attitude toward such a place "shares with magic and with mythology the self-containing, self-reinforcing character of a closed system, in which objects are what they are *because* they are what they are, for once, for all time, for ontological reasons that no empirical material can either dislodge or alter."[212]

We can thus understand why to people of the Han the continually repeated features and tales of this fantastic "West" possessed eternal value. All kinds of suppositions, associations, and fictions related to immortality crowded this alien sphere: a horse from the West was a "heavenly horse," and a tribute elephant, "a passenger of the gods."[213] Both beasts are portrayed as "auspicious omens" and "immortal animals" on a chariot ornament made at the beginning of the first century B.C. (Fig. 2.40).[214] Interestingly, not only was the elephant a foreign tribute, but its image also was derived from a foreign art tradition: almost identical "elephant-tending" motifs are found in India and Pakistan (Figs. 2.41a, b).

This example clinches the argument that at least by the

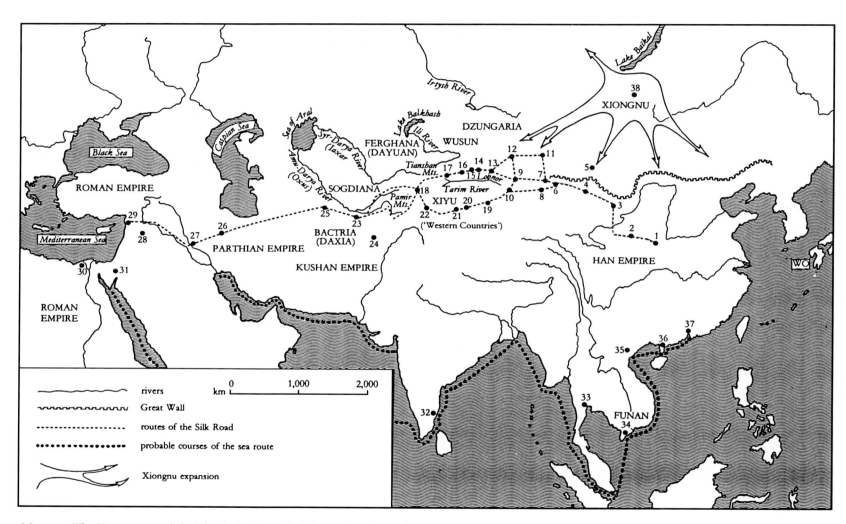

Map 2.4. The Han empire and the Silk Road (Pirazzoli-t'Serstevens 1982: 223)

a

b

Fig. 2.41. (a, b) Silver disks decorated with elephant-tending motifs. 2d century A.D. From Rawalpindi. British Museum.

second and first centuries B.C., certain Indian art motifs had been introduced to China and copied there. But such faithful copies of Indian motifs were still rare at that time—they required the importation of foreign art objects to China. What had greater influence on Chinese culture were vague ideas or "information" about the fantastic West—stories and "reports" spread orally and freely interpreted, modified, and adapted for the sake of their receivers.[215] The reception of western influence in such "twisted" fashion continued into later history: students of Chinese Buddhism are well aware that the early translations of Buddhist canons produced in the third and fourth centuries explained Indian concepts in traditional Chinese terms, and, as I discuss later in this section, during the first and second centuries A.D., the Buddha was viewed in China as nothing more than a foreign *xian* immortal. The people of the Western Han had an even more rudimentary understanding of Indian religion and art. Raised in a culture that had been longing for immortality for centuries, they readily believed the land over the Heavenly Mountains a "paradise," where many "an-

thropomorphic deities" dwelt. They related Indian Buddhism, which also attempted to provide solutions to the problems of suffering and death, with their own pursuit of eternal happiness; they equated the concept of Nirvana with their idea of life after death and interpreted the worship of the Buddha's relics as a kind of funerary practice. When they heard about the western rock-cut sanctuaries and stone carvings, they naturally related these foreign forms—not only their design but also their medium—to immortality and eternity, and willingly absorbed such forms into their own religious architecture.

This hypothesis explains the frequent connections among four essential elements in Han religion and religious art, namely, *immortality*, the *West*, *stone*, and *death*. The link between immortality and the West is the most evident. In fact, some scholars attribute Emperor Wu's western-oriented military actions to his desire for longevity: by obtaining the legendary "heavenly horse" in the West he could ride to Heaven.[216] Although this argument may need more evidence,[217] it is true that things in and from the West were customarily considered auspicious or

immortal. Most important, Mount Kunlun and the Queen Mother of the West, two primary immortality symbols related to the West, soon overshadowed the older Penglai myth.[218] The *Master Huainan* (*Huainan zi*) composed before 122 B.C., for example, identifies Kunlun as the ultimate designation of the search for immortality: "He who climbs onto the Chilly Wind peak of Kunlun will achieve deathlessness; he who climbs twice as high onto the Hanging Garden will become a spirit and will be able to make wind and rain; he who climbs twice as high again will reach Heaven and will become a god." The same text also locates the Queen Mother of the West at "the edge of the Flowing Sands," possibly the western limit of the Gobi Desert.[219] Sima Xiangru, the court poet of Emperor Wu, described the goddess's attraction in the following lines:

> I went back and forth among the Yin Mountains
> and soared in great curves;
> I was able to see the Queen Mother of the West.
> She, brilliant with her white head and high jade
> comb, dwells in a cave.[220]

Significantly, here the western goddess is said "to dwell in a cave" (or "to be worshipped in a cave"?). This account may be read together with a passage from the *History of the Former Han*: "To the northwest and beyond the defense line, there is the Stone Chamber of the Queen Mother of the West."[221] It seems that unlike traditional Chinese deities who had always been honored in wooden-framed temples and shrines, western immortals "beyond China's defense line" were associated with alien structures of stone.

Since immortality might be achieved either during one's lifetime or after one's death, both living people and departed souls could find hope in the Queen Mother and in the West, and structures dedicated to both the goddess and the deceased could be made of stone. Emperor Wu built the Jianzhang Palace—a replica of the Heavenly Court—west of Chang'an. The same emperor also located his mausoleum, quite unconventionally, in a spot directly west of the capital city (Map 3.6). Is it possible that the belief in a western paradise determined the sites of both

structures? Stone sculptures have been found in the graveyard of General Huo Qubing (140–117 B.C.), a chief commander in Emperor Wu's western expeditionary army. Based on a textual record, scholars commonly believe that this tomb, one of the many satellite burials attached to Emperor Wu's mausoleum, was built to resemble Mount Qilian on the northwest Chinese border. The existing tumulus above Huo's grave, however, is no different from other Han tumuli (Fig. 2.42a). The only unusual feature of this burial is a group of fourteen stone sculptures including the famous "horse trampling a barbarian" (Fig. 2.42b).[222] Standing in Huo's graveyard and covering the tomb mound, these unusual statues must have served a double role: their vivid images reminded people of the general's contribution to the western expansion of the Han empire, yet these images were frozen in stone, an "eternal" material belonging to the "western world" of immortality and death.

Four years after Huo Qubing's death in 117 B.C., Liu Sheng, Prince Jing of Zhongshan, was buried in a rock-cut tomb at Mancheng (Mancheng Tomb no. 1), in present-day Hebei. Other Western Han cave burials found in recent years include the tomb of Liu Sheng's wife Dou Wan (Mancheng Tomb no. 2), a group of five tombs at Jiulongshan near Qufu in Shandong (probably belonging to princes of the Lu principality), and four others near Xuzhou in Jiangsu that have been identified as mausoleums of the princes of Chu.[223] These examples, all dating from the late second century to the first century B.C., demonstrate the popularity of rock-cut tombs among members of the royal family during this period. The two Mancheng tombs are not the largest in the group (the burial at Beidongshan near Xuzhou, for example, is far grander and consists of a 55-meter-long passageway and nineteen chambers covering an area of 350 square meters; Fig. 2.43), but they are the only ones to have escaped grave robbers. Their dates and occupants can be precisely identified, and their excavations have been thoroughly reported.[224] These factors make these two tombs the best examples for studying Western Han rock-cut burials.

An often neglected feature of the Mancheng tombs is their site. A topographical map of the area (Map 2.5) shows

a

b

that two small hills, like two pillars of a gate, flanked the entrance to the burial ground on Lingshan (the Hill of Spirits). This design recalls Sima Qian's description of the First Emperor's magnificent Efang Palace, which was situated so that "the peaks of southern mountains formed its pillar gate."[225] At Mancheng, the ritual path running east–west through the "mountain gate" extended into the tomb passages, which again led to the underground palaces of Liu Sheng and his wife. At the end of each passage, a vestibule was flanked by two long side chambers (Figs. 2.44a, b). In Liu Sheng's tomb, the chamber on the right (if we assume a position facing inward) was filled with hundreds of jars and large cases containing goods of the sort found in a royal household. The opposite chamber held a tile-roofed and wooden-framed building; four chariots, along with skeletons of eleven horses, were found inside. Apparently this left chamber was supposed to be a royal stable; the right one, a storage room.

rear chamber

lavatories

ante-chamber

niches

music and dance hall

well

Fig. 2.42. above (a) Tomb of Huo Qubing at Xingping, Shaanxi province. Western Han. 117 B.C. (b) "Horse trampling a barbarian." Stone statue at Huo Qubing's tomb. H. 168 cm. L. 190 cm.

Fig. 2.43. left A large Western Han rock-cut tomb at Beidongshan, Xuzhou, Jiangsu province. 2d century B.C.

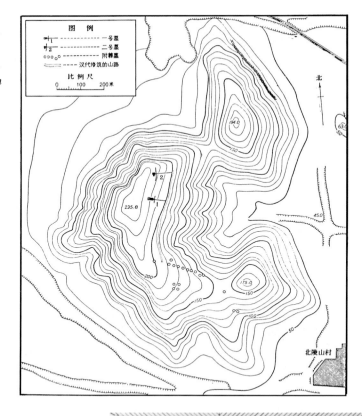

図 例

	一号墓
	二号墓
	附葬墓
	汉代修筑的山路

比例尺

0 100 200米

北

北陵山村

Fig. 2.44. (a) Plan of Liu Sheng's tomb (Tomb no. 1) at Mancheng, Hebei province. Western Han. 113 B.C. (b) Cutaway view showing a tentative reconstruction of Liu Sheng's tomb.

Behind the vestibule was a grand cave (Fig. 2.45) that originally contained another wooden-framed structure. Like the stable, it had collapsed long before the excavation; only roof tiles and metal joints scattered on the ground allowed the excavators to speculate on its original form. Inside this building, two seats were originally placed inside two separate wooden-structures covered with silk (Fig. 2.46a). Sacrificial vessels, lamps, incense burners, and figurines were lined up in rows in front of as well as beside the central seat (Fig. 2.44b). A group of smaller drinking vessels, a miniature chariot, and as many as 2,034 bronze coins, were placed behind this seat and before a thick stone gate that blocked the entrance to the rear chamber—the private space of the deceased prince. This chamber, the last free-standing structure built inside the tomb, housed the corpse dressed in a jade suit. Unlike the stable, the central hall and covered seats, however, it was made of stone, not of wood and tiles (Fig. 2.46b). Four stone figurines, two male and two female, guarded the stone rear chamber, whereas eighteen of the nineteen figurines found in the wooden-framed central chamber were made of clay. All these features indicate the symbolism of the

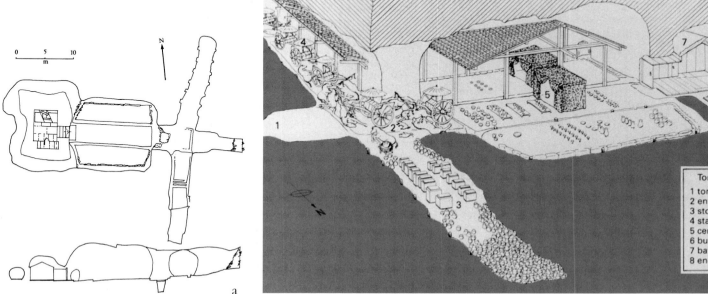

0 5 10
m

N

Tomb of Liu Sheng
1 tomb passage filled with rubble
2 entrance hall
3 storage area
4 stable
5 central chamber
6 burial chamber
7 bathroom
8 encircling corridor

a

b

divergent media. There is no doubt that the builders selected different materials for various sections of the tomb: wood and clay suited the front section, which mirrored a "living" household, while the stone chamber and figurines in the rear section constituted the eternal world of the dead.

Two other features of the Mancheng tombs are noteworthy. First, the builders seem to have been carpenters with little knowledge of masonry techniques. In constructing the burial chambers, they first cut and polished stone into thin, narrow panels that resembled wooden boards, and they may have also built a timber frame to support these panels and fix them in their assigned positions.[226] Second, a circular tunnel in Liu Sheng's tomb surrounded the rear burial chamber (Figs. 2.44a, 47a). In an attempt to explain this curious design, the excavators have tentatively suggested that the tunnel may have functioned as a "drainpipe" to protect the rear chamber from underground water.[227] This interpretation is not convincing because the tunnel is not connected with the rear chamber but opens to the central sacrificial hall, and because its scale is far beyond what would be required for drainage. About two meters tall and with an arched ceiling, it was more likely constructed to allow worshippers to walk around the burial chamber. A prototype of this architectural device may be found in an Indian rock-cut temple dating from the mid–second century B.C., in which a stone stupa, the symbol of the Buddha's Nirvana and relics, stood at the rear end of a ceremonial hall and was surrounded by a passageway for the rite of circumambulation (Fig. 2.47b). If this hypothesis contains any truth, the builders of the Mancheng tomb must have thought the stupa was a burial device and replicated its features in Liu Sheng's stone chamber. A Buddhist holy symbol was thus "transplanted" into a Chinese funerary context.

The second and first centuries B.C. were a transitional period, during which the Chinese may have heard about Buddhism and become aware of certain western religious art and architectural forms—possibly rock-cut temples and stone carvings.[228] This knowledge may have contributed to the creation of rock-cut tombs and stone sculptures

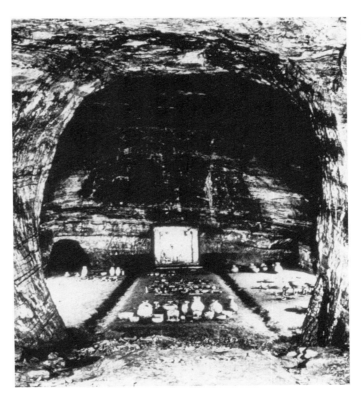

Fig. 2.45. The main chamber in Liu Sheng's tomb

in China. A century later, stone was used extensively not only for burial chambers but also for aboveground mortuary monuments, and Buddhist motifs were employed freely in decorating funerary structures. Both developments were strongly encouraged by Emperor Ming who, as noted in the previous section, was also responsible for the final establishment of the tomb district as the most important center of ancestor worship. It is said that this emperor's mausoleum, which was constructed before A.D. 71, contained a "stone palace" (*shidian*),[229] that his tomb bore images of the stupa and the Buddha,[230] and that his dispatch of an envoy to seek Buddhism in India marked the beginning of the official introduction of Buddhism to China.

The mortuary hall of Emperor Ming initiated a series of stone offering shrines (see Fig. 4.4).[231] Stone pillar-gates also appeared in the first century and soon became popular (Fig. 4.2).[232] Also around the same time, stelae bearing commemorative texts began to be made of stone

Fig. 2.46. (a) Reconstruction of a wooden structure inside the main chamber in Liu Sheng's tomb. (b) The stone rear chamber in Liu Sheng's tomb.

Fig. 2.47. (a) Cross section of Liu Sheng's tomb, showing the entrances to the tunnel and the burial chamber. (b) Plan of the assembly hall and meditation caves at Vat Bhājā, India. 2d century B.C.

(Fig. 4.5).[233] Stone mortuary statues in animal and human forms, which were extremely rare during the Western Han, now became abundant.[234] The tradition of rock-cut tombs survived in the southwestern part of the country (Figs. 2.48a, b); with an open vestibule and attached cells, their design resembled an Indian vihāra cave (Fig. 2.47b).[235] During the Eastern Han, aboveground stone structures and rock-cut burials were distributed in two distinctive regions: the area stretching from the capital Luoyang to the Shandong-Jiangsu border, and the Sichuan Basin (Map 2.6). Not coincidentally, these two regions were also under the strongest Buddhist influence. In Luoyang, Emperor Ming established the first Buddhist temple.[236] His favoritism toward the foreign religion was probably related to the activities of Liu Ying, the prince of Chu, who "observed fasting and performed sacrifices to the Buddha" around the same time.[237] These records have led Erik Zürcher to propose that "around

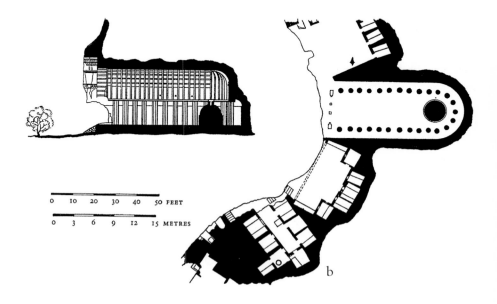

Temple, Palace, and Tomb

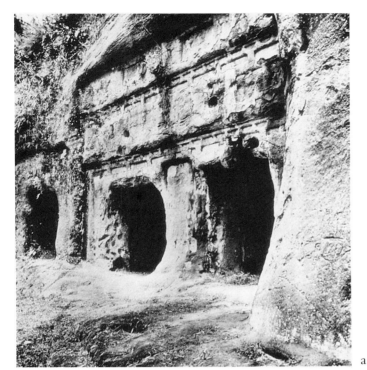

a

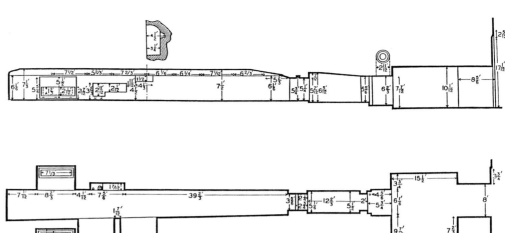

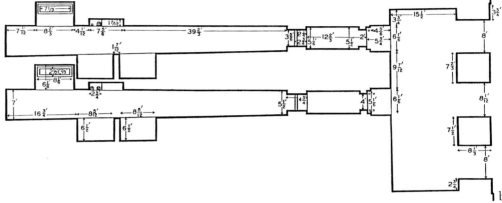

b

the middle of the first century A.D. Buddhism appears already to have penetrated into the region north of the Huai River, in eastern Henan, southern Shandong and northern Jiangsu," and that Pengcheng, the seat of the Chu principality, "was situated on the high-way from Luoyang to the South-East which actually formed an eastern extension to the continental silk-route by which foreigners from the West used to arrive."[238]

The Buddhist center in the Luoyang-Pengcheng region continued to develop during the second century. The arrival in 148 of a Parthian missionary, An Shigao, marked the beginning of what has been called "the Buddhist church" at Luoyang;[239] and Emperor Huan (r. 147–67) offered sacrifices to the Yellow Emperor, Laozi, and the Buddha for the sake of peace and prosperity.[240] In the Shandong-Jiangsu area, Xiang Kai from Shiyin submitted a memorial to the throne in 166 in which he quoted a Buddhist script;[241] and in Pengcheng, the notorious warlord Zha Rong erected a large Buddhist temple, made a statue of the Buddha, and held extraordinary ceremonies

toward the end of the second century.[242] As for Sichuan, it came under the dominance of religious Daoism during the second century; as I have argued elsewhere, the early Daoist canon and pantheon derived many elements from Buddhist tales and iconography.[243] It is also possible that a route directly linked this southwestern province with the Indian world—a hypothesis supported by both textual sources and artworks that most closely imitated Indian images.[244]

While freely combining Buddhist concepts with Daoist beliefs, the Eastern Han Chinese intensified the practice of absorbing Buddhist motifs into their mortuary art and architecture. This phenomenon was again most visible in the two regions centered on Luoyang-Pengcheng and Sichuan. The connection between stupa worship and funerary practices, only hinted at by the design of Liu Sheng's tomb, became explicit. It is said that a stupa was established (or depicted) in Emperor Ming's graveyard in Luoyang.[245] Whereas this record comes from a later text and is thus open to suspicion, a remarkable scene engraved on

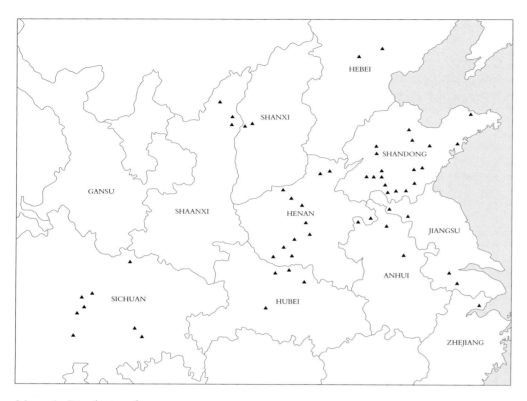

Map 2.6. Distribution of Han dynasty stone funerary structures (based on Zong mulu, 402)

Fig. 2.49. Worshipping the "stupa." Stone carving on the Left Wu Family Shrine at Jiaxiang, Shandong province. Late Eastern Han. 2d half of the 2d century A.D. Ink rubbing.

one of the famous Wu family shrines in Shandong illustrates two winged figures worshipping a building that looks like a broad-based bottle, with a flying immortal and a bird hovering over it (Fig. 2.49). A comparison of this scene and those of stupa worship in Sāñchī and Bhārhut (Fig. 2.50) reveals many similarities in composition, in the basic shape of the central structure, and in the flanked worshippers and celestial beings. A picture on another shrine portrays a man, possibly the famous filial paragon Yan Wu, kneeling before his father's tomb, a hemisphere on which a vertical shaft supports an umbrella-shaped ornament (Fig. 2.51). The resemblance of this architectural form to an Indian stupa is beyond doubt. What we find here are two interrelated aspects of the stupa in Eastern Han thought: the first picture reflects the (mis)understanding of stupa worship as a kind of immortality cult; the second demonstrates the influence of such worship on Chinese funerary practices.

These examples help us recognize a central characteristic of the early introduction of Buddhism to China: this foreign religion could be accepted because it was largely and willingly misinterpreted. Such misinterpretation is most clearly revealed by the Chinese perception and descriptions of the Buddha. *The Sutra in Forty-two Sections* (*Sishier zhang jing*) records events surrounding Emperor Ming's introduction of Buddhism: one night in a dream the emperor saw a golden deity flying into his palace and emanating sunlight from the neck. The next day he asked his ministers to identify the image. One of them, Fu Yi, replied that he had heard of a sage in India called "the Buddha," who had attained salvation, was able to fly, and whose body was of a golden hue.[246] Inspired by this report, the emperor sent envoys to seek Buddhism. After they brought back Buddhist scriptures and images, "everyone from the Son of Heaven to the princes and nobles became devotees; they were all attracted by the teaching that *one's spirit did not vanish after death.*"[247]

Other early Chinese descriptions of the Buddha were written in a similar vein. According to the *Record of the Latter Han* (*Hou Han ji*), "The Buddha is sixteen feet in height, golden in color, and wears light from the sun and moon on his neck. He can assume countless forms and enter anything at will. Thus, he is able to communicate with a myriad things and help people."[248] The description in Mouzi's *Disputation of Confusion* (*Lihuo lun*) is more detailed:

Temple, Palace, and Tomb

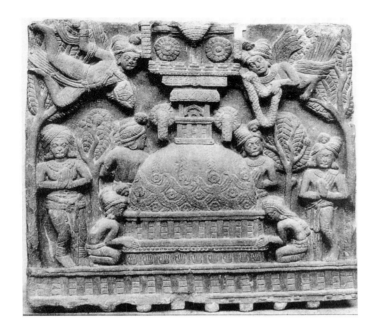

"Buddha" is a posthumous title, in the same way that "divine" [*shen*] is the title of the Three Sovereigns [Sanhuang], and that "sage" [*sheng*] is the title of the Five Emperors [Wudi]. The Buddha is the first ancestor of morality and divinity. His words are illuminating. The shape of the Buddha is unpredictable. He can assume endless manifestations. He can be concrete or elusive, large or small, round or square, old or young, emerge or disappear. He is unharmed when walking through fire, and uninjured when standing on a blade. In mud he cannot be tainted. His well-being is never spoiled or damaged by disaster. When he wishes to move, he flies; and when he sits, he emanates brilliant light. That is why he is called the Buddha.[249]

Only by understanding this specific meaning of the Buddha and Buddhism to people of the Eastern Han can we comprehend how they used Buddhist motifs in their art. First, almost all Eastern Han motifs of Buddhist origins appeared in funerary contexts.[250] These include a Buddha-like immortal riding a white elephant (Fig. 2.52), a six-tusked elephant (Fig. 2.53), immortals worshipping a lotus flower (Fig. 2.54), and immortals worshipping the stupa (Fig. 2.49).[251] Together with other immortality symbols, these foreign forms transformed a tomb or a shrine

into a paradise for the deceased. Second, iconic images for portraying the Queen Mother of the West appeared in China in the first and second centuries (Figs. 2.55a, b). As I have discussed elsewhere, unlike the traditional Chinese "episodic composition," a frontal iconic image emphasizes a direct relationship between the icon and the viewer (or worshipper), and this new composition can be traced to the Indian imagery of the Buddha (Fig. 2.56).[252] Third, in a funerary context, images of the Queen Mother of the West and the Buddha are either juxtaposed or replace each another.[253] For example, two sides of an octagonal column in the Yi'nan tomb in Shandong bear the images of the Queen Mother of the West and her counterpart deity, the King Father of the East; Buddha-like figures with halos behind their heads occupy the other two main sides (Fig. 2.57). In Sichuan, Buddha images decorate not only tombs (Figs. 2.58a, b) but also a kind of funerary paraphernalia called a "money tree" (Figs. 2.59a, b). In one instance the Buddha appears on a money tree base with dragons, a traditional Chinese symbol, beneath him (Fig. 2.60a); on another example, the Queen Mother is represented in a similar fashion, above an elephant-tending scene originating from India (Fig. 2.60b).

Fourth and last, the distribution of these "Buddhist" motifs overlaps with that of stone monuments (Map 2.6). In retrospect, we realize that in their search for a new art and architectural program, the Han Chinese eagerly

(text continues on page 142)

Fig. 2.50. Worshipping the stupa. Stone carving. 2d century A.D. Bhārhut. Freer Gallery of Art, Washington, D.C.

Fig. 2.51. Worshipping the dead in front of a tumulus. Stone carving. Late Eastern Han. 2d half of the 2d century A.D. W. 64 cm. Excavated in 1978 at Songshan, Jiaxiang, Shandong province. Ink rubbing.

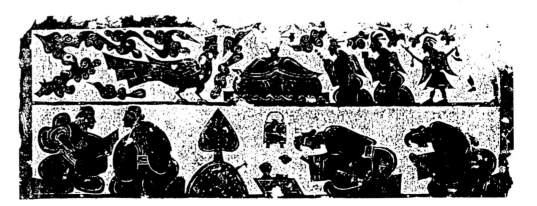

Fig. 2.52. Immortal riding a white elephant. Mural in the Helinge'er tomb, Inner Mongolia. Late Eastern Han. Late 2d century A.D. Drawing.

Fig. 2.53. Six-tusked elephant. Stone carving. Late Eastern Han. 2d half of the 2d century A.D. From Tengxian, Shandong province.

Fig. 2.54. Worshipping the lotus flower. Stone carving on the ceiling of the Wu Liang Shrine at Jiaxiang, Shandong province. A.D. 151. Reconstruction.

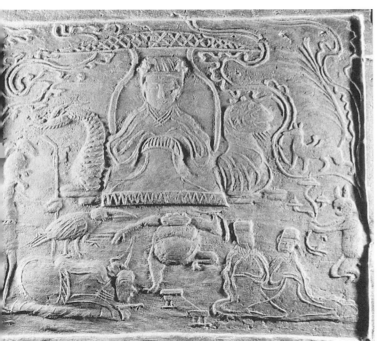

Fig. 2.55. (a) The Queen Mother of the West on the magic mountain Kunlun. Stone carving. Late Eastern Han. 2d half of the 2d century A.D. W. 66 cm. Excavated in 1978 at Songshan, Jiaxiang, Shandong province. (b) The Queen Mother of the West and her court. Pictorial tile. Late Eastern Han. 2d century A.D. Excavated from Qingbaixiang Tomb no. 1 at Xinfan, Chengdu, Sichuan province. Sichuan Provincial Museum.

Fig. 2.56. The Buddha's first sermon. Kushan dynasty. Late 2d century A.D. H. 67 cm. From Gandhara, Pakistan. Freer Gallery of Art, Washington, D.C.

Fig. 2.57. Carvings on the central column in the middle chamber of the Yi'nan tomb. Late Eastern Han. Late 2d century–early 3d century. Excavated in 1953 at Beizhai, Yi'nan, Shandong province. Drawing.

Fig. 2.58. (a) Front chamber of Mahao Cave-Tomb no. 1. Leshan, Sichuan province. Eastern Han. 2d century B.C. (b) The Buddha image in Mahao Cave-Tomb no. 1. H. 37 cm.

Fig. 2.59. (a) Fragment of a bronze "money tree" with the Buddha's image. Eastern Han. 2d century A.D. H. 6.5 cm. Excavated from Hejiashan Cave-Tomb no. 1 at Mianyang, Sichuan province. Mianyang Museum. (b) Drawing.

a

b

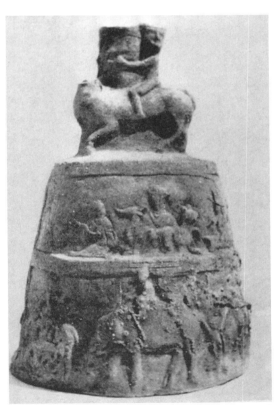

Fig. 2.60. (a) Clay stand of a "money tree," decorated with the Buddha's image. Eastern Han. 2d century A.D. H. 21 cm. Found at Pengshan, Sichuan province. Nanjing Museum. (b) Clay stand of a "money tree," decorated with the Queen Mother of the West on the upper register and with a procession of elephant chariots on the lower register. Eastern Han. 2d century A.D. Excavated in 1974 at Santai, Sichuan province. Sichuan Provincial Museum.

a

b

absorbed all the major ingredients of a foreign religious art, including its conventional media, composition, and motifs. But these foreign elements only served to enrich and reinforce indigenous Chinese culture. As a result, holy symbols of the Buddha were removed from public sanctuaries to be buried with the dead; and stone was given a paticular meaning as a signifier of both longevity and immortality. A Han dynasty folk song goes: "No one is made of gold and stone; / How could one escape death?"[254] But when an entire graveyard has been turned into stone, this premise was reversed, as expressed in another folk song: "At death he has attained the way of holy immortals."[255] Based on this second belief, numerous Han dynasty stone structures, bas-reliefs, and sculptures were made and served as evidence for a new kind of creative energy and imagination in art. The Han "discovery" of stone was thus as significant as the "discovery" of jade in prehistoric times and the "discovery" of bronze in the Three Dynasties—the consecutive employment of these three media changed the course of Chinese art history. Like the earlier art of *liqi*, Han stone monuments were part of their creator's social and religious lives, providing foci for ritual performances and political activities, and documenting shared beliefs as well as specific concerns, ambitions, desires, and memories. But I will postpone discussion of such specific messages in funerary art until we study one of the most important ancient Chinese cities—the Han capital Chang'an.

Temple, Palace, and Tomb

The Monumental City Chang'an

Withered orchids escort the departing statue along the
　　Xianyang road:
If heaven too had passions even heaven would grow old.
With a plate in hands, the statue comes forth alone under the
　　desolate moon:
The city on the Wei River far back now, quiet the waves.

THESE LINES ARE FROM Li He's (791–817) famous "A Bronze Immortal Takes Leave of Han" ("Jintong xianren ci Han ge"), which recounts an event that occurred thirteen years after the Han's fall.[1] In 233, Emperor Ming of the Wei decided to transport a bronze immortal from Chang'an to his new capital at Ye. The statue, which Emperor Wu of the Han had erected in his palace, originally held a plate over its head to catch sweet dew. The plate was broken off in moving the statue. As the immortal was about to be loaded in a cart, tears gushed from the bronze figure's eyes.

Both the story and Li He's melancholy song reflect a later concept of monumentality—a particular sensibility toward ruins as physical remains of the past, whose fragmented and eroded appearance evoked poetic lamentation and artistic admiration. To people of the ninth century, the Han capital Chang'an (the "city on the Wei River") had receded far back into history and memory and was no longer comprehensible as a whole; it had dissolved into disconnected images and tales, told and retold in literature and art. Chang'an's attraction to Tang–Song anti-

quarians and romantic writers had little to do with its original significance during the Han.

But were there ever objective records, descriptions, representations, or reconstructions of Chang'an? Did the people of the Han share a uniform view of the city and hold the same idea about its history? If not, what were their views and ideas? These questions lead me to add a new dimension to my investigation of ancient Chinese monuments: in addition to interpreting their historical development and significance, I will also consider *discourses* on these monuments. Although focusing on a single object or phenomenon, different authors often had divergent understandings of and criteria for its monumentality; their approaches formed an important aspect of the ancient Chinese conception of monumentality. This is why this chapter focuses on Chang'an alone: this Western Han capital was the first large Chinese city whose historical development and physical form can be approximately reconstructed, and whose significance as a "monumental city" ancient writers openly debated.

Two Views of Chang'an

The history of Western Han Chang'an began in 202 B.C. when the dynasty's founder, Emperor Gaozu, established his capital in the Wei River valley in present-day southern Shaanxi. It ended in A.D. 25, when "several hundred thousands of its residents had died of hunger; the city itself had become a vast deserted ruin; and most of its splendid temples and mausoleums had been destroyed and plundered." These haunting sentences conclude Ban Gu's *History of the Former Han*.[2]

But Chang'an would continue to fascinate people throughout the next two millennia. Numerous poems, eulogies, and memoirs would be written to commemorate its past glory and to lament its tragic destruction, and abundant field surveys and reconstruction plans would be conducted to trace its vanished image. The present chapter is one such reconstruction. The attempt of undertaking it naturally implies a certain dissatisfaction with previous efforts. Such dissatisfaction, however, should be understood in a historiographic sense, for, in Carl E. Schorske's words, "no man thinks of the city in hermetic isolation. He forms his image of it through a perceptual screen derived from inherited culture and transformed by personal experience."[3] Like previous reconstruction plans, the present one is not free from cultural and intellectual influences. But I hope that as a latecomer, I will have the privilege of pondering the premises and goals of earlier works, the various factors that have shaped an author's thinking, and the traditions and conventions that have both encouraged and restrained an attempt to depict the historical Chang'an.

Such a reflection helps clarify two alternative perspectives or positions in approaching this ancient city. In one view, Chang'an is a changing historical entity with specific causes for its birth, growth, and decay; the purpose of a reconstruction is to trace this process throughout the course of its development. In the other view, Chang'an is the sum of all its historical fragments and is often represented by its culminating stage; the observer tries to depict such an image and to interpret it according to some general cultural and ideological principles.[4] Indeed, these two views,

both retrospective in nature, emerged in the Eastern Han from two paradigms for interpreting the past. The historian Ban Gu (A.D. 32–92) synthesized old memories of Chang'an into a narrative; the classicist Zhang Heng (A.D. 78–139) transformed Ban Gu's narrative into a still life. Their works, in fact their own remembrances of Chang'an, then became two major sources of later "historical" knowledge. These and other early writings were again fragmented, indexed, integrated, and recomposed into new reconstructions.

Ban Gu and Zhang Heng wrote their pieces in the style of *fu* or rhapsody, the principal poetic form of the Han, which was characterized by florid verbal display and ornamental rhetoric.[5] Ban Gu begins his *Western Capital Rhapsody* (*Xidu fu*) with a conversation between two fictional personages, one (Xidu Bin or the Western Capital Guest) representing the Western Han capital, Chang'an, and the other (Dongdu Zhuren or the Eastern Capital Host) standing for the Eastern Han capital, Luoyang:

> The Western Capital Guest questions the Eastern Capital Host, "I have heard that when the great Han first made their plans and surveys, they had the intention of making the He-Luo area the capital. But they halted only briefly and did not settle there. Thus, they moved westward and founded our Supreme Capital. Have you heard of the reasons for this, and have you seen its manner of construction?" The Host said, "I have not. I wish you would
>
>> Unfold your collected thoughts of past recollections,
>> Disclose your hidden feelings of old remembrances;
>> Broaden my understanding of the imperial way,
>> Expand my knowledge of the Han metropolis."[6]

The opening speech of the Western Capital Guest concerns the most important episode in Chang'an's history, namely, the founding of this capital in the Wei River plain. Only because of this initial act could a great metropolis gradually appear in this region. It is said that before this decision was reached, a heated debate took place within Emperor Gaozu's newly established court. Most of his ministers and generals preferred to locate the capital at Luoyang, the seat of the Eastern Zhou dynasty and a place

not far from Shandong, the homeland of the Liu royal lineage as well as of themselves. For a while their opinion prevailed, and Gaozu held a temporary court at Luoyang until a foot soldier named Lou Jing (3d–2d centuries B.C.) forced his way into the palace and questioned the emperor to his face: "Your Majesty seems to have settled here—isn't it because you want to be considered as great as the Zhou lords?" When Gaozu admitted this, Lou Jing pointed out a crucial difference between the present dynasty and past dynasties that should determine the whereabouts of the emperor's throne: unlike the Zhou which prospered in peace over centuries, the Han had just gained power through military conquest and would have to secure its rule in the same manner. Chang'an's location and topography, according to Lou Jing, made it the single most important strategic point in China. He ended his argument with an analogy: "When you fight with a man, you have to grip his throat and strike him in the back before you can be sure of your victory. In the same way, if you will now enter the [Hangu] Pass and make your capital there, basing yourself upon the old land of Qin, you will in effect be gripping the throat and striking the back of the empire!" Supported by Gaozu's chief adviser Zhang Liang (?–189 B.C.), Lou Jing convinced the emperor. He rushed to Chang'an that day, and the 200-year-long history of the Supreme Capital began.[7]

The Western Capital Guest only alludes to this event, however, and his question—"Have you heard of the reasons for [the capital's location]?"—is not immediately answered. But Ban Gu's goal is achieved: by introducing his work with this question, he sets up a perceptual framework for the following description. He guides his readers—people of the Eastern Han represented by the Eastern Capital Host—straight back to the first day of the capital. All his later accounts of the city's environment, buildings, avenues, markets, and various activities are then presented as "past recollections" and "old remembrances"—*memories* of bygone scenes. The diachronic structure of his writing is further emphasized by his reminders of the city's chronology. Immediately after the introductory section, the poem describes Chang'an's environment and Gaozu's decision about the capital's location. The first major build-

ing to be introduced is the Weiyang Palace, which was also the first imperial hall constructed at the site. Then,

> Beginning with Emperor Gaozu and ending with
> Ping,
> Each generation added ornament, exalted beauty,
> Through a long succession of twelve reigns.
> Thus, did they carry extravagance to its limit, lav-
> ishness to its extreme.[8]

As if afraid that the rhapsody's typically florid language would blur Chang'an's historicity, here Ban Gu steps out and reminds his readers that the city began as a single palace compound, and layers of elaborations were added later. Only after this pause does he proceed to document Chang'an's walls, established by the second Han emperor, the subsequent appearance of "mausoleum towns" and the exciting life in these suburban cities, the expansion of the metropolis into Greater Chang'an, and the many new constructions by Emperor Wu, the fifth ruler of the dynasty, including the divine palace Jianzhang and the fantasy gardens of Shanglin. The last stanza of the rhapsody presents the final stage of this development; it is followed by a speech of the Western Capital Guest that echoes the poem's beginning and completes the perceptual frame of Ban Gu's narrative.

> At this time,
> It was city after city facing one to another;
> Village after village joined one after another.
> The kingdoms relied on a foundation of ten
> generations;
> The families received a heritage of a hundred
> years.
> .

One such as I, having merely beheld the vestiges of old ruins and having heard these things from old men, do not know even one part in ten. Therefore, I cannot offer it to you in detail.[9]

This concluding speech seems to come straight from Ban Gu's mouth. The reader suddenly realizes that all the things the Western Capital Guest has so vividly described are no more than hearsay, and that the whole history of Chang'an narrated in the rhapsody is based on "the ves-

tiges of old ruins" and tales of old men. No one could have actually experienced and witnessed the whole course of Chang'an's development; the fictional Western Capital Guest is actually a personification of "memories" left by the city. It was Ban Gu who, based on the standard chronological structure of *shi* (historical writing), stitched together such fragmentary memories into a coherent historical narrative. The result was his own remembrance of the destroyed city.

Ban Gu presented his rhapsody to the throne around A.D. 65. Some 40 years later, Zhang Heng composed a work on the same subject and in the same style and titled it the *Western Capital Rhapsody* (*Xijing fu*).[10] Such repetitions were deliberate; we are told that he "slighted and despised Ban Gu's work, and therefore wrote a new one to replace it."[11] This critical attitude must explain the entirely different structure of the new composition.[12] Although the subject is still the same, Ban Gu's indications of Chang'an's historical growth are gone. Zhang Heng begins with a lengthy description of the city's auspicious location and geomancy. This place, according to him, was favored by Heaven and brought fortune to its occupants. The selection of Chang'an as the Han capital site was thus *predestined* by fate: only because of Heaven's guidance could the founder of the Han have settled in this precious land. Retold in this mystical atmosphere, even the foot soldier Lou Jing becomes an instrument of Heaven's will:

> Anciently, the Great Lord of Heaven was pleased with Duke Mu of Qin, invited him to court, and feted him with the "Great Music of Harmonious Heaven." The Lord, in ecstasy, made a golden tablet, and bestowed on him this land, which was situated under the Quail's Head. At this time, those powerful states who had combined together numbered six. But soon the entire empire came to live in unison under the western Qin. Is that not amazing?
>
> When Our Exalted Ancestor first entered the Pass, the planets of Five Wefts were in mutual accord and thereby lined up with the Eastern Well [the constellation Gemini]. When Lou Jing cast off his cart yoke, he offered a corrective criticism of the emperor's opinion. Heaven opened the founder's mind, and Man taught him the plan. When it came time for the emperor to make his plans, his

mind also gave consideration to the spirit of Heaven and Earth, thus making certain it was right for him to establish Chang'an as the Celestial City.[13]

This idealistic approach sets up the basic tone for the whole rhapsody. Zhang Heng reorganizes Ban Gu's recollections of Chang'an's historical development into a new framework by categorizing them into isolated types, which he then describes in a hierarchical sequence: (1) the capital's boundary, (2) the palaces, (3) the walls and suburbs, (4) the imperial park and a hunting game. Described in highly ornate language, the hunting game supposedly held by the grandiose Emperor Wu finalizes Zhang Heng's vision of Chang'an as the epitome of extravagance. He thus contrasts Chang'an with the simpler capital of his own dynasty and praises his master, the Eastern Han emperor, at the end of his work:

> Just now our sage sovereign
> Being equal to Heaven, he is called Lord Radiance,
> He enfolds the Four Seas as his family.
> Of all rich heritages none is greater than ours.
> I only regret that lavish beauty may not serve as the
> glory of the state.
> But mere frugality to the point of niggling and
> piffling
> Ignores what the "Cricket" song [from the *Odes*]
> says.
> Do we want it but are unable?
> Or are we able but do not want it?[14]

We can hardly find better examples of such radically different "accounts" of a city. In the ancient *fu* tradition, a conscious alteration in interpretation only implies the author's intellectual excellence. According to Ban Gu himself, a *fu* writer "is aroused by a circumstance and creates his theme. When his talent and wisdom are profound and excellent, it is possible to consult with him on state affairs."[15] The idea is that a "circumstance"—the stimulus of discourse—may be shared, but the discourse must reveal an author's distinctive "talent and wisdom." Applied to writings on Chang'an, this theory means that memories of this historical city must thus be constantly updated, and the past one knows must be transformed into the past

one thinks should have been.[16] The past must also gleam by the light of the present, and the constant re-editing of memories adjusts recollection to current needs.

In the two rhapsodies by Ban Gu and Zhang Heng, each author not only demonstrated his specific apprehension of history through a reflection upon the former capital but also aimed to constitute a different relationship between the past and present.[17] Ban Gu was a professional historian, and to him Chang'an had to be viewed as a dynamic process consisting of a sequence of historical events. Having grown up at the beginning of the Eastern Han, he wrote this work to remind the new ruler of "the old patterns" of the former dynasty.[18] Zhang Heng, on the other hand, was a learned scholar of *jing* or the Confucian classics, which provided his work with a basic model.[19] Instead of compiling chronicles, a writer belonging to this tradition discoursed on fundamental historical, political, and moral principles by interpreting the Classics left by ancient sages. Moreover, when Zhang Heng composed his rhapsody in the early second century, the question faced by the court had become how to sustain its rule. The former capital was no longer a historical issue, but a political and theological one, and its image and history had to be reformulated according to the prevailing theory of the Heavenly Mandate. This changing attitude is most clearly reflected in Zhang Heng's description of Chang'an's founding process. To him, this heavenly endorsed Celestial Capital had to be a "planned city" with a coherent form from the moment of its birth:

> Heaven's decree is unvarying;
> Who would dare change it?
> Thereupon:
> He [Gaozu] measured the diameter and circumference,
> Reckoned the length and breadth.
> He ordered the city walls and moat built
> And the outer enclosures constructed.[20]

We will learn later that this report contains little truth: not only did Gaozu not build the city walls, but Chang'an never had "outer enclosures." Zhang Heng's description, in fact, was not based on reality but on literature—more specifically, on passages in the Confucian classics regarding the archaic capitals of the Three Dynasties. His appeal to Heaven echoes a speech in the *Documents*, given by the Duke of Zhou when he began to build the Zhou's royal town: "May the King come and assume the responsibility for the work of God on High and himself serve [in this capacity] at the center of the land."[21] His emphasis on Chang'an's corresponding celestial position is reminiscent of a poem in the *Odes*: "The Ding-star is in the middle of the sky, / We begin to build the palace at Chu."[22] His specifics of Chang'an's planning are derived, quite literally, from another ode that documents the beginning of a pre-dynastic Zhou capital not far from Chang'an:

> And so he [the Zhou ancestor Tan Fu] remained
> quiet, he stopped;
> He went to the left, he went to the right,
> He made boundaries, he made divisions,
> He measured to the cubit, he laid out acres;
> From west he went east,
> Everywhere he took the task in hand.[23]

Historically speaking, such ancient descriptions were not groundless. As discussed earlier, some Three Dynasties cities, such as the excavated Shang capitals at Erlitou and Zhengzhou, had rectangular shapes and a symmetrical layout—features indicative of an initial design. Western Han Chang'an, on the other hand, was definitely not a "planned" lineage town but an imperial capital that expanded gradually. This does not mean, however, that such differences would be openly documented in literature. On the contrary, following the canonization of the Confucian classics,[24] empirical experience and memory were forced to conform with these authoritative writings, which made the past intelligible only in their own light. When the Eastern Zhou treatise "Regulations of Workmanship" was integrated into the canonical *Rites of Zhou*, it became a standard model for both literary and visual representations of an imperial capital:

> The official architect [*jiangren*] constructs a state capital. He makes a square nine *li* on each side; each side has three gates. Within the capital are nine streets running north-south and nine streets running east-west. The north-south

streets are nine carriage tracks in width. On the left is the Ancestral Temple, and to the right are the Altars of Soil and Grain. In the front is the Audience Hall and behind the markets.[25]

From the third century on, this brief passage would become the blueprint for all Chinese capitals. But before that moment, during the Eastern Han, what it offered to scholars like Zhang Heng was the image of an "ideal capital" as well as a method to describe it. Illustrated in Fig. 2.20, this capital appears as a flat silhouette viewed from an imagined vantage point in the sky. In this way it best exhibits all its classical features—the perfect rectangular shape and symmetrical layout reinforced by gates, avenues, and the palace-temple compound. When this image is translated into words, the description proceeds from the city's outermost enclosure to its inner divisions and components—an order taken to be the actual sequence of the city's construction. Based on this "ideal capital," Zhang Heng redrew Chang'an's image and rewrote its history. His Chang'an has no chronology and thus no growth and decay. Like the ancient sovereigns, the great founder of the Han must have first determined his capital's celestial position, ascertained the four cardinal directions, and constructed the city's double walls and moat. Only after this general framework had been laid down did the emperor add other architectural features—palaces, streets, and other buildings—to the empty enclosure. In a way, Zhang Heng rebuilt Chang'an on paper.

The rhapsodies by both Ban Gu and Zhang Heng are retrospective reconstructions from present-minded vantage points. For Ban Gu, however, what is being commemorated and reconstructed are not only events but also their diachronic sequence, whereas in Zhang Heng's work, memories are reorganized according to an overarching, essentially synchronic model. The subject of their reconstructions thus differs fundamentally: Ban Gu's goal was to illustrate the *growth* of Chang'an; Zhang Heng was preoccupied with Chang'an's timeless *image*. These two perspectives, which may be called "historical" and "classical" respectively, have been adopted by all later reconstructors of Chang'an, but the "classical" view has played the leading role. One reason for this result is that to a later ob-

server, Chang'an always appears in its *final* and *total* image. As traces of the city's long evolution become less obvious, what is apparent is a simultaneous assemblage of architectural features: a city whose boundaries are marked by the surviving foundations of its walls and whose components are indicated by ruins of great palaces. As suggested by many drawings made from the Song to the present day (Figs. 3.1–4), efforts to reconstruct Chang'an have been dominated by the desire to bestow on this city a single triumphant image, superimposing walls, gates, palaces, parks, and many other types of buildings at once.[26] Even the most "historical" reconstructions only append dates and other information to individual buildings as secondary evidence (Fig. 3.3). The same method was also employed in literary reconstructions: the city's features are classified into major types (walls, gates, palaces, parks, ritual buildings, and mausoleums) and described in hierarchical sequence, with historical information cited to explain the origin of each structure. This format enabled these authors to merge *jing* (the Classics) and *shi* (history), so that their work could ascribe to the doctrine of traditional learning in which history functioned to illuminate and supplement the Confucian classics.[27]

This idealized image of Chang'an will be dismantled in the following sections. To me, there is not a single Chang'an, but a series of Chang'ans confined in their individual historical strata. According to this understanding, for example, the popular statement that "Chang'an had twelve gates" only reflects the city's image after 190 B.C., because the last city wall was not completed until the last month of this year. Similarly, the commonplace that "eleven royal mausoleums surrounded the city" only implies the view of a post-Han observer, because the last of these tombs was built in A.D. 6 for Emperor Ping (r. A.D. 1–6). In other words, my method is close to Ban Gu's, but rather than compiling a chronology of Chang'an and documenting the physical development of the city, I hope to reveal its changing monumentality—the shifting concerns behind its construction and the logic of its evolution.

The construction of Chang'an underwent four major

stages, during the reigns of the first Western Han emperor, Gaozu (r. 206–195 B.C.); the second emperor, Hui (r. 194–188 B.C.); the fifth emperor, Wu (r. 140–87 B.C.); and Wang Mang who usurped the Western Han throne in A.D. 9. Each of these stages stands out as a period of intensive construction centered on specific projects, and together they narrate the sequence of the city's development. Chang'an's 200-year-long construction was continuously undertaken because of the ambition of individual rulers to establish their own monuments with specific political and religious values. These monuments also reflect the rise and fall of different social forces and attest to changing modes of political rhetoric. The proliferation of political and religious monuments coincided with the social development of the city, since it was around these monuments that a large population gradually concentrated and abundant social activities took place. The construction of a new monument was always a major event in the lives of the city's residents. Once it had appeared, a new monument always reinterpreted the old ones and altered the city's architectural and symbolic structures. In this process, the imperial capital constantly changed its meaning. It is based on this reconstruction of Chang'an's history that I call it a city of monuments or a "monumental city."

Emperor Gaozu: The Birth of Chang'an

Upon accepting Lou Jing's suggestion to locate the capital in the "heartland of the former Qin dynasty," Emperor Gaozu immediately departed to revisit this area, traditionally called Guanzhong, or the region within the Hangu Pass. What he saw there must have been both shocking and depressing. Just four years earlier in 206 B.C., he had conquered the Qin capital and been amazed by its splendid palaces, and before he had been forced to leave, he had sealed all the palace halls with their treasures inside.[28] But now the whole capital of the former dynasty had literally vanished: General Xiang Yu (232–202 B.C.), Gaozu's chief competitor for the throne, had burned the city. The fire lasted for three months, and the Lishan mausoleum had been looted and some 300 pleasure palaces (ligong) of the First Emperor had been reduced to ashes.

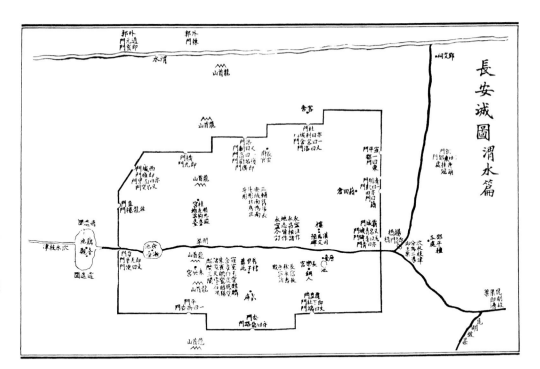

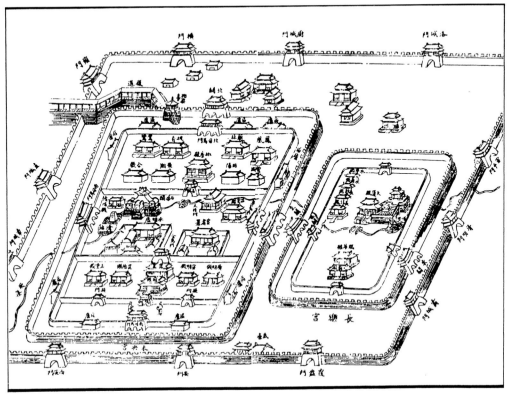

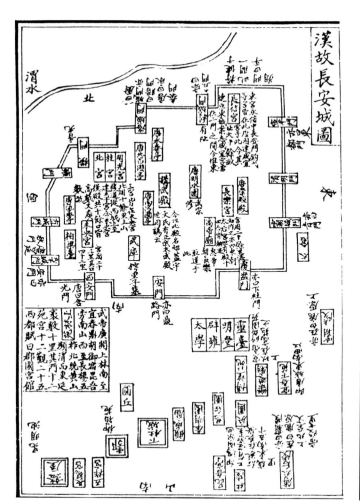

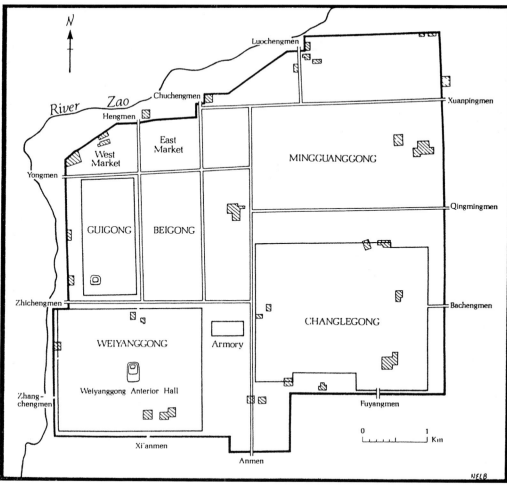

Fig. 3.3. left *Li Haowen's (14th century) reconstruction of Western Han Chang'an*

Fig. 3.4. right *Wang Zhongshu's reconstruction of Western Han Chang'an*

Among the few surviving structures was a palace complex south of the Wei River called the Xingle Palace (Palace of Prosperity and Joy). Since the wars continued and the country remained in turmoil, a practical decision was made to turn this summer resort of the previous emperor into the new ruler's throne hall. After Gaozu hurried to join his expeditionary army,[29] his prime minister, Xiao He (?–193 B.C.), took charge of repairing, redecorating, and perhaps also enlarging this group of buildings.[30]

No detailed report of this project is available, but the renovation of the Qin palace must have been substantial because the work took one and a half years.[31] The new palace, which was renamed the Changle Palace (Palace of Lasting Joy), was an architectural complex about 10 kilometers in circumference with fourteen halls inside.[32] The main palace, simply called the Anterior Hall (Qiandian), was more than 100 meters long.[33] Ten or twelve huge bronze figures originally made by the First Emperor for his Efang Palace had survived the fire and were repositioned in front of this hall.[34] Not far from the Anterior Hall was an imposing platform called the Wild Goose Terrace (Hong tai), reportedly some 92 meters in height.[35] The palace also retained two artificial lakes from Qin times, one called the Fish Pond and the other the Wine Pond.[36]

Compared with many Chinese palace complexes built before or after the Han, this fourteen-hall compound was modest in scale; however, it was the sole component of Han dynasty Chang'an as the capital first appeared on the map. In fact, in ancient texts this single compound is sometimes referred to as the Imperial City of Chang'an (*Chang'an gongcheng*) or simply the City of Chang'an (*Chang'an cheng*).[37] This explains a puzzling phenomenon during this period: although theoretically Chang'an had assumed the status of the dynasty's capital, the emperor rarely stayed in this "city." Consulting the Han history, we find that Gaozu visited Chang'an in the second month of 200 B.C. when the renovation of Changle Palace was completed, but after holding an audience in this palace he soon left for Luoyang in the fourth month.[38] He did not return until two and a half years later, in the tenth month of 198 B.C.[39] Interestingly, this second visit coincided with the inauguration of a new palace (the Weiyang, or Eternal, Palace), but again the emperor only stayed a short time and left in the twelfth month of the same year.[40] This pattern, which would continue till the emperor's death, leads me to propose that Chang'an during Gaozu's reign was essentially a political symbol and a ceremonial center, a contention supported by the nature of the rituals held in this "city" and the strong symbolic connotations of new palatial constructions.

The grand ceremony held in the Changle Palace is well documented in both the *Records of the Historian* and *History of the Former Han*.[41] The ceremony was orchestrated by Shusun Tong, a specialist in Confucian rituals from Shandong.[42] Shusun originally served the Qin as an official scholar. After Qin's fall, he went to Gaozu and made a proposal to the new Son of Heaven: "Confucian scholars are not much use when one is marching to conquest, but they can be of help in keeping what has already been won. I beg to summon the scholars of Lu, who can join with my disciples in drawing up a ritual for the court." Gaozu, who was from a commoner family and had been quite impatient with Confucian jargon, saw no harm in this suggestion but also warned the ritual master: "You may try and see what you can do, but make it easy to learn! Keep in mind that it must be the sort of thing

I can perform!" With this permission Shusun went to Lu, the homeland of Confucius, to recruit other ritual specialists. Some thirty scholars agreed to follow him; but two others rejected his offer, blaming his opportunism:

> You have served close to ten different masters, and with each of them you have gained trust and honor simply by flattering them to their faces. Now the world has just been set at peace, the dead have not been properly buried, and the wounded have not risen from their beds, and yet you wish to set up rites and music for the new dynasty. But rites and music can only be set up after a dynasty has accumulated virtue for a period of a hundred years. We could never bring ourselves to take part in what you are doing, for what you are doing is not in accord with the ways of antiquity.

To this criticism Shusun responded with laughter: "True pigheaded Confucianists you are! You do not know that the times have changed!"

The times had indeed changed for both Confucians and the ruler. The former had to modify their tradition in order to become useful, and the latter had to adapt himself to the ancient tradition in order to rule as king. After ascending the throne, Gaozu became increasingly annoyed by the lack of respect from his generals: these men who started their career as bandit leaders "were given to drinking and wrangling over their respective achievements, some shouting wildly in their drunkenness, others drawing their swords and hacking at the pillars of the palace." Their wild behavior and unrestrained manner began to threaten the emperor's authority. This political situation offered Shusun a rare opportunity to realize a scholar's ambition: "Confucius has said that the Xia, Shang, and Zhou dynasties did not merely copy their predecessors. It is my desire to select from a number of ancient codes of ritual, as well as from the ceremonies of Qin, and make a combination of these."[43] He finally managed to organize a group of 100 scholars. After practicing his own version of Confucian rites for a month in the outskirts, he held a rehearsal for the emperor. Gaozu decided that these rites did not seem too difficult to learn and ordered his ministers and generals to study them. The result was the first formal court ceremony of the Han, held in the newly

renovated Changle Palace at the beginning of the seventh year of Gaozu's reign:[44]

> In the seventh year, with the completion of the Xingle Palace, all the nobles and officials came to court to attend the ceremony in the tenth month. Before dawn the master of guests, who was in charge of the ritual, led the participants in order of rank through the gate leading to the hall. Within the courtyard the chariots and cavalry were drawn up. The foot soldiers and palace guards stood with their weapons at attention and their banners and pennants unfurled, passing the order along to the participants to hurry on their side of the stairway, several hundred on each step. The distinguished officials, nobles, generals, and other army officers took their places on the west side of the hall facing east, while the civil officials from the chancellor on down proceeded to the east side of the hall facing west. The master of ceremonies then appointed men to relay instructions to the nine degree of guests. At this point the emperor, borne on a litter, appeared from the inner rooms, the hundred officials holding banners and announcing his arrival. Then each of the guests, from the nobles and kings down to the officials of 600 piculs' salary, was summoned in turn to come forward and present his congratulations, and from the nobles down every one trembled with awe and reverence. . . . With this, the Emperor Gaozu announced, "Today for the first time I realize how exalted a thing it is to be an emperor!"[45]

I have quoted this long passage because it illuminates the political psychology behind the establishment of palace rituals in the early Han and hence explains the urgent need for the Changle Palace. But this palace only provided the ritual occasion with a physical setting; its architecture largely derived from the defunct Qin and could hardly be taken as the proper symbol of the new dynasty. This is why Han historians never tried to explain the architectural symbolism of the Changle Palace, and why all such explanations focused on a new palace built exclusively by and for the Han regime. Unlike the *borrowed* Changle Palace standing beside it, this second palace, the Weiyang Palace completed two years later in 198 B.C., was *designed* as an everlasting monument of Han sovereignty.[46]

> In this place,
> One could look out on Qin Mound,

> Catch a glimpse of North Hill,
> Be embraced by the Feng and Ba Rivers,
> And recline on the Dragon Head Hills.
> They planned a foundation of one million years;
> Ah! An immense scale and a grand construction![47]

The Dragon Head Hills, identified here by Ban Gu as the location of the new palace, is explained by Li Daoyuan in his *Annotated Canon of Waterways* (*Shuijing zhu*):

> From east of the Hangu Pass [in Luoyang] Gaozu ordered Xiao He to construct Weiyang. Xiao He then cut the Dragon Head Hills and built the palace [on it]. The hills, more than 60 *li* long, [are shaped like a dragon] whose head rises twenty *zhang* high and reaches the Wei River, and whose tail gradually declines to five or six *zhang* and stretches to the Fan Valley. . . . It is said that in the past a black dragon emerged from the South Mountain to drink in Wei, and as it passed along the hills it left its mark. The head of the dragon [i.e., the top of the hills] provided Weiyang with a natural foundation. Even without additional construction, it would raise the palace five or six *zhang* above the rest of Chang'an.[48]

Thus, all aspects of the Dragon Head Hills—their shape, height, name, and myth—made them an ideal location for the new imperial palace: standing on top of the hills, this palace overlooked the whole capital area and could be seen from afar. Moreover, the dragon was the general symbol of any Chinese emperor, and a "black dragon" was the specific symbol of the founder of the Han. In fact, on one occasion Gaozu had identified himself as the Black Power,[49] and the official astrologer Zhang Cang (256–152 B.C.) "had calculated the movement of the five elements and had determined that the Han possessed the virtue of water and should follow tradition to take black as its proper color."[50]

The remains of the foundation of the Weiyang Palace (Fig. 3.5a) have repeatedly been surveyed by archaeologists. As demonstrated by the drawing of Carl W. Bishop (Fig. 3.5b), the Dragon Head Hills were carved into a series of terraces, measuring 350 by 200 meters overall, gradually ascending to the north where the major structure of the palace, again called the Anterior Hall, was located.[51] Historically speaking, this layout was modeled

on the terrace palaces popular before the Han. As discussed in the previous chapter, almost all late Zhou feudal lords, and especially the First Emperor, built such structures.[52] Standing on tall earthen platforms, such palaces formed commanding centers of Eastern Zhou cities, accentuating the growing power and self-esteem of the new social elites. It is no coincidence that the first palatial monument of the Han empire took this architectural form, rather than a two-dimensional temple compound that defined the center of a Shang–Western Zhou city.

There was no reason for Gaozu to disapprove of the Weiyang Palace's location. Elevated by a natural hill, the palace, now destroyed, would have been even more eye-catching than the earlier terrace buildings on manmade platforms. But Gaozu was genuinely shocked by the new palace's scale. Reported by both Sima Qian and Ban Gu, the following exchange between the emperor and Xiao He, the chief architect of the new palace, throws much light on the purpose and function of the Weiyang Palace:

> When Gaozu returned and saw the magnificence of the palace and its tower-gates, he was extremely angry. "The empire is still in great turmoil," he said to Xiao He, "and although we have toiled in battle these several years, we cannot tell yet whether we will achieve final success. What do you mean by constructing palaces like this on such an extravagant scale?" Xiao He replied, "It is precisely because the fate of the empire is still uncertain that we must build such palaces and halls. A true Son of Heaven takes the whole world within the four seas to be his family. If he does not dwell in magnificence and beauty, he will have no way to manifest his authority, nor will he leave any foundation for his heirs to build upon." With these words, Gaozu's anger turned to delight.[53]

The significance of this conversation is twofold: on the one hand, it reveals the imperial symbolism of the Weiyang Palace; on the other, it demonstrates the crucial role of civil officers represented by Xiao He in constructing this palace and thus signifies the rise of this political group in the Han government. Sima Qian noted that as soon as Gaozu defeated Xiang Yu and ascended the throne, his attitude toward his ministers and generals changed rapidly. Before the construction of the Weiyang Palace, a court meeting was held to discuss the ranking and enfeoffment of the dynasty's founding ministers. To everyone's surprise, the emperor considered that Xiao He won the highest merit. His generals objected: "Xiao He, who has never campaigned on the sweaty steeds of battle, but only sat here with brush and ink deliberating on questions of state instead of fighting, is awarded a position above us—how can this be?" To this Gaozu answered with a famous analogy: "In a hunt, it is the dog who is sent to pursue and kill the beast. But the one who unleashes the dog and

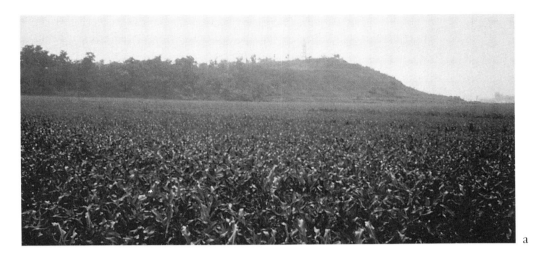

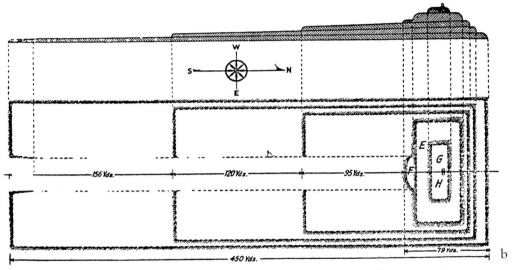

Fig. 3.5. (a) Remaining foundation of the Weiyang Palace. (b) Plan and elevation of the Weiyang Palace foundation.

points out the place where the beast is hiding is the hunts-man. You, gentlemen, have only succeeded in capturing the beast, and so your achievement is that of hunting dogs. But it is Xiao He who unleashed you and pointed out the place, and his achievement is that of the huntsman."[54]

But once the beast had been caught, the hunting dogs would have become superfluous and even potentially dangerous. Han Xin, the general commander of the Han army (?–196 B.C.), once sighed that "when the cunning hares are dead, the good dogs are boiled; when the soaring birds are gone, men put away the good bow; when the enemy states have been defeated, the ministers who plotted their downfall are doomed. The world is now at peace, and so it is fitting that I be boiled!"[55] Han Xin, as well as many other military officers, was indeed executed later; those who were able to consolidate the peaceful state were promoted. One major contribution of this second group of people was to help the founder of the dynasty establish his absolute authority. This role was symbolized by the Weiyang Palace, which they designed and constructed for the emperor. In a way, therefore, this building was also *their* monument and embodied their power. Xiao He, the chief administrator of the project, remained prime minister until his death, and Yang Chengyan, the actual architect of the palace, advanced from ordinary craftsman to lord.[56]

Later books often describe the huge dimensions of the Weiyang Palace and its many buildings. Such records should be used with great caution because this palace, actually a palace complex, was expanded by various rulers throughout the Western Han. The Weiyang Palace during Gaozu's reign, as attested to by Sima Qian and Ban Gu, consisted of little more than three architectural structures: the imposing Anterior Hall and two pillar-gates to its north and east.[57] According to post–Western Han sources, feudal princes entered the east gate to attend court audiences, and low officials and ordinary people used the north gate for petitions.[58] Such functional identifications, however, may have been based on later history, since there is no evidence that the Weiyang Palace was an administrative center during Gaozu's reign. The emperor's only activity in this palace recorded in Han historical writ-ings is a court meeting at the beginning of the ninth year when the palace was completed.[59] This audience, how-ever, was much more casual than the previous one held in the Changle Palace. The main event was a drinking party, during which the high-spirited Gaozu made a toast and addressed his father, the "Venerable Sire," who had been given the title of the Grand Supreme Emperor (Taishanghuang): "You used to think of me as a rascal unable to look after the family fortunes with only half the industry of my older brother, Zhong. Now how do you compare us by our achievements?" His words won a round of applause.[60]

What we find here, therefore, is an interesting contrast between Gaozu's two palaces (Map 3.1): the old palace, Changle, did not possess a distinctive architectural symbolism; its importance was as the site of the first court ceremony. The new palace, Weiyang, on the other hand, was mainly appreciated for its architectural symbolism; the ritual performed inside it became relatively unimportant. Indeed, we find that the significance of the Weiyang Palace lay in itself—in its construction and in its monumental image. As Xiao He stated, it was the construction of the palace that demonstrated Gaozu's mandate, and it was its lasting existence that would signify the regime's immortality. Thus, although this palace was rarely used by Gaozu after its completion and even the yearly audiences—the most important court rituals—were held somewhere else, it laid a "foundation for his heirs to build upon."

These two palaces, along with an arsenal (*wuku*), a granary (*taicang*), and an official market (*dashi*), were among the earliest constructions in Chang'an and formed the core of Gaozu's capital.[61] The founding process of this city thus contrasts sharply with that of a Three Dynasties capital, discussed in the preceding chapter. As recorded in the *Book of Songs*, when the Zhou ancestor Tan Fu began to build his town in the Plain of Zhou, he first "made the *temple* in careful order."[62] This archaic practice, then formulated into the ritual canons,[63] was significantly modified, if not fundamentally violated, by the founder of the Han: what had his first attention was no longer the ancestral temple, but his palace. This change further led to a new definition of a capital. The Eastern Zhou text

The Monumental City Chang'an

Master Zuo's Commentaries on the Spring and Autumn Annals
provides an old gloss: "A city with an ancestral temple
and the symbols of the ancestors is called a capital."[64] But
now it was explained in the Han text *Interpreting Names*
(*Shi ming*) that "a capital is the seat of the emperor."[65]

As the emperor's seat, this new type of capital had
twin centers: the emperor's palace and his tomb (Map 3.1).
This dual structure had emerged in Gaozu's Chang'an:
the palaces (as well as the market, the arsenal, and the
granary) were located south of the Wei River and related
to the living; tombs were built north of the river for the
dead. Gaozu constructed the first Han royal mausoleum
for his father by 198 B.C. near Liyang.[66] His own mauso-
leum, Chang ling, must have been completed by 195 B.C.—
he died in the fourth month in this year and was buried
merely 23 days later.[67] The location of these two tombs
north of the Wei River must not have been a coinci-
dence: a similar pattern seems to have underlaid the plan
of the last Shang capital, Yin. In both cases, a river marked
the boundary between life and death.

This comparison, however, should not be overempha-
sized, because the traditional location of graveyards now
gained a new significance. In the Shang case, the great
mausoleums with their thousands of human sacrifices lit-
erally constituted a realm of death, but during the Western
Han, royal mausoleums were accompanied by "mauso-
leum towns" (*lingyi* or *yuanyi*), which became the nuclei
of highly developed—in fact the most developed—resi-
dential and cultural centers in the whole country.[68] The
first such mausoleum town was Wannian Yi (Town of
10,000 Years), which Gaozu dedicated to his deceased
father. This town was located inside Liyang, the Grand
Supreme Emperor's fief. It is said that before his death the
old man was unhappy living alone in his empty palaces
hundreds of miles away from his hometown of Feng in
Shandong. All the ordinary people and street scenes that he
had enjoyed most—young butchers, pancake stands, liquor
stores, along with cockfighting and football games—were
absent there. When Gaozu learned of this, he ordered
that these people and scenes be transferred from Feng
to Liyang and that the town's name be changed to New
Feng (Xinfeng).[69] After a few years of living in this more

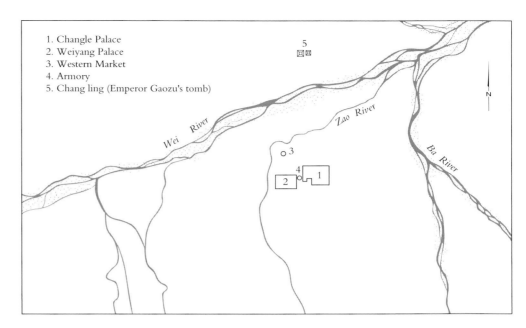

*Map 3.1. Chang'an dur-
ing Gaozu's reign*

comfortable environment, the Grand Supreme Emperor
died in 197 B.C. and was buried in the Wannian ling (Mau-
soleum of 10,000 Years) some 22 *li* north of his city.[70]
The city itself, either part of it or as a whole, was then
dedicated to the deceased as his mausoleum town.[71] It
is said that a thousand rich households were transferred
from all over the country to this town.[72] Moreover, the
Temple of the Grand Supreme Emperor (Taishanghuang
miao) was erected south of the Wei River to hold reg-
ular sacrifices.[73]

Gaozu's own mausoleum was built around the same
time,[74] and this dating explains some interesting similar-
ities between these two royal tombs.[75] Like his father's
tomb, Gaozu's mausoleum was located north of his own
"fief," the imperial Chang'an. Again like his father's mau-
soleum and mausoleum town, which were called Wannian
ling and Wannian Yi, respectively, Gaozu's tomb was
named Chang ling after Chang'an. In his father's case,
the Grand Supreme Emperor's original fief was turned into
a mausoleum town; Gaozu never constructed a specific
mausoleum town for himself before his death.[76] These
parallels may imply that in Gaozu's mind, the palatial city
Chang'an south of the Wei River would eventually be

turned into his own mausoleum town after his death, just as his father's fief had been transformed into Wannian Yi.

This plan, however, was never realized: when his son became the master of Chang'an, a smaller mausoleum town was dedicated to the dynastic founder near his tomb. The emperor was dead, and his proper place was north of the Wei River. But the city of Chang'an continued to grow, and it grew in directions quite different from the vision of its founder.

Emperor Hui and the Walls of Chang'an

Two months after the renovation of the Changle Palace began, Gaozu issued an edict in the eleventh month of 202 B.C. demanding that walls be built around all cities and towns.[77] At that time, the wall of the "city of Chang'an" was identical with that of the palace. According to the Song scholar Cheng Dachang, none of the Qin dynasty pleasure palaces, including the Xingle Palace before it became Gaozu's imperial city, had tall walls; rather, they were surrounded only by short barriers.[78] But a recent survey by Chinese archaeologists shows that the new Changle Palace was encircled by a huge wall some 10 kilometers long; its base was more than 20 meters in cross section, far thicker than the new and more famous "city walls" of Chang'an built after Gaozu's death, during the reign of the second Han ruler, Emperor Hui.[79]

Primary data concerning the construction of Chang'an's new walls can be found in Sima Qian's *Records of the Historian* and Ban Gu's *History of the Former Han*. Both authors, however, seem to have provided inconsistent information. The two relevant passages in Sima Qian's writing read:

The first year of Emperor Hui [194 B.C.], Spring, the first month: they started work on the northwest part of Chang'an's walls. . . . In the third year [192], the construction of Chang'an's walls began.[80]

The construction of Chang'an's walls did not begin till the third year of Emperor Hui; half the walls were finished in the fourth year [191]; and the whole enclosure was completed in the fifth and sixth years [190 and 189]. Feudal

princes came to attend a court audience, celebrating its completion in the tenth month.[81]

Ban Gu's accounts are more detailed, but again seem contradictory:

The first year of Emperor Hui . . . Spring, the first month: The city walls of Chang'an were under construction. . . .

The third year, Spring: 146,000 men and women from the area 600 *li* around Chang'an were called out to build the city walls. The construction lasted for 30 days. . . . In the sixth month, 20,000 convicts were called out from the domains of feudal princes and nobles to built the walls of Chang'an.

The fifth year, Spring, the first month: 145,000 men and women from the area 600 *li* around Chang'an were again called out to build the city walls. The construction again lasted for 30 days. . . . In the ninth month, the walls of Chang'an were completed.[82]

Chang'an was established by Gaozu in his fifth year. The building of its walls commenced in the first year of Emperor Hui, and concluded in the sixth year.[83]

Three confusing points are noticeable; the first two regard the beginning and ending dates of the project, and the third concerns Ban Gu's statement, that the working season of 190 B.C. had ended by the second month, but the city walls were completed in the ninth month. These puzzles, however, can be reasonably resolved. According to my reconstruction of the events, a section of wall was first built northwest of Chang'an in 194. But the systematic construction of the city walls began only in 192 and lasted for about three years. During these three years, the labor force used in the construction included peasants living near the capital and convicts sent from various principalities and prefectures. The former worked only during the slack agricultural season in the first month of the year; the latter must have formed a permanent force. Thus, after the peasants returned home, the convicts continued to work and finally finished the whole project. In the early Han calender, a year began with the tenth month. This means that the walls were completed toward the end of 190, and the celebration took place at the very beginning of 189. This is why Sima Qian and

Ban Gu dated the completion of the project in both years.[84] Moreover, an additional piece of evidence has survived from a lost book called *An Explanation of Han Dynasty Palatial Structures* (*Han gongque shu*): "They built the east city wall in the fourth year, and the north wall in the fifth year."[85] It is possible that the west and south sides were built in the third year (see Map 3.2).

The walls of Emperor Hui's Chang'an have been a major focus of archaeological investigations since the Song dynasty. The most recent result is summarized by Wang Zhongshu, the director of the PRC archaeological team:[86]

> When archaeologists investigated Chang'an's ruins, they found that most of the wall was still exposed above ground. Many wall sections had collapsed, but underground the foundations still remained. According to the two surveys of 1957 and 1962, the east wall was 6,000 m long, the south wall 7,600 m, the west wall 4,900 m, and the north wall 7,200 m. The total length of the four walls was 25,700 m, which corresponds to a little over 62 *li* according to the Han system of measurement. This basically conforms to the recorded 62 *li* in *Han jiuyi* [The old regulations of the Han]. The total area was about 36 square km. The city wall, which was built of rammed yellow earth, was over 12 m high, and the width at its base was 12–16 m. . . . Outside the city wall was a moat, about 8 m wide and 3 m deep. The excavations in 1962 of the area outside the Zhangchengmen Gate clarified the shape of the moat outside the city gate and also proved that wooden bridges were built over the moat.

Based on these investigations, Chinese archaeologists have redrawn Chang'an's outline. The result, shown in Fig. 3.4, which Wang Zhongshu published along with his description, differs only in detail from those of investigators since the eleventh century. In all these drawings, Chang'an is an irregular square with three gates on each side. Only the east wall, however, follows a straight line, and the most irregular part is the northwest section, which appears as a diagonal line with a number of sharp bends. Interestingly, according to the construction sequence proposed above, this part of the wall was built first, in 194 B.C., before the systematic construction began. The east wall was built three years later. The relationship between the

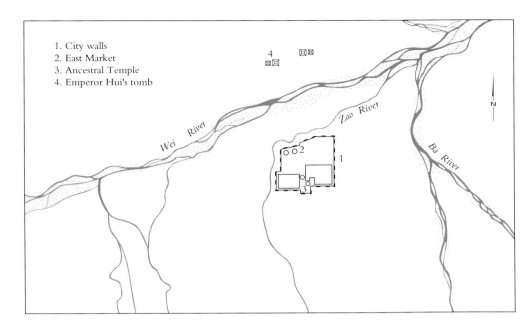

1. City walls
2. East Market
3. Ancestral Temple
4. Emperor Hui's tomb

Map 3.2. Chang'an during Emperor Hui's reign

shape and date of each section is unlikely to be coincidental. It suggests that when the northwest part was built, the builder had not yet developed the notion of shaping Chang'an as a "square" with its four sides corresponding to the four directions. This idea must have only appeared later and then guided the construction of the rest of the walls. The modern scholar Ma Xianxing has also suggested that the northwest section may have been built to stop floods and was then integrated into the whole enclosure.[87] In short, all ancient records and modern investigations lead me to propose that the walls' formal construction began in the third year of Emperor Hui's reign (192), and that this date implies an important change in Chang'an's design and monumentality.

Such a chronological view, however, has been largely neglected in traditional studies of Chang'an; a persistent subject in both ancient and modern scholarship has been the design of the walls as a static whole: Was the shape of the city modeled on the Big and Little Dippers (Fig. 3.6), planned according to certain "grid" systems (Fig. 3.7), or simply based on the area's topography? Without ruling out many insightful observations inherent in such speculations, I would start from a perhaps more essential point:

Why were these walls built? A common interpretation, that the walls were intended to protect the city residents, seems doubtful. As we have learned, Gaozu's "city of Chang'an" already had much stronger walls, and it is hard to imagine that within two years after Gaozu's death, Chang'an's population would have boomed so suddenly that a much larger city enclosure was needed.[88] I will argue later that in fact walled Chang'an remained an "imperial city" throughout the Western Han, and that the growing population of the capital area was concentrated mainly in the suburbs.

The construction of Chang'an's new walls was not an isolated phenomenon. A closer examination of early Han history will disclose that this work was part of a larger project that aimed to give the capital a more traditional and thus more authoritative image. This project, moreover, was related to a profound shift in early Han politics and ideology: namely, that "imperial sovereignty developed from a reliance on force to a dependence on belief and theory; from the seizure of control by armed strength to an initiation of rule backed by religious sanction."[89] This shift had become evident during the later years of Gaozu's reign: the questions faced by the new regime and posed by it had gradually changed from how to conquer the country to how to rule it. Governing methods were increasingly sought in old traditions, and a symbolic system was demanded to support a hierarchical political structure. The two influential figures in this transition were Lu Jia and Shusun Tong.

These two men differed in two ways from Xiao He, the chief designer of Gaozu's Chang'an. First, Xiao He died a year after Gaozu, but both Lu Jia and Shusun Tong lived through the new reign and played important roles in Emperor Hui's court. Second, unlike Xiao He, who was a practical administrator, Lu and Shusun were Confucian scholars with strong interests in history and ceremony. Both believed that only the Confucian tradition could put the country in order and that the past had to be the model for the present. The following passage from Lu Jia's biography sufficiently illuminates his political approach:

> In his audiences with Gaozu, Lu Jia on numerous occasions expounded and praised the *Songs* and the *Documents*, until one day Gaozu began to rail at him: "All I possess I have won on horseback!" said the emperor. "Why should I bother with the *Songs* and *Documents*?"
>
> "Your Majesty may have won it on horseback, but can you rule it on horseback?" asked Lu Jia. "Kings Tang and Wu in ancient times won possession of the empire through

Fig. 3.6. near right The constellations Ursa Major and Ursa Minor superimposed on the plan of Western Han Chang'an

Fig. 3.7. far right Reconstruction of Western Han Chang'an based on an idealized grid system

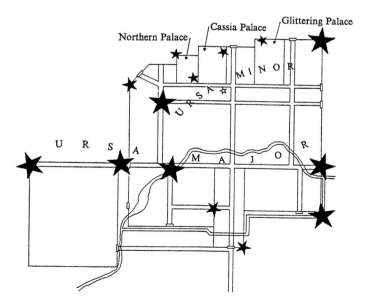

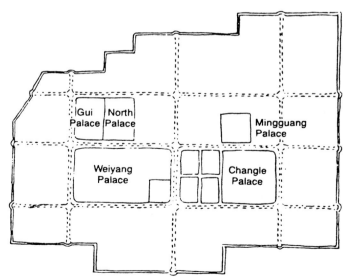

The Monumental City Chang'an

the principle of revolt, but it was by the principle of obedience that they assured the continuance of their dynasties. . . . If the Qin, after it had united the world under its rule, had practiced benevolence and righteousness and modeled its ways upon the sages of antiquity, how would Your Majesty ever have been able to win possession of the empire?"

This conversation ended with Gaozu's requesting Lu Jia's writings on "the successes and failures of the states of ancient times." Later, after Lu Jia had presented the twelve chapters of his *New Discourses* (*Xin yu*) to the throne, "the emperor never failed to express his delight and approval."[90]

Lu Jia's rhetoric is reminiscent of Shusun Tong's words quoted earlier in this chapter: "Confucian scholars are not much use when one is marching to conquest, but they can be of help in keeping what has already been won." As noted earlier, this reasoning led to Gaozu's first court ceremony, in the Changle Palace in 200 B.C. Shusun Tong's influence on the Han court, however, did not stop there.[91] According to his biographers, after 200 he was given the official title "grand ceremonialist" (*fengchang*) and ordered to take charge of all imperial ritual affairs. He set up the rites for ancestral sacrifices and also composed temple hymns. In 198, he was further named by Gaozu tutor of the crown prince. This new position enabled him to influence the next ruler and to take part in the secret arrangements regarding the royal succession. Partially because of a protest by Shusun, Gaozu gave up the idea of changing his heir, and this must explain Shusun's popularity in Emperor Hui's court.[92] As suggested by a number of instances recorded in his biography, the new ruler adopted all his suggestions regarding ritual affairs; his contribution was considered "to have laid a foundation for the various ceremonial procedures of the dynasty."[93]

Lu Jia and Shusun Tong, therefore, represented a new direction in the transformation of the Han court. Whereas in Gaozu's time this transformation was motivated by the desire to promote the emperor's absolute power, in the period leading up to and during Emperor Hui's reign the focus shifted to establishing a political institution backed by traditional ideology and rites. These successive political agendas found their most concrete manifestations and expressions in the changing forms of the dynasty's capital: Gaozu's imposing but isolated palaces symbolized sovereignty; Emperor Hui's Chang'an, with its various parts enclosed by a unifying wall, embodied a large political organization. Gaozu's palaces were modeled on the terrace buildings of powerful Eastern Zhou lords; Emperor Hui's Chang'an derived its form from China's "classical" architectural tradition exemplified by an idealized Zhou capital. The link between *tradition* and the Western Zhou was not accidental; it had been established long ago by Confucius himself: "Oh! How boundless is its refinement; it is the [Western] Zhou that I am going to follow."[94]

This traditionalistic or "classicist" tendency is evident in many of Emperor Hui's activities designed by his chief advisers. This emperor came to the throne at age fifteen. Three years later in 192 he reached adulthood and underwent a "capping ceremony" (*guanli*). This rite is regulated in great detail in Confucian ritual books, and the date of the emperor's ceremony agrees with such regulations.[95] In the same year, he also issued an edict to encourage and reward people practicing filial piety and brotherly love—again an unmistakable sign of his adoption of Confucian ideology.[96] This young emperor was a pupil of Shusun Tong, and all his recorded conversations with his teacher are about ritual affairs. Chang'an's new walls and other structures were constructed during the same period and reflected the same tendency—a contention based on the following observations:

1. The emperor moved into the Weiyang Palace and had the Temple of Gaozu (Gao miao) built east of the throne hall.[97] The juxtaposition of the palace and the temple thus accords with the plan of the idealized Zhou capital recorded in the "Regulations of Workmanship": "On the left [of the imperial palace] is the Ancestral Temple" ("left" means "east" because the emperor faces south).

2. In 189 B.C., a new official market called the West Market (Xishi) was built north of the Weiyang Palace. Its position again agrees with the "Regulations of Workmanship": "In front is the Hall of Audience and behind the markets."

3. Among Emperor Hui's additions to the old palaces

was an icehouse (*lingshi*) inside the Weiyang Palace complex. Such a structure is mentioned in the *Rites of Zhou* as part of the Zhou royal palace.[98]

4. During his reign, Emperor Hui constructed his mausoleum, An ling, to the west (or "right") of Gaozu's mausoleum (Map 3.3).[99] This location seems again to have been determined according to the *Rites of Zhou*: "The burial of the dynastic founder should occupy the central position. Those belonging to the *zhao* sequence in the royal lineage should be buried to its left and those belonging to the *mu* sequence to its right."[100] Emperor Hui was the first *mu* emperor of the Han and was thus buried to the right of his father's tomb.

5. According to the "Regulations of Workmanship" as well as the *Songs* and the *Documents*, the palace, the ancestral temple, and the markets are three essential components of a capital and should be enclosed by city walls. The market and the temple of the Grand Supreme Emperor built by Gaozu were located outside his city of Chang'an. Emperor Hui's city walls, however, installed these parts inside the capital. In fact, the orientations of the walls and the size of the new Chang'an were likely determined by these existing structures: the two palaces provided the east, south, and west walls with a fixed reference, but the north wall had to be extended to the south

bank of the Wei River in order to enclose the temple of the Grand Supreme Emperor (Map 3.2).

6. The new Chang'an's intended square shape, its twelve gates, and the three openings on each gate were also based on the plan offered by the "Regulations of Workmanship": "The royal architect constructs the state capital [of the Zhou]. He makes a square nine *li* on each side; each side has three gates. Within the capital are nine streets running north-south and nine streets running east-west." In fact, it is these gates that clinch a definite relationship between Emperor Hui's Chang'an and the idealized Zhou capital plan: not only do the number and locations of these gates agree with the traditional model, but some of these gates were constructed only for appearance. Most notably, four gates—the Zhangcheng Gate on the west side, the Xi'an Gate and Fuyang Gate on the south side, and the Bacheng Gate on the east side—were very close to the existing Weiyang and Changle palaces. According to archaeological excavations, the distances between these gates and the palaces were a mere 50 meters,[101] and streets running through these gates would have been blocked by the palaces' tall walls or would have become entryways into the palaces.[102]

7. As many scholars have suggested, Gaozu's palaces faced east. This is because according to an old belief, the west was the most honorable position,[103] and the emperor was supposed to face east toward his ministers during an audience. This convention in architectural planning did not disappear after Gaozu's reign (it especially persisted in the design of individual imperial graveyards), but the orientation of the walled Chang'an was changed to face south to tally with the Zhou plan in the "Regulations of Workmanship." This new orientation, which determined the locations of Gaozu's temple, Emperor Hui's mausoleum, and the new market, was emphasized by the establishment of a major avenue running along the city's north-south axis. The An Gate at the south end of this avenue then became the major entrance of Chang'an, and its specific status was indicated by its placement in a unique U-shaped wall section.

The result of these modifications was the new Chang'an illustrated in Map 3.2. This new city, however, was modeled

Map 3.3. Emperor Gaozu's Chang ling mausoleum and surviving satellite tombs (based on Liu Qingzhu and Li Yufang 1987: fig. 2)

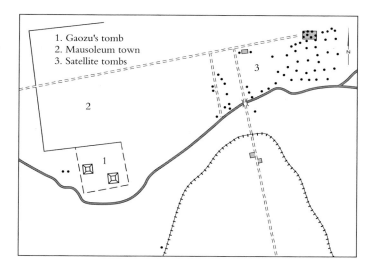

1. Gaozu's tomb
2. Mausoleum town
3. Satellite tombs

The Monumental City Chang'an

on an old architectural plan and restored a traditional sense of monumentality. The towering palaces constructed by Gaozu were now encircled and blocked by double walls; as monuments to sovereignty, they retreated from public sight and again became hidden and secret. With the erection of the walls, Chang'an gained a new measure for its internal structure: an "extrinsic space" was established to control "the relation between independent object systems" and to provide them "with standards of reference for their perceptual features."[104] No single structure claimed an independent monumentality; Chang'an had been transformed into a "monumental city"—an architectural system that synthesized its various parts into a whole. This new Chang'an is described by Ban Gu in his *Western Capital Rhapsody*:

> They erected a metal fortress a myriad spans long,
> Dredged the surrounding moat to form a gaping
> chasm,
> Cleared broad avenues three lanes wide,
> Placed twelve gates for passage in and out.
> Within, the city was pierced by roads and streets,
> With ward gates and portals nearly a thousand.
> In the nine markets they set up bazaars,
> Their wares separated by type, their shop rows dis-
> tinctly divided.[105]

But was Chang'an really turned into a faithful copy of the idealized Zhou capital? The answer is no. Emperor Hui had inherited the old Chang'an, and all he could do was superimpose a traditional structure onto the existing city. The new walls with their twelve gates built by some 320,000 laborers in five years only added a facade to Gaozu's palaces, and the buildings and streets within the enclosure could never be arranged or rearranged satisfactorily to meet the traditional standards. But there is a more profound reason for Chang'an's divergence from an archaic city: China had entered the imperial era, and its capital had to assume new functions and address new needs. Even during Emperor Hui's reign when traditionalism prevailed, it was unmistakably understood that the past could only serve the present; it could never challenge current values. Although a heroic effort was made to give

Chang'an a "classical" monumental image, whenever there was a direct confrontation between tradition and a contemporary need, the latter invariably won out.

Immediately after the new Chang'an came into being, its layout had to be altered somewhat in conjunction with the fundamental change in ancestor worship I have described above. Based on the Zhou code, Gaozu's temple was first built east of the Weiyang Palace close to the newly erected south city wall. Every month a ritual procession conveyed Gaozu's royal crown and robes from his mausoleum north of the Wei River to this temple to receive offerings. The road this procession took was the central north-south avenue. This seemingly well-organized ancestral rite, however, soon began to interfere with the living ruler's activities. Since Emperor Hui had moved into the Weiyang Palace and his mother, the powerful Empress Dowager Lü, occupied the Changle Palace, a raised passageway was built over the central avenue to allow the emperor to travel between these two palaces. The young emperor was thus walking *above* the path leading to his father's temple, and the ritual procession carrying Gaozu's relics had to proceed *beneath* his feet. Such disrespect to the dynasty's founder was intolerable. The conflict was resolved not by tearing down the imperial passageway, but by removing the ancestral temple. In making this decision, the Confucian master Shusun Tong once again demonstrated his flexibility:

> The ruler of men never makes a mistake! The walk is already built, and the common people all know about it. Now if Your Majesty were to tear it down, it would be admitting that you had made a mistake in the first place. I beg you instead to set up a second funerary temple north of the Wei River to which the late emperor's robes and caps may be taken each month. To enlarge or increase the number of ancestral temples is after all the beginning of true filial piety![106]

Shusun's message is clear: the Zhou capital plan was not absolute and should be revised according to the demands of realpolitik. The primary criterion for an adjustment was the authority of the living emperor, not tradition. Nevertheless, such an adjustment should still be based on

Confucian ideology: since filial piety provided the rationale for the relocation of Gaozu's temple, the revision of tradition was supported by tradition itself.

This event, which marked a crucial step in the transition of the religious and social center from temple to tomb, was related to two other equally important events that took place during or immediately after Emperor Hui's reign. The first was the establishment of the *peiling* (satellite tomb) system; the second, the construction of a series of mausoleum towns. As a result, a new type of imperial mausoleum became the center of religious and secular life and fundamentally changed the structure of the capital city.

Gaozu's prime minister, Xiao He, died in the second year of Emperor Hui's reign (193 B.C.). He was buried immediately outside the main gate of Gaozu's Chang ling mausoleum beside the imperial funerary path.[107] Three years later in 190, Cao Can, another chief minister of Gaozu, passed away. Like Xiao He, he was from the same town as the dynastic founder, and he succeeded Xiao as prime minister in 193. His tomb was next to Xiao He's to the east of Chang ling. More founding ministers were buried there during the following years of Emperor Hui's

and Empress Dowager Lü's reigns; among them were Zhang Liang, the Marquis of Liu (d. 189) and the Right Chief Minister and Grand Tutor Wang Ling (d. 181).[108] Such practices contradict the old tradition, in which the legitimate place of one's tomb was the family graveyard. The change must signify a new belief that emerged simultaneously with the birth of imperial China: to have one's tomb located near a deceased emperor was a great honor, and a minister's relation with the ruler surpassed his relation with his close kin. Supported by this new belief and the corresponding political concept, the number of satellite burials continued to increase throughout the Han. A present-day visitor to Chang ling would find some 63 pyramid-shaped tumuli crowded east of Gaozu's burial (Map 3.3), 12 tumuli near Emperor Hui's funerary park, and as many as 72 tombs around Emperor Wu's mausoleum, Mao ling (Map 3.4).[109] Some of these satellite tombs have been excavated, and their scale has amazed the excavators. The tomb of General Zhou Bo (d. 169) near Chang ling, for example, had an entranceway about 100 meters long, and from the ten sacrificial pits south of the grave chamber alone came 2,400 figurines, including more than 1,800 foot soldiers and 580 horsemen (Fig. 3.8).[110] The recent discovery of similar figurines from sacrificial pits near Emperor Jing's tomb allows us to realize the imperial model of such burial practices (Fig. 3.9). Indeed, accompanying and mirroring an emperor's tomb, each satellite burial was itself a small mausoleum.

As we have observed, Gaozu did not build a specific mausoleum town for either his father or himself. The tradition of constructing such towns began in 182 B.C., when Empress Dowager Lü, Gaozu's widow and Emperor Hui's mother, dedicated Chang Ling Yi (Chang Ling Town) to her departed husband.[111] Located north of the emperor's funerary park, this rectangular walled town was 2,200 meters north-south and 1,245 meters east-west (Map 3.3).[112] The town attached to Emperor Hui's mausoleum was similarly situated north of the emperor's funerary park and measured 1,548 meters in its longitudinal dimension.[113] The importance of these and other mausoleum towns, however, lay not in their size but in their residents. Surprisingly, we find that people living there

Fig. 3.8. Painted clay figurines. Western Han. Ca. 179–141 B.C. H. 68.5 cm. Excavated in 1960 at Yangjiawan, Xianyang, Shaanxi province. Xianyang Museum.

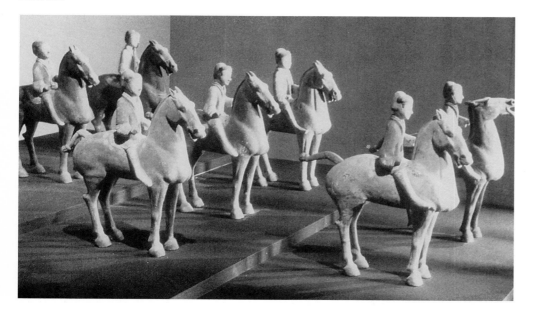

were not workers, royal servants, or ceremonial officials but members of old provincial clans and new aristocratic families. Those who dwelled in Gaozu's posthumous town were mainly descendents of the Tian clan from the former kingdom of Qi in Shandong, and those in Emperor Hui's town belonged to the Yuan, Ji, Hong, and Ban clans of the former state of Chu in the Yangzi River region.[114] Students of early Chinese history are well acquainted with these names: from Zhou times on these and other powerful clans had dominated the country's various regions and fought one another for local or central power. The establishment of such mausoleum towns near Chang'an, therefore, was not purely a ritual practice but had profound political implications.

In fact, the plan to move such powerful clans from the provinces to the capital had been implemented by Gaozu. The designer of this plan was again Lou Jing or Liu Jing (who had been granted the royal surname Liu for suggesting the dynasty's capital be established at Chang'an). Upon the completion of the Weiyang Palace in 198, Liu Jing gave the emperor another piece of advice:

Now, although Your Majesty has established the capital within the Pass, there are in fact few people in the area. Close to the north are the barbarian bandits, while in the east live those powerful clans of the Six States of former times, so that if some day trouble should arise somewhere, I fear you could never rest with an easy mind. I beg therefore that you move the various members of the Tian clan of Qi, the Zhao, Qu, and Jing clans of Chu, the descendents of the former royal families of Yan, Zhao, Han, and Wei, and the other powerful and renowned families to the area within the Pass. As long as things are going well, they can defend the area against the barbarians, and if there should be disaffection among the feudal lords, they would form an army which could be led east and used in putting down the trouble. This is the type of strategy known as "strengthening the root and weakening the branches" of the empire.[115]

Once more he convinced Gaozu, and the emperor sent him to supervise the relocation of over 100,000 persons to the capital area. When Gaozu and Emperor Hui's mausoleum towns were built, at least part of these immigrants were further transferred there.

The impact of this plan on Han politics is beyond the scope of the present discussion. Our focus is its profound

Fig. 3.9. Painted clay figurines (originally dressed with clothes made of fabric). Western Han. 143 B.C. H. ca. 62 cm. Excavated in 1989 near Emperor Jing's Yang ling mausoleum at Zhangjiawan, Xianyang, Shaanxi province. Shaanxi Provincial Institute of Archaeology, Xi'an.

Map 3.4. Emperor Wu's Mao ling mausoleum and surviving satellite tombs (based on Kaogu 64.2: 87)

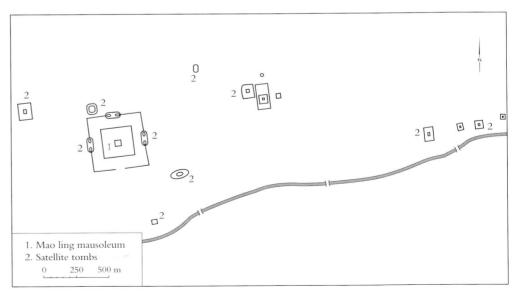

1. Mao ling mausoleum
2. Satellite tombs

0 250 500 m

influence on the development of Chang'an. Gaozu's massive relocations were repeated by later emperors. As a direct consequence, a large population was gradually concentrated in mausoleum towns in Chang'an's outskirts. By the end of the Western Han, altogether eleven such walled towns had been built near the tombs of deceased emperors and their parents.[116] A national census conducted in A.D. 2 shows that Gaozu's Chang Ling Town had 179,469 residents and that 277,277 people lived in Emperor Wu's Mao Ling Town.[117] Two modern Chinese scholars, Liu Qingzhu and Li Yufang, have suggested that these numbers are conservative, and that Emperor Xuan's Du Ling Town should have had at least 300,000 residents (Map 3.5).[118] Significantly, this census also informs us that the walled city of Chang'an had 246,200 residents—even fewer than the mausoleum towns attached to Emperor Wu's and Xuan's tombs.[119]

The residents of these mausoleum towns were from the richest and most renowned families in the country. Many of them were descendents of kings and lords of the previous dynasties and feudal kingdoms. The great concentration of wealth in these towns was further encouraged by Emperor Wu. Following the strategy of "strengthening the root and weakening the branches of the empire," he three times ordered rich provincial families, each possessing over three million cash, to move into his own mausoleum town.[120] It is said that a well-known official named Guo Jie wished to join those privileged immigrants, but his family fortune did not meet the requirement. Only with his colleagues' help did he finally accumulate more than ten million cash and fulfill his desire.[121] Han history records that in the same town the Zhi family was the "richest family under Heaven," that the Ma family possessed billions of cash, and that the Yuan family employed more than a thousand servants. These families were the largest merchants and financial magnates in the country.[122]

The economic strength of the mausoleum towns was matched by their political and cultural influence. During the Western Han, these towns became the main sources of high officials and leading literati. Chang Ling Town yielded two prime ministers, Tian Fen and Che Qianqiu; from An Ling Town came powerful courtiers Ji Ru and Hong Ru, as well as the famous historians Ban Biao, Ban Gu, and Ban Zhao. Three important literary figures— the Confucian theologian Dong Zhongshu, the historian Sima Qian, and the poet Sima Xiangru—lived in Mao Ling Town; and Emperor Zhao's Ping Ling Town produced four prime ministers and a large crowd of scholars. As for Emperor Xuan's Du Ling Town, almost all important officials of the time lived there, and it became a chief political center outside Chang'an. This is the reality behind the following stanza of Ban Gu's *Western Capital Rhapsody*:

> If then
>> One gazes upon the surrounding suburbs,
>> Travels to the nearby prefectures,
>> Then to the south he may gaze on the Du and
>>> Ba Mausoleums,
>> To the north he may espy the Five Mausoleums,
>> Where famous cities face Chang'an's outskirts,
>> And village residences connect one to another.
>> It is the region of the prime and superior talents,
>> Where official sashes and hats flourish,

Map 3.5. Emperor Xuan's Du ling mausoleum and surviving satellite tombs (based on Liu Qingzhu and Li Yufang 1987: fig. 7)

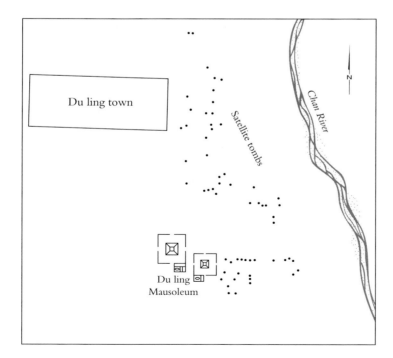

Where caps and canopies are as thick as clouds.
Seven chancellors, five ministers,
Along with the powerful clans of the provinces
 and commanderies,
And the plutocrats of the Five Capitals,
Those selected from the three categories, trans-
 ferred to seven locations,
Were assigned to make offerings at the mau-
 soleum towns.
This was to strengthen the trunk and weaken the
 branches,
To exalt the Supreme Capital and show it off to
 the myriad states.[123]

What Ban Gu described here certainly had not hap-
pened during Emperor Hui's reign. Nevertheless, the es-
tablishment of the first two mausoleum towns and the
system of satellite burials implied such a far-reaching de-
velopment. Reviewing Emperor Hui's construction or
reconstruction of Chang'an, we find that a new hierar-
chical structure had begun to emerge. The walled imperial
city now symbolized the institutionalization of the Han
regime. Inside this city were palaces, government depart-
ments, offices of princes, foreign embassies, and sacrificial
and commercial centers. Surrounding it were a number
of satellite towns attached to the individual emperor's
mausoleum. Each of these royal mausoleums formed a
secondary political and social center and was accompanied
by satellite tombs of high officials and royal relatives. These
satellite tombs again had their own walled enclosures
and satellite burials, mirroring descending levels of social
organization.

This hierarchical architectural design, which trans-
lated the new social and political structures into visual,
monumental forms, was never static and always reflected
the dynasty's own history. Surrounding the throne-city
Chang'an as an embodiment of China's lasting tradition,
individual imperial mausoleums with their huge pyramids
documented the dynasty's own past. It was understood
that as long as the Han's mandate continued, the number
of such pyramids would grow, more satellite towns and
burials would appear to exalt the Supreme Capital City,
and the whole capital would develop "as the 28 constella-
tions revolving about the North Star, and as the 30 spokes
of a wheel coming together at the hub, revolving end-
lessly without stop."[124]

Emperor Wu's Fictional Garden

Emperor Hui and Empress Dowager Lü were followed
by Emperors Wen (180–157 B.C.) and Jing (156–141).
Chang'an's rapid expansion suddenly halted, mainly be-
cause of a new economic policy of drastically reducing
taxation and government expenses.[125] Indeed, this policy
gave these two emperors a reputation as frugal sovereigns
ready to sacrifice luxuries for themselves for the good of
the public. Emperor Wen, for example, "made no move
to increase the size of the palaces or halls, the parks or
enclosure, or the number of dogs and horses, vestments
and carriages. Whenever a practice proved harmful, he
immediately abandoned it in order to ensure benefit to
the people." It is said that this emperor once thought
of constructing a terrace and called in a builder to discuss
the matter. When he was told that the structure would
cost 100 catties of gold, he cried out in rage: "A hundred
catties of gold is as much as the wealth of ten families
of moderate means! Since I inherited the palaces of the
former emperors, I have constantly been afraid that I might
dishonor them. What business would I have in building
such a terrace?"[126]

It is questionable, however, to what extent we can trust
this and similar records, which often have a strong flavor
of publicity stunts.[127] We do not know whether Emperor
Wen indeed forbade any additions to the palace, but we
do know about his tomb. His testamentary edict, a public
document recorded in both the *Records of the Historian*
and *History of the Former Han*, begins with a philosophical
statement:

I have heard that of all the countless beings beneath heaven
 which sprout or are brought to life, there is none which
 does not have its time of death, for death is a part of the
 abiding order of heaven and earth and the natural end of
 all creatures. How then can it be such a sorrowful thing?
 Yet in the world today, because all men rejoice in life and
 hate death, they exhaust their wealth in providing lavish

burials for the departed, and endanger their health by prolonged mourning. I can in no way approve of such practices.[128]

What this edict does not state, however, is that his mausoleum was the only Han imperial tomb dug into a mountain cliff and that he planned his burial rite in great detail before his death. The plan called for the Chief Military Commander Zhou Yafu to be appointed General of Carriage and Cavalry to direct the funerary procession; Director of Dependent States Xu Han to be the General of Encampment to administer the mausoleum town; and Chief of Palace Attendants Zhang Wu to assume the title of the General of Replacing the Grave Earth (in charge of the interment of the emperor's coffin and the excavation and replacement of the rock in the tomb's tunnel). Sixteen thousand soldiers from nearby districts and 15,000 additional soldiers from the whole capital area would serve at the funeral.[129]

Thus, whereas under Emperors Gaozu and Hui the construction of Chang'an was publicly stressed, under Wen and Jing it was deliberately played down. What we find here is that although the establishment of a monumental palace or city could effectively attract public attention, a loud refusal to engage in such "excessive construction" could play a similar role in shaping public opinion toward the emperor and the government. This second strategy, however, had to be presented as the antithesis of the first and required a reinterpretation of the earlier monuments. Its unspoken premise was that a palace or a mausoleum possessed no public, political function and exclusively served a ruler's private desires. Since the professed goal of Wen and Jing was to stabilize the country by practicing thrift, they could gain greater authority by rejecting such desires: in this way they became not only political leaders but also moral exemplars.

These two emperors, therefore, altered the meaning of Chang'an's palatial monuments by *opposing* such buildings to the public good. Once their rhetoric was widely accepted, it led to a new movement in the further construction of the capital: the next ruler, Emperor Wu, erected numerous structures of monumental scale both inside and outside Chang'an, but unlike Gaozu's Weiyang Palace

and Emperor Hui's city walls, these buildings were overtly constructed as the emperor's "personal" symbols and property to help fulfill his dream of immortality.

A fascinating figure in Chinese history, Emperor Wu began his career as a young, vigorous, strong-willed, and intelligent ruler. The abundant wealth accumulated during the peaceful reigns of his predecessors[130] and the extraordinary length of his tenure (54 years) provided him with more than enough time and resources to attain his goals. It was during his reign that the Han armies drove across the wastes of Central Asia to the fringes of the Western world, where, on one occasion, Chinese soldiers confronted Roman legions. It was also under his sponsorship that the Confucian Five Classics first gained official recognition at court. Hundreds of Daoist necromancers gathered around him to cultivate methods for achieving immortality, and the emperor left traces on all the sacred mountains throughout his vast empire. The same vigor and ambition are also evident in his construction of Chang'an (Map 3.6). The old Weiyang and Changle Palaces were redecorated and rebuilt.[131] Three huge new palace complexes—the Mingguang Palace (Palace of Brilliant Light), the Gui Palace (Cassia Palace), and the Bei Palace (Northern Palace)—finally filled up the interior of walled Chang'an, hitherto largely empty.[132] The enormous Shanglin Park with its many palatial halls was established west and southwest of the capital city, and the Ganquan Palace (Palace of Sweet Springs), a huge sacrificial center nineteen *li* in circumference, was founded in the northwest.[133] The emperor also built for himself the largest mausoleum and mausoleum town; the pyramid remaining above his tomb is still 46.5 meters tall.[134]

But what was Emperor Wu's exact role in these achievements? Historians have concluded that many of the social and political reforms attributed to the emperor were based on initiatives of people under his patronage.[135] It was Dong Zhongshu (179–104 B.C.) who convinced the emperor to establish Confucianism as the state ideology, Sang Hongyang (141–80) who engineered the emperor's economic policies, and Wei Qing (?–106) and Huo Qubing (140–117) who led the emperor's army to Central Asia.

A similar but subtler situation is also apparent in Emperor Wu's construction of his capital. The numerous architectural projects carried out during his reign shared two essential features. First, the traditional Confucian capital plan had lost its attraction, and Emperor Wu launched a search for new monumental forms. Second, neither practical administrators (like Xiao He) nor Confucian scholars and ceremonialists (like Lu Jia and Shusun Tong) were able to provide inspiration for such new structures; instead, the emperor's vision of Chang'an was strongly influenced by "magicians"—*necromancers* who played at conjuring and *writers* who played with words. Through the emperor, the fantasies of these two groups of men gained material form.

Necromancer is a loose translation of the Chinese term *fangshi*, which literally means "gentlemen from outlying areas."[136] Since the Eastern Zhou period the region along China's northeast seacoast, notably Yan and Qi around the Bohai Gulf, had been a center of professional diviners, doctors, and magicians who earned a livelihood by practicing exorcism, medicine, and divination.[137] But it was not until Emperor Wu's reign that such men deeply penetrated the central court. Their promises of immortality and longevity gave the emperor the hope of infinitely prolonging his rule, and in helping the emperor achieve this goal they also gained, though often briefly, personal wealth and high official status. Traditional Confucians frequently criticized their learning as "weird and unorthodox" and their search for patrons as "flattery and ingratiation." But such criticism only signifies that these "gentlemen from outlying areas" represented a cultural tradition distinct from orthodox Confucianism. In Kenneth De-Woskin's words, they "dealt most persistently with areas Confucius refused to discuss, namely, strange events, spirits, and fate," and their impact was "a dramatic diffusion of nontraditional knowledge and interests into the highly centralized, literate, and essentially conservative court mainstream."[138]

A number of instances recorded in the *Records of the Historian* enable us to observe these shadowy figures more closely and to detect their influence on Emperor Wu's architectural plans. The first to be favored by the emperor

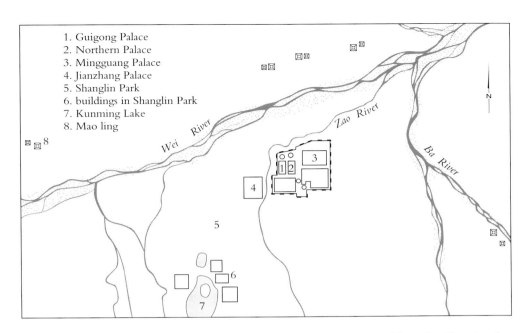

1. Guigong Palace
2. Northern Palace
3. Mingguang Palace
4. Jianzhang Palace
5. Shanglin Park
6. buildings in Shanglin Park
7. Kunming Lake
8. Mao ling

Map 3.6. Chang'an during Emperor Wu's reign

was Li Shaojun from Qi.[139] In his travels to various principalities and finally to the emperor's court, Li Shaojun successfully convinced his audience that he had achieved longevity and possessed the power of driving away death. His secret, he claimed, was that he had once reached the immortal island Penglai in the eastern sea, where Master Anqi (Anqi Sheng) fed him an elixir in the shape of jujubes as big as melons. He told the emperor that "Master Anqi is an immortal who roams about Penglai. If he takes a liking to someone, he will come to meet him, but if not he will hide." Stimulated by these words but too impatient to wait, the emperor dispatched teams of magicians to search for the island and its inhabitants. But as Li Shaojun had cleverly hinted, all the searches failed because the immortal was annoyed by this human intrusion.

Sima Qian attested that "after this, any number of strange and dubious magicians from the seacoast of Yan and Qi appeared at court to speak to the emperor about supernatural affairs. Among them was a man from Bo named Miu Ji who instructed the emperor on how to sacrifice to the Great Unity."[140] Following Miu Ji's teaching, Emperor Wu erected a shrine or altar southeast of

Chang'an to worship this deity. Around 121, another necromancer named Shao Weng entered the scene.[141] Emperor Wu had just lost one of his favorite consorts, and Shao Weng promised to make her reappear before the emperor's eyes. The magician then performed, perhaps for the first time in Chinese history, a shadow-puppet play: the emperor was asked to sit behind a curtain, and from there he saw the silhouette of his beloved consort projected onto a curtained screen. The success of this venture brought Shao Weng many gifts from the emperor, along with the title "general of peaceful accomplishments" (*wencheng jiangjun*), and led to another more important proposal, the construction of the Ganquan Palace:

> "I perceive that Your Majesty wishes to commune with the spirits. But unless your palaces and robes are patterned after the shapes of the spirits, they will not consent to come to you." . . . [Shao Wang] thus directed the emperor to build the Ganquan Palace, in which was a terrace chamber painted with pictures of Heaven, earth, the Great Unity, and all the other gods and spirits. Here Shao Weng set forth sacrificial vessels in an effort to summon the spirits of Heaven.[142]

It was from this time that the Ganquan Palace, located some 60 km northwest of Chang'an, began to grow into a huge religious center. In 116 B.C., an ancient *ding* tripod was found in Fenyin and was considered an extraordinarily auspicious omen from Heaven. The divine object was brought to Ganquan, where Emperor Wu greeted it in person.[143] In 112, an altar for worshipping the Great Unity was added to the palace. Modeled on the older one designed by Miu Ji, it had three levels and was surrounded by smaller altars dedicated to the Five Powers.[144] This project, however, was only a prelude to more intensive construction on a far greater scale. According to Sima Qian, "Emperor Wu started to enlarge the various palaces" at Ganquan from 109.[145] The new buildings included a pair of tall pavilions called Benefiting Life (Yishou) and Prolonging Life (Yanshou), as well as a terrace named Communing with Heaven (Tongtian).[146] It is said that this terrace, more than a hundred *zhang* high, pierced the clouds. During the rituals held there to summon heavenly

spirits, 300 eight-year-old boys and girls danced while singing a variety of songs. The building was thus also called Waiting for Divinities (Houshen) or Longing for Immortals (Wangxian).[147] According to historical records, all these new buildings and rituals were inspired by a necromancer from Qi called Gongsun Qing, who had made an important proposal to Emperor Wu earlier that year.

> "It is quite possible to meet with the immortals. It is only that Your Majesty always rushes off in great haste to see them and therefore never succeeds. Now if you would only build some turrets like those on the city wall of Gou [where Gongsun Qing had previously observed the traces of the immortals] and set out dried meat and jujubes, I believe that spirits could be induced to come, for they like to live in towers!"[148]

It is interesting to compare this statement with Xiao He's reasoning for Gaozu's Weiyang Palace, which was also a "terrace building" of unusual height: "A true Son of Heaven takes the whole world within the four seas to be his family. If he does not dwell in magnificence and beauty, he will have no way to manifest his authority." Emperor Wu's imposing terraces and palaces, however, were made not for the human ruler but for supernatural beings who "like to live in towers." Indeed, all the architectural projects promoted by necromancers shared a single premise: compared with the spirits, human beings were infinitely inferior; even the Son of Heaven was no exception. "The immortals do not seek for the ruler of men; it is the ruler who must seek for them!"[149] In order to establish contact with the immortals and to eventually become one of them, the ruler had first to please them—he had to act like a humble student, to learn *their* language, to become familiar with *their* likings and habits, and to offer *them* suitable dwellings as well as food and drink. The necromancers became extremely powerful because they alone controlled this knowledge; thus Luan Da, another magician from Qi, could even put pressure on the emperor: "My [divine] teacher has no reason to seek for men. It is men who seek for him. If Your Majesty really wishes to summon him, then you must first honor his passenger [i.e., Luan Da himself], making him a member

of the imperial family, and treating him as a guest rather than a subject, doing nothing that would humiliate him."[150] Emperor Wu met all his demands.

Luan Da's words reveal another important aspect of the necromancers' rhetoric: all claimed acquaintance with the immortal world through intimate personal experience. Li Shaojun claimed to have met Master Anqi at Penglai; Miu Ji possessed a magical formula from the Great Unity; Luan Da was a disciple of an immortal and "frequented the magical island in the ocean"; and Gongsun Qing, among his many miraculous adventures, had encountered a Great Man several *zhang* tall in Eastern Lai. According to them, the immortal paradise was neither an abstract idea nor a fairy tale, but a concrete realm that they had seen and could describe vividly. For example, the immortal island Penglai consisted of three island-mountains; all the birds and animals were pure white, and all palaces and gates were made of gold and silver. From afar, the mountains looked like clouds, but, as one drew closer, they seemed instead to be submerged beneath the water.[151] These and other vivid images became the models for architectural designs and decoration, since in order to induce the spirits, a "likeness" of the immortal world had to be reconstructed and duplicated.

From this we can understand the "nonfictional" nature of the necromancers' teaching. Although their tales would eventually become the material of the post-Han literary genre *zhiguai* (records of oddities),[152] what were perceived later as fictions and marvels were first presented as real things and real events. The "truthfulness" of their reports was supported by the reporters' assertions of the empirical origins of their knowledge, which demanded that their audience not only listen but, more important, *believe*. "Belief" thus became a central factor in their rhetoric. As Gongsun Qing insisted: "When men discuss spiritual matters, their words are apt to sound wild and irrational, but if these matters are pursued for a sufficient number of years, the spirits can eventually be persuaded to come forth!"[153] Such propositions, however, also put the necromancers themselves at risk, because they had offered what they could not afford to offer. Their assertion, that their tales were nonfictional, had to be confirmed not only by

internal proofs but also by real happenings—the arrival of the immortals—which unfortunately never occurred. Consequently, Emperor Wu's necromancers were executed one by one, and their "factual reports" exposed as fabrications; the elaborate halls at Ganquan and other places remained empty, the portrayals of immortals and divinities lifeless.

The modern scholar Kendall Walton has offered a simple but effective formula to distinguish fiction from nonfiction: "What is true is to be believed; what is fictional is to be imagined."[154] It is exactly at this conjunction that necromancers and writers—another inspiration for Emperor Wu's architectural ventures—were set apart. The rhetoric of necromancers, as I have just shown, is based on the principles of truth and belief. The works of writers, on the other hand, aim to construct a fictional world that has no need of external proofs. The main support of this fictional world, according to Walton, is not belief but imagination: "The imagination is meant to explore, to wander at will through our conceptual universe. In this respect imagination appears to contrast sharply with belief. Beliefs, unlike imaginings, are correct or incorrect. Belief aims at truth. What is true and only what is true is to be believed. We are not free to believe as we please. We are free to imagine as we please."[155]

To apply this theory to the Han situation, necromancers constantly failed because their claims could easily be proved groundless. They thus became martyrs of their own propaganda. But this did not mean that the road toward transcendence was entirely blocked, since immortality could be the subject not only of religious belief but of literary imagination. In fact, during the long years of his search for immortality, Emperor Wu never allowed any opportunity to pass by. Even though one necromancer after another failed to help him and all his envoys to Penglai returned empty-handed, he was still willing to "believe" anyone who came with a magic wand. But the failure of this sort of adventure also forced him to pay increasing attention to the alternative and safer path: one might not be able to *encounter* the spirits and receive their elixir, but one could certainly *imagine* such an encounter. Better yet, one could create an immortal world on earth and place

oneself at its center. Thus, while searches for the "real" immortal land continued, the creation of a "fictional" paradise was speeded up. Unlike the searches, which demanded passivity and patience, the creation of this manufactured paradise was exciting and even fun. The difference between the two is similar to that between waiting on the seashore for a mirage and making a sand castle; in the Emperor Wu's case, the "castle" required far greater imagination and took him more than 30 years to complete. As in many other cases, the imagination was supplied by one of his advisers, who happened to be the most celebrated poet of the Han.

Two events took place shortly after 138 B.C., the year Emperor Wu reached adulthood and was able to exercise his authority in a fuller capacity. First, he re-established the imperial Shanglin Park southwest of Chang'an; and second, he read a *fu* rhapsody describing the great hunting parks of the states of Qi and Chu. In this work (which has fortunately survived), Chu's Cloudy Dream Park (Yunmeng) is said to measure 900 square *li*; a great mountain in the center winds and twists upward and invades the blue clouds. Precious plants and strange animals are found inside the park, and the Chu prince, driving a quadriga of tamed hippogriffs and riding a chariot of carved jade, holds his hunting parties there. The royal park of Qi, on the other hand, is so large that it could swallow eight or nine of Yunmeng Park, which "would not even be a splinter or straw in its throat." [156] The poem gave the young emperor such a strong impression that upon finishing it he sighed: "What a pity that I could not have lived at the same time as the author of this!" He did not wish to have been born a lord of Chu or Qi—he was the Son of Heaven with far greater power. What he hoped was to know the man who *represented* these fantastic parks in such elaborate words.

To the emperor's astonishment, the author of the rhapsody was a contemporary figure—an imperial dog trainer from Sichuan attested that it was written by a man named Sima Xiangru (179–117 B.C.) from his province. Xiangru was immediately summoned to the capital and received by the eager ruler. To His Majesty's great delight, the poet, who appeared to be a man of unsurpassed elegance, volunteered to compose another rhapsody for the throne. "My earlier piece concerns the affairs of the feudal lords and is not worthy of Your Majesty's attention. If I may be permitted, I would like to compose a new prose poem about your own imperial park." This new composition, entitled *Rhapsody on the Shanglin Park* (*Shanglin fu*), is a sequel to the earlier one: its narrator, Lord No-such (Wang-shi Gong),[157] first concludes the debate about the superiority of the Qi and Chu parks and then begins his discourse on the Han royal garden:[158]

> Chu has lost its case, but neither has Qi gained anything to its credit. . . . Have you not seen what is truly great and beautiful? Have you alone not heard of the Imperial Park of the Son of Heaven?

> To its left is Verdant Parasol,
> To its right is Western Limits;
> The Cinnabar River traverses its south,
> The Purple Gulf intersects its north.[159]

The park's territory defined here demands some discussion. Verdant Parasol, or Cangwu, is a mountain located on China's east coast;[160] Western Limits, or Xiji, indicates the western terminus of the world. Cinnabar River (Danshui) and Purple Gulf (Ziyuan) are two watercourses found in the mythical text *Classic of Mountain and Seas* (*Shanhai jing*); one flows into the South Sea, and the other originates in the Genqi Mountains in the far north.[161] Within this imaginary enclosure:

> Gazing about the expanse of the park
> At the abundance and variety of its creatures,
> One's eyes are dizzied and enraptured
> By the boundless horizons,
> The borderless vistas.
> The sun rises from the eastern ponds
> And sets among the slopes of the west;
> In the southern part of the park,
> Where grasses grow in the dead of winter
> And the waters leap, unbound by ice,
> Live zebras, yaks, tapirs, and black oxen,
> Water buffalo, elk, and antelope,
> "Red-crowns" and "round-heads,"

Aurochs, elephants, and rhinoceroses.
In the north, where in the midst of summer
The ground is cracked and blotched with ice
And one may walk the frozen streams or wade the
 rivulets,
Roam unicorns and boars,
Wild asses and camels,
Onagers and mares,
Swift stallions, donkeys, and mules.

The park thus possesses all manners of beasts from the four quarters of the world; one can similarly find all sorts of fish and birds in its eight swirling rivers and Cinnamon Forests. But the park is certainly not a wild zoo; as the garden of the Son of Heaven, it features the most exquisite buildings for human pleasure.

Here the country palaces and imperial retreats
Cover the hills and span the valleys,
Verandas surrounding their four sides;
With storied chambers and winding porticoes,
Painted rafters and jade-studded corbels,
Interlacing paths for the royal palanquin,
And arcaded walks stretching such distances
That their length cannot be traversed in a single day.
Here the peaks have been leveled for mountain halls,
Terraces raised, story upon story,
And chambers built in the deep grottoes.
Peering down into the caves, one cannot spy their
 end;
Gazing up at the rafters, one seems to see them
 brush the heavens;
So lofty are the palaces that comets stream through
 their portals
And rainbows twine about their balustrades.

The reliability of Xiangru's description of the Shanglin Park was questioned by the poet's contemporaries. Sima Qian, who first recorded this work in his *Records of the Historian*, remarked that "the extravagant language of the poet overstepped the bounds of reality and displayed too little respect for the dictates of reason and good sense."[162] Later historians, however, often took the opposite position, either trying to find evidence for the poem's historical credibility or attempting to reconstruct the park based

on the rhapsody.[163] In so doing, they have ignored the *fictionality* of this work, which, in my opinion, the Song scholar Cheng Dachang explains best:

When Lord No-such describes the Shanglin Park, he is actually talking about the whole world within the four seas. In defining the park's boundary, he refers to the Verdant Parasol to the east and Western Limits to the west. In setting the four directions, he says that the sun and moon rise from the eastern ponds and descend among the western slopes. In the south, plants grow in the dead of winter and waters leap and wave, while in the north, the ground is cracked and blotched with ice in the midst of summer, and one can walk the frozen streams and wade the rivulets. When he lists the places where the emperor's hunting team reaches, he tells us that "the Yangzi and Yellow Rivers are the corral and Mount Tai is the lookout tower." All of these are meant to show that the world is within the park of the Son of Heaven, and that Qi and Chu's proud gardens are both encompassed by it. . . . Lord No-such describes this park as real, so how can it be not real? Later people have tried to examine the truthfulness and faultiness of the poem against the actual Shanglin—indeed one cannot talk about a dream in front of idiots![164]

Cheng Dachang also observes in another essay:

When Xiangru was writing his rhapsody on Shanglin, he stated clearly that it came from the mouth of Lord No-such—a name that means there is no such a person. If there is no such a person, how can his words in the poem be other than fictional [*wuyou*]? Knowing the poem is fictional but taking it for real and thus criticizing it—this is the trouble with the previous arguments.[165]

Unlike Sima Qian and other historians who judged the rhapsody in terms of truth and belief, Cheng Dachang read it as a fabrication of the poet's fertile imagination. Someone else who must have shared this view was the Emperor Wu, the intended reader of the literary work. All available historical records indicate that when the emperor received the rhapsody, his royal garden was nothing like the one described in Xiangru's ornate lines. It is true that Shanglin had been the site of royal parks since Zhou times and that the First Emperor had built his magnifi-

Fig. 3.10. (a) Chariot ornament. Bronze with gold, silver, and stone inlay. Late Western Han. Early 1st century B.C. Excavated in 1965 from Tomb no. 122 at Sanpanshan, Dingxian, Hebei province. (b) Drawing of the decoration.

cent Efang Palace there, but this and many other pleasure palaces had been burned down some 65 years earlier by General Xiang Yu. At the beginning of the Han, this former imperial park had been turned into fields and occupied by farmers.[166] In 138, right before Emperor Wu claimed the park as his personal property, he traveled there incognito and held a hunting party, which was interrupted by a crowd of angry peasants berating the hunters for destroying their crops. Such "inconveniences" led to the emperor's decision to reclaim the park, but in order to do so he had to first purchase the land and to transfer the owners to other places.[167]

It is not necessary to list the many pieces of evidence for the fictional nature of Xiangru's work.[168] But it is important to understand that although the rhapsody was well received by Emperor Wu and the poet became one of his personal attendants, it must have also made the emperor consider the real Shanglin Park rather shabby. His subsequent effort was to create an actual park on earth that matched Sima Xiangru's fictional garden, with all its landscape features, strange animals and birds, magnificent palaces and towers, beautiful women and brave warriors. Although no plan or chronicle of this project has survived, by piecing together fragmentary records from various texts and by consulting pictures that may be related to Shanglin Park (Figs. 3.10–13), we can outline the emperor's general vision and goal.

Shortly after 138, officials all over the country were encouraged to present tributes of unusual plants. Some officials, in order to stress the preciousness and strangeness of their own tributes, labeled their own goods with "beautiful names." More than 3,000 kinds of flowers and trees, as well as some "artificial" plants, found a new home in Shanglin Park.[169] Among the latter was a huge coral tree presented by the prince of South Yue. Planted inside one of the park's ten ponds, its 462 luminous branches emitted light at night.[170] Strange objects were also gained by confiscations. Chang'an financial magnate Yuan Guangmin, for example, owned one of the most beautiful gardens in the country, with manmade rivers and an artificial mountain several *li* long. Yuan had collected "all sorts of unusual plants" and "all kinds of strange animals and precious

a

b

birds," including white parrots, purple mandarin ducks, yaks, and a black rhinoceros. He had also built multistoried pavilions connected by winding corridors; to travel through them all took hours and hours. "Yuan Guangmin was later executed for certain crimes, and his private garden was confiscated and integrated into the imperial garden. All the birds, beasts, trees, and plants were transferred to Shanglin Park."[171]

Two other sources of "strange and precious goods" were military conquests and foreign tributes. In 121, Emperor Wu put down a rebellion in present-day Vietnam. A tropical garden called the Fuli Palace (Palace of Cultivating Lichi Trees) was then built inside Shanglin Park

to house the "strange and rare plants" gained from the victory. A surviving inventory lists more than a thousand plants of various kinds.[172] Indeed, during those years the most exciting events in the capital were arrivals of foreign tributes of strange creatures. Following Emperor Wu's military expeditions to the far west and south, exotic animals and birds were sent to Shanglin Park in a steady stream. Ban Gu later recalled that the park contained unicorns from India, heavenly steeds from Turkestan, rhinoceroses from Thailand, and ostriches from Persia: "All the different species of animals and birds were sent to Shanglin Park from various places, some as far away as 30,000 *li*, from beyond the Kunlun Mountains and from the other side of the ocean."[173] Among these foreign tributes were a white elephant and "talking birds," which arrived in 121 B.C.[174] These were interpreted as good omens from Heaven, and Emperor Wu himself wrote a poem in congratulation:

> The elephant, white like jade,
> Comes here from the west.
> It eats the sweet dew from Heaven,
> And drinks luminescent spring water.
> The red geese gather together
> In an unmeasurable number.
> Each has distinctive features on its neck,
> And five-colored patterns on its body.
> They are sent down by the Lord on High;
> Bringing happiness to human beings.
> Oh! It is on the immortal island Penglai,
> Where we reach the infinitude of longevity![175]

The irony of this enterprise, as we can clearly perceive in this poem, is that rather than the emperor visiting the remote Penglai, these wild animals and birds were bought into the fenced imperial garden to make this place a "magical land." The transformation of the park coincided with a transformation in the spectator's eyes and mind: since the object of viewing was no longer an ordinary landscape but a series of strange scenes, the viewer (i.e., Emperor Wu as the master of the garden) was persuaded to forget his earthly existence and to fantasize himself as living in an immortal realm. Many "viewing spots" were then designed for this purpose, including the Pavilion for

Viewing the Elephant (Guanxiang guan), the Pavilion of the Albino Deer (Bailu guan), the Pavilion of the Three-legged Crow (Sanque guan), and the Pavilion of the Divine Tripod (Dingjiao guan).[176] The word *pavilion* in these names hardly conveys the meaning of the original Chinese character *guan*, which means both "to view" and "the place from which one views."[177] Each of these *guan* lookouts was oriented toward an individual "stage" with specific "props"—rare animals, birds, and plants—to stimulate the spectator's imagination.[178] The blueprint for this architectural design, however, had been drawn by Sima Xiangru years ago:

> Green dragons slither from the eastern pavilion;
> Elephant carriages prance from the pure hall of the
> west,
> Bringing immortals to dine in the peaceful towers
> And bands of fairies to sun themselves beneath the
> southern eaves.
> .
> Such are the scenes of the imperial park,
> A hundred, a thousand settings.[179]

Emperor Wu faithfully realized these lines; and the result was constant additions of "stages" and "settings." According to the *History of the Former Han*, Shanglin Park occupied an area of some 300 square *li* and contained more than seventy pleasure palaces; each palace was large enough to accommodate thousands of chariots and horsemen.[180] *A Record of the Guanzhong Region* (*Guangzhong ji*) provides a more detailed inventory: "Shanglin Park had 12 gates, 36 individual gardens, 12 palace complexes, and 25 *guan* pavilions."[181] Inside the park, the emperor also created the huge Kunming Lake in 121. Statues of the Weaving Maid (the star Vega) and the Cowherd (the star Altair) were placed on the opposite shores of the lake to turn it into a replica of the Milky Way, and a big stone whale was placed in the water to identify it as an ocean.[182] All three statues have been found during recent years (Figs. 3.11a, b).

In *Rhapsody on the Shanglin Park*, Sima Xiangru created a microcosm without a focal point. The fantastic park is

a b

Fig. 3.11. (a) Cowherd. H. 258 cm. (b) Weaving Maid. H. 228 cm. Stone. Western Han. 2d–1st centuries B.C. Located at Caotangsi, Chang'an, Shaanxi province.

described from an ever-shifting point of view, and the poet seems to travel in his imaginary landscape without pausing. The real Shanglin Park mimicked this literary structure. Until 104, the construction of the park was motivated by the desire to create an endless series of individual "scenes"—palaces, pavilions, and ponds embellished with rare creatures and plants. Each scene constituted part of the general environment and atmosphere, never dominating the whole landscape. But in 104 an intensive architectural campaign began. All energy was suddenly concentrated on a single group of palatial monuments called Jianzhang Palace (Palace for Establishing the Statutes). The reasons for this development are perhaps complex, but I believe that the central factor must be sought in Emperor Wu's deepening engagement in creating his *fictional* paradise.[183] Most interesting, this new project, which finally provided Shanglin Park with a focus, was again inspired

by last rhapsody Sima Xiangru composed before his retirement. Sima Qian documented the context of this work in his *Records of the Historian*:

> Xiangru observed that the emperor desired immortality and took occasion to remark, "My description of the Shanglin Park is hardly deserving of praise. I have something that is still finer. I have begun a rhapsody called *The Mighty One [Daren fu]* but have not completed it yet. I beg to finish it and present it to Your Majesty." [Before Xiangru,] immortals had been pictured as emaciated creatures dwelling among the hills and swamps, but the poet judged that this was not the kind of immortality for great emperors and kings. He finally presented his *Rhapsody on the Mighty One* to the throne, which read as follows:

> In this world there lives a Mighty One
> Who dwells in the Middle Continent [i.e., China].
> Though his mansion stretches ten thousand miles,
> He is not content to remain in it a moment
> But, saddened by the sordid press of the vulgar world,
> Nimbly takes his way aloft and soars far away.[184]

In a trance, the Mighty One finds himself traveling in the sky, accompanied by fantastic beasts. His chariot is drawn by winged dragons, with red serpents and green lizards writhing beside it. He snatches a shooting star for a flag and sheathes the flagstaff in a broken rainbow. He crosses to the eastern limit of the universe and then to the west, summoning all the fairies of the Magic Garden to his service. A host of gods ride behind him on the Star of Pure Light, and he orders the Emperors of the Five Directions to be his guides. He surveys the eight dimensions and the four outer wastes, and visits the Nine Rivers and the Five Streams of the world.

This part of the poem deliberately echoes the earlier *Rhapsody on the Shanglin Park*, and the heavenly "Magic Garden" mirrors Shanglin Park on earth. Indeed, up to this point, this composition is a new version of the old one; but instead of describing the physical appearance of an imaginary park, the poet focuses on the viewer's perception and imagination. In other words, if the subject of Xiangru's first work was a vision of Shanglin Park that had not yet been realized, the subject of his second work

was an imaginary journey inside the park. During the two decades between these two works, his original vision had been turned into reality. The parallelism between these two rhapsodies, however, stops here. The Mighty One's heavenly journey culminates with his attainment of immortality:

> He gazes west to the hazy contours of Mount
> Kunlun,
> He gallops off to the Mountain of the Three
> Pinnacles.
> He opens the Changhe Gate of Heaven,
> Entering the palace of the Celestial Emperor,
> And bringing the Jade Maiden back home.[185]

It is said that these lines made Emperor Wu "ecstatic and feel as though he were whirling away over the clouds and wandering between Heaven and Earth."[186] The same lines also directly link the rhapsody to the new Jianzhang Palace, whose gate was also named Changhe and whose main hall was called Jade Palace (Yutang). The emperor thus once again followed the poet's steps to change the level of his discourse: he was no longer constructing an imaginary universe; he was now establishing a center, or his own "heavenly court," in this universe.

The Jianzhang Palace included two palatial halls called Jiaorao and Taidang, obscure names signifying the "loftiness" and "vastness" of paradise. There were also the Divine Terrace (Shenming tai) and a 46-meter-high bronze pillar upon which a sculptured immortal raised a plate above his head (Fig. 3.12). Sweet dew falling onto the plate was mixed with powdered jade—a kind of elixir for spirits that was now served to the Mighty One. A large artificial lake was created and given the name of Cosmic Liquid (Taiye); the immortal island was duplicated in its center (Fig. 3.13), surrounded by sculptured fish and turtles.[187] But the central building of Jianzhang Palace was Jade Hall behind the heavenly Changhe Gate, both built of translucent white stone. The gate had three layers and was reportedly 60 meters tall (Fig. 3.14). Within it, a labyrinth with "a thousand doors and ten thousand windows" surrounded Jade Palace, which soared over this architectural maze. More than one historian testified that this

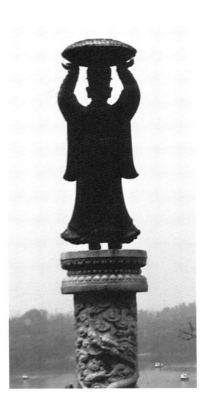

Fig. 3.12. *Immortal receiving sweet dew. Bronze statue inspired by Emperor Wu's statue in the Jianzhang Palace. Qing dynasty. 18th century. Beihai Park, Beijing.*

hall was so tall that it overlooked Gaozu's Weiyang Palace, and that its amazing height was further emphasized by a gilded phoenix on the roof, shining under the sun and turning in the wind.[188] The building was thus counterpoised to the old throne hall: standing side by side but separated by the city walls, Weiyang Palace was the heart of the administrative city; Jade Palace dominated the cosmic Shanglin Park.[189] Weiyang Palace was a wooden-framed structure heavily painted with bright colors; Jade Palace, with its pure marble walls and golden phoenix, must have appeared as a mirage in the sky. These contrasting images seem to have been based on the opening lines in Sima Xiangru's rhapsody: although the Mighty One's imperial halls stretch 10,000 miles, saddened by the sordid press of the vulgar world, he takes his way aloft and soars far away.

Emperor Wu would remain on the throne for another eighteen years, but Jianzhang Palace was the last major

structure he built in Shanglin Park. With the completion of this project, the development of the emperor's *fictional* garden and his search for a monument of immortality had reached the end. Indeed, when fiction has become reality, there is no room left for further imagination; when immortality has been granted by architecture, no more building is necessary.

Wang Mang's Bright Hall

The reconstruction of Chang'an's history has begun to reveal a dialectical process: new monumental forms were constantly modified by tradition, and again challenged and altered by innovation. The central determinant of this process was changes in notions of authority. When the Han was first established, its founder alone stood for the new ruling power; the imposing Weiyang Palace emerged as his personal monument, documenting his victory and symbolizing his mandate. The city of Chang'an was thus created by and for the One Man Under Heaven, and in this way epitomized China's historical transition into the new imperial era. Chang'an's symbolism, however, was substantially revised under the second Han ruler, Emperor Hui. Power once again became hereditary and imperial authority increasingly relied on autonomous political institutions backed by traditional ideology. The Confucian orthodox or "classical" city design prevailed: Gaozu's palace was integrated into a walled enclosure, becoming one of many elements of an institutionalized capital. This new Chang'an represented the supremacy of the state, and secondary monuments centered on individual mausoleums were established in the suburbs to commemorate the glory of dynastic rulers. The city as a whole thus documented the history of the dynasty within the Chinese political tradition. The construction of Chang'an again changed direction under Emperor Wu, an extraordinary figure who attempted to recreate himself as a mythical hero-sovereign. The city was expanded to include an even larger area, in which new religious monuments, with their dazzling images and astonishing scale, became counterparts of the administrative town. Sovereignty had to be immortalized; the enormous Ganquan Palace and

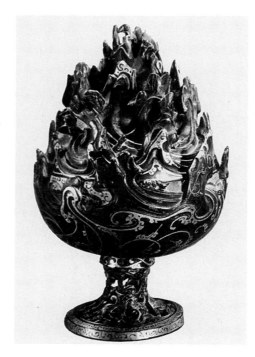

Fig. 3.13. Incense burner. Bronze with gold and silver inlay. Western Han. Before 113 B.C. H. 26 cm. Excavated in 1968 from Liu Sheng's tomb at Mancheng, Hebei province. Hebei Provincial Institute of Cultural Relics, Shijiazhuang.

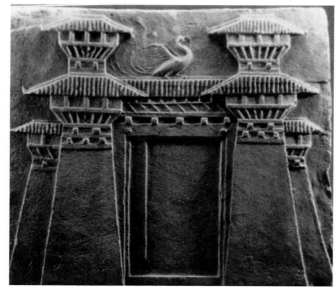

Fig. 3.14. The "Phoenix" Gate. Clay tile. Eastern Han. 2d century A.D. H. 48 cm. W. 39 cm. Found in 1975 in vicinity of Chengdu, Sichuan province. Chengdu Museum.

Shanglin Park resulted from the emperor's insistent pursuit of eternal life beyond his worldly domain.

A century later, at the beginning of the first century A.D., a new architectural fanaticism again seized Chang'an. Wang Mang (45 B.C.–A.D. 23), then regent, launched a new building campaign as an essential part of his political scheme to take over the dragon throne. Acting as the defender and restorer of traditional values, he destroyed Emperor Wu's magnificent Jianzhang Palace and many other structures in Shanglin Park.[190] Building materials gained from this destruction were reused to found a group of Confucian monuments. Of all the antagonisms between the "orthodox" and "heterodox" traditions in constructing the capital, this was the most violent.[191]

The central structure of this new monumental complex was Bright Hall (Mingtang), said to have been invented by sages of remote antiquity as the most authoritative symbol of sovereignty. According to Han Confucians, the ancient tradition of this monument had been largely "forgotten" after the Zhou and could only be "restored" with the aid of relevant passages scattered in ancient texts. Any person able to accomplish this historical mission would prove himself the legitimate successor of the former sage-kings. His success in rebuilding Bright Hall would be a definite sign of Heaven's approval of his ruling mandate. This "restoration" work—or rather the "creation" of the most important Confucian monument of imperial China—had begun during the Eastern Zhou and was finally realized in Wang Mang's Bright Hall.[192] The pursuit of this structure over a period of some two centuries was sustained by a profound political and intellectual movement with strong "scholastic" or "classicist" tendencies. Unlike all previous monuments in Chinese history, Wang Mang's Bright Hall was based on a synthesis and exegesis of ancient texts.[193] Its manifold symbolism was governed by highly abstract elements such as measurement, direction, and geometrical shape—architectural references derived from the study of cosmology, astronomy, mathematics, geography, and musicology. Bright Hall was, on the one hand, a definite sign of the Confucian dominance in Han politics and, on the other, a political integration

and interpretation of all branches of humanistic and scientific knowledge in early imperial China.

This monument was discovered in 1956 south of Chang'an almost directly facing the central gate on the city's southern wall (Map 3.7).[194] The remaining foundation suggests an architectural complex of strict geometrical forms (Fig. 3.15a). In the center of this complex was Bright Hall, about 42 meters north-south and east-west, superimposed on an earthen core (Fig. 3.15b). This building can be tentatively reconstructed based on archaeological reports and ancient records (Fig. 3.16b).[195] On the third and top level, a single round room, called the Room of Communing with Heaven (Tongtian wu), stood directly above a square hall on the second level. This hall was surrounded by eight small free-standing halls radiating from the four corners,[196] and all nine chambers on the second story were erected on the solid "earthen core." On the first story, four rectangular halls stood against this "core" and faced the four directions. Each of these four halls was most likely divided into three sections with a central room flanked by two small ones. A covered portico extended outward from these halls and gave the building a stable look.

Map 3.7. Chang'an during Wang Mang's reign

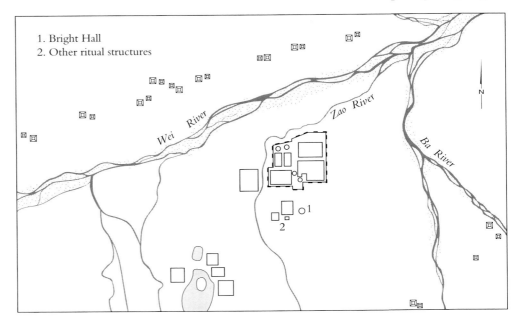

1. Bright Hall
2. Other ritual structures

Wei River

Zao River

Ba River

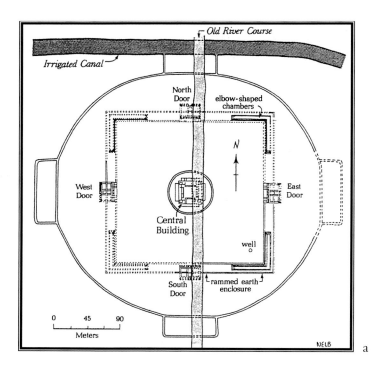

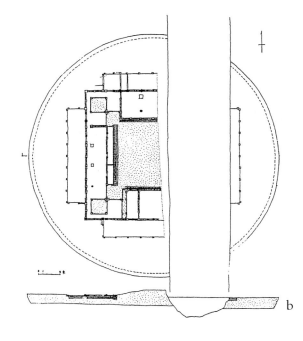

Fig. 3.15. (a) Floor plan of the ritual site of the Bright Hall and Biyong. Xin dynasty. A.D. 4. Excavated in 1956 at Chang'an, Shaanxi province. (b) Floor plan of the Bright Hall.

Fig. 3.16. page 179 (a) Reconstruction of the ritual site of Bright Hall and Biyong. (b) Reconstruction of Bright Hall.

This central structure was founded on a circular platform about 62 meters in diameter (Fig. 3.16a), which was again raised by a large square platform, measuring 1.6 meters tall and 235 meters on each side. Walls originally surrounded this square platform, with two-storied gatehouses corresponding to the four compass points. Outside this walled courtyard was a large circle, formed by a ditch about 360 meters in diameter and 2 meters wide. Four rectangular areas, outlined by ditches, protruded from this circle at the four cardinal points. This network of ditches was connected with the Golden River (Jinshui) to the north, so that water could flow into it to make it a moat called the Biyong (the Jade Disk Moat).

The original plan of Wang Mang's Bright Hall has long been lost.[197] The most valuable textual reference is an essay of slightly later date, the Eastern Han scholar Cai Yong's "Treatise on Bright Hall and Monthly Observances" ("Mingtang yueling lun").[198] The section translated below highlights the three essential foci of Confucian discourse on Bright Hall: the hall as a synthesis of classical ritual

structures, the hall as a symbol of the Universe, and the hall as a guide to rulership. The treatise begins with the following section on the hall's nomenclature:

Bright Hall is the Great Temple [Tai miao] of the Son of Heaven, the place where the emperor pays respect to his ancestors in conjunction with worshiping the Lord on High. People of the Xia dynasty called this building the Chamber of Generations [Shishi]; people of the Shang named it the Layered House [Chongwu]; and people of the Zhou gave it the name Bright Hall. The east chamber is called Spring Shrine [Qingyang]; the south chamber is called Bright Hall; the chamber to the west is called Assembly of Decorations [Zongzhang]; the chamber to the north is called Somber Hall [Xuantang]; and the central chamber is called Great Hall [Taishi or Dashi]. The *Book of Changes* says: "*Li* means brightness";[199] this is a trigram referring to the south. The sage-king faces the south to administer the state and sits toward the sun-brightness to govern the world—the position of a human ruler cannot be more upright than this. Thus, although there are five [major] chambers with different names, that of the south

chamber, Bright Hall, is the principal name [and is used for the whole building]. . . .

Bright Hall is the greatest thing among all things and possesses the deepest meaning of all meanings. People who are attracted by the appearance of its ancestral rituals call it Pure Temple [Qing miao]; those who cast their eyes on its central chamber call it Great Temple; those who focus on its loftiness call it Great Hall; those who favor its chambers call it Bright Hall; those who appreciate the schools in its four gatehouses call it Great Academy [Taixue]; and those who prefer the circular river surrounding it call it Jade Disk Moat. All these different names actually refer to the same building.

This last sentence encapsulates Cai Yong's central argument, which has become difficult for us moderns to grasp. "All these different names" given for Bright Hall are actually the names of ancient ritual structures recorded in the Confucian classics. These buildings, such as Great Temple, Pure Temple, Great Hall, and Biyong Moat, served various functions during the Three Dynasties. By arguing that all these names refer to Bright Hall—either to individual sections or to the entire building—Cai Yong could trace the tradition of Bright Hall back to the Golden Age in China's antiquity and could claim that this monument, as "the greatest thing among all things," ought to combine the forms and functions of all ancient ritual structures. Bright Hall was thus a religious center where gods and royal ancestors were worshipped, an administrative center where court audiences were held, and an educational center where history and moral principles were taught. Not coincidentally, these were exactly the three major functions of the emperor according to Han Confucianism, as Cai Yong documented in another passage:

[Bright Hall is constructed] for the emperor to observe Heaven and seasonal orders, to carry forward the virtuous ancestral rites, to confirm the contributions of royal predecessors and feudal lords, to declare the principles of honoring the old, and to promote the education of the young. Here, the emperor receives feudal lords and selects learned scholars in order to illuminate the regulations. Here, living people come to demonstrate their special skills, and the dead are offered various sacrifices accord-

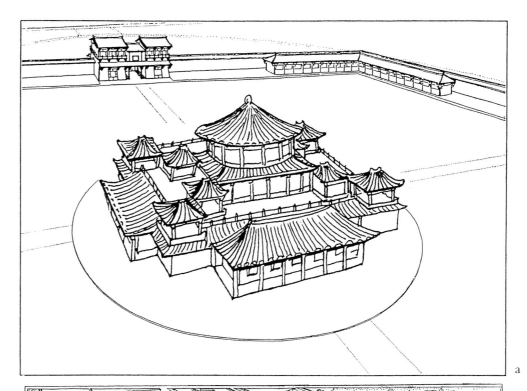

a

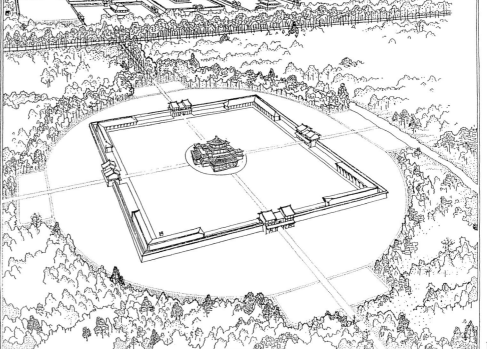

b

ing to their merits. Bright Hall is also the Palace of Great Learning, equipped completely with the four academies and all the government departments. It is like the North Pole, which stays in its own place while countless stars surround it and a myriad creations assist it. Bright Hall is thus the origin of administration and education, and the source of changes and transformations. It brings all things into its unifying light, and this is why it is called Bright Hall.

But it would be too simplistic to understanding Bright Hall only in its exegetic and functional sense, since the meanings of this monument, according to all ancient writers, resided in the building's structure, form, and measurements. In other words, it is this monument that defines itself as the pivot of the world and the embodiment of Confucian principles. As Cai Yong stated clearly in the following section, this architectural symbolism is achieved through translating Confucian cosmology and ideology into a system of secret codes, which regulate the hall's design:

> The various sections of Bright Hall have their regulations. The whole building has a square floor plan of 144 *chi* on each side, a measurement determined by the numerical value assigned to Earth. The round roof is 216 *chi* in diameter, which is based on the numerical value assigned to Heaven. Great Temple [in the center] is three *zhang* on each side, and the Room of Communing with Heaven [above Great Temple] is nine *zhang* in diameter, because nine and six represent the transformation of *yin* and *yang*. [On the other hand,] to place the round room on top of the square chamber implies the reverse *yin-yang* transformation from six to nine. The building's eight openings imply the eight trigrams [of the *Changes*]. The nine chambers [on the second floor] symbolize China's nine provinces. The twelve rooms [on the first floor] correspond to the twelve [zodiac] constellations. Each of the nine chambers has four doors and nine windows, so there are altogether 36 doors and 72 windows. The doors are all open outward and never close, meaning that there is nothing hidden. The Room of Communing with Heaven is 81 *chi* high, a measurement based on squaring the length of the Yellow Bell pitch pipe [*huangzhong*]. Twenty-eight columns are arranged along the four sides of the building; each group of seven columns symbolizes the seven stars [of the Big Dipper]. Each chamber is three *zhang* tall, a measurement based on the three realms [of Heaven, Earth, and Man]. The building has four sides and is painted with five colors; four and five are the numbers [of the four seasons and the Five Elements, which determine] the activities taking place there. The structure covers an area of 24 *zhang* on each side, a figure that echoes the 24 divisions of the year. It is surrounded by water, which symbolizes the four seas.

Not every section of Bright Hall mentioned here can be precisely identified, and to explore the various numerical systems would require a highly specialized study of Han cosmology, astronomy, musicology, and geography.[200] Generally speaking, the architectural complex is designed according to four major sets of codes: the *two* cosmic forces *yin* and *yang*, the *four* seasons (as well as the twelve months and 24 divisions of the year), the *Five* Elements of earth, wood, fire, metal, and water, and the *nine* provinces of China. Other systems, such as the *three* realms of Heaven, Earth, and Man, the *seven* stars of the Big Dipper, and the *nine cun* of the *huangzhong* pitch pipe, serve as secondary references. Based on *yin-yang* principles, the whole complex is designed as a series of alternating concentric circles and squares—two basic shapes symbolizing the two cosmic forces. The circular moat surrounds the square yard; the square yard encloses the round platform; the round platform supports the square hall; and on the summit of this hall is the round Room of Communing with Heaven. The repeated juxtapositions and alternations of these two shapes thus signify the three aspects of *yin-yang* cosmology: their opposition, interdependence, and transformation.

If a *yin-yang* pattern determines the overall design of the architectural complex, other systems govern the individual sections. Bright Hall in the center of the complex is said to have "nine chambers [*tang*] and twelve rooms [*shi*]." Cai Yong explains that the "nine chambers" on the second level symbolize China's nine provinces; the radiating pattern of these chambers seems to be based on a geometric map of the country in ancient texts (Fig. 3.17).[201] Cai Yong also informs us that the twelve rooms on the first floor stood for the twelve months. These rooms are

The Monumental City Chang'an

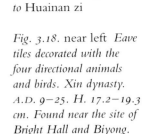

Fig. 3.17. far left *A conceptual geography of China according to Huainan zi*

Fig. 3.18. near left *Eave tiles decorated with the four directional animals and birds. Xin dynasty. A.D. 9–25. H. 17.2–19.3 cm. Found near the site of Bright Hall and Biyong.*

grouped into the four rectangular halls on the four sides of the building. While corresponding to the four seasons and the four directions (Fig. 3.18), these four halls are also associated with the Great Temple in the center on the second floor to form a "Five Element" pattern (Fig. 3.19). This Great Temple, therefore, links all chambers and rooms in the building into a dynamic whole. Its focal location determines its multiple symbolism and extraordinary importance: it is the center of the Universe, the link with Heaven, the midpoint of the year, and the embodiment of Earth—the element associated with the Han dynasty.

Bright Hall thus presents a classification of cosmic elements as well as their transformation. Surrounding the Center, all the seasons and elements move in endless cycles. The building itself, however, does not move or change; the only movable element is its occupant. In other words, the hall's symbolism required the activities and movements of the emperor to complete it. Cai Yong suggests this most interesting aspect of Bright Hall in the following statement:[202]

> As for the great ceremonies of the emperor, it is stated in the "Monthly Observances" ["Yueling"] that human

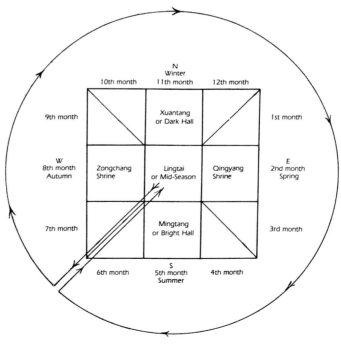

Fig. 3.19. Twelve rooms of Bright Hall and the imperial positions during the twelve months

regulations must be based on the rhythm of Heaven. In each month, the Son of Heaven should give different orders, make offerings to different deities, and assume different roles. This is called the "monthly observances," which enable the emperor to follow the movement of *yin* and *yang*, to obey the transformation of the four seasons, to modify his activities according to seasonal phenomena, and therefore to practice royal administration. Such regulations, which have been completed on the basis of monthly and yearly divisions, are concealed in Bright Hall. [By acting in accordance with these regulations,] the Son of Heaven demonstrates his succession to his ancestors' spirits and his ultimate respect [to Heaven].

The "Monthly Observances" mentioned here is a treatise in the *Book of Rites*,[203] which is based on a section in the third-century B.C. text *Master Lü's Spring and Autumn Annals*.[204] The treatise is rigidly divided into thirteen sections, corresponding to the twelve months plus the day in the middle of the year. Each section begins with a statement of the locations of the sun and stars, the god and spirit of the period, the month's corresponding creature, taste, smell, musical tone and pitch pipe, the position and object of the monthly sacrifice, and changes in the natural world. It then proceeds to regulate the king's position, costume, and utensils in Bright Hall. For example, we read in its first section: "[In the first Spring month,] the Son of Heaven occupies the left room of the Spring Shrine chamber; he rides in a carriage with phoenix decoration and drawn by azure-dragon horses; he carries a green flag; he wears green robes and jade ornaments of the same color; he eats wheat and mutton; his vessels have simple decor and imply the sense of 'openness.'"[205] Also in this month and in this particular chamber, the emperor gave orders to hold the ceremonies of the Inauguration of Spring and the Great Plowing, to reward his ministers, to perform certain songs and dances, and to offer certain victims to certain deities. He would also declare prohibitions in this month of growing, mainly against warfare, which implies "killing." The section ends with a severe warning against any disturbance of seasonal regulations: "No change in the ways of Heaven is allowed; nor any extinction of the principles of earth; nor any confounding of the bonds of

men. . . . If the proceedings proper to autumn were carried out, there would be great pestilence among the people; boisterous winds would work their violence; and rain would descend in torrents."[206]

Figure 3.19 reconstructs the pattern of the emperor's movement in the hall, which also defines the basic structure of the ritual monument. The emperor would begin his year from "the left room of the Spring Shrine hall," or the north room on the east side where the *yang* ether rises. He would move clockwise in the hall; each month he would dwell in the proper room, dress in the proper color, eat the proper food, listen to the proper music, sacrifice to the proper deities, and attend to the proper affairs of state. The emperor thus literally becomes a moving hand on a big clock. It was understood that only his synchronous movement with Heaven and Earth would secure harmony between his rule and the natural world. In retrospect, we find that this structure, though called a Great Temple, differs fundamentally from a Three Dynasty temple in architectural form, and this difference implies a radical departure from traditional ritual and historiography. Unlike an archaic temple, which consisted of layers of halls and gates along a central axis (Figs. 2.7a, b), the sections of Bright Hall all surround a fixed center. In a Three Dynasties temple, members of a clan or lineage proceeded in a linear fashion to "return" to their Origin, but in Bright Hall it was the emperor who moved alone in endless cycles. History is no longer perceived as a linear progression with a definite beginning and end, but is remodeled into a circular movement constantly repeating itself. The chief function of this hall is to establish the absolute authority of the emperor through "scientific" means: the emperor's circular movement and his metamorphic appearance in different garb made him an integral part of the dynamic universe. His movement was interrupted regularly at the middle of the year when he ascended to the Great Temple. At that moment, he located himself in the center of the universe and proved himself the Son of Heaven.

The "Monthly Observances," which appeared toward the end of the Zhou, signified a general interest in Bright

Hall at the dawn of imperial China. But what it presented was a particular model of this monument promoted by the rising School of Five Elements. Encouraged by this school's strong interest in cosmology, the author of this text imagined Bright Hall as a cosmic mandala demonstrating the normal workings of both the natural and human worlds. This plan, however, lacked a historical dimension and did not link the hall with former dynasties. Those who established such links were orthodox Confucians, whose social vision was largely modeled on an idealized past exemplified by the Western Zhou dynasty. Instead of stressing the cosmological significance of Bright Hall, these Confucians viewed it as a prime symbol of both an idealized past and a glorious future. They frequently recalled a "lost" Zhou dynasty Bright Hall, which is reminiscent of a traditional Three Dynasties temple.[207] But their descriptions of this hall were "prophetic" rather than "reminiscential": to them, the construction of a new Bright Hall was synonymous with the founding of a unified political state governed by Confucian ideology. Thus, for example, a political proposal presented by the philosopher and politician Xunzi to a king of Qin:

> [As for good politics,] military domination should be restrained and civilian matters should be stressed. Gentlemen who are correct, sincere, trustworthy, and accomplished should be employed to govern the world. Your Majesty should collaborate with them in the administration of the state, should distinguish right and wrong, should separate the crooked and straight, and should adjudicate from your capital Xianyang. Those who are obedient should be rewarded with official posts; those who are not should be executed. If things are done in this way, then without sending the army outside the Pass, your commands will be followed by the whole world. *If things are done this way, then Bright Hall can be constructed, and you can hold court there to receive the feudal lords.*[208]

The pre-Han textual references to Bright Hall thus follow two separate traditions of discourse. On the one hand, Bright Hall was claimed to be an ageless symbol of ideal sovereignty and was used as a metaphor for the forthcoming Confucian state; on the other, it was required to demonstrate an understanding of the Universe and was

taken as a cosmic symbol. These two trends began to intermingle during the Western Han. The *Master Huainan*, a text written by a number of authors during the second century B.C., contains a version of the "Monthly Observances,"[209] as well as passages that attribute the cosmic Bright Hall to various sage-kings in China's Golden Age:[210]

> In the past, the Five Emperors and Three Kings based their administration and education on the codes "Three" and "Five." What do these two figures mean? "Three" means that they obtained their symbols from Heaven above, their measurements from Earth below, and their rules from Man in the middle. Thereupon they established their courts in [the five chambers of] Bright Hall and practiced the "observances" regulated by this hall. They were thus able to harmonize the *qi* ether of *yin-yang* and to adjust the rhythm of the four seasons.[211]

In addition to integrating the two earlier discourses on Bright Hall, this text also reveals associations between the hall and new philosophical and political concepts such as the three realms of Heaven, Earth, and Man.[212] This elusive monument constantly attracted new concepts and was enriched by current thinking. Gradually, it was taken not only as a symbol of the Five Elements and sagehood, but also as a manifestation of *yin-yang* principles and the eight trigrams of the *Changes*.[213] It was linked with the idea of immortality; and later, when the virtue of filial piety prevailed, Bright Hall was again viewed as the embodiment of this most important moral standard.[214] Its impact on Han politics also increased: emperors attempted to construct this hall in order to demonstrate their mandate, and scholars insisted upon their right to interpret it. These scholars' specifications of the hall's design functioned as political propositions, with an unspoken premise that if a ruler wanted to build the monument, he had to accept the whole of their political plan.

Such exchanges between rulers and scholars, which had begun at the start of the Han dynasty,[215] heightened during Emperor Wu's reign. When this emperor ascended the throne, the first thing discussed in his court was the construction of Bright Hall. Sima Qian remarked that this intent clearly indicated the new ruler's favoring of Confucianism, and Ban Gu also reported that the emperor sent

a special envoy to Master Shen, a famous Confucian scholar in Shandong, to inquire about the hall's proper form.[216] This plan, however, ended with a violent court struggle: Empress Dowager Dou, a believer in Daoism, interfered and the scholars engaged in the project were forced to commit suicide.[217] Only thirty years later did Emperor Wu gain enough confidence to attempt the monument again. Interestingly, this time the design was supplied by a necromancer named Gongyu Dai, who produced a "Diagram of Bright Hall Transmitted from the Yellow Emperor." The proposed building seems to have pandered to the emperor's increasing desire for immortality: its central hall was called Kunlun, the symbol of eternity.[218]

Neither the location of this building (it was founded at the foot of Mount Tai, not in the capital) nor its association with Kunlun could convince Confucian scholars that this was an orthodox Bright Hall.[219] But it did force them to realize the absence of a precise design for this monument in their own arguments: pre-Han and early Han documents on Bright Hall were either too vague or self-contradictory, and even the plan in the "Monthly Observances" had become insufficient to illustrate the ideas increasingly associated with the hall. From the first century B.C. on, there appeared an effort to construct an up-to-date Bright Hall on paper. Following the old traditions, this effort was twofold and centered on the hall's cosmological and political significance. First, the hall was conceived to be a symbol of the universe demonstrating the systems of the Five Elements as well as other cosmic forces. This meant that the design of Bright Hall, instead of being determined by the teaching of a single school, had to synthesize various scholarly and philosophical traditions. Second, this hall was seen as a political statement of Confucian scholars, who by this time had concluded that the Han court had lost its mandate due to its corruption and unjust rule.[220] The result of this effort was the appearance of a series of texts entitled "The Yinyang Principles of Bright Hall" ("Mingtang yinyang"),[221] which provided workable architectural designs for the monument.[222] Like their Eastern Zhou predecessors, the authors of these texts believed that Bright Hall possessed a prophetic significance: the monument they proposed

could only be built by a future sage, a true Confucian comparable in virtue and conduct to ancient sages.[223] This is the point at which Wang Mang came on the scene.

Wang Mang was a relative of the Western Han royal house; his aunt Wang Zhengjun was the consort of Emperor Yuan (r. 48–33 B.C.) and the mother of Emperor Cheng (r. 32–7 B.C.). But this family association did not provide him with immediate political privileges, since a strict line separated the members of the Liu royal house from relatives by marriage, who had no right to become princes, not to mention the legitimate ruler. Moreover, Wang Mang's father died young and left him no noble rank or fief. It was his image as a learned Confucian scholar and virtuous man that opened his path to political power. The *History of the Former Han* records: "Wang Mang was a poor orphan, and he was even humbler in his behavior, always paying full respect to others. He first received instructions in ancient ritual canons, studying with Chen Can from Pei. He was diligent and acquired extensive learning. He wore the clothes of a scholar. He served his widowed mother and sister-in-law, and reared the orphaned son of his elder brother. His behavior was always extremely proper."[224] It is impossible in this short section even to outline the fascinating political campaign that finally led him to the throne; interested readers may consult his biography, which has been translated into English, as well as scholarly discussions.[225] My purpose here is to explore the role of Bright Hall in this dramatic moment in Chinese history.

Broadly speaking, Wang Mang's political campaign consisted of two stages, before and after A.D. 4. His first goal was to become regent. He found his model in the Duke of Zhou, a Confucian sage who at the beginning of the Zhou dynasty had acted as regent during the minority of King Cheng. Once this goal was achieved, Wang Mang went one step further and replaced the Han emperor. This dynastic transition was based on a newly written Chinese history that predicted Wang Mang's mandate. Bright Hall, established in A.D. 4, served both purposes: the Duke of Zhou was said to have erected the Zhou dynasty Bright Hall, and the pattern of history would

be most concretely represented by Wang Mang's new monument.

Wang Mang's effort to link himself with the Duke of Zhou became evident in A.D. 1. In this year, a nine-year-old prince was brought to the throne (Emperor Ping, r. A.D. 1–5). A strange event immediately occurred. Some men identifying themselves as the people of Yueshang sent a tribute of a white pheasant to the Han court. An identical event recorded in the *Book of Documents* was recalled. When the Duke of Zhou was assisting King Cheng to rule the country, the Yueshang people had come to China to present the same kind of bird. When people asked the reason for their tribute, they replied: "In recent years there have been no harmful storms or violent winds in our kingdom; our elders determined that a sage must have appeared in the Central Kingdom and they sent us here to present the tribute." When this event recurred, a memorial was delivered to the young Emperor Ping:

> Wang Mang's virtues and accomplishments have led to the reappearance of the "white pheasant" omen of the Duke of Zhou and King Cheng, an omen that links our dynasty to the Zhou of a thousand years ago. According to the precepts of the sage-kings, if a minister has great merit, then he should have honorable titles. Of old the Duke of Zhou, while still alive, was given his title, which included the dynasty's name. Since Wang Mang has the great merit of having settled the country and of having secured peace for the Han royal house, Your Majesty should bestow upon him the title of "Duke Protector of Han."[226]

This event reveals an important aspect of Wang Mang's political rhetoric: his constant use of historical allusions. Through these allusions, he established parallels between the present and the past and between himself and an ancient sage. This technique enabled him to collapse historical time, to recuperate antiquity, and to transform formulated textual references into reality. Indeed, we may say that before A.D. 4, what Wang Mang had accomplished was to manipulate people's perception: his tireless uses of historical allusions actually transformed the present into a mirror image of the past. His training in the Classics allowed him to screen all historical records and to train

public attention on a single focus: the Duke of Zhou.[227] He restaged all events relating to the ancient duke and reiterated all his speeches. During the five years from 1 B.C. to A.D. 3, more than 700 auspicious omens were reported as signs of Heaven's approval of Wang Mang's service. Many of them, like the "white pheasant omen," were originally associated with the Duke of Zhou. Then, some people from Sichuan dropped a lawsuit—the same event had also occurred under the Duke's peaceful rule.[228] This manipulative process culminated in the construction of Bright Hall, which provided the final evidence for the rebirth of the Golden Age. The event was staged as a spontaneous act: more than a hundred thousand supporters of Wang Mang—scholars and commoners who had been convinced by his propaganda—gathered south of Chang'an and completed the hall in a mere twenty days.[229] Following this event, another memorial was presented to the throne:

> Formerly, when the Duke of Zhou accepted the duty of assisting the heir of the Zhou and occupied the honorable position of Superior Duke; yet only after more than seven years did the regulations of the dynasty become settled. Bright Hall and the Jade Disk Moat have been in disrepair and discarded for a thousand years, and no one has been able to restore them. . . . Indeed, even the achievements of former sages such as Tang [i.e., Yao], Yu [Shun], King Cheng, and the Duke of Zhou could not surpass what Wang Mang has done.[230]

But Emperor Ping would soon reach adulthood and would not need a regent; conveniently he fell ill right after the completion of Bright Hall.[231] Again imitating the Duke of Zhou, Wang Mang prayed to Heaven to let him die in place of the emperor, but for the first time Heaven ignored his petition.[232] The new ruler was selected from among 53 Liu royal family members: the youngest one, Liu Ying (Infant Liu), was chosen. The two-year-old emperor was called "Boy Ying" (Ruzi Ying), which reminded people of King Cheng's nickname, "Ruzi." Wang Mang was now not only regent but acting emperor. The first stage of his political campaign ended with his complete victory.[233]

When the next stage of this campaign began, however,

the Duke of Zhou allusion could no longer support Wang Mang's further advance to the throne, since this ancient sage had finally yielded power to the adult Zhou king. New evidence had to be found to legitimate the dynastic transition. Once again, Bright Hall played a crucial role. This monument, according to the memorial submitted to the throne in A.D. 4, assumed a new function as the site of sacrifices to a "dynastic lineage."[234] A masterpiece in Chinese political historiography, this "dynastic lineage" was Wang Mang's most ambitious creation. All former dynasties, either legendary or real, were organized into a circular transmission pattern in accordance with the structure of Bright Hall.[235] The modern historian Gu Jiegang has reconstructed this pattern (Fig. 3.20), which predicted Wang Mang's Xin (New) dynasty.[236]

The fundamental premise of this pattern of history is that dynastic successions are predestined by Heaven and regulated by the internal movement of the universe. Each dynasty corresponds to one of the Five Elements and finds its position in a particular chamber in Bright Hall. To be

sure, this theory was not Wang Mang's invention and had been associated with various cosmological models since the Eastern Zhou.[237] But Wang Mang's historiography had nothing to do with China's actual past. Rather, it was created to anticipate a future event—his takeover of the Han throne. Old patterns of history were thus deliberately altered to suit this specific need. Among other alterations, he changed the corresponding element of the Han dynasty from "earth" to "fire" and claimed the element

"earth" for his own dynasty. This change served a dual purpose: first, according to the "mutual production" order of the five elements (Fig. 3.21a), "fire" naturally produces "earth." By taking "earth" as his element, Wang Mang could claim that his dynasty should naturally replace the Han through a peaceful transformation. Second, the element "earth" was represented by the central chamber of Bright Hall. By identifying himself with this element, Wang Mang located his dynasty in the center of the cosmic monument, directly under Heaven and as the pivot of the Universe.

This historical transformation from "fire" to "earth" finally took place in A.D. 9 (Fig. 3.22). Wang Mang, now the founder of the New dynasty, issued his first edict:

> I, unvirtuous one, as a descendent of my original imperial ancestor, the Yellow Emperor, as a descendent of my second imperial ancestor, Emperor Yu [i.e., Shun], and as a humble relative of the Grand Empress Dowager, have been abundantly protected by Heaven and Lord on High, which have given me the mandate for the continuation of the succession. The omens and symbols of authority, the "River Diagram" and the "Luo Writing," and the golden casket and the documents, all clearly indicate the divine commands entrusting to me all people under Heaven. The spirit of Emperor Gaozu of the Red (i.e., fire) lineage has received Heaven's order to transmit his kingdom to me through golden documents. Can I dare not accept this order with reverence?[238]

This was the triumph, and the end, of Wang Mang's political campaign. In retrospect, we realize that his rhetorical means had changed from historical *allusions* to a historical *pattern*. Whereas allusions to the Duke of Zhou had helped him reorient people's mind toward the past, the "dynastic lineage" led people to anticipate an inevitable future. The allusions were derived from old texts and referred to concrete figures and events. When these events recurred, history was condensed into a single archetype represented by both remote and present sages. The "dynastic lineage," on the other hand, was an abstract linear pattern without tangible figures and events. It was constructed and perceived as a macrocosmic model of history, a chronology expanding on its own in accordance with the internal movement of the universe. There were no theoretical correlations between these two historical modes. In fact, Wang Mang's own practices demonstrated that he could never simultaneously employ both. Returning from his inauguration ceremony, he escorted the dismissed young emperor out of the capital. He held the boy's hands and wept: "In the past the Duke of Zhou made his master a great king. How unfortunate that I could not follow my heart's desire to follow his example, just because Heaven has demanded that I become the king."[239] The same logic can be applied to Bright Hall. This monument was first constructed to restage a historical event in order to complete Wang Mang's image as a reincarnation of the Duke of Zhou. But when his goal changed from imitating a past sage to becoming a future ruler, the monumentality of Bright Hall had to be altered according to this need: this monument, now the embodiment of "dynastic cycles," could not possibly be manufactured by any human being, neither by the Duke of Zhou nor by Wang Mang of the present day; it could only by created by Heaven, a mythical power that "demanded that Wang Mang become king."

Voices of Funerary Monuments

How swiftly it dries,
The dew on the garlic-leaf,
The dew that dries so fast
Tomorrow will fall again.
But he whom we carry to the grave
Will never more return.

WITH ITS PLAIN message, this Han folk song transports us from the urbane world of Chang'an to an ordinary graveyard.[1] I proposed in Chapter 2 that the funerary monuments of the Han resulted from a profound shift of the religious center in ancient China from temple to tomb, a shift paralleled in the movement of the political center from temple to palace seen in Chang'an. But rather than great emperors whose ambition and desire for power, glory, and immortality mobilized Chang'an's creation and expansion, the subjects of this chapter include people from lower social strata. My basic methodological premise, however, remains the same: we can comprehend the monumentality of Han mortuary structures—memorial stelae, offering shrines, and tombs—only when we reinstall their fragmented and silent remains into their original ritual and social environment.

Official Han histories and other texts record the series of ritual events that followed a person's death.[2] The primary descendent, usually the eldest son, announced the news to all clan members and associates of the deceased, including friends, colleagues, and students. Close members of the family traveling to or holding posts in remote areas were expected to hasten home to pay their final respects; those who failed to do so were punished by the government. Chen Tang, for example, was jailed because he did not rush home when his father died, and even his friend Marquis Zhang Bo, who had recommended him for an official post, was divested of part of his fief.[3] Friends and colleagues who offered their condolences in person were treated as honored guests and invited to feasts featuring musical and acrobatic performances. According to contemporary writers, some "shameless" people lived off such services: they traveled from one funeral to another, pretending to have been friends of the dead; they filled their stomachs with good food and wine and even demanded the company of dancers and singing girls.[4]

Diviners were hired to decide the location of the tomb and the time of the burial. An inauspicious place or date was thought capable of bringing misfortune to the family and perhaps even the extinction of the whole clan.[5] A possible consequence of such practices was the irregular interval between death and burial recorded in Han ar-

chives: the deceased was sometimes buried soon after death, but often the corpse had to be preserved for months or years before it was finally buried in a permanent tomb.[6] Practical concerns, however, may also have caused delays. Unless a person had prepared his own tomb and funerary monuments before his death, his descendents needed a considerable period to build a graveyard. If these descendents were not wealthy, they had to save enough money before any serious mortuary construction could be undertaken. Indeed, such preparations sometimes took so long that a temporary tomb had to be built first and upgraded later.[7]

Once the family had prepared the tomb, memorial monuments, and other funerary paraphernalia, the burial ceremony was held. Friends, colleagues, and students of the deceased waited along the road for the hearse to pass and then accompanied the funerary procession to the graveyard. It was not rare for several thousand people to attend the funeral of a prominent official or Confucian master.[8] As part of their condolences to the deceased's family, these guests also established memorial monuments in the graveyard and inscribed long texts on these structures to commemorate the virtues of the deceased. After the burial, the direct descendents of the dead went into mourning for a long period. The cemetery, in most cases, was not closed to the public. People with good intentions were encouraged to visit the graveyard, so that the deceased's fame and his family's virtue could spread.[9]

This brief introduction to the public dimensions of Han funerary rites should not be entirely new to students of early Chinese art. A similar discussion is included in my 1989 monograph on the famous Wu Liang shrine.[10] Martin Powers, more than anyone else, has contributed to our understanding of the social, political, and economic aspects of Han mortuary art through a series of articles and his important *Art and Political Expression in Early China*, published in 1991. These two book-length studies of Han funerary art, however, are the products of diverse research strategies: *The Wu Liang Shrine* reconstructs a single monument and explores its political, religious, and intellectual implications; Powers's work discusses issues against a broad social spectrum and shows how Han art and poli-

tics were shaped by the rise of the Confucian literati. The present study experiments with an "intermediate" level of interpretation: its organizing concept is neither a single structure nor the whole of society, but a "family graveyard"—a monumental complex consisting of multiple commemorative structures commissioned and constructed by several groups of people. This focus allows me to include a variety of monuments in a historical reconstruction and provides me with a definable ritual and architectural context, within which I hope to establish *direct* and *specific* links between monuments and their creators and audience.

Although no Eastern Han cemetery has survived intact, physical remains and textual records demonstrate a standard layout and a number of essential features (Fig. 4.1).[11] The boundary of the burial site is marked by a stone pillar-gate (Fig. 4.2), and the Spirit Path running through this gate determines the central axis of the graveyard. Flanking this path close to the gate stand pairs of sculptured stone animals and/or guardian figures (Fig. 4.3). At the end of this path is the tomb, whose earthen mound covers underground chambers. In front of the tumulus are sometimes built an offering shrine (Fig. 4.4) and memorial stela(e) (Fig. 4.5).

For the present discussion, what is most important is the multiple patrons responsible for the construction of such a cemetery. The three mortuary structures at the heart of the cemetery were the tomb, the shrine, and the stela(e). The tomb contained the physical remains of the dead and was thought to be the site of the deceased's earthly *po* soul; the shrine, the dwelling of the heavenly *hun* soul, housed offerings to the dead.[12] These two structures were in most cases established by the family who owned the graveyard, either purchased by the deceased during his lifetime or by his descendents. The stela, on the other hand, was in most cases erected by visitors. None of these patrons actually built these monuments, however; they were constructed by professional builders. The establishment of a burial site, therefore, combined the efforts of at least four groups of people: the deceased, his family, his former friends, colleagues, and students, and the builders.

This recognition confirms that a Han cemetery represented a cross section of society: it was not only a center

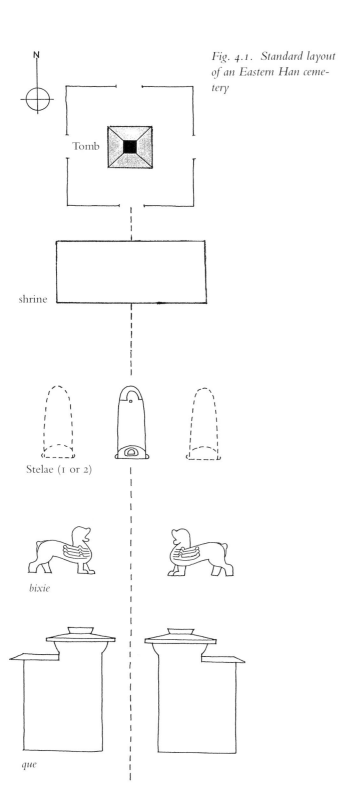

Fig. 4.1. Standard layout of an Eastern Han cemetery

Tomb

shrine

Stelae (1 or 2)

bixie

que

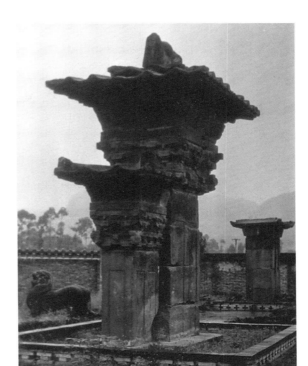

Fig. 4.2. Que pillar-gate of Gao Yi's graveyard. Late Eastern Han. A.D. 209. Ya'an, Sichuan province.

Fig. 4.3. Stone beast. Late Eastern Han. 2d–3d centuries B.C. H. 108 cm. L. 168 cm. Found in 1955 at Sunqitun, Luoyang, Henan province. Luoyang Stone Carving Museum.

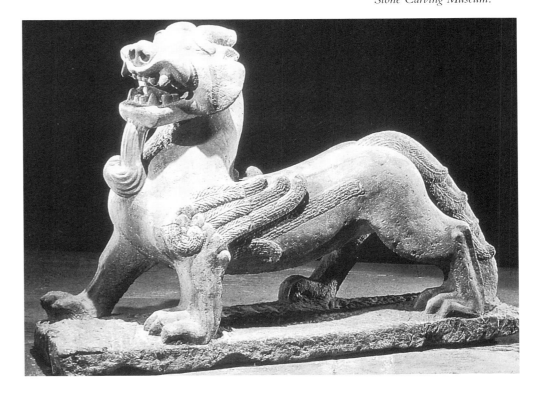

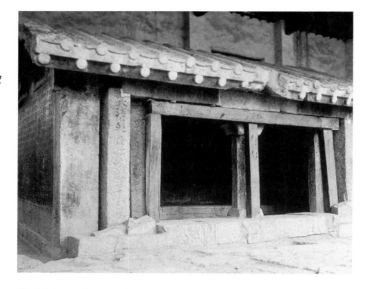

Fig. 4.4. Xiaotangshan Shrine. Early Eastern Han. Ca. mid-1st century A.D. H. 210 cm. W. 380 cm. Changqing, Shandong province.

Fig. 4.5. Gao Yi's memorial stela. A.D. 209. Ya'an, Sichuan province.

of ancestor worship within the family but also a focus of social relationships. Its monuments not only were the property of the dead but also bore witness to the concerns of patrons and builders. Rather than reiterating this general understanding, however, my purpose here is to test it—to uncover such relationships and concerns by reconstructing a number of "scenarios" based on existing funerary inscriptions and carvings. Such a study would ideally focus on a single family graveyard—by identifying its patrons and exploring their intentions, one could write a social history of this particular monumental complex. But since the available data are too scattered to support such a plan, my scenarios must utilize information from divergent sources. To emphasize that these scenarios represent complementary aspects of a Han funerary complex, I select my main examples from a single region in present-day western Shandong and eastern Henan and from a limited period between A.D. 150 and 170.

The Family (1)

The troubled reign of Emperor Huan (A.D. 147–67) witnessed a heated struggle among scholar-officials, eunuchs, and royal relatives. Endless evil portents—earthquakes, landslides, solar eclipses, floods, strange animals and birds—were reported to the throne as signs of Heaven's disapproval of current politics.[13] The emperor's biography in the *History of the Latter Han* is a litany of such disasters, along with apologies by the Son of Heaven. A single passage under the first year of the Yongxing reign period (153) reads: "Autumn, the seventh month: a plague of locusts spread over all 32 prefectures and principalities. The dike of the Yellow River is breached. As many as several hundred thousand hungry and destitute people are roaming the roads." A few months later, in early 154, an earthquake shook the capital, and the emperor issued an edict in response: "Stars and constellations move in disorder; the whole universe is shaking. So many inauspicious omens surely predict a future of misfortune." His prophecy came true: in June the Si River in southern Shandong suddenly flowed backward; in September a solar eclipse was observed; and toward the end of the year

a more fatal disaster took place: a violent rebellion led by Gongsun Ju broke out in the Taishan area in central Shandong; the angry peasants killed the local governor.[14]

The Taishan area had special significance for the Han royal house. Taishan, or Mount Tai, was a sacred place where emperors received their mandate to rule from Heaven. Not far from this mountain was Qufu, the home town of Confucius, whose teachings had become the foundation of the Han state religion and ideology. South of Qufu was Pei, the origin of the Liu royal clan of the Han. To Emperor Huan, whose rule was already in trouble, nothing was worse than disturbances in this "holy land." He adopted two measures to put down the uprising: first, to prevent more people from joining the rebellion, he decreed tax relief for "those who had suffered from the disorders"; and second, he established a special military post at Taishan to deal with the riot. But the rebellion continued to spread. By 156, armed peasants had occupied three key districts in Shandong. Alarmed, Emperor Huan ordered his chief ministers to select a capable general to lead an expedition army. Duan Ying, an officer with an impressive military record, was recommended to the throne and immediately set off to the region. His consequent success was largely due to the severe measure of massacring all troublemakers: by July 156, half of the 30,000 rebellious peasants had been beheaded.[15]

Records of this rebellion stop here in the official Han history.[16] But other sources suggest that the uprising continued at least to the end of the year. A funerary inscription found in 1980 in Jiaxiang, some 40 miles southwest of Taishan, is dedicated to a low-ranking officer in the government army named An Guo, who was sent to the center of the rebellion some time before 157 (Fig. 4.6). Falling ill or wounded, he fled and struggled home. Seven people in his family received him: his parents, three younger brothers, two sons, and also presumably his wife. All efforts to save An Guo's life were in vain, and he died at the beginning of 157 at age 34. During the following year the family was struck by further calamities: both An Guo's sons died, and the major branch of the family perished with them (since he was the eldest son of the family). Following tradition, his younger brothers carried out the fu-

neral service: they built a tomb for their older brother and buried their nephews along the Spirit Path leading to the tomb. They also planted evergreen trees around the earthen tumulus and hired itinerant builders to construct a stone offering shrine in front of it. This took about a year, and upon the shrine's completion an inscription was engraved on it to record the family's devotion. Like many similar buildings, An Guo's shrine was destroyed in the third century during the iconoclastic movement mobilized by Cao Pi, and its stone slabs were reused for new tombs. This is why the inscribed stone, which may have formed the ceiling of An Guo's shrine, was discovered in a post-Han burial.[17] Consisting of 490 characters, the inscription is not only the longest text from a Han offering shrine ever found but also the most vivid record of a funerary monument constructed for a deceased family member.[18]

[This text is inscribed] on the sixteenth day of *guisi*, in the twelfth month of *wuyin*, in the third year of the Yong-shou reign period [A.D. 157].

A military officer of the Xu district, An Guo, endowed with courteousness and uprightness, quietness and sincerity, kindness and generosity, met with calamity at age 34. Powerful robbers had arisen in the Taishan area. [Serving in the expedition army] as an officer, he fell ill. Hesitatingly, he went southwest [back home]. From the first ten days of the first month, he became seriously ill and could not leave his bed. Divination was sought, and medicines applied, but none was efficacious. Before long he passed away, returning to the Yellow Springs. [Death is a human destiny that] even the ancient sages could not avoid, and the allotted span of his life could not be extended. Alas! He died so early, leaving his parents and three younger brothers behind!

Melancholy and full of grief, An Guo's younger brothers, Ying, Dong, and Qiang, carried out the funeral service with their parents. Practicing filial piety to the utmost, engaging in outstanding conduct, and faithfully maintaining their integrity—all these are praised by people of excellence. They cultivate the household virtues, obediently serving their parents and congenially associating with each other. They long for An Guo with deep sorrow and cannot bear to leave his tumulus. They erected a funerary shrine and transported soil on their backs to

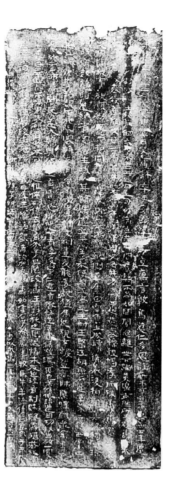

Fig. 4.6. Inscription on An Guo's shrine. A.D. 157. Excavated in 1980 at Songshan, Jiaxiang, Shandong province. Shandong Provincial Gallery of Stone Carvings.

ers and pavilions of unequal heights; great processions of chariots set forth. Above, there are clouds and immortals; below, figures of filial piety, excellent virtue, and benevolence. Superiors are dignified, and their attendants, respectful. Inferiors are obedient and look agitated as well as joyous. Month by month, the craftsmen worked on this hall, expending tremendous effort. The hall cost 27,000 cash.

An Guo's parents and his three younger brothers cannot stop longing for him with all their hearts. Yet the span of our days is allotted by Heaven and cannot be regained. They are wan and sallow with broken hearts. But both life and death are predetermined by fate. How could An Guo's sons die so young in following their father? How could they forget their duty of carrying out their father's funeral and their gratitude to him? The funerary banners were made according to the regulations, and the furnishing goods were buried safely. The wandering soul grieves; the living are filled with sorrow.

Why shed bitter tears? We advise our descendents to lead honorable lives. You, observers, please offer your pity and sympathy. Then may your longevity be as gold and stone, and may your descendents extend your line for 10,000 years. You boys who herd horses and tend sheep and cows are all from good families. If you enter this hall, please just look and do not scribble [on the walls]. Then you will enjoy a long life. Please do not destroy the hall or make any trouble: this will cause disaster to your descendents. We are stating clearly to people of virtue and kindheartedness within the four seas: Please regard these words and do not ignore them.

[This text] was carved on the sixteenth day of the twelfth month, the third year of the Yongshou era. The planet Jupiter was in the position of *wu.*

The following lines are inscribed on the other end of the slab:

The elder son of An Guo, named Nan with the style name Boxiao, died at age six and was buried near the east road. Boxiao's younger brother, whose style name was Runde, also died at an early age. Both are following their father.

The inscription remains emotionally powerful almost two millennia later. Nevertheless, only a short segment describes the life of the deceased; the focus of the text is

make the tomb mound. They continuously plant lofty juniper trees. They make offerings every morning and night and present various delicious foods at all times, as if their older brother were still alive.

Exhausting their savings, they hired famous craftsmen of Gaoping [principality], named Wang Shu, Wang Jian, and Jiang Hu, to build this small [offering] hall. Tirelessly they carted unhewn stones from a small hill southwest of the county town, Yangshan. They cut, ground, and polished the slabs. They measured and built the hall. On the eaves and outer walls[?], they carved different designs. And [inside the hall] they engraved decorations and pictorial scenes: there are interlocking dragons and winding serpents; fierce tigers stretch forward their heads, gazing into the distance; black apes ascend heights; lions and bears roar, strewn everywhere like clouds. There are tow-

clearly the patrons of the ritual building. It was these patrons—An Guo's three younger brothers—who in fulfilling their filial duty became "wan and sallow." It was they who "transported soil on their backs to make the tomb mound" and who "cannot bear to leave the tumulus."[19] Their devotion was not only spiritual but financial: the shrine exhausted their savings, 27,000 cash in all (this was the equivalent of three to four years' salary for a prefect of a county with 10,000 or more households). As we read through the inscription, we cannot help feeling that the brothers—the "narrators" of the text—were calling for the reader's sympathy not so much toward their departed brother as toward themselves. Indeed, the inscription was written for people who would appreciate their filial devotion; they ended with a strong appeal: "We are stating clearly to people of virtue and kindheartedness within the four seas: Please regard these words and do not ignore them."

Significant similarities link this funerary inscription with investiture inscriptions on Western Zhou ritual bronzes, which also focus on the virtues and achievements of living devotees rather than on the life and ambition of departed ancestors (see Chapter 1). In both the Western Zhou and Eastern Han cases, the mortuary or sacrificial texts seems to have been composed "to make oneself known," and in this way a consecrated object—a bronze vessel or a stone shrine—was readily understood as a monument established not only for the deceased but also for the donor. The most fundamental link between these two cases, however, is the moral code of *xiao*, or filial piety, which, though a product of the ancestor religion itself, stimulated and rationalized ancestral dedications, including Zhou ritual vessels and Han funerary structures.

It would be too simplistic to understand the concept and application of filial piety only in broad religious terms. During the Han, this virtue gained new social significance and a quasi-divine status. The *Classic of Filial Piety* (*Xiao jing*), a canonical Confucian text that enjoyed enormous popularity at the time, teaches that "filial piety is the foundation of all virtues and the root of civilization" and that "filial piety is the first principle of Heaven, the ultimate

standard of Earth, and the norm of human conduct."[20] This doctrine was based on the Han notion that the father-son relation is the most fundamental of all human relations. It is not difficult to understand the historical origin of this emphasis: following China's transformation from a clan-lineage society to a family-oriented society, the principal subject of ancestor worship changed from a remote lineage ancestor to close family members, especially one's father. The important point here, however, is not so much social and religious change, but a new standard that this change brought about in political philosophy and rhetoric. The father-son relationship became analogous to relations between Heaven and ruler and between ruler and subject; the practice of filial piety was no longer a private family business but one's most important public duty. Thus, the *Classic of Filial Piety* teaches: "The superiority of the lord and father, the simplicity of the way of men, and the beginning of Heaven and Earth, all are contained in filial piety." During the Han the motto of rulership was "To govern the country with filial piety," and the *Classic of Filial Piety* was assigned to students in all schools throughout the nation. In the early Han, the government established a special official rank called "filial and uncorrupt." Local officials were responsible for recommending for this rank "filial sons, obedient grandsons, virtuous daughters, righteous wives, men who yielded property in order to relieve the distressed, and scholars who were a model to the people."[21] Not coincidentally, the posthumous titles of all Han emperors bear the prefix *xiao*, or "filial."

Filial piety, therefore, had multiple meanings and functions during the Han. These meanings and functions were reflected most directly in funerary practices. As Martin Powers has pointed out, filial piety mobilized the construction of funerary monuments and was expressed by these monuments; it was recognized on public occasions such as a funeral, and such recognition was crucial for a person's political career.[22] In short, the practice of filial piety fulfilled moral obligations and helped win respect from others. Once recognized as a filial son, daughter, or brother, a person was automatically considered a reliable member

of his or her family and community, as well as a loyal subject of the state. Such a reputation could lead to concrete gains: a person of outstanding filial conduct might be rewarded by the local authorities or the central government. He or she might be exempted from taxation, and a filial son might even be recommended for an official post through the recommendation system, which had become a routine channel for entering the imperial bureaucracy.

A useful means of stabilizing the social organization, such encouragement of filial practices nevertheless produced a strong counter-reaction. Once a reputation for filial piety became indispensable for material and political benefits, the practitioner's question often shifted from fulfilling the moral duty to demonstrating the virtue. The *Classic of Filial Piety* defines five major filial practices: "The service that a filial son does his parents is as follows: in his general conduct to them, he manifests the utmost reverence; in nourishing them, he endeavors to give them the utmost pleasure; when they are ill, he feels the greatest anxiety; in mourning for them, he exhibits every demonstration of grief; in sacrificing to them, he displays the utmost solemnity."[23] Interestingly, a filial son had to "exhibit" his grief and "display" his solemnity in mourning and sacrifices. The first three filial practices were concerned with domestic affairs inside the family; only the last two took place on public occasions during the funerary rites. The first three practices were aimed at the comfort and security of parents; the last two practices were essentially a matter of a filial son's self-expression; the degree of his "grief" and "solemnity" had to be judged by the audience of his ritual performance.

It is not difficult to imagine that funerary services, including the erection of mortuary monuments and the composition of mortuary inscriptions, provided a filial son with the best chance "to make himself known." This tendency, which gradually grew into a fanatic exhibition of filial piety during the second century, led the scholar Huan Kuan to write the following bitter criticism:

> Nowadays when parents are alive their children do not show love and respect, but when they die their children elevate them to very lofty positions through extravagant [spending]. Even though they have no sincere grief, they

are nonetheless regarded as filial if they give [their parents] a lavish burial and spend a lot of money. *Therefore their names becomes prominent and their glory shines among the people.* Because of this, even the commoners emulate [these practices] to the extent that they sell their houses and property to do it.[24]

Huan Kuan offers an explanation for the hypocrisy behind lavish funerary monuments during the Eastern Han, but he also challenges us to detect the intention behind the construction of a specific monument. Can we determine the meaning and function of an offering shrine— as an expression of a family's genuine filial devotion, as a convenient means of manipulating public opinion, or as a mixture of both? To what extent did a funerary monument demonstrate its meaning and function through its architecture and decoration? A number of difficulties prevent straightforward answers. First, most Han dynasty shrines were decorated with popular scenes illustrating virtuous men and women from Chinese history, as well as conventional images of banquets, chariot processions, immortals, and auspicious omens. In many cases these stereotypical motifs do not bear witness to the family's particular concerns. Second, since most Eastern Han shrines were destroyed after the dynasty's fall; the surviving slabs of a shrine rarely permit us to reconstruct its entire decorative program, which is often the key to understanding the meaning of its decoration.[25] Third, scholars have tried to explore the social and political implications of specific pictures on certain shrines. Because the owners of these buildings are often unknown, however, such speculations must perforce stop at a general level. This reflection implies that a comprehensive study of a funerary monument should be based on at least two groups of data: (1) an intact or reconstructible architectural structure and its decorative program, and (2) biographical sources of the patron and the deceased. To my knowledge, only two or three examples, all belonging to the Wu family from Jiaxiang in Shandong, meet these criteria; I discuss one of these in a later section. Fortunately, we have another important group of evidence consisting of some fourteen inscriptions written by patrons of funerary shrines; the An Guo inscription is the longest of these. Although the structures

Voices of Funerary Monuments

that originally bore these texts can no longer be reconstructed, the inscriptions form a collective body of information, allowing us to observe the shifting focus and intention behind the construction of funerary monuments during the first and second centuries.[26]

The earliest inscription is also the simplest. Engraved on a stone column that may have been a central pillar of a funerary shrine are four characters, which can roughly be translated as "an offering shrine in a sacrificial park" (*shizhai ciyuan*) (Fig. 4.7).[27] Neither the deceased nor the donor are mentioned. The inscription simply identifies the ritual function of the building. Whereas the early date ascribed this inscription is based largely on the pictorial style of its accompanying carvings,[28] a second example, originally carved on an offering shrine at Wenshang in Shandong, bears the date of A.D. 16 (Fig. 4.8). The inscrip-

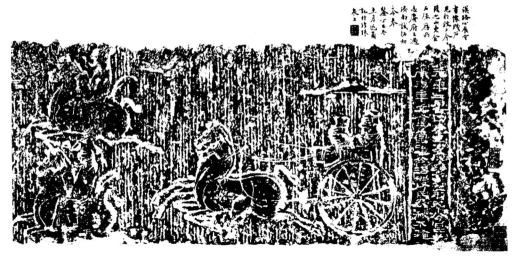

Fig. 4.8. Carving and inscription on Lu gong's shrine. A.D. 16.

tion, though still brief, includes a short introduction of the deceased. But a more crucial change is the narrative's voice: the construction of the ritual building is described by patrons who identify themselves at the end of the text. Labeled with this text, the funerary monument was no longer anonymous but devoted to a Confucian scholar by his filial brothers. "In the third year of the Tianfeng reign period [A.D. 16], we erected this offering hall for Gentleman Lu, who ceaselessly studied *Master Yan's Commentaries on the Spring and Autumn Annuals* [*Yanshi chunqiu*]. On the tenth day of the second month, in the first year [eight characters missing]. Gentleman Lu's brothers."

This text remains the only decipherable shrine inscription written during the first century.[29] The next example, an inscription dated to A.D. 106, demonstrates a dramatic shift in both content and style (Fig. 4.9). It records that a certain Marquis of Beixiang dedicated a shrine to his deceased father.[30] Upon completion of the building, he ordered his father's surname and honorable title, Yang sanlao (Thrice Venerable Yang), carved on it beside a far longer text describing his own filial devotion:

> This stone hall was completed on the fourteenth day, in the twelfth month of *jiachen*, in the first year of the Yan-ping reign period [A.D. 106]. The planet Jupiter was in

Fig. 4.7. left "Shizhai ciyuan" carving and inscription. Late Western Han to early Eastern Han. 1st century B.C.–1st century A.D.

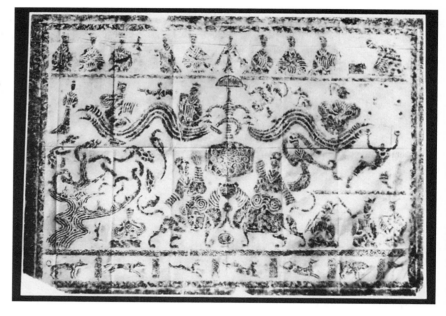

Fig. 4.10. Carving and inscription on the Dai family shrine. A.D. 113. From Liangcheng, Wei-shan, Shandong province.

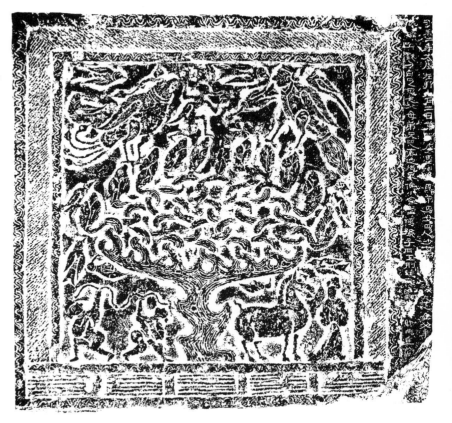

Fig. 4.11. Carving and inscription on the Yang family shrine. A.D. 137. From Liangcheng, Wei-shan, Shandong province. Now in the Confucian Temple in Qufu.

Fig. 4.9. Inscription on Yang sanlao's shrine. A.D. 106. H. 51 cm. Found in the early 20th century at Qufu, Shandong province. Museum of Chinese History, Beijing.

the position of *bingwu*. I, the Marquis of Beixiang of the Lu principality, reflect that I am staying in my rural home in mourning, neither attending the imperial court nor pursuing Classical learning. I am bent on serving and worshipping [my deceased father]. I am grievous and sorrowful that I have not repaid [his favor] with filial piety. Wailing without end, I am afraid that soon I will be unable to keep myself alive. I make sacrifices every morning, and offer food at all times [several characters missing].

The inscription seems to deliberately echo the filial practices required by the *Classic of Filial Piety*: "in mourning for them [i.e., the deceased parents], he [the filial son] exhibits every demonstration of grief; in sacrificing to them, he displays the utmost solemnity." In fact, in composing the inscription, the marquis simply replaced the indefinitive subject and object of filial devotion in the *Classic of Filial Piety* (an assumed filial son and his parents) with a definite subject and object (the marquis himself and his dead father). The inscription can thus be understood as an appropriation: "in mourning for my father, *I* am exhibiting every demonstration of grief; in sacrificing to him, *I* am displaying the utmost solemnity."

The focus of this commemorative text has thus shifted to the exhibition of the patron's filial devotion. The same tendency is also evident in another type of shrine inscription that appeared around the same time; it, however, demonstrates filial piety by providing the most calculable evidence—the amount of money a patron spent on a monument. The first such document is found on a large pictorial slab, originally installed on the back wall of a shrine belonging to a Dai family in Shandong (Fig. 4.10). The text on the left margin gives the names and death dates of the parents to whom the shrine was dedicated. The text to the right introduces the patrons and provides a detailed financial account:

Dai Mu, whose style name is Kongdao, spent 5,000 cash to build this stone hall, and again spent 2,500 cash to make the *guobao* [carved ceiling?]. Two other sons of the Dai family, as well as Wu Zhu with the style name Chengchao, Yang Xun with the style name Bieqing, and Zhang Nian, together contributed 9,500 cash. [This shrine] was com-

pleted on the eighteenth day in the intercalary month of the seventh year in the Yongchu reign period [A.D. 113].

Martin Powers has associated this type of inscription with scholars and low-ranking officials from families of "middle to lower-middle income."[31] But in my opinion, the authors may have been commoners with little Classical education. The inscription on the Dai family shrine differs markedly from that written by the Marquis of Beixiang or by the brothers of Gentleman Lu. The deceased is not identified as a Confucian scholar, nor are the donors listed with official titles. A slightly later shrine was constructed in A.D. 137 by four brothers and sisters of a Yang family long after their parents' death (Fig. 4.11). They explained the reason for this delay: "As now we the brothers and sisters have accumulated sufficient money, we long for our parents and are full of sorrow; we upgraded their tombs and built a small offering hall. . . . The shrine cost 10,000 cash."[32] Their words remind us of Huan Kuan's statement: "Even the commoners emulate [the prevailing filial practices] to the extent that they sell their houses and property to do it." It is understandable that for the less well off the best means of demonstrating filial piety was the money they earned, saved, and finally spent to erect a funerary monument. The elaborate verbal displays of "grief" and "solemnity" may have been reserved for members of the elite such as the Marquis of Beixiang.

The inscription of the Marquis of Beixiang and that on the Dai family shrine, therefore, typify two kinds of funerary texts of the early second century; their differences may have been related to the differing social status and financial condition of the donors. These two literary modes, however, were soon integrated. Writers of shrine inscriptions from the mid-second century tried to employ every available means to stress their filial devotion. The result was the standardization as well as the inflation of texts. An inscription before this time rarely exceeded 50 characters, but the Xiang Tajun inscription of A.D. 154 (Fig. 4.12) consists of some 400 characters; the An Guo inscription of A.D. 158 has 490 characters (Fig. 4.6). Some sentences and phrases such as "transporting soil on one's back to build a tomb" and "planting pines and junipers in

Fig. 4.12. Carving and inscription on Xiang Tajun's shrine. A.D. 154. H. 120 cm. Found in 1934 at Dong'a, Shandong province. Palace Museum, Beijing.

Fig. 4.13. page 201 Carvings and inscription on the Wu family pillar-gate. A.D. 147. Jiaxiang, Shandong province.

rows in a graveyard" became formulas for expressing filial practices. A latecomer, however, always had the advantage of being able to synthesize new formulas. As a traditional Chinese proverb puts it, "When the river rises, the boat goes up"; filial piety had to be measured against the going rate. Thus as shrine inscriptions became inflated, the amount of money spent on a mortuary monument also increased. In 137 the descendents of the Yang family may have been proud of themselves for saving 10,000 cash to build their parents' shrine. But twenty years later, Xiang Tajun's brothers and An Guo's brothers (both from ordinary families) had to donate 25,000 and 27,000 cash, respectively, to prove their sincerity. Rich families, understandably, had to spend even more: a pillar-gate erected in 147 by the four Wu brothers from a Shandong gentry family cost 190,000 cash (Fig. 4.13). In 182 Kong Dan, chancellor of a principality, enlarged his grandmother's cemetery and added a new offering shrine. Interestingly, we learn of this last instance not from an inscription on the shrine but from the commemorative text on Kong Dan's own memorial stela (Fig. 4.14). This text, in fact Kong Dan's biography, recounts his outstanding filial practices in familiar sentences: "When he had managed his family estate to some extent, he longed for his grandmother and was engaged in building funerary structures to her memory. . . . He enlarged his ancestress's tomb, erected an offering hall, and increased the soil for planting juniper trees. His filial piety is indeed genuine."[33] The same text also records that the funerary structures Kong Dan built for himself cost 300,000 cash.

It would be misleading to conclude that all Eastern Han funerary monuments were motivated purely by their patrons' desires for fame and practical gain. Nevertheless, in an age when the rhetoric of filial piety was so prevalent, it is indeed difficult to distinguish genuine expressions of grief from fake and exaggerated ones. This is perhaps why the only truly moving funerary inscription to survive from this period is a eulogy dedicated to a child by his parents, which I discuss in the following section. Since filial piety was by nature an obligation of the young toward the old, it seems that only when this order was reversed could funerary devotion free itself from the conven-

tional rhetoric and gain a measure of authenticity. But as we will see, even in such cases, parents' "private love" toward their children still had to be cast in the light of "public duty."

The Family (2)

A child who died in A.D. 170 is portrayed on a stone relief, originally part of an offering shrine but reused in a later tomb (Fig. 4.15a).[34] The picture is divided into two registers; the child appears on the upper frieze, sitting on a dais in a dignified manner, and his name, Xu Aqu, is inscribed beside him. Three chubby boys are walking or running toward him; clad only in diapers, their tender age is also indicated by their *zongjiao* hairstyle: two round tufts protrude above their heads. Releasing a bird or pulling and driving a large turtledove, they seem to be amusing their young master. The theme of entertainment is continued on the lower register on a grander scale: two musicians are playing a *qin* zither and a windpipe; their music accompanies the performance of a male juggler and a female dancer. With her sleeves swirling, the dancer is jumping on top of large and small disc-drums, beating out varying rhythms with her steps.[35]

A eulogy in the Han poetic style called a *zan* is inscribed beside the relief (Fig. 4.15b).

> It is the Jianning era of the Han,
> 　　The third year since our emperor [i.e., Emperor
> 　　　Ling] ascended the throne.
> In the third month of *wuwu*,
> 　　On the fifteenth day of *jiayin*,
> We are expressing our grief and sorrow
> 　　For Xu Aqu, our son.
>
> You were only five years old
> 　　When you abandoned the glory of the living.
> You entered an endless night,
> 　　Never to see the sun and stars again.
> Your spirit wanders alone
> 　　In eternal darkness underground.
> You have left your home forever;
> 　　How can we still hope to glimpse your dear face?

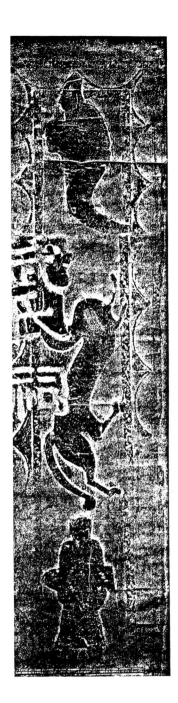
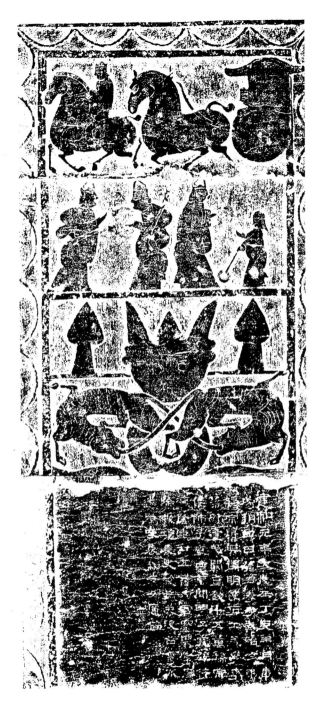

Longing for you with all our hearts,
 We came to pay an audience to our ancestors;
Three times we increased offerings and incense,
 Mourning for our deceased kin.
But you did not even recognize your ancestors,
 Only running east and west, crying and weeping.
Finally you vanished with them,
 While still turning back from time to time.

Deeply moved, we your father and mother . . .
 [inscription damaged]
To us all delicacies have become tasteless.
Wan and sallow,
 We are exhausting our savings [to build your
 shrine and to make offerings],
 Hoping your spirit will last forever.
. . . [inscription damaged]

You, the visitors,
 When you come here and see dust on this grave,
 Please sweep it without delay.
 Your kindness will make the deceased happy.

This carving occupies a special position in Han art. Whereas most figurative images engraved on funerary monuments are part of illustrations of didactic stories from historical texts, this is a portrait of a real, contemporary child.[36] The parents of Xu Aqu ordered the carving made to express their grief, and in the eulogy they spoke directly to their son who tragically died so young. This eulogy, which assumes the parents' point of view, may be read together with a poem in a Han *yuefu* collection, in which an orphan appeals to his departed father and mother:

 To be an orphan,
 To be fated to be an orphan,
 How bitter is this lot!
 When my father and mother were alive
 I used to ride in a carriage
 With four fine horses.
 But when they both died,
 My brother and my sister-in-law
 Sent me out to be a merchant.
. .

Fig. 4.14. Hong Gua's record of the memorial inscription dedicated to Kong Dan (d. A.D. 182)

I didn't get back till night-fall,
My hands were all sore
And I had no shoes.
I walked the cold earth
Treading on thorns and brambles.
As I stopped to pull out the thorns,
How bitter my heart was!
My tears fell and fell
And I went on sobbing and sobbing.
In winter I have no great-coat;
Nor in summer thin clothes.
It is no pleasure to be alive.
I had rather quickly leave the earth
And go beneath the Yellow Springs.

.

I want to write a letter and send it
To my mother and father under the earth,
And tell them I can't go on any longer
Living with my brother and sister-in-law.[37]

In a broader sense, both poems—the Xu Aqu eulogy and the *yuefu* poem (which must have been written by an adult in imitation of a child's voice)—express a kind of intimate love and consequent fear: a child who had lost his parents' protection was extremely vulnerable. In the underground world, he (or his soul) would be surrounded by dangerous ghosts and spirits; in the human world he would be subject to ill-treatment and cruelty, especially from relatives with no direct blood relationship with him who were entitled to control his life. He would be helpless and lonely, with neither the strength nor the ability to defend himself.

Such anxiety about the security of one's children, specifically one's male children, seems to have heightened during Han times (similar expressions are rare in pre-Han art and literature). We may attribute this psychological crisis to China's transformation into a family-oriented society. Textual and archaeological evidence reveals that the basic social unit increasingly became small "nuclear families" consisting of a married couple and their unmarried children.[38] Encouraged by the Qin and Western Han governments, this type of family soon became prevalent throughout the newly united country.[39] Although the

Fig. 4.15. (a) Carving and inscription on Xu Aqu's shrine. A.D. 170. Excavated in 1973 near Nanyang, Henan province. Nanyang Museum. (b) Inscription.

Fig. 4.16. page 205
Story of Ming Sun. (a, b)
Wu Liang Shrine carving.
A.D. 151. Jiaxiang, Shan-
dong province. Ink rubbing
and reconstruction. (c) Line
engraving. Eastern Han.
2d century A.D.

official policy was somewhat modified in the Eastern Han and the "extended family" was promoted as an ideal model, the result was a more integrated residential pattern, not the elimination of the "nuclear family" as the essential social element.[40] In fact, tension between individual families within a large household even increased; numerous instances of family struggles over property are reported in Eastern Han historical documents and reflected in art and literature.

From this social reality emerged the belief that the only reliable bond was that between parents and children; all other kin and non-kin relationships had to be treated with suspicion. But the problem was that the parent-child tie was inevitably challenged and conditioned by death. When a child died young, his soul would enter eternal darkness; to protect and nourish him, his parents had to rely on religious means. Thus Xu Aqu's father and mother constructed an offering shrine for their son and entrusted him to the family's ancestors. When parents were about to die, however, the problem would become far more serious and practical: Who would take care of their orphan in this dangerous world? The answer was not easy: they had to entrust their children to certain "agents," not ancestral spirits but living persons—a stepmother, relatives, friends, or servants—but were these agents dependable and trustworthy? As a solution to the problem, the responsibility of these agents to the orphan had to be cast as a serious "duty," and parents had to find some methods to keep reminding them of this duty. Not coincidentally, such concerns became an important theme in the decoration of a funerary monument: numerous pictures focus on the fate of the orphan, but unlike the Xu Aqu carving the emphasis of these pictures is on "public duty," not "private love."[41]

The hardship faced by the orphan described in the *yuefu* poem quoted earlier is reiterated in the story of Min Sun (style name Ziqian; Figs. 4.16a–c). The original tale is recorded in various versions of the *Biographies of Filial Sons* (*Xiaozi zhuan*). After Sun's mother died, his father remarried a woman who treated Sun with cruelty:

Sun's winter clothes were all filled with reed catkins, but his stepmother's own son wore clothes filled with thick cotton. Sun's father asked him to drive. The winter day was cold, and Sun dropped the horsewhip. When the stepmother's son drove, he managed everything well. The father was angry and interrogated him, but Sun kept silent. Then his father looked at the two sons' clothing and understood the reason.[42]

Even worse, it was thought that once in a stepmother's evil clutches an orphan's life could be in great danger, especially once the child's father had also died. Such a calamity is the subject of pictures illustrating the story of Jiang Zhangxun.

Jiang Zhangxun had the style name Yuanqing. He lived with his stepmother . . . who was an immoral woman and hated him. Zhangxun was aware of this and went to his father's tomb yard, where he built a thatched shack and planted many pine trees. The trees grew luxuriantly, and local people often rested in their shade. Even travelers stopped there to relax. Because of this his stepmother hated him even more. She put poison into wine that Zhangxun drank, but he did not die. She then attempted to kill Zhangxun with a knife at night, but Zhangxun was roused suddenly from sleep and again did not die. His stepmother then sighed, saying: "He must be protected by Heaven. It was a crime to intend to kill him."[43]

The underlying theme of both picture-stories was summarized by the sixth-century scholar Yan Zhitui in his famous *Family Instructions for the Yan Clan* (*Yanshi jiaxun*): "The second wife is certain to maltreat the son of the previous wife."[44] Ironically, in both stories an orphan's unconditioned obedience and submission to cruelty finally saved him. (Min Sun's obedience won back his father's love, and Jiang Zhangxun's piety moved and reformed his immoral stepmother.) The juxtaposition between a son and a stepmother highlights an important feature of Han didactic art: a human relationship, which by definition includes at least two parties, must be approached from both angles; correspondingly, these pictorial stories provide alternative solutions to a given problem. (For example, many narratives and their illustrations on Han monuments propagate the virtue of ministers and assassins who carry

Voices of Funerary Monuments

out their masters' orders; other stories and illustrations emphasize rulers who pay respect to their subjects.)[45] In the case of an orphan, the potential destruction might be avoided through the child's own and often extremely painful effort; on the other hand, wouldn't it be far better if a stepmother were exceptionally virtuous and able to fulfill her assigned duty? Instead of being a destructive force, an ideal stepmother was supposed to protect the orphan, even at the cost of sacrificing her own son. In such a case she would be admired as an "exemplary woman," and her illustrated biography would be presented on mortuary monuments to the public.

One such example is the Righteous Stepmother of Qi (Qi yijimu; Figs. 4.17a, b). In the picture, a murdered man lies on the ground; an official on horseback has come to arrest the criminal, and the woman's two sons, one kneeling beside the corpse and the other standing behind it, are both confessing to the murder. According to the story recorded in the *Biographies of Exemplary Women* (*Lienü zhuan*), the official could not decide which brother to arrest; the mother (portrayed in the picture at far left) was finally required to make the decision and surrender one of her sons.

> The mother wept sadly and replied: "Kill the younger one!" The minister heard her reply and asked: "The youngest son is usually the most beloved, but now you want him killed. Why is that?" The mother replied: "The younger son is my own; the older son is the previous wife's son. When his father took ill and lay dying, he ordered me raise him well and look after him, and I said, 'I promise.' Now, when you receive a trust from someone and you have accepted it with a promise, how can you forget such trust and be untrue to that promise? Moreover, to kill the older brother and let the younger brother live would be to cast aside a public duty for a private love; to make false one's words and to forget loyalty are to cheat the dead. If words are meaningless and promises are not distinguished [from non-promises], how can I dwell on this earth? Although I love my son, how shall I speak of righteousness?" Her tears fell, bedewing her robe, and the minister related her words to the king.[46]

Here we find the opposition between "private love"

a

b

c

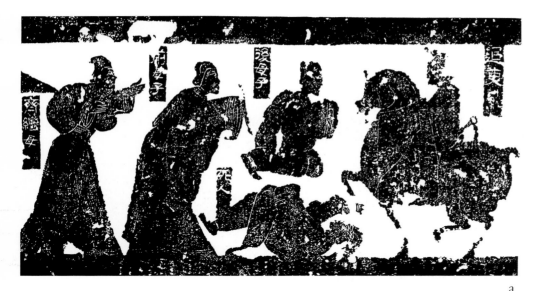

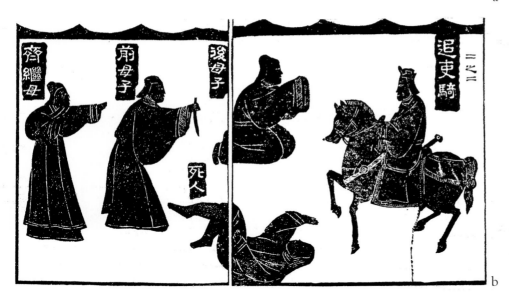

Fig. 4.17. *Story of the Righteous Stepmother of Qi. Wu Liang Shrine carving. (a) Ink rubbing. (b) Reconstruction.*

(*si ai*) and "public duty" (*gong yi*): the stepmother was praised for her fulfillment of her "duty"—loyalty and righteousness—and she was given the honorific title "yi" (righteous). But in order to achieve this, she had to be ready to give up her own "love." She was forced to choose one or the other, and her own example clearly indicated which was the right way.

In this sense a stepmother, though called a "mother," was here not so different from an orphan's relatives or even servants, whose responsibility toward an orphan, as we find in carvings on Han funerary monuments, also fell into the category of "public duty." Two pictures illustrate such righteous relatives, one the Public-Spirited Aunt of Lu (Lu yigujie) and the other the Virtuous Aunt of Liang (Liang jiegujie).[47] It is said that the Public-Spirited Aunt met an enemy when she and two boys were working in the fields. Being pursued by cavalrymen, she dropped one child while escaping with the other (Figs. 4.18a, b). When she was finally caught, the commander found out that the child she had cast aside was her own and the other was the son of her brother. The commander inquired:

> "A mother always loves her son, and her love is deep in her heart. Today, you put him from you and carried the son of your brother. How is that?"
>
> "To save my own son is a work of private love, but to save my brother's child is a public duty. Now, if I had turned my back on a public duty and pursued my private love, and if I had abandoned my brother's child to die to save my own child, even if by good fortune I should have escaped, still my sovereign would not tolerate me; the officials would not support me; and my compatriots would not live with me. If that were the case, then I should have no place to harbor my body and no ground for my tired feet to tread upon."[48]

A new theme is introduced: not only did the aunt have to place "public duty" over her "private love," but her sacrifice was based on a practical concern about her own livelihood. The lesson of the story appears to mix both enticement and threat. Indeed, the unseen instructor of this lesson must have been the brother (or the social grouping the brother represented), who so successfully

Fig. 4.18. Story of the Public-Spirited Aunt of Lu. (a, b) Wu Liang Shrine carving. Ink rubbing and reconstruction. (c) Carving on the Front Wu Family Shrine.

transplanted his own fear into his relatives' hearts. We may condense his instructions into a simple form: those who failed to take care of his (orphaned) son would be held in contempt by the whole world, whereas those who fulfilled "public duty" would not only live in peace but would be rewarded by the king. Thus, whereas one version of the picture story highlights the theme of sacrifice (Figs. 4.18a, b), another version represents its happy ending (Fig. 4.18c): two ministers come to present gold and silk to the Public-Spirited Aunt, and the woman kneels to thank them for the king's bounty. She is still holding her nephew in her arms, and her own son is jumping happily behind his glorious mother.

The woman's frightened voice in this story becomes a scream in the tale of the Virtuous Aunt of Liang, another decorative motif of Eastern Han funerary monuments (Figs. 4.19a, b). The woman's house catches on fire with both her own son and her brother's son inside. She wants to rescue her nephew but in her haste she picks up her own son. In desperation she runs back into the fire and commits suicide. The following words are her final testament: "How can I tell every family in the state and let everyone know the truth? . . . I would like to cast my son into the fire, but this would violate a mother's love. In such a situation I cannot go on living." The official version of the story is concluded by the remark of a certain "Noble Gentleman" (*junzi*): "The Virtuous Aunt was pure and not debased. The *Book of Songs* says: 'That great gentleman would give his life rather than fail his lord.' This could be said of her."[49] In quoting the passage from the sacred Confucian text, the commentator compares the aunt's "public duty" toward her brother to that of a minister to his lord.

These illustrations seem to suggest that the selection of didactic stories for mortuary monuments reflected people's intense concerns about posthumous family affairs. These concerns included the chastity of widows and the relationship between family members, but the safety of their children was overwhelmingly important. It is misleading to simply attribute this concern to the selfishness of individuals. The Confucian sage Mencius had announced several hundred years earlier that "among the three sins

of being unfilial, having no descendents is the greatest one,"[50] and filial piety, as explained in the *Classic of Filial Piety*, was the most fundamental virtue of humanity. If a person had no descendents, his family line was broken and his ancestors could no longer enjoy offerings. No disaster could be greater than this in a family-centered society.

As I explained earlier, a common method to express such concerns was to quote historical allusions from standard books. The analogues people drew did not necessarily (and could hardly completely) coincide with reality; hagiographic tales provided stereotypes, not real personages. A viewer of such pictures on a funerary monument was expected to discern the general parallels between himself or herself and a certain type. He or she would thus "identify" with this type and follow the moral lesson it embodied. In addition to virtuous stepmothers and relatives, another such type was the loyal servant. Understandably, a servant could play a considerable role in an orphan's life (and in fact some servants in a household were remote, poor relatives of the family).[51] The epitome of the loyal servant during the Han was a man named Li Shan, a veteran servant in the family of a certain Li Yuan. He saved his young master from other "evil servants" and helped him recover the family property.

> During the Jianwu era [A.D. 25–55], an epidemic broke out, and people in Yuan's family died one after the other. Only an orphan, who was named Xu and had been born only a few weeks earlier, survived. The family had property worth a million cash. The maids and a manservant plotted to murder Xu and then divide his property. Shan was deeply sympathetic about the [bad fortune] of the Li family, but he could not control the situation single-handedly. So he secretly carried Xu and fled, hiding in the territory of Xiaqiu in the Shanyang district. He nursed the child himself and fed him with raw cow's milk. He gave a dry place [to the child], while he himself stayed in a damp place. Although Xu was in his arms, he served the child as his elder master. Whenever something came up, he kneeled a long while before the child, reported on the matter, and then went to do it. The neighbors were inspired by his behavior, and all started to cultivate righteousness. When Xu reached the age of ten, Shan returned

to the county to rebuild the household. He brought a suit before the officials against the male and female servants, and all of them were arrested and put to death.[52]

This event must have created a sensation at the time: it was recorded in the chapter entitled "Distinctive Behavior" ("Duxing") in the Eastern Han official history, transformed into several folktale versions, and illustrated on funerary monuments. One of these illustrations is still extant. Its surviving portion shows an evil servant pulling the infant out of a basket (Fig. 4.20a). A nineteenth-century reproduction of the carving reconstructs the missing part (Fig. 4.20b): Li Shan kneels by the child and raises his arms in a gesture of reverence. This picture graphically highlights the opposition between the evil and the loyal servant, but the focus is still the orphan.

Although each of these stories has a happy ending, their depiction on funerary monuments reveals a deep suspicion toward the intended viewers of the pictures. The unspoken premise was that although "public duty" sounded glorious and might occasionally be carried out by relatives or servants, it was preferable to rely on direct kin, primarily parents themselves, whenever possible. This understanding was formulated in A.D. 79 in an Eastern Han official document, the *Proceedings from the White Tiger Hall* (*Baihu tong*): the relationship between natural parents and children was considered one of the Three Bonds, but "paternal uncles, brothers, clan members, maternal uncles, teachers, and friends" were called the Six Strings (*liuji*): "The major relations are the Bonds, and the minor relations are the Strings."[53] Scholars have also proposed that during the Han, various kin relationships were classified into two distinct systems: the first was a linear patriline including the nine generations of a family from the great-great-grandfather to the great-great-grandson; the second included three indirect kin groups—paternal relatives, maternal relatives, and in-laws.[54] The last group was considered most distant and unreliable. The *Classic of Filial Piety* teaches that "the connecting link between serving one's father and serving one's mother is love."[55] Corre-

a

b

Fig. 4.19. Story of the Virtuous Aunt of Liang. Wu Liang Shrine carving. (a) *Ink rubbing.* (b) *Reconstruction.*

李氏遺孤
思孝李善

a

b

Fig. 4.20. Story of Li Shan. Wu Liang Shrine carving. (a) Ink rubbing. (b) Reconstruction.

implication, that a man's household, as well as his young children, would inevitably "be dominated by a woman" if his wife outlived him. Even worse, she could remarry and his children would be taken to another household. This worry must have had a solid basis: many passages in Han texts reveal that the parents of a widow would advise her or even force her to find another husband.[58] In these cases, the widow's paternal family relationship resurfaced and overpowered her marital relationship, which, in a sense, had been broken by the husband's death. To keep the widow in the husband's household to take care of *his* children, the time-honored rhetoric of "public duty" was again employed. In other words, her "private love" toward her children had to be reinterpreted as a "duty"—*xin* or "fidelity" to her deceased husband. Liang the Excellent, who destroyed her face to avoid the danger of remarrying, best exemplified this virtue of a widow (Figs. 4.21a, b). Remarking on her story translated below, the Noble Gentleman (*junzi*) says: "Liang was chaste, decorous, single-hearted, and pure. The *Book of Songs* states: 'You thought I had broken faith; I was true as the bright sun above.' This could be said of her."

> Gaoxing was a widow from the state of Liang. She was glorious in her beauty and praiseworthy in her conduct. Although her husband died, leaving her widowed early in life, she did not remarry. Many noblemen of Liang strove among themselves to marry her, but no one could win her. The King of Liang heard of this and sent his minister with betrothal gifts. Gaoxing said, "My husband unfortunately died early. I live in widowhood to raise his orphans, and [I am afraid that] I have not given them enough attention. Many honorable men have sought me, but I have fortunately succeeded in evading them. Today the king is seeking my hand. I have learned that the principle of a wife is that once having gone forth to marry, she will not change over, and that she will keep all the rules of chastity and faithfulness. To forget the dead and to run to the living is not faithfulness; to be honored and forget the lowly is not chastity; and to abandon righteousness and follow gain is not worthy of a woman." Then she took up a mirror and knife, and cut off her nose, saying, "I have become a disfigured person. I did not commit suicide

spondingly, the basic core in caring for one's children was also love, or in Mencius' words, "family feeling."[56]

The concept of "parents," however, is a generalization: a father and mother were from different families and, logically and practically, must have had divergent and even conflicting concerns. The old question about a child's security thus again surfaced, but this time posed by the father to the mother. More specifically, was a mother's love toward her (husband's) sons forever trustworthy? Had not many mothers in Chinese lore, from an empress to an ordinary housewife, betrayed their husband's family by bringing their own brothers and nephews (their own paternal relatives) to power? Such anxiety is reflected in a bitter letter by an Eastern Han gentleman named Feng Yan, in which he bitterly accused his wife of multiple crimes including having "destroyed the Way of a good family." It is interesting, however, that to Mr. Feng his personal tragedy was an example of a nightmare shared by all members of his sex: "Since antiquity it has always been considered a great disaster to have one's household dominated by a woman. Now this disaster has befallen me."[57]

To his contemporaries Feng's statement had a further

a

b

Fig. 4.21. Story of Liang the Excellent. Wu Liang Shrine carving. (a) Ink rubbing. (b) Reconstruction.

because I could not bear to see my children orphaned a second time. The king has sought me because of my beauty, but today, after having been disfigured, I may avoid the danger [of remarrying]." Thereupon, the minister made his report, and the king exalted her righteousness and praised her conduct. He restored her liberty and honored her with the title *Gaoxing*.[59]

Liang's statement that she must remain a widow to raise the orphans is reminiscent of the speech of the Righteous Stepmother of Qi, in which she likewise emphasizes the importance of keeping her "promise" to her deceased husband to raise his orphan. Indeed, once a wife had lost her husband, her conduct and morality were judged not on the grounds of her being a good mother but on the grounds of chastity and faithfulness. The difference between a widowed natural mother and a widowed stepmother thus largely disappeared: they both bore the liability of keeping their "promises" to their dead husband to bring up *his* son. In fact, a widowed mother was approached not that differently from relatives and servants, since the virtue they shared was classified as "loyalty." The Virtuous Aunt of Liang was praised for her faithfulness to her "lord," and Li Shan served the orphan "as his elder master." The moral presented to a widow was the same: "A loyal minister does not serve two lords, neither may a faithful widow marry a second husband."[60]

A widowed mother, however, differed from other guardian figures of an orphan: she was often forced to display some extreme proof of her fidelity such as self-disfigurement. Liang's example is not necessarily fictional; similar instances can be found in historical accounts.[61] Usually, the women who disfigured themselves (by cutting off their hair, ears, fingers, or noses) were widowed mothers being forced into remarriage by their parents or paternal relatives. Three such model widows named Peng Fei, Wang He, and Li Jin'e are presented in a single paragraph in the *Records of the Huayang Kingdom* (*Huayang-guo zhi*), which ends with the sentence: "They all brought up their sons and fulfilled their public duty."[62]

Such behavior must be understood as a kind of symbolic self-immolation. Incidents of widows' suicide were not uncommon during the Han,[63] but, as Liang testified,

she did not commit suicide because she had to care for her husband's children. Her self-execution had to be performed symbolically, since in actuality she had to remain functional as a mother. Women's self-disfigurement becomes even more alarming if we re-read Feng Yan's letter, in which he blamed his wife not only for her scandalous behavior but also for her slovenliness and lack of female refinement. But beauty or even a normal appearance would have become useless and even dangerous after the husband's death. By removing such useless and dangerous features, the widow became more "trustworthy" and "safe." (So Liang the Excellent said: "After having been disfigured, I may avoid the danger of remarrying.") Is it coincidence that the designer of her picture-story chose the moment of her "symbolic suicide" as the subject of illustration (Figs. 4.21a, b)? In the picture, a chariot drawn by four horses halts on the left, and the king's messenger stands beside the chariot waiting for Liang's answer. A female servant acts as an intermediary to present the king's betrothal gifts to the widow. The famous beauty is holding a knife in the left hand about to cut off her own nose; the mirror she holds in her right hand brings the theme of disfigurement into sharp focus.

In these pictures engraved on Han funerary monuments, we have gradually traced the vantage point from which these moral tales were told and from which the myth of "public duty" was created—this vantage point was set by the "father." Significantly, no father is depicted on Han funerary monuments as taking care of his son, nor is his responsibility to a motherless orphan referred to as a "public duty." The reason may be simple: he was the invisible instructor behind all these moral lessons. As T'ien Ju-K'ang has observed, "Throughout Chinese history, as a general rule morality has been vigorously propagated whenever immorality was actually prevailing."[64] The figures who devoted their lives to an orphan were virtuous widows, stepmothers, sisters-in-law, and loyal servants, because from the viewpoint of the husband-brother-master these were all untrustworthy: a widow naturally wished to find a second home; "the second wife is certain to maltreat the son of the previous wife"; "sisters-

in-law are the cause of many quarrels";[65] and servants commonly schemed against their masters. The hagiographic stories were illustrated on funerary monuments to discourage these dangers, not to reward good individuals.

A maxim in the Confucian classic, *Master Zuo's Commentaries on the Spring and Autumn Annals,* typifies this anxiety: "If one be not of my kin, one is sure to have a different heart."[66] Who could be closer kin to a son than his father? The relationship between a son and his father differed radically from all other relationships, including the mother-son relationship: the son bore his father's surname and continued his father's family line. In other words, the father identified himself with his son and considered the son his incarnation. Moreover, in a patrilineal family the father-son relationship was repeated generation after generation (as indicated by the repetition of the family surname). A man was often simultaneously both a father and a son, a situation that again differed fundamentally from one's relations with mother, wife, relatives, friends, and servants (who all belonged to or came from "other families"). Such a patrilineal chain demanded and produced a specific moral code to sustain it—*xiao,* or filial piety. All male heroes represented in a family context on funerary monuments were therefore filial paragons.

Generally speaking, filial piety is the virtue of a child toward his parents: "The essence of this primal virtue is none other than to honor and obey one's parents while they are alive, to sacrifice to them reverently after their death, and to adhere to their guidance throughout one's whole life."[67] By practicing this virtue one thus identifies oneself *as* a child. This point requires a brief examination of the definition of *child.* Two different standards coexisted in early Imperial China. The first was based on age. Normally when a man reached twenty years old, he was considered an adult man; a special "capping ceremony" (*guanli*) was held to mark his coming-of-age. Before this age he was called a *tong* or *tongzi,* meaning "child."[68] The other definition of *child* is based not on age but on family relationships. As a popular saying goes: "As long as his parents are alive, a son is always a boy." This does not imply, as a modern person may imagine, that the son was treated by his parents as their "baby boy." Rather, it means

that the son, though an adult, should remain a boy—to behave as a child and cultivate the child's virtue of filial piety. The epitome of such "elderly boys" is Laizi, whose portrayal was a favorite motif on Han funerary monuments (Figs. 4.22a, b).

> Elder Laizi was a native of Chu. When he was 70 years old, his parents were still alive. With the ultimate filial piety, he often wore multicolored clothes to serve his parents food in the main hall. Once he hurt his feet. Afraid to sadden his parents, he made himself tumble stiffly to the ground and bawled like an infant. Confucius remarked: "One does not use the word 'old' when one's parents are getting old, because one fears this will make them grieve about their elderliness. A person like Elder Laizi can be called one who does not lose a child's heart."[69]

In Confucius' view, another famous "elderly boy" named Bo Yu, whose image also appears frequently on funerary monuments (Figs. 4.23a, b), would be less filial because he, though a paragon, let his mother realize her elderliness. Also 70 years old, Bo Yu was willing to be beaten by his mother whenever he made a mistake. But one day he wept, and his mother asked him: "I did not see you weep when I punished you before. Why do you cry today?" To his mother's surprise he answered: "Before, when I offended you and you beat me with the stick, I often felt pain. But today your weakness could not make me feel pain. That is why I am weeping."[70]

Logically speaking, if parents were not supposed to become "old," then the son had to be always "young," and this is exactly what the Laizi picture tells the viewer. This intention is manifested in the pictorial representations: the old Laizi is portrayed as a boy with a small frame, a plump body, and wearing a three-pointed baby hat; his aged parents (who in reality must have been close to a hundred years old) appear as a healthy young couple, the father wearing a gentleman's cap and the mother an elaborate headdress. What the artist tried to express seems to have been the moral implication of the story, not reality.

Thus, the images of these men-children are not "portraiture" at all, an artistic genre defined by Richard Delbrücl as "the representation, intending to be like, of a

Fig. 4.22. Story of Laizi. Wu Liang Shrine carving. (a) Ink rubbing. (b) Reconstruction.

definite individual."[71] In these carvings, the figures' physical likeness is vitiated to serve the moral content, and their identities as submissive "children" are shown in their juxtaposition with their parents. To understand this, we need only compare all nine filial sons "portrayed" on the famous Wu Liang Shrine. From textual sources we know that these men's ages range from 5 (Zhao Xun) to 70 (Laizi and Bo Yu), but their representations are by and large indistinguishable. Most of them kneel before their parents—a standard gesture of respect and submission. What these images represent is a particular species created by Han Confucian ideology, which we may call the "ageless child." A physically old filial son had to pretend to be young (and had to be represented as young); a filial son who was really young had to be mature enough to be insistently virtuous and morally unshakable. The former category is the "man-child" and the latter, the "child-man." The heroes' individuality is entirely omitted—their "portraits" have become simply tokens of ideas. What remains is their morality, which, in the patrilineal society of Han China, was further promoted as the foundation of the whole universe. The *Classic of Filial Piety* teaches: "Filiality is the first principle of heaven, the ultimate standard of earth, the norm of conduct for the people."[72] It is hardly possible to imagine anything more "public" then the duty of filial piety, anything further removed from private family love.

Real children and "ageless children" are depicted in very different ways on Han funerary monuments. The former are mostly nameless creatures protected by virtuous mothers, stepmothers, relatives, and servants. The latter are famous paragons who nourished and protected their parents. This distinction further implies that a child labeled "filial," even if he were only five years old, had gained adulthood—he had become a symbol of the fundamental moral principle and an exemplar for the whole population. Once this idea prevailed, a whole group of child-men emerged in both fiction and reality. As mentioned earlier, from the early Western Han, the government regularly selected officials through a recruitment system. People with reputations for being "filial and uncorrupt" were recommended by local offices to the throne

on a regular basis. The chosen ones included young boys who were not only morally distinguished but also well versed in the Confucian classics. They were honored with a special title, *tongzi lang*, or "boy gentleman."[73]

Such Confucian prodigies were frequently represented in art. Xiang Tuo, a child of extraordinary wisdom and learning, was said to have been a teacher of Confucius himself, and his portrait regularly appears on funerary monuments between Confucius and Laozi (Figs. 4.24a, b): the small boy is holding a pull-toy, and the two masters are gazing at him instead of each other. Audrey Spiro has remarked on this image: "The child is meant to be seen, not as an opponent, but as a Confucian prodigy, ready to discourse on the highest subjects."[74] Martin Powers has further pointed out that Confucian scholars used the story as a political metaphor: it meant that "any man has a legitimate right to speak out if his words are righteous," and that "merit is to be determined by wisdom and intelligence, not by appearance, title, or pretense."[75] But once such a "metaphor" prevailed, it was often taken literally. Michel Soymié, for example, has cited a tomb inscription (A.D. 179, Shandong), lamenting the premature death of a son from a certain Feng family. The child was described as having memorized the whole *Book of Songs* and the ritual canons. Indeed, so great was his learning that he was called a second Xiang Tuo.[76]

Then there were children who, rather than being specialists in the Confucian classics, were distinguished by their moral conduct. Zhao Xun (Fig. 4.25) had consistently demonstrated his filial piety since he was five years old and thus "became well known and his reputation spread far." He was finally promoted by the emperor himself to be a royal attendant.[77] The most interesting figure illustrated on Eastern Han funerary monuments, however, was the boy Yuan Gu (Figs. 4.26a, b), whose filial piety transformed his vicious father into a filial son.

> When Yuan Gu's grandfather was old, his parents detested the old man and wanted to abandon him. Gu, who was fifteen years old, entreated them piteously with tears, but his parents did not listen to him. They made a carriage and carried the grandfather away and abandoned him. Gu

a

b

Fig. 4.23. Story of Bo Yu. Wu Liang Shrine carving. (a) Ink rubbing. (b) Reconstruction.

> brought the carriage back. His father asked him, "What are you going to do with this inauspicious thing?" Gu replied: "I am afraid that when you get old, I will not be able to make a new carriage, and so I have brought it back." His father was ashamed and carried the grandfather back and cared for him. He overcame his selfishness and criticized himself. He finally became a "purely filial son," and Gu became a "purely filial grandson."[78]

The characters in this story belong to three generations. Yuan Gu's father violates filial piety in his treatment of his own father; Yuan Gu demonstrates his extraordinary filial piety not only by rescuing his grandfather but, more important, by reforming his father. The moral of the illustrated story is twofold: Yuan Gu criticizes his father's behavior, but not directly. He employs a rhetorical method called *feng*, or remonstration, through metaphors and analogies. The key to his rhetoric is the carriage, which is depicted purposefully in the center of the scene. By bringing back the carriage the boy hints at the parallel between his own relation with his father and his father's relation with the grandfather; the implication is that although the father was now in control, in time he could well become a victim of his own model. In fact, Yuan Gu neither tries to prove the universality of filial piety nor advises his father to follow this moral law. What he does is to appeal to his

Fig. 4.24. Xiang Tuo with Confucius and Laozi. Eastern Han. 2d century A.D. Excavated in 1978 at Songshan, Jia-xiang, Shandong province. Ink rubbings. (a) W. 66 cm. (b) W. 68 cm.

father's concerns about his own security and well-being. And he succeeds.

In this section I have tried to decipher the messages conveyed by the images of children depicted on Han funerary monuments. What we have found is an essential paradox in social attitudes and notions of responsibility toward a child. On the one hand, the concept of "private love" was often associated with a child's natural parents (especially the mother), whereas "public duty" was required from a child's stepmother, relatives, and servants. Upon closer investigation, however, we have seen that even one's relationship with one's own children or parents could become a social responsibility, determined by

moral obligations assigned by society at large. Thus, although the desire for "private love" was sometimes murmured, the common themes represented on funerary monuments are "public duty"—the loyalty of a stepmother, aunt, friend, or servant; the fidelity and chastity of a widowed mother; and the filial piety of a son. Executed on a memorial shrine or pillar-gate, these pictures were exposed to the public, and their social function was again emphasized by inscriptions engraved alongside: "We are stating clearly to people of virtue and kindheartedness within the four seas: Please regard these [pictures and] words and do not ignore them."[79]

The general social and moral implication of these carvings contradict and dismiss any artistic representation of

individuality—an individual's distinctive features and personality. The images of children and other types of figures on funerary monuments are symbols—"a particular [that] represents the more general"[80]—that index people's mutual and conventional responsibilities in a community. Even the Xu Aqu carving (Fig. 4.15a)—the image of a "real" child—is not an exception: the "portrait" is based on a standard image of a male master receiving an audience and enjoying musical and dance performances (Fig. 4.27). Since the adult figures are replaced by children in this carving, Xu's "portrait" is again transformed into an idealized "public" image, as if the memory of the child could survive only in such a stereotype in a public art, as if his parents' love, so vividly expressed in their private appeal to their son in the eulogy, could be expressed only in the generic language of funerary monuments.

Friends and Colleagues

When the rebellion broke out in Taishan in 154, a few local officials, Confucian scholars for the most part, refused to carry out the severe measures adopted by the government to punish the rebels, for in their view the rebels were desperate people suffering from human and natural disasters. One such official was Han Shao, the prefect of a small county called Ying in central Shandong. According to the *History of the Latter Han*, instead of attacking the destitute peasants, he let them pour into his county. "He opened up the official granary, relieving them from hunger; more than 10,000 families received his aid. The county's financial officer tried to stop him, but he responded: 'If I shall be punished for rescuing these men and women from their graves, I will die with a smile on my face.'"[81]

Han Shao was not punished, but he was never promoted to a higher post. After he died in his county office, a group of people, including Li Ying (109–69), Du Mi (d. 169), Xun Yu (d. 169), and Chen Shi (103–87), paid him homage by erecting a stone stela in front of his tomb to commemorate his virtue.[82] The stela's inscription was never recorded; only its *establishment* is mentioned in the *History of the Latter Han* at the conclusion of Han Shao's

Fig. 4.25. Story of Zhao Xun. Wu Liang Shrine carving. Ink rubbing.

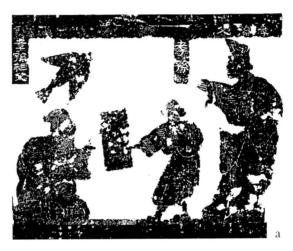

Fig. 4.26. Story of Yuan Gu. (a) Wu Liang Shrine carving. Ink rubbing. (b) Line engraving. Eastern Han. 2d century A.D.

a

b

Fig. 4.27. Entertainment. Eastern Han. 2d century A.D. Found in Nanyang region, Henan province.

quent rise of eunuchs in state affairs, however, and formed a political faction to regain power from the "castrated evils." Their bravest leader was Li Ying.

Beginning his official career as a "filial and uncorrupt person," Li Ying finally attained the high office of grand commandant (*taiwei*).[84] Most of the activities recorded in his official biography are concerned with his tireless struggles against the eunuchs. He once enforced the law by executing a well-known tyrant who was the younger brother of the chief eunuch, Zhang Rang. Li Ying was thereupon interrogated by the emperor himself in a special court session. Later, he found out that an innocent man had been murdered, but no one dared to look into the case because the criminal's father, the popular necromancer Zhang Cheng, had intimate connections with eunuchs and even with the emperor. Li Ying managed to capture the murderer and beheaded him without reporting it to the throne. This event in 166 led to an explosion of the heightening tension between eunuchs and scholar-officials. Li Ying and more than 200 of his friends and followers were arrested. But this only increased his fame. Even before 166, more than a thousand young Confucians had studied with him; now he was honored as a national hero. Nevertheless, he maintained a high standard in choosing friends and students. We are told by his biographer that he never paid attention to the rich and the powerful, and that "those who received audiences from him were so proud that they called themselves 'the ones who had entered the Dragon Gate.'" In Confucian circles, he was considered a "model within the four seas" and one of the Eight Sterling Men (*bajun*).

Emperor Huan died in 167 and left no designated heir. The next ruler, Emperor Ling (r. 168–89), was a young boy brought to the throne from the provinces. The Confucians and their allies saw this as a chance to seize power, and one of them even plotted a coup d'état to execute all eunuchs. But news of their plan leaked out, and their enemies got the upper hand. The persecution of Confucians, known as the Great Proscription (*danggu*), began in 168 and continued throughout Emperor Ling's reign. Li Ying bore the brunt: in 169 he and 600 other scholars were tortured to death. His wife was exiled to the frontier, and

brief biography. Why was the act of constructing the stela considered so important and who were the men responsible? Surprisingly, there is no evidence of relations between Han Shao and the patrons of his memorial stela during his lifetime. Moreover, unlike Han Shao, who remained a low-ranking official in a small county, the donors of the funerary monument were the nation's leading Confucians and famous statesmen at court. They also belonged to a single political group, and three of them—Li Ying, Du Mi, and Xun Yu—were later martyred in the struggles against the powerful eunuchs who dominated the Han court during most of Emperor Huan's and Emperor Ling's reigns. In Han society, a memorial stela dedicated by such renowned personages carried extraordinary weight:[83] it meant formal approval of the political agenda and moral deeds of the deceased; it indicated a kindred relationship between the donors and the deceased; and it gained the deceased national attention. It was Han Shao's memorial stela that brought posthumous fame and glory to this petty official and made him a model for other Confucians.

The struggle between the scholar-officials and eunuchs surfaced shortly after 159. In this year, with the eunuchs' help, Emperor Huan dismissed Liang Ji, the brother of the empress dowager and the chief power in the state for eighteen years. Confucian courtiers resented the subse-

his relatives, students, and subordinate officials were thrown into jail.

Du Mi and Xun Yu, two other contributors to Han Shao's memorial stela, died together with Li Ying. The three men had known one another from childhood: they were from Yingchuan in southern Shandong, and Xun Yu's uncle Xun Shu had initiated Li Ying into Confucian learning. After Xun Shu passed away, Li Ying mourned him for three years—an act of ritual homage usually paid only to one's parents. The central factor uniting these three scholars-officials, however, was their common political goal. Du Mi, who held the lofty position of grand tutor in both Emperor Huan's and Emperor Ling's reigns, "would catch eunuchs' adherents and bring them to trial whenever they were found doing evil in office."[85] Xun Yu took even more extreme action: during his tenure of office in Pei, "he executed the followers and protégés of eunuchs in his county even when they had only committed a minor crime."[86] Like Li Ying, they headed the list of Eight Sterling Men.

The fourth person to take part in establishing Han Shao's memorial stela was Chen Shi.[87] A close friend of Li Ying and a member of the Confucian group, Chen Shi nevertheless tried to disengage himself from worldly affairs and to maintain his spiritual purity in reclusion. In this way, he became a representative of those "retired worthies" whose withdrawal from the corrupt court was itself a political gesture.[88] Chen Shi's growing reputation resulted not from his direct engagement in political struggles, but from the risks he took in maintaining a seemingly impartial position. Thus, when Li Ying was arrested in 166 and many scholars tried to flee, he went straight to prison and asked to be jailed along with his friend. But when the father of the chief eunuch Zhang Rang died, he was the only Confucian gentleman to attend the funeral held by Zhang Rang, one of the most hated men in the country and the engineer of the 166 trial. His seemingly unbiased position may have helped him escape the Great Proscription. After the tragic event, he continued to refuse any official assignment, even the highest post in the court. Chen Shi died in 187 at age 84. More than 30,000 people from all parts of the country attended his funeral; sev-eral hundred guests wore white mourning clothes; and a number of stone stelae were erected in front of his tomb to praise his virtues.

The scale of Chen Shi's funerary ceremony was not unique during the Han. According to historical records, more than 10,000 chariots accompanied the funeral of the famous scholar-official Kong Guang (65 B.C.–A.D. 5) to his burial ground, and when the Confucian master Zheng Xuan (127–200) died, "all those who had studied with him, from those who held the official post of governor on down, put on their mourning robes to attend the funeral, over a thousand in all."[89] As Martin Powers has pointed out, many such funeral services served important social and political purposes.[90] The guests attended a service because they had or felt some specific connection with the deceased and because they wanted to stress that connection publicly. Since graveyards had become centers of social life during the Eastern Han, funerary ceremonies provided the most appropriate occasions for emotional and political expressions.

Han Shao's funeral was probably not a grand spectacle like the funerals held for Kong Guang, Zheng Xuan, and Chen Shi, but it served the same purpose. Li Ying, Du Mi, Xun Yu, and Chen Shi may have never had much contact with Han Shao, but this only made their tribute more significant. The stela they erected for Han Shao, in fact, expressed their spiritual relationship with this virtuous Confucian gentlemen, a relationship that transcended death. That these four men erected the stela together also emphasized their own comradeship. Moreover, their devotion to this humble scholar made it clear that status differences were irrelevant to the morals shared by true Confucians. Not coincidentally, we find that this stela was most likely established in 167 or 168, when Li Ying and Du Mi were forced to retire to their hometown in Shandong and Xun Yu held office in the same region.[91] During this period they as well as Chen Shi were active in the same area, teaching students and advocating Confucian virtues. The homage they paid to Han Shao was one such activity.

Han Shao's stela no longer exists, but another surviv-

a

b

ing example allows us to speculate on the content and style of its inscription. This is the stela dedicated to a gentleman named Kong Zhou, who died in 163 at age 61 (Figs. 4.28a, b). The lives of Kong Zhou and Han Shao were surprisingly similar. They were contemporary scholar-officials who held office in adjacent counties. They were both involved in the Taishan rebellion and took a similar strategy in dealing with the riot. The inscription on Kong Zhou's stela reads:

THE STELA OF MASTER KONG, THE HAN CHIEF COMMANDANT OF TAISHAN

Our lord's personal name was Zhou and his style name Jijiang. A nineteenth-generation descendent of Confucius, his heaven-endowed nature was pure and flawless, and he attained sagehood and reached the great Dao.

In his childhood he studied the doctrines of his great ancestor, and concentrated on *Master Yan's Commentaries on the Spring and Autumn Annals.* As his scholarship deepened and presaged a bright future, he behaved even more obediently in his family. His outstanding virtues became well known, and he was granted the title "Filial and Incorrupt." He became a Gentleman in the Palace [*langzhong*] and was then assigned to Duchang county as an officer. There he imparted widely the five principal Confucian teachings; he honored the virtuous, cared for the aged, and extended benevolence and magnanimity to all. Following the examples of Yu and Tang [the founders of the Xia and Shang dynasties], he was critical of himself. Thus he could carry forward honesty and sincerity when these virtues were vanishing [in his time] and could accomplish great exploits through simple practices. Based on his record during his first three years in office, the government promoted him to prefect of Yuancheng.

At that time gangs in the Eastern Mountain [Taishan] area rebelled against the central authority. Although the royal armies were sent to the region, the turmoil had not yet been suppressed. The government then assigned our lord to a military post [the chief commandant of Taishan], but [instead of resorting to force] he tried to cultivate people's civil virtues. Within a few months all the rebels took off their armor and admitted their guilt. They abandoned weapons in favor of agricultural implements. Desolate fields were cultivated, and merchants could travel safely even along dangerous routes. People could again welcome their guests by singing the ancient ode "The Deer's Cry," and the proper order between the old and the young was restored through the practice of peaceful rituals.

But our lord fell ill in that harmonious harvest year. He handed in his resignation and his appeal was granted. He died in the first month of *yiwei* in the sixth year of the Yanxi reign period [A.D. 163] at age 61. He had hoped that his dead body would decompose quickly so that his spirit could return to its true origin, and he had also admired the principles of simplicity and thrift. His tomb has no decoration, and no funerary goods are on display. People deeply revere his loftiness, and all hope to recount his merits. Thus we his students and subordinate officials traveled to famous mountains to find an auspicious stone, on which we have inscribed this text to show future generations an exemplar of virtue. Our praise goes:

O! Our glorious lord,
Your virtues were manifest.
Following your sage ancestor you chose the career
 of a scholar,
And you established yourself and made your name
 renowned.
As a Gentleman in the Palace,
You faithfully guarded the imperial domain.
Day and night you were at court,
And at court you were discriminating and intelligent.
You then restored peace in two counties,
Where commoners could thus prosper.
It was your hope to bring peace to the people,
A hope that guided you to pacify the region of
 Taishan.
You led those fierce rebels
Back to virtue and loyalty.
The fields in the south yielded abundant crops;
The roads through the Eastern Mountains were
 smooth again.
The year was good, and there was a bumper harvest
 of millet;
Everyone was happy and raised toasts in congratu-
 lation.
The emperor depended on your achievements;
People relied on your support.

When you fell ill you hoped to retire from office,
Leaving all worldly glory behind.
The court tried hard to persuade you to stay,
And finally granted your retirement only after re-
 peated appeals.
You maintained the virtues of reverence and thrift
 till the end of your life;
And even ritual vessels were not displayed during
 your funeral service.
Your reputation for loftiness had spread far during
 your lifetime,
And your eternal glory transcends your death.
We pledge to keep our loyalty to you, our lord,
All carrying out your teachings and advocating your
 name.

This stela was erected in the second month of *wuchen* in the seventh year of the Yanxi reign period [A.D. 164].

This text is a good example of the literary genre called *minglei* (eulogy and dirge). Even before the Han, Xunzi defined its basic function: "one's *minglei* and genealogy [*xishi*] spread one's 'name' in reverence."[92] Some 150 surviving Han dynasty *minglei* on funerary stelae are the results of this desire.[93] Writers engraved these words on stone, hoping that the "names" of their dead friends or colleagues would thus become eternal. As a form of historical and biographical writing, a *minglei* was required to stick to the facts[94] regarding both the deceased's family history and his personal conduct. It usually begins by recounting the genealogy of the dead (which could be either factual or based on a "legendary" family history).[95] The text then states his education, talents, virtues, official assignments, and achievements. In many cases a particular episode in his career (such as Kong Zhou's pacification of the Taishan rebellion) is singled out to highlight his life. This narrative would then lead to a pledge of loyalty by the donors. In the case of Kong Zhou's stela, the 62 people who contributed to this memorial included his direct students (*dizi*), indirect students (*mensheng*), boy-students (*mentong*), subordinate officials (*guli*), and a commoner under his administration (*gumin*). Their names, birthplaces, and relationships with Kong Zhen are inscribed

on the back of the stela (Fig. 4.28b). An inscription always ends with a dirge, which paraphrases the preceding prose description in verse containing abundant quotations and allusions from the Confucian classics.

Such a text inscribed on a memorial stela by friends, students, and colleagues of the dead differs, therefore, from a text engraved by family members on an offering shrine. A stela inscription was supposed to be a formal and public document and follow a set of rigid and well-established rules. A shrine inscription, on the other hand, was essentially a private expression, and its content and style were far less formulaic. Stela inscriptions are modeled on "biographies" in historical writings; shrine inscriptions derive from a variety of sources, including poetry and even financial accounts. Stela inscriptions emphasize the public image of the dead and the donors' loyalty toward him; shrine inscriptions stress the patrons' filial piety. A stela is a memorial without other functions. A shrine is the dwelling of the *hun* soul of the deceased and the place where sacrifices are performed.

These two kinds of funerary texts and structures attest to different concepts of monumentality that arise from divergent relationships with the deceased. Standing side by side in a graveyard, however, an offering shrine and a memorial stela(e) also formed a single cluster of monuments that communicated with each other. The subjects of this communication were again the two groups of patrons. The guests who attended a funeral ceremony paid their respects not only to the deceased but also to his family. Their homage not only brought posthumous fame to the dead but also offered a chance for his living descendents to exhibit their filial virtue. Interestingly, all three funerals mentioned in this section—those of Han Shao, Chen Shi, and Kong Zhou—had a profound impact on the descendents.

Chen Shi's grand funeral made his son, Chen Ji, a famous person: he cried to the point of spitting blood, and "even after the mourning period was over, he was still wan and sallow, almost going insane [in longing for his father]."[96] His filial conduct was reported to the throne and was illustrated in pictures distributed throughout the

country. He finally accepted the post of grand herald. As for Han Shao's son, Han Rong, his father's much-delayed glory nevertheless made him "prosper in his youth. All the five principal departments of the central government offered him positions. He finally attained the office of the grand tutor during Emperor Xian's reign [189–220]."[97]

Kong Zhou's son, Kong Rong, became even more famous in Chinese history.[98] In early childhood Kong Rong was an admirer of Li Ying. When he lost his father at age thirteen, according to the *History of the Latter Han*, "His excessive grief destroyed his physiognomy, and only with people's help could he sit up. His filial piety won the sympathy and admiration of all the people in his village and district." Later, when the warlord He Jin planned to assassinate him because of his brazen antagonism toward court eunuchs, the schemer was warned by one of his advisers: "Kong Rong has a famous name [*ming*]. If you make him your enemy, all the Confucian gentlemen in this country will leave you at once." In all these cases, the *ming* of the deceased, which had been spread far and wide by their friends and colleagues, seems to have been transmitted to their filial sons.

The Deceased

The decoration of an Eastern Han funerary structure was not always determined by the descendents of the dead or his former associates. Some people may have participated in the planning process before their death in order to express their thoughts or feelings. They may have ordered favorite scenes and motifs to be depicted on their own (future) funerary monuments; in such cases they were the "designer" of the decorative program. One such person was Zhao Qi (alias Zhao Jia, d. 201).[99] As a young man, he gained a reputation as a learned scholar with high moral principles. He married a daughter of the head official scholar, Ma Rong (79–166), but refused to speak to his famous father-in-law because the latter lacked "a gentleman's integrity."[100] He fell ill before celebrating his fortieth birthday and was confined to his bed for seven years. When he finally decided that death was imminent, he summoned his nephew and told him his final wish:

Although born into this world as a man of destiny, I cannot match Xu You in pursuing a reclusive life, nor can I compare myself to Yi Yin and Lü Shang in worldly achievements. Heaven has abandoned me—what can I say about it! Please place a stone in front of my tomb and inscribe it with the following words:

> There was a free man during the Han.
> His name was Zhao Jia.
> He had high aspirations but no fortune.
> Should such a fate be bestowed on him?

Zhao Qi did not die, however. After his recovery, he served in several official posts, until he incurred the enemy of powerful court eunuchs and was forced into hiding in 158. All his relatives were imprisoned and executed. He changed his name, wandered all over the country, and earned his living selling pancakes. One day he was recognized in a marketplace by a righteous man named Sun Song, who took him home and hid him inside a hollow wall. Only after the Great Proscription ended did Zhao Qi leave his living grave, where he had spent several years. He won respect from fellow Confucians and was finally promoted to a prominent office. But even during this period of glory, the idea of building a funerary monument for himself continued to occupy his mind. According to his biography in the *History of the Latter Han*, "He constructed his graveyard when he was still living. He painted four famous historical figures—Jizha, Zichan, Yan Ying, and Shuxiang—as guests flanking his self-portrait in the position of host. He also inscribed a eulogy alongside each image."[101] Zhao Qi's tomb still existed in the early sixth century, when the renowned geographer Li Daoyuan visited it and recorded its mural in his *Annotated Canon of Waterways*: "The tomb of Zhao Taiqing [Zhao Qi's style name] is [now] inside the city of Ying. It was built by Zhao Qi himself when he was still alive. He painted a host with his guests to preserve his good feelings toward his friends and to express the values he had always admired."[102]

It is possible that Zhao Qi had the four ancient worthies painted in his tomb because he admired these men so highly that he wanted them to keep him company for eternity. Li Daoyuan's reading of the picture, however,

reveals a more specific meaning: these ancient figures stood for Zhao Qi's own friends who had helped save him during the years of trouble. By portraying these historical figures beside his self-portrait, Zhao Qi could express his deep gratitude toward his friends as well as his moral and political values. This design leads us to investigate once more the use of historical allusions. A check of historical records reveals that this trend developed into a standard mode of self-expression toward the end of the Western Han. Following this development came a massive effort to classify and catalogue all famous historical figures and events. Liu Xiang (77 B.C.?–A.D. 6), for example, compiled three large works entitled the *Biographies of Exemplary Women*, the *Biographies of Exemplary Men* (*Lieshi zhuan*; also known as the *Biographies of Filial Sons*), and the *Biographies of Immortals* (*Liexian zhuan*), as well as a book entitled *A Garden of Talk* (*Shuo yuan*) whose 784 entries illuminate various political principles.[103] Another kind of catalogue contained various omens that conveyed Heaven's responses to human affairs.[104] These and other compilations formed a huge collection of classifications of historical knowledge and provided an enormous number of examples for anyone making a demonstration or argument. Some of these catalogues were illustrated, and their illustrations became the prototypes for the popular "pictorial allusions" used in decorating monuments.[105]

The comment that Zhao Qi "painted" the four ancient worthies in his tomb, therefore, does not necessarily imply that he created the images; models for these figures could have been found in illustrated biographies or "copybooks."[106] By selecting his own "heroes," however, Zhao Qi was able to make his personal ideas known. The same method was employed on a far greater scale by another Eastern Han Confucian scholar named Wu Liang (78–151) in designing his own funerary monument. We learn this, however, not from textual references as in the case of Zhao Qi, but from the coherent ideology reflected in the pictorial carvings on Wu Liang's memorial shrine, which I have thoroughly discussed in an earlier monograph.[107] The following summary emphasizes the "intentionality" of the monument's design, clarifies some crucial arguments about the "authorship" and pictorial program of

the design, and offers a new formulation of the narrative and symbolic structure of the decorative program.

A concise biography of Wu Liang can be found in the epitaph on his memorial stela:

> The late Han Attendant Wu had the personal name Liang and the style name Suizong. The attendant embodied the outstanding virtues of loyalty and filial piety. He studied the *Commentary of the Han School on the "Book of Songs"* [*Han shi*] and gave lectures [on this text]. He also mastered the "River [Chart]" and the "Luo [Writing]," as well as the works of the different schools. He studied widely and examined [the texts] in detail. He inquired into the roots of texts, and there was no book that he did not read. The departments of the prefecture and the district invited and summoned him [to official posts], but he declined on the grounds of illness. He contented himself with the poverty of his humble home and was pleased with the righteousness that he learned every morning. He never wearied of teaching people the great Dao. He felt ashamed of the [conventional] way in which people copied one another in the world, and he never even paid attention to those who wielded power. When he reached the age of 60, he followed only his mind, maintaining his inflexible purity without vacillation. Alas! He did not ascend to high official posts, but was instead hurt by public opinion. In the summer of the first year of the Yuanjia reign period [A.D. 151], at age 74, he fell ill and died.

This passage enables us to draw a general contour of Wu Liang's life and thought. In scholarship, he belonged to the New Text school, a scholastic tradition characterized by its emphasis on the exegesis of the Confucian classics and omen theories.[108] Politically, he was a "retired worthy," who escaped from the corrupt court dominated by royal relatives and eunuchs and sought spiritual purity in private learning and teaching.[109] In morality, he took the general Confucian principles of filial piety and loyalty as his guide. Wu Liang's epitaph singles out one particular event that summarizes his life: his declining of official posts offered by local authorities. Not coincidentally, this is also the only episode in his life portrayed on his memorial shrine. Illustrated in Fig. 4.29, this scene is identi-

Fig. 4.29. A county official paying his respects to a retired gentleman. Wu Liang Shrine carving. A.D. 151. Ink rubbing.

fied by a cartouche as a "county official" paying respect to an invisible "retired gentlemen" in a humble ox-drawn carriage.

Like Zhao Qi's self-portrait, this scene denotes Wu Liang's presence in his memorial hall. The importance of this scene, however, lies not only in its content but also in its position on the shrine, which signifies the "authorship" of the whole decorative program. Engraved at the lower left corner on the left wall, it is the last scene in the whole decorative program (Fig. 4.30, no. 44).[110] This placement accords with a deeply rooted convention in Chinese historiography: as the observer of ongoing historical events, the historian actually "ends" history; by concluding his work with a "self-statement," he adopts a rhetorical form to consolidate this role. This convention had been firmly established in the first comprehensive Chinese history. Sima Qian (145–86 B.C.) of the Western Han ended his *Records of the Historian* with a chapter titled the "Self-statement of the Grand Historian."[111] His precedent was followed by Ban Gu (32–92) in compiling his *History of the Former Han* during the early Eastern Han. Their example was followed by Wu Liang in the second century. In all these cases, the "authors" come forth to conclude their historical observations—to identify themselves explicitly, to let their lives and ambitions be known, and to claim their works as their own lasting monuments.

This crucial parallel between the Wu Liang shrine and the *Records of the Historian* led to the discovery of other structural links between these two monumental works. As scholars have noted, advanced historical writings had appeared long before the Han.[112] But the *Records of the Historian*, in Burton Watson's words, "represents an entirely new departure in Chinese historiography" by initiating a coherent structure for a "general history" (*tongshi*).[113] Instead of following the year-by-year chronicle style popular during the Eastern Zhou period, Sima Qian divided his materials into a number of large "blocks." The "Treatises" ("Shu") deal with important subjects including "spirits and gods, [and] the relationships of heaven and man."[114] In most of the *Records of the Historian*, however, history as a whole is illustrated by the lives of selected individuals, who are grouped together by lineage, political ties, or by similar attributes and deeds. These groups are further classified into three lengthy sections: the "Basic Annals" ("Benji"), which narrates China's dynastic history from its beginning to the historian's time; the "Hereditary Houses" ("Shijia"), which describes noble lineages assisting their lords and rulers; and the "Memoirs" ("Liezhuan"), which records individuals of distinguished behavior.[115] Furthermore, the *Records of the Historian* includes the historian's judgments as an integral part of the history. Sima Qian ends most chapters with his own comments, introduced by the phrase "The Grand Historian remarks," and concludes the whole book with his "Self-statement."

Fig. 4.30. The 44 scenes identified by cartouches on the walls of the Wu Liang Shrine. Drawing.

The "designer" of the Wu Liang shrine adopted these general principles in decorating a three-dimensional structure. The ceiling of the shrine is covered with omen images representing "the relationship of heaven and man." Its two gables are decorated with "spirits and gods." Forty-three "biographies" of men and women are illustrated on its three walls, representing the entire course of Chinese history up to Wu Liang's time. Eulogies inscribed beside pictures are the designer's comments, and the last scene echoes Sima Qian's "Self-statement." Created two and a half centuries after the *Records of the Historian*, however, these carvings also reflect new social, ethical, and religious currents, as well as a different compilation process. The omen images on the ceiling reflect the political values of the retired worthies, of which Wu Liang was a loyal member. The spirits and gods on the gables are represented by the Queen Mother of the West and the King Father of the East—two immortals who became extremely popular only from the second century.[116] The "biographies" of historical figures depicted on the walls are organized into a new structure determined by the Three Bonds (*sangang*; the relations between ruler and subject, father and son, husband and wife), a Confucian doctrine overwhelmingly emphasized during the Eastern

Han period. Moreover, unlike Sima Qian who wrote the first general history in China, the designer of the Wu Liang shrine only selected his materials from existing catalogues—again a trend current in Wu Liang's time. Rather than inventing stories or scenes, this designer's creativity lay in his selection and organization of allusions for his own purpose.

As I have demonstrated elsewhere, the omen images on the ceiling and their explanatory cartouches are derived from annotated good-omen illustrations called *Ruitu*, which had appeared by the first century B.C. and gained increasing popularity among Confucian scholars during the first and second centuries A.D.[117] Ban Gu, for example, described his use of this text in a poem:

> I opened the *Spiritual Text*,
> and read the *Pictures of Auspicious Omens* [*Ruitu*].
> I found the [image of] the white pheasant,
> which resembles that of a pure crow.[118]

The rationalist Wang Chong, in his attacks on scholars of the New Text school, criticized such practices: "The scholars in their essays claim for themselves the faculty of knowing the phoenix and the unicorn when they see

them. They, of course, rely on the pictures of the phoenix and the unicorn."[119]

Neither Ban Gu's account nor Wang Chong's criticism, however, say much about the function of Wu Liang's omen images, since these images were not randomly copied from omen catalogues but were carefully selected to convey a specific political ideology. Whereas a Han omen catalogue must have contained hundreds of items related to all spheres of human life,[120] the much smaller number engraved on the Wu Liang Shrine had distinctive implications, explained by accompanying cartouches that identify the conditions for the omens' appearances:[121]

> 1. A manifestation of the *qilin* unicorn, the yellow dragon, the white tiger, or the intertwining trees admonishes the ruler to display virtues such as benevolence, righteousness, propriety, wisdom, and sincerity (Figs. 4.31a–d).
> 2. An appearance of the jade horse, the birds joined at the wing, the fish joined at the eye, the white horse with a red mane, or the red bear requires that the ruler honor and employ virtuous men and retired worthies, and exclude sycophants (Figs. 4.31e–i).
> 3. Three omens, the lake horse, the six-legged beast, and the beasts joined at the shoulder, demand that the ruler be concerned for ordinary people (Figs. 4.31j–l).
> 4. A sighting of the silver jar requires that the ruler practice "quiescence" and that punishments be properly applied (Fig. 4.31m).
> 5. The dark *gui* tablet, the jade *sheng* headdress, and the intertwining trees require that the country under the ruler's leadership be strong, peaceful, and unified (Figs. 4.31n, o).
> 6. A manifestation of the *bi* disk of glass requires that the ruler not dissemble his faults (Fig. 4.31p).

It is clear that these omens have nothing to do with popular beliefs in longevity and immortality. Rather, they dictate a series of demands on the ruler of the state: the ruler must be a model of Confucian virtues; he must employ Confucian worthies and take care of his subjects; his court should have no place for evil "sycophants"; his governance should be just; his country should be peaceful and strong; and, finally, he should criticize himself if he does not meet these criteria. The same ideas occur in the *Commentary of the Han School on the "Book of Songs,"* in which Wu Liang specialized: "By serving the old and nourishing the orphaned, the ruler transforms the people. By promoting the worthy and rewarding the meritorious, he encourages [people] to do good. By punishing the wicked and dismissing the negligent, he makes evil hateful."[122]

The omen images, therefore, reflected a general Confucian view of an ideal political state. On the other hand, they also voiced the Confucian criticism of the contemporary political scene, since all the ingredients of this state were absent in Emperor Huan's court. It was the unanimous view of Confucian scholars that this court was corrupt and controlled by sycophants—first by royal relatives and then by eunuchs. Virtuous men were forced into hiding or were brutally murdered. Commoners lived in an abyss of misery; wars and natural disasters were ceaseless. This situation, recorded in detail in various versions of the dynasty's written history, is summarized in the *History of the Latter Han*:

> During the reigns of Huan and Ling, the emperors were negligent, the government confused, and the fate of the empire rested with the eunuchs. Scholars were ashamed to be in league with these people and therefore there were those who went about voicing their grievances, and the retired scholars were liberal with their criticism. Consequently their reputations waxed high, and they mutually reviled or boasted about one another. They examined and evaluated all the high officials and criticized those who were in charge of the government. Thus the fashion of indignantly voicing criticism became widespread.[123]

Wu Liang's epitaph clearly identifies him as one of these "retired scholars." The selection and portrayal of specific omens on his memorial hall thus preserved and expressed his political ideals and criticisms. In fact, the two main themes implied in these images—the privilege of knowing Heaven's will and the glorification of virtuous retirement—are essential to the Han school teachings that Wu Liang had mastered. We read in a basic text of the school: "[The Confucian scholar] first understands the beginnings of disaster and good fortune, and his mind will be without illusions. For this reason the sages lived

Fig. 4.31. Omen images carved on the ceiling of the Wu Liang Shrine. A.D. 151. (a) Qilin unicorn; (b) yellow dragon; (c) white tiger; (d) intertwining trees; (e) jade horse; (f) birds joined at the wing; (g) fish joined at the eye; (h) white horse with red mane; (i) red bear; (j) lake horse; (k) six-legged beast; (l) beasts joined at the shoulder; (m) silver jar; (n) black gui tablet; (o) jade sheng headdress; (p) glass bi disk. Reconstruction.

in retirement and reflected profoundly; they were unique in their apprehension and insight."[124] The third quality of a Confucian scholar, according to the same text, is his deep understanding of history and his effort to preserve correct human relationships.

> In the thousand undertakings and the ten thousand transformations their Way is unexhausted—such are the Six Classics. Now as to appropriate relations between prince and subject, the love between father and son, the distinction between husband and wife, and precedence between friends—these are what the Confucian takes care to preserve; daily he "cuts and polishes" without ceasing. Though he live in a poor alley and in a wretched hut, not having enough to fill his emptiness or to clothe himself, and though he be without so much as an awl's point of territory, still his understanding is sufficient to control the empire.[125]

Wu Liang practiced this teaching wholeheartedly: "He inquired into the roots of texts, and there was no book that he did not read"; "he contented himself with the poverty of his humble home and was pleased with the righteousness that he learned every morning"; and "he never wearied of teaching people the great Dao." We are also told that "When he reached the age of 60, he followed only his mind, maintaining his inflexible purity without vacillation." From a Confucian approach, such a stage of mind represented the highest achievement of a scholar's learning and spiritual cultivation: historical patterns and essential human values would become crystal clear to him, and his personal existence would find its own justification in this macrocosmic universe. This approach underlies the wall carvings of the Wu Liang Shrine, the most ambitious representation of human history ever attempted in Chinese art.

This historical narrative begins with a series of ten archaic sovereigns (Fig. 4.30, nos. 1–10), a composition comparable to the "Basic Annals" in Sima Qian's *Records of the Historian*. The eulogy beside the image of Fu Xi, who, with his consort Nü Wa, initiates the sequence (Fig. 4.30, no. 1; Fig. 4.32), reads:

Fu Xi, the Black Spirit:
He initiated leadership;
He drew the Trigrams and made knotted cords,
To administer the land within the seas.[126]

Standing at the beginning of history, Fu Xi was thought to be an intermediary between divine and human spheres, and his greatness lay in his transmission of divine wisdom (symbolized by the Trigrams) to human knowledge. His unique role is represented by portraying him as a hybrid figure, half-human and half-serpent, holding a carpenter's square, which signifies his ability to "design" the world. He was thought to have instituted the laws of marriage—the most important rule of human society. This belief explains why he was depicted together with the goddess Nü Wa. From their union was born a child who, shown in the picture holding his parents with both hands, metaphorically represents the infant mankind.

Fu Xi and the two following figures, Zhu Rong and Shen Nong, are grouped together as the Three Sovereigns (*Sanhuang*) (Fig. 4.30, nos. 1–3; Fig. 4.32), who symbolize the first stage of human history, a utopian period of natural harmony and balance. This concept is revealed in cartouches as well as pictorial imagery: these figures wear short robes or shorts, with simple turbans to bind their hair. Their plain costumes form a sharp contrast with the elaborate crown and long robes of the next five figures (Fig. 4.30, nos. 4–8; Fig. 4.33) who belonged to the second stage of history, the period of the Five Emperors (*Wudi*).

Fig. 4.32. The Three Sovereigns. Wu Liang Shrine carvings. A.D. 151. Ink rubbing.

Fig. 4.33. The Five Emperors. Wu Liang Shrine carvings. A.D. 151. Ink rubbing.

The symbolism of these costumes is stated in the inscription beside the image of the Yellow Emperor, the first of the Five Emperors:

The Yellow Emperor:
He created and improved so much!
He invented weapons and regulated fields;
He had upper and lower garments hang down,
And erected temples and palaces.

The phrase "had upper and lower garments hang down" is commonly used in Chinese classical writings as an analogy for the creation of kingship and statecraft.[127] It was believed that at the end of the age of the Three Sovereigns the world had fallen into chaos and the Yellow Emperor established peace by using force: he defeated the troublemakers and became master within the four seas. The ages of the Three Sovereigns and the Five Emperors, therefore, are distinguished by oppositions such as "nonaction" and "action," simplicity and refinement, equality and stratification; these distinctions are given visual forms in the carvings.

The period of the Five Emperors is again contrasted to the following historical stage in the manner of transmitting rulership. It was thought that political power was handed down among the Five Emperors according to the system called *shanrang*, meaning "to cede" or "to yield." Under this system, a ruler abdicated his throne to the worthiest man in the country regardless of origin or social class. The non-hereditary *shanrang* system, therefore, was based purely on virtue; as a logical consequence, all these rulers were cast as models of human excellence. The demolition of this system marked the beginning of dynastic history; political succession based on genealogy was established. History no longer proceeded in a peaceful linear fashion but began to follow a spiral pattern: each dynasty experienced a rise and decline. Each dynasty was founded by a virtuous king who was wise, benevolent, and hardworking, and each was terminated by an evil ruler who was corrupt, selfish, violent, and lustful. This new pattern, as well as the two opposing types of dynastic rulers, are represented by the portraits of Yu and Jie (Fig. 4.30, nos. 9–10; Fig. 4.34), the first and last rulers of the Xia dynasty. Like Sima Qian, Wu Liang's aim in portraying these archaic rulers was to "examine the deeds and events of the past and investigate the principles behind their success and failure, their rise and decay."[128]

These ancient sovereigns are embodiments of historical concepts, but the remaining three series of images on the shrine's walls—eminent wives, filial sons, and loyal subjects—are represented by dramatic events from their lives. The sources of motifs also vary: whereas descriptions of the ancient rulers are included in the *Records of the Historian* and other historical texts,[129] a close relationship exists between these three series and Liu Xiang's compilations of historical allusions (the *Biographies of Exemplary Women*, the *Biographies of Filial Sons*, and *A Garden of Talk*). But since Liu Xiang's books contain far more

Fig. 4.34. Yu and Jie of the Xia dynasty. Wu Liang Shrine carvings. A.D. 151. Ink rubbing.

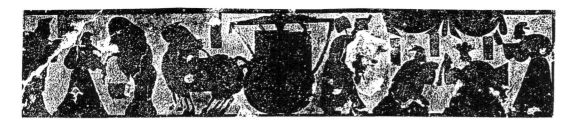

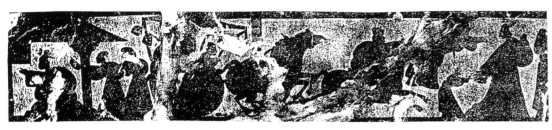

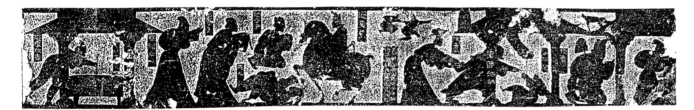

Fig. 4.35. Chaste, obedient, and righteous women. Wu Liang Shrine carvings. A.D. 151. Ink rubbing.

examples than a handful of dynastic rulers, Wu Liang faced a severe challenge in selecting his motifs. An analysis of the pictorial stories on the Wu Liang Shrine suggests that at least three criteria were taken into account in motif selection. The first was chronology: following the archaic rulers from antiquity to the Xia, the eight virtuous women all lived during the Zhou; the series of filial sons begins with Zeng Shen of the Eastern Zhou and ends with two filial paragons who lived not long before Wu Liang's time. The second criterion was the basic Confucian virtues: these three series present, sequentially, chastity, filial piety, and loyalty. The third criterion was a certain personal preference; that is, particular messages pertaining to the wishes of the deceased.

The emphasis on female chastity is disclosed in the selection of heroines from the *Biographies of Exemplary Women*, which records the lives of 105 famous women from antiquity in seven categories. None of the seven ex-

emplary women depicted on the top register of the shrine walls (Fig. 4.30, nos. 11–17, Fig. 4.35) are chosen from Liu Xiang's categories of "reasoning and understanding," "virtuous and wise," and "benevolent and wise." All are from the two domestic types: "chaste and obedient" and "chaste and righteous."[130] This focus differs markedly from those in other surviving portraits of virtuous women: a screen from the tomb of Sima Jinlong (a relative of the Wei royal house) is painted with queens and palace ladies (Fig. 4.36),[131] and a handscroll painting attributed to Gu Kaizhi (ca. 345–406) portrays only "benevolent and wise" female figures (Fig. 4.37).[132]

Moreover, the selected historical allusions were reorganized in the shrine's decoration into a new sequence that placed special importance on its "title scene." This structure derives from the Han interpretation of the Confucian classics; for example, the poems initiating the four chapters of the *Book of Songs* were called the Four Begin

Fig. 4.36. Painted screen panel. Wood and lacquer. Northern Wei dynasty. Before A.D. 484. H. 80 cm. W. 20. cm. Excavated from Sima Jinlong's tomb at Datong, Shanxi province. Datong Museum.

nings (*sishi*) and were believed to imply a "secret code" for interpreting the whole classic. On the Wu Liang Shrine, the portrayal of eminent women begins with the story of Liang the Excellent (Fig. 4.30, no. 11; Figs. 4.21a, b). As mentioned earlier, Liang was a famous beauty; after her husband died, she was sought by noblemen including the king himself. To prevent the danger of remarriage, she disfigured herself by cutting off her nose. Of all the *Biographies of Exemplary Women*, this story demonstrates most dramatically the correct behavior for widows with sons, and the words attributed to her in her biography highlight the basic teaching of the scene engraved on the Wu Liang shrine: "My husband unfortunately died early, and I live in widowhood to raise his orphans; I have learned that the principle of a wife is that once having gone forth to marry, she will not change over, that she will keep all the rules of chastity and loyalty."[133]

As a counterpart of this story, the famous filial son Zeng Shen leads the group of seventeen virtuous men (Fig. 4.30, no. 18; Figs. 4.38a, b). It was widely believed during the Han that Zeng Shen's extraordinary filial piety led to a telepathic communication between him and his widowed mother. Once when Zeng Shen followed Confucius on a trip to the South, he suddenly felt a palpitation; he later learned that at that moment his mother had thought of him and bit her fingers. It is rather surprising, however, to find this story, which emphasizes the tie between a son and his (widowed) mother, given particular importance on the Wu Liang Shrine, since during the Han filial piety was primarily expressed in the father-son relationship.[134] It is even more surprising that among the five filial personages at the beginning of the series, four include a living mother who is served, amused, and protected by her son.[135] The exception is the story of Ding Lan, whose filial piety is directed toward his father, but in this case the father is dead. These pictures seemed to have been aimed at a particular audience—namely, Wu Liang's widow and orphaned sons—advising them to maintain harmonious relationships in the household and to be loyal and filial toward their deceased husband and father. In my opinion, only this hypothesis can explain the irregularities in the carvings: the designer of these carvings deliberately changed

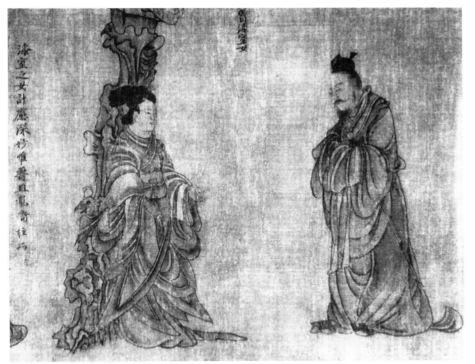

Fig. 4.37. Girl from Qishi of Lu. Ink and color on silk. Detail of the "Portraits of Benevolent and Wise Women," attributed to Gu Kaizhi, but probably a 12th-century copy of a post-Han painting. Palace Museum, Beijing.

Fig. 4.38. Story of Zengzi. Wu Liang Shrine carving. (a) Ink rubbing. (b) Reconstruction.

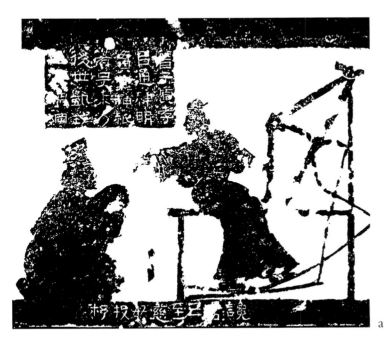

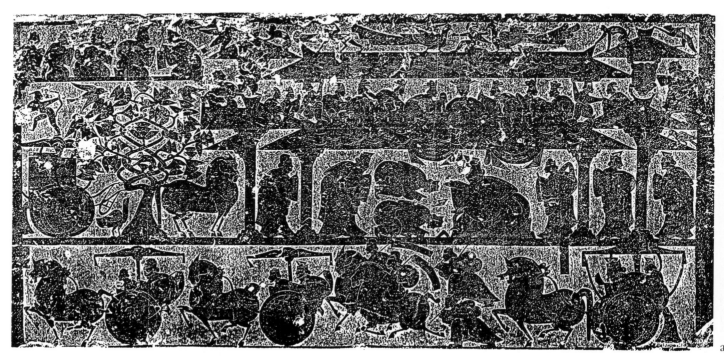

Fig. 4.39. Homage scenes from the Jiaxiang area. Late Eastern Han. 2d half of the 2d century A.D. (a) Carving on the Left Wu Family Shrine. Ink rubbing. (b) Excavated in 1978 at Songshan. Ink rubbing.

a

b

the sex of some characters in the illustrated stories. For example, in most literary versions of the Ding Lan story, this filial son made a wooden statue in the likeness of his mother and worshiped it. But on the Wu Liang Shrine the statue is an image of the deceased father. A similar transformation occurs in the picture depicting Jin Midi's filial conduct. Jin's biography in the *History of the Former Han* records that every time Jin saw his mother's portrait in the palace he would wail in pain. But the inscription accompanying the illustration on the Wu Liang Shrine identifies Jin as paying homage to his deceased father.[136] The last of the seventeen virtuous men is a "filial grandson"; not coincidentally, we learn from Wu Liang's epitaph that he had a grandson.

The lower section of the shrine's walls follows a different compositional rule: here a grand pavilion at the center establishes a strong visual focus, so that the composition becomes symmetrical. The interior scene of the pavilion is damaged, but it can be easily reconstructed by consulting similar images widely copied in the Jiaxiang area (Figs. 4.39a, b): a figure of enormous size is receiving an audience in the main hall, and women with elaborate crowns are seated on the second floor. I have contended elsewhere that the central grand figure represents the concept of monarchy—an idealized ruler of the empire.[137] Some reviewers have found this opinion unacceptable because similar images portray the deceased in other Han dynasty funerary structures.[138] This rejection, however, is based on an erroneous methodological assumption, which I have tried to correct, that there is a rigid iconography in Han pictorial art and individual images with identical or similar features must possess the same meaning. I suggest the opposite: because there was no rigid iconography in Han pictorial art (comparable with the iconographic system in Christian or Buddhist art), people often employed similar images for different purposes. The precise content of an image is either identified by the accompanying inscription or is defined within its pictorial context.

My identification of the central pavilion in the Wu Liang Shrine as a symbolic representation of sovereignty is, therefore, not intended to offer a standard definition of all such scenes in Han art. Rather, this identification is based mainly on the scene's specific pictorial context—its relationship with the picture-stories flanking it. All nine heroes and heroines portrayed here are public and political figures. There are two wise ministers (Fig. 4.30, nos. 38, 39), six assassins who died serving their masters (Fig. 4.30, nos. 35–37, 40–42), and a virtuous queen who helped her husband rejuvenate the country (Fig. 4.30, no. 43). There is Lin Xiangru, who saved his state of Zhao from the fierce Qin (Figs. 4.40a, b), and Jing Ke who

a

b

Fig. 4.40. Story of Lin Xiangru. Wu Liang Shrine carving. (a) Ink rubbing. (b) Line engraving. Eastern Han. 2d century A.D.

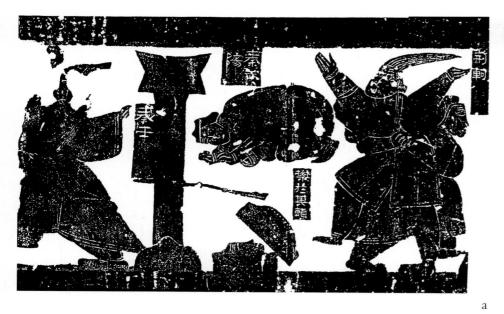

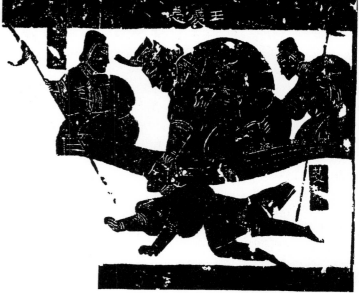

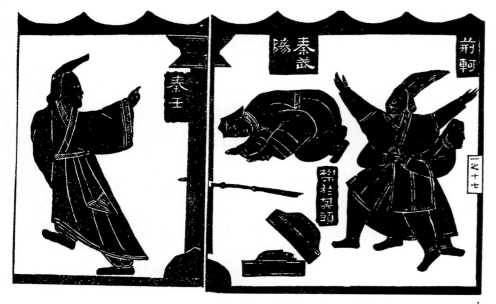

a

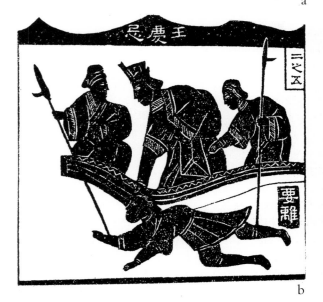

b

Fig. 4.41. Story of Jing
Ke. Wu Liang Shrine
carving. (a) Ink rubbing.
(b) Reconstruction.

Fig. 4.42. Story of Yao
Li. Wu Liang Shrine
carving. (a) Ink rubbing.
(b) Reconstruction.

gave his life in his attempted assassination of Ying Zheng, the future First Emperor (Figs. 4.41a, b). Unlike the domestic men and women in the preceding series, these are political heroes whose virtues lay in their absolute loyalty to their sovereigns. Yao Li (Figs. 4.42a, b) was a commoner and physically weak; simply because a king trusted him, he decided to take on the task of assassinating the king's political enemy, Prince Qing Ji, a Herculean figure in Chinese history. Yao Li asked the king to kill his wife and children and to burn their bodies in the marketplace so that he could present himself to Qing Ji as a victim of the king's brutality, win the prince's trust, and find a chance to kill him. The carving on the Wu Liang Shrine represents the climax of the story: Yao Li's plan has succeeded, but the dying prince is still powerful enough to hurl him into a river. But he does not kill Yao Li, because, in Qing Ji's words, "the two bravest men in the world should not die on the same day." But a Han viewer of the picture would have known that in the end both men did die that day: after his victory, Yao Li denounced his three odious crimes of killing his wife, his children, and the new master who trusted him. He then "cut off his hands and feet, fell on his sword and died." With such exaggerated description of violence, this and similar stories place blind loyalty above all other ethical rules.

Although by no means complete, this survey of the Wu Liang Shrine carvings allows me to define the monumentality of this commemorative building by exploring the basic logic of its decoration, uncovering its intentions, and identifying the voice of the man responsible for the selection and compilation of the pictorial scenes. A number of internal and external factors have convinced me that this man was none other than Wu Liang himself.[139] Most important, the uniqueness of the pictorial program—its extraordinary sophistication and unusual coherence—implies a mastermind that could not possibly have belonged to Wei Gai, the named builder of the shrine.[140] As I discuss in the following section, the concerns of funerary monument builders differed from those of patrons, especially a politically minded Confucian scholar. It is also unlikely that Wu Liang's three sons and grandson were

responsible for the pictorial program. They did append a short paragraph to Wu Liang's epitaph to specify their filial devotion in constructing the shrine, but this description is stereotypical and fails to mention anything about the shrine's extraordinary interior decoration. Possibly they did what they said they did—hire a "master workman" to erect their ancestor's monument. But it was the ancestor himself who planned his monument before his death.

To be sure, an intense concern with one's own mortuary monument emerged as soon as the tomb became the center of ancestor worship. As mentioned earlier, even in the fourth century B.C., a king of Zhongshan designed his funerary park and warned that anyone failing to complete it deserved execution. This tradition intensified during the Han, and it became conventional for a person to build his grave while still living. Kong Dan, for example, not only dedicated an offering shrine to his deceased grandmother but also built funerary structures for himself and commemorated this event on his memorial stela (Fig. 4.14):

> I realized that even gold and stone would erode and that everything in the world had its beginning and end. I then began to consider the great span of time after one's life, and settled on an auspicious posthumous home in the heavenly kingdom. As I looked at the structures which the craftsmen were fashioning, I rejoiced that I would abide there after this life. Inside there are chambers opening to the four cardinal directions; outside there are long corridors covered with roofs. The entire work cost 300,000 cash and was completed in the sixth month, in the summer of the fifth year of *renxu* in the Guanghe reign period [A.D. 182].[141]

It was only natural that some intellectuals, such as Zhao Qi and Wu Liang, would approach their own tomb and shrine as vehicles for expressing their ideas. In so doing they created a type of funerary monument that was truly "personal." True, nowhere can we find a written record about Wu Liang's choosing pictorial motifs for his shrine. But why can we not make such an inference based on a most unusual pictorial record? Wu Liang's voice—that of a scholar of the Confucian New Text school, a member

of the "retired worthies," a husband, and a father—cannot be confused with the voices of his family members, friends and colleagues, and builders. The important point is that we hear his distinct voice from the engravings on his memorial hall: the pictures of the heavenly omens, the chaste widows, and the filial descendents reveal a definite vantage point, from which these political images and domestic scenes were selected, revised, annotated, and compiled. This vantage point becomes most explicit in his "self-statement" at the end of an epic historical narrative. As I have argued, following an established Han historiographic convention, this scene concludes the Wu Liang Shrine carvings with the author's signature.

As a comprehensive presentation of Wu Liang's ideas and scholarship, the decoration on the shrine is a hierarchy consisting of four levels. On the first and most basic level, individual scenes depict stories or images of famous personages (Figs. 4.38, 40–42). The common themes and implications of the stories then lead to the second level of reading, where individual scenes constitute a series and are comprehended collectively as allusions to political and moral concepts (Figs. 4.32–35). The representation thus changes from narrative to abstraction. These series again become the elements of a larger narrative on the third level, which describes Chinese history from its beginning to the time of recording (Fig. 4.30). This historical narrative, however, is an element of an even larger abstraction. Depicted on the three walls, it is an integral part of a pictorial universe; the other two parts of this universe are Heaven (portrayed on the ceiling) and the immortal worlds (on the two gables; Fig. 4.43). On this fourth level, the whole decorative program achieves its final static form. It transforms the architectural structure that bears it into an everlasting symbol, a monument documenting Wu Liang's scholarship and ambition, and an offering hall where his descendents would come to place their sacrifices year after year, while listening to their father's teachings from the silent stones.

Builders

Neither the deceased nor his descendents, friends, and colleagues actually built any shrine or stela. These funerary monuments were created by workers, including carvers, painters, masons, and presumably ordinary laborers. The existence of this group of people, whom I call collectively the "builders" of Han funerary monuments, is revealed in a number of inscriptions composed by the families of the dead, who hired such artisans to construct their family graveyards. An early set of evidence is related to the Wu family cemetery. In 147, the four sons of the family—Wu Shigong, Wu Liang, Wu Jingxing, and Wu Kaiming—employed the masons Meng Fu and Meng Mao to build a stone pillar-gate for their departed mother and hired a sculptor named Sun Zong to erect a pair of stone lions behind the pillar-gate (Fig. 4.13).[142] Four years later, in 151, the second son of the family, Wu Liang, passed away, and his three sons and a grandson "exhausted their savings" to build a memorial hall, probably according to the plan of their deceased ancestor. The result of their devotion was the famous Wu Liang Shrine discussed in the preceding section.

> They [i.e., the builders] chose excellent stones from south of the southern mountains; they took those of perfect quality with flawless and unyellowed color. In front they established an altar; behind they erected an offering shrine. The master workman Wei Gai engraved the cartouches and carved the pictures in ordered sequences. He gave free rein to his talent, yet his gracious images exhibit perfect rules. This work will be transmitted to the sight of later generations and for 10,000 generations it will endure.[143]

It is uncertain whether Wei Gai built and decorated the Wu Liang Shrine single-handedly or whether he was a contractor or the head of a group of workers. But the 158 inscription on An Guo's shrine (Fig. 4.6) makes it clear that a funerary monument was often a team result: An Guo's younger brothers hired three artisans—Wang Shu, Wang Jian, and Jiang Hu—from the nearby Gaoping principality, whose work was then recorded in the inscription that the family engraved on the shrine upon its com-

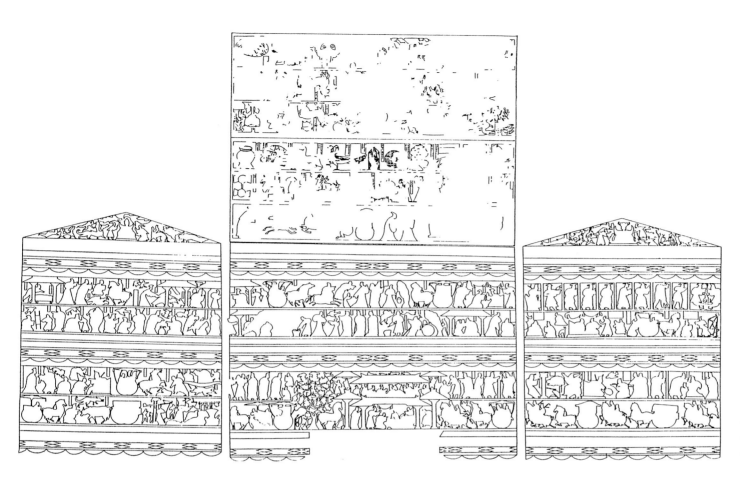

Fig. 4.43. The Wu Liang Shrine carvings. Drawing.

pletion (see above). A third important reference to the builders of Han funerary monuments is found in a text originally carved on an offering hall at Dong'a, dedicated to the gentleman Xiang Tajun and his wife by their sons in 154 (Fig. 4.12):[144]

> The shrine is small, but its construction took long. Its stones were quarried from southern hills. Only after two years of work is the hall now finally complete. We employed more than ten workers, including the craftsmen Cao Yi and Rong Bao from Xiaqiu in the Shanyang district, the painter Dai Sheng from Gaoping, and Shao Qiangsheng. The shrine cost 25,000 cash. We served these master workmen carefully morning and night, fearing to lose their favor and thus become unable to express our thanks to heaven and our gratitude to our parents.

Some generic features are easily observed in these passages, which were composed in the same decade by people who lived in adjacent areas. The stones for a shrine were always derived from "the southern hills," a vague designation that simply refers to the relative southern locations of the hills and their auspicious association with the *yang* force. The builders' work is mentioned and admired, but both the description and praise appear to be stereotyped and impersonal.[145] The formulaic language repeated by the writers of these texts neither documents a monument's specific form and decor nor conveys a genuine appreciation of the workers' creative talent. Thus, although some art historians have suggested we take such references as direct evidence for the role of Han builders and their achievements,[146] I would argue that these words

represent not the voice of the people who created the monuments but that of the patrons who "bought" their services and benefited from them. The respect that the families paid to the builders was considered part of their filial devotion toward their ancestors, and they emphasized such respect in their inscriptions to demonstrate their piety. As Xiang Tajun's sons stated plainly: "We served these master workmen carefully morning and night, fearing to lose their favor and *thus become unable to express our thanks to heaven and our gratitude to our parents.*"

In fact, until 1973, all known funerary texts dating from the Han were written by patrons of mortuary structures; no composition by the builders themselves was identifiable.[147] But in 1973, Chinese archaeologists from the Shandong Provincial Museum discovered a long inscription in an ancient tomb that was, in all likelihood, from the hand of ordinary artisans. The tomb, located in western Cangshan county in southern Shandong, consists of two principal sections constructed of 60 stone slabs, ten of which are carved with pictorial scenes (Figs. 4.44a–c).[148] The rear section of the tomb is further divided into two narrow compartments by a partition wall, on which two "windows" are left open. The front section is a rectangular hall, whose facade is formed by three columns supporting a horizontal lintel. There is a shallow niche in the east wall of this "reception hall" (*tang*), and a tiny side chamber on the hall's west side. The facade of this side chamber is again constructed with a lintel and three supporting columns; the inscription appears on the central and right columns and consists of 238 characters (Fig. 4.45). The informal and irregular characters of the text make it difficult to read and interpret. My translation takes into consideration a number of readings by Chinese scholars,[149] and tries to relate the text with the pictorial scenes decorating the tomb.

> On the twenty-fourth day of the eighth month,
> in the first year of the Yuanjia reign period
> [A.D. 151],
>
> We completed the construction of this tomb
> chamber,

to send you, the honorable member of the
 family, off on your journey.[150]
If your soul has consciousness,
 please take pity on your descendents,
Let them prosper in their livelihood and achieve
 longevity.

[Allow us] to list and explain the pictures inside the
 tomb.[151]

The rear wall [Fig. 4.46]:
 The Red Bird encounters a roaming immortal.
 Phoenixes trail after the White Tiger who is
 strolling in the middle.

The central column [in front of the rear section]
 [Fig. 4.47]:
 Here a pair of intertwining dragons,
 Guard the tomb's heart and ward off evil.[152]

The ceiling of the [rear] chamber:[153]
 A *wuzi* carriage is followed by servant girls who
 are driving carps;
 The chariot of the White Tiger and the Blue
 Dragon runs ahead [Fig.4.48];
 The Duke of Thunder on wheels brings up the
 rear;
 And those pushing the vehicle are the assistants—
 foxes and mandarin ducks.

[The lintel above the west chamber] [Fig. 4.49]:
 Ascending the bridge over the Wei River,
 Here appear official chariots and horsemen.
 The Head Clerk is in front,
 And the Master of Records is behind.
 Together with them are the Chief of a
 Commune,
 The Assistant Commandant of Cavalry,
 And a barbarian drawing his cross-bow.
 Water flows under the bridge;
 A crowd of people are fishing.
 Servant boys are paddling a boat,
 Ferrying [your] wives across the river.

[The lintel above the east niche] [Fig.4.50]:
 [The women] then sit in small *ping* carriages;[154]

Fig. 4.45. Inscription in
the Cangshan tomb.
H. 44–45 cm. This and
other engraved slabs from
the tomb are preserved in
the Cangshan County
Cultural House. Ink rub-
bing.

Fig. 4.46. below Auspi-
cious birds, white tiger,
and an immortal. Carving
on the back chamber
(rear wall) of the Cang-
shan tomb. H. 90 cm.
W. 184 cm. Ink rubbing.

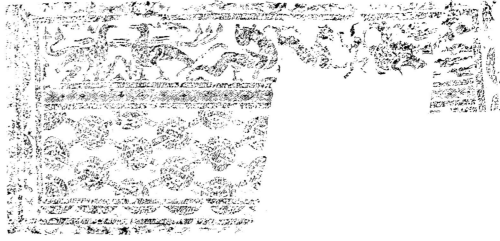

Following one another they gallop to a *ting*
station.[155]
The awaiting officer *youjiao*[156] pays them an
audience,
And then apologizes for his departure.
Behind [the procession],
A ram-drawn carriage symbolizes a hearse;[157]
Above, divine birds are flying in drifting clouds.

The portrait inside [the east niche] [Fig. 4.51]:
Represents you, the member of the family.
The jade maidens are holding drinking vessels
and serving boards—
How fine, how fragile, how delicate!

The face of the door lintel [Fig.4.52]:
You are now taking a tour.
Chariots are guiding the retinue out,
While horsemen remain at home.
The *dudu*[158] is in front,
And the *zeicao*[159] is at the rear.
Above, tigers and dragons arrive with good
fortune;
A hundred birds fly over bringing abundant
wealth.

The back of the door lintel [Fig. 4.53]:
Here are the musicians and singing girls
Playing the wind-instruments of *sheng* and *yu*
in harmony,
While the sound of a *lu* pipe strikes up.
Dragons and birds are driving evil away;
Cranes are poking at fish.

The three columns of the front hall [Fig. 4.54]:
In the middle, dragons ward off evil;
At the left, are the Jade Fairy and immortals;
And on the right column . . . [two characters
missing],
The junior master is called upon,
And drink is served by his newly wedded
wife.[160]

The ceiling of the front hall is decorated
beautifully:

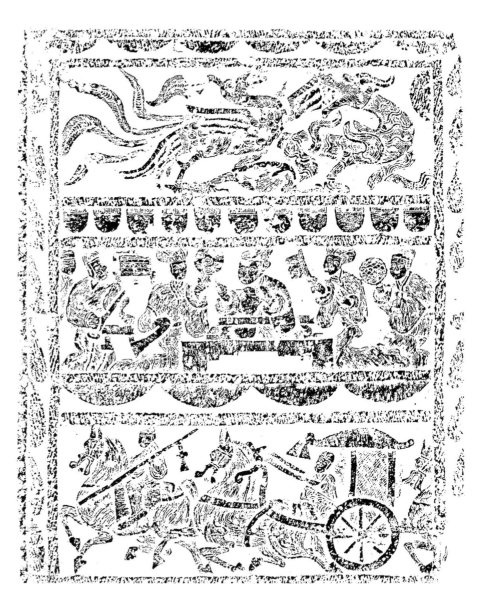

Fig. 4.51. Portrait of the *the east wall) of the Cang-*
deceased. Carving in the *shan tomb. H. 107.5 cm.*
central chamber (niche on *W. 77 cm. Ink rubbing.*

Fig. 4.52. Chariot procession. Carving on the facade (lintel) of the Cangshan tomb. H. 51 cm. W. 246 cm. Ink rubbing.

Fig. 4.53. Entertainment. Carving in the central chamber (above the door) of the Cangshan tomb. H. 50 cm. W. 242 cm. Ink rubbing.

Surrounding a round protrusion,
 Melon-leaf patterns embellish the center;
 And fish patterns are added to the tips of the leaves.

[All these figures and animals,] when you eat and
 drink,
 May you eat in the Great Granary,
 And may you drink from the rivers and seas.
You who devote yourselves to learning,
 May you be promoted to high rank and be
 awarded official seals and symbols.
You who devote yourselves to managing your
 livelihoods,
 May your wealth increase 10,000-fold in a single
 day.
[But you, the deceased,] have entered the dark
 world,
 Completely separated from the living.
After the tomb is sealed,
 It will never be opened again.

A number of factors enable us to identify the writer of this text as the designer/builder of the tomb. In addition to many incorrect characters and homonyms in the text that suggest an ill-educated author,[161] the indefinite appellations of the deceased are an obvious clue. In two places the occupant of the tomb is addressed as *guiqin*, "an honorable member of the family," and *jiaqin*, "a member of the family." The writer's attitude toward the dead, therefore, differs fundamentally from that of the patrons of a funerary structure, who always first identified and introduced the dead in their devotional writings. All the information about the deceased usually provided in a stela inscription—his education, official career, and virtuous conduct—is absent here, and the text gives no account of the family's practices of filial piety as in a shrine inscription. In fact, the Cangshan text seems to have been composed by a writer who did not know the identity of the deceased. The writing could have been used in any

tomb, since a dead person could always be referred to as "an honorable member of the family."

The modern Chinese scholar Li Falin has noticed this unusual feature of the Cangshan inscription. Unfortunately, his observation has led him to draw a misleading comparison: "This text does not record the name, official occupations, characteristics, virtues, achievements, and the family of the deceased, nor does it provide an elaborate dirge. From this point of view, it is inferior to the An Guo inscription and the Xiang Tajun inscription, which contain more detailed information in these respects."[162] Li's mistake is to confuse two different kinds of funerary texts: those written by patrons and those written by builders. The absence of such information in the Cangshan inscription is not due to the author's failings or carelessness; rather, it indicates his different relationship with the dead, his different interest in composing the text, and his distinct cultural background.

We first recognize this writer's background in his language, which differs markedly from that used in both stela inscriptions and shrine inscriptions. Stylistically, the Cangshan text is a rhymed ballad, with most lines consisting of three, four, and seven characters.[163] This form is unknown in all other funerary inscriptions, which are often prose compositions sometimes followed by a dirge in uniform four-character lines.[164] In content, the Cangshan text does not allude to the Confucian classics or use filial formulas, which abound in inscriptions by patrons, either by the descendents or by friends and colleagues of the dead. This is not to say, however, that the writer of this inscription was free from cultural conventions. On the contrary, his language is likewise formulaic and stereotyped, but of a different sort. The text contains many popular sayings related to folk beliefs of the time. Many of its sentences and phrases are "auspicious words" (*jiyu*) in couplets, which one can also find on contemporary bronze mirrors and other objects of daily use: "Tigers and dragons arrive with good fortune; / A hundred birds fly over to bring abundant wealth"; "You who devote yourselves to learning, / May you be promoted to high rank and be awarded official seals and symbols. / You who devote yourselves to managing your livelihoods, / May your

Fig. 4.54. Immortals, intertwining dragons, and the donors. Carvings on the facade of the Cangshan tomb. (a) Right column; (b) front of the central column; (c) back of the central column; (d) left column. H. 107.5–109.5. Ink rubbings.

wealth increase a 10,000-fold each day"; "In the middle, dragons ward off evil; / At the left, are the Jade Fairy and immortals." Other formulas employed in the text include prayers, among which is the well-known expression: "All these figures and animals, when you eat and drink, / May you eat in the Grand Granary / And may you drink from the rivers and seas." The Grand Granary (*taicang*) refers to the Han state granary established by the chief minister Xiao He in 200 B.C. During Han times, however, people used this term to symbolize the greatest grain depository, just as rivers and seas symbolized the greatest depository of water. By inscribing this sentence on a mortuary structure, the writer expressed the wish that the figures and animals depicted in the tomb would not seize food from the living but would eat and drink from greater natural sources.[165]

But more important, the Cangshan inscription reflects a different interest. Whereas the writers of shrine inscriptions and stela inscriptions were preoccupied with the desire to demonstrate their filial conduct or loyalty, this text was written by someone who was interested in the tomb itself. Accordingly, most of the inscription documents this tomb or, more likely, its design.

This last statement contains an important proposal; namely, that prior to the construction of a mortuary structure, a Han builder would first have planned the general layout of its decoration and documented it in a written form. The possibility that the Cangshan inscription documented a design rather than the finished tomb is suggested by certain inconsistencies between the pictorial scenes as described and the actual tomb carvings. For example, most pictures found in the tomb accord with those mentioned in the text, but not those on the ceiling. According to the inscription, a group of vivid images—strange chariots, girls driving carps, foxes and mandarin ducks, and the Duke of Thunder on wheels—should have been depicted on the ceiling of the rear chamber. But in the Cangshan tomb only a tiger and a dragon appear in this position. The remaining images are missing and can only be observed on carved slabs from other sites. For example, two stone bas-reliefs from Honglou on the

Shandong-Jiangsu border are filled with mythical images (Fig. 4.55), including chariots drawn by dragons and tigers, the bear-like Duke of Thunder beating drums, a fish with human feet, and an enormous mandarin duck. I have tried to reconstruct the original architectural form of these and other scattered slabs from Honglou and found that these two stones most likely formed the ceiling of a mortuary structure.[166] It is possible that in designing the Cangshan tomb, the builder recalled these scenes from his motif repertoire but was never able to realize his plan.

A similar fate befell the ceiling of the front chamber: its proposed decoration—melon leaves embellished with fish images—is likewise absent in the tomb. Again, carvings from other sites in Shandong prove that this pattern was not merely the writer's fantasy. In 1980, eight square or rectangular slabs with such a decor were discovered in Songshan (Fig. 4.56); one of them bears the An Guo inscription (Fig. 4.6). Their excavators proposed that these slabs must have come from several abandoned mortuary buildings, perhaps from their ceilings.[167] It is interesting to speculate why all the pictures on walls and columns described in the Cangshan text exist in the tomb, and only the ceiling designs are missing or incomplete. A possible explanation may be the building sequence of the tomb: the construction of the ceiling, naturally the last step of the whole project, was for some reason hurriedly finished before the planned decoration could be completed.

We thus obtain another determinant for the authorship of the Cangshan inscription: only the builder could document the intended design; the patrons of the tomb could only describe (and would only wish to describe) its actual finished form. As an architectural design written in words, the inscription translates pictures planned for a three-dimensional structure into a linear narrative. This narrative begins from the scenes in the rear chamber—the sacred quarter of the burial that contained the coffin of the dead. All the images designed for this chamber were mystical in nature. Intertwining dragons would guard its entrance, and heavenly beasts and birds would be depicted on its ceiling and walls to transform the solid stone room into a world of wonder.

The builder then moves on to tell us his design for the

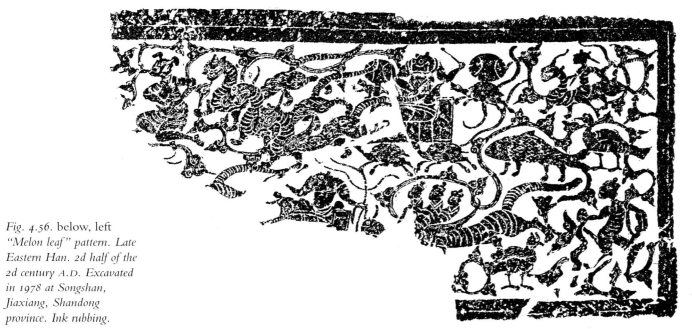

Fig. 4.55. left *Duke of Thunder and other fantastic creatures. Eastern Han. 2d century A.D. H. 106 cm. W. 190 cm. Excavated at Honglou, Xuzhou, Jiangsu province. Ink rubbing.*

Fig. 4.56. below, left *"Melon leaf" pattern. Late Eastern Han. 2d half of the 2d century A.D. Excavated in 1978 at Songshan, Jiaxiang, Shandong province. Ink rubbing.*

Fig. 4.57. *Detail of a tomb gate, with inscriptions identifying the standing figures as Tingzhang (innkeeper). Eastern Han. 2d century A.D. Probably from Nanyang, Henan province. Art Institute of Chicago.*

front chamber, which provided him with another enclosed space for the second part of his pictorial program. Here, human figures would become the main subject of depiction, and a funerary journey would be represented in two compositions on the east and west walls. The first picture above the west side chamber would show the procession crossing the Wei River Bridge. Two famous Han emperors, Jing and Wu, had built bridges across the Wei River north of Chang'an to link the capital with their own mausoleums; imperial guards of honor and hundreds of officials had accompanied their departed lords across these bridges. The Wei River must have become a general symbol of death.[168] Inspired by these royal precedents, the designer decided to label the riders in his pic-

ture with official titles, but he used only the local ranks that he knew. He also decided to draw the wives of the deceased, who were expected to accompany their husband to his burial ground. But the women had to take a boat across the river, since female (*yin*) had to be separated from male (*yang*) and since water embodied the *yin* principle.

The second stage of the journey would be presented on the opposite east wall. Having crossed the River of Death, the women would get into special female carriages, escorting the hearse to a tomb prepared for the dead in the suburbs. The procession would arrive at a *ting* station and be greeted by officials in front of it. This *ting* station, which was in real life a public guesthouse for travelers, should be understood here as the symbol of the tomb, and the official who greets the procession should be identified as the tomb's guardian. The same idea is expressed by depicting the *tingzhang* (the officer at a *ting* station) on the gate of a tomb (Fig. 4.57) or by erecting stone statues in cemeteries with the title *tingzhang* inscribed on their chests (Fig. 4.58).[169] Moreover, we find that in the finished carving of this scene in the Cangshan tomb, the two doors of the *ting* station are half open, and a figure emerges from the unknown interior behind each door. Holding the still closed door-leaf, he (or she) seems to be about to open it for the funerary procession. Very similar images can be found on stone sarcophagi (Figs. 4.59, 5.10). But in these cases, it is clearly the "gate" to the world inside the coffin, a universe of the deceased defined by motifs of immortality and cosmic symbols.[170]

In retrospect, we realize that these two pictures depict events prior to the burial of the deceased but in an overtly symbolic language. Stated plainly, in the first scene the deceased is sent off with a formal ceremonial procession; in the second scene he is escorted by close family members to his graveyard. This funerary journey ends at his tomb—the building with the half-opened gate. Entering this gate signifies the burial of the dead. This is why the designer of the Cangshan tomb informs us, immediately after his description of these two scenes, that he will now portray the dead in the same front chamber, in a niche that functioned as a small shrine.

Fig. 4.58. Tingzhang. Stone statue originally erected in the graveyard of Mr. Pao, the magistrate of Le'an in Shandong. H. 254 cm. Preserved in the Confucian Temple, Qufu, Shandong province. Woodblock illustration.

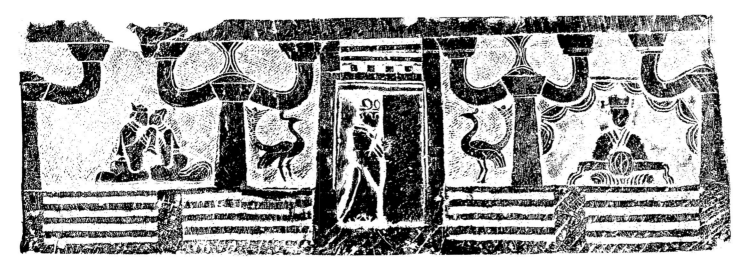

Fig. 4.59. Carving on a stone sarcophagus. Eastern Han. 2d century A.D. From Xinjin, Sichuan province. Ink rubbing.

In a more profound sense, this journey symbolizes the transition from death to rebirth followed in the designer's narrative. This narrative begins from the rear chamber, where the coffin concealing the corpse of the deceased is evidence of his former existence. The designer then describes the ritual process in which the coffin was transported to the graveyard—the otherworldly home of the deceased. Only after this step could the designer portray the deceased in his human form in the front tomb chamber—a definite indication of his rebirth in the underground world. It was understood that the dead, or his soul, was now *living* there with regained human desires. Logically, the third part of the tomb's decoration would illustrate the fulfillment of such desires. For the front side of the facade lintel, the designer planned a scene representing an outdoor tour; for the back of the same stone, he designed an elaborate musical performance. These two pictures, one facing out and the other in, epitomized the two main aspects of the leisurely life that the occupant of the Cangshan tomb would enjoy.

This analysis leads us to compare once more the Cangshan inscription with Han funerary texts composed by patrons. We find differences not only in their language and the degree of literacy but, more fundamentally, in their

basic premises and points of view. First, the designer of the Cangshan tomb described his pictures in a sequence from death to rebirth and from the rear coffin chamber to the front reception hall. In a way, this designer was undergoing the (supposed) experiences of the dead: his corpse would be put into a coffin; his coffin would be carried out and transported to his tomb; he would be buried; and he would be reborn in a new home where he could again enjoy all sorts of entertainments. This series of experiences was depicted in a continuous pictorial narrative. The patron of a funerary monument, on the other hand, often assumed a visitor's viewpoint. As exemplified by the inscription on An Guo's shrine, the writer of the text approached the pictorial carvings as isolated images without obvious narrative links, and he described these images from exterior to interior, as though he were entering the building and recording what he saw as he went along. Unlike the designer, a patron would never have identified himself with the dead—his father, brother, former master, or friend. To him the whole significance of a devotional monument must have lain in the opposition between the deceased and himself—between the object of devotion and the devotee.

Second, the designer of the Cangshan tomb was guided by what I call the *primary or shared symbolism* of funerary

art, in which images were understood in light of a general interest in death, the transformation of the soul, and immortality. On this basic level of religious thinking, little attention was paid to the particularities of the deceased or to the social and political values of a funerary structure. The builder of the Cangshan tomb apparently had a strong fear of the dead tracing and haunting him, and so he ended his inscription with a prayer: "You, the deceased, have entered the dark world, / Completely separated from the living. / After the tomb is sealed, / It will never be opened again." Except for the payment agreed upon for his labor, he hoped to have nothing more to do with the departed soul.

The patron of a monument, on the other hand, was attracted by the *secondary or specific symbolism* of funerary art; he was often more inclined to read social and moral meanings into pictorial carvings. To him, the establishment of the mortuary monument was a moral and political event, and he expected that this monument would continue to exert influence on public opinion. His funerary inscription never explained the journey and life of the deceased in the underground world. Rather, he emphasized filial piety, loyalty, and other correct social norms. Understandably, the patron was himself a spectator of the carvings on the monument, and his description instructed other spectators how to comprehend these scenes. It is not strange, therefore, that during the Han, a patron's account of funerary art was often alarmingly similar to those visitors produced. An Guo's brothers urged "people of virtue and kindheartedness within the four seas" to pay attention to the "figures of filial piety, excellent virtue, and benevolence" depicted on their family shrine, and to scenes representing the "dignified superiors" and the "agitated yet joyous inferiors." Their words seem to echo Wang Yanshou's description of the mural in the Hall of Spiritual Light of the Lu principality (Lu Lingguang dian), which the poet visited at the beginning of the second century:

> From the later period of the Xia, Shang, and Zhou dynasties are shown the concubines who debauched their masters, loyal ministers and filial sons, noble knights and virtuous women. No detail of their wisdom or stupidity, successes or failures, is omitted from these records. Their evil deeds may serve to warn later generations; their good deeds may set an example for posterity.[171]

In both cases, the voice of the builders is obscured, if not entirely buried, by the patron's and visitor's ideological glorification of the monuments.

The Transparent Stone: The End of an Era

On foot I climbed up Beimang's slopes
and gazed afar on Luoyang's hills.
Luoyang, so silent and forlorn,
its halls and palaces all burned away.
Each wall has collapsed and crumbled,
briars and brambles stretch to sky.
I saw no old folks from times before,
in my eyes were only new young men.

I walked at an angle, there was no path,
fields had run wild, tilled no more.
Long had the traveler not returned,
he can no longer tell the boundary paths.
And the moors, so barren and bleak,
no hearth-fires seen for a thousand miles.
When I think on this place I used to live,
breath chokes within, I cannot speak.[1]

COMPOSED BY Cao Zhi in the early third century, this poem is an early example of the poetic genre *huai gu*, or "meditation on the past." Often inspired by the sight of ruins, such writings transform history into a site of lamentation. A broken stela, a collapsed palace, an abandoned city—old monuments no longer possess their original form; only their destruction and decay now arouse the spectator's sentiment and add another layer of meaning. It is fair to say the *huai gu* tradition depends on a particular notion of the past: separated by a huge gulf from the present, the past emerges as a distant image that one can gaze at and speculate on. Time alone can never create this gulf: Wu Liang of the Eastern Han felt an unbroken connection with paragons from bygone eras; Cao Zhi looked on Luoyang, the city where he used to live, and saw an infinitely remote territory.

Cao Zhi's Luoyang was a double, however: the past Luoyang in his *memory* and the current Luoyang in his *view*. These two sharply contradictory images intensified the tragedy shared by the poet and the city. Like the once glorious but now ruined capital, Cao Zhi belonged to both the past and the present and therefore to neither. He found no one of his own generation: "I saw no old folks from times before, / in my eyes were only new young men." No longer inside the city looking out, he was now standing in the Beimang Hills and gazing at Luoyang. Stephen Owen, the English translator of Cao's poem, comments on this new point of view:

One of the most durable openings of *yuefu* and the "old poems" was going out the gates of Luoyang, the Eastern Han capital, as in "Nineteen Old Poems" XIII. From the eastern gates could be seen the great cemetery in the Beimang Hills. In what seems to be a return poem, an ironic reversal occurs: Cao Zhi . . . climbs Beimang and looks back on Luoyang itself, in ruins, sacked by Dong Zhuo in 190 and now virtually deserted.[2]

Cao Zhi's reversal of the traditional way of describing Luoyang in literature indicated his own transformation from insider to outsider. The hills where he now stood symbolized the irrevocable nature of that shift: all Eastern Han Emperors were buried there, and the name Beimang

had become synonymous with death. The poet took the position of the dead, looking back to their (and his) former home, which was now nothing but a "ghost town." In the third century, social reality and one's personal experience caused this radical change in point of view. Two or three hundred years later, people would manipulate point of view to stimulate new experiences.

Reversed Image and Inverted Vision

Near the modern city of Nanjing in eastern China, some ten mausoleums surviving from the early sixth century bear witness to the past glory of emperors and princes of the Liang dynasty (502–57).[3] The mausoleums share a general design (Fig. 5.1). Three pairs of stone monuments are usually erected in front of the tumulus: a pair of stone animals—lions or *qilin* unicorns according to the status of the dead are placed before a gate formed by two stone pillars; the name and title of the deceased appear on the flat panels beneath the pillars' capitals. Finally two opposing memorial stelae bear identical epitaphs recording the career and merits of the dead person. This sequence of paired stones defines a central axis or a ritual path leading to the tomb mound. As indicated by its ancient designation *shendao*, or "the spirit road," this path was built not for the living but for the departing soul, which, it was commonly believed, traveled along the path from its old home to its new abode, crossing the pillar-gate that marked out the boundary between these two worlds.[4]

Fifteen hundred years have passed, and these mausoleums have turned into ruins. The stone animals stand in rice fields; the stelae are cracked and their inscriptions blurred. Ann Paludan's photograph wonderfully captures the sentiments aroused by their decay (Fig. 5.2). But the "spirit road," which never takes a material form but is only defined by the shapes surrounding it, seems to have escaped the ravages of time. As long as the pairs of monuments—even their ruins—still exist *in situ*, a visitor recognizes this "path" and he, or his gaze, travels along it (Fig. 5.3). Like the ancients, he would first meet the twin stone animals, each with its body curving from crest to tail to form a smooth S-shaped contour. With their large

Fig. 5.1. Standard layout of a Liang royal tomb

Tomb

stelae

columns

bixie or qilin

round eyes and enormous gaping mouths, the mythical beasts seem to be in a state of alarm and amazement (Fig. 5.4). Compared to the bulky animal statues created three centuries earlier during the Han, these statues evince a new interest in psychology rather than in pure physique, in momentary expression rather than in permanent existence, in individuality rather than in anonymity, and in a complex combination of fantastic and human elements rather than in uniformity. The vividness of the animals

even seems at odds with the solemn atmosphere of a grave-yard. Standing in front of the stone pillars, these strange creatures seem to have just emerged from the other side of the gate and are astonished by what they are confronting.

The powerful imagery of these stone beasts must have contributed to the invention of abundant legends about them: people have repeatedly reported seeing them jump-ing up in the air.[5] In 546, the animals in front of the Jian ling mausoleum, the tomb of the dynastic founder's father, reportedly suddenly got up and began to dance. They then fought violently with a huge serpent under the pillar-gate, and one beast was even injured by the evil reptile.[6] This event must have created a great sensation at the time: it was recorded in the dynasty's official history, and the famous poet Yu Xin (513–81) incorporated it into his writ-ings.[7] This and other tales, obviously originating from the statues' symbolic function of warding off evil and from the desire to explain their decay over time, nevertheless demanded and inspired further political interpretations. Thus when a similar event was later reported to the court, some ministers considered it a good omen, but the em-peror feared it as an inauspicious indication of future re-bellions—underlying both interpretations was the belief that the stone beasts carried divine messages to the living.[8]

Having passed the animal statues, the visitor finds him-self before the stone pillars. As I mentioned a little earlier,

Fig. 5.2. above left Qilin *unicorn in Emperor Wu's (d. A.D. 494) An ling mausoleum. Qi dy-nasty. Danyang, Jiangsu province.*

Fig. 5.3. above *Tomb of Prince Xiao Ji (d. A.D. 527). Liang dynasty. Ju-rong, Jiangsu province.*

Fig. 5.4. left *The head of a* qilin *unicorn (detail of Fig. 5.2). A.D. 494. Danyang, Jiangsu province.*

a

b

Fig. 5.5. (a) Mirror-image inscriptions on the stone pillars in Emperor Wen's tomb. A.D. 502. H. 62.5 cm. W. 142 cm. Danyang, Jiangsu province. (b) English translation.

Fig. 5.6. Diagram: reversed images

reversed images a ——————— ——————— a′

Fig. 5.7. Diagram: reversed vision

reversed vision a ——————— ——————— a′

these bear two panels with identical inscriptions. In the example illustrated in Fig. 5.5a, the passage reads: "The spirit road of Grand Supreme Emperor Wen," the father of the founder of the Liang dynasty. There is nothing strange about the content of these inscriptions; what is puzzling is the way they are written: the inscription on the left panel is a piece of regular text, but the one on the right panel is reversed.[9]

Readers unfamiliar with Chinese writing may gain some sense of the irony created by this juxtaposition from an English "translation" of the Chinese passages (Fig. 5.5b): although the content of the two inscriptions is identical, their effect is entirely different. The inscription on the left is as a series of words forming a coherent and readable text. But the inscription on the right, at first sight, consists of no more than individual and illegible signs. A temporal reading sequence is thus established: even though the two inscriptions would be *seen* simultaneously from the spirit path, they must be *comprehended* sequentially. It would not take more than a few seconds for a literate person to read the normal inscription on the left, but to understand the inscription on the right he would first need to find clues. Such clues are found *visually* in the physical relationship between the two inscriptions: both their symmetrical placement and echoing patterns suggest that the illegible text "mirrors" the legible one. Unconsciously, the visitor would have taken the normal text as his point of reference for the other's meaning.

There would be no need to compare the individual characters of the two inscriptions: the problem no longer exists once the visitor realizes they are the *same*. The "illegible" inscription has become legible because he can read its mirror-image (Fig. 5.6). In other words, the mystery of its content has vanished: it is simply a reversed version of a regular piece of writing. What remains is the mystery of its reading: *it would become not only legible in content but normal in form if the reader could invert his own vision to read it from the "back"—from the other side of the column* (Fig. 5.7).[10] Once this inference is made, the reversed inscription changes from a subject to be deciphered to a stimulus of the imagination.[11] Controlled and deceived by the engraved signs, the visitor has mentally transported

 The Transparent Stone

himself to the other side of the gate. He has forgotten the solid and opaque stone material, which has now become "transparent."

All this may seem a psychological game and a quite subjective interpretation, but the perceptual transformation explored here is seen frequently in the funerary art and literature of the Six Dynasties. During a funerary rite, the "visitor" whom I have just described would have been a mourner; and as a mourner, his frame of mind would be focused on the function of a funerary ritual and the mortuary monuments framing it. Who was supposed to be in a position to read the reversed inscription "obversely"? In other words, who was thought to be on the other side of the stone column looking out? A gate always separates space into an interior and an exterior; in a cemetery these are commonly identified as the world of the dead and the world of the living. The pair of inscriptions on the twin pillars signifies the junction of these two worlds and the meeting point of two gazes projecting from the opposite sides of the gate (Fig. 5.7): the "natural" gaze of the mourner proceeding from the outside toward the burial ground (Fig 5.8), and his "inverted" gaze, which is now attributed to the dead at the other end of the spirit road (where his body was buried and his life was recorded on memorial tablets).

The important point is that this reading/viewing process forces the mourner to go through a psychological dislocation from this world to the world beyond it. Confronted by the "illegible" inscription, his normal, mundane logic is disrupted and shaken. The discovery of the mirror relationship between the two inscriptions forges a powerful metaphor for the opposition between life and death. The sequential reading of the inscriptions creates a temporal shift from within to without; by mentally dislocating himself to the other side of the gate he identifies himself with the dead and assumes the viewpoint of the dead. The function of the gate is thus not merely to separate the two spaces and realms. As a static, physical boundary it can easily be crossed, but it is always *there*. More important, to completely fulfill the ritual transformation, the material existence of the gate has to be rejected. The un-

Fig. 5.8. A man kneels between two pillars and pays homage to a tomb mound. Stone carving. Northern Wei dynasty. Early 6th century A.D. H. 45.5 cm. From Luoyang, Henan province.

derlying premise of this ritual transformation is that only when a living person accepts the otherworldly view can he enter the encircled graveyard without violating it, and only then can he not only pay respect to the dead but also speak for the dead.

In this light we can understand the progression traced by Lu Ji's (261–303) series of three mourning songs.[12] In the first song a funeral is narrated as if it were being watched by an anonymous but dispassionate observer:

> By divination an auspicious site is sought.
> .
> For early departure attendants and drivers are
> roused.
> .
> Life and death have different principles;
> To carry out the coffin there must be a time.
> A cup of wine is set before the two pillars;
> The funeral is begun, and the sacred carriage
> advanced.

The funeral procession is still the focus of the second song, but the description becomes subjective and emotional. The poet speaks for the mourners and sees through their eyes:

> Wandering, the thoughts of relatives and friends;
> In their distress their spirits are uneasy.
> .
> The soul carriage is silent without sound;
> Only to be seen are his cap and belt,
> Objects of use represent his past life.
> .
> A mournful wind delays the moving wheels;
> Lowering clouds bind the drifting mists.
> We shake our whips and point to the sacred
> mound;
> We yoke the horses and thereafter depart.

The point of view changes again as soon as the funeral procession finally departs toward the sacred mound. In the third and last song, it is the deceased who is seeing, hearing, and speaking in the first person. The poet now identifies not with the mourners but with the dead:

> The piled-up hills, how they tower!
> My dark hut skulks among them.
> Wide stand the Four Limits;
> High-arched spreads the azure skies.
> By my side I hear the hidden river's flow;
> On my back, I gaze at the sky roof suspended.
> How lonely is the wide firmament!

When Prince Xiao Ziliang (459–94) went to Mount Zixing, he gazed at his family tombs there and lamented: "Looking north there is my [dead] uncle; directly before me I see my [deceased] brother—if you have consciousness after your death, please let me be buried here in your land."[13] Ziliang was grieving for both his deceased kin and himself—as the survivor of the family he already saw himself buried in a dark tomb. Sentimental and self-pitying, he seems to have set an example for Xiao Yan (464–549), the founder of the Liang and a great patron of literature. Xiao Yan, or Emperor Wu of Liang, dedicated the Jian ling mausoleum to his deceased father, Xiao Shunzhi (444–94; his mirror inscriptions have been

the focus of our discussion); he also had the Xiu ling mausoleum constructed for himself. During a trip in the third month of 544, he sacrificed at his father's graveyard and then visited his own tomb, where "he was deeply moved and began to cry."[14] One wonders what moved him to tears in this second mausoleum; the only possible answer is the vision of himself lying underground on the other side of the pillar-gate.

The concept of "mourner" thus needs to be redefined. A mourner was not only a living person who came to a graveyard to meet a deceased Other, but also possibly a person who visited his own tomb to mourn for himself as the Other. In the first case, the pillar-gate separated yet connected the dead and the living; in the second case, it separated and connected a man's split images that confronted each other. In the late third century, Lu Ji had tried to speak for both the mourners and the dead; in the fifth and sixth centuries people lamented for themselves as though they were dead.[15] From this second tradition emerged three great songs by Tao Qian (365–427), which chillingly observe the world from a dead person's silent perception:

> How desolate the moorland lies,
> The white poplars sough in the wind.
> In the ninth month of sharp frost,
> They escort me to the far suburbs.
> There where no one dwells at all
> The high grave mounds rear their heads.
> The horses whinny to the sky,
> The wind emits a mournful sound.
> Once the dark house is closed
> In a thousand years there will be no new dawn.
> There will be no new dawn
> And all man's wisdom helps not at all.
> The people who have brought me here
> Have now returned, each to his home.
> My own family still feel grief—
> The others are already singing.
> What shall we say, we who are dead?
> Your bodies too will lodge on the hill.[16]

Tao Qian must have been fascinated by the various possibilities of "inverting" himself—observing and describ-

ing himself and his surroundings as though he had become a bodiless and transparent "gaze," moving along the funeral procession like a camera lens. He wrote *jiwen*—sacrificial eulogies—for his relatives, and in these pieces he presents himself as a living member of the family lamenting dead kin.[17] But he also composed a sacrificial eulogy for himself. Unlike the funeral song in which he (as a dead man) follows and watches the entire mortuary rite, in the short preface to his self-eulogy he placed himself in the shifting zone between life and death:

> The year is *dingmao* [A.D. 427] and the correspondence of the pitch pipe is *wuyi*. The weather is cold and the night is long. The atmosphere is mournful; the wild geese are on the move; plants and trees turn yellow and shed their leaves. Master Tao [i.e., Tao Qian himself] is about to take leave of the "travelers inn" [life] to return forever to his eternal home [death]. His friends are sad in their grief for him; they will join in his funeral feast this very evening, make offering of fine vegetables and present libations of clear wine. The faces he sees already grow dim; the sounds he hears grow fainter.[18]

If life and death are separated by a pillar-gate, the experience described here must take place between the two pillars on the gate's threshold. Unlike Lu Ji, who narrated a funeral in distinct stages progressing from the living to the dead, Tao Qian assumes a position between the two. This suspended position was not completely Tao's invention, however; we find a classical example in Confucius' life:

> In the year *rensi* [479 B.C.], on the morning of the 11th of the 4th moon, Confucius arose, and then supporting himself with his walking stick in one hand while the other hand rested behind his back he advanced majestically to the front door of his apartment and began to chant the following words: "The mountain saint is going to disappear; the main beam of the empire is going to be broken; the sage is going to die!" After the rhythmic recital of this solemn prediction he went and placed himself *in the center of the gate way.* . . . After seven days, on the 18th day of the 4th moon, near mid-day, he expired at the age of seventy-three.[19]

With this anecdote we return to the theme of the gate, but with a new interest in the elusive, two-dimensional plane between its two pillars rather than in the two spaces separated by it. Guided by this interest, our attention also shifts from the actual gates standing in a cemetery to their image depicted on flat stone. From the second century on, such images were often engraved on the frontal sides of sarcophagi.[20] In some cases an empty gate indicates the entrance to the other world (Fig. 5.9); in other cases horses or a rider guide the wandering soul through the gate (Fig. 5.10). A third variation offers a more complex illustration (Fig. 5.11), which would be repeated by artists as late as the Song dynasty (Fig. 5.12): a figure emerges from a half-opened gate, holding the still closed door-leaf. The gate is thus half-empty and half-solid; the empty space recedes into an unknown depth, while the solid door-leaf blocks the spectator's gaze from penetrating the hidden space. The figure crosses these two halves, both exposing himself against the empty space and concealing himself behind the closed door-leaf. It seems that he (or she) is about to vanish into the emptiness but is still grasping the door and looking at the world to which he once belonged.[21] Almost graphically, this image signifies an intermediary stage between life and death.

Fig. 5.9. Stone sarcophagus decorated with a que *gate on the front end. Eastern Han. 2d century A.D. L. 217.5 cm. H. 58.5 cm. From Shapingba, Chongqing, Sichuan province. Chongqing Museum.*

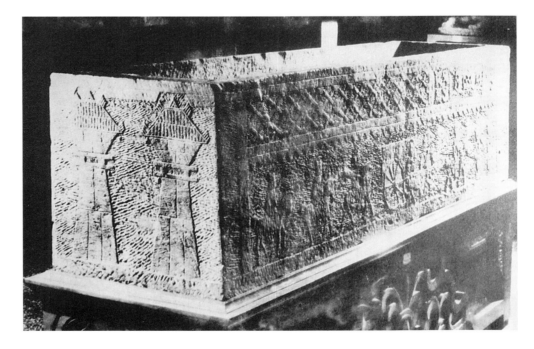

Fig. 5.10. Que gate and a guardian. Carving on the front side of a stone sarcophagus from Xinjin, Sichuan province. Eastern Han. 2d century A.D. Sichuan University Museum, Chengdu. Ink rubbing.

Fig. 5.11. Half-opened gate. Carving on the front side of the Wang Hui sarcophagus. A.D. 211. H. 83 cm. L. 101 cm. Found in 1942 at Lushan, Sichuan province. Lushan Museum. Ink rubbing.

Fig. 5.12. Half-opened gate. Mural in Song Tomb no. 2. Excavated in 1983 at Xin'an, Luoyang, Henan province. Ca. 12th century A.D. Luoyang Ancient Tomb Museum.

We are reminded of Tao Qian's depiction of himself in his eulogy: "Master Tao is about to take leave of the 'traveler's inn' to return forever to his eternal home. His friends are sad in their grief for him. . . . The faces he sees already grow dim; the sounds he hears grow fainter." We can imagine that the same words could be murmured by the depicted figure who, with half of his or her body inside the dark sarcophagus, belongs to neither this world nor the world beyond it. Both the implied artist and the poet Tao Qian assume a "liminal position" on the threshold of the gate (Fig. 5.13). Their vision may be called a "binary vision" because they look in the two opposite directions of life and death at the same time (Fig. 5.14).

This mode of visualization is related to a general phenomenon during the Six Dynasties: many contemporary writers, painters, and calligraphers sought to see the "two facets of the universe" simultaneously. As we return to the "reversed inscriptions," the focus of this investigation shifts from the viewer's perception to the artist's ambition to create such inscriptions. But first, who was the artist? Usually we assume that an engraved stone inscription copies a piece of writing and reflects the original style of the calligrapher. But if a calligrapher wrote only a single "regular" text, which was then inscribed twice as both the front and back inscriptions on the two pillars, the calligrapher's work was essentially irrelevant to the final output; he can hardly be claimed as the writer of the "reversed" inscription. But if he had indeed created both versions of the text, it would be far more intriguing. This would mean that the mirror inscriptions directly reflected the artist's creativity and state of mind, for, as Emperor Wu of the Liang once stated himself, "the hand and mind [of a calligrapher] must work in correspondence."[22] This, in turn, would mean that the calligrapher had first tried to "reverse" himself; before there was any "transparent stone" he had to make himself transparent.

Two methods may enable us to solve this puzzle. We can check contemporary literary records for mentions of "reversed" or "inverted" writing. We can also try to find other clues from existing inscriptions. In an essay, the master calligrapher Yu Yuanwei (sixth century) introduces himself as a calligraphic acrobat who once inscribed

Fig. 5.13. Diagram: liminal viewpoint

Fig. 5.14. Diagram: binary vision

a screen in a hundred different scripts, both in ink and in color. He lists all the fancy names of these scripts (such as "immortal script," "flower-and-grass script," "monkey script," "pig script," "tadpole script"). Toward the end of this long inventory appear two names: *daoshu* (reversed writing) and *fanzuoshu* (inverted and left writing).[23] Even more fascinating, in the same essay he identifies the origin of a type of reversed writing.

> During the Datong reign period [535–46], a scholar [named Kong Jingtong] working in the Eastern Palace could write cursive script [*caoshu*] in a single stroke. His brush stroke, which broke only at the end of a line, was fluent, graceful, and restrained, and reflected his distinctive nature. Since then no one has been able to follow him. [Kong] also created the "left-and-right script" [*zuoyoushu*]. When people exchanged their writings at a gathering, no one could read his piece.[24]

Yu Yuanwei's record offers at least three kinds of information. First, the term "left writing" (*zuoshu*) or "inverted and left writing" (*fanzuoshu*) should indicate completely inverted "mirror calligraphy," so that "no one could read" it at first sight. (As I explain below, the term *daoshu* or "reversed writing" probably refers to the method of writing a text in reverse order; the characters are not necessarily inverted.) Second, Kong Jingtong wrote both regular and inverted versions of a single text ("left-and-right writing") and exhibited them on a single occasion.

As a gifted and popular calligrapher, he must have first learned the conventional way of writing but later mastered the inverted style of calligraphy through a painful self-inversion. Third, Kong developed two different calligraphic styles: the first was the "cursive script" (*caoshu*) in a single fluent brush stroke; and the second was the "left-and-right" mirror texts. Both writing styles place "form" over "content."

To examine existing "inverted and left inscriptions," we can employ a simple method: turning over a rubbing of such an inscription and placing it against a light table, we should find standard calligraphy if the inscription was made by reversing a piece of regular writing. The best preserved "inverted inscription" is found in Prince Xiao Jing's tomb (Fig. 5.15; the counterpart "front" inscription was unfortunately lost long ago). Following the method suggested above, I have reversed this inverted inscription (Fig. 5.16a) to obtain the version shown in Fig. 5.16b. Any

Chinese calligrapher of even an elementary level would immediately point out its weakness: the structure of several characters is unbalanced, and the horizontal strokes generally drop instead of rising as in normal writing. Both are typical symptoms of reversed writing or left-handed writing done by a right-handed person. This examination reveals that the term "left-and-right writing" may also mean that a calligrapher used both hands to write. From his right hand came a normal and readable text; from his left hand, reversed and illegible signs. Such ambidextrous skill seems almost supernatural. (Similar legends are still being created in modern Chinese literature. In a popular martial arts novel by the writer Jin Yong, the heroine Little Dragon Girl [Xiaolongnü] has mastered the amazing skill of using her left and right hands simultaneously to fight in two entirely different yet complementary styles of swordplay. She thus combines two *gongfu* masters in one and, by making her moves incomprehensible even to a master opponent, becomes undefeatable.)

The inversion of an existing convention, however, may also create a new convention. Suppose that the "left-and-right scripts" were standardized and became a norm— they would lose their power to confuse readers, and the supernatural calligrapher would become merely a humble craftsman. Upon receiving such writing from Kong Jingtong, a guest would immediately lay bare his trick, and when a funeral procession proceeded toward a pillar-gate, no mourner would be intrigued by the pair of inscriptions because they would now be readily understandable. The stone columns would remain solid and opaque, and although the boundary marked out by the gate could be physically crossed, it would never be erased.

All seven surviving inscriptions on the pillar-gates of Liang tombs have been called *zhengfanshu* (front and reversed writing). But if we examine these inscriptions more closely, we find three distinctly different ways of "reversing" or "inverting" regular writing. The case that I discussed earlier (Fig. 5.5a) exemplifies one of these methods: regular writing is completely reversed to form a true mirror-image.[25] Another method, represented by the inscriptions reconstructed and "translated" in Figs. 5.16a–c, is to write the characters backward while keeping the

Fig. 5.15. Reversed inscription on a stone pillar in the graveyard of Prince Xiao Jing (d. 523). Liang dynasty. Nanjing, Jiangsu province.

Fig. 5.16. (a, b) Recon-
struction of the inscriptions
on the pair of pillars in
Prince Xiao Jing's grave-
yard. Ink rubbing.
(c) English translation.

standard right-to-left sequence of writing and reading
(left-to-right sequence in English).[26] The third way is
again an inversion of the second method (Figs. 5.17a, b):
the normal right-to-left sequence is changed to left-to-
right (right-to-left in English), but all characters are written
in their regular form.[27] This last script may be identified
as *daoshu,* a type of reversed script found on Yu Yuan-
wei's list.

All inscriptions "inverted" according to these three
methods were made during a short period of some 30 years.
We must assume that some profound reason led to such
interest in metamorphosis.[28] Such rapid changes can only
testify to a deliberate effort to escape from a fixed pattern.
The task is not easy since a regular inscription must be
paired with an inverted one on the two pillars so that
they can together define the junction of two opposing
views, yet any standardization would turn the inscriptions
into static symbols without psychological power. It is
probably no coincidence that only the earliest surviving
examples of "front and back" writing—the pair of inscrip-
tions dedicated to the father of the dynasty's founder—
appear as true mirror-images. To avoid repeating the same
imagery, later people either reversed the characters or re-
versed the writing (and reading) sequence. In fact, these
three methods are the *only* possible ways to "reverse" a
text. The Liang tried them all.

"Binary" Imagery and the Birth of Pictorial Space

The period known as the Northern and Southern Dy-
nasties (386–589; the Liang is one of the Southern Dynas-
ties) is commonly recognized as a turning point in Chinese
art history. Major developments during these two cen-
turies include the construction of enormous Buddhist
cave chapels, the emergence of great painters and callig-
raphers, and a profound change in visual perception and
representation.[29] This last achievement has often been
characterized as the discovery of pictorial space, meaning
that the artist was finally able to turn an opaque canvas
or stone slab into a transparent "window" open to an il-
lusory reality. The assertion is not false, but it often at-
tributes this development to some master artists or views

Fig. 5.17. (a) Inscriptions on the pair of pillars in Prince Xiao Ji's (d. 527) graveyard. Jurong, Jiangsu province. Ink rubbing. (b) English translation.

The spirit road of the late Liang Dynasty Palace Attendant, General of the Central Army, Commander Unequalled in Honor, King Jian of Nankang

late the of road spirit The Palace Dynasty Liang the of General Attendant Commander, Army Central King, Honor in Unequalled Nankang of Jian

it as an independent evolution of pictorial forms. An alternative approach advanced here is that the new visual forms rebelled against traditional ritual art and monumentality. While old types of monuments—mortuary gate, shrine, and sarcophagus—continued, surface patterns—inscriptions and decorations—became independent. Although still ceremonial or didactic in content, an inscription or pictorial scene intrigued the eye and the mind. By transforming a monument into the sheer surface for pictures and writing, these forms allowed people to see things that had never been seen or represented before.

A number of stone funerary structures created at the beginning of the sixth century best demonstrate this transition. Dating from 529 (and thus contemporary with the reversed inscriptions), a small funerary shrine now in Boston's Museum of Fine Arts (Fig. 5.18) shows no major difference in form and structure from a Han shrine established some four centuries earlier (Fig. 4.4).[30] What distinguishes it from a Han ritual building are its engravings, especially those executed on the single stone panel that forms the shrine's rear wall (Figs. 5.19). Here, a faintly delineated architectural framework represents the timber facade of a building, a "frame" enclosing the portraits of three gentlemen. Attired in similar costumes and each accompanied by a female figure, the three men differ from one another mainly in age. The figure to the right is a younger man with a fleshy face and a strong torso; the one to the left is heavily bearded with an angular face and a slender body. Whereas these two figures, both shown in three-quarter view facing outward, appear vigorous and high-spirited, the third figure in the middle is a fragile older man retreating into an inner space. Slightly humpbacked and lowering his head, he concentrates on a lotus flower in his hand. The flower—a symbol of purity and wisdom—originated in Buddhism, which had rapidly spread among Chinese literati by the sixth century. Lost in deep contemplation, this focal figure is about to enter the wooden-framed building, leaving this world and us the viewers behind.

The modern Chinese scholar Huang Minglan has offered an interesting reading of this composition. He suggested that all three images represent Ning Mao, to whom

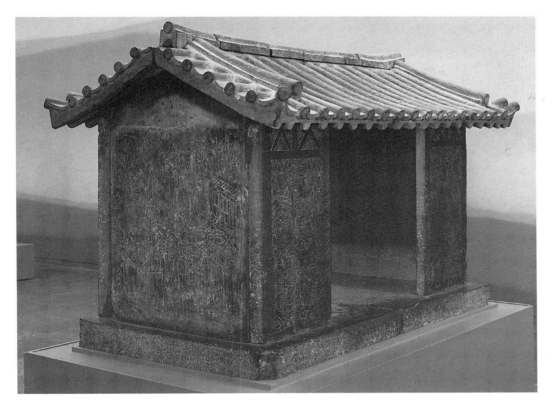

Fig. 5.18. Shrine of Ning Mao (d. 527). Northern Wei dynasty. H. 138 cm. W. 200 cm. From Luoyang, Henan province. Museum of Fine Arts, Boston.

Fig. 5.19. Back wall of Ning Mao's shrine.

Fig. 5.20. Ning Mao's epitaph. Northern Wei dynasty. A.D. 529. W. 41 cm. L. 41 cm. From Luoyang, Henan province. Ink rubbing.

the mortuary shrine was dedicated, and that these images together narrate the stages of Ning's life, from his vigorous youth to his final spiritual enlightenment.[31] Ning Mao's epitaph, which may still exist in China,[32] includes his biography (Fig. 5.20). It mentions three dated events: at the age of 35 (486) he became a clerk at the Ministry of the Imperial Cabinet. A few years later, in 489, he was promoted to general of the Imperial Mausoleum Guards in charge of ritual affairs. After the Northern Wei moved the capital to Luoyang in 494, he assumed the post of chief of the Construction Corps in charge of building new palaces and temples. He was promoted to chief secretary of the Construction Office after the completion of the main palace, but soon fell ill and died in 501.[33] Although the three portraits on Ning's shrine do not necessarily coincide with these specific events, they do show the general contour of his life as described in the epitaph. His positions as ritual specialist and imperial architect must also explain the unusually high quality of the engravings on his memorial shrine. The sentiment conveyed by the portraits—transformation from engagement in worldly affairs to the internal pursuit of spiritual peace—was a favorite intellectual subject during the Northern and Southern Dynasties; Lu Ji and Tao Qian's poems quoted earlier describe similar experiences. But in the pictorial representation, the conflict between life and death, between worldly activities and internal peace, is crystallized in the "front and back" images. Again, we find that lived experience ends at the point where someone turns inward, about to penetrate the solid surface of the stone.

The juxtaposition of "front and back" images became a pictorial formula. In many cases this composition no longer possessed a specific ritual or philosophical implication, but was used as a standard device to increase the complexity of representation. Figure 5.21 reproduces the engravings on a famous Northern Wei sarcophagus now in the collection of the Nelson Gallery–Atkins Museum in Kansas City.[34] On the two long sides of the stone box, stories of filial paragons are delineated in a landscape setting. Compared with Han depictions of similar subjects (Figs. 4.16–26), these pictures signify many new developments, most noticeably, a new sequential narrative mode

and a three-dimensional landscape setting. Framed by a patterned band, each composition seems a translucent "window" onto an elusive world.

The strong sense of three-dimensionality in these pictures has enticed scholars to interpret them in light of some standard criteria in a linear perspective system, such as overlapping forms and the technique of foreshortening.[35] In such an analysis the researcher, either consciously or unconsciously, equates the Chinese example with post-Renaissance painting that employs linear perspective as the most powerful means to create pictorial illusions. But if we examine the pictures on the sarcophagus more carefully, we find some peculiar features that do not agree with the basic principles and purposes of linear perspective but fit perfectly well with the "binary" or "front-and-back" representational mode developed in fifth- and sixth-century China. In simplest terms, the single station-point assumption of linear perspective is that the artist's and viewer's gaze travels from a chosen vantage point to a fixed vanishing point (Fig. 5.22).[36] The "binary" mode, however, is based on the assumption that a form should be seen from both the front and the back; when a form is represented as such, it guides the viewer's gaze back and forth but never toward a real or implied vanishing point in the picture (Fig. 5.23).

A detail on the Nelson sarcophagus (Fig. 5.24) depicts the story of the famous Confucian paragon Wang Lin, who saved his brother from bandits. A tall tree in the middle divides the scene into two halves. Alexander Soper has boldly suggested that the images in both halves actually represent a single episode—the confrontation of Wang Lin and the bandits; the difference between the two scenes is that one is depicted from the front and the other from the rear.[37] It seems to me that in making this assertion Soper has gone too far. In the left-hand scene a rope is tied around Wang Lin's brother's neck, and Wang Lin has thrown himself on his knees in front of the bandits, begging them to take him instead of his brother. In the right-hand scene, both Wang Lin and his brother have been released. These two scenes, therefore, represent two consecutive episodes of the story in a temporal sequence.

This iconographic explanation, however, does not rule out Soper's basic observation regarding the different views of the two scenes. What is most important here is not which episode or episodes the picture stands for (since similar stories had been abundantly illustrated from the Han), but how these episodes are depicted and viewed. In the left scene we find that the bandits have just emerged from a deep valley and are meeting Wang Lin. (In a more general sense, they meet us the viewers.) In the next scene, Wang Lin and his brother are leading the bandits into another valley and the whole procession has turned away from us; all we can see are people's backs and the rear end of a horse. This composition once again reminds us of the reversed inscriptions, one confronting us and the other showing us its "back." But here our vision is controlled by the figures' motion. In viewing the left "frontal" scene our eyes take in the arriving figures, but when we turn to the next scene we cannot help but feel that we are abruptly and, in a way, very rudely abandoned and ignored. The figures are leaving us and about to vanish, and in an effort to catch them our gaze follows them into the deep valley.

This binary mode allows us to discover the compositional formula of another famous example of Northern and Southern Dynasties art: the celebrated handscroll "The Admonition of the Instructress to Palace Ladies" ("Nüshizhen tu") attributed to the master painter Gu Kaizhi (ca. 345–406).[38] This attribution is not secure: there is no pre-Tang reference for Gu's depiction of the subject; yet a newly discovered fifth-century screen bears a picture (Fig. 5.25a) almost identical in composition to one of the seven scenes on the "Admonition" scroll (Fig. 5.25b). Provided with this piece of evidence, we can view the scroll and the Nelson sarcophagus as approximately contemporary works. Not surprisingly, one of the most interesting features of the scroll is the binary composition, which, however, has been even further removed from its original ritual context to become a purely pictorial mode.

The painting illustrates the third-century poet Zhang Hua's composition of the same title. One of the scenes (Fig. 5.26) depicting Zhang's line—"Human beings know how to adorn their faces"—demonstrates an extremely

Fig. 5.21. (a, b) The two
long sides of a stone sar-
cophagus. Northern Wei
dynasty. Ca. A.D. 525.
H. 64 cm. L. 225 cm.
From Luoyang, Henan
province. Nelson-Atkins
Museum of Art, Kansas
City, Missouri.

a

b

267

Fig. 5.22. Diagram:
single-station perspective

Fig. 5.23. Diagram:
binary composition

his mother (Fig. 4.38). In viewing these pictures our eyes travel along the surface of stone slabs, whose striped patterns only make the medium even more impenetrable. Even pictures created during the fourth century do not substantially alter this traditional representational mode. It is true that the well-known portraits of the "Seven Worthies in the Bamboo Grove" ("Zhulin qixian") exhibit some new elements: more relaxed and varying poses, "spatial cells" formed by landscape elements, and an emphasis on fluent lines (Fig. 5.28). But the images are still largely attached to the two-dimensional picture surface, never guiding our eyes to penetrate it. The real revolution took place only in the fifth and sixth centuries: the figures in the Wang Lin picture seem to be coming and going of their own free will, and the ladies in the "Admonition" scroll stare at their own reflections and their gaze guides us to see them. In both cases our vision follows the pictured figures in and out, effortlessly crossing the transparent stone or canvas.

All these pictorial works—the engravings on the Ning Mao shrine and the Nelson sarcophagus, and the painted images on the "Admonition" scroll—testify to a desire to see things that had never been seen or represented before. The new points of view pursued by the artists, however, were not actual (or assumed) station points on earth. The mundane achievement of seeing and representing things "naturalistically" could hardly fulfill the artists' high aspirations, for art, they claimed, should allow them to transcend observed reality with its temporal and spatial boundaries. The relationship between "seeing" and "imagining," or between eyes and the mind, became a central topic of art criticism at the time. Sometimes the relationship was considered antithetical. Wang Wei (415–43), for example, criticized painters who relied only on their physical faculties and "focused on nothing but appearances and positioning." When a good artist painted, he told his contemporaries, "it is not in order to record the boundaries of cities or to distinguish the locale of prefectures, to mark off mountains and hills or to demarcate floods and streams. For things which are rooted in form must be smelted with spiritual force, and that which activates the

sophisticated use of the binary composition. The scene is divided into two halves, each with an elegant palace lady looking at herself in a mirror. The lady on the right turns inward with her back toward us, and we see her face only in the mirror. The lady on the left faces us; her reflection in the mirror becomes implicit (only the mirror's patterned back is visible). The concept of a "mirror-image" is thus presented literally (Fig. 5.27): each group is itself a pair of mirror-images, and the two groups together again form a reflecting double. We may also imagine that this composition may be viewed from "both sides" of the scroll: an invisible viewer at the other side of the canvas would find the same picture as we do, but the images he sees would be reversed ones.

No picture like this existed before the Northern and Southern Dynasties. What we find on Han monuments are silhouette images "attached" to the pictorial plane: the virtuous widow Liang holding a mirror in her hand (Fig. 4.21) or the filial paragon Zengzi kneeling before

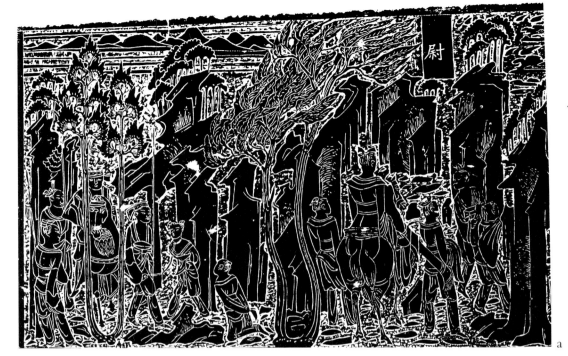

a

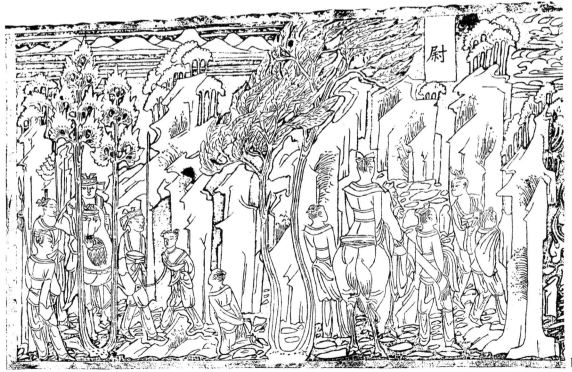

b

Fig. 5.24. Story of Wang Lin. Carving on the Northern Wei sarcophagus in Nelson-Atkins Museum of Art, Kansas City, Missouri, detail. (a) Photograph. (b) Negative on ink rubbing showing line engravings.

Fig. 5.25. Story of Ban Jieyu. (a) A scene on the Sima Jinlong screen from Datong, Shanxi province. Northern Wei dynasty. Before A.D. 484. Datong Museum. (b) A scene from the "Admonition of the Instructress to Palace Ladies." Scroll painting. Ink and color on silk. Attributed to Gu Kaizhi, but probably a Tang dynasty copy of a post-Han painting. British Museum.

permutation is the heart-mind."[39] His view may have represented an extreme; other critics such as Xie He (fl. 500–535) considered both "physical likeness" (*yinwu xiangxing*) and "spirit resonance" (*qiyun shengdong*) necessary qualities of good art; nevertheless he placed the latter at the top of his "Six Laws" of painting.[40]

Simultaneously there appeared the notion of an ideal painter who could realize the artistic goals the new age demanded, and whose unrestrained imagination would make him an immortal:

> He moves along with the four seasons and sighs at
> their passing on,
> Peers on all the things of the world, broods on their
> profusion.
> .
> Thus it begins: retraction of vision, reversion of
> listening,
> Absorbed in thought, seeking all around,
> [His] essence galloping to the world's eight bounds,
> [His] mind roaming ten thousand yards, up and
> down.
> .
> He empties the limpid mind, fixes his thoughts,
> Fuses all his concerns together and makes words.
> He cages Heaven and Earth in fixed shape,
> Crushes all things beneath the brush's tip.
> At first it hesitates on his dry lips,
> But finally flows freely through the moist pen.[41]

Such description was not considered purely metaphorical; when Xie He came to rank painters based on artistic merit (thus giving himself the status of an authoritative viewer), he employed similar criteria and found his ideal artist in Lu Tanwei of the fifth century:

> He fathomed the principles [of the universe] and exhausted the nature [of man]. The matter is beyond the power of speech to describe. He embraced what went before him and gave birth to what succeeded him: from ancient times up till now he stands alone. Nor is he one whom even [the most] fervent enthusiasm could [adequately] praise. For is he not simply the pinnacle of all that is of highest value? He rises beyond the highest grade, and that is all that there is to be said.[42]

Fig. 5.26. Palace ladies. A scene from the "Admonition of the Instructress to Palace Ladies" (see Fig. 5.25).

Fig. 5.27. Diagram: compositional scheme of Fig. 5.25

a ——————— a' a' ——————— a

a ——————— a'

a

b

Fig. 5.28. "Seven Sages and Rong Qiqi." Brick relief. Western Jin dynasty. Late 4th–early 5th century A.D. H. 80 cm. L. 240 cm. Excavated in 1960 at Xishanqiao, Nanjing, Jiangsu province. Nanjing Museum. Ink rubbing.

Fig. 5.29. (a, b) The two long sides of a stone sarcophagus. Northern Wei dynasty. A.D. 524. From Luoyang, Henan province. Minneapolis Institute of Arts. Ink rubbing.

a

b

273

Xie He seems to have felt short of words. Of an artist who has fathomed the universe and exhausted human nature, there is indeed nothing one can say except to acknowledge his god-like existence. Such glorification gives us little sense of the actual masterpieces from that period (which have all long since disappeared), but the pictures on another sixth-century stone sarcophagus (created when Xie was compiling his classification of painters) may allow us to perceive the kind of art he had in mind. Like the Nelson sarcophagus, this example in the Minneapolis Institute of Art was unearthed at Luoyang, the capital of the Northern Wei after 494 (Fig. 5.29).[43] Again like the Nelson sarcophagus, both long sides of the sarcophagus are covered with a rich combination of pictorial and decorative images. At the bottom of each rectangular composition, a rolling hillock establishes a continuous foreground and further extends into the depths along the picture's vertical sides. Tall trees further divide this U-shaped picture frame into a number of subframes or "space cells" for depicting individual stories of famous filial paragons. Scholars have been astonished by the "naturalism" of these narrative scenes: well-proportioned figures—a series of famous filial sons from China's past—sit or kneel on a tilted ground or on platforms that recede into the depths (Fig. 5.30a). Behind them are a mountain range and floating clouds, whose greatly reduced size indicates their remoteness.

This coherent spatial representation serves symbolic purposes, however. It groups historical figures of different times and places into a synchronic setting; the rationale of this synthesis is that all these figures share the same virtue and their lives show a similar contour. The naturalism of the illustrations thus diminishes any vestige of historical reality. The figures belong neither to the past nor to the present; rather, they represent timeless Confucian paragons, who are again abstractions of history and human deeds. This may be why these virtuous men are positioned in the lower half of the pictures: they are still earth-bound, and so the naturalism of their portrayal attests to the trueness of the human principles they embody.

The historical Confucian figures, as well as the realistic pictorial style associated with them, disappear from the

upper half of the composition, where we find fantastic and possibly Daoist images (Fig. 5.30b): an enormous dragon juxtaposed with a huge phoenix, beautiful fairies riding on clouds or exotic birds, fierce demons roaring against the wind. The decoration on the Minneapolis sarcophagus thus combines images of historical figures like those on the Kansas City sarcophagus with motifs of immortality— fairies and fantastic animals and birds—that embellish two other sarcophagi unearthed at Luoyang (Fig. 5.31).[44] This sarcophagus thus exhibits binary pictorial styles and spatial concepts. Instead of being united by a three-dimensional landscape, these images are harmonized by the swelling, rhythmic lines that shape them. We may say that these fluent lines are themselves a metaphor of the vital energy of the universe,[45] from which all these images of the imagination—heavenly flowers, auspicious birds, mystical beasts, fairies, and demons—emerge. Floating and everchanging, these line images seem to shift smoothly on the two-dimensional picture plane without penetrating it.

The design is further complicated by a focal image crossing the upper and lower halves—an animal mask with a ring hanging from its mouth (Fig. 5.30c). The model for this image is a sculptured mask made of gilded copper attached to a wooden coffin. Here it has been transformed into a flat silhouette on stone. A new layer of visual rhetoric is added: integrated into the overall two-dimensional pictorial representation, the mask seems suspended in air in front of the surrounding scenes, which recede and vanish behind it. Firm and unyielding, the mask reminds us of the stone surface and forces us to pull our gaze (and mind) back from the distant and fantastic worlds, reasserting our own proximity to the solid sarcophagus. This image restores the surface of the picture plane but only to allow the artist to decompose and recompose it again. On either side of the mask, two windows, perfectly square, guide our gaze "into" the sarcophagus. Two figures stand inside each window and stare at us.[46] These windows, which allow us to see what is concealed *behind* the pictorial surface, thus reject any coherent system of pictorial illusion and any fixed spatial or temporal station.[47]

Viewing such a complex picture that integrates so many contradictory elements, we feel that the artist is constantly

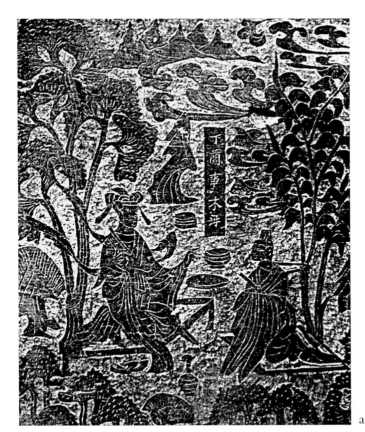

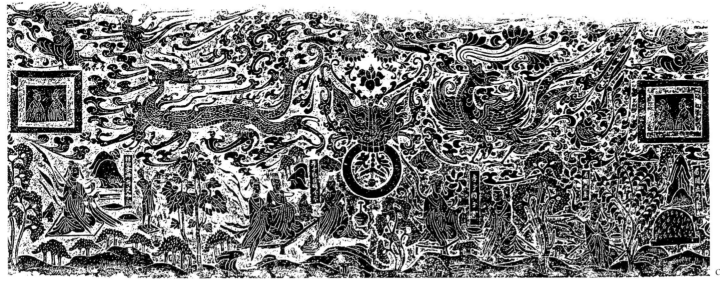

Fig. 5.30. (a–c) Details of the stone sarcophagus in the Minneapolis Institute of Arts. Ink rubbing.

challenging us with new modes of pictorial representa-
tion. Traveling through time and space, he leads us to
confront different realms and states of beings—to "gallop
to the world's eight bounds" and to "peer on all the things
of the world, brood on their profusion." He creates and
recreates tension between different images and between
these images and the medium: whenever a scene is about
to assume its independence and become "real," he brings
in a conflicting image or style that dismisses any sense
of illusionism and restocks the pictorial surface with new
possibilities to further expand the visual field. Thus we
find that the picture seems to ceaselessly rebel against it-
self—"reversing" itself and then balancing itself. The illu-
sionist narrative-landscape scene is juxtaposed with the
elusive, decorative immortal imagery; the "relief" animal
mask is juxtaposed with the "sunken" windows. The first
set of motifs transforms the pictorial surface into images
and thus erases it; the second set restores the surface be-
cause the mask must be attached to it and the windows
must be opened on it.[48] The structural key to understand-
ing the creation of such a composition, therefore, is again
the binary mode: the artist develops his imagery along
opposite yet complementary paths. In making such an
effort he breaks away from conventional representation
and pushes the possibility of human perception to a new
limit.

Epilogue: The Gate

When Wang Ziya, the governor of Shu, died in the sec-
ond century A.D., he left abundant wealth, three daughters,
but no son. Longing for their father and thinking about
his burial, the three daughters said to one another:

> Now the spirit of our lord should dwell peacefully in
> an underground home where he would accompany the
> divine Master of Earth. But we do not have a brother to
> succeed him and make his virtue renowned. Let's take
> over a son's duty, each contributing five million cash. One
> of us will build his tomb and the other two will erect a
> *que* pillar-gate. In this way we may express our filial piety
> and longing.

Three centuries later, the famous geographer Li Dao-
yuan traveled to Wang Ziya's hometown of Xi'e in present-
day Henan. He found two stone towers standing side by
side, forming the entrance to an abandoned burial site.
About eighteen *chi* high and five *chi* wide, the pillars were
made of jade-like green stone, polished as smooth and
shiny as a mirror. Imitating a wooden-framed tower, each
pillar was exquisitely carved to represent a tiled roof, sup-
ported by complex brackets and sloping down on four
sides. The late governor's name and official title were
engraved on the pillars, followed by an inscription de-
scribing his daughters' filial devotion. Li Daoyuan recorded

this group of funerary monuments in his *Annotated Canon of Waterways* as a landmark that documented the region's bygone history.[49]

The Wang Ziya que have long since disappeared, but Li Daoyuan's record of its construction attests to the radically different concept of monumentality that separated a second-century gate from those established before and after the Han. A gate of the Three Dynasties, as discussed earlier in this book, was always an integral element of a larger architectural complex; it was never an independent "monument" like the Han example. Gates were absent in graveyards, and a series of gates along a temple's central axis created suspense and made the compound deep and inexhaustible. A free-standing earthen screen further blocked the temple's main entrance, concealing both the gates and the temple vessels behind it (Fig. 2.7). The "public" of this closed monumental complex were strictly insiders—the members of the clan or lineage to whom the temple and all its paraphernalia belonged. Only they could walk through the gates in ritual processions, and only they had access to the sacred vessels, which consolidated their social privilege, strengthened their mutual blood ties, and refreshed their shared memory of history. Underlying the whole architectural and ritual program was the notion that power resulted from secrecy.

Changes took place during the late Zhou, when ambitious feudal lords were struggling for independence, and new political groups emerged and demanded a share of power. The old ritual system collapsed—at least on the surface—when an iron tripod bearing legal codes was displayed in a public space. The implication of this event, that power had to openly exhibit and demonstrate itself, was best signified by the transformation of the gate. Official documents began to be posted on the front gate of the palace. Both the gate and the documents were called *xiangwei*, meaning "legal codes" (*xiang*) and "loftiness" (*wei*).[50] The gate was then detached from its original architectural context to become a self-contained "monument" (Fig. 2.22). Almost graphically, this transformation symbolized the changing notion of political power—from keeping it secret to exhibiting it publicly. Some writers claimed that only the Son of Heaven could enjoy a *que* gate with

a pair of flanking *guan* towers.[51] Others considered the height of the *guan* towers as well as the number of their "wings" measures of social privilege.[52] Gates not only dominated the facade of the palace but also marked the entrance to a mausoleum.[53] Ban Gu later summarized the new symbolism of the gate in the *Proceedings from the White Tiger Hall* (*Baihu tong*): "Why must a gate have [flanking] towers? This is because the towers 'embellish' a gate and distinguish the superior from the inferior."[54]

Ban Gu's words indicate the conceptual transformation of a gate. The original definition of a *que*, or a gate, was simply "a gap"—the empty space framed by some architectural forms.[55] This understanding corresponded to the archaic architectural program in which a gate provided an entrance into an enclosed space. The new social and political significance of an Eastern Zhou gate, however, had to be conveyed by the flanking *guan* towers, whose concrete shape and height could symbolize social status. A new definition was then coined to equate a gate with its towers; as the *Er ya* dictionary stated plainly: "*Guan* means a *que* gate."[56] Interestingly, the meaning of the word *guan* was "to look," which implied two alternative explanations of a tower. Standing in front of a palace, a gate's multistoried towers invited its owner to climb onto them and look out; a *guan* thus raised the viewpoint—it empowered a lord who could now "overlook" his kingdom and subjects.[57] But as a concrete symbol of authority, a *guan* was also an object of "looking"—its imposing appearance and intricate design inspired public awe.[58] When this wooden-framed tower was duplicated in stone in a Han cemetery, it lost its practical function and became a solid, sculptured pillar. It retained only the second significance of a *guan*, and here we return to the Wang Ziya que.

This gate obviously had an overwhelming importance for its patrons: Wang's daughters used most of their savings (ten million cash!) to build it, spending only half as much on their father's tomb, and nothing at all on other ritual buildings and sculptures. It seemed that the gate alone could make their virtue renowned. (Being an aboveground structure, the gate was a public monument; the underground tomb was the private domain of the deceased.) By imitating a timber structure in stone, the gate signified

the contemporary interest in the transformation from this life to the eternal afterlife. Its inscription, which followed the Eastern Zhou precedent of posting documents on a palace gate, best demonstrated the gate's social significance. Although the text must have begun with the name and official title of the dead father, its central theme was the daughters' filial devotion. Its content identifies it as a kind of "autobiographical" writing[59]—the daughters intimately describe their anxiety and fear, their conversation and decision. Exposed to travelers and local townsmen, both the gate and the inscription displayed the patrons' urgent desire for publicity: through images and words their reputation would spread far and wide.

About fifteen pillar gates surviving from the Eastern Han are examples of this type of monument (Fig. 4.2).[60] These are all sculptured, free-standing stone structures. In fact, one can hardly call them "gates"—without attached walls they retain only a symbolic function. Some of the pillars bear long inscriptions resembling the Wang Ziya eulogy.[61] Many have surface engravings (Fig. 4.13): galloping horses and official chariots, Confucius meeting the boy-genius Xiang Tuo, a host honoring his guests, a superior receiving his subordinates. The social and moral implications of these pictures accord with those of the pillar-gates; their forms—low reliefs in parallel registers—reinforce the gates' three-dimensionality and solidity.

Only in comparison with these Han examples do the Liang dynasty pillar gates show their true revolutionary nature (Fig. 5.32). The Liang works are not simply "forms that developed from Han gates," as some scholars have claimed. What they signify is a historical challenge to the traditional concept of monumentality. Instead of imitating timber towers in the Chinese palace, these pillars derived their form from foreign Buddhist architecture (Fig. 5.33). Both the strategy and reference of the visual rhetoric have changed: a funerary gate no longer related itself to a counter-image in the living world and derived its meaning from this opposition; rather, it directly expressed the idea of transcendence and enlightenment. Confucian motifs and genre scenes no longer decorate the gate—fantastic creatures soaring in the sky have replaced these favorite Han themes (Fig. 5.34). Most im-

portant, the mirror inscriptions on the gate (Fig. 5.5) completely alter the relationship between a monument and its audience: instead of presenting readable texts confirming the shared values of filial piety, they "reverse" the conventional way of writing and challenge the viewer's perception, forcing him to reinterpret a funerary monument and to view it with fresh eyes. These engraved inscriptions have become independent of their bearers, and their independence destroys the sense of the monument's durability. The strange style of writing, invented by master calligraphers such as Kong Jingtong, is not aimed at the common reader but appeals to individuals like Tao Qian, whose refined mind would detect the subtle irony implied in the metamorphosis of words and images.

Fig. 5.32. Stone pillar in the graveyard of Prince Xiao Jing (d. 523). Liang dynasty. Nanjing, Jiangsu province.

The Transparent Stone

As I have shown, this rebellion against traditional monumental art was part of an effort to redefine art and artistic creation during the Northern and Southern Dynasties. This crucial period literally divides the course of Chinese art into two broad phases. The mainstream of earlier Chinese art from Neolithic times to the end of the Han can be characterized as a "ritual art tradition," in which political and religious concepts were transformed into material symbols. In this tradition, forms that we now call works of art were integral parts of larger monumental complexes such as temples and tombs, and their creators were anonymous craftsmen whose individual creativity was generally subordinated to larger cultural conventions. From the third and fourth centuries on, however, there appeared a

Fig. 5.33. Lion column. 243 B.C. Lauriyā Nandangarh, India.

Fig. 5.34. above *Fantastic beasts. Carvings on the side of the memorial stela of Prince Xiao Hong (d. 526). Liang dynasty. Nanjing, Jiangsu province. Ink rubbing.*

Fig. 5.35. left *Calligraphy by Wang Ci (451–91). Ink on paper. Qi dynasty. Liaoning Provincial Museum.*

group of individuals—scholar-artists and art critics—who began to forge their own history. Although the construction of religious and political monuments never stopped, these men of letters attempted to transform public art into their private possessions, either physically, artistically, or spiritually. They developed a strong sentiment toward ruins, accumulated collections of antiques, placed miniature monuments in their houses and gardens, and "refined" common calligraphy and painting idioms into individual styles. All the people mentioned by name in this chapter—Lu Ji, Tao Qian, Yu Yuanwei, Kong Jingtong, and Gu Kaizhi—belonged to this group. Their work, both literary and artistic, reflected their concern with abstract artistic elements—structure, brush line, and point of view—rather than with the general ritual function and symbolism of traditional public monumental art.

What the reversed inscriptions symbolize, therefore, is a liminal point in Chinese art history. Although such a radical reversal of conventions might temporarily destroy traditional concepts of monumentality, it was not necessarily the last word. Recall that Kong Jingtong, said to be the inventor of "left-and-right writing," was also a master of cursive calligraphy: "His brush stroke, which broke only at the end of a line, was fluent, graceful, and restrained, and reflected his distinctive nature." Significantly, although both his calligraphic styles emphasize the form of calligraphy over the content of writing, only the cursive style survived and developed into a brilliant artistic genre (Fig. 5.35). His "negative" mirror writing soon died out. Similarly, although new pictorial images first appeared on shrines, gates, and sarcophagi, the ambitious scholar-artist could never conquer the territory of ritual art. He finally retreated and found more private media—the scroll and album—while continuing to interact with new forms of "popular" religious and political monuments.

REFERENCE MATTER

Illustration Credits

Fig. I.2. Oldenburg 1969: pl. 48.

Fig. I.3. *Qingtongqi, yi*, pl. 135.

Fig. I.4. "Shi suo," 4.22.

Fig. I.5. *Huaxiangshi huaxiangzhuan*, pl. 70.

Fig. I.6. Rawson 1987: fig. 17; courtesy of the Trustees of the British Museum.

Fig. I.7. Chavannes 1913: vol. 2, no. 121.

Fig. 1.1. Tokyo National Museum 1986: pl. 23.

Fig. 1.2. Seibu Museum 1986: pl. 20.

Fig. 1.3. Shandong Provincial Cultural Relics Administration and Ji'nan City Museum 1974: pls. 12, 17.4.

Fig. 1.4. Seibu Museum 1986: pl. 8.

Fig. 1.5. Ibid., pl. 12.

Fig. 1.6. *Guyu tukao*, 55b–56a.

Fig. 1.7. *Kaogu* 1984.2: color pl. 2.

Fig. 1.8. *Wenwu* 1988.1: color pl. 2.2; p. 33, fig. 1.

Fig. 1.10. (a–c): Zhejiang Provincial Institute of Archaeology 1989: pls. 156, 123, 221; (d): Childs-Johnson 1988: fig. 19.

Fig. 1.11. (a) *Taoci, yi*, pl. 38. (b) *Kaogu xuebao* 1978.1: 64.

Fig. 1.12. Zhejiang Provincial Institute of Archaeology 1989: pl. 164.

Fig. 1.13. Zhejiang Provincial Institute of Archaeology 1989: pls. 24, 25.

Fig. 1.14. Han Wei 1986: fig. 1.

Fig. 1.15. Zhejiang Provincial Institute of Archaeology 1989: pl. 44.

Fig. 1.16. Ibid., pl. 58.

Fig. 1.17. Ibid., pls. 237, 238.

Fig. 1.18. Ibid., pls. 6, 7.

Fig. 1.19. Ibid., pl. 71.

Fig. 1.20. Murray 1983: fig. 4.

Fig. 1.21. *Taoci, yi*, pl. 45.

Fig. 1.22. (a–c) Shandong Provincial Cultural Relics Administration and Ji'nan City Museum 1974: figs. 94.1, 2, 5; (d–f) Li Xueqin 1987: figs. 3–5.

Fig. 1.23. Murray 1983: figs. 6, 7.

Fig. 1.24. *Zhongguo yuqi quanji, yi*, pl. 190.

Fig. 1.25. Ibid., pls. 191, 192.

Fig. 1.26. Deng Shuping 1993: figs. 11.1b–2a.

Fig. 1.27. *Zhongguo yuqi quanji, yi*, pl. 231.

Fig. 1.28. Deng Shuping 1993: fig. 2.1.

Fig. 1.29. Based on ibid., table 2.

Fig. 1.31. (a) *Taoci, yi*, pl. 51; (b) *Zhonghua renmin gongheguo chutu wenwu zhanlan zhanpin xuanji*, pl. 22.

Fig. 1.32. Photograph by the author.

Fig. 1.33. *Zhongguo yuqi quanji*, pl. 18.

Fig. 1.34. (a) *Qingtongqi, yi*, pl. 2; (b) *Kaogu* 1978.4: 270, fig. 1.2.

Fig. 1.35. (a) *Yuqi*, pl. 49; (b) *Kaogu* 1976.4: 262.

Fig. 1.36. Based on W. Fong 1980: fig. 1.

Fig. 1.37. *Qingtongqi, yi*, pl. 6.

Fig. 1.38. K. C. Chang, *The Archaeology of Ancient China*, 4th ed. (Yale University Press, 1986), fig. 286, © Yale University Press, 1986; reprinted by permission.

Fig. 1.39. (a) Bagley 1987: fig. 59—courtesy of the Royal Ontario Museum, Toronto, Canada; (b) *Shanghai hakubutsukan shutsudo bumbutsu seidōki tōjiki*, pl. 28.

Fig. 1.40. *Qingtongqi, yi*, pl. 20.

Fig. 1.41. Guo Baojun 1956: pls. 13.6, 14.1–4; fig. 37.

Fig. 1.42. Henan Provincial Institute of Cultural Relics and Zhengzhou Museum 1983: fig. 4.

Fig. 1.43. Ibid., figs. 18, 19.

Fig. 1.44. Ibid., figs. 12–15.

Fig. 1.45. *Yinxu qingtongqi*, pl. 22.

Fig. 1.46. *Qingtongqi, yi*, pl. 111.

Fig. 1.47. Photograph courtesy of The Arthur M. Sackler Museum, Harvard University Art Museums, bequest of Grenville L. Winthrop.

Fig. 1.48. National Palace Museum 1989: pl. 26.

Fig. 1.49. *Zhonghua renmin gongheguo chutu wenwu zhanlan zhanpin xuanji*, pl. 28.

Fig. 1.50. Institute of Archaeology, CASS 1980: figs. 38.4, 25.2, 27.1.

Fig. 1.51. *Henan chutu Shang Zhou qingtongqi*, pl. 377.

Fig. 1.52. Umehara 1947: 1.18.

Fig. 1.53. Bagley 1987: fig. 10.1; courtesy of The Saint Louis Art Museum.

Fig. 1.54. *Henan chutu Shang Zhou qingtongqi*, pl. 321.

Fig. 1.55. Bagley 1987: fig. 103.12.

Fig. 1.56. Ibid., fig. 103.11.

Fig. 1.57. W. Fong 1980: pl. 61, fig. 41.

Fig. 1.58. *Xuanhe bogu tulu*, 9.31.

Fig. 1.59. Pope et al. 1967: pl. 16.

Fig. 1.60. Ibid., pl. 49.

Fig. 1.61. Courtesy of Asian Art Museum of San Francisco, The Avery Brundage Collection (B60 B1032).

Fig. 1.62. Museum of Fine Arts, Boston, Anna Mitchell Richards Fund—photograph courtesy of the Museum of Fine Arts, Boston.

Fig. 1.63. *Qingtonqi, yi*, pl. 153.

Fig. 1.64. W. Fong 1980: pl. 53, fig. 60.

Fig. 1.65. Photograph courtesy of the Harvard University Art Museums.

Fig. 1.66. Rong Geng and Zhang Weichi 1959: figs. 38, 55, 56, 87.

Fig. 1.67. *Gugong tongqi xuancui*, pl. 10, fig. 10.

Fig. 1.68. (a) *Qingtongqi, yi*, pl. 130; (b) Seibu Museum 1986: pl. 40.

Fig. 1.69. Guo Baojun 1963: pl. 2.2.

Fig. 1.70. Jiangxi Provincial Institute of Archaeology and Jiangxi Xin'gan Museum 1991: fig. 9.

Fig. 1.71. Photograph courtesy of The Arthur M. Sackler Museum, Harvard University Art Museums, bequest of Grenville L. Winthrop.

Fig. 1.72. *Sandai jijin wencun*, 20.49, 50.

Fig. 1.73. Li Xueqin 1984: figs. 147, 156.

Fig. 1.74. Li Ji 1990: fig. 13.

Fig. 1.75. Photograph courtesy of Freer Gallery of Art.

Fig. 1.76. *Qingtongqi, yi*, pl. 26.

Fig. 1.77. Pope et al. 1967: pl. 106, fig. 53b.

Fig. 1.78. *Qingtongqi, er*, pl. 76.

Fig. 1.79. Palace Museum 1959: pls. 6a–b.

Fig. 1.80. *Qingtongqi, er*, pls. 103, 154.

Fig. 2.2 *Gongshi kao*, as quoted in K. C. Chang 1983: fig. 17.

Fig. 2.3. J. H. An 1986: fig. 9.

Fig. 2.4. Li Xueqin, *Eastern Zhou and Qin Civilization* (Yale University Press, 1985), fig. 62, © Yale University Press 1985; reprinted by permission.

Fig. 2.5. (a, b) *Kaogu* 1974.4: 235; (c) Chinese Academy of Architecture 1982: 24.

Fig. 2.6. *Kaogong ji tu*, 113.

Fig. 2.7. (a) Steinhardt 1990: fig. 35; (b) *Wenwu* 1981.3: 25.

Fig. 2.8. C. Y. Hsu and K. M. Linduff, *Western Zhou Civilization* (Yale University Press, 1988), tables 5.1, 5.2, © Yale University Press, 1988; reprinted by permission.

Fig. 2.9. Based on *Kaogu xuebao*, 1956.1: 110.

Fig. 2.10. (a) W. Fong 1980: fig. 78; (b) Rawson 1987: fig. 12; courtesy of the Trustees of the British Museum.

Fig. 2.11. *Shaanxi chutu Shang Zhou qingtongqi*, fig. 15.

Fig. 2.12. Ibid., fig. 24.

Fig. 2.13. Ibid., fig. 27.

Fig. 2.14. Ibid., fig. 29.

Fig. 2.15. Ibid., fig. 31.

Fig. 2.16. Ibid., fig. 54.

Fig. 2.17. Ibid., fig. 59.

Fig. 2.18. (a) Chinese Academy of Architecture 1982: 31; (c) *Qingtongqi, er*, pl. 112; (b) Li Xueqin, *Eastern Zhou and Qin Civilization* (Yale University Press, 1985), fig. 48, © Yale University Press, 1985; reprinted by permission.

Fig. 2.19. Li Xueqin, *Eastern Zhou and Qin Civilization* (Yale University Press, 1985), fig. 55, © Yale University Press, 1985; reprinted by permission.

Fig. 2.20. *Yongle dadian*, 9591.

Fig. 2.21. *Qingtongqi, er*, pl. 112.

Fig. 2.22. (a) Yang Hongxun 1976*b*: fig. 6; (b) Chinese Academy of Architecture 1982: 33.

Fig. 2.23. *Taoci, yi*, pls. 126, 127.

Fig. 2.24. *Yuanshi shehui zhi Nanbeichao huihua*, pls. 47, 48.

Fig. 2.25. Chinese Academy of Architecture 1982: 30.

Fig. 2.26. (a) Institute of Archaeology, CASS 1980: fig. 2; (b) photograph courtesy of David Joel Cohen.

Fig. 2.27. Institute of Archaeology, CASS 1984: fig. 61.

Fig. 2.28. (a) Yang Hongxun 1980: fig. 5; (b) *Qingtongqi, er*, pl. 111.

Fig. 2.29. Fu Xinian 1980: 110.

Fig. 2.30. Segalen 1914–17: vol. 1, pl. 1.

Fig. 2.31. Thorp 1983*a*: fig. 1.

Fig. 2.32. Courtesy of the Museum of the Qin Terra-cotta Army.

Fig. 2.33. Guo Baojun 1956: fig. 118.

Fig. 2.34. *Kaogu xuebao* 1964.10: 110.

Fig. 2.35. Fairbank 1942: fig. 15.

Fig. 2.36. *Yuanshi shehui zhi Nanbeichao huihua*, pl. 42.

Fig. 2.37. Tokyo National Museum 1986: fig. 29.

Fig. 2.38. *Yuanshi shehui zhi Nanbeichao huihua*, pl. 40.3.

Fig. 2.39. (a, b) *Qingtongqi, er*, pls. 209, 210; (c) *Taoci, yi*, pl. 153.

Fig. 2.40. *Zhonghua renmin gongheguo chutu wenwu zhanlan zhanpin xuanji*, fig. 85.

Fig. 2.41. Rowland 1967: figs. 192c, d.

Fig. 2.42. (a) Segalen 1914–17: vol. 1, pl. 2; (b) *Qin Han diaosuo*, pl. 36.

Fig. 2.43. Y. D. Li 1990: fig. 1.

Fig. 2.44. (a) Based on Institute of Archaeology, CASS, and Hebei Provincial Cultural Relics Administration 1980: fig. 4; (b) W. Fong 1980: fig. 112.

Fig. 2.45. Institute of Archaeology, CASS, and Hebei Provincial Cultural Relics Administration 1980: pl. 3.

Fig. 2.46. Ibid., figs. 112, 141.

Fig. 2.47. (a) Ibid., fig. 6; (b) Rowland 1967: fig. 6.

Fig. 2.48. (a) Segalen et al. 1914–17: vol. 1, pl. 64; (b) Rudolph 1951: fig. a.

Fig. 2.49. Chavannes 1913: vol. 2, no. 116.

Fig. 2.50. Cunningham 1879: pl. 31.

Fig. 2.51. Shandong Provincial Museum and Shandong Cultural Relics and Archaeology Institute 1982: pl. 184.

Fig. 2.52. Inner Mongolia Museum 1978: pl. 118.

Fig. 2.53. Fu Xihua 1950: vol. 1, pl. 113.

Fig. 2.54. Chavannes 1913: vol. 2, no. 81.

Fig. 2.55. (a) Shandong Provincial Museum and Shandong Cultural Relics and Archaeology Institute 1982, pl. 187; (b) *Huaxiangshi, huaxiangzhuan*, pl. 248.

Fig. 2.56. Lippe 1970: pl. 14.

Fig. 2.57. Zeng Zhaoyue et al. 1956: figs. 65–68.

Fig. 2.58. (a) *Lingmu jianzhu*, pl. 14; (b) *Qin Han diaosuo*, pl. 106.

Fig. 2.59. *Wenwu* 1991.3: pl. 1.2; p. 6, fig. 19.

Fig. 2.60. (a) *Qin Han diaosuo*, pl. 127; (b) *Kaogu* 1976.6: pl. 11.6.

Fig. 3.1. *Shuijing zhu tu*, 630–31.

Fig. 3.2. *Guanzhong shengji tukao*, "Xi'an fu," 23b, 24a.

Fig. 3.3. *Chang'an zhi tu*, 1.5.

Fig. 3.4. Wang Zhongshu, *Han Civilization* (Yale University Press, 1982), fig. 30, © Yale University Press, 1982; reprinted by permission.

Fig. 3.5. (a) Photograph courtesy of David Joel Cohen; (b) Bishop 1938: 76.

Fig. 3.6. Wheatley 1971: fig. 26.

Fig. 3.7. Le Jiazao 1977: fig. 102.

Fig. 3.8. Pirazzoli-t'Serstevens 1982: pl. 9.

Fig. 3.9. *Zhongguo wenwu jinghua*, pl. 140.

Fig. 3.10. *Zhonghua renmin gongheguo chutu wenwu zhanlan zhanpin xuanji*, fig. 85.

Fig. 3.11. *Qin Han diaosuo*, pls. 34, 35.

Fig. 3.12. Photograph by the author.

Fig. 3.13. *Qingtongqi, er*, pl. 201.

Fig. 3.14. Gao Wen 1978*a*: pl. 90.

Fig. 3.15. (a) Wang Zhongshu, *Han Civilization* (Yale University Press, 1982), fig. 30, © Yale University Press, 1982; reprinted by permission; (b) Tang Jinyu 1959.

Fig. 3.16. Based on Liu Dunzhen 1980: figs. 30.3, 30.4.

Fig. 3.17. Major 1984: fig. 6.

Fig. 3.18. Chinese Academy of Architecture 1982: 42.

Fig. 3.19. Based on Steinhardt 1984: pl. 3.5, courtesy of the China Institute Gallery.

Fig. 3.20. Based on Gu Jiegang 1982: 584.

Fig. 3.22. *Qingtongqi, er*, pl. 235.

Fig. 4.1. Based on A. Paludan, *The Chinese Spirit Road* (Yale University Press, 1991), chart 2a, © Yale University Press, 1991; reprinted by permission.

Fig. 4.2. *Lingmu jianzhu*, pl. 17.

Fig. 4.3. *Qin Han diaosuo*, pl. 93.

Fig. 4.4. *Lingmu jianzhu*, pl. 13.

Fig. 4.5 Segalen 1914–17: vol. 1, pl. 10.

Fig. 4.6. *Shang Zhou shi Qin Han shufa*, pl. 78.

Fig. 4.7. Chavannes 1913: vol. 2, no. 180.

Fig. 4.8. Fu Xihua 1950: pl. 120.

Fig. 4.9. Beijing Library 1989: 1.37.

Fig. 4.10. Sekino Tei 1916: pl. 110.

Fig. 4.11. Shandong Provincial Museum and Shandong Cultural Relics and Archaeology Institute 1982: pl. 32.

Fig. 4.12. *Shang Zhou zhi Qin Han shufa*, pl. 75.

Fig. 4.13. Sekino Tei 1916: pls. 36, 37.

Fig. 4.14. *Li shi*, 5.5–6.

Fig. 4.15. (a) Editorial Committee 1985, pl. 204; (b) *Shang Zhou zhi Qin Han shufa*, pl. 89.

Fig. 4.16. (a, b) Rong Geng 1936: 5b–6b; "Shi suo," 3.20–21. (c) Chavannes 1914: pl. 4.

Fig. 4.17. (a) Rong Geng 1936: 19a–20a; (b) "Shi suo," 3.34–35.

Fig. 4.18. (a, b) Rong Geng 1936: 17b–18b, and "Shi suo," 3.50–53; (c) Chavannes 1913: vol. 2, no. 104.

Fig. 4.19. (a) Rong Geng 1936: 17b–18b; (b) "Shi suo," 3.32–33.

Fig. 4.20. (a) Rong Geng 1936: 43ab; (b) "Shi suo," 3.61.

Fig. 4.21. (a) Rong Geng 1936: 33a–35a; (b) "Shi suo," 3.46–47.

Fig. 4.22. (a) Rong Geng 1936: 7a–8a; (b) "Shi suo," 3.22–23.

Fig. 4.23. (a) Rong Geng 1936: 39ab; (b) "Shi suo," 3.57.

Fig. 4.24. Shandong Provincial Museum and Shandong Cultural Relics and Archaeology Institute 1982: pls. 166, 168.

Fig. 4.25. Rong Geng 1936: 23b.

Fig. 4.26. (a) Rong Geng 1936: 24ab; (b) Chavannes 1914: pl. 3.

Fig. 4.27. Zhang Wanfu 1984: figs. 98, 100.

Fig. 4.28. Beijing Library 1989: 123, 124.

Fig. 4.29. Rong Geng 1936: 30b–32b.

Fig. 4.30. Based on Nagahiro Toshio 1965: 62b.

Fig. 4.31. "Shi suo," 4.22–23.

Fig. 4.32. Rong Geng 1936: 1a–2a.

Fig. 4.33. Ibid., 2b–3b.

Fig. 4.34. Ibid., 4ab.

Fig. 4.35. Chavannes 1913: vol. 2, nos. 75–77.

Fig. 4.36. *Qiqi*, pl. 75.

Fig. 4.37. Palace Museum 1978: pl. 31.

Fig. 4.38. (a) Rong Geng 1936: 5ab; (b) "Shi suo," 3.18–19.

Fig. 4.39. (a) Chavannes 1913: vol. 2, no. 129; (b) *Wenwu*, 1982.5: 67, fig. 20.

Fig. 4.40. (a) Rong Geng 1936: 45ab; (b) Chavannes 1914: pl. 3.

Fig. 4.41. (a) Rong Geng 1936: 11b–12b; (b) "Shi suo," 3.30–31.

Fig. 4.42. (a) Rong Geng 1936: 25ab; (b) "Shi suo," 3.39.

Fig. 4.44. Based on Shandong Provincial Museum and Cangshan Cultural House 1975: fig. 1.

Fig. 4.45. Shandong Provincial Museum and Shandong Cultural Relics and Archaeology Institute 1982: pl. 403.

Fig. 4.46. Ibid., pl. 412.

Fig. 4.47. Ibid., pl. 413.

Fig. 4.48. Ibid., pl. 411.

Fig. 4.49. Ibid., pl. 407.

Fig. 4.50. Ibid., pl. 403.

Fig. 4.51. Ibid., pl. 410.

Fig. 4.52. Ibid., pl. 406.

Fig. 4.53. Ibid., pl. 409.

Fig. 4.54. Ibid., pls. 406–7, 414–15.

Fig. 4.55. Jiangsu Provincial Administration of Cultural Relics 1959: pl. 53.

Fig. 4.56. Li Falin 1982: pl. 18.

Fig. 4.57. Photograph courtesy of the Art Institute of Chicago.

Fig. 4.58. Chavannes 1913: vol. 3, no. 181.

Fig. 4.59. *Huaxiangshi huaxiangzhuan*, pl. 99.

Fig. 5.1. A. Paludan, *The Chinese Spirit Road* (Yale University Press, 1991), chart 2b, © Yale University Press, 1991; reprinted by permission.

Fig. 5.2. Ibid., fig. 66; reprinted by permission.

Fig. 5.3. Segalen 1914–17: vol. 2, pl. 86.

Fig. 5.4. A. Paludan, *The Chinese Spirit Road* (Yale University Press, 1991), fig. 65, © Yale University Press, 1991; reprinted by permission.

Fig. 5.5. (a) Kanda Kiichirō 1957–61: vol. 5, fig. 46.

Fig. 5.8. Nagahiro Toshio 1969: pl. 54.

Fig. 5.9. Gao Wen 1987b: 58.

Fig. 5.10. Ibid., 86.

Fig. 5.11. Ibid., 56.

Fig. 5.12. Photograph courtesy of Luoyang Ancient Tomb Museum.

Fig. 5.15. Yao Qian and Gu Bing 1981: fig. 284.

Fig. 5.16. (a, b) Based on ibid., fig. 285.

Fig. 5.17. (a) Kanda Kiichirō 1957–61: vol. 5, pls. 54, 55.

Fig. 5.18. Museum of Fine Arts, Boston, Anna Mitchell Richards and Martha Silsbee Funds—photograph courtesy of the Museum of Fine Arts, Boston.

Fig. 5.19. Photograph courtesy of the Fine Arts Library of Harvard University.

Fig. 5.20. Beijing Library 1989: 5.73.

Fig. 5.21. Nelson-Atkins Museum of Art, Kansas City, Missouri (Purchase: Nelson Trust), 33-1543/1,2—photographs courtesy of Nelson-Atkins Museum of Art.

Fig. 5.24. (a) Nelson-Atkins Museum of Art, Kansas City, Missouri (Purchase: Nelson Trust), 31-1543/2, detail—photograph courtesy of Nelson-Atkins Museum of Art; (b) Okumura Ikura 1939: fig. 2.

Fig. 5.25. (a) *Qiqi*, pl. 75; (b) photograph courtesy of the British Museum.

Fig. 5.26. Photograph courtesy of the British Museum.

Fig. 5.28. Yao Qian and Gu Bing 1981: figs. 162, 163.

Fig. 5.29. Okumura Ikura 1939: 258.

Fig. 5.30. Ibid., 258.

Fig. 5.31. *Kaogu* 1980.3: 234–35.

Fig. 5.32. Yao Qian and Gu Bing 1981: fig. 7.

Fig. 5.33. Rowland 1967: pl. 8.

Fig. 5.34. Chavannes 1913: vol. 3, no. 191.

Fig. 5.35. *Wei Jin Nanbeichao shufa*, pl. 77.

Map I.1. Based on K. C. Chang 1981: fig. 6.

Map 2.2. Li Xueqin, *Eastern Zhou and Qin Civilization* (Yale University Press, 1985), figs. 1, 2, © Yale University Press, 1985; reprinted by permission.

Map 2.3. Based on Wang Xueli 1985: 68.

Map 2.4. Pirazzoli-t'Serstevens 1982: 223.

Map 2.5. Institute of Archaeology, CASS, and Hebei Provincial Cultural Relics Administration 1980: fig. 3.

Map 2.6. Based on *Zong mulu*, 402.

Map 3.3. Based on Liu Qingzhu and Li Yufang 1987: fig. 2.

Map 3.4. Based on *Kaogu* 64.2: 87.

Map 3.5. Based on Liu Qingzhu and Li Yufang 1987: fig. 7.

Notes

DDLJ	*Da Dai liji*	*TPYL*	*Taiping yulan*
HHS	*Hou Han shu*	*WW*	*Wenwu*
HS	*Han shu*	*WX*	*Wenxuan*
KG	*Kaogu*	*WXTK*	*Wenxian*
KGXB	*Kaogu xuebao*		*tongkao*
LJ	*Li ji*	*YWLJ*	*Yiwen leiju*
LNZ	*Lienü zhuan*	*ZGMSQJ*	*Zhongguo*
SFHT	*Sanfu huangtu*		*meishu*
SHJ	*Shanhai jing*		*quanji*
SJ	*Shi ji*	*ZL*	*Zhou li*
SJZ	*Shuijing zhu*	*ZZ*	*Chunqiu Zuo*
SSJZS	*Shisanjing*		*zhuan*
	zhushu		
SW	*Shuowen jiezi*		
SZCZ	*Song zhu*		
	Chang'an zhi		

For complete author names, titles, and publication data for the works cited here in short form, see the Works Cited, pp. 327–49. The Works Cited is divided into two sections: Western-Language References (pp. 327–33) and Chinese- and Japanese-Language References (pp. 333–49). Authors with a Chinese or Japanese surname are cited by initials followed by the surname (e.g., X. Q. Li) when the work in question appears in the Western-Language section of the Works Cited, and by surname followed by full given name (Li Xueqin) when the work is listed in the Chinese- and Japanese-Language section. Chinese corporate authors are cited by an English version of their name (e.g., Archaeological Team of the Qin Terra-cotta Army) here and in the Works Cited to allow non-Chinese speakers to understand the nature of the source being cited. With one exception, the full forms of all such citations in the Notes may be found in the Chinese- and Japanese-Language section of the Works Cited. That exception is "Chinese Academy of Architecture 1982," which is found in the Western-Language section.

The abbreviations at left are used in the Notes and Works Cited.

1. This understanding is implied in Georges Bataille's description in his 1929 article "Architecture": "Thus great monuments are erected like dikes, opposing the logic and majesty of authority against all disturbing elements: it is in the form of cathedral or palace that Church or State speaks to the multitudesand imposes silence upon them" (see Hollier 1992: 47). In the early 1940's, S. Giedion wrote articles criticizing what he called "pseudomonumentality" and promoting "new monuments" that would express "man's highest cultural needs." Both terms refer to architectural forms (Giedion 1958: 22–39, 48–51). Two of the most recent studies on monuments also limit their focus to "monumental architecture," which, according to their authors, is "more or less monstrous exaggerations of the requirement that architecture be permanent" (Harbison 1991: 37; Trigger 1990: 119–20).

2. Quoted in Haskel 1971: 59. For a related discussion, see Doezema and Hargrove 1977: 9.

3. Reigl 1903. For discussions of Reigl's theory, see Forster 1982a; Colquhoun 1982.

4. Jackson 1980: 93, 91.

5. Conference program by Marian Sugano and Denyse Delcourt. The conference, sponsored by the Center for the Humanities of the University of Washington, was held in Seattle, Feb. 27–29, 1992.

6. Ibid.

7. *Webster's New International Dictionary*, s.v. "monumentality."

8. The original sentence is "King Cheng fixed the Tripods in Jiaru." In Eastern Zhou texts, *Jiaru* refers to the locality of the Zhou capital and sometimes to the capital itself; see Tang Lan 1979: 3–4.

9. Trans. based on Legge 1871: 5.292–93.

10. Reigl 1903: 38.

11. The largest extant bronze vessel, the Si Mu Wu tripod of the late Shang, is 52.4 inches tall and weighs 1,929 pounds.

12. *LJ*, 1256; trans. based on Legge 1967: 1.100. Different dates have been suggested for the *Book of Rites*. Most likely, this book was compiled during the early Han; see Legge 1967: 1.xlvi. Since my discussion here concerns some general principles of early Chinese religion and art, *LJ* and other later documents are used as secondary sources complementing archaeological evidence.

13. *Mozi*, 256.

14. *Ruiying tu*, 10a. Sun Ruozhi, the author of this omen catalogue, lived in the post-Han era, but a similar inscription is found on the Wu Liang Shrine built in A.D. 151. See H. Wu

1989: 236. For a longer discussion of the Nine Tripods legend, see ibid., 92–96.

15. Most inscribed bronze vessels from the Shang and Western Zhou were dedicated to deceased ancestors. As David N. Keightley (1978b: 217) has stated, the religion of the ancient Chinese was "primarily a cult of the ancestors concerned with the relationships between dead and living kin."

16. In addition to the two passages discussed below, other records about the feudal lords' desire for the Nine Tripods can be found in *Zhanguo ce*, 19, 21; *SJ*, 163. See Zhao Tiehan 1975: 129–32.

17. *SJ*, 2282.

18. *Zhanguo ce*, 22–23.

19. Rose 1968: 83.

20. *SJ*, 1365. But Sima Qian also offered a different account: the Nine Tripods were seized by the Qin during its attack on the Zhou in 256 B.C. (*SJ*, 169, 218, 1365). Ban Gu, however, dated this event to 327 B.C. (*HS*, 1200). See Zhao Tiehan 1975: 135–36.

21. For a concise explanation of these two principles, see Trigger 1990: 122–28.

22. Veblen 1899.

23. Trigger 1990: 119, 125.

24. *SJ*, 248; *SJZ*, 327.

25. K. C. Chang 1983: 9–32.

26. *LJ*, 1439, 1441, 1595.

27. Powers has discussed such issues in a number of articles; see especially his 1991 book on Han pictorial art.

CHAPTER ONE

1. Liu Jie 1941: 163–65.

2. Legge 1871: 4.541.

3. See *Mengzi*, 2749; *Shi jing*, 568.

4. Here Liu Jie followed Fu Sinian's (1936) interpretation of *wu*.

5. Robert J. Sharer and Wendy Ashmore (1979: 278) add: "All societies maintain a kind of cultural classification or 'cognitive structure,' and different societies structure their world in different ways."

6. The study of ancient objects in Europe followed a similar path. As Sharer and Ashmore (ibid.: 33) summarize: "Amassing a collection leads to attempts to bring order to the assembled material, resulting in the first efforts at *classification*."

7. Some Song antique catalogues contain both categories of *jin* and *shi*; others focus on one and exclude the other. The first major catalogue of antiques in Chinese history, for example, is entitled *Xian-Qin guqi ji* (Archaic bronze vessels from pre-

Qin periods). The most sophisticated Song antiques catalogue, *Xuanhe bogu tulu* (Illustrated catalogue of various antiques in the Xuanhe imperial collection), records 839 bronzes in twenty formal-functional types; objects belonging to a type are further classified into periods. The whole hierarchy of classification, therefore, consists of three levels based on medium, form and function, and chronology.

8. Zhao Ruzhen 1984.

9. Bushell 1910: 1.2.

10. Ibid.

11. C. C. Liang 1928: 456.

12. Owen 1985: 3.

13. See Sharer and Ashmore 1979: 278.

14. *LJ*, 1258.

15. *LJ*, 1347; see Legge 1967: 1.244.

16. *LJ*, 1344.

17. *ZL*, 757–71.

18. Quoted in Legge 1967: 1.11.

19. According to the *Book of Rites* (*LJ*, 1348), "The six ceremonial observances were capping, marrying, mourning rites, sacrifices, feasts, and interviews" (trans. based on Legge 1967: 1.248).

20. A definite line between the secular and the sacred is, however, difficult to draw, as Noah Edward Fehl (1971: 3) has stated: "*Li* is an alternative to the specifically religious and the moral—an alternative so pervasive, persistent and successful in Chinese civilization that Chinese as well as western Sinologists can find no better word than 'moral' to define the perspective of Chinese philosophy and historiography." Here I use *sacred* for relations and communication between humans and supernatural beings and *secular* for relations and communication between people.

21. Herbert Fingarette (1972: 16) remarks in his influential *Confucius: The Secular as Sacred*: "Rite brings out forcefully not only the harmony and beauty of social forms, the inherent and ultimate dignity of human intercourses; it brings out also the moral perfection implicit in achieving one's ends by dealing with others as beings of equal dignity, as free coparticipants in li. Furthermore, to act by ceremony is to be completely open to the other; for ceremony is public, shared, transparent; to act otherwise is to be secret, obscure and devious, or merely tyrannically coercive. It is in this beautiful and dignified, shared and open participation with others who are ultimately like oneself that man realizes himself. This perfect community of men—the Confucian analogue to Christian brotherhood—becomes an inextricable part, the chief aspect, of Divine worship—again an analogy with the central Law taught by Jesus."

22. *LJ*, 1249.

23. *LJ*, 1619; see Legge 1967: 2.285.

24. Legge 1967: 2.261.

25. See K. C. Chang 1983: 9–32.

26. *LJ*, 1602; see Legge 1967: 2.236.

27. See K. C. Chang 1983: 37–38.

28. *LJ*, 1416; trans. based on Legge 1967: 1.369–70.

29. *LJ*, 1416; see Legge 1967: 1.369–70. Legge mistakenly translates the last sentence of the second paragraph of this passage as "In all these things we follow the example of that early time." My translation is based on Kong Yingda's commentary on the text (*LJ*, 1416) and is also determined by the textual context of the passage: in the following paragraph, forms of offerings and objects used in ancestral worship are all later inventions and not derived from "early times."

30. *LJ*, 1415; see Legge 1967: 1.368.

31. The *shi* radical (a symbol for divinity) of the present character *li* was probably not added till the time of the Qin or Han; see Fehl 1971: 4. Legge (1967: 1.10) explains: if according to the *Kangxi zidian* (Kangxi dictionary), the right part of the character "was anciently used alone for the present compound, still the spiritual significance would attach to it, and the addition of the *khih* [*shi*] to complete the character, whensoever it was made, shows that the makers considered the rites in which the vessel was used to possess in the first place a religious import."

32. *SW*, 2; see Legge 1967: 1.9.

33. *LJ*, 1440; see Legge 1967: 1.410.

34. Quoted in Zhu Jianxin 1940: 68–70.

35. *SW*, 86.

36. Ibid.

37. The word *qi* is used extensively in *Huangdi neijing su wen* for human organs; see Guo Aichun et al. 1991: 949.

38. *Yi jing*, 83.

39. *Zhuangzi*, 160.

40. *LJ*, 1530; see Legge 1967: 2.100.

41. *Huainan zi*, 8.122.

42. See Legge 1967: 2.339, 344.

43. *Yi jing*, 83; see Wilhelm 1967: 323–24.

44. *Yi jing*, 81.

45. *LJ*, 1455; see Legge 1967: 1.434–35.

46. From a speech given at the dedication of the monument for the mother of George Washington at Mount Vernon; quoted in Jackson 1980: 92.

47. Quoted in Hollier 1992: 47.

48. Jackson 1980: 94–95.

49. Summarized in Mothersill 1984: 342.

50. I follow David Keightley's (1987: 94) definition of the

East Coast cultural tradition: "Even though it is important to think, both first and last, in terms of a mosaic of Neolithic cultures whose edges blur and overlap, I believe that, for analytical purpose, one can—with all due allowance being taken for the crudity of the generalizations involved—still conceive of the Chinese Neolithic in terms of at least two major cultural complexes: that of Northwest China and the western part of the Central Plains, on the one hand, and that of the East Coast and the eastern part of Central Plains, on the other. I shall, for simplicity, refer to these two complexes, which should be regarded as ideal types, as those of the Northwest and the East Coast (or, more simply, East). There were numerous regional cultures within these two complexes. In the sixth and fifth millennia, for example, cultures like Laoguantai, Dadiwan, and Banpo flourished in the Northwest; cultures like Hemudu, Qingliangang, and Majiabang arose in the area of the East Coast." See also K. C. Chang 1977: 152−53. I discuss the Eastern coast tradition in a number of studies, including H. Wu 1985, 1990*a*, *b*.

51. As I have suggested elsewhere (H. Wu, 1985: 30−34), works dating before the Dawenkou period, especially ivory and jade carvings from the Hemudu and Hongshan cultures, are made of "precious materials." But to create an explicit "costly" impression is not the purpose of these works. These carvings represent vivid zoomorphic images. In such sculptured forms, a precious material is used as a "media" of representation; its value in color, texture, and hardness becomes secondary.

52. See Hansford 1968: 26. In modern terminology, *yu* refers to two different minerals: "soft jade," or nephrite, a calcium and magnesium silicate with a fibrous structure; and "hard jade," or jadeite, a sodium and aluminium silicate with a crystalline structure. It was not until the eighteenth century that the Chinese began to use jadeite widely for carvings.

53. See ibid., 49. Different cultures in the ancient world shared this basic method; see Digby 1972: 14−17.

54. One such example is Tomb no. 10 at Dawenkou. The deceased was buried in a carefully constructed wooden encasement and was covered with thick clothes. He wore an elaborate headdress of marble and turquoise, as well as a green jade bracelet. The corpse was surrounded by numerous articles, including more than 80 pottery vessels, 84 alligator scales, and two ivory tubes engraved with elaborate openwork patterns. A finely polished, dark-green jade axe was placed close to the waist of the deceased and was probably held in his hand. See Yu Zhonghang 1976: 70.

55. Some scholars have proposed that the graph for *father* in Chinese writing evolved from the image of an axe.

56. Dissanayake 1988: 99.

57. For the unique aesthetics of such products in comparison with painted Yangshao pottery, see H. Wu 1990*b*: 40−49.

58. Wu Ruzuo 1989: 40.

59. Ibid., 39−41.

60. *LJ*, 1455; see Legge 1967: 1.434−35.

61. *Guyu tukao* includes four *bi* disks (25a−26b), a tall *cong* (55b), and a short *cong* (68a) identifiable as Liangzhu products.

62. Shi Xin'geng 1938.

63. See Wang Zunguo 1984; Mu Yongkang et al. 1989: ii−iii.

64. For a summary of the excavations and research on the Liangzhu culture, see An Zhimin 1988.

65. Nanjing Museum 1984.

66. Fanshan Excavation Team of the Zhejiang Provincial Institute of Archaeological and Cultural Relics 1988; Zhejiang Provincial Institute of Archaeology and Cultural Relics 1988. For an English summary of these two excavations, see James 1991: 46−55.

67. Zhejiang Provincial Institute of Archaeology 1989: iv. *Zhongguo wenwu bao* no. 245, Aug. 11, 1991; no. 294, Aug. 2, 1992.

68. *Zhongguo wenwu bao*, no. 370, Feb. 6, 1994.

69. Zhejiang Provincial Institute of Archaeology and Cultural Relics 1988: 50−51; James 1991: 47.

70. James 1991: 46.

71. Zhejiang Provincial Institute of Archaeology and Cultural Relics 1988: 50.

72. Some Chinese scholars have attempted such an evolutionary sequence; see, e.g., Wang Wei 1986; Liu Bin 1990. Both authors make interesting proposals, but their classifications of Liangzhu *cong* differ markedly. Wang Wei bases his typology first on shape and size; Liu Bin considers decoration the primary feature. Both authors try to establish a linear, chronological sequence and neglect geographical factors important to the understanding of the development of *cong*.

73. Schapiro 1969: 224.

74. See Gombrich 1984: 33−62.

75. Grabar 1992: 41.

76. Uspensky 1975: 33.

77. Ibid., 38.

78. Zhang Minghua 1990.

79. For a discussion of the iconic mode in later Chinese art, see H. Wu 1989: 132−40.

80. Developing Lévi-Strauss's (1963: 245−68) observation of dualistic phenomena in ancient Chinese culture, K. C. Chang (1964; 1983: 77−78) has proposed that "the artistic dualism on Shang bronzes is merely one component, and integral

part, of a dualism that permeated Shang institutions and Shang thoughts." According to Chang, other Shang dualistic phenomena are found in the layout of the palaces and the royal cemetery, the composition of inscriptions on oracle bones, the ritual institutions of the Shang kings, and the two general styles of Shang bronzes.

81. The line between these two decorative modes is not absolute. As I discuss later in this section, it is only natural that they would influence each other and sometimes be employed in decorating a single object.

82. Arnheim 1982: 87.

83. Liu Bin 1990: 33.

84. Wang Wei 1986: 1012, 1014.

85. James 1991: 54.

86. Salmony 1963: pl. VII, 1–3. Julia K. Murray (1983) has found more details on these *bi* disks. According to her, "One of the *bi* is also incised on the narrow surface of its slightly concave rim. The rim design is organised in quadrants, with a flying bird seen from above and a fish skeleton alternating at the head of each quadrant. The space between the four emblems contains a loose meander pattern resembling elongated *leiwen* [thunder patterns]."

87. As I discuss later in this section, the circular motif resembles graphs for the sun or "sun-brightness" in early Chinese writing.

88. Salmony 1963: pl. VII, 3.

89. Salmony (1963: pl. VII, 1), however, did compare these images with some Shang dynasty bronzes published by C. Hentze that show a bird standing on a shrine. Based on Hentze's symbolic interpretation, he identified these motifs as symbols which "connect the soul with the stars of day and night."

90. Hayashi Minao (1965) has hypothesized that these jars were ritual vessels.

91. Chinese scholars have different explanations for this sign. Dominant opinion identifies it as the graph for "fire" (see Tang Lan 1981: 80; Li Xueqin 1987).

92. Wang Shuming 1986; Li Xueqin 1987.

93. Hayashi Minao 1981: 22–23; Murray 1983: 14–22; H. Wu 1985.

94. Shi Zhilian 1987; Hayashi Minao 1991.

95. Li Xueqin 1987: 78–79; Deng Shuping 1993: 14.

96. Mu Yongkang and Yun Xizheng 1992: figs. 229–31.

97. Deng Shuping 1993: 14.

98. Rowley 1959: 27.

99. For an illustration, see Childs-Johnson 1988: fig. 22a.

100. As I have suggested, the incisions on the three Freer *bi*

seem to indicate a chronological development in style and a gradual "abstraction" of pictorial signs.

101. Friesen 1969: 55.

102. In a previous study (H. Wu 1985: 40–41), I discuss the relationship between these motifs and ancient Chinese legends and propose an analytical method for studying and identifying such a relationship.

103. For various versions of this legend, see Xu Xusheng 1960: 67–74.

104. *SHJ*, 357. The phrase *jun ji* in the present version of the *Classic of Mountains and Seas* is difficult to understand. I suspect that the character *ji* is an error; the original character should be *zu* (clan).

105. See H. Wu 1990a.

106. See Legge 1870: 3.108–11.

107. In a previous study (H. Wu 1985: 35–36), I suggest that the three Freer *bi* were likely made in the Huai River region. After the publication of that paper, I learned that *bi* disks similar to the Freer examples in both shape and engraving had been discovered at Anqi in Yuhang county, Zhejiang; see Deng Shuping 1993: 14; Y. S. Qiu and B. X. Hu 1990: fig. 8.

108. Xu Xusheng 1960: 73.

109. I have demonstrated elsewhere (H. Wu 1985) that there was a long tradition in the lower Yangzi River region of presenting "birds" on ritual objects.

110. For the possible Longshan date of these jades, see Wu Hong 1979 and H. Wu 1985.

111. The historical identity of the Erlitou site (and Erlitou culture in general) has been the subject of a prolonged debate ever since its discovery. Some scholars believe that this site holds the remains of a late Xia capital; others identify it, or its upper strata, as an early Shang city. For a summary of this debate, see K. C. Chang 1986: 307–16. The discovery of an early Shang city in 1983 seems to support the first opinion: it was founded later than the Erlitou settlement but predated the mid-Shang city at Zhengzhou. See Henan Provincial Institute of Cultural Relics 1990: 178–79; Zhao Zhiquan 1989. Here I follow the opinion accepted by most Chinese archaeologists, including the excavators of the Erlitou site.

112. Bagley in W. Fong 1980: 74.

113. Some Erlitou pottery shards are decorated with zoomorphic motifs such as animal masks and dragons. Although scholars have suggested that these designs imitate bronze decoration, this contention still needs to be proved, especially because it does not answer the question why all bronze vessels from Erlitou are plain or bear only simple decoration.

114. Two turquoise-inlaid plates excavated from Erlitou

show "mask" motifs; seven similar plates exist in different collections. See Li Xueqin 1991a: 2. Since these works are covered with precious stones, they cannot be considered pure bronze objects; rather, they are akin to jade or stone ornaments.

115. There are different opinions regarding the periodization of the Shang dynasty. Some scholars who consider Erlitou a Xia site divide the Shang into two broad periods—the early Shang and the later Shang—represented by Erligang in Zhengzhou and Anyang, respectively. Other scholars periodize the Shang into three parts; the early Shang is represented by the two upper strata at Erlitou, the mid-Shang by the Erligang upper stratum at Zhengzhou, and the late Shang by Anyang. See K. C. Chang 1986: 335–37; Soper 1966: 5–38; Thorp 1985: 8. Here I follow the second opinion, recently systematically stated in Institute of Archaeology, CASS 1984: 211–48, 323–26.

116. Langer 1957: 98.

117. Consten 1957: 300.

118. Paper 1978: 20.

119. For discussions of the origins of the *taotie* mask, see Hayashi Minao 1979; Rawson 1980: 36–40, 70–79.

120. An alternative interpretation is that the two types of mask in Liangzhu art—the frontal mask on a two-dimensional surface and the "split" mask along a corner of a *cong*—were inherited by the middle Shang people. This hypothesis, however, does not explain why two-dimensional *taotie* images on Shang bronzes are often shown as "split" ones. It is more logical to see such images as descendents of the "split" mask on Liangzhu *cong*.

121. Quoted from Gombrich 1969: 267.

122. Loehr 1953.

123. These summaries can be found in W. Fong 1980: 182; Rawson 1980: 67; Soper 1966: 37–38.

124. Loehr 1968: 13.

125. As Robert Thorp (1985: 38) has pointed out, Loehr himself did not date his Style I, which was later placed at the beginning of the evolutional sequence of Shang bronze decoration.

126. To judge from excavated materials, bronzes decorated with zoomorphic motifs became popular only from the late part of the Zhengzhou period, or Upper Erligang phase, from 1400 to 1200 B.C. Bronzes from the earlier Lower Erligang phase are often undecorated or decorated only with simple geometric patterns; see Zhengzhou Museum 1981: 97. Styles I–III characterize mid-Shang bronzes belonging to both the Upper Erligang phase and the "transitional period" defined by Thorp (1985: 37–51). Style IV decoration may have also appeared before the late Shang. As Robert Bagley has argued, "Tentative

versions of Style IV are in evidence already among the bronzes, predominantly Style III, from the Taixicun, Gaocheng, site in Hebei Province; these may predate the Anyang period" (W. Fong 1980: 182). Such "tentative Style IV designs" may, however, still belong to the general category of Style III, since the motif-ground distinction is still far from mature. A more definite Style IV example is a *zun* found in 1954 in Huixian, Henan province (see *Henan chutu Shang-Zhou qingtongqi* 1: pl. 119). A detailed description of a stylistic development of Style IV can be found in Huber 1981. Thorp (1988) discusses the chronological relationship between Styles IV and V. While agreeing that Style IV antedated Style V, he also emphasizes, quite correctly in my opinion, that these two styles should be "regarded as a single change in the way that Shang bronze designers created their art" (Thorp 1988: 57). After the discovery of Fu Hao's tomb, most scholars have agreed that Style V must have been invented before 1200 B.C. when King Wu Ding, Fu Hao's consort, began his rule. As I discuss below, most bronze vessels from the tomb are decorated with mature Style V designs; this suggests that Style V must have been invented before Fu Hao's time.

127. Thorp (1985: 38, 41–42) has pointed out that "unfortunately, there has been little archaeological evidence, as opposed to theoretical logic, that would in fact assign absolute chronological priority to this technique [of placing Style I before Style II]. It has frequently been noted, for example, that both Styles I and II can be found on a single vessel, and some vessel types that appeared only well into the Upper Erligang Phase or in the Transitional Period have thin relief line decoration." A number of *jue* and *jia* tripods, for example, share a decorative formula: the upper frieze is filled with thready, linear patterns, and the lower band is characterized by a pattern of flat relief ribbons. Even more telling, on a very complicated *you* vessel from a mid-Shang tomb at Zhengzhou, the main mask motif unmistakenly falls into the category of Style II, the sculptured handle required advanced precasting and cast-on techniques, and the shoulder is decorated with "primitive" Style I fine threads (see W. Fong 1980: 107).

The following statistics on bronze from some excavated mid-Shang tombs in Henan demonstrates the wide coexistence of Style I and Style II vessels. (Style I: bronzes with pure Style I decor; Style Ia: bronzes with simple raised parallel lines; Style II: bronze with pure Style II decor; Style I + II: bronzes combining decorations of the two styles. The sites listed do not include those of the Transitional Period defined by Thorp. For sources, see Thorp 1985: 60–62.

Sites	Style I	Style Ia	Style II	Style I+II
Minggonglu M2		3	3	
Minggonglu M4	1			1
Erqilu M1	1		4(?)	
Erqilu M2	1	2	1	
Liulige M110	1		2	
Liulige M148	1		1	
Lilou no. 1	1		2	

Objects from mid-Shang hoards exhibit similar mixtures. The thirteen bronzes from Xiangyang in Zhengzhou, for example, are decorated with Styles I and II patterns and with *taotie* classified by Loehr as Style III. High-relief images also appear on some vessels in this group (see Henan Provincial Institute of Cultural Relics and Zhengzhou Museum 1983).

128. For example, two of the four vessels from Tomb no. 110 in Huixian bear designs in fine relief lines (Style I), whereas similar motifs on other vessels are delivered in broad, ribbon-like bands (Style II) (see Guo Baojun 1981: 10; pl. 4, nos. 1–2; pl. 5, no. 1). As I discuss below, the thirteen bronzes from a storage pit (H 1) near Zhengzhou display combinations of various styles.

129. For one such example, a *jia* vessel in the British Museum, see W. Watson 1962: 53, pl. 8.

130. In addition to Fu Hao's tomb, another example is Shang royal mausoleum no. 1400 at Anyang. See W. Watson 1962: 53.

131. In an excellent study of Shang bronze styles, Huber (1981: 37) distiguishes "two new and diametrically opposed decorative styles [which] appear during the Late Anyang period": "on the one hand we find vessels decorated by narrow horizontal bands of purely geometric patterns, with the largest portion of the surface left plain; on the other, designs covering the entire surface in high relief, stark in effect, with minimal linear embellishment, and typically raised from a ground that is perfectly smooth."

132. In fact, Loehr (1953: 50) has noticed the coexistence of Style I and II designs on a single bronze: "It may be argued that this Chueh [i.e., a *jue* in the Sumitomo Collection] shows Styles I and II to be coeval; that they overlap; that they differ only technically. Secondly, the typological position of this Chueh has to be considered. A third inference would be this: the decor of the Chueh reveals that Style I lives on in the period of Style II without becoming obsolete. And indeed we shall have to reckon with a continually widening repertory of motifs: perpetuated older ones existed side by side with the new ones and did not necessarily recede as these later were invented." Although Loehr's speculation is very suggestive, he nevertheless

considered that such a "hybrid" bronze, as he called it, combines "in its decoration elements of two successive styles, and on that account might be termed a 'transitional' specimen" (ibid., 49).

133. Harrie A. Vanderstappen (Vanderstappen et al. 1989: 28) has noticed that "even granting overlaps and progressive and retrogressive steps in the process, Loehr's sequence is seriously challenged by the content of Tomb 5 of Fu Hao. Among the many bronze vessels fround in the tomb [of Fu Hao], there is clear evidence establishing the contemporaneity of Loehr's styles III through V—instead of a chronological developmental sequence."

134. Gombrich 1984: 261.

135. *Huainan zi*, 8.123.

136. Thorp (1985: 42) employs the concept of "mirror images" in describing the relationship between Style I and II motifs.

137. Loehr 1968: 13.

138. Thorp (1985: 42) rightly calls attention to the coexistence of Style I and Style II on bronzes from Erligang. His solution is to view these two styles not as a polarity but as variations of a "spectrum": "When many examples of Erligang Phase decoration are scrutinized, one finds many varieties of thick bands and thin lines and considerable free variation in the composition of the motifs."

139. Bagley 1987: 20.

140. Henan Provincial Institute of Cultural Relics and the Zhengzhou Museum 1983.

141. Although these examples, especially the pair of square *ding*, have convinced me that their opposing decorative styles must have been deliberate, I do not want to suggest that this is a universal rule in mid-Shang bronze art. For example, a pair of *zun* from the same pit are basically identical in decorative style (Style I), although the lines on one vessel are slightly thicker than those on the other. Another pair of square *ding* discovered in 1974 in Zhengzhou are both embellished with Style I masks (see Henan Provincial Museum 1975).

142. Chinese archaeologists periodize the late Shang into four phases and term them Yinxu I–IV. Yinxu I, which predates the Wu Ding period (ca. 1200–1180 B.C.), is represented by a series of tombs excavated both in Anyang and in other places. Bronzes from these sites differ markedly from those found in Fu Hao's tomb of the Wu Ding period, but basically continue the mid-Shang tradition while exhibiting some significant changes. See Zheng Zhenxiang and Chen Zhida 1985: 39–45; Thorp 1988: 48–49.

143. Loehr 1968: 12.

144. W. Fong 1980: 182.

145. Thorp (1988: 57) has made an important discovery related to my contention here. As he comments on the relationship between Style IV and V: "The two 'styles' bear a complementary relationship to each other. Differing in technique but not in function, they are perhaps better regarded as a single change in the way that Shang bronze designers created their art. In that respect, the situation is comparable to styles I and II of the Early Shang period, which again were different methods of rendering invoked in the service of a common goal. While I continue to refer to Loehr's styles as a five-part sequence, it may also be apt to think of the total development as a three-part evolution in which the first and third phases exhibit prominent alternative techniques. . . . It seems therefore that each phase of Shang decoration had its complementary aspects. This complementarity also strikes one as a pervasive aspect of Shang culture as a whole."

146. Some scholars believe that instead of being Wu Ding's consort, the deceased named Fu Hao in this tomb belonged to a later period. This opinion has been rejected by most scholars. For the absolute date of Wu Ding's reign, see Keightley 1978a: 203, table 14.

147. In Bagley's words, such an image "ceases to be synonymous with the pattern filling entire frieze units, and becomes instead a well-defined creature displayed against a background, in the frame provided by the frieze unit" (W. Fong 1980: 179).

148. Flanges are seen on a limited number of mid-Shang bronzes, such as those catalogued in *Henan chutu Shang-Zhou qingtongqi*, pls. 76, 126.

149. For a detailed discussion of "flanges," see Bagley 1987: 1.4, 1.5; the decorative function of "flanges" is also pointed out in Rawson 1990: 2a.27.

150. In analyzing a *lei* in the Shanghai Art Museum, Jessica Rawson (1990: 2a.29) observes that "each of the surface compartments formed by its flanges and horizontal divisions encloses a different dragon or *taotie*. . . . It is highly unlikely that any of these designs was considered to represent a particular beast, whether natural or imaginary."

151. Z. X. Zheng 1986: 90.

152. We know from archaeological excavations that marble sculptures representing mythical animals were arranged in Shang royal tombs, which were also painted with murals of similar images. Extant bronzes, jade, and ivory vessels, musical instruments, weapons, and chariot fittings are universally decorated with motifs from the same repertoire (see C. Li 1977: 209–34).

153. See Gombrich 1969: 258–61.

154. See Cao Shuqin 1988.

155. Kane 1973.

156. Keightley 1991: 17.

157. A popular opinion considers "Mother Xin" Fu Hao's temple name. But Keightley (ibid., 16–17) argues that this is impossible because Fu Hao's temple name could be decided only after her death. He thus proposed that the bronzes bearing the names "Queen Mother Xin" and "Queen Tu Mother Gui" must have been used by Fu Hao in her lifetime to worship these ancestresses and that these vessels were buried with her.

158. Keightley (ibid.) believes that a person's temple name was chosen by divination after his or her death and hence one could not possibly make a bronze with one's own temple name.

159. Keightley (ibid., 16) speculates on this issue and reaches a different conclusion: "I assume that even in the case of the shortest inscriptions, which may consist of only two words, like 'Father Ji,' the full but unrecorded message was 'This is a vessel that I, the maker, made for my late Father [or Mother, Grandmother, etc.], whose temple name is Ji and who is to receive cult, on ji days, in this vessel.'" In my opinion, one of the distinct features of such short inscriptions is their omission of the commissioner, or "I" in Keightley's reading. Only in later and longer inscriptions did a commissioner made him or herself known.

160. None of the 190 inscriptions on the bronzes from Fu Hao's tomb include the verb "to make." This suggests that the practice of including the verb in inscriptions must date to after the early thirteenth century B.C., when the tomb was constructed.

161. These inscriptions have been gathered in Yetts 1949; Chen Mengjia 1954; Bagley 1987: 525–30; Kane 1973.

162. *ZZ*, 1911.

163. The inscriptions on one group of bronze vessels record a single place, perhaps the Shang royal temple, in which the award ceremonies were held. These include a *jiao* vessel in the Sumitomo Collection (20 *si* of Di Xin's reign; see Bagley 1987: fig. 24.6), a *gui* vessel in the Guangdong Museum (see ibid., fig. 103.13), the Shu Si Zi *ding* tripod (inscription translated in the text), and the Li *gui* (see Fig. 1.57) made at the beginning of the Western Zhou (see W. Fong 1980: no. 41). Moreover, the inscription on the Si *gui* in the Sackler Art Museum in Washington, D.C., reads: "On the day *wuchen*, Bi Shi awarded me, Si, a sack of (large?) cowries from X-place, which I then used to make this precious vessel for [my deceased] father Yi. It was in the eleventh month, the king's twentieth *si*, a day in the *xie* sacrificial cycle, on the occasion when a pig was sacrificed to Ancestress Wu, King Wu Yi's consort. [Clan emblem]." It is clear that this vessel was also made after Si received an

award while participating in a royal sacrifice. For a discussion of this vessel, see Bagley 1987: fig. 103 and interpretation.

164. This *ding* was excavated from a sacrificial pit in Hougang at Anyang; see Guo Moruo 1960: 1–5; Bagley 1987: fig. 103.14.

165. These bronzes include a *you* vessel in the Hakutsuru Bijutsukan (see Bagley 1987: fig. 71.4); a *xian* tripod in the Museum of Chinese History in Beijing (ibid., fig. 103.12), a *gui* vessel, whose inscription is published in Luo Zhenyu 1936: 8.33.2, and a rhinoceros *zun* vessel (see Fig. 1.56) in the Asian Art Museum of San Francisco (Bagley 1987: fig. 103.11).

166. Some statements are general, as indicated by the inscription of the Zuoce Ban *xian* (inscription translated in the text). Others are more specific; for example, the Xiaozi X *you* in the Hakutsuru Bijutsukan first records a superior's command in the context of the military campaign: "On the day *yisi*, Zi ordered [me], Xiaozi X, to engage the Ren [Fang] at X-place. Zi awarded me, X, two strings of cowries. Zi said, 'The cowries are in recognition of your merits.' I, X, then used them to make this vessel for [my deceased] mother Xin. It was in the tenth month, when Zi issued the order to annihilate the chief[?] of the Ren Fang" (see Kane 1973: 368*n*55).

167. Ibid.

168. For vessels related to these political events, see Rawson 1990: 2a.145. The earliest among them is a *gui* made by Li only seven days after the Zhou's conquest of the Shang. It follows the Shang narrative mode of first introducing the historical event; see W. Fong 1980: no. 41.

169. One such example is a *zun* vessel made by He during the reign of King Cheng. Its inscription reads: "It was at the time when the king moved the Zhou capital to Chengzhou, and offered a *fu* sacrifice in the Hall of Heaven to [his deceased father] King Wu. In the fourth month, on the day *bingxu*, the king was in the Jing Hall and exhorted me, saying: 'In days past, your late ancestor Gong Shi was able to serve King Wen. King Wen accepted the great command, and King Wu carried out the conquest of the Great City of Shang, announcing it to Heaven with the words: "I must dwell in the center and from there rule the people." Now take heed! You must cherish the memory of the services that Gong Shi rendered to Heaven. Sacrifice to him with reverence!' Our king has indeed a virtuous character, compliant to Heaven, and is an inspiring example for my own feebleness. When the king had concluded, I, He, was given thirty strings of cowries, which I have used to make this vessel for sacrifices to Gong Shi. This happened in the king's fifth year" (based on Bagley's trans. in W. Fong 1980: 198).

170. Major studies of these inscriptions include Qi Sihe 1947;

Chen Mengjia 1955–56, 1956; Huang Ranwei 1978; Zhang Guangyu 1979; Kane 1982–83; Chen Hanping 1986.

171. Among the 80 examples Chen Hanping (1986: 21–25) lists, only three were from the early Zhou.

172. Bagley's trans. in W. Fong 1980: 246–47.

173. "Anciently the intelligent rulers conferred rank on the virtuous, and emoluments on the meritorious; and the rule was that this should take place in the Grand Temple, to show that they did not dare to do it on their own private motion. Therefore, on the day of sacrifice, after the first presenting [of the cup to the representative], the ruler descended and stood on the south of the steps on the east, with his face to the south, while those who were to receive their appointments stood facing the north. The recorder was on the right of the ruler, holding the tablets on which the appointments were written. He read these, and [each man] bowed twice, with his head to the ground, received the writing, returned [home], and presented it in his [own] ancestral temple:—such was the way in which rank and reward were given" (*LJ*, 1605; trans. from Legge 1967: 2.247). For other ancient records of the "investiture" ceremony, see Chen Hanping 1986: 12–20.

174. Trans. based on Legge 1967: 2.251. The same idea is stated elsewhere in the text: "In this way the superior men of antiquity panegyrised the excellent qualities of their ancestors, and clearly exhibited them to future generations, thereby having the opportunity to introduce their own personality and magnify their states" (ibid., 253).

175. Ibid.

176. Huber 1981: 33.

177. To my knowledge, this style was first defined in Kane 1970: 76–78.

178. Huber 1981: 35.

179. Quoted in ibid., 33.

180. Allan 1991.

181. For an excellent description of this development, see Rawson 1980: 103–23; 1987: 33–45; and 1990.

182. The Chinese archaeologist Guo Baojun (1959: 13) was the first to study such "vessel sets" and invented the term *lieding* (a series of *ding*). He concluded: "During the Zhou from King Xuan and King Li on, rich nobles often used groups of *lieding* consisting of 3, 5, 7, or 9 bronzes in decreasing size as tomb furnishings." Other studies of such groups of bronzes include Yu Weichao and Gao Ming 1978–79; Yu Weichao 1985; Wang Shimin 1987.

183. See Guo Baoju 1963: 16.

184. Lucretius wrote in his poem *De Rerum Natura*: "The earliest weapons were the hands, nails, and teeth; then came

stone and clubs. These were followed by iron and bronze, but bronze came first, the use of iron not being known until later" (MacCurdy 1933: 1.9). In interpreting objects from burial mounds, Johann von Eckart asserted that there must have been an age prior to the invention of metal tools and that this era (Stone Age) was followed by a Bronze Age and finally an Age of Iron (see Sharer and Ashmore 1979: 52).

185. See Daniel 1967: 93–95.

186. See ibid.; McNairn 1980: 74–77.

187. K. C. Chang 1980b: 35–36.

188. Orenstein's word; quoted in ibid., 202.

189. For some scholars' opinions, see Lei Haizong 1957; Yu Xingwu 1957, 1958; Chen Mengjia 1956.

190. K. C. Chang 1980b: 45.

191. Ibid., 35, 45.

192. The Shang royal army was equipped with bronze weapons and chariots (see Zuo Heng 1979: 75–82).

193. Hu Huoxuan's estimate, in Guo Baojun 1963: 21.

194. An Zhimin 1954: 91; *Zhengzhou Erligang*, 37.

195. Guo Baojun 1963: 21.

196. Jiangxi Provincial Institute of Archaeology and Jiangxi Xin'gan Museum 1991; esp. 8–10.

197. For the positions of the tomb furnishings, see ibid., 2–4.

198. The most important agricultural ritual in Bronze Age China was the plowing ceremony (see Yang Kuan 1965: 218–33). Interestingly, among the "tools" from the Xin'gan tomb are three large bronze plows decorated with *taotie* masks.

199. *Renmin ribao*, May 13, 1961; see also Gao Zhixi 1963: 648; Institute of Archaeology, CASS 1984: 242.

200. Gao Zhixi 1963: 646–48; Hunan Provincial Museum 1972; see also Wenwu Press 1979: 311.

201. See Guo Baojun 1963: 20.

202. For a summary of these finds, see Institute of Archaeology, CASS 1984: 218.

203. Shi Zhangru 1933; An Zhimin 1947.

204. Lei Haizong 1957: 42.

205. Yu Xingwu 1957, 1958.

206. Chen Mengjia 1956: 541–42.

207. For discussions about the relationship between Childe's ideas and Marxist historical materialism, see McNairn 1980: chap. 6; Thomas 1982.

208. Tang Lang 1960. Tang's opinion has been repeated, "confirmed," and elaborated by some recent authors, see Chen Zhenzhong 1982; Ma Chengyuan et al. 1991: 24–44; Li Xueqin 1991b: 36. Among these scholars, Chen Zhongzhong "updated" Tang Lan's study by collecting more examples of Shang-Zhou "tools." He provided an impressive inventory of 207

such examples. This list, however, includes very few excavated Shang and Western Zhou objects. There are only two "hoes" (6.2 cm and 4 cm wide, respectively) and seventeen "spades" (seven from Fu Hao's tomb) from this period. Methodologically, Chen also accepted all the assumptions Tang Lan made more than thirty years ago. His study is therefore not reviewed here in the text.

209. Among these finds, for example, the 1,928 objects found in Fu Hao's tomb include 468 bronzes, weighing 1,625 kg. The excavators have identified some of these bronzes as "tools," but these are chisels with relief *taotie* masks, knives with intricate openwork designs, and spades with fragile hooked shoulders. It is apparent that these objects could hardly have been used in real productive activities (see Institute of Archaeology, CASS 1980: 15, 100–103). Two years after the excavation of the Fu Hao tomb, some 140 bronzes were found in the tomb of Marquis Yi of the Eastern Zhou state of Zeng; a set of bronze bells from this tomb alone weighed 2,500 kg. Archaeologists failed to find even a single bronze implement from the tomb that could have been used in production (see Hubei Provincial Museum 1980: 1–2).

210. Tang Lan 1960: 20–22.

211. This argument is made in Chen Mengjia 1956: 541–42. It might be argued that tools were probably not buried in tombs, but this contention is again rejected by archaeology: thousands of stone tools were discovered in Shang royal tombs, and virtually no bronze implements have been found in excavated Shang-Zhou village sites.

212. *Yuejue shu*, 50.

213. For the "achievements" and historical symbolism of the Yellow Emperor, see H. Wu 1989: 158–59.

214. See, e.g., *Guo yu* ("Qi yu") and *Guanzi*, 156.

215. Clarke et al. 1985: 12.

216. Ibid., 5; see also Althusser 1971; Poulantzas 1973: 99–105.

217. Miller and Tilley 1984: 5.

218. Foucault 1981: 94; see also Foucault 1977, 1980; Miller and Tilley 1984: 5–9.

219. For criticism of Foucault's interpretation of power, see Miller and Tilley 1984: 7.

220. K. C. Chang 1980b: 45; quotation from *ZZ*, 1911.

221. Benton 1981.

222. This interpretation is given in Miller and Tilley 1984: 7.

223. Ibid.

224. K. C. Chang 1983: 9–16.

225. See Luo Kun 1982: 178–91. Military conquests were not, however, the only means of accumulating wealth. Progress in production was achieved during the Shang-Zhou period

through other means, including the development of irrigation systems, new technology, and the organization of labor. For example, it is commonly believed that the establishment of the Xia was a consequence of a grand water project directed by the dynastic founder, Yu, and the Zhou developed the famous *jingtian* (well-field) system.

226. The flourishing of the Shang during this period is best reflected in the abundant furnishings of Fu Hao's tomb, among which many objects are from remote regions. More than 300 inscriptions on oracle bones record Wu Ding's military expeditions against the Gong Fang; over 70 inscriptions pertain to the wars with the Tu Fang. Some of these expeditions were led by Fu Hao.

227. I discuss the social and political significance of Western Zhou investitures in Chapter 2, second section, "From Temple to Palace."

228. *LJ*, 1348; Legge 1967: 1.248.

229. In Foucault's words (1981: 93), "it is the moving substrata of force relations, which by virtue of their inequality, constantly engender states of power."

230. Clarke et al. 1985: 4–6.

231. The original passage in *Yi Zhou shu*, 53, states that King Wu obtained "the Nine Tripods and *sanwu* (three shamans)." In the *SJ* account of the same episode, the term *sanwu* is replaced by *baoyu* (precious jades). Because the characters for *sanwu* and *baoyu* are similar in shape, Tang Lan (1979: 3) has suggested that the correct term should be *baoyu*, *sanwu* being a copyist's mistake. The present version of *Yi Zhou shu* includes documents of different dates and schools. According to Jiang Shanguo (1988: 440), only ten articles in this collection, including "Ke Yin," "Shi fu," "Shang shi," "Du yi," and "Zuo Luo," are authentic works of the Shang and Zhou period and comparable with the *Book of Documents* in historical value. In this study, I draw evidence only from these five documents.

232. *ZZ*, 1743.

233. *Yi jing*, 96.

234. According to Sima Qian (*SJ*, 133), King Cheng ordered the Duke of Zhou and the Duke of Zhao to determine the location of the capital, or the "dwelling of the Tripods" through divination." Li Daoyuan (*SJZ*, 210) recorded that "Jiashan is the name of a town in Ru. After a divination was made, the Tripods were located at this place, which was also the king's eastern capital. It was called the New Capital and was used by the king as his own city. The southeastern [gate] of the city was called the Gate of Tripods."

235. One of these vessels is a *gui* made by Li (see Fig. 1.57) whose inscription begins with the sentence: "It is the time when

King Cheng first moved to the capital Chengzhou" (see W. Fong 1980: no. 42).

236. Yu Weichao (1985: 68–69) and Gao Ming argue that this represents the Western Zhou system, which was then changed during the Eastern Zhou when feudal princes began to use nine *ding*. Sima Qian (*SJ*, 1734) called the Nine Tripods "Three *li* and Six *yi*." According to Sima Zhen, the *li* is a type of tripod with baggy legs, and the *yi* is another type of tripod with handles attached to its outer walls. Bronzes of the first type appeared during the mid-Shang, and those of the second type appeared during the Western Zhou and became popular during the Eastern Zhou.

237. Clarke et al. 1985: 38.

238. John Ruskin (1904: 11.6–7) defines "luxuriance" or "extravagance" in artistic taste as "that character of extravagance in the ornament itself which shows that it was addressed to jaded faculties; a violence and coarseness in curvature, a depth of shadow, a lusciousness in arrangement of lines, evidently arriving out of an incapability of feeling the true beauty of chaste form and restrained power." See also Gombrich 1969: 42–46; Powers 1986; 1991: 74–82.

239. *ZZ*, 2124–25.

240. This is not to say that *liqi* were completely abolished in the late Eastern Zhou. But ritual vessels and luxury goods produced during this period seem very different in form and function. The bronzes from the famous Zhongshan mausoleums in Pingshan, Hebei province, can be classified into two large groups; one group consists of inlaid objects used in palaces, and the other of commemorative bronzes bearing long inscriptions and fashioned in traditional styles.

CHAPTER TWO

EPIGRAPH *Shi jing*, 568; trans. based on Waley 1978: 259.

1. Such studies are often sociological reconstructions and interpretations of *li*; for two representative studies, see Yang Kuan 1965; Chen Shuguo 1991.

2. See Hollier 1992: 46–47.

3. According to the poem "Gong Liu" in the *Book of Songs* (*Shi jing*, 542), Gong Liu, a Zhou ancestor preceding Tan Fu, had built houses at Xu and Bin. But as Cho-yun Hsu (C. Y. Hsu and Linduff 1988: 62) has pointed out, Gong Liu only constructed a temporary settlement, whereas "Tan Fu engaged in large-scale construction in order to build a capital. The endeavors differed not only in scale, but also in intent."

4. Jing was originally the name of the site where Tan Fu built his town, but later this term came to mean "capital." The character *gong* means temple (see Tang Lan 1962: 27–28).

5. Waley's translation quoted in K. C. Chang 1980a: 159–60.

6. *ZZ*, 1782.

7. *LJ*, 1589, 1258.

8. *LJ*, 1258; trans. based on Legge 1967: 1.103–4. Legge translated the character *jia* as "clan," but the corresponding Chinese term for "clan" is *zu* (see *LJ*, 1508). Here the character *jia* means "lineage" or "extended family."

9. See C. Y. Hsu and Linduff 1988: 68–93.

10. *Shi jing*, 615; trans. based on Waley 1978: 270.

11. *Shi jing*, 526; trans. from Waley 1978: 263.

12. Here I follow Tang Lan's (1962: 18) interpretation.

13. See Wang Guowei, "Zhou fengjian kao" (On the Zhou dynasty *fengjian*), in *Guantang jilin*, juan 12.

14. *Shi jing*, 597; trans. from Waley 1978: 232.

15. *Yi Zhou shu*, 52–53; *SJ*, 125–26. Li Xueqin (1959: 9) suggests that since at the time King Wu was far from his homeland, these rituals must have been held in a temporary or "borrowed" ritual site.

16. *Yi Zhou shu*, 54.

17. Ibid., 55; *Lüshi chunqiu*, 53.

18. For a brief introduction to King Cheng's reign, see C. Y. Hsu and Linduff 1988: 123–28.

19. According to *SJ* (128–29) and the "Du yi" (Planning the city) in *Yi Zhou shu*, King Wu first decided to establish a capital in the Luo area. Wei Tingsheng (1970: 68–70) suggests that the construction of Chengzhou during King Cheng's reign followed and realized King Wu's original plan. Scholars usually focus on the political and military significance of Chengzhou: since trouble most frequently arose from the east where the Shang's old base lay, the "eastern capital" Chengzhou was founded in response. Chengzhou, however, was not simply a strategic town but *the* capital of dynastic Zhou. As discussed later in this section, this significance is most clearly revealed by the building of a new dynastic temple in Chengzhou and by placing the Nine Tripods in this city.

20. Chengzhou's construction is most carefully recorded in "Zhao gao" (The announcement of the Duke of Zhao) and "Luo gao" (The announcement concerning Luo) in the *Book of Documents*, and in "Zuo Luo jie" (On the construction of Luo) in *Yi Zhou shu*.

21. *Shang shu*, 211; trans. based on Karlgren 1950a: 48.

22. In "The Announcement Concerning Luo," the Duke of Zhou described his activities in the first person: "On the day *yimao*, in the morning I came to [the intended] capital Luo. I prognosticated about [the region of] the Li River north of the He; I then prognosticated about [the region] east of the Chen River; but again, it was [the region of] Luo that was ordered. I have sent a messenger [to the king] and to bring a map and to present the oracles" (trans. based on Karlgren 1950a: 48).

23. Trans. based on Legge, 1871: 3.451–52; and Karlgren 1950a: 53–55.

24. Jiaxu *ding*, a Western Zhou bronze vessel, bears an inscription that identifies the temple in Chengzhou as Jingzong or Jinggong (*Xi-Qing xujian jiabian*, 1.36).

25. *Yi Zhou shu*, 55.

26. *Shi jing*, 525.

27. *Yi Zhou shu*, 78.

28. The "Methods of Sacrifices" ("Ji fa") section of the *Book of Rites* describes this organization: "Thus the king made for himself seven ancestral temples . . . the temples were—his father's; his grandfather's; his great-grandfather's; his great-great-grandfather's; and the temple of the [High] ancestor. At all of these a sacrifice was offered every month. The temples of the more remote ancestors formed the receptacles for the tablets as they were displaced; they were two, and at these only the seasonal sacrifices were offered"(*LJ*, 1589; trans. from Legge 1967: 2.204). Zheng Xuan identified these two "more remote ancestors" as King Wen and King Wu; see *ZL*, 753, 784. A somewhat different record is found in the "Royal Regulations" ("Wang zhi") section of the *Book of Rites*: "[The ancestral temple of] the son of Heaven embraced seven fanes [or smaller temples]; three on the left and three on the right, and that of his great ancestor [fronting the south]" (*LJ*, 1335; Legge 1967: 1.223). Wang Su of the Wei dynasty argued that all six side shrines belonged to the direct ancestors of the living king and did not include the *tiao*. For a brief discussion of these different opinions, see Tang Lan 1962: 25–26.

29. Only during King Gong's reign could the four *zhao* and *mu* shrines be fully occupied by dynastic kings (Cheng, Kang, Zhao, and Mu). Tang Lan (1962: 26), however, argued that the organization of the Zhou royal temple must have undergone an important change after King Kang's death, as indicated by the posthumous titles of the two following kings, Zhao and Mu. According to the old sequence of temple worship, King Zhao should have belonged to the *mu* sequence and King Mu should have belonged to the *zhao* sequence. The positions of these two kings in the new system seem to have been reversed.

30. *ZL*, 784.

31. According to Wei Tingsheng (1970: 93–101), after King Zhao, Chengzhou was called Zongzhou—the seat of the Zhou lineage.

32. Ibid.

33. *ZZ*, 1743.

34. *SJ*, 133.

35. This vessel, a *zun* commissioned by He, was found in 1963 in Baoji (Shaanxi). Here I follow Tang Lan's (1976) interpretation of its inscription, which has been supported by a number of scholars, including Wang Rencong (1990) and Chen Changyuan (1982). For a summary of different opinions, see Wang Rencong 1990.

36. *LJ*, 1439, 1441, 1595.

37. *Shi jing*, 528–32, 622–27; Waley 1978: 239–80; see also K. C. Chang 1983: 10–15.

38. *Shi jing*, 528; trans. based on Waley 1978: 241.

39. *Shi jing*, 614; trans. from Waley 1978: 269.

40. *Shi jing*, 528; trans. from Waley 1978: 241.

41. *Shi jing*, 532; trans. from Waley 1978: 243.

42. K. C. Chang 1980a: 272–283, 297–306.

43. For preliminary excavations of Qufu by Japanese scholars in the early 1940's, see Komai Kazuchika 1950. Later excavations are reported in Shandong Team of the Institute of Archaeology, CASS, and the Qufu County Cultural Relics Administration 1965. For a summary of these excavations, see Steinhardt 1990: 46–47.

44. Thorp 1983b: 22–26.

45. *Kaogong ji tu*, 104–7, 113. Zou Heng (1979: 27) first noted similarities in the architectural plan of the Erlitou buildings and a Three Dynasties ancestral temple reconstructed by Dai Zhen. He also contended that the Erlitou buildings were royal temples during the late Xia dynasty.

46. Arnheim 1986: 83.

47. These structures were built inside a "palace town," a walled area at the center of the early Shang city at Shixianggou in Yanshi. Excavation reports of this site include Work Team at the Han-Wei Capital Site in Luoyang, Institute of Archaeology, CASS 1984; Henan Work Team No. 2 of the Institute of Archaeology, CASS 1984, 1985, 1988.

48. Thorp 1983b: 26–31. A number of Chinese scholars have discussed the date, function, and identification of this building. For an up-to-date discussion, which includes a summary of different opinions, see Chen Quanfang 1988: 37–69.

49. *LJ*, 1416; trans. based on Legge 1967: 1.370–71.

50. *Shi jing*, 510–11; see Chang 1980a: 159–60; trans. slightly modified.

51. *Shi jing*, 614; trans. based on Waley 1978: 269.

52. *Shi jing*, 583; trans. based on Waley 1978: 226.

53. I suggest in Chapter 1 that ritual bronzes were not the subject of ancestral worship. As sacrificial vessels, they were instruments of this worship. Although their zoomorphic decorative motifs have often been viewed as representations of deities and even the Lord on High, these are not self-contained icons but are surface elements of ritual objects. In fact, Chinese art before the Eastern Zhou was essentially non-iconic. Spirits and deities remained shapeless, and this is why ancestral deities, the most important subjects of religious worship in ancient China, were represented merely by plain wooden tablets. K. C. Chang (1983: 56–80) contends that ritual bronzes, as well as their decoration, were a means of religious communication between man and divinities. It is likely that ritual bronzes served such a religious function through metamorphic animal images.

54. Although many buildings and sacrificial sites have been discovered in Anyang, the site of the last Shang capital, their identities and functions are still the subject of speculation. For discussions, see Shi Zhangru 1959: 326; 1960. Very limited records about the Shang temple system exist. In this chapter, I focus on the Western Zhou temple, whose structure and ritual activities are described in transmitted texts and bronze inscriptions.

55. Creel 1937: 336. For a more detailed discussion of the political functions of the royal temple during the Three Dynasties, see Yang Kuan 1965: 167–74.

56. *LJ*, 1508; see also K. C. Chang 1983: 15–16.

57. *ZZ*, 2134–35; trans. based on Legge 1871: 5.754.

58. Legge 1871: 5.754. The investiture of Kangshu is also recorded in the "Kang gao" (The announcement of Kangshu) in the *Book of Documents*; see Legge 1871: 3.386–91.

59. *Xunzi*, 73. Ancient authors attributed the establishment of these vassal states to the Duke of Zhou. But as Cho-yun Hsu (C. Y. Hsu and Linduff 1988: 127) has pointed out, "There was . . . no actual disparity between the activities of kings Ch'eng and K'ang and those of the duke. The regency of the Duke of Chou and the reign of King Ch'eng overlapped; the duke is simply taken historically as the symbol of the early reigns of the dynasty."

60. For a detailed discussion of this segmentation process, see C. Y. Hsu and Linduff 1988: 153–85.

61. Ibid., 177.

62. *LJ*, 1611.

63. *LJ*, 1335.

64. According to Zheng Xuan's commentary on the *Rites of Zhou*, "*Ce* means to record the king's order on bamboo splits" (*ZL*, 820).

65. For reconstructions of a Western Zhou investiture ceremony, see Chen Mengjia 1956: 109–10; Chen Hanping 1986: 101–30.

66. Chen Mengjia 1956: 110.

67. Sometimes the king announced the order himself, but such examples are very rare; see Chen Hanping 1986: 119.

68. For textual records of Western Zhou investiture ceremonies, see Chen Hanping 1986: 12–20. For a list of Western Zhou bronzes bearing investiture inscriptions, see ibid., 21–25.

69. Chen Hanping (1986: 29–31) actually classified investiture ceremonies into six types. The last type was not held in the Zhou royal temple, however, and was never recorded in bronze inscriptions. It is called *zhuiming*, or a "posthumous order" given to a deceased minister or relative. Usually the Zhou king sent an official to the home state of the deceased to conduct this ritual.

70. In a poem from the *Book of Songs* (*Shi jing*, 565–68; see Legge 1871: 4.536–39), the Zhou king ordered the Lord of Shen to continue the services of his forebears.

71. For examples of these two kinds of investiture, see Chen Hanping 1986: 30.

72. Ibid., 30. In fact, Sima Qian (*SJ*, 127) recorded that it was King Wu who enfeoffed the Duke of Zhou and his other brothers. If this record is reliable, then the orders King Cheng gave his uncles belonged to the type of investiture called *chongming*.

73. *Baihu tong*, "Jue." Similar statements are found in the "Ji tong" ("Tradition of sacrifices") and "Ji yi" ("Meaning of sacrifices") sections in the *Book of Rites*; see Chen Hanping 1986: 65.

74. An archaeological complex discovered at Majiazhuang village in Fengxiang (Shaanxi) may be identified as the remains of the temple of a Zhou lord. But this group of ritual buildings, presumably the ancestral temple of the state of Qin, was constructed during the Spring and Autumn period after the Western Zhou; see Yongcheng Archaeological Team of Shaanxi Province 1985; Han Wei 1985. I therefore exclude this example from my discussion.

75. Luo Xizhang 1988. According to an inventory list included in Luo's article, 454 bronzes have been found in Western Zhou "storage pits" since 1949. But the number of articles from four hoards discovered before 1949 are unclear. To my knowledge, three of these four hoards (the Liangqi group from Renjiacun, the Hanhuangfu and Baixian group from Kangjiacun, and the group from Qishan including the famous Maogong *ding* and Dafeng *gui*) yielded hundreds of bronzes.

76. Huang Shengzhang 1978: 199–20.

77. Guo Moruo 1963: 5.

78. Luo Xizhang 1988: 44.

79. For example, members of the Ta lineage and Baigong Fu's descendents buried their ritual bronzes in at least two hoards, respectively; see ibid., 43.

80. For a concise report on this excavation, see Zhouyuan Archaeological Team 1978.

81. Rawson 1990: 2a.19.

82. Li Xueqin 1978: 157.

83. Falkenhausen 1988: 985n55. Falkenhausen interprets this phenomenon in terms of the Wei clan's fission, which, according to traditional texts, would occur regularly every five generations. For this custom, see K. C. Chang 1976: 72–74.

84. As mentioned earlier, this hoard yielded bronzes datable to the late Shang or early Zhou based on their shape and decoration. But their inscribed commissioners were probably not members of the Wei clan. One of them, named Shang, may have belonged to the Ji royal clan of the Zhou. It is possible that the Wei clan acquired such bronzes through marriage. See Tang Lan 1978: 21; Falkenhausen 1988: 985.

85. For illustrations and inscriptions of these bronzes, see *Shaanxi chutu Shang Zhou qingtongqi* 2.28–42; and Zhouyuan Archaelogical Team 1978: 3–4.

86. The following English rendering of the inscription is based on C. Y. Hsu and Linduff 1988: 115, and a manuscript that Falkenhausen kindly provided to this author. For discussions of this inscription, see Tang Lan 1978; Li Zhongcao 1978; Qiu Xigui 1978; Xu Zhongshu 1978; Li Xueqin 1978; Chen Shihui 1980.

87. As Falkenhausen (1988: 981) has pointed out, the first paragraph of this new inscription is derived from the Shi Qiang *pan* inscription: "They quote two short passages of 24 characters each that are separated by 109 characters in the much longer *pan* inscription."

88. A group of bronzes from the hoard, commissioned by a certain Bo Xian Fu, can be dated to the late Western Zhou according to their formal attributes. It is unclear whether Bo Xian Fu is another of Xing's names or the name of Xing's son; see Li Xueqin 1979: 30.

89. *Lidai zhongding yiqi kuanzhi*, 10.88ab; see Tang Lan 1978: 19. This also suggests that the Wei lineage may have buried their temple bronzes in more than one pit.

90. Some authors date this bronze to King Yi's reign. Here I follow Li Xueqin's (1979: 35) opinion.

91. Trans. partially from Falkenhausen 1988: 976–78.

92. Trans. based on ibid., 967–71.

93. Gernet 1972: 58.

94. Ibid., 62.

95. For a concise summary of these excavations, see Steinhardt 1990: 46–53.

96. For a discussion of the Western Zhou regulations on city planning, see He Yeju 1983: 200–201.

97. *ZZ*, 1716.

98. According to recent surveys, the Royal Capital (Wang-

cheng) at Luoyang was square in shape, with a north wall 2,890 meters long; the length of the entire city wall was thus about 12,500 meters. Qufu, the capital of Lu, had a 12,000-meter wall. The wall of Linzi, the capital of Qi, was about 15,000 meters. The outer city of Xinzheng, the capital of Zheng, was about 16,000 meters in circumference. The walls of Yan's Lower Capital were over 27,000 meters, including the partition wall between its eastern and western cities (see Ye Xiaojun 1988: 61–76).

99. Cultural Relics Work Team of the Hebei Provincial Cultural Bureau 1965.

100. *Kaogong ji tu*, 102; see Steinhardt 1990: 33. Scholars commonly consider the *Kaogong ji* an independent treatise written during the Warring States period by Confucians from the state of Qin. After it was integrated into the *Rites of Zhou* during the Han, this treatise was canonized, and the "state capital" described in the text was believed to be the Zhou royal capital. But the text does not provide this identification.

101. Shandong Provincial Cultural Relics Administration 1961; Qun Li 1972; Liu Dunyuan 1981; Zhang Longhai and Zhu Yude 1988.

102. *Xin yu*, 134.

103. See *TPYL*, 861–64.

104. *Hanzi* (The writing of Hanzi), quoted in ibid., 862.

105. *SJ*, quoted in *TPYL*, 861.

106. *Shuo yuan*, quoted in *TPYL*, 863.

107. *SJ*, 192.

108. *Xin xu*, quoted in *TPYL*, 863.

109. Precisely speaking, Shang Yang moved the Qin capital from Liyang to Xianyang. But Liyang was only one of several temporary capitals of the kingdom; before the establishment of Xianyang, Yong had been the Qin's chief political and religious center. Sima Qian (*SJ*, 2232) thus stated that "Lord Shang moved the capital from Yong to Xianyang."

110. Ibid.

111. Wang Xueli 1985: 18.

112. Sima Zhen's commentary at *SJ*, 2232.

113. Sun Yirang's commentary at *ZL*, 648; see also *Lüshi chunqiu*, 281.

114. Archaeological Station at the Qin Capital Xianyang 1976. The authors of this and some other articles initially identified the buildings as part of the Xianyang Palace of the First Emperor. But other scholars have argued, quite convincingly in my opinion, that they were actually founded by Shang Yang and were later enlarged by the First Emperor; see Wang Xueli et al. 1979; Wang Xueli 1982.

115. Yang Hongxun 1976*b*.

116. Yang Kuan 1965.

117. According to Yang Hongxun's (1987: 72, 100) reconstruction, both the Shang temple at Erlitou and the Western Zhou temple at Fengchu had a foundation of about 1 meter high.

118. For a statement of this theory, see ibid., 82.

119. Ibid., 155. I will discuss the *guan* in greater detail in the final section of this book.

120. *SFHT*, 3–4. For an inventory of these palaces, see Wang Xueli 1985: 38–54.

121. *Miao ji* (A record of temples), quoted in Zhang Shoujie's commentary in *SJ*, 241.

122. *SJ*, 239; trans. based on H. Y. Yang and G. Yang 1979: 168.

123. Ibid.

124. I discuss the symbolism of the Nine Tripods in the Introduction to this book.

125. *SJ*, 256; trans. based on H. Y. Yang and G. Yang 1979: 179.

126. Keightley 1978*b*: 217.

127. See *LJ*, 1605–7.

128. *LJ*, 1495, 1508, 1589; see also K. C. Chang 1983: 37–41.

129. Institute of Archaeology, CASS 1980: 4–6. Remains of aboveground mortuary houses from the later Shang dynasty have also been found in Dasikong village; see Ma Dezhi et al. 1953: 20.

130. K. C. Chang 1980*a*: 119–24.

131. *ZL*, 757–59.

132. *LJ*, 1595–96.

133. It is important to distinguish "funerary rituals" (*sangli*) from "grave sacrifices" (*muji*) in ancient Chinese ritual practices. The former were carried out immediately following a death; the latter refer to rituals practiced routinely in graveyards. The Three Ritual Canons describe the "funerary ritual" at great length but make no mention of the "grave sacrifice."

134. The origin of "grave sacrifices" has been the focus of a debate among Chinese scholars for some 2,000 years. Scholars of the Eastern Han held similar opinions on this issue. Wang Chong provided a typical statement (*Lun heng*, 469): "Ancient people held ancestral sacrifices in temples; nowadays people have the custom of sacrificing in graveyards." Similar statements also appear in the writings of two distinguished Eastern Han historians, Ying Shao and Cai Yong. Ying Shao reported: "In ancient times the ritual of 'grave sacrifices' did not exist. . . . Emperors [of the present] hold ceremonies in the first month of the year at the Yuan ling Mausoleum" (quoted in *HHS*, 99). The same idea was expressed even more categorically in a statement by Cai Yong quoted in note 168 below.

Confusion about the origin of grave sacrifices first appeared during the Jin dynasty. Sima Biao's statement that "the mausoleum sacrifice had been practiced during the Western Han"

(*HHS*, 3103) contradicted the belief of Eastern Han historians that the ceremony had not existed until Emperor Ming created it. Going even further, Sima Biao argued that the "grave sacrifice" had actually been initiated during the Qin dynasty: "In ancient times the ritual of the 'grave sacrifice' did not exist. The Han mausoleums all contained a *qin* hall because the Han followed the regulation of the Qin" (*HHS*, 3199–200).

This issue became a favorite topic in the Qing dynasty. Some scholars, such as Xu Qianxue and Gu Yanwu disagreed with Sima Biao and returned to the view of Han historians (*Duli tongkao*, 94.1b; *Rizhi lu*, 15.1–3). Other scholars represented by Yan Ruoju (Yan Ruoju et al. 1967: 20.14ab) derived their evidence from historical writings and the Confucian classics to prove that the ritual of the "grave sacrifice" not only had existed during the Qin and Western Han but had actually been practiced by disciples of Confucius and even by King Wu of the Zhou dynasty.

This debate has been renewed during recent years. In 1982, Yang Hongxun (1982: 403) declared that the ritual practice of the grave sacrifice can be traced back as far as the Shang dynasty. He provided archaeological evidence including the sacrificial ground discovered at the Shang royal cemetery, the remains of Shang-Zhou aboveground mortuary houses, and the "design of the royal cemetery of the Zhongshan kingdom." Opposing him was the noted historian Yang Kuan (1982: 31; 1983: 636–40), who based his entire argument on the argument built by Gu Yanwu and Xu Qianxue, and concluded that the pre-Han funerary structures found in archaeological excavations "could only be *qin* halls—the 'retiring room' for the soul of the deceased, rather than 'offering halls' in which people held ritual sacrifices to their ancestors." A third scholar, Wang Shimin (1981: 465), returned to Sima Biao's opinion, saying that the official "grave sacrifice" was initiated by the First Emperor.

In my opinion, this debate has been caused by different understandings and uses of the term *muji*, or "grave sacrifice." Yan Ruoju and Yang Hongxun understood the word in its general, broad sense as any kind of ritual held in a graveyard; Sima Biao and Wang Shimin understood it in a narrower sense as the imperial sacrifices held in mausoleums; the Han dynasty scholars, as well as Gu Yanwu, Xu Qianxue, and Yang Kuan, used the term in a specific sense to mean the most important official ancestral sacrifice held in the royal mausoleums in the first month of the year—that is, the *shangling* ceremony initiated by Emperor Ming of the Eastern Han in A.D. 58.

In short, these scholars have focused on two different historical problems: one is the origin of the ritual practice of grave sacrifices; the other is the formulation of the official "mausoleum sacrifice." Both kinds of ritual are important for our understanding of the development of ancestor worship in ancient China.

135. *LJ*, 1275.

136. Ibid., 1292.

137. For two reconstruction plans of the Zhongshan mausoleum, see Yang Hongxun 1980 and Fu Xinian 1980. In addition to the plan of the Zhongshan mausoleum, an important Warring States mausoleum excavated in Guweicun, Hebei, has been identified as a royal burial of the state of Wei. The plan of the mausoleum is similar to that of the Zhongshan mausoleum; the square funerary park, encircled by double walls, was centered on three individual sacrificial structures built in a row on a terrace (see Yang Hongxun 1980: 131–32).

138. *ZL*, 786. This passage records that the *zhongren*, or the officer in change of tombs, was "to regulate the measurement of the tumuli and the number of trees [planted in the graveyards] according to the rank of the deceased." For a specific study on the Qin funerary system, see Ma Zhenzhi 1989.

139. *Shangjun shu*, 74.

140. *Lüshi chunqiu*, 98.

141. General excavation reports and studies on the Lishan Mausoleum include Shaanxi Provincial Cultural Relics Administration 1962: 407–11; Thorp 1983a; Yang Kuan 1985: 183–201.

142. *SJ*, 265.

143. See note 53 to this chapter.

144. Han Wei 1983; Shaanxi Provincial Archaeological Institute 1987.

145. Lishan xuehui 1987. My discussion does not follow the Lishan xuehui's suggestion that the Lishan mausoleum was one of the Lintong Qin royal tombs.

146. Remains of buildings have been found between the two walls of the funerary park. Pottery vessels unearthed there are stamped with inscriptions such as *Lishanyuan* (Lishan mausoleum) and *Lishan shiguan* (the sacrificial officer of the Lishan mausoleum), and thus identify these buildings as departments of ritual affairs (see Zhao Kangmin 1980; Wang Xueli 1989).

147. This architectural complex consisted of four individual buildings arranged in an east-west row. The largest was about 20 meters long and 3.4 meters wide, with an elaborate limestone doorway. Its walls were constructed of plastered stone and the walkways were paved with stones. Other remains, including postholes, large bricks, and decorated tiles, suggest that these buildings were wooden-framed structures with tiled roofs (Zhao Kangmin 1979).

148. *Du duan*, 20; see Yang Kuan 1985: 638.

149. Lishan xuehui, 89.

150. Quoted at ibid., 89.

151. Important archaeological reports regarding excavations in the outer district of the Lishan mausoleum include Archaeological Team of the Qin Terra-cotta Army 1975; 1978; 1979; 1980a; 1980b; 1982a; 1982b.

152. The pre-dynastic Qin temple system is not clear. According to *SJ* 266, the most important royal temples were located in the two capitals, Yong and Xianyang. Other records, however, suggest that from King Zhao's reign on a temple was built near a deceased ruler's mausoleum; see Yang Kuan 1985: 24.

153. *SJ*, 241.

154. Ibid., 266.

155. *LJ*, 1292; trans. based on Legge 1967: 1.155−56.

156. Z. S. Wang 1982: 175−79.

157. Luo Fuyi 1960.

158. *Li shi*, 6806.

159. Quoted in Zhu Kongyang 1937, 13.5a.

160. *LJ*, 1589: "The mass of ordinary officers and the common people had no ancestral temple. Their dead were left in their ghostly state" (trans. Legge 1967: 2.206).

161. According to the biography of Wei Xuancheng (*HS*, 3115−16), a Western Han mausoleum contained four major architectural units: the *qin* or "retiring hall," the *biandian* or "side hall," the *yeting* or place for concubines, and the imperial offices.

162. According to textual evidence, free-standing sculptures of the Qin, such as the famous Twelve Golden Men, were erected above ground only in the imperial palace (see *SJ*, 239). From the epoch of Emperor Wu of the Western Han, large stone figures for funerary purposes began to be placed on the ground in front of mausoleums. Remains of such statues were repeatedly found in front of Emperor Wu's tomb, flanking the Spirit Path (see Xie Mincong 1979: 58). The stone statues in front of Huo Qubing's tomb may support the authenticity of this report. Huo was a famous general under Emperor Wu, and his tomb was one of the satellite burials near the emperor's mausoleum.

As I discuss in Chapter 3, in the early Han dynasty, a satellite burial system was established. In this system, an emperor's tomb was the focal point of the mausoleum complex and surrounded by the tombs of his concubines, relatives, and meritorious ministers and generals. The scale of such burials is astonishing. According to archaeological surveys, at least 175 satellite burials surrounded Emperor Gaozu's tomb, 34 surrounded Emperor Jing's, and 59 surrounded Emperor Xuan's (see Liu Qingzhu and Li Yufang; Yang Kuan 1985: app. 1).

163. *SJ*, 2725−26.

164. Wang Pizhong et al. 1980; Li Hongtao and Wang Pizhong 1980. It is also reported that a large architectural foundation, 51 meters long and 29.6 meters wide, was found southeast of Emperor Xuan's mausoleum. The reporter identified this building as a *qin* hall, but since the foundation was located outside the funerary park, it was more probably the remains of a *miao* (see Archaeological Team of the Du Mausoleum 1984).

165. *HS*, 2130.

166. For example, we read in texts that King Wuling of Zhao passed on the throne to his younger son in the Zhao ancestral temple; that Ying Zheng, the future emperor of Qin, stayed overnight in the Qin ancestral temple at Yong before becoming the heir; and that all the emperors of the Western Han designated their crown princes in the Great Ancestral Temple dedicated to the founder of the dynasty (see *SJ*, 1812; *SFHT*, 43). Again, according to *HS* (3115−16), only daily meals were offered to a deceased emperor in his *qin*; the more important monthly sacrifices were held in his *miao*.

167. *HHS*, 99.

168. For example, Cai Yong stated in A.D. 172 after attending the "mausoleum sacrifice" that year: "I heard that the ancients did not sacrifice to their ancestors in graveyards, and I had wondered about the necessity of the ritual of the 'mausoleum sacrifice' practiced by the present court. Only after I witnessed the dignified manner of the ceremony today did I begin to realize its original motivation. Now I understand the complete filial piety and sincerity of Emperor Filial Ming [who initiated the ritual]. It would be improper to replace this ritual with the old custom" (*HHS*, 3101).

169. Ibid., 27−28, 3194−95.

170. Ibid., 32.

171. Ibid., 1−87.

172. *Rizhi lu*, 15.2−3.

173. *HHS*, 123−24.

174. Zhao Yi 1960: 32ab.

175. See Powers 1984.

176. During the Eastern Han, the funerary shrine of a family was open to the public. This is most clearly indicated by the An Guo inscription translated in Chapter 4; see Li Falin 1982: 101.

177. *Sanguo zhi*, 81; *Jin shu*, 634.

178. For a discussion of these archaeological finds and their implications, see Wu Hong 1989. Some Chinese archaeologists have tried to explain why Han pictorial carvings were reused in constructing these Wei-Jin tombs. For example, Li Falin (1982: 50) suggested that the custom of making funerary pictorial carvings ceased around the end of the Eastern Han and considered that this change was caused by the Yellow Turban

rebellion in the Shandong region, which "smashed local feudal despots and landlords so that they could not continue this sort of extravagant funerary services, which wasted a great amount of time, manpower, and material." In my opinion, this interpretation is too vague to explain the destruction of funerary shrines on a nationwide scale.

179. G. D. Su 1964: 203; cited in Li Yunhe 1982: 29.

180. Liu Zhiping 1957a: 22.

181. Needham 1954–88: IV.3.90.

182. Patterned bronze panels and joints were used in some elaborate Eastern Zhou palatial structures. But this technique never developed into a prevalent architectural convention. In fact, understood in the Eastern Zhou social context, this way of using bronze reflected the decline of traditional ritual art and the growing importance of architectural monuments.

183. To my knowledge, the only pre-Han funerary stone inscription is found in the mausoleum of a Zhongshan king. But since the stone retains its natural shape and the inscription has nothing to do with the deceased, it is difficult to identify it as a memorial stela (see Hebei Cultural Relics Administration 1979; Fan Bangjin 1990: 52).

184. Passage from the inscription on Wu Liang's memorial stela; see H. Wu 1989: 25. A similar statement is found in a long inscription from Songshan, Shandong, discussed later in this chapter.

185. As mentioned earlier in this book, the ancient Chinese distinguished jade from stone and gave jade a special symbolism. Likewise, the exquisite marble carvings found in great Shang royal tombs, including imitations of bronze ritual vessels and large and small sculptures, must also be distinguished from ordinary stone products. Some texts record the construction of certain stone buildings before the Qin-Han period. For example, it is said that King Zhao of Yan honored the philosopher Zou Yan with a "stone palace" (SJ, 2345). But such instances are extremely rare.

186. In addition to a "stone chamber" of the Queen Mother of the West recorded in SJ, 3163–64, extant stone structures dedicated to gods and immortals include pillar-gates at Dengfeng in Henan, one forming the entrance to the sacred mountain Shaoshi and the other belonging to the temple of a legendary figure Qimu (the Mother of Qi; see Chen Mingda 1961: 10–11).

187. Loewe 1982: 25.

188. Gu Jiegang 1935: 16.

189. Trans. from Watson 1968b: 33. Ying-shih Yü (1987: 387) remarks: "The only difference between the *hun* [soul] and the *hsien* [*xian*; immortal] is that while the former leaves the body at death the latter obtains its total freedom by transform-

ing the body into something purely ethereal, that is, the heavenly *ch'i* [*qi*; breath, ether, etc.]."

190. See my discussion of the relationship between Emperor Wu and necromancers in Chapter 3.

191. Y. S. Yü 1987: 378.

192. This understanding is most clearly stated in *Xunzi*, 231–51.

193. Mori 1943. A recent archaeological discovery indicates that even during the early Western Han, the underground bureaucracy was still modeled upon the social hierarchy: Mawangdui Tomb no. 3 yielded a wooden tablet on which an inscription, written by the "family retainer" (*jiachen*) of the deceased, informs the assistant master of funerary goods (*zhucang langzhong*) that a complete collection of burial goods (*cangwu*) had been transmitted to the lord administrator of funerary goods (*zhucangjun*; Hunan Provincial Museum and Institute of Archaeology, CASS 1974: 43).

194. During Emperor Wu's time, Penglai was often associated with a divine master named Anqi Sheng, who was originally a necromancer of pre-Qin times (SJ, 453–55; Watson 1958: 2.38–40). Another legendary figure, Xiwangmu or the Queen Mother of the West, was first among a number of personages who, according to Zhuangzi, had succeeded in attaining immortality (see Legge 1891: 293). This figure became associated with Mount Kunlun during the Han (H. Wu 1989: 117–26).

195. SJ, 1388.

196. For a sociological explanation of the development of Han funerary art, see H. Wu 1988.

197. *Baopu zi*, 2.6. This record is an elaborate version of a passage in SJ, 1386.

198. SJ, 1396.

199. Quoted in *Baopu zi*, 2.6.

200. Sima Qian only stated that Ba ling was a rock-cut burial but said nothing about its internal structure. We find an interesting record in the *Yong da ji* (Record of the greater Yong area) by He Jingming of the Ming dynasty: "In the autumn of the *xinmao* year during the Zhiyuan reign period [1291], the flood of the Ba River broke up Ba ling's outer gate. More than 500 stone slabs were washed out [from the rock-cut tomb]." It seems that stone structures may have been originally built inside the tomb—an assumption supported by excavated rock-cut Western Han tombs at Mancheng and other places. According to the SJ, before his death Emperor Wen ordered that only clay objects be buried in his tomb and that no gold and silver decoration should be used. But when the tomb was looted in A.D. 315, grave robbers found that the burial chamber was

filled with "shining gold and jades" (see Lin Liming and Sun Zhongjia 1984: 28–29).

201. *SJ*, 364.

202. *SJ*, 2753.

203. Bauer 1976: 95–100.

204. Gu Jiegang 1935: 15–17.

205. *SJ*, 3166; Watson 1958: 280.

206. Sickman and Soper 1956: 21.

207. See Said 1979: 49–73. For Said, Orientalism was a specific historical phenomenon in European culture. But his analysis may help explain the Han fascination with the idea of a mysterious alien space.

208. These places are identified in Watson 1958: 274–75.

209. For example, Zhang Qian told the emperor that "the coins of Anxi [Persia] are made of silver and bear the face of the king. When the king dies, the currency is immediately changed and new coins issued with the face of his successor" (*SJ*, 3162; trans. based on Watson 1958: 278).

210. "The old men of Anxi say they have heard that in Tiaozhi are to be found the River of Weak Water and the Queen Mother of the West" (*SJ*, 3163–64; trans. based on Watson 1958: 278). Some scholars have identified the Weak Water as being near the Persian Gulf; see Loewe 1979: 150*n*51.

211. Bachelard 1964: 183–231.

212. Said 1979: 54, 72, 70.

213. It is said that winged heavenly horses were found in the third year of the Yuanshou era (120 B.C.) and again in the fourth year of the Taichu era (101 B.C.). In celebrating these events, Emperor Wu wrote two poems: " . . . The horse of Heaven has come. / Open the far gates, / Raise up my body, / I go to Kunlun"; and "The horse of Heaven has come. / Mediator for the dragon, / He travels to the gates of Heaven, / And looks on the Terrace of Jade" (*HS* 176, 202, 1067). The same emperor also wrote a poem for a tribute elephant: "The elephant, white like jade / Came here from the West . . . / It reveals Heaven's will, / Bringing happiness to human beings" (*HS*, 176, 1069).

214. H. Wu 1984: 43.

215. "After Zhang Qian achieved honor and position by opening up communications with the lands of the West, all the officials and soldiers who had accompanied him vied with one another in submitting reports to the emperor telling of the wonders and profits to be gained in foreign lands and requesting to become envoys. The emperor considered that, since the lands of the West were so far away, no man would choose to make the journey simply for his own pleasure, and so when he had listened to their stories he immediately presented them

with the credentials of an envoy. In addition he called for volunteers from among the people and fitted out with attendants and dispatched anyone who came forward, without inquiring into his background, in an effort to broaden the area that had been opened to communication." Some of these envoys indeed reached the West, but others spent the emperor's money somewhere else. "All of them," said Sima Qian who lived in that age, "would in turn start at once enthusiastically describing the wealth to be found in the foreign nations; those who told the most impressive tales were granted the seals of an envoy, while those who spoke more modestly were made assistants. As a result all sorts of worthless men hurried forward with wild tales to imitate their examples" (*SJ*, 3171; trans. based on Watson 1958: 286).

216. Waley 1955.

217. Anthony F. P. Hulsewé rejects Waley's interpretation as unproved, and puts forward two other suggestions: either the horses were sought for Emperor Wu's stables, or they were prized as a means of improving the Chinese breed of horses (Loewe and Hulsewé 1979: 134*n*332).

218. For a detailed discussion of the development of the Kunlun myth and the belief in the Queen Mother of the West, see H. Wu 1989: 110–41, esp. 117–26.

219. *Huainan zi*, 4.13.

220. *HS*, 2596; trans. from Dubs 1942: 232.

221. *HS*, 1611; see Dubs 1942: 233; Loewe 1979: 96.

222. For photos and descriptions of these stone works, see Paludan 1991: 17–27. It is tempting to link these sculptured works with a statue that Huo Qubing seized during his expedition to the northwest. The records of this event, however, remain open to doubt. In the earliest sources the statue was named "the golden man [used by] the king of the Xiutu in sacrificing to Heaven." Another version of the story is found in the *Han Wu gushi* (The tale of Emperor Wu of the Han): "After the king of Kunxie killed the king of Xiutu, he surrendered his tribe to [the Han court]. He obtained the divine golden men [from Xiutu], and [after these statues were presented to the Han court], they were placed in the Ganquan Palace. These golden men were all more than ten *chi* high. No cows or sheep were used in sacrifices to them, and only incense was burned and people worshipped." Based on the description of the ritual, Liu Xiaobiao (462–521 A.D.) suspected that these were actually Buddhist images. This interpretation is unreliable because even Indians did not make anthropomorphic images of the Buddha during the second century B.C. For discussions of records related to the statue, see Ren Jiyu 1981: 61–62; Zürcher 1959: 21.

223. For excavation reports and discussions of these rock-

cut tombs, see Shandong Provincial Museum 1972; Xuzhou Museum et al. 1988; Li Yinde, 1990. Nanjing Museum and Tongshan Cultural House 1985; Nanjing Museum 1973; Xuzhou Museum 1984; Thorp 1987, 1991.

224. Institute of Archaeology, CASS, and Hebei Provincial Cultural Relics Administration 1980. For an English introduction to the tombs, see Thorp 1991.

225. *SJ*, 256.

226. Nails with traces of wood were found in the rear chamber. The excavators hypothesized that in order to secure the stone panels, pieces of wood may have been inserted into the gaps between these panels (Institute of Archaeology, CASS, and Hebei Provincial Cultural Relics Administration, 1980: 1: 22). This method, however, could not possibly secure the stone ceiling without the support of beams and lintels.

227. Ibid.

228. It is said that Zhang Qian, after staying in the Western Territories (Xiyu) from 138 to 126 B.C., "reported on Indian Buddhism" to the emperor on his return. For discussions of this episode and related historical records, see Ren Jiyu 1981: 59–60; Zürcher 1959: 20–21. According to another tradition, a Chinese envoy named Jing Lu was instructed in the teachings of Buddhist sutras by the Yuzhi prince in the year 2 B.C. This story occurs first in the *Wei lue* (A brief history of Wei), compiled around the mid–third century by Yu Huan; see *Sanguo zhi*, 366b.

229. The Eastern Han text *Gujin zhu* (Commentaries on past and present events) by Fu Wuji records architectural plans of the mausoleums of the twelve Eastern Han emperors. According to this record, five Eastern Han imperial cemeteries shared the same design, and each contained a "stone palace." The earliest one belonged to Emperor Ming (*HHS*, 3149).

230. *Luoyang jialan ji*, 196, records: "Upon the emperor's death, [a model of] Jetavana Garden was built on his tomb. Thereafter stupas were sometimes constructed [even] on the graves of the common people" (trans. based on Y. T. Wang 1984: 173). *Lihuo lun* also records that Emperor Ming's tomb bore an image of the Buddha; quoted in *Luoyang jialan ji*, 198.

231. Based on archaeological finds, old texts, and inscriptions, I have identified 33 stone shrines. All these examples were built during the 150 years from the mid–first century to the end of the second century. A study of the 23 Han imperial funerary shrines further confirms that the change in building material from wood to stone occurred in the mid–first century A.D. According to archaeological surveys, the offering shrines of all Western Han emperors were wooden-framed structures covered with tile roofs. Remains of large foundations, roof tiles,

and pillar bases have been observed in the funerary parks of five Western Han rulers, namely, Emperors Jing, Wu, Zhao, Xuan, and Yuan. As mentioned earlier, the first imperial stone shrine was built for Emperor Ming soon after A.D. 58 (see H. Wu 1987a: 426–504).

232. A pillar-gate at Zitong in Sichuan has been attributed to Li Ye, who died in A.D. 36. Although this gate lacks an original inscription, two other early stone gates that bear inscribed dates are the Huang Shengqing gate and the Gongcao gate, both located at Pingyi in Shandong. The Huang Shengqing gate was built in A.D. 86, and the Gongcao gate in A.D. 87 (see Chen Mingda 1961: 11).

233. Some Western Han stone tablets have been found, but their inscriptions are short and usually only document the construction of burial structures. These early examples differ from Eastern Han stelae, which recorded the life and merit of the deceased (see Yang Kuan 1985: 154–56).

234. According to *SJZ*, 294, stone horses and elephants were erected along the Spirit Road at the mausoleum of Emperor Guangwu, the founder of the Eastern Han. But according to *Dongguan Han ji*, 13, the construction of this mausoleum only began in A.D. 50 (see Lin Liming and Sun Zhongjia 1984: 37). For a general introduction to Eastern Han mortuary statues, see Yang Guan 1985: 150–51.

235. For discussions of Eastern Han rock-cut tombs in Sichuan, see T. K. Cheng 1957: 139–54; Fairbank 1972: 19–28; H. Wu 1987a: 459–64.

236. For the history and textural resources of this temple, see Ren Jiyu 1981: 101–3.

237. *HHS* 1428–29. Evidence for Liu Ying's worship of the Buddha can also be found in an edict issued by Emperor Ming: "The Prince of Chu recites the subtle words of Huanglao, and respectfully performs the gentle sacrifices to the Buddha. After three months of purification and fasting, he has made a solemn covenant (or: a vow) with the spirits. What dislike or suspicion (from Our part) could there be, that he must repent (for his sins)? Let [the silk which he sent for] redemption be sent back, in order thereby to contribute to the lavish entertainment of the upāsakas and śramanas" (*HHS* 72. 5; trans. based on Zürcher 1959: 1.27). Emperor Ming and Liu Ying grew up together, and they remained close. *HHS* (102, 109, 110, 114) records that after Liu Ying became prince of Chu in A.D. 41, he met the emperor in Luoyang at least four times, in 56, 59, 63, and 68.

238. Zürcher 1959: 1.26.

239. Ibid., 1.30.

240. *HHS* 1092, 2922. See Tang Yongtong 1938: 56. I have

proposed elsewhere that the emperor sacrificed to the Buddha as part of his Daoist worship (H. Wu 1986: 300–301).

241. *HHS*, 1075.

242. The original record reads: "He erected a large Buddhist temple. From bronze he had a human [effigy] made, the body of which was gilded and dressed in silk and brocade. [At the top of the building] nine layers of bronze scales were suspended, and below there was a building of several stories with covered ways, which could contain more than 3,000 people, who all studied and read Buddhist scriptures. He ordered the Buddhist devotees from the region [under his supervision] and from the adjacent prefectures to listen and to accept the doctrine. [Those people] he exempted from the other statutory labor duties in order to attract them. Those who on account of this from near and afar came to [the monastery] numbered more than 5,000. Whenever there was [the ceremony of] 'bathing the Buddha,' he had always great quantities of wine and food set out [for distribution], and mats were spread along the roads over a distance of several tens of *li*. [On these occasions] some 10,000 people came to enjoy the spectacle and the food. The expenses [of such a ceremony] amounted to many millions [of cash]" (*HHS* 2368; *Sanguo zhi*, 1185; trans. based on Zürcher 1959: 1.28).

243. H. Wu 1986: 297–303.

244. Sima Qian recorded that when Zhang Qian visited Daxia, he saw bamboo canes from Qiong and cloth made in Sichuan, which were imported to Daxia via India. He therefore speculated that a direct route must have connected India and southwest China. Upon receiving this report, Emperor Wu sent troops to attempt to reopen this route (*SJ*, 3166). In a previous study I have examined some 50 motifs and artworks that show Indian influences. Only those from Sichuan imitate Indian prototypes in a quite literal manner; those from eastern China are free interpretations of Indian works (H. Wu 1986: 266–73).

245. *Luoyang jialan ji*; quoted in Zhu Kongyang 1937: 13.10a.

246. *Chu sanzang ji*, 42–43. Zürcher (1959: 1.29–30) believes that the *Sutra in Forty-two Sections* was written during the late first or early second century.

247. *Fayuan zhulin*, juan 13.

248. *Hou Han ji*, juan 10, 122.

249. See Tang Yongtong 1938: 3–4. There are many conflicting opinions concerning the authenticity of the *Lihuo lun*. Some leading scholars, e.g., Hu Yinling, Liang Qichao, Tokiwa Daijo, and Lü Zheng, have considered this treatise a spurious work. Others, more numerous, e.g., Sun Yirang, Hu Shi, Tang Yongtong, Henri Maspero, and Paul Pelliot, regard it as an in-

valuable source of information on the earliest history of Chinese Buddhism. Fukui Kojun (1952) reexamines most of these opinions in his extensive study on this work. He concluded that the treatise was written around the middle of the third century (see also Zürcher 1959: 1.13–15).

250. I have found a number of mirrors bearing Buddha images, but these were all created after the second century. Buddhist images have also been found on a cliff near Lianyungang in Jiangsu, but these may have been created after the second century. For a discussion of these works, see H. Wu 1986: 273–302.

251. For a more detailed discussion of these motifs and their contexts, see ibid., 268–73.

252. H. Wu 1989: 132–40.

253. H. Wu 1986: 266–69.

254. These are lines from the Han folk song, "Buchu Ximen xing" (Strolling out the western gate).

255. Translation from Birrell 1988: 75.

CHAPTER THREE

1. My quotation of the poem is based on the trans. in Graham 1965: 106.

2. *HS*, 4193.

3. Schorske 1963.

4. For a concise and critical introduction to these two approaches, see Kostof 1991: 43–45. Some scholars have consciously tried to employ these two views as alternative methods in their reconstruction of a city. Thus, the first and second chapters in Anselm L. Strauss's (1961: 5–31) popular book, *Images of the American City*, focus on the spatial and temporal aspects of a city, respectively.

5. For a discussion of the literary genre of *fu*, see Knechtges 1976: 12–43.

6. *WX*, 1.21–22; trans. based on Knechtges 1982: 99.

7. *SJ*, 2715–17; *HS*, 58, 2119–21; trans. based on Watson 1958: 1.218.

8. *WX*, 1.46; trans. from Knechtges 1982: 103.

9. *WX* 1.151–52; trans. from Knechtges 1982: 143–44.

10. Zhang Heng wrote his two rhapsodies on the Eastern and Western capitals when he served as master of documents in Nanyang some time between A.D. 100 and 108.

11. *YWLJ*, 1098.

12. In this discussion I focus only on the beginnings of the two rhapsodies. Knechtges (1982: 28) compares the two works on a larger scale: "Zhang Heng, who must have been dissatisfied with Ban Gu's treatment of the subject, wrote two much longer rhapsodies on the Han capitals. In his treatment of Chang'an,

Zhang pokes fun at the Former Han emperor's obsession with material comfort, his futile efforts to discover the 'secret of immortality,' and his infatuation with pretty young consorts. In his Luoyang rhapsody, Zhang describes in detail many of the important Eastern Han rituals, that were either omitted or only casually mentioned in Ban Gu's *fu*."

13. *WX*, 1.271–75; trans. based on Knechtges 1982: 185–86.

14. *WX*, 1.488–90; trans. from Knechtges 1982: 241.

15. *HS*, 1755; trans. based on Knechtges 1976: 12–13.

16. Lowenthal 1975: 28.

17. For an excellent discussion of the rhetorical tradition of *fu*, see Knechtges 1976: 21–25.

18. Ban Gu wrote in the preface to his two rhapsodies on the western and eastern capitals: "Even though this matter is inconsequential, the old patterns of former statesmen and the good deeds bequeathed by the reigning house cannot be forgotten. I humbly observe the area within the sea is calm and peaceful and the court has no problems. At the capital they have built palaces and halls, dredged moats and ditches, erected parks and enclosures in order to complete the institutions. Aged men from the western territory, all harboring resentment and hoping for a kind glance from the emperor, lavishly praise the old institutions of Chang'an and hold the opinion that Luoyang is a shabby place. Therefore, I have written the 'Two Capitals Rhapsody' in order to present an exhaustive account of the things that daze and dazzle the Chang'an multitudes and rebut them by means of the patterns and institutions of the present" (*WX*, 1.18–21; trans. from Knechtges 1982: 99).

19. Zhang Heng's biography records that he "comprehended all the Five Classics." Although he was given the position of grand historian, he never wrote a historical work and later became an attendant (*shizhong*) of Emperor Shun (*HHS*, 1897–951).

20. *WX*, 1.274–75; trans. based on Knechtges 1982: 187.

21. Trans. from Wheatley 1971: 430.

22. *Shi jing*, 315; trans. from Waley 1978: 281.

23. *Shi jing*, 510; trans. from Karlgren 1950b: 189–90. There are other similar descriptions in the Classic. For example, the poem "Wen Wang you sheng" (*Shi jing*, 526–27) records the first Zhou king's construction of his capital Feng: "King Wen made a city in Feng. . . . / The wall he built was moated. . . . / The walls of Feng were where the four quarters came together; / the royal ruler was their support" (Karlgren 1950b: 198–99).

24. For a concise introduction to these Classics and the growth of classical scholarship, see Twitchett and Loewe 1986: 754–64.

25. Trans. based on Steinhardt 1990: 33.

26. It should be noted that this "classical" model has also offered possibilities for different interpretations. In some works, mostly those completed shortly after the Han but also including modern reconstructions, the Confucian classical tradition is adapted in a literal sense. Chang'an is thought of as a well-planned metropolis "60 *li* on each side," its shape modeled on stars and constellations, and its streets forming a rigid grid as in the "Records of Workmanship" plan. In many other cases, especially in works done from the Song dynasty on, historical information is increasingly integrated into a general reconstruction plan.

27. During recent years the "classical" tradition has begun to lose its grip. Encouraged by extensive archaeological excavations of Chang'an, some Chinese scholars have began to shift their focus to the complex history of the city. But such works have just begun and a reconstruction of Chang'an's development is often blurred by generalizations based on references from various periods. The excellent work on Chang'an by Liu Yunyong (1982), for example, roughly follows the city's history from its birth to its flourishing and fall. But chapters within this framework are devoted to various aspects of this city and synthesize early and late historical records.

28. *HS*, 22–23. From the time when Gaozu was forced by Xiang Yu to leave Xianyang until 202 B.C., he conquered several places in southern Shaanxi, including Yong (*HS*, 31) and Shaan (*HS*, 33), and established a temporary capital in Liyang (*HS*, 33). There is no record that he went back to Xianyang before 202.

29. In 202 B.C., following his visit to Xianyang in the fifth month, Gaozu attacked the King of Yan and Li Ji in Yingchuan (*HS*, 58; *SJ*, 381).

30. *Chang'an ji* records: "The Xingle Palace was built by the First Emperor, and was repaired and redecorated during the Han" (quoted in *SZCZ*, 2.12b). For Xiao He's activities during this period, see *HS*, 2007–11.

31. It is said that the construction began in the ninth month of 202 B.C. and was completed in the second month of 200 (see Liu Yunyong 1982: 5).

32. *Guanzhong ji* (A record of the Guanzhong region) states that the whole complex was more than 20 *li* in circumference and had fourteen halls (quoted in *SZCZ*, 3.12b). A Han *li* equals 417.5 meters. The names of some of these halls are recorded in *SFHT*, 13.

33. *SFHT* (13) states that the hall was 49 *zhang* and 7 *chi* east and west. A Han *chi* equals 23.1 cm.

34. According to *SFHT*, quoted in *SZCZ*, 3.13a. It is un-

clear whether these figures were the Qin emperor's Twelve Golden Men.

35. See Liu Yunyong 1982: 7.

36. According to *Miao ji* (A record of temples) quoted in *SZCZ*, 3.5a.

37. See *SFHT*, 13, 14.

38. *HS*, 64; *SJ*, 385.

39. Sima Qian's record of this event is rather confusing: under the eighth year of Gaozu (199 B.C.) he stated that the emperor saw the Weiyang Palace and complained about its extravagance. But he also relates that the palace was not completed until the ninth year (198). Ban Gu redated this event to the seventh year (200) and partially resolves the problem: it can be inferred that the emperor saw the unfinished Weiyang Palace when he went to Chang'an to hold the ceremony marking the completion of the Changle Palace (*SJ*, 385–86; *HS*, 64).

40. *HS*, 65–66.

41. *SJ*, 2723; *HS*, 2127–28.

42. Both *SJ* and *HS* contain biographies of Shusun Tong (*SJ*, 2720–26; *HS*, 2124–31). The translations of the following quotations from the *SJ* biography are based on Watson 1958: 222–29.

43. *SJ*, 2722; *HS*, 2126; trans. from Watson 1958: 224.

44. Different dates of this ceremony are given in *SJ* and *HS*. Whereas Gaozu's biographies in both books record that the Changle Palace was completed in the second month of the seventh year and the emperor went there on that occasion (*SJ*, 385; *HS*, 64), it is stated in the biographies of Shusun Tong that these events took place in the tenth month of the year. This second record is suspicious, because according to Ban Gu, in the tenth month Gaozu was leading an expeditionary army to attack the rebellious general Han Xin (*HS*, 63). It is possible that the ceremony, actually held in the second month, was later assigned a new date because in the Han calender the tenth month marked the beginning of the new year.

45. *SJ*, 2723; *HS*, 2126; trans. from Watson 1958: 224.

46. *SJ*, 385. Ban Gu gives a different date, see note 39 above.

47. *WX*, 1.42–45; trans. based on Knechtges 1982: 103.

48. *SJZ*, 241.

49. *HS*, 1210.

50. *HS*, 2098.

51. This measurement is given in Z. S. Wang 1982: 4. Other measurements and descriptions of this site can be found in Bishop 1938: 68–78; Adachi Kiroku 1933; Liu Dunzhen 1932.

52. See Wang Yi 1990: 36. The *Zuo zhuan* (1783, 2149) records that Duke Zhuang of Lu built three *tai* in a single year, and that even ministers constructed similar buildings.

53. *SJ*, 385–86; trans. based on Watson 1958: 137. The same passage is also given in *HS*, 64.

54. *SJ*, 2015; *HS*, 2008; trans. based on Watson 1958: 151–52. This event and the tension between military generals and civil officers are also recorded in *HS*, 2031–32.

55. *SJ*, 2629; *HS*, 1876; trans. from Watson 1958: 197.

56. *HS*, 617. For Yang Chengyan's role in Chang'an's early construction, see Ma Xianxing 1976: 233–34.

57. *SJ*, 385; *HS*, 64. It is also said that Xiao He built two pavilions, one called Tianlu ge and the other Qilin ge, to house official documents. But this record is from a much later text and is not supported by Sima Qian and Ban Gu's writings; see *SZCZ*, 3.9b.

58. See Yan Shigu's commentary in *HS*, 64.

59. *HS*, 67, records a formal audience at the beginning of the tenth year, but according to *SJ*, 387, it was held in the Changle Palace.

60. *SJ*, 386–87; *HS*, 66.

61. The arsenal and granary were built by Xiao He in the seventh or eighth year of Gaozu's reign (*HS*, 64; *SJ*, 385). The market was probably established in the sixth year; see *Shi ji dashiji* (A *Shi ji* chronicle), quoted in Wang Yizhi 1937: 17.

62. Karlgren 1950b: 198.

63. *LJ*, 1589.

64. *ZZ* cited in *SZCZ*, 2.2a.

65. *Shi ming*, 2.10b.

66. Gaozu's father died in the seventh month of 197 B.C. and was immediately buried. His tomb should have been prepared before his death (*SJ*, 387; *HS*, 67).

67. *SJ*, 392; *HS*, 79–80. Gaozu died on the *jiachen* day in the fourth month and was buried 23 days later on the *bingyin* day in the fifth month.

68. The tradition of the "mausoleum town" can be traced back to the Qin dynasty. It had been noted as early as in the first century A.D. that "the [subsequent] flourishing of 'mausoleum towns' originated from the powerful Qin" (*HHS*, 1437). Not long after the future First Emperor started to construct his Lishan mausoleum, a small town called Li Yi, or the Town of Li(shan), was established near the site in 231 B.C.; and it was further expanded in 221 B.C., when he claimed the title of emperor. The purpose of this Qin town, however, was to house and administer the large number of workers, and thus differed essentially from that of the Han dynasty mausoleum towns, which functioned both "to serve the dead" and "to strengthen the root [i.e., the capital area] of the dynasty" (*HS*, 2123). See Liu Qingzhu and Li Yufang 1987: 224.

69. According to a passage from *Kuodi ji* (A geographic record), cited in a commentary in *SJ*, 387.

70. For a general introduction to this mausoleum, see Liu Qingzhu and Li Yufang 1987: 126–31.

71. According *SFHT*, 51, a section of this city was separated as the mausoleum town of Gaozu's father and was named Wannian Xian (County of 10,000 Years). But two modern archaeologists, Liu Qingzhu and Li Yufang (1987: 130), have argued that Wannian Xian was simply another name for Liyang.

72. *Han jiuyi* (Old ceremonies of the Han) cited in *WXTK*, *juan* 124, *kao* 1115.

73. Upon Gaozu's death his heir and ministers held a ceremony in this temple (*HS*, 80). It thus must have been built during Gaozu's reign.

74. It is unclear when Gaozu began to built his tomb. According to Han ritual codes, each emperor began to construct his own tomb on ascending the throne. But this rule was probably put into practice after Gaozu's reign. It is possible that Gaozu started the construction of his tomb after he moved his capital to Chang'an in 200 B.C.

75. For an up-to-date introduction to Gaozu's mausoleum, see Liu Qingzhu and Li Yufang 1987: 3–24.

76. Ban Gu provides two contradictory dates for the founding of Chang Ling Town: in the "Geography" chapter of *HS* he states that it was founded during Gaozu's reign (*HS*, 1545), but in the "Biography of Empress Lü" he records that it was established in 182 B.C., thirteen years after the emperor's death (*HS*, 99). The second date is confirmed by Liu Qingzhu and Li Yufang 1987: 21.

77. *HS*, 59.

78. *Yong lu*, *juan* 2.

79. Z. S. Wang 1982: 4. The same author also states that the base of the later Chang'an city wall was 12 to 16 meters in width (ibid., 2).

80. *SJ*, 1122.

81. *SJ*, 398.

82. *HS*, 88–91.

83. *HS*, 1543.

84. Ma Xianxing (1976: 226–32) has reached a similar conclusion regarding the building of the Chang'an wall. He also suggests that the second *SJ* passage cited may have been miscopied during the book's transmission and that the original text should have read: "In the fifth year it was completed; and in the sixth year feudal princes came to a court audience, celebrating [its inauguration] in the tenth month."

85. *SJ*, 399.

86. Z. S. Wang 1982: 2; I have made minor changes based on the Chinese version of his book (Wang Zhongshu 1984: 4–5).

87. Ma Xianxing 1976: 229.

88. According to historical records, the population of the Guanzhong area was reduced by two-thirds during the war. Gaozu had tried to increase this population by moving a large number of households from the provinces to the capital area. These immigrants, as many scholars have suggested, settled down north of the Wei River in the mausoleum district.

89. Loewe 1982: 144.

90. *SJ*, 2699; *HS*, 2113; trans. based on Watson 1958: 210–11.

91. The information about Shusun Tong is derived from his biographies in *SJ* and *HS*, and from the *HS* chapter on ritual and music (1943–44). For a trans. of Shusun's biography, see Watson 1958: 222–29.

92. Watson's trans. of the relevant passage (1958: 227) creates the erronious impression that Shusun Tong was criticized by the new ruler: "After Kao-tsu had passed away, and Emperor Hui had come to the throne, he sent for Shu-sun T'ung. 'None of the officials know what sort of ceremonies should be performed at the funerary park and temple of the former emperor,' he complained, and transferred Shu-sun T'ung back to the position of master of ritual." The original text and commentaries, however, do not suggest any such criticism. In fact, the rest of the biography focuses on Shusun's authority over the emperor.

93. *HS*, 2129.

94. *Lun yu*, 56.

95. The capping ceremony is a major Confucian rite. The *Book of Rites*, compiled during the Han based on old materials, says that the ritual should be held when a man reaches age 20. The *Yi li* states that the proper age for the ceremony is 19. Emperor Hui was born in the 37th year of the First Emperor (210 B.C.) and was 19 *sui* in 192. The date of his "capping ceremony" agrees with the *Yi li* regulation.

96. *HS*, 90.

97. See *SFHT*, 41; Jin Zhuo's commentary in *HS*, 2130. When Hui came to the throne, the inauguration ceremony was held in the temple of Gaozu's father; only from Emperor Wen were such ceremonies held in Gaozu's temple. This implies that this temple was constructed during Hui's reign (see *HS*, 80, 110).

98. *ZL*, 671.

99. Traditional Chinese scholars considered a tomb east of Gaozu's Chang ling to be the mausoleum of Emperor Hui. Based on both textual and archaeological evidence, some modern scholars have pointed out that this is a misidentification, and

that the real An ling should be a large tomb in the present-day Baimiao village (see Liu Qingzhu and Li Yufang 1987: 26).

100. *ZL*, 786.

101. See Institute of Archaeology, CASS, 1962.

102. See Liu Yunyong 1982: 20–22.

103. See Yang Kuan 1985: 190–92; Liu Qingzhu and Li Yufang 1987: 176–77.

104. Arnheim 1986: 83.

105. *WX*, 1.47–51; trans. from Knechtges 1982: 104–5.

106. *HS*, 2130; trans. from Watson 1958: 228.

107. See Liu Qingzhu and Li Yufang 1987: 12.

108. Liu Qingzhu and Li Yufang (ibid.) suggest that Zhang Er, the king of the state of Zhou, was also buried near Chang ling. But this is quite impossible: not only had Zhang Er died in 202 B.C., even before Gaozu's death, but his tomb has been found in Hebei province, far from Chang'an (see Shijiazhuang Library 1980).

109. The first two persons buried there were Gaozu's daughter Princess Luyang (d. 187 B.C.) and her husband, Zhang Ao (d. 182). They belonged to Emperor Hui's generation, and their tombs thus flanked the mausoleum of this second Han ruler. This genealogical pattern, however, seems to have been applied only to members of the royal house. Zhang Cang (d. 152), the occupant of another satellite burial near An ling, was the prime minister of the next ruler, Emperor Wen (r. 179–157), and it was Wen's son, Emperor Jing (r. 156–141), who honored him with a burial ground near Emperor Hui's funerary park. A third situation is represented by Emperor Jing's Great Ceremonialist Yuan Ang (d. 148). The Yuan family had dwelled in the mausoleum town of An Ling Yi since the early Han, and so Yuan Ang's tomb was located not only near the emperor's mausoleum, but also close to his home.

110. Zhan Li et al. 1977. See Liu Qingzhu and Li Yufang 1987: 15–21; Z. S. Wang 1982: 209.

111. *HS*, 99.

112. Liu Qingzhu and Li Yufang 1987: 23. According to ancient texts, this town had only north, south and west walls. See *Guanzhong ji* quoted in *SZCZ*, juan 13, 86. This record seems to be confirmed by archaeological surveys.

113. Liu Qingzhu and Li Yufang 1987: 31.

114. Ibid., 24, 32, 225.

115. *SJ*, 2719–20; *HS*, 2123; trans. based on Watson 1958: 221.

116. These were the seven mausoleum towns of the Western Han emperors from Gaozu to Emperor Xuan, as well as those of Gaozu's father, Empress Dowager Bo (Emperor Wen's natural mother), Empress Dowager Gouyi (Emperor Zhao's natural mother), and Emperor Xuan's parents.

117. *HS*, 1545, 1547.

118. Liu Qingzhu and Li Yufang 1987: 68, 103.

119. *HS*, 1543.

120. *HS*, 170, 205; *SFHT*, 53.

121. *SJ*, 3187–88.

122. See Liu Qingzhu and Li Yufang 1987: 67.

123. *WX*, 1.55–59; Knechtges 1982: 107–9.

124. *SJ*, 3319; trans. based on Watson in de Bary 1960: 1.232–33. Sima Qian wrote these sentences to summarize the chapters on "Hereditary Houses" ("Shijia"). I have argued elsewhere that this statement reflects a Han idea of the political relationship between the ruler and the feudal lords and ministers under him (H. Wu 1989: 151–52).

125. Many historians have pointed to the tax reduction as a major reform of the Wen-Jing period; as Loewe (Twitchett and Loewe 1986: 150) has summarized: "In 168 B.C. the standard rate of the tax on produce was reduced from one-fifteenth to one-thirtieth part; in the following year it was abolished altogether. When it was reintroduced in 156 B.C., the levy was kept at the lower rate of one thirtieth, which remained standard throughout the Han period."

126. *SJ*, 433; *HS*, 134; trans. based on Watson 1961: 1.362.

127. Yi Feng, a famous official scholar under Emperor Yuan, once recalled in a memorial that during Emperor Wen's reign the Weiyang Palace included the Anterior Hall, two terraces called Qu tai and Jian tai, and three palatial halls called Xuanshi, Wenshi, and Chengming (*HS*, 3175). The Anterior Hall is the only one of these buildings mentioned in the historical records as existing before Emperor Wen's reign. But generally speaking, Chang'an witnessed no dramatic changes during the 40 years of the Wen-Jing period. The city grew almost biologically: each emperor left a royal tomb with a tumulus, funerary park, shrine, and mausoleum town, and when a prominent minister or royal relative died, his or her tomb joined the satellite burials around an imperial mausoleum. Besides these mortuary structures, the only significant addition is an altar that Emperor Wen dedicated to the Five Supreme Powers in 164 B.C. northeast of Chang'an (*SJ*, 430; *HS*, 127). This altar, however, was soon abandoned; the emperor discovered that its designer, the necromancer Xin Yuanping, was a swindler and executed him (*SJ*, 1383).

128. *SJ*, 433–34; *HS*, 131–32; trans. from Watson 1961: 1.363.

129. *SJ*, 434; *HS*, 132; see Watson 1961: 1.364.

130. We are told that when he came to the throne "the granaries in the cities and the countryside were full and the government treasuries were running over with wealth. In the capital

the strings of cash had been stacked up by the hundreds of millions until the cords that bound them had rotted away and they could no longer be counted. In the central granary of the government, new grain was heaped on top of the old until the building was full and the grain overflowed and piled up outside, where it spoiled and became unfit to eat" (*SJ*, 1420; trans. from Watson, 1961: 2.81).

131. *SFHT*, 14–15; *Taiping huanyu ji* (A record of the peaceful universe) cited in *SZCZ*, 3.13a.

132. For information regarding these three palaces, see *SFHT*, 16–17, 23, 28.

133. Ibid., 17.

134. For information regarding Emperor Wu's tomb, see Liu Qingzhu and Li Yufang 1987: 47–68.

135. See Twitchett and Loewe 1986: 153; Grousset 1964: 54.

136. For a more detailed discussion of the term and especially the key character *fang*, see DeWoskin 1983: 1–2.

137. "Song Wuji, Zhengbo Qiao, Chong Shang, Xianmen Gao, and Zui Hou were all men of Yan who practiced magic and followed the way of the immortals, discarding their mortal forms and changing into spiritual beings by means of supernatural aid. Zou Yan won fame among the feudal lords for his theories of *yin* and *yang* and the succession of the Five Elements, but the magicians who lived along the seacoast of Qi and Yan, though they claimed to transmit his teachings, were unable to understand them. Thus from time to time there appeared a host of men, too numerous to mention, who expounded all sorts of weird and fantastic theories and went to any lengths to flatter the rulers of the day and ingratiate themselves with them" (*SJ*, 1368–69; trans. based on Watson 1961: 2.25–26). For an excellent discussion of the *fangshi* tradition, see DeWoskin 1983: 1–42.

138. DeWoskin 1983: 3.

139. For information regarding Li Shaojun, see *SJ*, 453–55; Watson 1961: 2.38–40.

140. *SJ*, 456; Watson 1961: 2.40.

141. For information about Shao Weng, see *SJ*, 458–59; Watson 1961: 2.41–42.

142. *SJ*, 1388; trans. based on Watson 1961: 2.42.

143. *SJ*, 1392; Watson 1961: 2.48.

144. *SJ*, 1394; Watson 1961: 2.52. For the religious context of this new altar, see Bilsky 1975: 2.315–18.

145. *SJ*, 1400; see Watson 1961: 2.63.

146. *SJ*, 1400; see Watson 1961: 2.63.

147. *SFHT*, 38. The rituals held there are also described in *SJ*, 1178.

148. *SJ*, 1400; trans. based on Watson 1961: 2.63.

149. *SJ*, 1396; Watson 1961: 2.54.

150. *SJ*, 1390; trans. based on Watson 1961: 2.46.

151. *SJ*, 1369–70; Watson 1961: 2.26.

152. DeWoskin (1983: 3, 21) has proposed that such tales were "the stuff of early hagiography, remote-land geography, and miracle lore, and this put *fangshi* at the center of important developments in early fiction." He also noticed that a well-known *fangshi* named Dongfang Shuo often entertained Emperor Wu with stories of exotic places and at imperial request compiled the *Account of Ten Continents* (*Shizhou ji*). A number of post-Han collections of strange tales followed this tradition and included Zhang Hua's *Records of the Widely Diverse Things* (*Bowu zhi*) and Gan Bao's *In Search of the Supernatural* (*Soushen ji*).

153. *SJ*, 1396; trans. from Watson 1961: 2.55.

154. Walton 1990: 41.

155. Ibid., 39.

156. *WX*, 4.1602–1710; Knechtges 1987: 53–71.

157. Wangshi Gong literally means "Master it is not." Knechtges translates the name as "Lord No-such"; Watson as "Master Not-real."

158. For this rhapsody, see *WX*, 4.1711–881; unless noted, trans. based on Watson 1961: 2.307–21.

159. Trans. from Knechtges 1987: 75.

160. See commentaries in *WX*, 4.1719.

161. *SHJ*, 1.9a, 3.3b.

162. *SJ*, 3043; trans. based on Watson 1961: 2.321.

163. Many scholars, for example, have argued that the poem's initial definition of the park's boundary is realistic, and that all the four place names—Verdant Parasol, Western Limits, Cinnabar River, and Purple Gulf—refer to real places near Chang'an (see commentaries in *WX*, 4.1719–22; Knechtges 1987: 74). Art historians and architectural historians also frequently quote the poem in studies of Han garden designs.

164. *Yan fanlu*, juan 11.

165. *Yong lu*, 9.7a.

166. *HS*, 2011.

167. *HS*, 2847.

168. For example, a lengthy section in the rhapsody describes an imperial hunting party: among the captured animals and birds are sagacious stags, spiritual apes, white tigers, albino deer, peacocks, and phoenixes. In pursuing such strange creatures, the emperor is said to "transcend the mundane realm" (*WX*, 4.1834; Knechtges 1987: 101). But the emperor's hunting party in 138 B.C. ended with a dispute, and all he killed were a few foxes and rabbits. Moreover, Sima Xiangru relates that after the hunt Emperor Wu returns to worldly business: he changes the calender, regulates rituals and court costumes, and holds a

grand ceremony in Bright Hall. In real history, however, these events took place some thirty years later in 109 and 104 (*SJ*, 194, 199, 1401).

169. *SFHT*, 29.

170. Ibid., 35.

171. Ibid., 29–30.

172. These include 10 Rangoon creepers, 12 giant banana trees, 100 cassia-bark trees, and 100 honey-scented flowering balsams, as well as lichi, longan, palm, canary, and sweet tangerine trees, and a kind of vine producing fruits called "seeds of a thousand years" (ibid., 26–27).

173. *WX*, 1.75.

174. *SJ*, 176.

175. *HS*, 1069. Emperor Wu wrote this poem in 94 B.C., but its contents clearly refer to the earlier elephant tribute.

176. *SFHT*, 30. *Guanzhong ji* quoted in *SZCZ*, 4.7ab.

177. The two meanings are given in two Han dictionaries, respectively. *SW* (408) defines *guan* as "viewing and gazing," and *Shi ming* (5.18a) interprets the terms as "viewing from a lofty spot."

178. For the relationship between "props" and "imagination," see Walton 1990: 35–43.

179. *WX*, 4.1781–84; 1815; trans. from Watson 1961: 2.312, 314.

180. *SFHT*, 29.

181. Quoted in *SZCZ*, 4.6b, 8a.

182. According to *Guanfu guyu* (Ancient dialogues about the capital area) and *Sanfu gushi* (Stories about the three capital districts) quoted in *SFHT*, 32.

183. Earlier that year the Terrace of Cypress Beams (Bailiang tai) in Weiyang Palace reportedly caught fire and was destroyed. A shaman from Yue advised the emperor to erect a taller building "in order to overcome evil influences" (*SJ*, 1402; Watson 1961: 2.65–66). In that year, the emperor also changed the dynasty's calender and symbolic systems and named the new reign period the "Great Beginning" (Taichu). The new palace was possibly related to this important reform, which had been brewing for a hundred years (*SJ*, 1402; Watson 1961: 2.66–67). This reform had been advocated by Gongsun Chen, a Confucian from Lu, during Emperor Wen's reign (*SJ*, 1381). These two factors, however, are still insufficient to explain the new palace, especially the reason it was built as part of Shanglin Park.

184. *SJ*, 3056; *HS*, 2592; trans. from Watson 1961: 2.332.

185. *WX*, 4.2596; trans. based on Watson 1961: 2.334.

186. *SJ*, 3063.

187. The bronze censer was discovered in 1968 in the tomb of Liu Sheng, the prince of Zhongshan and one of Emperor Wu's brothers. The censer has layers of soaring peaks on top to form the contour of a conical mountain, which emerges from an ocean indicated by the inlaid wave patterns on the bowl-shaped base. Small human and animal figures among the mountain peaks include celestial beasts and an archer chasing animals—motifs related to scenes and activities in Shanglin Park.

188. See *SZCZ*, 3.11a.

189. The western location of Jianzhang Palace may have been associated with the magical mountain Kunlun in the west, which Sima Xiangru identified in his poem as the foundation of the heavenly court. Perhaps for the same reason Emperor Wu also founded his tomb, Mao ling, directly west of Chang'an.

190. *HS*, 4161–62.

191. The establishment of Bright Hall (Mingtang) was part of Wang Mang's restoration of the Confucian tradition. Ban Gu records its historical context: "That year [A.D. 4] Wang Mang proposed to construct Bright Hall, the Jade Disk Moat [Biyong], the Spiritual Terrace [Ling tai], and ten thousand residences for scholars. He also built a marketplace and equalizing granaries [*changman cang*]. The regulations were exceedingly elaborate. He established the *Canon of Music* [as a Confucian Classic], increased the number of Imperial Doctors to five for each of the Classics, and sought throughout the empire persons who possessed ability in any of the [Six] Arts who had taught groups of eleven men and more, together with those who comprehended the ideas of the *Lost Ritual Canons* [*Yili*], the Old Text version of the *Documents*, the *Songs* with Master Mao's commentaries, the *Institutes of Zhou* [*Zhou guan*], the *Er ya* dictionary, and texts on astronomy, divination, musical pitches, monthly observances, the art of war, and historiography" (*HS*, 4069; trans. based on Sargent 1947: 125–26).

192. As I discuss later in this section, the Bright Hall built by Emperor Wu beneath Mount Tai was not based on a synthesis of the Confucian classics and thus differed fundamentally from the one constructed by Wang Mang.

193. Because Bright Hall synthesized and reinterpreted ancient texts, it differed from structures such as Emperor Huan's Chang'an walls, which were more strictly based on a single classic.

194. For reports of the excavation, see Liu Zhiping 1957*b*; Wang Shiren 1957; Qi Yingtao 1957; Luo Zhongru 1957; Han City Excavation Team, Institute of Archaeology 1960; Tang Jingru 1959. For a discussion and reconstruction of Wang Mang's Bright Hall, see Huang Zhanyue 1960; Wang Shiren 1963; Xu Daolin and Liu Zhiping 1959; Steinhardt 1984: 70–77; Yang Hongxun 1987: 169–200.

195. Among various reconstruction plans, those proposed

by Wang Shiren (1963) and Yang Hongxun (1987) have been widely cited by scholars of Chinese architectural history. It must be realized, however, that the archaeological reports provide little evidence for reconstructing the aboveground part of Bright Hall, and that Yang and Wang's plans are largely based on their own visions of this monument. My reconstruction differs in some major points from both plans. For example, the round "Room of Communing with Heaven" recorded in all ancient texts is missing from Wang Shiren's reconstruction, and the number of chambers reconstructed by Yang Hongxun differ from those documented by ancient writers.

196. Wang Shiren (1963: 504–5) has reconstructed four of these halls. Yang Hongxun (1987: 185), however, suggests that there was only a central hall on the top floor.

197. The existence of such designs is revealed in *HHS*, 1196: When Zhang Chun proposed to establish another Bright Hall at the beginning of the Eastern Han, he presented to the emperor, among other documents, "the conference records of Emperor Ping's [Bright Hall]" established by Wang Mang and a "diagram of Bright Hall."

198. "Mingtang yueling lun." Wang Shiren (1963: 503) believes that the subject of this treatise is the Eastern Han Bright Hall in Luoyang, which was modeled on Wang Mang's Bright Hall. He also suggests that before writing this essay Cai Yong had visited Chang'an and possibly also investigated Wang Mang's building.

199. See Wilhelm 1967: 118.

200. Readers interested in these issues may consult Tjan Tjoe Som's translation and discussion of *Baihu tong* (Proceedings from the White Tiger Hall), the most important official theological text of the Eastern Han.

201. For an interesting discussion of such geometric maps, see Major 1984.

202. Another passage in Cai Yong's essay suggests a similar movement: "It is stated in the 'Great Origin' ['Taichu'] chapter of the 'Great Commentary' ['Dazhuan'] to the *Book of Changes*: 'In the early morning the Son of Heaven goes to [study in] the eastern academy; during the day he goes to [study in] the southern academy; in the evening he goes to [study in] the western academy; the Great Academy is in the center and the place of the Son of Heaven, where he studies by himself.' The 'Grand Tutors' ('Baofu') chapter of the *Book of Rites* says: 'The emperor goes to the eastern academy in order to honor his kin and praise righteousness; he goes to the western academy in order to honor virtuous men and praise goodness; he goes to the southern academy in order to honor elder men and praise faith; he goes to the northern academy in order to honor noble men and

praise the ranks; and he goes to the Great Academy in order to seek for the Dao from masters.' This record agrees with that in the 'Great Commentary.'" ("Mingtang yueling lun," 2b–3a).

203. *LJ*, 1352–88; Legge 1967: 1.236–310.

204. *Lüshi chunqiu*, 1–3, 12–14, 23–25, 34–35, 44–46, 54–56, 65–66, 75–77, 84–86, 94–96, 104–6, 114–5.

205. *LJ*, 1352–55; trans. based on Legge 1967: 1.249–52.

206. *LJ*, 1357; trans. from Legge 1967: 1.257.

207. This Zhou dynasty Bright Hall is documented in the "Places in Bright Hall" ("Mingtang wei"), a treatise later incorporated into the *Book of Rites*, and in the "Regulations of Workmanship," which then became a chapter of the *Rites of Zhou*. The author of the "Places in Bright Hall" states that this hall functioned "to differentiate the ranks of feudal lords," a definition testifying to a strong Confucian interest in political organization and hierarchy. This political organization gained its most idealized and concrete form in a court audience held by the Duke of Zhou in this legendary Bright Hall: "Formerly, when the Duke of Zhou gave an audience to the feudal princes in their several places in Bright Hall, the Son of Heaven stood with his back to the axe-embroidered screen and faced the south. The three dukes were in front of the steps. . . . The places of the marquises were located east of the eastern steps. . . . The lords of the earldoms were west of the western steps. . . . The counts were east of the gate, facing north. . . . The barons were west of the gate. . . . The chiefs of the nine Li tribes were outside the eastern door. . . . The chiefs of the eight Man tribes were outside the southern door. . . . The chiefs of the six Rong tribes were outside the western door. . . . The chiefs of the five Di tribes were outside the northern door. . . . The chiefs of the nine Cai areas were outside the Ying Gate" (*LJ*, 1487–89; see Legge 1967: 2.29–31). A reconstruction of this ceremony suggests that the Zhou Bright Hall was centered on a south-facing building inside a courtyard; the architectural complex has nothing to do with the ritual structure implied in the "Monthly Observances," but resembles the traditional temple-palace compound found in Shang-Zhou sites and recorded in ancient texts. The specific ritual function of this Bright Hall is also indicated in two other places in the *Book of Rites* (*LJ*, 1543, 1600): "The purpose of holding sacrifices in Bright Hall is to instruct the feudal lords on the virtue of filial piety"; and "The king sacrifices in Bright Hall, thus his subject can realize [the importance] of filial piety." According to the "Regulations of Workmanship" (*ZL*, 104–6), the Zhou Bright Hall, which derived its form from the Chamber of Generations of the Xia and the Layered House of the Shang, was 81 *chi* wide, 63 *chi* deep, and con-

sisted of five chambers. It is obvious that this rectangular build-
ing does not fit the Five Element diagram, which requires a
square chamber in the center. Yang Hongxun (1987: 78−79) has
also suggested a close relationship between this type of building
and the Three Dynasty temple-palace structure excavated at
Erlitou.

208. *Xunzi*, 202; trans. based on Knoblock 1989: 1.246. My
translation of the last sentence is based on an original comment
in the Chinese text. Mencius makes a similar political statement
in his conversation with an Eastern Zhou prince: "King Xuan
of Qi said: 'People all tell me to pull down Bright Hall. Shall
I pull it down, or stop the movement for that object?' Mencius
replied, 'Bright Hall is a hall appropriate to the sovereigns. If
Your Majesty wishes to practice true royal government, then
do not pull it down.'" He then proceeded to instruct the king
on "the true royal government." A third reference to Bright
Hall along the same lines can be found in *Master Zuo's Com-
mentaries on the Spring and Autumn Annals*: "It is said in one of
the histories of Zhou: 'The violent man who killed his superior
shall have no place in Bright Hall'" (Legge 1871: 5.231).

209. Important changes in this version of the "Monthly Ob-
servances" concern the names of different chambers. Unlike the
earlier *Lüshi chunqiu* version, the name "Great Temple" refers
to the central room in each of the four main chambers, and the
central chamber is called the Central Palace (*Huainan zi*, 69−87).

210. Ibid., 127−28, 149, 351.

211. Ibid., 351.

212. For a discussion of this concept, see Fung 1948−53:
2.46−55.

213. The *History of the Former Han* (HS, 3139) records that
in the early first century B.C., the Confucian scholar Wei Xiang
(?−59 B.C.) proposed a plan to the throne based on "a combi-
nation of the *Changes*, *yin-yang*, and the 'Monthly Observances'
in Bright Hall." Fung Yu-lan and D. Bodde (Y. L. Fung 1953: 2.8)
have outlined the integration of these philosophical schools:
"During the fourth and third century B.C. the Yin-yang school
and the School of the Five Elements seem to have existed quite
separately from one another, but during the Han dynasty, in
accordance with the eclectic trend of the time, they coalesced.
The resulting amalgam was in turn taken over by that particular
brand of Confucianism represented by the New Text school."
Again, "This correlation of the eight trigrams with the eight
compass points and with the seasonal fluctuations of the yin
and yang is of later date than that based on the Five Elements.
Once promulgated, however, it had the advantage of being
readily understandable, and therefore soon gained wide cur-
rency, even though the earlier correlation of the Five Elements

with the phases of the year also enjoyed continued popularity"
(ibid., 2.104).

214. See *Mingtang dadao lu*, 1.18.

215. For the influences of the "Monthly Observances" on
the rules of Emperors Gaozu and Wen, see *HS*, 3140.

216. *SJ*, 452; *HS*, 157.

217. *SJ*, 452.

218. Ibid., 1401.

219. Some texts suggest that Emperor Wu also built a Bright
Hall south of Chang'an. But as many scholars have pointed
out, these records do not have a substantial historical basis. See
Yang Hongxun 1987: 169−70.

220. Such criticism became unmistakable during the later
years of Emperor Wu. Wei Xiang frequently pointed out in his
memorials the problems in the state administration and related
them to the "disharmony of *yin* and *yang*." His advice to the
emperor to follow the "Monthly Observances" ends with a warn-
ing: "I consider that Your Majesty has much fortune, yet the
noxious influences have not yet been eradicated. I am afraid
that not all your edicts and orders are in accordance with the
seasonal orders" (*HS*, 3139−40).

221. *HS*, 1709. One important piece of writing belonging
to this category is Dai De's (active 48−33 B.C.) *Elder Dai's Book
of Rites* (*Da Dai liji*). See *HS*, 3615; *DDLJ*, 4−7; Yang Hongxun
1987: 200n30. Titles of Han texts on Bright Hall can be found
in the biography of Niu Hong in *Sui shu*, 1302.

222. A surviving fragment of "The Yin-yang Principles of
Bright Hall" reads: "The regulation of the Bright Hall com-
pound is as follows: it is surrounded by water that flows coun-
terclockwise to symbolize the sky. Its central chamber is called
the Great Hall [Taishi], which stands for Ziyuan [or Ziweiyuan;
Circumpolar Enclosure]; its south chamber, which shares the
name of the whole building [Mingtang], symbolizes the Taiwei
[stars in Virgo, Coma Berenices, and Leo], its western chamber,
called Zongzhang, symbolizes the Wuhuang; its northern
chamber, Yuantang, symbolizes the Yingshi, and its eastern
chamber, Qingyang, symbolizes the Tianshi. The God on High
and the four seasons govern these five spaces as their palaces;
the sovereign, who follows Heaven to rule the world, holds au-
diences of state affairs in corresponding directions" (*TPYL*,
2418). A more detailed plan in the *Elder Dai's Book of Rites* is
too long and complex to be translated and discussed here; see
DDLJ, 149−52.

223. "Whenever people are sick, epidemic diseases spread
among six kinds of livestock, and natural disasters fall upon the
five kinds of crops, the reason must be found in Heaven. The
disharmony of Heaven is caused by the neglect of Bright Hall"

(DDLJ, 143). Emperor Yuan's reign (when this text is thought to have been written) was full of such disasters. Epidemic diseases, natural disasters, and rebellions were reported almost every year, and a great shortage of food forced people to cannibalism. There were also endless evil portents—eclipses, fires, earthquakes, irregular movements of stars, frost in the summer, and rain in the winter. The author of the text attributed such cosmological and political disorders to the ruler's disobedience of Confucian principles, symbolically stated as his "neglect of Bright Hall."

224. HS, 4039; see Sargent 1947: 48.

225. Sargent 1947. See also Bielenstein's discussion of Wang Mang in Twitchett and Loewe 1986: 223–40.

226. HS, 4046; see Sargent 1947: 79.

227. For Wang Mang's screening and forging of ancient texts, see Gu Jiegang 1982: 5.450–613.

228. It is said that two persons engaged in a lawsuit went to the Duke for a judgment. But when they entered the Zhou territory, they found that everyone was polite and peaceful. Bashfully they said to each other: "What we are arguing for is exactly what the Zhou people are ashamed about. Let's drop the case and return home to be good people" (HS, 4068–69).

229. The construction of Wang Mang's Bright Hall is only briefly mentioned in a memorial included in the History of the Former Han: "At present the Duke Protector of Han has arisen among royal relatives and assisted Your Majesty for a period of four years. His accomplishments and virtue have been brilliant. The Duke, in the eighth month at the beginning of the waxing moon, on the gengzi day, received documents from the court authorizing the conscription of labor and the construction of the monuments. On the next day [xinchou], scholars and citizens held a great assembly, and 100,000 persons gathered together. They worked zealously for twenty days, and the great work was completed" (HS, 4069; trans. based on Sargent 1947: 128).

230. HS, 4069; trans. based on Sargent 1947: 128.

231. Both Emperors Ling and Xian had married when they were fifteen years old. Emperor Ping died when he was fourteen.

232. HS, 4098. According to Yan Shigu (HS, 360), Emperor Ping was murdered by Wang Mang.

233. An important memorial preceded this event: "When the Duke of Zhou held audiences with the feudal lords in Bright Hall, using the royal screen of the Son of Heaven and facing south, he stood like the Son of Heaven. This is to say that the Duke of Zhou occupied the position of the Son of Heaven for six years, during which he gave audiences to feudal nobles, established the ceremonies, and arranged the ritual music; and the empire completely submitted. . . . We, your courtiers,

request that the Duke Protector of Han act as regent and occupy the throne, and that he wear the imperial robes and crown. At his back he shall have the imperial screen between the doors and windows. He shall face south and receive the courtiers in audience and hear the affairs of the court. His carriage and costume shall indicate his imperial authority; and when he goes out or enters the palace, the people shall retire from the streets. The populace and courtiers shall call themselves vassal subjects. Everything shall be according to the regulations for the Son of Heaven. When he performs the suburban sacrifices to Heaven and Earth, the Dynastic Lineage Sacrifices in Bright Hall, when he sacrifices in the Ancestral Temples, and when he sacrifices to the various spirits, the master of ceremonies shall proclaim: 'The Acting Emperor.'" (HS, 4080–81; trans. based on Sargent 1947: 149–50).

234. See the memorial cited in the previous note.

235. An important figure who helped Wang Mang create this system was the Confucian scholar Liu Xin, who also played a central role in designing Bright Hall; see HS, 359, 4045–46, 4077; Gu Jiegang 1982: 5.450–613.

236. Gu Jiegang 1982: 5.583. For the complex history of this new historical system, see ibid., 554–617.

237. See Gu Jiegang 1982: 5.417–25, 441–50.

238. HS, 4095; trans. based on Sargent 1947: 178.

239. HS, 4100.

CHAPTER FOUR

1. "Xie lu" (Dew on the garlic-leaf); trans. from Waley 1982: 49.

2. For textual information about Han funerary practices, see Yang Shuda 1933: 72–289.

3. HS, 3007.

4. Yantie lun, 6.48.

5. See HHS, 1546. For conventions for selecting burial sites and dates, see Lun heng, 477–81.

6. See Yang Shuda 1933: 132–44.

7. The inscription on the An Guo shrine contains the sentence: "Exhausting their savings, they hired famous craftmen of Gaoping kingdom [to construct the shrine]." The patron of the Yan family shrine mentioned that "since now the brothers and sisters have sufficient money, they long for their parents and are full of sorrow. They upgraded the tomb mound and built a small offering hall that will be transmitted to future generations" (Shandong Provincial Museum and Shandong Cultural Relics and Archaeology Institute 1982: 15–16).

8. See H. Wu 1989: 225.

9. This is suggested by a number of texts engraved on funer-

ary monuments. For example, the patrons of the An Guo shrine advise visitors "to offer their pity and sympathy" and "to regard" their inscription. The inscription on the Xiang Tajun shrine ends with a similar appeal. For a discussion of these two inscriptions, see H. Wu 1987a: 496–99.

10. H. Wu 1989: 225–28.

11. For a discussion of the structures of Eastern Han cemeteries, see H. Wu 1989: 30–37. The layout described here is based on Yin Jian's graveyard recorded in *SJZ*, 391.

12. As I explain in Chapter 2, some inscriptions on Han mortuary structures disclose the belief that the tomb and shrine housed the *po* and *hun*, respectively. But many textual sources also reveal that people of the Han did not always distinguish the two clearly. Terms such as *hun*, *po*, and *hunpo* were often used interchangeably. Sometimes we are told that the soul resided in a tomb.

13. For a concise introduction to the political situation during Emperor Huan's reign, see Twitchett and Loewe 1986: 311–16.

14. *HHS*, 298–300.

15. Ibid., 301, 2145–46.

16. After an interval of a decade, the rebellion resurfaced in A.D. 170; see ibid., 307.

17. Jining Cultural Relics Group and Jiaxiang Cultural Relics Administration 1982.

18. Several scholars have tried to punctuate, transcribe, and interpret this inscription. My translation is based on ibid.; Li Falin 1982: 101–8; idem, 1984; Feng Zhou 1983: 98–100.

19. Such descriptions had become conventional during the Eastern Han and may have been copied from standard books. This becomes clear if we compare this inscription with a passage from the Xiang Tajun Shrine inscription: "[The second son,] Wuhuan, is carrying on the family line. He deeply bears in mind his parents' bounty and remembers constantly the mournfulness and grief [which he felt at his parents' death]. He and his younger brother worked in the open air in their parents' graveyard, even in the early morning or the heat of summer. They transported soil on their backs to build the tumulus, and planted pine and juniper trees in rows. They erected a stone shrine, hoping that the *hun* souls of their parents would have a place to abide." This inscription is engraved on the frontal side of a stone column now in the collection of the Palace Museum, Beijing (Luo Fuyi 1960).

20. Trans. based on Makra 1961: 2–3, 15.

21. See T. T. Ch'u 1972: 205–6.

22. Powers 1991: 42–43.

23. Trans. based on Legge 1881: 10.72.

24. *Yantie lun*, 6.48; trans. based on Powers 1984: 148.

25. See H. Wu 1989: 69–70. Only two complete Han dynasty shrines have survived; one is Wu Liang's shrine and the other is the Xiaotang Shan shrine, both in Shandong. I discuss their pictorial programs in ibid., 73–230.

26. These include the inscriptions from the following funerary shrines: (1) the "Shizhai ciyuan" (early 1st century A.D.), (2) the Lu gong shrine (A.D. 16), (3) the "Yongyuan eighth year" shrine (A.D. 96), (4) the Yang sanlao shrine (A.D. 106), (5) the Boshuang shrine (A.D. 109), (6) the Dai family shrine (A.D. 113), (7) the "Yongjian fifth year" shrine (A.D. 130), (8) the Yang family shrine (A.D. 137), (9) the Huan Sangzhong shrine (A.D. 141), (10) the Wen Shuyang shrine (A.D. 144), (11) the Wu Liang shrine (A.D. 151), (12) the Xiang Tajun shrine (A.D. 154), (13) the An Guo shrine (A.D. 158), (14) the Kong Dan shrine (A.D. 182). For sources and translations of these inscriptions, see H. Wu 1987a: 484–507.

27. Xin Lixiang 1982: 47. But in my opinion, the slab seems too short to be such a pillar and more likely was an individual tablet erected in a graveyard, possibly in front of an offering shrine.

28. A guardian figure in frontal view is executed rather naively in simple sunken lines on the unpolished surface of the stone. Similar images and carving technique are observable on two other slabs dated to this period: one from Baozhaishan (80–75 B.C.) and the other from Pingyi (A.D. 26); see Li Falin 1982: 45–46.

29. A pictorial stone from Yutai in Shandong bears an inscription on its right margin. Most of the text has been obscured beyond recognition, and only four or five characters at the beginning of the inscription can be read as "the eighth year of the Yongyuan era" (A.D. 96) (see Shandong Provincial Museum and Shandong Cultural Relics and Archaeology Institute 1982: 2).

30. This slab was unearthed around 1888 in Qufu. The inscription is recorded only in Fang Ruo 1923: 1.5ab. According to Fang, originally there were pictorial designs on the stone but these had completely "peeled off" by the time of discovery. The noble rank, Marquis of Beixiang, was established in the Western Han for members of the royal house. Only during the Eastern Han was the title also assigned to ministers. The *History of the Latter Han* records three persons who held this title; none of them, however, had the surname Yang and could be identified as the man who commissioned this shrine.

31. Powers 1991: 135.

32. Shandong Provincial Museum and Shandong Cultural Relics and Archaeology Institute 1982: 15–16.

33. *Li shi*, 6806. As I discuss below, Kong Dan also constructed his own funerary structures.

34. Nanyang Museum 1974. As the excavators have demonstrated, the tomb is not Xu Aqu's grave; the carving was reused as a building stone by fourth-century builders. For the practice of reusing early stone carvings in later tombs, see Wu Hung 1989.

35. Such entertainment scenes are common in Eastern Han pictorial art; for a discussion, see DeWoskin 1987.

36. For a discussion of the definition of *portrait* in the Chinese context, see Spiro 1990: 1–11. In this study I use the term in a stricter sense, not for fictional or mythological figures based on texts (which I call "illustration"), but only for images representing real personages.

37. Trans. from Waley 1982: 44–45.

38. For textual information, see T. T. Ch'u 1972: 5, 8–9. Unlike pre-Qin cemeteries, which usually belonged to large clans or lineages, Western Han funerary sites were small and often included tombs for members of an individual family. A representative of this type of cemetery is the famous Mawangdui site whose three graves belonged to the first Marquis Dai (Li Cang), his wife, and one of their sons; the second Marquis Dai was not buried in this cemetery. Another product of the same social transformation was the "single-pit tomb" containing the corpses of a deceased couple, which became popular during the Western Han (see Institute of Archaeology, CASS 1984: 413–15; Z. S. Wang 1982: 175–77).

39. During the Qin–Western Han period a law required families with two or more adult sons living at home to pay double taxes. For textual sources and the impact of this law, see T. T. Ch'u 1972: 8–9.

40. The Eastern Han periodically established models of such "extended families" based on Confucian morality: in one place a scholar who lived with his paternal relatives and whose whole family held its property in common for three generations was highly praised (see T. T. Ch'u 1972: 301; H. Wu 1989: 32–37).

41. The public/private issue is one of the major themes in Martin Powers's works (esp. 1986, 1991). Whereas Powers discusses this problem mainly in its large social and political context, I observe the issue in a family context and hope to explore the significance of funerary structures within local communities.

42. A version of the story is quoted in *YWLJ*, 369. The present translation is based on another version in Shi Jueshou's *Biographies of Filial Sons*. For a full discussion of the story, see H. Wu 1989: 278–80.

43. This story is recorded in a version of the *Biographies of Filial Sons* housed in Tokyo University. For a full English translation and discussion, see H. Wu 1989: 291–92.

44. Trans. from S. Y. Teng 1968: 13.

45. See H. Wu 1989: 167–85.

46. *LNZ*, 70; O'Hara 1945: 147. For a full discussion and translation of the story, see H. Wu 1989: 264–66.

47. The story of the Public-Spirited Aunt of Lu is illustrated on the Wu Liang Shrine and, according to textual information, also on Li Gang's shrine, which is no longer extant. The story of the Virtuous Aunt of Liang is depicted on the Wu Liang Shrine and on the Front Shrine in the Wu family cemetery (see H. Wu 1989: 256–58, 262–64).

48. *LNZ*, 65; O'Hara 1945: 138. For a full discussion and translation of the story, see H. Wu 1989: 256–58.

49. *LNZ*, 70; O'Hara 1945: 147. For a full discussion and translation of the story, see H. Wu 1989: 262–64.

50. *Mengzi*, 2723.

51. Besides the loyal servant Li Shan discussed below, a wet nurse is praised in the *Biographies of Exemplary Women* because she became a martyr in protecting the orphaned heir of the state of Wei (*LNZ*, 69).

52. *HHS*, 2679; see H. Wu 1989: 295.

53. *Baihu tong*, 7.15ab; see D. L. Hsü 1970–71: 30.

54. See Lang 1946: chaps. 2 and 14; H. Y. Feng 1948.

55. Trans. from Makra 1961: 11.

56. Ware 1960: 72.

57. *HHS*, 1003–4; trans. from Ebrey 1981: 34–35.

58. See Yang Shuda 1933: 53–64.

59. *LNZ*, 58; O'Hara 1945: 122–24. See H. Wu 1989: 253–54.

60. See J. K. Ti'en 1988: 17.

61. For examples, see Yang Shuda 1933: 56–57.

62. *Huayangguo zhi*, 10.86; see Yang Shuda 1933: 56–57.

63. Yang Shuda 1933: 57–62.

64. J. K. T'ien 1988: 17.

65. S. Y. Teng 1968: 13, 10.

66. Legge 1871: 5.355.

67. J. K. T'ien 1988: 149.

68. Some texts further separate *you* from *tong*. For example, the *Book of Rites* records: "During the first ten years in life one is called *you*. After this age one begins to study" (*LJ*, 1232).

69. *TPYL*, 1907–8; see Huang Renheng 1925: 11b. Another version of the story quoted in *Chuxue ji* contains one more detail: "At age seventy he . . . played with a nesting chick beside his parents" (Huang Renheng 1925: 11b). This image is also found in Han pictorial carvings. For a fuller discussion of the Laizi story and pictorial illustrations, see H. Wu 1989: 280–81.

70. *Song shu*, 627. For a fuller discussion of the story, see H. Wu 1989: 286–87.

71. Quoted in Breckenridge 1968: 7. This definition is by

no means final or universal. Spiro (1990: 1–11) has demonstrated the necessity of redefining the art of portraiture in the context of ancient Chinese art.

72. Makra 1961: 15.

73. *HHS*, 2020–21; see also *WXTK* 35, "Xuanju" ("Election"), and 8, "Tong ke" ("Children").

74. Spiro 1990: 31.

75. Powers 1991: 205.

76. Soymié 1954: 378.

77. *TPYL*, 1909; see Huang Renheng 1925: 13b. For a fuller discussion of this story, see H. Wu 1989: 303–4.

78. *TPYL*, 2360; see Huang Renheng 1925: 28ab. For a fuller discussion of the story, see H. Wu 1989: 304–5.

79. This passage is from the inscription on the An Guo shrine, which also describes scenes on the memorial hall, including "personages of filial piety, excellent virtue, and benevolence."

80. Wellek 1955: 1.211.

81. *HHS*, 2063.

82. Ibid. The *History of the Latter Han* gives the name Xun Shu instead of Xun Yu. This is obviously a mistake because Xun Shu died in 149, some ten years before Han Shao's death. Moreover, since Xun Shu was the teacher of Li Ying, it is quite impossible that his name would be listed last and following that of his student. It is very possible that the person who joined Li Ying and others to erect the stela was Xun Yu, a nephew of Xun Shu. At the time, Xun Yu was the governor of Pei county in Shandong; he and Han Shao were both from Yingchuan; and he was a radical member of the Confucian faction to which the other three commissioners of the stela belonged.

83. See Ebrey 1980.

84. The following introduction to Li Ying's life is based mainly on *HHS*, *juan* 67 (2183–218), which includes his biography. Dates of his persecution and death are given in *HHS*, 318, 330–31. For the struggle between different political factions during the reigns of Emperors Huan and Ling, see Twitchett and Loewe 1986: 286–90, 311–30.

85. *HHS*, 2198.

86. Ibid., 2050.

87. The following introduction to Chen Shi's life is based on his biography in ibid., 2065–67.

88. See Powers 1983: 8–11; C. Y. Chen 1975:19–20.

89. *HS*, 3364; *HHS*, 1211.

90. For an excellent discussion of this subject, see Powers 1984: 142–54.

91. The *History of the Latter Han* does not provide the date of Han Shao's death and the time of the stela's establishment is thus uncertain. During the Han, such a dedication required

the donors to be at the funerary ceremony. According to *HHS* (2066, 2195, 2198), after being released from jail in 167, Li Ying and Du Mi returned home to Shandong. Du Mi was reinstated before Emperor Huan's death in 167, and Li Ying returned to the court shortly afterward. Both men died in 169. In 167 Chen Shi, after a brief incarceration, returned to his hometown, Yingchuan (*HHS*, 2066). Only Xun Yu seemed to have kept his official post in Pei (*HHS*, 2050).

92. *Xunzi*, 246.

93. For a useful index to these inscriptions, see Yang Dianxun 1940. For a brief introduction to Han epitaphs and other types of inscriptions, see Ebrey 1980.

94. Cao Pi wrote in his "Dian lun" (Authoritative discourses): "Though all writing is essentially the same, the specific forms differ. Thus memorials [*zou*] and deliberations [*yi*] should be decorous; letters [*shu*] and essays [*lun*] should be logical; inscriptions [*ming*] and dirges [*lei*] should stick to the facts; poetry [*shi*] and rhymeprose [*fu*] should be ornate" (trans. from Hightower 1957: 513). For discussions of this subject, see Holzman 1978; R. Miao 1972: 1025; Watson 1968a; and Kinney 1990: 21–22.

95. Such cases are numerous; for example, a member of the Wu family in Jiaxiang identified his remote ancestor as King Wu Ding of the Shang, though Wu Ding's surname was not even Wu. Another famous stela dedicated to Zhang Qian records that Zhang's ancestors include Zhang Zhong of the Zhou, and three famous Western Han figures: Zhang Liang, Zhang Shizhi, and another Zhang Qian. None was actually related to Zhang Qian, however.

96. *HHS*, 2067–68.

97. Ibid., 2063.

98. The following information about Kong Rong is from his biography in ibid., 2261–63.

99. Unless noted, information about Zhao Qi is from his biography in ibid., 2121–25.

100. *Sanfu juelu* (Records of the Sanfu area reexamined); cited in *HHS*, 2121.

101. *HHS*, 2124.

102. See Shi Zhecun 1987: 405.

103. For a brief discussion of these works, see H. Wu 1989: 188–89, 252–53, 272–75.

104. For a discussion of Han omen catalogues, see H. Wu 1989: 76–92.

105. According to historical records, such illustrated texts included the *Biographies of Exemplary Women*, the *Annotated Good-Omen Illustrations*, and the *Classic of Mountains and Seas*; see H. Wu 1989: 76–95, 171–73.

106. One such copybook recorded in the "Bibliography"

chapter of the *History of the Former Han* is called *The Method of Painting Confucius' Disciples* (*Kongzi turen huafa*) (*HS*, 1717).

107. H. Wu 1989: 73–230, esp. 96–107, 173–80, 182–86.

108. For a discussion of these characteristics of the New Text school, see ibid., 97–101.

109. For Wu Liang's relationship with the "retired worthies," see ibid., 102–7.

110. This argument is based on (1), as I will demonstrate later, the historical narrative depicted on the shrine's walls develops from right to left and from top to bottom; and (2) traditional Chinese writing, painting, and reading always followed this order.

111. Part of this chapter is translated in Watson 1958: 42–57.

112. Ibid., 70–100.

113. Ibid., 92.

114. Sima Qian's own words, in reference to the "Treatise on Heavenly Signs" ("Tianguan shu") and the "Treatise on the Feng and Shan Sacrifices" ("Fengshan shu"); see ibid., 115.

115. For discussions of the structure of the *Historical Records*, see Watson 1958: 101–34; H. Wu 1989: 151–52.

116. For the development of the Queen Mother myth and iconography, see H. Wu 1989: 108–41.

117. Ibid., 76–80, 234–35.

118. *HHS*, 1373.

119. Forke 1962: 259.

120. Extant omen catalogues date to post-Han periods, but as I have argued elsewhere, these later works are very likely based, partially or entirely, on Han examples (H. Wu 1989: 234–35).

121. For translations of these cartouches and their textual sources, see ibid., 235–43.

122. Trans. based on Hightower 1952: 265–66.

123. *HHS*, 2185; trans. based on Powers 1983: 7.

124. Trans. based on Hightower 1952: 229.

125. Ibid., 173.

126. The source of this inscription is the "Xi ci" section of the *Book of Changes*: "When in early antiquity Fu Xi ruled the world, he looked upward and contemplated the images in Heaven; he looked downward and contemplated the patterns on earth. He contemplated the markings of birds and beasts and the adaptations to the regions. He proceeded directly from himself and indirectly from objects. Thus he invented the eight trigrams in order to enter into the wisdom of the gods and to regulate the conditions of all beings. He made knotted cords and used them for nets and baskets in hunting and fishing" (trans. based on Wilhelm 1967: 328–29).

127. A passage from *Fengsu tong* (1.9) reads: "The Yellow Emperor invented the royal crown, and had upper and lower garments hang down." A similar expression appears in the "Xi ci": "The Yellow Emperor . . . had upper and lower garments hang down, so the world was in order" (trans. based on Wilhelm 1976: 332).

128. *SJ*, 3319.

129. H. Wu 1989: 244–45.

130. An exception is the story of Zhongli Chun, which is included in the sixth chapter of the *Biographies of Exemplary Women*, "Reasoning and Understanding." On the Wu Liang shrine, this picture is separated from other female images and is placed in the lower section. As I have argued elsewhere, this position emphasizes the figure's loyalty toward the ruler (H. Wu 1989: 191).

131. Datong Museum 1972.

132. Palace Museum 1978: figs. 20–32.

133. *LNZ*, 4.58.

134. For example, it was said that Confucius once claimed: "Of all the actions of man, there is none greater than filial piety; and in filial piety there is nothing greater than the reverential awe of one's father." The *Xiao jing*, or *Classic of Filial Piety*, states in the first chapter that in practicing filial piety one should extend the love of one's father to one's mother.

135. These are the stories of Zeng Shen, Min Ziqian, Elder Laizi, and Han Boyu.

136. See H. Wu 1989: 296–98.

137. Ibid., 193–213.

138. Berger 1990: 231–34.

139. See H. Wu 1989: 222–23.

140. For a different view, see Hay 1993: 171.

141. The stela, called "Tablet of the Divine Shrine of the Late Chancellor of Liang, Kong Dan," is now missing; only its inscription is recorded by Hong Gua (*Li shi*, 6806). According to Hong, the stela was originally located in Yongcheng near Xuzhou. A passage at the end of the inscription identifies its author as Kong Dan's son, who wrote the text when his father was still alive.

142. For information about these monuments and their inscriptions, see ibid., 5–9, 24–25.

143. Trans. partially based on Fairbank 1941: 8.

144. The inscription is engraved on the front side of a stone column, now in the collection of the Palace Museum in Beijing. According to Luo Fuyi (1960), this column was found in 1934 on a small hill called Tietoushan about 22 miles west of Dong'a county in present-day Shandong. It consists of two connected sections, a four-sided shaft and a lion base. Human figures, mythical animals, and geometric patterns in low relief appear

on the front, the right side, and the back of the shaft. The left side is plain. Luo Fuyi thought that this column was originally a central pillar located in the entrance of a tomb. Based on the inscription and the decorative features of the column, Nagahiro Toshio (1965: 46–47) has argued, rightly in my opinion, that it may have been a pillar standing in the facade of a shrine and attached to the left wall. I discuss and translate this inscription in H. Wu 1987a: 496–99.

145. As I discuss later in this section, the inscription on the An Guo shrine is a rare Han funerary text that describes the shrine's decoration. But even in this case the writer only mentions the most common scenes in Han art and offers no information about the shrine's specific decoration. We also find interesting parallels between the An Guo inscription and Wang Yanshou's "Rhapsody on the Hall of Spiritual Light of the Lu" (translated in Bush and Shih 1985: 26). Both texts seem to follow a standard literary formula at the time.

146. Hay 1993: 171.

147. These patrons could be the family members of the deceased, the former associates of the deceased, and the deceased himself. Workers' signatures and marks inscribed inside tombs were known, but these can hardly be considered "texts."

148. Shandong Provincial Museum and Cangshan Cultural House 1975. The date of the Cangshan tomb has been the focus of a scholarly debate, primarily because the date on its inscription is ambiguous: "the first year of the Yuanjia reign period" could be either A.D. 151 or 424. The excavators first dated the tomb to 424, but most scholars have been rejected their opinion (see Li Falin 1982: 68–77).

149. A rough transliteration of the text appeared in the excavation report, and some passages were quoted as iconographic sources for the pictures engraved in the tomb. The authors of the report, however, cautiously avoided punctuating and interpreting the whole text. Five years after the publication of the report in *Kaogu*, a short publisher's note appeared in the magazine, saying that the editorial board had received several articles criticizing the transliteration and interpretation of the inscription as provided in the report. Since then, three articles on the inscription, two by Li Falin (1980, 1982) and the other by Fang Pengjun and Zhang Xunliao (1980), have been published, laying a foundation for a more comprehensive study of the text. In addition, Jiang Yinju and Wu Wenqi proposed another reading in a catalogue of Shandong pictorial carvings in 1982 (Shandong Provincial Museum and Shandong Cultural Relics and Archaeology Institute 1982: 42).

Li Falin's two articles exhibit only minor differences. His basic method is to discover references for individual words and phrases and then to find the relationships between these units. Fang Pengjun and Zhang Xunliao, on the other hand, first focused on phonology and punctuation. They found that the whole text is actually a rhymed composition. After a careful phonological study, the two authors concluded that "the recognition of (these rhyming rules) is the key to interpreting the text" (1980: 271).

These studies provide the present author with important clues. My identification of characters takes into consideration the different opinions. Fang Pengjun and Zhang Xunliao's punctuation differs markedly from that proposed by Li Falin and, in my opinion, is more convincing. Except for one place, I accept it as the basis for my punctuation of the text. On the other hand, Li Falin has provided many literary sources important for our understanding of the text. Unless noted, I follow his interpretations of words and phrases.

150. Li Falin (1982: 96) interpreted the character *song* as "to present" or "to donate" and the sentence as "we completed the construction of this tomb chamber and presented it to you, the honorable member of a family." The later parts of the inscription, however, clearly suggest that this tomb was a vehicle to transport the dead to the other world. The character *song* can thus be more properly translated as "to send off" or "to send away."

151. Li Falin provided two different interpretations for the terms *boshu* and *huaguan*. In 1982: 96, he explained *boshu* as "simple and coarse," and *huaguan* as "rooms decorated with pictures." The sentence would then read: "Chambers decorated with pictures are inside the simple and coarse tomb." In 1980: 72, he explained *boshu* as "decoration and carving," and *huaguan* as "paintings people can view and enjoy." The sentence would then be interpreted as: "In the decorated and engraved tomb chambers are pictures people can see and enjoy." My understanding of this sentence differs. In Han literature the character *bo* and *bu* are interchangeable; the latter means "a list" or "to list." The meaning of *shu* is close to *bu* and can be translated in certain contexts as "to list," "to explain," or "to propose" (see *HS*, 2128). As defined in *SW* (408), the original meaning of *guan* is "to see." Its secondary meanings include "to show," "to appear," or "appearance." The word *huaguan* thus means "the appearance of the pictures" or simply "the pictures."

152. A commentary to the "Yueling" chapter in *LJ* (1372) reads: "*Zhongliu* means the central chamber. The element 'earth' governs the center, and its spirit is in the chamber."

153. Li Falin (1982: 96) misidentifies the character *yang* as *jia* and reads *jiashi* together to mean the tomb's side chamber. Two factors lead me to identify the supposed placement of these

scenes (hence the meaning of the phrase *shishangyang*) as the ceiling of the rear chamber: (1) the location of the images of the Blue Dragon and the White Tiger in the present tomb, and (2) the narrative sequence of the inscription, which describes the pictures in the tomb from the rear to the front section.

154. A *ping* is a type of carriage used by women. According to *Shi ming* (364–65), "*Ping* means 'to shield.' A *ping* chariot is covered on all four sides; it is an ox-drawn carriage for female transportation."

155. *Fengsu tong* defines a *ting* as "the inn where travelers rest" (see Li Falin 1982: 98). Yan Shigu's commentary on *HS*, 3 reads: "*Ting* means 'to stop'; it is the inn where travelers rest and dine."

156. *Youjiao* is a low official rank in an administrative body called a *xiang* (a large village). His principal duty was to maintain public order and to catch thieves and robbers. *Xu Han shu*, "Baiguan zhi" (A record of official ranks) records that "in every *xiang* district there is a *youjiao* who is in charge of the prohibition against stealing and robbing" (see Li Falin 1982: 98).

157. According to *SW* (270) and *HS* (310–11), the character *hui* in the inscription means "coffin" or "small coffin." A hearse carrying a coffin is thus called a *hui* carriage.

158. The title *dudu* does not appear in Han official documents but can be found in several Eastern Han inscriptions. On the "Stela of the Divine Master White Stone," donors' names are listed in order of their official ranks. Two persons entitled *dudu* are listed after those who held the post *jijiu* (official in charge of ceremonies) but before those entitled *zhubu* (the chief of records). Li Falin (1982: 71) thus suggests that *dudu* was a relatively low official rank during the Eastern Han.

159. According to the "Baiguan zhi" in *Xu Han shu*, "The responsibility of a *zeicao* is to guard against robbery" (quoted in Li Falin 1982: 99).

160. Li Falin (1982: 99) interprets the term *chengqing* as "favorite official assistant." Indeed, the character *cheng* was usually used in official titles to mean "assistant" or "junior." *Qing* is not a Han official post, however, but is sometimes used as *gongzi*, meaning "young master." The term *chengqing*, therefore, can be understood in the context of the inscription as the "junior master"—the son of the deceased—who stands at the entrance of the reception hall to greet guests, while the *xinfu*, his bride, is serving drink to guests. The term *xinfu* was used in Han times for either a "daughter-in-law" or a "bride." This reading is further supported by an Eastern Han carving from Xinjin in Sichuan. Three kneeling figures are portrayed on two door leaves of a tomb. According to the accompanying cartouches, the woman is "a filial daughter-in-law" and the two men are

worthy son Zhao Yuanfu and his younger brother Zhao Mai (see Wen Yu 1956: interpretations of pls. 21, 22; Rudolph 1951: 30). It is not difficult to find parallels between this carving and the Cangshan images both in terms of decorative position and subject matter.

161. For a listing of these characters, see Li Falin 1982: 100; Fang Pengjun and Zhang Xunliao 1980: 273–74.

162. Li Falin 1982: 100.

163. According to Fang Pengjun and Zhang Xunliao (1980: 271), the beginning and ending sections of this text both consist of four-character lines, with rhymes on odd-numbered lines. The rest of the inscription is composed of three-character, four-character, and seven-character lines. All seven-character sentences are rhymed, whereas rhyming words only end the second three-character line if there is a pair. These two authors also suggest that "except for the character *jun*, the remaining 45 rhymes in the inscription are all consistent with those in Han literature" (1980: 273).

164. This literary form, which is most commonly seen in stela inscriptions, is sometimes imitated by the family members of the dead in their devotional texts. One such example is the inscription composed by Wu Liang's descendents, which begins with a prose narrative and ends with a paragraph consisting of rhymed four-character lines (see H. Wu 1989: 25).

165. For a discussion of this expression, see Chen Zhi 1962.

166. H. Wu 1987a: 446–53.

167. Jining Area Cultural Relics Group and Jiaxiang Cultural Relics Administration 1982: 70.

168. Li Falin (1982: 97) identifies the bridge mentioned here as one of the three Wei Bridges outside the Western Han capital Chang'an. He thus infers that the person buried in the Cangshan tomb must have held an official post in the capital before his death. In my opinion, the inscription uses *Wei Bridge* in a general and symbolic sense. The first or Middle Wei Bridge was built by the First Emperor to connect the Xianyang Palace and the Changle Palace, which were separated by the Wei River. The second or East Wei Bridge was constructed by Emperor Jing of the Han to connect the capital and his tomb. The third or West Bridge built by Emperor Wu linked the capital with his tomb. The two bridges built during the Han were both part of imperial funerary constructions. By connecting the capital and imperial tombs, they made it possible for ritual processions to cross the river to the imperial mausoleums.

169. For such figures, see Omura Seigai 1915: 1.143–45.

170. For the iconography and symbolism of the Wang Hui sarcophagus, see H. Wu 1987a: 75.

171. Trans. based on Bush and Shih 1985: 26.

CHAPTER FIVE

1. Trans. from Stephen Owen, *An Anthology of Chinese Poems*. Cambridge, Mass.: Harvard University Press, forthcoming (romanization altered).

2. Ibid. (romanization altered).

3. According to the recent inventory in Yao Qian and Gu Bing 1981, altogether eleven Liang mausoleums have been found: (1) Jian ling (of Emperor Wen, Xiao Shunzhi; probably built in 535), (2) Xiu ling (of Emperor Wu, Xiao Yan; built before 549 when the emperor died), (3) Zhuang Liang (of Emperor Jianwen, Xiao Gang; built before 552), (4–11) tombs of eight Liang princes—Xiao Hong (d. 526), Xiao Xiu (d. 518), Xiao Hui (d. 527), Xiao Dan (d. 522), Xiao Jing (d. 523), Xiao Ji (d. 529), Xiao Zhengli (d. before 548), and Xiao Ying (d. 544). The remains of the Zhuang ling of Emperor Jianwen, however, are buried and cannot be seen. The relationship between the deceased is shown in the following table (the tombs of those whose names are in parentheses have not been found):

The Liang tombs and other mausoleums of the Southern Dynasties in the Nanjing area have been recorded since Tang times (for traditional sources, see Zhu Xizu et al. 1935: 2–4). Important investigation reports and synthetic studies by modern scholars include H. Chang (14 mausoleums of the Six Dynasties are recorded); Zhu Xizu et al. 1935 (28 mausoleums are recorded, and Chang's mistakes are corrected); Zhu Xie 1936, 1957; Jin Qi 1959; Kanda Kiichirō et al. 1957; Yao Qian and Gu Bing 1981 (31 mausoleums are recorded).

4. The terms *shendao* and *suidao* denote the path extending from the pillar-gate to the tomb; see Zhu Xizu et al. 1935: 100, 202. This is why the word *shendao* is always inscribed on the pillar-gate.

5. Zhu Xizu et al. 1935: 23.

6. *Jiankang shilu*, 17.19b. I interpret the word *suitou*, which means literally "the opening of a *suidao* path," as the place under the pillar-gate. As Zhu Xizu has explained, the term *suidao* or *sui* indicates the path extending from the pillar-gate to the tomb mound; see note 4 to this chapter.

7. *Liang shu*, 90; Yu Xin's "Ai Jiangnan fu" quoted in Zhu Xie 1936: 24.

8. *Yudi zhi* (A geographical record) cited in *Danyangxian zhi* (A gazetteer of Danyang county); see Zhu Xie 1936: 23.

9. Here I assume a visitor's view. Chinese and Japanese authors usually describe the pillars from the position of the tomb mound (i.e., from the position of the deceased), thus the "right pillar" in their writings is the left one in mine and vice versa.

10. Most inscriptions on the pillar-gates in the Liang mausoleums face outward; the only exception are those on Emperor Wen's gates, which face each other and form a pair of true mirror-images. My analysis here focuses on the majority cases.

11. In other words, the binary inscriptions first appeared as something external to and independent of the visitor; they then became something to be visualized and comprehended and finally become the stimulus for an imagined vision or visualization. For a concise discussion of images and imagination, see Frazer 1960. Here I also borrow ideas from P. Yu 1987: 3–19.

12. *Lu Shiheng ji*, 7.3b–41; trans. from Davis 1983: 1.168–70.

13. *Nan Qi shu*, 701.

14. *Liang shu*, 88.

15. As scholars have noted, writing funeral songs in the voice of the dead was not Tao Qian's invention; Lu Ji and Miao Xi (186–245) wrote a number of such works (see Davis 1983: 1.167–68). This tradition may be even traced back to the Han; the author of the *yuefu* poem "Battle South of the City" ("Zhan chengnan") assumes the view of a dead soldier. But only Tao Qian wrote funeral songs for himself.

16. This is the third of the three songs. *Tao Yuanming ji*, 142; trans. based on Hightower 1970: 248.

17. *Tao Yuanming ji*, 191–96.

18. Ibid., 196–97; trans. based on Davis 1983: 1.240–41.

19. Doré 1938: 8.89.

20. For the decorative programs of such sarcophagi and the symbolism of the "gate" motif, see H. Wu 1987b.

21. In an earlier article (ibid., 75–77), I suggested that this figure stands at the entrance of the other world to receive the dead. Although this interpretation is not impossible, my present discussion offers an alternative understanding. Supported by Tao Qian's writings and other literary evidence, this interpretation focuses on changes in perception after the Han.

22. Quoted in *TPYL*, 3315.

23. "Master" is based on Yu Yuanwei's self-introduction. In fact, we know nothing about Yu and his works except for this piece of writing which, moreover, is preserved only as fragments in *TPYL*, 3318.

24. Quoted in *Zhongguo meishujia renming cidian*, 27.

25. The only existing example of this type of inscription is found in Emperor Wen's mausoleum.

26. An example of such an inscription is found on a surviving pillar in Xiao Jing's (Emperor Wen's nephew) tomb. Only two "reversed" characters in the inscription dedicated to Xiao Xiu have survived. According to Mo Youzhi, the original inscription was also written in the regular right-to-left order; see Zhu Xizu et al. 1935: 57.

27. Examples of this type of inscription has been found in tombs of Xiao Hong (Emperor Wen's son), and Xiao Ying, Xiao Zhengli, and Xiao Ji (Emperor Wen's grandsons).

28. According to *Yudi zhi*, the stone animals in front of the Jian ling Mausoleum (and perhaps other stone carvings as well) were made in 535; quoted in *Danyangxian zhi*; see Zhu Xie 1936: 23.

29. Bachhofer 1931; Soper 1948.

30. For introductions to the Boston shrine, see K. Tomita 1942; Guo Jianbang 1980. Here I follow Tomita's dating of the shrine. For the structure of the Zhu Wei Shrine, see Fairbank 1942.

31. *Zhongguo meishu quanji* 1, pt. 19; interpretation of fig. 5.

32. Laurence Sickman first saw the stone shrine in Kaifeng in 1933. Later, he came upon a complete set of rubbings in Beijing, including both the engravings on the shrine and an epitaph on a separate stone; see K. Tomita 1942: 109*n*1.

33. See ibid., 109–10.

34. This sarcophagus was probably made for Lady Yuan in 522. It has been repeatedly studied by scholars; for references, see Cleveland Museum of Art 1980: 5–6.

35. One such study is Soper 1948; for his discussion of the Nelson sarcaphogus, see 180–85.

36. There are numerous studies of the history and principles of the linear perspective system. For a recent discussion, see Hagen 1986: 142–65. For discussions on the Wang Lin scene, see Siren 1956: 1.58; Soper 1941: 159–60.

37. Soper 1941: 159–60.

38. This painting has been repeatedly published and discussed. For references, see Cahill 1980: 12–13.

39. See Bush and Shih 1985: 38–39.

40. Ibid., 36–40.

41. *Lu Shiheng ji*, 1.1a–4b; trans. based on Owen 1992: 90–110. See P. Yu 1987: 33, 35. Owen (1992: 96) comments on the expression *shoushi fanting* ("retraction of vision, reversion of listening"), which is intimately related to the "reversed perception" discussed in this section: "Most Chinese exegetes . . . interpret this passage as a cutting off of sense perceptions, taking *shou* [retract] in a common usage as 'cease,' and apparently taking *fan* [revert] as the attention of listening 'reverting' to non-attention. Chinese theorists often spoke of the necessity of cutting oneself off from the determinations of the lived world in order to write."

42. Translation based on Acker 1954: 1.6–7.

43. For a stylistic study of the sarcophagus's engravings, see Okumara Ikura 1939: 359–82. This sarcophagus has been dated to 524 as part of a larger group of funerary paraphernalia of a Northern Wei prince (Minneapolis Institute of Arts 1948). Nagahiro Toshio (1969: 173–218) discussed it and the Kansas City sarcophagus, along with other Northern Wei stone engravings dating from the early sixth century. The Chinese scholar Wang Shucun (1986: 11) recently reported that more than ten such "pictorial sarcophagi" have been found in the Luoyang area.

44. See Huang Minglan 1987: 117–18, figs. 13–34.

45. I explore this idea at a greater length in H. Wu 1984: 46–48.

46. These figures may represent servants of the deceased: another Northern Wei sarcophagus discovered in 1973 in Guyuan is decorated on two sides with similar windows and figures, and the deceased is portrayed on the front side of the coffin (Guyuan Cultural Relics Work Station 1984).

47. There are interesting parallels—both superficial and profound—between this picture and Velasquez's famed painting "Las Meninas," which also employs sets of (seemingly) disconnected images to extend the visual field. In particular, directly facing the spectator in the background, a framed rectangular mirror holds in its glow two standing figures who are staring at the spectator. In Foucault's words, this mirror "shows us nothing of what is represented in the picture itself. Its motionless gaze extends out in front of the picture, into that necessary invisible region which forms its exterior face, to apprehend the figures arranged in that space. Instead of surrounding visible objects, this mirror cuts straight through the whole field of the representation, ignoring all it might apprehend within that field, and restores visibility to that which resides outside all view" (Foucault 1973: 7–8). This mirror-imagery is thus comparable with the window imagery on the sarcophagus.

48. Norman Bryson (1983: 92, 94) has compared Western painting and Chinese painting in terms of their different notions and treatments of the pictorial plane: "Through much of the Western tradition oil paint is treated primarily as an *erasive* medium. What it must first erase is the surface of the picture-plane: visibility of the surface would threaten the coherence of the fundamental technique through which the Western representational image classically *works* the trace, of ground-to-figure

relations: 'ground,' the absence of figure, is never accorded parity, is always a *subtractive* term. . . . The individual history of the oil-painting is therefore largely irretrievable, for although the visible surface has been worked, and worked as a total expanse, the viewer cannot ascertain the degree to which other surfaces lie concealed beneath the planar display: the image that suppresses deixis has no interest in its own genesis or past, except to bury it in a palimpsest of which only the final version shows through, above an indeterminable debris of revisions." In Chinese painting, on the other hand, "Everything that is marked on the surface remains visible, save for those preliminaries or errors that are not considered part of the image." A Chinese painting "cannot be taken in all at once, *tota simul*, since it has itself unfolded within the *duree* of process; it consists serially, in the somatic time of its construction." The engraving on the sarcaphogus, however, also show these two modes of representation in a single composition: some scenes erase the surface and other images restore the surface.

49. *SJZ*, 373–94.

50. *ZL*, 648; *Guo yu*, 223, 225n17.

51. According to *Gongyang's Commentaries on the Spring and Autumn Annals* (*Chunqiu Gongyang zhuan*, 473), only the Son of Heaven could enjoy a pair of *guan* towers. For similar regulations, see *LJ*, 1433 and 1448.

52. In the *Book of Rites*, a *que* is called a *taimen* (terrace gate)— "the taller the more honorable" (*LJ*, 1433).

53. We know that at least from the second century B.C., the elite began to erect *que* in graveyards to distinguish the ranks and status of the deceased. For example, Huo Guang's wife built imperial *que* with "three wings" (*sanchu*) to honor her dead husband, and this practice was viewed as an omen presaging the fall of the Huo family (*HS*, 2950–51). It is possible that *que* gates had already appeared in Eastern Zhou graveyards. *Zuo zhuan* (*ZZ*, 1773, 1886) records a kind of building called *diehuang*, or "funerary *huang*," which the Jin dynasty commentator Du Yu identified as *que* pillars in front of cemeteries. Some scholars also believe that *que* gates originally marked the entrances of the Lishan mausoleum of the First Emperor.

54. Quoted in *SJZ*, 215.

55. *Shi ming* (5.17b): "*Que* means *que*—'short of.' It stands at either side of a gate; the gap in the middle is a path."

56. *Er ya*, 171. Similarly, *SW* (588a): "A *que* is the *guan* at a gate."

57. *Shi ming* (5. 18): "*Guan* means 'to see.' On its top one observes." *LJ* (1413): "In the past, Confucius attended a *la* ritual. Upon the completion of the ceremony he came out, strolled on top of a *guan* terrace, and sighed. What he sighed for was the state of Lu." The Han commentator Zheng Xuan explained: "*Guan* means *que*."

58. Sun Yan wrote: "[*Que* is called *guan* because] in the past, legal documents were hung on the pair of *que* in front of the palace. It thus became the place people always looked at" (quoted in Kong Yingda's commentary to *LJ*, 1413).

59. As exemplified by Sima Qian's "Self-statement of the Grand Historian" ("Taishigong zixu"), it is an established convention in ancient China to write an autobiography in third person.

60. These inscriptions can be classified into four types. Type 1 identifies the pillars as forming the gate to a cemetery. Thus, the inscriptions on Huang Shengqing que (A.D. 86) reads: "The main gate [*damen*] to the tomb of Huang Shengqing from Pingyi in South Wuyang, who [died] in the third year of the Yuanhe reign period [A.D. 86]." Type 2, which identifies the pillars as *que*, includes Wang Zhizi que (A.D. 105), the Wu Family que (A.D. 147; Jiaxiang, Shandong), Li Ye que (A.D. 36, Zitong, Sichuan). Type 3, which identifies a pillar gate as the beginning point of the spirit road, includes Pingyang Fujun que and Shanyongzhang que (respectively in Mianyang and Deyang, Sichuan; second century A.D.), Feng Huan que (A.D. 121, Quxian, Sichuan), Shen Fujun que (Quxian, Sichuan; second century A.D.), and Er Yang que (Sichuan; second century A.D.). Pillars belonging to Type 4 bear only the name and title of the deceased, an example is the Gao Yi que (A.D. 209, Sichuan).

61. One such example is the gate of the Wu Family cemetery at Jiaxiang in Shandong; see H. Wu 1989: 25.

Works Cited

WESTERN-LANGUAGE REFERENCES

Acker, W. R. B. 1954. *Some T'ang and Pre-T'ang Texts on Chinese Painting*. 2 vols. Leiden: E. J. Brill.

Allan, S. 1991. *The Shape of the Turtle: Myth, Art, and Cosmos in Early China*. Albany: State University of New York Press.

Althusser, L. 1971. *Lenin and Philosophy and Other Essays*. London: New Left Books.

An, J. H. (An Chin-huai). 1986: "The Shang City at Chengchou." In K. C. Chang, ed., *Studies of Shang Archaeology*. New Haven: Yale University Press, 15–48.

Arnheim, R. 1982. *The Power of the Center*. Berkeley: University of California Press.

———. 1986. *New Essays on the Psychology of Art*. Berkeley: University of California Press.

Bachelard, G. 1964. *The Poetics of Space*. Trans. Maria Jolas. New York: Orion Press.

Bachhofer, L. 1931. "Die Raumdarstellung in der chinesischen Malerei des ersten Jahrtausends n. Chr" (The representation of space in Chinese paintings of the first millennium A.D.). In *Münchner Jahrbuch der Bildenden Kunst* (Munich yearbook of pictorial arts), vol. 3. Trans. H. Joachim into English. MS in the Rübel Art Library, Harvard University.

Bagley, R. W. 1987. *Shang Ritual Bronzes in the Arthur M. Sackler Collection*. Washington, D.C., and Cambridge, Mass.: A. M. Sackler Foundation and A. M. Sackler Museum.

Barnard, N. 1980–81. "Wrought Metal-Working Prior to Middle Shang (?): A Problem in Archaeological and Art-Historical Research Approaches." *Early China* 6: 4–30.

Bauer, W. 1976. *China and the Search for Happiness*. Trans. M. Shaw. New York: Seabury Press.

Benton, T. 1981. "'Objective' Interests and the Sociology of Power." *Sociology* 15.2: 161–84.

Berger, P. 1990. "An Ideology of One: The Offering Shrine of Wu Liang." *Early China* 15: 223–35.

Bielenstein, H. 1980. *The Bureaucracy of Han Times*. Cambridge, Eng.: Cambridge University Press.

Bilsky, L. J. 1975. *The State Religion of Ancient China*. 2 vols. Taibei: Asian Folklore and Social Life Monographs Series.

Birrell, A. 1988. *Popular Songs and Ballads of Han China*. London: Unwin Hyman.

Bishop, C. W. 1938. "An Ancient Chinese Capital, Earthworks at Old Ch'ang-an." *Antiquity* 13: 68–78.

Breckenridge, J. D. 1968. *Likeness: A Conceptual History of Ancient Portraiture*. Evanston, Ill.: Northwestern University Press.

Bryson, N. 1983. *Vision and Painting: The Logic of the Gaze*. New Haven: Yale University Press.

Bush, S., and H. Y. Shih. 1985. *Early Chinese Texts on Painting.* Cambridge, Mass.: Harvard University Press.

Bushell, S. W. 1910. *Chinese Art.* 2 vols. London: Board of Education.

Cahill, J. 1980. *An Index of Early Chinese Painters and Paintings.* Berkeley: University of California Press.

Chang Huang. 1912. "Tombeau des Liang." *Variétés sinologiques* 33.

Chang, K. C. 1964. "Some Dualistic Phenomena in Shang Society." *Journal of Asian Studies* 24: 45–61. Reprinted in Chang 1976: 93–114.

———. 1976. *Early Chinese Civilization: Anthropological Perspectives.* Cambridge, Mass.: Harvard University.

———. 1977. *Archaeology of Ancient China.* 3d ed. New Haven: Yale University Press.

———. 1980a. *Shang Civilization.* New Haven: Yale University Press.

———. 1980b. "The Chinese Bronze Age: A Modern Synthesis." In W. Fong 1980: 35–36.

———. 1981. "In Search of China's Beginnings: New Light on an Old Civilization." *American Scientist* 69.2: 30–41.

———. 1983. *Art, Myth, and Ritual.* Cambridge, Mass.: Harvard University Press.

———. 1986. *The Archaeology of Ancient China.* 4th ed. New Haven: Yale University Press.

Chavannes, E. 1913. *Mission archéologique dans la Chine septentrionale* (An archaeological mission to northern China). 13 vols. Paris: Imprimerie nationale.

———. 1914. *Six monuments de la sculpture chinoise.* Paris: Librairie d'art et d'histoire.

Chen, C. Y. 1975. *Hsün Yüen: The Life and Reflections of an Early Medieval Confucian.* London: Cambridge University Press.

Cheng Te-k'un. 1957. *Archaeological Studies in Szechwan.* Cambridge, Mass.: Harvard University Press.

Childs-Johnson, E. 1988. "Dragons, Masks, Axes and Blades from Four Newly-Documented Jade-Producing Cultures of Ancient China." *Orientations* 19.4: 30–41.

Chinese Academy of Architecture. 1982. *Ancient Chinese Architecture.* Beijing: China Building Industry Press.

Ch'u, T. T. 1972. *Han Social Structure.* Ed. J. L. Dull. Seattle: University of Washington Press.

Clarke, D. V., T. G. Cowie, and A. Foxon. *Symbols of Power at the Time of Stonehenge.* Edinburgh: National Museum of Antiquities of Scotland.

Cleveland Museum of Art. 1980. *Eight Dynasties of Chinese Painting: The Collections of the Nelson Gallery–Atkins Museum, Kansas City, and the Cleveland Museum of Art.* Cleveland: Cleveland Museum of Art.

Colquhoun, A. 1982. "Thought on Riegl." In Forster 1982b: 79–83.

Costen Erdberg, E. von. 1957, 1958. "A Terminology of Chinese Bronze Decoration." 2 parts. *Monumenta Serica* 16: 287–314; 18: 208–54.

Creel, H. G. 1937. *The Birth of China: A Study of the Formative Period of Chinese Civilization.* New York: Reynal & Hitchcock.

Cunningham, A. 1879. *Stupa of Bharhut.* London: Secretary of State for India in Council.

Daniel, G. 1967. *The Origins and Growth of Archaeology.* Harmondsworth, Eng.: Penguin.

d'Argencé. R. L. *Ancient Chinese Bronzes in the Avery Brundage Collection.* San Francisco: M. H. de Young Memorial Museum.

Davis, A. R. 1983. *T'ao Yüan-ming: His Works and Their Meaning.* 2 vols. Cambridge, Eng.: Cambridge University Press.

de Bary, W. T., ed. 1960. *Sources of Chinese Tradition.* 2 vols. New York: Columbia University Press.

DeWoskin, K. J. 1983. *Doctors, Diviners, and Magicians: Biographies of Fang-shi.* New York: Columbia University Press.

———. 1987. "Music and Voices from the Han Tombs: Music, Dance, and Entertainments During the Han." In Lim 1987: 64–71.

Digby, A. 1972. *Maya Jades.* London: British Museum.

Dissanayake, E. 1988. *What Is Art For?* Seattle: University of Washington Press.

Doezema, M., and J. Hargrove. 1977. *The Public Monument and Its Audience.* Cleveland: Cleveland Museum of Art.

Doré, H. 1938. *Researches into Chinese Superstitions,* vol. 8. Trans. M. Kennelly. Shanghai: T'usewe Printing Press.

Dubs, H. H. 1938. *Pan Ku: The History of the Former Han Dynasty.* 3 vols. Baltimore: Waverly Press.

———. 1942. "An Ancient Chinese Mystery Cult." *Harvard Theological Review* 35: 221–40.

Ebrey, P. B. 1980. "Later Han Stone Inscriptions." *Harvard Journal of Asiatic Studies* 40.2: 325–53.

———. 1983. "Patron-Client Relations in the Late Han." *Journal of the American Oriental Society* 103.3: 533–42.

Ebrey, P. B., ed. 1981. *Chinese Civilization and Society: A Sourcebook.* New York: Free Press.

Ekman, P. 1969. "The Repertoire of Nonverbal Bahavior: Categories, Origins, Usage, and Coding." *Semiotica* 1.1: 49–98.

Fairbank, W. 1941. "The Offering Shrines of 'Wu Liang Tz'u.'" *Harvard Journal of Asiatic Studies* 6.1: 1–36. Reprinted in Fairbank 1972: 43–86.

———. 1942. "A Structural Key to Han Mural Art." *Harvard*

Journal of Asiatic Studies 7.1: 52–88. Reprinted in Fairbank 1972: 89–140.

———. 1972. *Adventures in Retrieval.* Harvard-Yenching Institute Studies 28. Cambridge, Mass.: Harvard University Press.

Falkenhausen, L. von. 1988. "Ritual Music in Bronze Age China: An Archaeological Perspective." Ph.D. dissertation. Harvard University.

Fehl, N. E. 1971. *Rites and Propriety in Literature and Life.* Hong Kong: Chinese University of Hong Kong.

Feng Han-yi. 1948. *The Chinese Kinship System.* Cambridge, Mass.: Harvard University Press.

Fingarette, H. 1972. *Confucius: The Secular as Sacred.* New York: Harper & Row.

Fong, Wen, ed. 1980. *The Great Bronze Age of China.* New York: Metropolitan Museum of Art.

Forke, A. 1962. *Lun-Heng: Philosophical Essays by Wang Ch'ung.* 2 vols. New York: Paragon.

Forster, K. W. 1982a. "Monument/Memory and the Morality of Architecture." In Forster 1982b: 2–19.

Forster, K. W., ed. 1982b. *Monument/Memory.* Oppositions special issue, 25.

Foucault, M. 1973. *The Order of Things: An Archaeology of the Human Sciences.* New York: Vintage Books.

———. 1977. *Discipline and Punish.* New York: Vintage Books.

———. 1980. *Power/Knowledge.* Ed. C. Gordon. Hassocks, Eng.: Harvester.

———. 1981. *The History of Sexuality.* Harmondsworth, Eng.: Penguin.

Frazer, R. 1960. "The Origin of the Term 'Image.'" *ELH* 27: 149–61.

Fung Yu-lan. 1948, 1953. *History of Chinese Philosophy.* 2 vols. Trans. and comm. D. Bodde. Princeton: Princeton University Press.

Gernet, J. 1972. *A History of Chinese Civilization.* Cambridge, Eng.: Cambridge University Press.

Giedion, S. 1958. *Architecture, You and Me.* Cambridge, Mass.: Harvard University Press.

Gilson, E. 1968. "Aesthetic Existence." In Lee A. Jacobus, ed. *Aesthetics and the Arts.* New York: McGraw-Hill.

Gombrich, E. H. 1969. *Art and Illusion: A Study in the Psychology of Pictorial Representation.* 2d ed. Princeton: Princeton University Press.

———. 1984. *The Sense of Order.* 2d ed. Ithaca, N.Y.: Cornell University Press.

Grabar, O. 1992. *The Mediations of Ornament.* Princeton: Princeton University Press.

Graham, A. C. 1965. *Poems of the Late T'ang.* Harmondsworth, Eng.: Penguin.

Grousset, R. 1964. *The Rise and Splendour of the Chinese Empire.* Berkeley: University of California Press.

Hagen, M. A. 1986. *Varieties of Realism: Geometries of Representational Art.* Cambridge, Eng.: Cambridge University Press.

Hansford, H. 1968. *Chinese Carved Jades.* London: Faber & Faber.

Harbison, R. 1991. *The Built, the Unbuilt and the Unbuildable: In Pursuit of Architectural Meaning.* Cambridge, Mass.: MIT Press.

Haskel, B. 1971. *Claes Oldenburg: Object into Monument.* Pasadena, Calif.

Hay, J. 1993. "Review: Wu Hung, *The Wu Liang Shrine: The Ideology of Early Chinese Pictorial Art* and Martin J. Powers, *Art and Political Expression in Early China.*" *Art Bulletin* 75.1: 169–74.

Hightower, J. R. 1952. *Han Shih Wai Chuan.* Cambridge, Mass.: Harvard University Press.

———. 1957. "The *Wen Hsüan* and Genre Theory." *Harvard Journal of Asiatic Studies* 20: 512–33.

———. 1970. *The Poetry of T'ao Ch'ien.* Oxford: Clarendon Press.

Hollier, D. 1992. *Against Architecture: The Writings of Georges Bataille.* Cambridge, Mass.: MIT Press.

Holzman, D. 1978. "Literary Criticism in China in the Early Third Century A.D." *Asiatische Studien* 28.2: 113–49.

Hsu, C. Y., and K. M. Linduff. 1988. *Western Zhou Civilization.* New Haven: Yale University Press.

Hsü, D. L. 1970–71. "The Myth of the 'Five Relations' of Confucius." *Monumenta Serica* 29: 27–37.

Huber, L. G. F. 1981. "Some Anyang Royal Bronzes: Remarks on Shang Bronze Decor." In G. Kuwayama, ed., *The Great Bronze Age of China.* Los Angeles: Los Angeles County Museum of Art, 16–43.

Jackson, J. B. 1980. *The Necessity for Ruins.* Amherst: University of Massachusetts Press.

James, J. 1991. "Images of Power: Masks of the Liangzhu Culture." *Orientations* 22.6: 46–55.

Kane, V. C. 1970. "Chinese Bronzes of the Shang and Western Chou Period." Ph.D dissertation, Harvard University.

———. 1973. "The Chronological Significance of the Inscribed Ancestor Dedication in the Periodization of Shang Dynasty Bronze Vessels." *Artibus Asiae* 35: 335–70.

———. 1982–83. "Aspects of Western Chou Appointment Inscriptions: The Charge, the Gifts, the Response." *Early China* 8: 14–28.

Karlgren, B. 1950a. "The Book of Documents." *Bulletin of the Museum of Far Eastern Antiquities* 22: 1–81.

—————. 1950*b*. *The Book of Odes*. Stockholm: Museum of Far Eastern Antiquities.

Keightley, D. N. 1978*a*. *Sources of Shang History: The Oracle-Bone Inscriptions of Bronze Age China*. Berkeley: University of California Press.

—————. 1978*b*. "The Religious Commitment: Shang Theology and the Genesis of Chinese Political Culture." *History of Religions* 17.3–4: 211–25.

—————. 1987. "Archaeology and Mentality: The Making of China." *Representations* 18: 91–128.

—————. 1991. "The Quest for Eternity in Ancient China: The Dead, Their Gifts, Their Names." In Kuwayama 1991: 12–25.

Kinney, A. B. 1990. *The Art of the Han Essay: "Wang Fu's Ch'ien-fu Lun."* Tempe: Arizona State University, Center for Asian Studies.

Kleinbauer, W. E. 1971. *Modern Perspectives in Art History*. New York: Holt, Rinehart & Winston.

Knechtges, D. R. 1976. *The Han Rhapsody*. Cambridge, Eng.: Cambridge University Press.

—————. 1982, 1987. *Wen Xuan, or Selections of Refined Literature*. 2 vols. Princeton: Princeton University Press.

Knoblock, J. 1989–90. *Xunzi*. 2 vols. Stanford: Stanford University Press.

Kostof, S. 1991. *The City Shaped: Urban Patterns and Meanings Through History*. Boston: Little, Brown.

Kuwayama, G., ed. 1991. *Ancient Mortuary Traditions of China*. Los Angeles: Los Angeles County Museum of Art, Far Eastern Art Council.

Lang, O. 1946. *Chinese Family and Society*. New Haven: Yale University Press.

Langer, S. K. 1957. *Problems of Art*. New York: Charles Scribner's Sons.

Legge, J. 1871. *The Chinese Classics*. 5 vols. Vol. 1: *Confucian Analects, The Great Learning, and the Doctrine of the Mean*; vol. 2: *The Works of Mencius*; vol. 3: *The Shoo King or the Book of Historical Documents*; vol. 4: *The She King or the Book of Poetry*; vol. 5: *The Ch'un Ts'ew, with the Tso Chuen*. Oxford: Clarendon Press.

—————. 1881. *The Religions of China*. New York: Charles Scribner's Sons.

—————. 1891. *The Tao Te Ching, the Writings of Chuang-tzu, the Tai-shan*. In *Sacred Books of the East*, vols. 39–40. London: Oxford University Press.

—————. 1967 [1885]. *Li Chi: Book of Rites*. 2 vols. New York: University Books.

Lévi-Strauss, Claude. 1963. *Structural Anthropology*. New York: Basic Books.

Li Chi (Li Ji). 1977. *Anyang*. Seattle: University of Washington Press.

Li Xueqin. 1985. *Eastern Zhou and Qin Civilizations*. Trans. K. C. Chang. New Haven: Yale University Press.

Li Yinde. 1990. "The 'Underground Palace' of a Chu Prince at Beidongshan." *Orientations* 21.10: 57–61.

Liang Ch'i-ch'ao (Liang Qichao). 1928. "Archaeology in China." *Smithsonian Report for 1927*. Washington, D.C.: Smithsonian Institution, 453–66.

Lim, L., ed. 1987. *Stories from China's Past*. San Francisco: Chinese Cultural Center.

Lippe, A. 1970. *The Freer Indian Sculptures*. Washington, D.C.: Smithsonian Institution.

Loehr, M. 1953. "Bronze Styles of the Anyang Period." *Archives of the Chinese Art Society of America* 7: 42–53.

—————. 1968. *Ritual Vessels of Bronze Age China*. New York: Asia Society.

Loewe, M. 1979. *Ways to Paradise: The Chinese Quest for Immortality*. London: George Allen & Unwin.

—————. 1982. *Chinese Ideas of Life and Death*. London: George Allen & Unwin.

Loewe, M., and A. F. P. Hulsewé. 1979. *China in Central Asia: The Early Stage, 125 B.C.–A.D. 23. Annotated Translation of Chapters 61 and 96 of the History of the Former Han Dynasty*. Sinica Leidensia 14. Leiden: Brill.

Lowenthal, D. 1975. "Past Time, Present Place: Landscape and Memory." *Geographical Review* 65.1: 1–36.

MacCurdy, G. G. 1933. *Human Origins*. New York: Appleton-Century.

Major, J. 1984. "The Five Phases, Magic Squares, and Schematic Cosmology." In H. Rosemont, Jr., ed. *Explorations in Early Chinese Cosmology*. Thematic Studies of the *Journal of the American Academy of Religion* 50.2. Chico, Calif.: Scholars Press, 133–46.

Makra, M. L. 1961. *The Hsiao Ching*. Washington, D.C.: St. John's University Press.

McNairn, B. 1980. *The Method and Theory of V. Gordon Childe*. Edinburgh: Edinburgh University Press.

Miao, R. 1972. "Literary Criticism at the End of the Eastern Han." *Literature East and West* 16.3: 1013–34.

Miller, D., and C. Tilley, eds. 1984. *Ideology, Power and Prehistory*. Cambridge, Eng.: Cambridge University Press.

Minneapolis Institute of Arts. 1948. "A Stone Sarcophagus of the Wei Dynasty." *Bulletin of the Minneapolis Institute of Arts* 37.23: 110–16.

Mothersill, M. 1984. *Beauty Restored*. Oxford: Clarendon Press.

Murray, J. K. 1983. "Neolithic Chinese Jades." *Orientations* 14.11: 14–22.

Needham, J. 1954–88. *Science and Civilization in China*. 6 vols. in multiple parts. Cambridge, Eng.: Cambridge University Press.

O'Hara, A. R. 1945. *The Position of Women in Early China*. Washington, D.C.: Catholic University of American Press.

Oldenburg, C. 1969. *Proposals for Monuments and Buildings, 1965–69*. Chicago: Big Table Publishing Company.

Owen, S. 1985. *Remembrances: The Experience of the Past in Classical Chinese Literature*. Cambridge, Mass.: Harvard University Press.

———. 1992. *Readings in Chinese Literary Thought*. Cambridge, Mass.: Harvard University Press.

Paludan, A. 1991. *The Chinese Spirit Road*. New Haven: Yale University Press.

Paper, J. 1978. "The Meaning of the 'T'ao-t'ie.'" *History of Religions* 18.1: 18–41.

Pirazzoli-t'Serstevens, M. 1982. *The Han Dynasty*. Trans. J. Seligman. New York: Rizzoli.

Pope, J. A., et al. 1967. *The Freer Chinese Bronzes*, vol. 1. Washington, D.C.: Smithsonian Institution.

Poulantzas, N. 1973. *Political Power and Social Classes*. London: New Left Books.

Powers, M. J. 1983. "Hybrid Omens and Public Issues in Early Imperial China." *Bulletin of the Museum of Far Eastern Antiquities* 55: 1–55.

———. 1984. "Pictorial Art and Its Public Issues in Early Imperial China." *Art History* 7.2: 135–63.

———. 1986. "Artistic Taste, the Ecomony and the Social Order in Former Han China." *Art History* 9.3: 285–305.

———. 1991. *Art and Political Expression in Early China*. New Haven: Yale University Press.

Qiu Yongsheng and Hu Baoxi. 1990. "Highlights of the Huating Neolithic Site." *Orientations* 20.10: 54–56.

Rawson, J. 1980. *Ancient China, Art and Archaeology*. London: British Museum.

———. 1987. *Chinese Bronzes: Art and Ritual*. London: British Museum.

———. 1990. *Western Zhou Ritual Bronzes from the Arthur M. Sackler Collections*. 2 vols. Washington, D.C.: Arthur M. Sackler Foundation.

Riegl, A. 1903. "The Modern Cult of Monuments: Its Character and Its Origin." Trans. K. W. Forster and D. Chirardo. In Forster 1982a: 20–51.

Rose, B. 1968. "Blow Up: The Problem of Scale in Sculpture." *Art in America* 56: 80–91.

Rowland, B. 1967. *The Art and Architecture of India*. 3d ed. Baltimore.

Rowley, G. 1959. *Principles of Chinese Painting*. 2d ed. Princeton: Princeton University Press.

Rudolph, R. C. 1951. *Han Tomb Art of West China*. Berkeley: University of California Press.

Ruskin, J. 1904. *The Works of John Ruskin*. 39 vols. Eds. E. T. Cook and A. Wedderburn. London.

Said, E. W. 1979. *Orientalism*. New York: Vintage Books.

Salmony, A. 1963. *Chinese Jade Through the Wei Dynasty*. New York: Ronald.

Sargent, C. B. 1947. *Wang Mang*. Shanghai: Graphic Art.

Schapiro, M. 1969. "On Some Problems in the Semiotics of Visual Art: Field and Vehicle in Image-Signs." *Semiotica* 1.3: 223–42.

Schorske, C. E. 1963. "The Idea of the City in European Thought: Voltaire to Spengler." In O. Handlin and J. Burchard, eds., *The Historian and the City*. Cambridge, Mass.: MIT Press, 95–114.

Segalen, V. G., et al. 1914–17. *Mission archéologique en Chine* (Archaeological mission to China). Paris: Geuthner.

Sharer, R. J., and W. Ashmore. 1979. *Fundamentals of Archaeology*. Menlo Park, Calif.: Benjamin/Cummings.

Sickman, L., and A. Soper. 1956. *The Art and Architecture of China*. Harmondsworth, Eng.: Penguin.

Sirén, O. 1956. *Chinese Painting: Leading Masters and Principles*. 5 vols. New York: Ronald.

Soper, A. C. 1941. "Early Chinese Landscape Painting." *Art Bulletin* 23: 159–60.

———. 1948. "Life-Motion and the Sense of Space in Early Chinese Representational Art." *Art Bulletin* 30: 167–86.

———. 1966. "Early, Middle, and Late Shang: A Note." *Artibus Asiae* 28: 5–38.

Soymie, M. 1954. "L'Entrevue de Confucius et de Hiang T'o." *Journal asiatique* 242: 311–92.

Spiro, A. 1990. *Contemplating the Ancient*. Berkeley: University of California Press.

Steinhardt, N. S. 1984. *Chinese Traditional Architecture*. New York: China Institute.

———. 1990. *Chinese Imperial City Planning*. Honolulu: University of Hawaii Press.

Strauss, A. L. 1961. *Images of the American City*. New York: Free Press.

Su, Gin Djih. 1964. *Chinese Architecture, Past and Contemporary*. Hong Kong.

Teng Ssu-yü. 1968. *Family Instructions for the Yen Clan*. Leiden: E. J. Brill.

Thomas, N. 1982. "Childe, Marxism, and Archaeology." *Dialectical Anthropology* 6.3: 245–52.

Thorp, R. L. 1983a. "An Archaeological Reconstruction of the Lishan Necropolis." In G. Kuwayama, ed., *The Great Bronze Age of China: A Symposium*. Los Angeles: Los Angeles County Museum of Art, 72–83.

———. 1983b. "Origins of Chinese Architectural Style: The Earliest Plans and Building Types." *Archives of Asian Art* 36: 22–26.

———. 1985. "The Growth of Early Shang Civilization: New Data from Ritual Vessels." *Harvard Journal of Asiatic Studies* 45.1: 5–67.

———. 1987. "The Qin and Han Imperial Tombs and the Development of Mortuary Architecture." In Los Angeles County Museum of Art, *The Quest for Eternity: Chinese Ceramic Sculpture from the People's Republic of China*. San Francisco: Chronicle Books, 17–37.

———. 1988. "The Archaeology of Style at Anyang: Tomb 5 in Context." *Archives of Asian Art* 41: 47–69.

———. 1991. "Mountain Tombs and Jade Burial Suits: Preparations for Eternity in the Western Han." In Kuwayama 1991: 26–39.

T'ien Ju-k'ang. 1988. *Male Anxiety and Female Chastity*. Leiden: E. J. Brill.

Tjan Tjoe Som. 1949, 1952. *Po Hu T'ung: The Comprehensive Discussions in the White Tiger Hall*. 2 vols. Leiden: E. J. Brill.

Tomita, Kojiro. 1942. "A Chinese Sacrificial Stone House of the Sixth Century A.D." *Bulletin of the Museum of Fine Arts* (Boston) 40.242: 98–110.

Trigger, B. G. 1990. "Monumental Architecture: A Thermodynamic Explanation of Symbolic Behaviour." In R. Bradley, ed., *Monuments and the Monumental*. *World Archaeology* special issue, 22.2: 119–32.

Twitchett, D., and M. Loewe, eds. 1986. *The Cambridge History of China*, vol. 1, *The Ch'in and Han Empires*. Cambridge, Eng.: Cambridge University Press.

Uspensky, B. A. 1975. "'Left' and 'Right' in Icon Painting." *Semiotica* 13.1: 34–39.

Vanderstappen, H. A., et al. eds. 1989. *Ritual and Reverence: Chinese Art at the University of Chicago*. Chicago: David and Alfred Smart Gallery.

Veblen, T. 1899. *The Theory of Leisure Class*. New York: Macmillan.

Waley, A. 1955. "The Heavenly Horses of Ferghana: A New View." *History Today* 5.2: 95–103.

———. 1978. *The Book of Songs*. New York: Grove Press.

———. 1982. *Chinese Poems*. London: Unwin.

Walton, K. L. 1990. *Mimesis as Make-Believe*. Cambridge, Mass.: Harvard University Press.

Wang, Yi-t'ung. 1984. *A Record of Buddhist Monasteries in Luoyang*. Princeton: Princeton University Press.

Wang Zhongshu. 1982. *Han Civilization*. Trans. K. C. Chang. New Haven: Yale University Press.

Ware, J. R. 1960. *The Sayings of Mencius*. New York: New American Library.

Watson, B. 1958. *Ssu-ma Ch'ien, Grand Historian of China*. New York: Columbia University Press.

———. 1961. *Records of the Grand Historian of China*. 2 vols. New York: Columbia University Press.

———. 1963. *Basic Writings of Mo Tsu, Hsün Tzu, and Han Fei Tzu*. New York: Columbia University Press.

———. 1968a. "Literary Theory in the Eastern Han." In *Yoshikawa hakase taikyū kinen Chūgoku bungaku ronshū*. Tokyo: Chikuma Shobō, 1968, 1–13.

———. 1968b. *The Complete Works of Chuang Tzu*. New York: Columbia University Press.

Watson, W. 1962. *Ancient Chinese Bronzes*. London: Faber & Faber.

Weber, C. D. 1968. *Chinese Pictorial Bronze Vessels of the Late Chou Period*. Ascona, Switz.: Artibus Asiae.

Webster's New International Dictionary of the English Language. 1934. Springfield, Mass.: G. & C. Merriam Co.

Wellek, R. 1955. *A History of Modern Criticism*. New Haven: Yale University Press.

Wheatley, P. 1971. *Pivot of the Four Quarters*. Edinburgh: Edinburgh University Press.

Wilhelm, R. 1967. *The I Ching*. 3d ed. Princeton: Princeton University Press.

Wu Hung. 1984. "A Sanpan Shan Chariot Ornament and the Xiangrui Design in Western Han Art." *Archive of Asian Art* 37: 38–59.

———. 1985. "Bird Motifs in Eastern Yi Art." *Orientations* 16.10: 30–41.

———. 1986. "Buddhist Elements in Early Chinese Art (2d and 3d centuries A.D.)." *Artibus Asiae* 47: 263–376.

———. 1987a. "The Wu Liang Ci and Eastern Han Offering Shrines." Ph.D. dissertation, Harvard University.

———. 1987b. "Myths and Legends in Han Funerary Art: Their Pictorial Structure and Symbolic Meanings as Reflected in Carvings on Sichuan Sarcophagi. In Lim 1987: 72–81.

———. 1988. "From Temple to Tomb: Ancient Chinese Art and Religion in Transition." *Early China* 13: 78–115.

———. 1989. *The Wu Liang Shrine: The Ideology of Early Chinese Pictorial Art*. Stanford: Stanford University Press.

———. 1990a. "A Great Beginning: Ancient Chinese Jades and the Origin of Ritual Art." In Wu Hung and B. Morgan, *Chinese Jades from the Mu-Fei Collection*. London: Bluett & Sons.

———. 1990b. "The Art of Xuzhou: A Regional Approach." *Orientations* 21.10: 40–49.

Yang Hsien-yi and Gladys Yang, trans. 1979. *Selections from Records of the Historian*. Beijing: Foreign Languages Press.

Yetts, P. 1949. "A Datable Shang-Yin Inscription." 2 parts. *Asia Major* (London), n.s. 1: 74–98, 275–77.

Yu, P. 1987. *The Reading of Imagery in the Chinese Poetic Tradition*. Princeton: Princeton University Press.

Yü, Ying-shih. 1987. "'O Soul, Come Back!' A Study in the Changing Conceptions of the Soul and Afterlife in Pre-Buddhist China." *Harvard Journal of Asiatic Studies* 47.2: 363–95.

Zheng Zhenxiang (Cheng Chen-hsing). 1986. "A Study of the Bronze with the 'Su T'u Mu' Inscriptions Excavated from the Fu Hao Tomb." In K. C. Chang, ed., *Studies of Shang Archaeology*. New Haven: Yale University Press.

Zürcher, E. 1959. *The Buddhist Conquest of China*. 2 vols. Leiden: E. J. Brill.

CHINESE- AND JAPANESE-LANGUAGE REFERENCES

The following abbreviations are used in this section:

CASS	Chinese Academy of Social Sciences 中國社會科學院
KG	*Kaogu* 考古
KGXB	*Kaogu xuebao* 考古學報
KW	*Kaogu yu wenwu* 考古與文物

SBCK	*Sibu congkan* 四部叢刊
SSJZS	*Shisanjing zhushu* 十三經注疏
WW	*Wenwu* 文物
ZGMSQJ	*Zhongguo meishu quanji* 中國美術全集
ZZJC	*Zhuzi jicheng* 諸子集成

Adachi Kiroku. 1933. *Chōan shiseki no kenkyū* (Research on the remains of Chang'an). 2 vols. Tokyo: Tōyō bunko. 足立喜六. 長安史迹の研究. 東洋文庫.

An Zhimin. 1947. "Yinxu de shidao" (Stone knives from the Ruins of Yin). *Yanjing xuebao* 33: 77–94. 安志敏. 殷墟的石刀. 燕京學報.

———. 1954. "Yijiuwuer nian qiuji Zhengzhou Erligang fajueji" (Report of the 1952 fall excavation at Erligang in Zhengzhou). *KGXB* 8: 109–26. 一九五二年秋季鄭州二里崗發掘記.

———. 1988. "Guanyu Liangzhu wenhua de ruogan wenti" (Some problems concerning the Liangzhu culture). *KG* 3: 236–45. 關於良渚文化的若干問題.

Archaeological Station at the Qin Capital of Xianyang. 1976. "Qin du Xianyang diyihao gongdian jianzhu yizhi jianbao" (Brief report on Palace site no. 1 at the Qin capital of Xianyang). *WW* 11: 12–24. 秦都咸陽考古站. 秦都咸陽第一號宮殿建築遺址簡報.

Archaeological Team of the Du Mausoleum. 1984. "Yijiubaer–yijiubasan nian Xi-Han Duling de kaogu gongzuo shouhuo" (Achievements of the archaeological work during 1982–1983 at the Du ling mausoleum of the Western Han). *KG* 10: 887–94. 杜陵考古隊. 一九八二——一九八三年西漢杜陵的考古工作收獲.

Archaeological Team of the Qin Terra-cotta Army. 1975. "Lintongxian Qinyongkeng shijue diyihao jianbao" (Preliminary report on the test excavation of the Qin terra-cotta army in Lintong county). *WW* 11: 1–18. 秦俑坑考古隊. 臨潼縣秦俑坑試掘第一號簡報.

———. 1978. "Qinshihuang ling dongce dierhao bingma yongkeng zuantan shijue jianbao" (Brief report on the investigation and test excavation of terra-cotta army pit no. 2, east of the mausoleum of the First Emperor of the Qin). *WW* 5: 1–19. 秦始皇陵東側第二號兵馬俑坑鑽探試掘簡報.

———. 1979. "Qinshihuang ling dongce disanhao bingma yongkeng qingli jianbao" (Brief report on the excavation of terra-cotta army pit no. 3, east of the mausoleum of the First Emperor of the Qin). *WW* 12: 1–12. 秦始皇陵東側第三號兵馬俑坑清理簡報.

———. 1980a. "Lintong Shangjiaocun Qinmu qingli jianbao" (Brief report on the excavation of the Qin tombs at Shangjiao village in Lintong). *KW* 2: 42–50. 臨潼上焦村秦墓清理簡報.

———. 1980b. "Qinshihuang ling dongce majiukeng zuantan qingli jianbao" (Brief report on the excavation of the "horse stable" pit east of the mausoleum of the First Emperor of the Qin). *KW* 4: 31–41. 秦始皇陵東側馬厩坑鑽探清理簡報.

———. 1982a. "Qinshihuang ling xice Zhaojiabeihucun Qin xingtu mu" (The burials of Qin convicts at Zhaojiabeihu village west of the mausoleum of the First Emperor of the Qin). *WW* 3: 1–11. 秦始皇陵西側趙家背戶村秦刑徒墓.

———. 1982b. "Qinshihuang lingyuan peizangkeng zuantan qingli jianbao" (Brief report on the excavation of the "satellite" burials near the mausoleum of the First Emperor of the Qin). *KW* 1: 25–29. 秦始皇陵園陪葬坑鑽探清理簡報.

Baihu tong (Proceedings from the White Tiger Hall), by Ban Gu. In Congshu jicheng, nos. 238–39. 白虎通. 班固. 叢書集成.

Baopu zi (Master Simplicity), by Ge Hong. ZZJC 8. 抱朴子. 葛洪. 諸子集成.

Beijing Library. 1989. *Beijing tushuguan cang Zhongguo lidai shike tuoben huibian* (Rubbings of stone inscriptions from successive Chinese dynasties in the Beijing Library). 10 vols. Zhengzhou: Zhongzhou guji chubanshe. 北京圖書館. 北京圖書館藏中國歷代石刻拓本滙編. 中州古籍出版社.

Cao Shuqin. 1988. "Shangdai zhongqi youming tongqi chutan" (Preliminary examination of inscribed mid-Shang bronzes). *KG* 3: 246–57. 曹淑琴. 商代中期有銘銅器初探.

Chang'an zhi tu (Illustrated record of Chang'an), by Li Haowen. In Bi Yuan, ed., *Jingxun tang congshu* (The Jingxun Studio collectanea), no. 24. Reprinted—Taipei: Shangwu yinshuguan, 1978. 長安志圖. 李好文. 畢沅. 經訓堂叢書. 商務印書館.

Chaomiao gongshi kao (A study of ancient palaces and temples), by Ren Qiyuan. In Wang Xianqian, ed., *Huang Qing jingjie xubian* (Interpretations of the Classics by Qing scholars, supplement). N.p.: Nanjing shuyuan, 1888. 朝廟宮室考. 任啓運. 王先謙. 皇清經解續編. 南菁書院.

Chen Changyuan. 1982. "Youguan He zun de jige wenti" (Some problems concerning the He zun). *Zhongyuan wenwu* 2: 52–57. 陳昌遠. 有關何尊的幾個問題. 中原文物.

Chen Hanping. 1986. *Xi-Zhou ceming zhidu yanjiu* (A study of Western Zhou investitures). Shanghai: Xuelin chubanshe. 陳漢平. 西周册命制度研究. 學林出版社.

Chen Mengjia. 1954. "Yindai tonqi" (Yin bronzes). *KGXB* 7: 15–59. 陳夢家. 殷代銅器.

———. 1955–56. "Xi-Zhou tongqi duandai" (The periodization of Western Zhou bronzes). *KGXB* 1955, no. 9: 137–76; no. 10: 69–142; 1956, no. 1: 65–114; no. 2: 85–94; no. 3: 105–27; no. 4: 85–122. 西周銅器斷代.

———. 1956. *Yinxu boci zongshu* (A comprehensive introduction to divinatory texts from the Ruins of Yin). Beijing: Kexue chubanshe. 殷墟卜辭綜述. 科學出版社.

Chen Mingda. 1961. "Handai de shique" (Stone pillar-gates of the Han dynasty). *WW* 12: 9–23. 陳明達. 漢代的石闕.

Chen Quanfang. 1988. *Zhouyuan yu Zhou wenhua*. Shanghai: Shanghai renmin chubanshe. 陳全方. 周原與周文化. 上海人民出版社.

Chen Shihui. 1980. "Qiang pan mingwen jieshuo" (Interpreting the Qiang *pan* inscription). *KG* 5: 433–35. 陳世輝. 牆盤銘文解說.

Chen Shuguo. 1991. *Xian-Qin lizhi yanjiu* (A study of pre-Qin ritual systems). Changsha: Hunan jiaoyu chubanshe. 陳戌國. 先秦禮制研究. 湖南教育出版社.

Chen Zhenzhong. 1982. "Yin Zhou de qian, bo: qingtong chan he chu" (Bronze spades and hoes of the Shang and Zhou). *KG* 3: 289–99. 陳振中. 殷周的錢鎛：青銅鏟和鋤.

Chen Zhi. 1962. "Wangdu Hanmu bihua tizi tongshi" (A comprehensive interpretation of the inscriptions in a tomb decorated with murals at Wangdu). *KG* 3: 161–64. 陳直. 望都漢墓壁畫題字通釋.

Chu sanzang ji, by Seng You. In Takakusu Junjirō and Watanabe Kaigyoku, eds., *Taishō shinshū Daizōkyō* (The Taishō edition of the Tripitaka). Tokyo: Taishō Issai-kyō kankōkai, 1922–24, no. 2145. 出三藏集. 僧佑. 高楠順次郎. 渡邊海旭. 大正新脩大藏經. 大正一切經刊行會.

Chunqiu Gongyang zhuan (The Gongyang commentary on the *Spring and Autumn Annals*). References are to Du Yu et al., *Chunqiu sanzhuan* (The Three Schools' commentaries on the *Spring and Autumn Annals*). Shanghai: Shanghai guji chubanshe, 1987. 春秋公羊傳. 杜預等. 春秋三傳. 上海古籍出版社.

Chuxue ji (The beginner's encyclopedia), by Xu Jian. Beijing: Zhonghua shuju, 1962. 初學記. 徐堅. 中華書局.

Cultural Relics Department of the Henan Provincial Cultural Bureau. 1959. *Zhengzhou Erligang* (The archaeological site of Erligang at Zhengzhou). Beijing: Kexue chubanshe. 河北省文化局文物處. 鄭州二里崗. 科學出版社.

Cultural Relics Work Team of the Hebei Provincial Cultural Bureau. 1965. "Hebei Yixian Yan Xiadu gucheng kancha he shijue" (Investigation and test excavation of the

old city of the Lower Capital of Yan at Yi county in Hebei). *KGXB* 1: 83–106. 河北省文化局文物工作隊. 河北易縣燕下都故城勘察和試掘.

Datong Museum. 1972. "Shanxi Datong Shijiazhai Bei-Wei Sima Jinlong mu" (The tomb of Sima Jinlong of the Northern Wei dynasty in Shijiazhai, Datong, Shanxi). *WW* 3: 20–33. 大同博物館. 山西大同石家寨北魏司馬金龍墓.

DDLJ: *Da Dai Liji* (Elder Dai's *Book of Rites*), by Dai De. References are to Wang Pinzhen, *Da Dai liji jie gu* (Annotated *Elder Dai's Book of Rites*). Beijing: Zhonghua shuju, 1983. 大戴禮記. 戴德. 王聘珍. 大戴禮記解詁. 中華書局.

Deng Shuping. 1984. *Yuqi pian, yi* (Chinese jades, 1). Zhonghua wuqiannian wenwu jikan (Five thousand years of Chinese art). Taipei: Zhonghua wuqiannian wenwu jikan bianji weiyuanhui. 鄧淑蘋. 玉器篇一. 中華五千年文物集刊. 中華五千年文物集刊編輯委員會.

———. 1993. "Zhongguo xinshiqi shidai yuqi shang de shenmi fuhao" (Mysterious symbols on Chinese Neolithic jades). *Gugong xueshu jikan* 10.3: 1–50. 中國新石器時代玉器上的神秘符號. 故宮學術季刊.

Dongguan Han ji (Han history recorded in the Eastern Pavillion), by Liu Zhen. References are to Wu Shuping, *Dongguan Han ji jiaozhu* (An edited and annotated version of the *Han History Recorded in the Eastern Pavillion*). 2 vols. Henan: Zhongzhou guji chubanshe, 1987. 東觀漢記. 劉珍. 吳樹平. 東觀漢記校註. 中州古籍出版社.

Du duan (A solitary determination), by Cai Yong. In Cheng Rong, comp., *Han Wei congshu* (Han and Wei dynasties collectanea). Preface dated 1592; published by the Cheng family in Xin'an, *juan* 14. 獨斷. 蔡邕. 程榮. 漢魏叢書. 明萬曆壬辰序. 新安程氏刊本.

Duli tongkao (A comprehensive examination of ancient ritual canons), by Xu Qianxue. 1696 ed. Harvard-Yenching Library, Harvard University. 讀禮通考.

Editorial Committee. 1985. *Nanyang Handai huaxiang shi* (Han dynasty pictorial carvings from Nanyang). Beijing: Wenwu chubanshe. 編輯委員會. 南陽漢代畫像石. 文物出版社.

Fan Bangjin. 1990. "Dong-Han mubei shuoyuan" (The origin of Eastern Han funerary stelae), in Zou Zhenya et al., *Han bei yanjiu* (Studies of Han stelae). Ji'nan: Qilu shushe, 49–63. 范幫瑾. 東漢墓碑溯源. 鄒振亞等. 漢碑研究. 齊魯書社.

Fang Pengjun and Zhang Xunliao. 1980. "Shandong Cangshan Yuanjia Yuannian huaxiangshi tiji de shidai he

youguan wenti de taolun" (A discussion of the date and related problems of the stone inscription dated A.D. 151 with pictorial carvings at Cangshan in Shandong). *KG* 3: 271–78. 方鵬鈞. 張勛燎. 山東蒼山元嘉元年畫像石題記的時代和有關問題的討論.

Fang Ruo. 1923. *Jiao bei suibi* (Notes on collating stela inscriptions). Kyoto: Hōyū shoten. 方若. 校碑隨筆. 朋友書店.

Fanshan Excavation Team of the Zhejiang Provincial Institute of Archaeological and Cultural Relics. 1988. "Zhejiang Yuhang Fanshan Liangzhu mudi fajue jianbao" (Preliminary excavation report on the Liangzhu cemetery at Fanshan in Yuhang in Zhejiang). *WW* 1: 1–31. 浙江省文物考古研究所反山考古隊. 浙江余杭反山良渚墓地發掘簡報.

Fayuan zhulin (The jeweled forest of Buddhist wisdom), by Daoshi. Shanghai: Shangwu yinshuguan, 1929. 法苑珠林. 道釋. 商務印書館.

Feng Zhou. 1983. "Kaogu zaji, er" (Miscellaneous notes on archaeology, 2). *KW* 3: 96–103. 豐州. 考古雜記. 二.

Fengsu tong (A comprehensive record of customs), by Ying Shao. SBCK no. 100. 風俗通. 應劭.

Fu Sinian. 1936. "Ba Chen Pan jun 'Chunqiu Gong she yu Tang shuo'" (A comment on Mr. Chen Pan's "An Interpretation of the Record About the Duke Shooting Fish at Tang in the *Spring and Autumn Annals*"). *Lishi yuyan yanjiusuo jikan* (Bulletin of the Institute of History and Philology, Academia Sinica) 7.2. 傅斯年. 跋陳槃「春秋公射於棠說」. 歷史語言研究所集刊.

Fu Xihua. 1950. *Handai huaxiang quanqi* (A complete collection of Han dynasty pictorial carvings). 2 vols. Beijing: Zhong Fa Hanxue yanjiusuo. 傅惜華. 漢代畫像全集. 中法漢學研究所.

Fu Xinian. 1980. "Zhanguo Zhongshanwang Xi mu chutu Zhaoyutu jiqi lingyuan guizhi de yanjiu" (A study of the "Diagram of the Funerary District" from the tomb of King Xi of Zhongshan and the regulations of the funerary park). *KGXB* 1: 97–119. 傅熹年. 戰國中山王嚳墓出土兆域圖及其陵園規制的研究.

Fukui Kojun. 1952. *Dōkyō no kisoteki kenkyū* (Fundamental studies of Daoism). Tokyo: Risō sha. 福井康順. 道教の基礎的研究. 理想社.

Gao Wen. 1987a. *Sichuan Handai huaxiangzhuan* (Han dynasty pictorial tiles from Sichuan). Shanghai: Shanghai renmin meishu chubanshe. 高文. 四川漢代畫像磚. 上海人民美術出版社.

———. 1987b. *Sichuan Handai huaxiangshi* (Han dynasty

pictorial stones from Sichuan). Chengdu: Bashu shushe. 四川漢代畫像石. 巴蜀書社.

Gao Zhixi. 1963. "Hunan Ningxiang Huangcai faxian Shangdai tongqi he yizhi" (New finds of Shang dynasty bronzes and sites at Huangcai in Ningxiang, Hunan province). *KG* 12: 646–48. 高至喜. 湖南寧鄉黃材發現商代銅器和遺址.

Gu Jiegang. 1935. *Handai xueshu shilüe* (A brief history of Han dynasty scholarship). Shanghai: Yaxiya shuju. 顧頡剛. 漢代學術史略. 亞細亞書局.

———. 1982. "Wude zhongshishuo xia di zhengzhi he lishi" (Politics and history under the theory of Five Elements). In Gu Jiegang, ed. *Gushi bian* (An examination of ancient history). 7 vols. Reprinted—Shanghai: Shanghai guji chubanshe, 5: 404–617. 五德終始說下的政治和歷史. 古史辨. 上海古籍出版社.

Guanzhong shengji tukao (An illustrated study of famous sites in the Guanzhong region), by Bi Ruan. 1776. 關中勝蹟圖考. 畢沅.

Guanzi (Writings of Guan Zhong). References are to Dai Wang, *Guanzi jiaozheng* (A collated version of the *Guanzi*). In ZZJC 5. 管子. 戴望. 管子校正.

Gugong tongqi xuancui (Masterpieces of Chinese bronzes in the National Palace Museum). Taibei: Gugong bowuyuan, 1974. 故宮銅器選粹. 國立故宮博物院.

Guo Aichun et al. 1991. *Huangdi Neijing cidian* (A glossary of the Yellow Emperor's *Inner Classic*). Tianjin: Tianjin kexue jishu chubanshe. 郭靄春等. 黃帝內經詞典. 天津科學技術出版社.

Guo Baojun. 1956. *Huixian fajue baogao* (Report on the excavations in Huixian county). Beijing: Kexue chubanshe. 郭寶鈞. 輝縣發掘報告. 科學出版社.

———. 1959. *Shanbiaozhen yu Liulige* (The archaeological sites at Shanbiaozhen and Liulige). Beijing: Kexue chubanshe. 山彪鎮與琉璃閣. 科學出版社.

———. 1963. *Zhongguo qingtongqi shidai* (The Chinese Bronze Age). Beijing: Sanlian shudian. 中國青銅器時代. 三聯書店.

———. 1981. *Shang Zhou tongqiqun zonghe yanjiu* (A comprehensive study of Shang and Zhou bronze vessel groups). Beijing: Wenwu chubanshe. 商周銅器羣綜合研究. 文物出版社.

Guo Jianbang. 1980. "Bei-Wei Ning Mao shishi he muzhi" (Ning Mao's stone chamber and epitaph of the Northern Wei). *Henan wenbo tongxun* (Report on cultural relics and museums in Henan) 1: 22–40. 郭建邦. 北魏寧懋石室和墓誌. 河南文博通訊.

Guo Moruo. 1960. "Anyang yuankeng muzhong dingming kaoshi" (An interpretation of the inscription on a *ding* from a round pit at Anyang). *KGXB* 1: 1–5. 郭沫若. 安陽圓坑墓中鼎銘考釋.

———. 1963. *Fufeng Qijiacun qingtongqi qun* (The group of bronzes from Qijia village at Fufeng). Beijing: Wenwu chubanshe. 扶風齊家村青銅器羣. 文物出版社.

Guo yu (Talks on the states). Shanghai: Shanghai guji chubanshe. 1988. 國語. 上海古籍出版社.

Gushi yuan (Sources of old-style poetry), by Shen Deqian. References are to Wang Chunfu, *Gushi yuan jianzhu* (Annotated *Sources of Old-style Poetry*). Taipei: Huazheng shuju, 1983. 古詩源. 沈德潛. 汪莼父. 古詩源箋註. 華正書局.

Guyu tukao (Illustrated examination of ancient jades), by Wu Dacheng. Shanghai: Tongwen shuju, 1889. 古玉圖考. 吳大澂. 同文書局.

Guyuan Cultural Relics Work Station. 1984. "Ningxia Guyuan Bei-Wei mu qingli jianbao" (Brief excavation report on the Northern Wei tomb at Guyuan, Ningxia). *WW* 6: 46–56. 固原縣文物工作站. 寧夏固原北魏墓清理簡報.

Han City Excavation Team, Institute of Archaeology. 1960. "Han Chang'an cheng nanjiao lizhi jianzhu yizhiqun fajue jianbao" (Brief report on the group of ritual structures south of the Han city of Chang'an). *KG* 7: 36–39. 考古研究所漢城發掘隊. 漢長安城南郊禮制建築遺址羣發掘簡報.

Han Wei. 1983. "Fengxiang Qin-gong lingyuan zuantan yu shijue jianbao" (Brief report on the investigation and test excavation of the mausoleums of Qin rulers in Fengxiang). *WW* 7: 30–37. 韓偉. 鳳翔秦公陵園鑽探與試掘簡報.

———. 1985. "Majiazhuang Qin zongmiao jianzhu zhidu yanjiu" (A study of the architectural plan of the Qin temple at Majiazhuang). *WW* 2: 30–38. 馬家莊秦宗廟建築制度研究.

Hayashi Minao. 1965. "Chūgoku kodai no shuō" (Wine jars of ancient China). *Kōkogaku zasshi* 65.2: 1–22. 林巳奈夫. 中國古代の酒甕. 考古學雜誌.

———. 1979. "Sen In shiki no gyokki bunka" (The jade culture of pre-Shang periods). *Museum* 334: 4–16. 先殷式の玉器文化

———. 1981. "Ryōsho bunka no gyokki jakkan o megutte" (Jades of the Liangzhu culture). *Museum* 360: 22–33. 良渚文化と玉器若干をめぐって.

———. 1990. "Ryōsho bunka to Daibunkō bunka no zushō

kigō" (Pictographs of the Liangzhu and Dawenkou cultures). *Shirin* 73.5: 116–34. 良渚文化と大汶口文化の図象記号. 史林.

———. 1991. "Chūgoku kodai ni okeru hi no un to shinwateki zuzō" (Mythological images and sun-brightness in ancient China). *Shirin* 74.4: 96–121. 中国古代における日の暈と神話的図像. 史林.

He Yeju. 1983. "Shilun Zhoudai liangci chengshi jianshe gaochao" (The two waves of urban construction during the Zhou dynasty). In Li Runhai, ed., *Zhongguo jianzhushi lunwen xuanji* (Selected papers on Chinese architectural history). Taipei: Mingwen shuju. 賀業鉅. 試論周代兩次城市建設高潮. 李潤海：中國建築史論文選輯. 明文書局.

Hebei Cultural Relics Administration. 1979. "Hebei sheng Pingshanxian Zhanguo shiqi Zhongshanguo muzang fajue jianbao" (Brief excavation report on tombs of the Zhongshan kingdom of the Warring States period in Pingshan county in Hebei). *WW* 1: 1–31. 河北省文物管理處. 河北省平山縣戰國時期中山國墓葬發掘簡報.

Henan chutu Shang Zhou qingtongqi (Shang and Zhou bronzes unearthed in Henan). Beijing: Wenwu chubanshe, 1981. 河南出土商周青銅器. 文物出版社.

Henan Provincial Institute of Cultural Relics. 1990. "Jin shinian Henan wenwu kaogu gongzuo de xin jinzhan" (New developments in archaeology and research on cultural relics in Henan during the past decade). In *Wenwu* Editorial Committee, *Wenwu kaogu gongzuo shinian* (A decade of archaeology and researches on cultural relics). Beijing: Wenwu chubanshe, 1990, 176–91. 河南省文物研究所. 近十年河南文物考古工作的新進展. 文物編輯委員會. 文物考古工作十年. 文物出版社.

Henan Provincial Institute of Cultural Relics and Zhengzhou Museum. 1983. "Zhengzhou xinfaxian Shangdai jiaocang qingtongqi" (Newly excavated bronzes from a hoard in Zhengzhou). *WW* 3: 49–59. 河南省文物研究所. 鄭州市博物館. 鄭州新發現商代窖藏青銅器.

Henan Provincial Museum. 1975. "Zhengzhou xinchutu de Shangdai qianqi datongding" (Large, early Shang bronze *ding* newly unearthed in Zhengzhou). *WW* 6: 64–68. 河南省博物館. 鄭州新出土的商代前期大銅鼎.

Henan Work Team No. 2 of the Institute of Archaeology, CASS. 1984. "Yijiubasan nian qiuji Henan Yanshi Shang cheng fajue jianbao" (Brief report on the fall 1983 exacavations of the Shang city at Yanshi in Henan). *KG* 10: 872–79. 中國社會科學院考古研究所河南第二工作隊. 一九八三年秋季河南偃師商城發掘簡報.

———. 1985. "Yijiubasi nian chun Yanshi Shixianggou Shang cheng gongdian yizhi fajue jianbao" (Brief report of the spring 1984 excavations of palatial remains in the Shang city at Shixianggou in Yanshi). *KG* 4: 322–35. 一九八四年春偃師尸鄉溝商城宮殿遺址發掘簡報.

———. 1988. "Henan Yanshi Shixianggou Shang cheng diwuhao gongdian yizhi fajue jianbao" (Brief report on the excavation of the foundation of Palace no. 5 in the Shang city at Shixianggou, Yanshi, Henan). *KG* 2: 128–40. 河南偃師尸鄉溝商城第五號宮殿遺址發掘簡報.

HHS: *Hou Han shu* (History of the Latter Han), by Fan Ye. Beijing: Zhonghua shuju, 1965. 後漢書. 范曄. 中華書局.

Hou Han ji (A record of the Latter Han), by Yuan Hong. Shanghai: Shangwu yinshuguan, 1937. 後漢紀. 袁宏. 商務印書館.

HS: *Han shu* (History of the Former Han), by Ban Gu. Beijing: Zhonghua shuju, 1962. 漢書. 班固. 中華書局.

Huainan zi (Writings of Master Huainan), by Liu An. In ZZJC 7. 淮南子. 劉安.

Huang Minglan. 1987. *Luoyang Bei-Wei shisu shike xianhua ji* (A collection of Northern Wei stone line-engravings from Luoyang). Beijing: Renmin meishu chubanshe. 黃明蘭. 洛陽北魏世俗石刻線畫集. 人民美術出版社.

Huang Ranwei. 1978. Yin Zhou qingtongqi shangci mingwen yanjiu (Study of Western Zhou investiture inscriptions). Hong Kong: Longmen shudian. 黃然偉. 殷周青銅器賞賜銘文研究. 龍門書局.

Huang Renheng. 1925. *Guxiao huizhuan* (Collected biographies of ancient filial sons). Guangzhou: Juzhen yinwuju. 黃任恒. 古孝滙傳. 聚珍印務局.

Huang Shengzhang. 1978. "Xi-Zhou Wei shi jia jiaocang qiqun chubu yanjiu" (Preliminary study of the group of bronzes from a hoard of the Western Zhou Wei family). *Shehui kexue zhanxian* 3: 194–206. 黃盛璋. 西周微氏家窖藏器羣初步研究. 社會科學戰綫.

Huang Zhanyue. 1960. "Han Chang'an cheng nanjiao lizhi jianzhu de weizhi jiqi youguan wenti" (The location of the ritual structures to the south of the Han city of Chang'an and related problems). *KG* 9: 53–58. 黃展岳. 漢長安城南郊禮制建築的位置及其有關問題.

Huangdi neijing suwen (The Yellow Emperor's inner classic and the Pure Maiden's questions on medicine). References are to Wang Bing, *Buzhu Huangdi neijing suwen* (*The Yellow Emperor's Inner Classic* and the *Pure Maiden's Questions on Medicine*, with additional commentaries). 黃帝內經素問. 王冰. 補註黃帝內經素問.

Huaxiangshi huaxiangzhuan (Pictorial stone carvings and

bricks). In *ZGMSQJ*. Shanghai: Shanghai renmin meishu chubanshe, 1988. 畫像石畫像磚. 上海人民美術出版社.

Huayangguo zhi (Records of Huayang kingdom). SBCK no. 85. 華陽國志.

Hubei Provincial Museum. 1980. *Suixian Zenghou Yi mu* (Tomb of Marquis Yi of Zeng in Sui county). 2 vols. Beijing: Wenwu chubanshe. 湖北省博物館. 隨縣曾侯乙墓. 文物出版社.

Hunan Provincial Museum. 1972. "Hunan sheng gong-nongbing reai zuguo wenhua yichan" (The people of Hunan love their country's cultural heritage). *WW* 1: 6–7. 湖南省博物館. 湖南省工農兵熱愛祖國文化遺產.

Hunan Provincial Museum and Institute of Archaeology, CASS. 1974. "Changsha Mawangdui er san hao Han mu fajue jianbao" (Brief excavation report on Mawangdui tombs nos. 2 and 3 of the Han dynasty in Changsha). *WW* 7: 39–48. 湖南省博物館. 中國社會科學院考古研究所. 長沙馬王堆二, 三號漢墓發掘簡報.

Inner Mongolia Museum. 1978. *Helinge'er Han mu bihua* (Murals in the Han dynasty tomb at Helinge'er). Beijing: Wenwu chubanshe. 內蒙古自治區博物館. 和林格爾漢墓壁畫. 文物出版社.

Institute of Archaeology, CASS. 1956. *Huixian fajue baogao* (Report on the archaeological excavations at Huixian). Beijing: Kexue chubanshe. 中國社會科學院考古研究所. 輝縣發掘報告. 科學出版社.

———. 1962. "Zhongguo kexueyuan Kaogu yanjiusuo yijiuliuyi nian tianye gongzuo de zhuyao shouhuo" (Major achievements in field archaeology conducted by the Institute of Archaeology, CASS, in 1961). *KG* 5: 272–74. 中國科學院考古研究所一九六一年田野工作的主要收獲.

———. 1980. *Yinxu Fu Hao mu* (Tomb of Lady Hao at Yinxu in Anyang). Beijing: Wenwu chubanshe. 殷墟婦好墓. 文物出版社.

———. 1984. *Xin Zhongguo de kaogu faxian he yanjiu* (Archaeological excavations and researches in New China). Beijing: Wenwu chubanshe. 新中國的考古發現和研究. 文物出版社.

Institute of Archaeology, CASS, and Hebei Provincial Cultural Relics Administration. 1980. *Mancheng Han mu fajue baogao* (Excavation report on the Han tombs at Mancheng). 2 vols. Beijing: Wenwu chubanshe. 中國社會科學院考古研究所. 河北省文理管理處. 滿城漢墓發掘報告. 文物出版社.

Jiang Shanguo. 1988. *"Shangshu" zongshu* (A comprehensive introduction to the *Book of Documents*). Shanghai: Shanghai guji chubanshe. 蔣善國. 尚書綜述. 上海古籍出版社.

Jiangsu Provincial Administration of Cultural Relics. 1959. *Jiangsu Xuzhou Han huaxiangshi* (Han dynasty pictorial stones from Xuzhou, Jiangsu). Beijing: Kexue chubanshe. 江蘇省文管會. 江蘇徐州漢畫像石. 科學出版社.

Jiangxi Provincial Institute of Archaeology and Jiangxi Xin'gan Museum. 1991. "Jiangxi Xin'gan Dayangzhou Shang mu fajue jianbao" (Brief report on the excavation of the Shang dynasty tomb at Dayangzhou in Xin'gan, Jiangxi). *WW* 10: 1–23. 江西省文物考古研究所. 江西省新干縣博物館. 江西新干大洋洲商墓發掘簡報.

Jiankang shilu (A factual record of the history of Nanjing). Beijing: Zhonghua shuju, 1984. Photoreprint of the Northern Song edition. 建康實錄. 中華書局.

Jin Qi. 1959. "Nanjing fujin Liu chao lingmu shike zhengxiu jiyao" (Brief report on the renovation of the stone carvings in the Six Dynasties mausoleums near Nanjing). *WW* 4: 26–31. 金琦. 南京附近六朝陵墓石刻整修紀要.

Jining Cultural Relics Group and Jiaxiang Cultural Relics Administration. 1982. "Shandong Jiaxiang Songshan yijiubaling nian chutu de Han huaxiangshi" (The pictorial stone carvings unearthed in 1980 at Songshan in Jiaxiang, Shandong). *WW* 5: 60–69. 濟寧地區文物組. 嘉祥文管所. 山東嘉祥宋山一九八〇年出土的漢畫像石.

Jin shu (History of the Jin dynasty), by Fang Xuanling. Beijing: Zhonghua shuju, 1974. 晉書. 房玄齡. 中華書局.

Kanda Kiichirō et al. 1957–61. *Shodō zenshū* (Corpus of calligraphy). 25 vols. Rev. ed. Tokyo: Heibonsha. 神田喜一郎. 書道全集. 平凡社.

Kaogong ji tu (Illustrated "Examination of workmanship"), by Dai Zhen. Shanghai: Shangwu yinshuguan, 1955. 考工記圖. 戴震. 商務印書館.

Komai Kazuchika. 1950. *Kyokufu Rojō no iseki* (The remains of the Lu capital Qufu). Tokyo: Tōkyō daigaku Kōkogaku kenkyūshitsu. 駒井和愛. 曲阜魯城の遺蹟. 東京大學考古學研究室.

Le Jiazao. 1977 [1933]. *Zhongguo jianzhu shi* (A history of Chinese architecture). Taipei: Huashi chubanshe. 樂嘉藻. 中國建築史.

Lei Haizong. 1957. "Shijieshi fenqi yu shanggu zhongguoshi zhong de yixie wenti" (Periodization of world history and problems in prehistory and early history). *Lishi jiaoxue* 7: 41–47. 雷海宗. 世界史分期與上古中古史中的一些問題. 歷史教學.

Li Falin. 1980. "Shandong Cangshan Yuanjia yuannian huaxiangshi mu tiji shishi" (A tentative interpretation of

the inscription on the stone tomb dated A.D. 151 with pictorial carvings at Cangshan in Shandong). *KW* 1: 72–73. 李發林. 山東蒼山元嘉元年畫像石墓題記試釋.

———. 1982. *Shandong Han huaxiangshi yanjiu* (Studies of Han dynasty pictorial stone carvings from Shandong). Ji'nan: Qilu shushe. 山東漢畫像石研究. 齊魯書社.

———. 1984. "Guanyu 'Jiaxiang Songshan An Guo muci tiji shidu' de yijian" (My opinions about the essay "A Transcription of the Inscription on An Guo's Funerary Shrine at Songshan in Jiaxiang"). *KW* 6: 105–6. 關於「嘉祥宋山安國墓祠題記釋讀」的意見.

Li Hongtao and Wang Pizhong. 1980. "Han Yuandi Weiling diaochaji" (An investigation report on the Wei ling mausoleum of Emperor Yuan of the Han). *KW* 1: 40–41. 李宏濤. 王丕忠. 漢元帝渭陵調察記.

Li Ji (Li Chi). 1990 [1951]. "Yinxu youren shiqi tushuo" (An illustrated discussion of stone blades from the Ruins of Yin). Reprinted in Zhang Guangzhi and Li Guangmo, eds., *Li Ji kaoguxue lunwen xuanji* (Selected papers on archaeology by Li Chi). Beijing: Wenwu chubanshe, 373–453. 李濟. 殷墟有双石器圖說. 張光直. 李光謨. 李濟考古學論文選集. 文物出版社.

Li shi (Interpreting Han clerical writings), by Hong Gua. In *Shike shiliao xinbian* (A new compilation of historical materials on stone carvings). Taipei: Xinwenfeng chuban gongsi, 1957, 9: 6747–7042. 隸釋. 洪適. 石刻史料新編. 新文豐出版公司.

Li Xueqin. 1959. *Yindai dili jianlun* (Brief discussion of Shang geography). Beijing: Kexue chubanshe. 李學勤. 殷代地理簡論. 科學出版社.

———. 1978. "Lun Shi Qiang pan jiqi yiyi" (On the Shi Qiang *pan* and its significance). *KGXB* 2: 149–58. 論史牆盤及其意義.

———. 1979. "Xi-Zhou zhongqi qingtongqi de zhongyao biaochi: Zhouyuan Zhuangbai, Qiangjia liangchu qingtongqi jiaocang de zonghe yanjiu" (An important standard for dating mid–Western Zhou bronzes: a synthetic analysis of bronzes from two hoards at Zhuangbai and Qiangjia in Zhouyuan). *Zhongguo lishi bowuguan guankan* (Journal of the Museum of Chinese History), 1: 29–36. 西周中期青銅器的重要標尺：周原莊白, 強家兩處青銅器窖藏的綜合研究. 中國歷史博物館館刊.

———. 1984. *Dong-Zhou yu Qindai wenming* (Eastern Zhou and Qin civilization). Beijing: Wenwu chubanshe. 東周與秦代文明. 文物出版社.

———. 1987. "Lun xin chutu de Dawenkou wenhua taoqi fuhao" (On newly found Dawenkou pottery marks). *WW* 12: 75–80. 論新出土的大汶口文化陶器符號.

———. 1991a. "Lun Erlitou wenhua de taotie wen" (On the taotie motifs of Erlitou culture). *Zhongguo wenwubao*, Oct. 20. 論二里頭文化的饕餮紋. 中國文物報.

———. 1991b. "Xin'gan Dayangzhou Shang mu de ruogan wenti" (Some problems regarding the Shang tomb at Dayangzhou in Xin'gan). *WW* 10: 33–38. 新干大洋洲商墓的若干問題.

Li Yunhe. 1982. *Huaxia yijiang: Zhongguo gudian jianzhu sheji yuanli fenxi* (Cathay's idea: design theory in classical Chinese architecture). Hong Kong: Guangjiaojing chubanshe. 李允鉌. 華夏意匠：中國古典建築設計原理分析. 廣角鏡出版社.

Li Zhongcao. 1978. "Shi Qiang pan mingwen shishi" (A tentative interpretation of the Shi Qiang *pan* inscription). *WW* 3: 33–34. 李仲操. 史牆盤銘文試釋.

Liang shu (History of the Liang dynasty), by Yao Silian. Beijing: Zhonghua shuju, 1973. 梁書. 姚思廉. 中華書局.

Lidai zhongding yiqi kuanshi fatie (Inscriptions on bronzes of different dynasties), by Xue Shanggong. Haicheng Yu shi, 1935. 歷代鐘鼎彝器疑識法帖. 薛尚功. 海城于氏.

Lin Liming and Sun Zhongjia. 1984. *Zhongguo lidai lingqin jilüe* (Brief record of Chinese imperial burials throughout the dynasties). Harbin: Heilongjiang renmin chubanshe. 林利明. 孫仲嘉. 中國歷代陵寢紀略. 黑龍江人民出版社.

Lingmu jianzhu (Funerary architecture). In *ZGMSQJ*. Beijing: Zhongguo jianzhu gongye chubanshe, 1988. 陵墓建築. 中國建築工業出版社.

Lishan xuehui. 1987. "Qin Dongling tancha chuyi" (Preliminary discussion of the excavation of the Eastern Mausoleum District of the Qin). *KW* 4: 86–88. 驪山學會. 秦東陵探查初議.

Liu Bin. 1990. "Liangzhu wenhua yucong chutan" (Preliminary research on the jade *cong* of the Liangzhu culture). *WW* 2: 30–37. 劉斌. 良渚文化玉琮初探.

Liu Dunyuan. 1981. "Chunqiu shiqi Qi guo gucheng de fuyuan yu chengshi buju" (Reconstruction and layout of the old city of the Qi capital in the Spring and Autumn period). *Lishi dili* (Historical geography) 1: 148–59. 劉敦願. 春秋時期齊國故城的復原與城市佈局. 歷史地理.

Liu Dunzhen. 1932. "Handai Chang'an cheng ji Weiyang gong" (The Han city of Chang'an and the Weiyang Palace). *Zhongguo yingzao xueshe huikan* (Journal of the Chinese Architectural Society) 3.3: 147–69. 劉敦禎. 漢代長安城及未央宮. 中國營造學社會刊.

———. 1980. *Zhongguo gudai jianzhu shi* (A history of ancient Chinese architecture). Beijing: Zhongguo jianzhu gongye chubanshe. 中國古代建築史. 中國建築工業出版社.

Liu Jie. 1941. "Shuo yi" (An interpretation of the term *yi*). *Tushu jikan* 3.3/4. Reprinted in idem, *Gushi kaocun* (An examination of ancient history). Beijing: Renmin chubanshe, 1958, 163–73. 劉節. 說彝. 圖書季刊. 古史考存. 人民出版社.

Liu Qingzhu and Li Yufang. 1982. "Xi-Han zhuling diaocha yu yanjiu" (The investigation and study of the Western Han royal mausoleums). *Wenwu cankao ziliao* 6: 1–15. 劉慶柱, 李毓芳. 西漢諸陵調查與研究. 文物參考資料.

———. 1987. *Xi-Han shiyi ling* (The eleven mausoleums of the Western Han). Xi'an: Shaanxi renmin chubanshe. 西漢十一陵. 陝西人民出版社.

Liu Yunyong. 1982. *Xi-Han Chang'an* (Western Han Chang'an). Beijing: Zhonghua shuju. 劉運勇. 西漢長安. 中華書局.

Liu Zhiping. 1957a. *Zhongguo jianzhu leixing yu jiegou* (Chinese architectural typology and structure). Beijing: Jianzhu gongcheng chubanshe. 劉致平. 中國建築類型與結構. 建築工程出版社.

———. 1957b. "Xi'an xibeijiao gudai jianzhu yizhi kancha chuji" (An initial record of the survey of the ancient architectural remains in the northwestern suburbs of Xi'an). *Wenwu cankao ziliao* 3: 5–12. 西安西北郊古代建築遺址勘察初記. 文物參考資料.

LJ: *Li ji* (Book of rites). References are to Kong Yingda, *Li ji zhengyi* (The correct interpretation of the *Book of Rites*). In *SSJZS*, 1221–696. 禮記. 孔穎達. 禮記正義.

LNZ: *Lienü zhuan* (Biographies of exemplary women), by Liu Xiang. SBCK no. 60. 列女傳. 劉向.

Lu Shiheng ji (Collected writings of Lu Ji), by Lu Ji. Sibu beiyao ed. Shanghai: Zhonghua shuju, 1930. 陸士衡集. 陸機. 四部備要. 中華書局.

Lun heng (Disquisitions), by Wang Chong. References are to Liu Pansui, *Lun heng jijie* (*Disquisitions*, with collected commentaries). Beijing: Guji chubanshe, 1957. 論衡. 王充. 劉盼遂. 論衡集解. 古籍出版社.

Lun yu (The Analects). References are to Liu Baonan, *Lun yu zhengyi* (The correct interpretation of *The Analects*). ZZJC 1. 論語. 劉寶楠. 論語正義.

Luo Fuyi. 1960. "Xiang Tajun shicitang tizi jieshi" (An interpretation of the inscription of the stone offering shrine of Xiang Tajun). *Gugong bowuyuan yuankan* (Journal of the Palace Museum) 2: 178–80. 羅福頤. 薌它君石祠堂題字解釋. 故宮博物院院刊.

Luo Kun. 1982. "Shangdai renji ji xiangguan wenti" (Human sacrifices during the Shang and related problems). In Hu Houxuan, ed., *Jiagu tanshi lu* (Historical researches based on oracle bone inscriptions). Beijing: Sanlian shudian, 112–91. 羅焜. 商代人祭及相關問題. 胡厚宣. 甲骨探史錄. 三聯書店.

Luo Xizhang. 1988. "Zhouyuan qingtongqi jiaocang jiqi youguan wenti de tantao" (Bronze hoards in the plain of Zhou and related problems). *KW* 2: 40–47. 羅西章. 周原青銅器窖藏及其有關問題的探討.

Luo Zhenyu. 1936. *Sandai jijin wencun* (Inscriptions on Three Dynasties bronzes). Tokyo: Shangyu Luo shi. 羅振玉. 三代吉金文存. 上虞羅氏.

Luo Zhongru. 1957. "Xi'an xijiao faxian Handai jianzhu yizhi" (Han dynasty architectural remains found in the western suburbs of Xi'an). *Kaogu tongxun* 6: 26–30. 雒忠如. 西安西郊發現漢代建築遺址. 考古通訊.

Luoyang jialan ji (A record of Buddhist temples at Luoyang), by Yang Xuanzhi. References are to Fan Xiangyong, *Luoyang jialan ji jiaozhu* (An annotated and collated edition of *A Record of Buddhist Temples at Luoyang*). Shanghai: Shanghai guji chubanshe, 1978. 洛陽伽藍記. 楊衒之. 見范祥雍. 洛陽伽藍記校註. 上海古籍出版社.

Lüshi chunqiu (Mr. Lü's spring and autumn annals). ZZJC 6. 呂氏春秋.

Ma Chengyuan et al. 1991. *Zhongguo qingtongqi* (Chinese bronzes). Shanghai: Shanghai guji chubanshe. 馬承源等. 中國青銅器. 上海古籍出版社.

Ma Dezhi et al. 1953. "Yijiuwusan nian qiu Anyang Dasikongcun fajue baogao" (Report on the excavation of Dasikong villiage at Anyang in fall 1953). *KGXB* 9: 25–40. 馬得志等. 一九五三年秋安陽大司空村發掘報告.

Ma Xianxing. 1976. *Hanjian yu Handai chengshi* (Han dynasty bamboo slips and Han cities). Taibei: Jiandushe. 馬先醒. 漢簡與漢代城市. 簡牘社.

Ma Zhenzhi. 1989. "Shilun Qin guo lingqin zhidu de xingcheng fazhan ji tedian" (On the formation and characteristics of the Qin funerary system). *KW* 5: 110–16. 馬振智. 試論秦國陵寢制度的形成發展及特點.

Mengxi bitan (Jotted conversations from the Dreamed Spring), by Shen Gua. References are to *Yuan kan Mengxi bitan* (A Yuan edition of *Jotted Conversations from the Dreamed Spring*). Beijing: Wenwu chuban gongsi, 1975. Photoreprint of 1305 edition. 夢溪筆談. 沈括. 元刊夢溪筆談. 文物出版公司.

Mengzi (Mencius). References are to Sun Shi, *Mengzi zhushu*

(Annotated *Mencius*). In *SSJZS*, 2659–782. 孟子. 孫奭. 孟子注疏.

Mingtang dadao lu (The great dao of Bright Hall), by Hui Dong. 2 vols. Shanghai: Shangwu yinshuguan, 1937. Congshu jicheng nos. 1035–36. 明堂大道錄. 惠棟. 叢書集成. 商務印書館.

"Mingtang yueling lun" (A discussion of Bright Hall and the monthly regulations), by Cai Yong. In *Cai zhonglan wenji* (Collected writings of Cai Yong). Shanghai: Hanfenlou, 1931, 10.1a–6b. 明堂月令論. 蔡邕. 蔡中郎文集. 涵芬樓.

Mori Mikisaburō. 1943. "Shina no kamigami no kanryōteki seikaku" (The bureaucratic nature of Chinese gods). *Shinagaku* 11.1: 49–81. 森三樹三郎. 支那の神々の官僚的性格. 支那學.

Mozi (Writings of Mozi). References are to Sun Yirang, *Mozi xiangu* (The *Writings of Mozi*, with supplementary annotation). ZZJC 4. 墨子. 孫詒讓. 墨子閒詁.

Mu Yongkang and Yun Xizheng. 1992. *Zhongguo yuqi quanji: Yuanshi shehui* (A complete collection of Chinese jades: primitive society). Shijiazhuang: Hebei meishu chubanshe. 牟永抗, 雲希正. 中國玉器全集. 原始社會. 石家莊: 河北美術出版社.

Mu Yongkang et al. 1989. *Liangzhu wenhua yuqi* (Jades of the Liangzhu culture). Beijing: Wenwu chubanshe. 牟永抗等. 良渚文化玉器. 文物出版社.

Nagahiro Toshio. 1965. *Kandai kazō no kenkyū* (The representational art of the Han dynasty). Tokyo: Chūō Kōron bijutsu shuppan. 長廣敏雄. 漢代畫像の研究. 中央公論美術出版.

———. 1969. *Rikuchō jidai bijutsu no kenkyū* (The representational art of the Six Dynasties period). Tokyo: Bijutsu shuppansha. 六朝時代美術の研究. 美術出版社.

Nan Qi shu (History of the Southern Qi), by Xiao Zixian. Beijing: Zhonghua shuju, 1972. 南齊書. 蕭子顯. 中華書局.

Nanjing Museum. 1973. "Tongshan Xiaoguishan Xi-Han yadong mu" (The Western Han cave tomb at Xiaoguishan, Tongshan). *WW* 4: 21–35. 南京博物院. 銅山小龜山西漢崖洞墓.

———. 1984. "Yijiubaer nian Jiangsu Wujin Sidun yizhi de fajue" (The 1982 excavation of the Sidun site at Wujin in Changzhou, Jiangsu). *KG* 2: 109–29. 一九八二年江蘇武進寺墩遺址的發掘.

Nanjing Museum and Tongshan Cultural House. 1985. "Tongshan Guishan erhao Xi-Han yadong mu" (Cave tomb no. 2 of the Western Han at Guishan, Tongshan).

KGXB 1: 119–33. 南京博物院. 銅山縣文化館. 銅山龜山二號西漢崖洞墓.

Nanyang Museum. 1974. "Nanyang faxian Dong-Han Xu Aqu muzhi huaxiangshi" (The Eastern Han pictorial carving on Xu Aqu's memorial tablet from Nanyang). *WW* 8: 73–75. 南陽市博物館. 南陽發現東漢許阿瞿墓志畫像石.

National Palace Museum. 1989. *Shang Zhou qingtong jiuqi tezhan tulu* (Catalogue of the special exhibition of Shang and Zhou bronze wine vessels). Taipei: Guoli gugong bowuyuan. 國立故宮博物院. 商周青銅酒器特展圖錄. 國立故宮博物院.

Okumura Ikura. 1939. *Kaka* (Melons and eggplants). Kyoto: Kaka kenkyūjo. 奧村伊九良. 瓜茄. 瓜茄研究所.

Omura Seigai. 1915, 1920. *Shina bijutsu shi: chōso hen* (A history of fine arts in China: sculpture). 2 vols. Tokyo: Bukkyō kankōkai, Zuzōbu. 大村西崖. 支那美術史: 雕塑篇. 佛教刊行會圖像部.

Palace Museum. 1959. *Lidai yishuguan* (The art gallery of successive centuries). Beijing: Gugong bowuyuan. 故宮博物院. 歷代藝術館. 故宮博物院.

———. 1978. *Zhongguo lidai huihua: Gugong bowuyuan canghua ji, yi* (Chinese paintings through the ages: collections of the Palace Museum, 1). Beijing: Renmin meishu chubanshe. 中國歷代繪畫: 故宮博物院藏畫集, 一. 人民美術出版社.

Qi Sihe. 1947. "Zhoudai ximingli kao" (A study of Zhou investiture rituals). *Yanjing xuebao* (Yanjing University journal) 32: 197–226. 齊思和. 周代錫命禮考. 燕京學報.

Qi Yingtao. 1957. "Xi'an de jichu Handai jianzhu yizhi" (Several Han dynasty architectural remains in Xi'an). *Wenwu cankao ziliao* 5: 57–58. 祁英濤. 西安的幾處漢代建築遺址. 文物參考資料.

Qin Han diaosuo (Sculpture of the Qin and Han dynasties). In *ZGMSQJ*. Beijing: Renmin meishu chubanshe, 1985. 秦漢雕塑. 人民美術出版社.

Qingtongqi, yi, er (Bronzes, 1, 2). 2 vols. In *ZGMSQJ*. Beijing: Wenwu chubanshe, 1985, 1986. 青銅器, 一, 二. 文物出版社.

Qiqi (Lacquerwares). In *ZGMSQJ*. Beijing: Wenwu chubanshe, 1989. 漆器. 文物出版社.

Qiu Xigui. 1978. "Shi Qiang pan ming jieshi" (An interpretation of the Shi Qiang *pan* inscription). *WW* 3: 25–32. 裘錫圭. 史牆盤銘解釋.

Qun Li. 1972. "Linzi Qi guo gucheng kantan jiyao" (Notes on the exploration of the old capital city of Qi near Linzi). *WW* 5: 45–54. 羣力. 臨淄齊國故城勘探紀要.

Ren Jiyu, ed. 1981. *Zhongguo fojiao shi* (History of Chinese Buddhism). Beijing: Zhongguo shehui kexue chubanshe. 任繼愈. 中國佛教史. 中國社會科學出版社.

Renmin ribao (People's daily). 人民日報.

Rizhi lu (Records of daily learning), by Gu Yanwu. References are to Huang Rucheng, *Rizhi lu jishi* (*Records of Daily Learning*, with collected commentaries). Sibu beiyao ed. Shanghai: Zhonghua shuju, 1927. 日知錄. 顧炎武. 黃汝成. 日知錄集釋. 四部備要. 中華書局.

Rong Geng. 1936. *Han Wu Liang ci huaxiang lu* (A record of the Wu Liang Shrine carvings of the Han). Beijing: Beiping kaogu xueshe. 容庚. 漢武梁祠畫像錄. 北平考古學社.

Rong Geng and Zhang Weichi. 1958. *Yin Zhou yiqi tongkao* (A comprehensive study of Shang and Zhou ritual bronzes). Beijing: Kexue chubanshe. 容庚. 張維持. 殷周彝器通考. 科學出版社.

Ruiying tuji (Annotated illustrations of good omens), by Sun Ruozhi. In Ye Dehui, *Guangutang suozhushu* (Books catalogued in the Guangu Hall). Xiangtan: Ye family, 1902. 瑞應圖記. 孫柔之. 葉德輝. 觀古堂所著書. 湘潭葉氏.

Sandai jijin wencun (Collected rubbings of bronze inscriptions of the Three Dynasties), by Luo Zhenyu. Reprinted— Shanghai: Zhonghua shuju, 1983. 三代吉金文存. 羅振玉. 中華書局.

Sanguo zhi (Records of the Three Kingdoms), by Chen Shou. Beijing: Zhonghua shuju, 1959. 三國志. 陳壽. 中華書局.

SBCK: *Sibu congkan* (Collectanea of books in the four bibliographic categories). First series, reduced ed. Shanghai: Shangwu yinshuguan, 1937. 四部叢刊. 初編. 商務印書館.

Seibu Museum. 1986. *Daikōga bummei no nagare: Santōshō bumbutsu ten* (The flow of Yellow River civilization: exhibition of cultural relics from Shandong). Tokyo: Seibu bijutsukan and Asahi shimbunsha. 西武美術館. 大黃河文明の流れ：山東省文物展. 西武美術館. 朝日新聞社.

Sekino Tei. 1916. *Shina Santōshō ni okeru Kandai fumbo no hyōshoku* (Catalogue of Han dynasty decorations in Shandong). Tokyo: Imperial University of Tokyo, College of Engineering. 關野貞. 支那山東省に於ける漢代墳墓の表飾. 東京帝國大學工科大學.

SFHT: *Sanfu huangtu* (The diagram of the imperial district). References are to Zhang Zongxiang, *Jiaozheng Sanfu huangtu* (An edited and annotated version of *The Diagram of the Imperial District*). Beijing: Gudian wenxue chubanshe, 1958. 三輔黃圖. 見張宗祥. 校正三輔黃圖. 古典文學出版社.

Shaanxi chutu Shang Zhou qingtongqi (Shang and Zhou bronzes unearthed in Shaanxi). 3 vols. Beijing: Wenwu chubanshe, 1980. 陝西出土商周青銅器. 文物出版社.

Shaanxi Provincial Archaeological Institute. 1987. "Qin Dongling diyihao lingyuan kanchaji" (Investigation report on Tomb no. 1 in the Eastern Mausoleum District of the Qin). *KW* 4: 19–28. 陝西省考古研究所. 秦東陵第一號陵園勘察記.

Shaanxi Provincial Cultural Relics Administration. 1962. "Qinshihuang ling diaocha jianbao" (Brief investigation report on the mausoleum of the First Emperor of the Qin). *KG* 8: 407–11. 陝西文物管理委員會. 秦始皇陵調察簡報.

Shandong Provincial Cultural Relics Administration. 1961. "Shandong Linzi Qi gucheng shijue jianbao" (Brief report on the test excavations of the old Qi city of Linzi in Shandong). *KG* 6: 289–97. 山東省文物管理處. 山東臨淄齊故城試掘簡報.

Shandong Provincial Cultural Relics Administration and Ji'nan City Museum. 1974. *Dawenkou* (The archaeological site at Dawenkou). Beijing: Wenwu chubanshe. 山東省文管會. 濟南市博物館. 大汶口. 文物出版社.

Shandong Provincial Museum. 1972. "Qufu Jiulongshan Han mu fajue jianbao" (Brief report on the excavation of the Han tombs at Jiulongshan in Qufu). *WW* 5: 39–44. 山東省博物館. 曲阜九龍山漢墓發掘簡報.

Shandong Provincial Museum and Cangshan Cultural House. 1975. "Shandong Cangshan Yuanjia yuannian huaxiangshi mu" (The stone tomb dated A.D. 151 with pictorial carvings at Cangshan in Shandong). *KG* 2: 124–34. 山東省博物館. 蒼山縣文化館. 山東蒼山元嘉元年畫像石墓.

Shandong Provincial Museum and Shandong Cultural Relics and Archaeology Institute. 1982. *Shandong Han huaxiangshi xuanji* (Selected Han dynasty pictorial stone carvings from Shandong). Ji'nan: Qilu shushe. 山東省博物館. 山東省文物考古研究所. 山東漢畫像石選集. 齊魯書社.

Shandong Team of the Institute of Archaeology, CASS, and Qufu County Cultural Relics Administration. 1965. "Shandong Qufu kaogu diaocha shijue jianbao" (Brief report on the survey of and test excavations at Qufu in Shandong). *KG* 12: 599–613. 中國社會科學院考古研究所山東工作隊. 曲阜縣文物管理委員會. 山東曲阜考古調察試掘簡報.

Shanghai hakubutsukan shutsudo bumbutsu seidōki tōjiki (Unearthed bronze and ceramic relics in the Shanghai

Museum). Tokyo: Heibonsha, 1976. 上海博物館出土文物青銅器陶磁器. 平凡社.

Shangjun shu (Writings of Lord Shang). References are to Zhu Shizhe, *Shangjun shu jiegu dingben* (An authoritative and annotated version of *Writings of Lord Shang*). Beijing: Guji chubanshe, 1956. 商君書. 見朱師轍. 商君書解詁定本. 古籍出版社.

Shang shu (Book of documents). References are to Kong Yingda, *Shang shu zhengyi* (The correction interpretation of the *Book of Documents*). In *SSJZS*, 109–258. 尚書. 孔穎達. 尚書正義.

Shang Zhou zhi Qin Han shufa (Calligraphy from the Shang-Zhou to Qin-Han dynasties). In *ZGMSQJ*. Beijing: Renmin meishu chubanshe, 1987. 商周至秦漢書法. 人民美術出版社.

Shi jing (Book of songs). References are to Kong Yingda, *Mao shi zhengyi* (The correct interpretation of the *Book of Songs* and Mr. Mao's original commentaries). In *SSJZS*, 259–629. 詩經. 見孔穎達. 毛詩正義.

Shi ming (Interpreting names), by Liu Xi. References are to Wang Xianqian, *Shi ming shuzheng bu* (*Interpreting Names*, with supplementary annotations). Shanghai: Shanghai guji chubanshe, 1984. 釋名. 劉熙. 王先謙. 釋名疏証補. 上海古籍出版社.

"Shi suo" (Index to stone carvings), by Feng Yunpeng and Feng Yunyuan. In *Jinshi suo* (An index to bronzes and stone carvings). Reprinted—Shanghai: Shangwu yin-shuguan, n.d. 石索. 馮雲鵬. 馮雲鶴. 金石索. 商務印書館.

Shi Xingeng. 1938. *Liangzhu: Hangxian dierqu heitao wenhua yizhi chubu baogao* (Liangzhu: a preliminary report on a black pottery culture site in Hangzhou, District no. 2). Hangzhou: Zhejiang jiaoyuting. 施昕更. 良渚：杭縣第二區黑陶文化遺址初步報告. 浙江教育庭.

Shi Zhangru. 1933. "Diqici Yinxu fajue" (The seventh excavations at the Ruins of Yin). *Anyang fajue baogao* (Reports on the excavations at Anyang) 4: 709–28. 石璋如. 第七次殷墟發掘. 安陽發掘報告.

———. 1959. *Xiaotun diyiben. Yizhi de faxian yu fajue yibian: Yinxu jianzhu yicun* (Xiaotun, book 1. The excavations at the Ruins of Yin and archaeological finds, second series: architectural remains at the Ruins of Yin). Taipei: Academia Sinica, Institute of History and Philology. 小屯第一本：遺址的發現與發掘乙編：殷墟建築遺存. 中央研究院歷史語言研究所.

———. 1960. "Henan Anyang Xiaotun Yindai de sanzu jizhi" (Three groups of Shang dynasty architectural foundations at Xiaotun in Anyang, Henan province). *Dalu zazhi* 21.1/2: 19–26. 河南安陽小屯殷代的三組基址. 大陸雜誌.

Shi Zhecun. 1987. *Shuijing zhu beilu* (Stone tablets recorded in the *Annotated Canon of Waterways*). Tianjin: Tianjin guji chubanshe. 施蟄存. 水經注碑錄. 天津古籍出版社.

Shi Zhilian. 1987. "Zuida zuigu de kewen yucong" (The largest and oldest jade *zong* with engraving). *Zhongguo wenwu bao*, Oct. 1. 石志廉. 最大最古的刻紋玉琮. 中國文物報.

Shijiazhuang Library. 1980. "Hebei Shijiazhuang beijiao Xi-Han mu fajue baogao" (Report on the excavations of the Western Han tomb in the northern suburbs of Shijiazhuang in Hebei). *KG* 1: 52–55. 石家莊圖書館. 河北石家莊北郊西漢墓發掘報告.

SHJ: Shanhai jing (Classic of mountains and seas). References are to Yuan Ke, *Shanhai jing jiaozhu* (*Classic of Mountains and Seas*, collected and annotated). Shanghai: Shanghai guji chubanshe, 1980. 山海經. 袁珂. 山海經校注. 上海古籍出版社.

Shuijing zhu tu (Illustrations to *Annotated Canon of Waterways*), by Yang Shoujing. Reprinted—Taipei: Wenhai chubanshe, 1966. 水經註圖. 楊守敬. 文海出版社.

Shuo yuan (The garden of talk), by Liu Xiang. References are to Lu Yuanjun, *Shuo yuan jinzhu jinyi* (An annotated edition of *The Garden of Talk*, with modern Chinese translations). Tianjin: Tianjin guji chubanshe, 1988. 説苑. 劉向. 盧元駿. 説苑今註今譯. 天津古籍出版社.

SJ: Shi ji (Historical records), by Sima Qian. Beijing: Zhonghua shuju, 1959. 史記. 司馬遷. 中華書局.

SJZ: Shuijing zhu (Annotated canon of waterways), by Li Daoyuan. Shanghai: Shijie shuju, 1936. 水經注. 酈道元. 世界書局.

Song shu (History of the Liu-Song dynasty), by Shen Yue. Beijing: Zhonghua shuju, 1974. 宋書. 沈約. 中華書局.

SSJZS: Shisanjing zhushu (Annotated Thirteen Classics), comp. Ruan Yuan. Beijing: Zhonghua shuju, 1980. 十三經注疏. 阮元. 中華書局.

Sui ji (Records of the Sui dynasty). In Wu Chulin, *Gangjian yizhi lu* (History made easy to understand). Taipei: Hualian chubanshe, 1964. 隋紀. 吳楚林. 網鑑易知錄. 華聯出版社.

Sui shu (History of the Sui dynasty), by Wei Zheng. Beijing: Zhonghua shuju, 1973. 隋書. 魏徵. 中華書局.

Sun Yirang. 1934. *Zhou li zhengyi* (The correct interpretation of the *Rites of Zhou*). Sibu beiyao ed. Shanghai: Zhonghua shuju. 孫詒讓. 周禮正義. 四部備要. 中華書局.

SW: *Shuowen jiezi* (Interpretations of characters and words), by Xu Shen. References are to Duan Yucai, *Shuowen jiezi zhu* (Annotated *Interpretations of Characters and Words*). Shanghai: Shanghai guji chubanshe, 1981. 説文解字. 許慎. 段玉裁. 説文解字注. 上海古籍出版社.

SZCZ. *Song zhu Chang'an zhi* (*Records of Chang'an* with Song Minqiu's commentaries), ed. Ruan Yuan. Xi'an: Chang'an xianzhi ju. 宋注長安志. 阮元. 長安縣志局.

Tang Jinyu. 1959. "Xi'an xijiao Handai jianzhu yizhi fajue baogao" (Report on the excavations of Han dynasty architectural sites in the western suburbs of Xi'an). *KGXB* 2: 45–54. 唐金裕. 西安西郊漢代建築遺址發掘報告.

Tang Lan. 1960. "Zhongguo gudai shehui shiyong qingtong nongqi wenti de chubu yanjiu" (A preliminary study of problems concerning the use of argricultural implements in ancient Chinese society). *Gugong Bowuyuan yuankan* (Journal of the Palace Museum) 2: 10–34. 唐蘭. 中國古代社會使用青銅農器問題的初步研究. 故宮博物院院刊.

———. 1962. "Xi-Zhou tongqi duandai zhong de Kang gong wenti" (The problem of Kang *gong* in the periodization of Western Zhou bronzes). *KGXB* 1: 15–48. 西周銅器斷代中的康宮問題.

———. 1976. "He zun mingwen jieshi" (An explanation of the inscription on the He zun). *WW* 1: 60–63. 何尊銘文解釋.

———. 1978. "Luelun Xi-Zhou Weishi jiazu jiaocang tongqiqun de zhongyao yiyi" (A brief discussion of the major significance of the group of bronzes from the hoard of the Western Zhou Wei lineage). *WW* 3: 19–24. 略論西周微氏家族窖藏銅器羣的重要意義.

———. 1979. "Guanyu 'Xia ding'" (About the "Xia dynasty tripods"). *Wen shi* (Literature and history) 7: 1–8. 關於「夏鼎」. 文史.

———. 1981. "Cong Dawenkou wenhua de taoqi wenzi kan woguo zuizao wenhua de niandai" (Dating the earliest Chinese civilization based on Dawenkou pottery inscriptions). In *Dawenkou wenhua taolun wenji* (Papers on Dawenkou culture). Ji'nan: Qilu shushe, 1981. 79–84. 從大汶口文化的陶器文字看我國最早文化的年代. 大汶口文化討論文集. 齊魯書社.

Tang Yongtong, 1938. *Han Wei Liang Jin Nanbeichao fojiaoshi* (The history of Buddhism during the Han, Wei, Western and Eastern Jin, and the Northern and Southern Dynasties). Shanghai: Shangwu yinshuguan. 湯用彤. 漢魏兩晋南北朝佛教史. 商務印書館.

Tao Yuanming ji (Writings of Tao Yuanming), by Tao Qian. Beijing: Zhonghua shuju, 1979. 陶淵明集. 陶潛. 中華書局.

Taoci, yi (Ceramics, 1). In *ZGMSQJ*. Shanghai: Shanghai renmin meishu chubanshe, 1988. 陶瓷, 一. 上海人民美術出版社.

Tokyo National Museum. 1986. *Kōga bummei tenran* (Exhibition of cultural relics from the Yellow River civilization). Tokyo: Chūnichi shimbunsha. 東京國立博物館. 黄河文明展覽. 中日新聞社.

TPYL: *Taiping yulan* (Imperially reviewed encyclopedia of the Taiping era), comp. Li Fang. Beijing: Zhonghua shuju, 1960. 太平御覽. 李昉. 中華書局.

Umehara Sueji. 1947. *Kankerō kikkinzu* (Illustrated bronzes from the Kankerō). Kyoto. 梅原末治. 冠斝樓吉金圖.

Wang Guowei. *Guantang jilin* (Collected writings of Wang Guowei). Taipei: Shijie shuju, 1961. 王國維. 觀堂集林. 世界書局.

Wang Pizhong et al. 1980. "Han Jingdi Yang ling diaocha jianbao" (Brief investigation report on the Yang ling mausoleum of Emperor Jing of the Han). *KW* 1: 36–37. 王丕忠等. 漢景帝陽陵調察簡報.

Wang Rencong. 1990. "He zun mingwen jieshi yu Chengwang qiandu wenti" (The explanation of He *zun*'s inscription and the problem of King Cheng's moving the Zhou capital). *KW* 3: 47–51. 王人聰. 何尊銘文解釋與成王遷都問題.

Wang Shimin. 1981. "Zhongguo Chunqiu Zhanguo shidai de zhongmu" (Tombs with tumuli during China's Spring and Autumn and Warring States periods). *KG* 5: 459–66. 王世民. 中國春秋戰國時代的冢墓.

———. 1987. "Guanyu Xi-Zhou Chunqiu gaoji guizu liqi zhidu de yixie kanfa" (Some points on the regulations on ritual vessels of high-ranking nobles during the Western Zhou and the Spring and Autumn period). In Wenwu Press, *Wenwu kaogu lunji* (Treatises on archaeology and culture). Beijing: Wenwu chubanshe, 158–66. 關於西周春秋高級貴族禮器制度的一些看法. 文物出版社. 文物考古論集.

Wang Shiren. 1957. "Xi'an shi xijiao gongdi de Handai jianzhu yizhi" (Han dynasty architectural remains in the construction site in the western suburbs of Xi'an). *Wenwu cankao ziliao* 3: 11–12. 王世仁. 西安市西郊工地的漢代建築遺址. 文物參考資料.

———. 1963. "Han Chang'an cheng nanjiao lizhi jianzhu yuanzhuang de tuice" (Speculations on the original form

of the ritual structures in the southern suburbs of Han dynasty Chang'an). *KG* 9: 501–15. 漢長安城南郊禮制建築原狀的推測.

Wang Shucun. 1986. "Zhongguo shike xianhua lüeshi" (A brief history of Chinese line engravings). Preface to *ZGMSQJ*, vol. 1, pt. 19. 王樹村. 中國石刻線畫略史. 中國美術全集.

Wang Shuming. 1986. "Lingyanghe yu Dazhucun chutu taozun shang de wenzi" (Writing on pottery jars from Lingyanghe and Dazhucun). In *Shandong shiqian wenhua lunwenji* (Papers on prehistoric cultures of the Shandong region). Ji'nan: Qilu shushe. 王樹明. 陵陽河與大竹村出土陶尊上的文字. 山東史前文化論文集. 濟南. 齊魯書社.

Wang Wei. 1986. "Liangzhu wenhua yucong chuyi" (A discussion of the jade *cong* of Liangzhu culture). *KG* 11: 1009–16. 王巍. 良渚文化玉琮芻議.

Wang Xueli. 1982. "'Qin du Xianyang' yu 'Xianyang gong' bianzheng" (On the "Qin capital Xianyang" and the "Xianyang Palace"). *KW* 2: 67–71. 王學理. 「秦都咸陽」與「咸陽宮」辨正.

———. 1985. *Qin du Xianyang* (The Qin capital of Xianyang). Xi'an: Shaanxi renmin chubanshe. 秦都咸陽. 陝西人民出版社.

———. 1989. "'Lishan shiguan' (dongduan) fuyuan de gouxiang" (A proposal for reconstructing the sacrificial halls at Lishan [eastern section]). *KW* 5: 125–29. 「麗山食官」(東段)復原的構想.

Wang Xueli et al. 1979. "Qin du Xianyang fajue baodao de ruogan buchong yijian" (Some supplemental opinions about the report on the excavation of the Qin capital of Xianyang). *WW* 2: 85–86. 王學理等. 秦都咸陽發掘報導的若干補充意見.

Wang Yi. 1990. *Yuanlin yu Zhongguo wenhua* (Gardens and Chinese culture). Shanghai: Shanghai renmin chubanshe. 王毅. 園林與中國文化. 上海人民出版社.

Wang Yizhi. 1937. *Xi-Han nianji* (A chronicle of the Western Han). Guoxue jiben congshu (Basic sinological series), no. 17. Shanghai: Shangwu yinshuguan. 王益之. 西漢年紀. 國學基本叢書. 商務印書館.

Wang Zhongzhu. 1957. "Han Chang'an cheng kaogu gongzuo de chubu shouhuo" (Preliminary results of the archaeological work on the Han dynasty city of Chang'an). *Kaogu tongxun* 5: 102–4. 王仲殊. 漢長安城考古工作的初步收獲. 考古通訊.

———. 1984. *Handai kaoguxue gaishuo* (A general introduction to Han archaeology). Beijing: Zhonghua shuju. 漢代考古學概說. 中華書局.

Wang Zunguo. 1984. "Liangzhu wenhua 'yujianzang' shulüe" (A general discussion of the "jade-furnished burials" of the Liangzhu culture). *WW* 2: 23–35. 汪遵國. 良渚文化「玉斂葬」述略.

Wei Jin Nanbeichao shufa (Calligraphy of the Wei, Jin, and the Northern and Southern Dynasties). Beijing: Renmin meishu chubanshe, 1987. 魏晉南北朝書法. 人民美術出版社.

Wei Tingsheng. 1970. *Zhou zi Mu wang du Luo kao* (A study of King Mu's establishment of the Zhou capital at Luo). Taipei: Zhonghua xueshuyuan. 衛挺生. 周自穆王都洛考. 中華學術院.

Wen Yu. 1956. *Sichuan Handai huaxiang xuanji* (A selection of Han dynasty pictorial carvings from Sichuan). Beijing: Zhongguo gudian yishu chubanshe. 閻閻. 四川漢代畫像選集. 中國古典藝術出版社.

Wenwu Press. 1979. *Wenwu kaogu gongzuo sanshinian* (Three decades of cultural and archaeological work). Beijing: Wenwu chubanshe. 文物出版社. 文物考古工作三十年. 文物出版社.

Work Team at the Han-Wei Capital Site in Luoyang, Institute of Archaeology, CASS. 1984. "Yanshi Shang cheng de chubu kantan he fajue" (Preliminary survey and excavation of the Shang city at Yanshi). *KG* 6: 488–504. 中國社會科學院考古研究所,洛陽漢魏故城工作隊. 偃師商城的初步鉗探和發掘.

Wu Hong [Hung]. 1979. "Yizu zaoqi de yushi diaoke" (A group of early jade and stone carvings). *Meishu yanjiu* (Studies of fine arts) 1: 64–70. 巫鴻. 一組早期的玉石雕刻. 美術研究.

———. 1989. "Han Ming, Wei Wen de lizhi gaige yu Handai huaxiang yishu zhi shengshuai" (The ritual reforms of Emperor Ming of the Han and Emperor Wen of the Wei and the rise and fall of Han pictorial art). *Jiuzhou xuekan* (Chinese cultural quarterly) 3.2: 31–44. 漢明,魏文的禮制改革與漢代畫像藝術之盛衰. 九州學刊.

Wu Ruzuo. 1989. "Cong heitaobei kan Dawenkou-Longshan wenhua fazhan de jieduanxing jiqi zhongxin fanwei" (Investigating the developmental stages and central regions of Dawenkou-Longshan cultures based on black pottery cups). In Su Bingqi, ed., *Kaoguxue wenhua lunji* (An anthology on archaeological cultures), 2: 31–43. 吳汝祚. 從黑陶杯看大汶口—龍山文化發展的階段性及其中心範圍. 蘇秉琦. 考古學文化論集.

WX: *Wenxuan* (Selections of refined literature), by Xiao Tong. References are to Gao Buying, *Wenxuan Li zhu yishu* (*Selections of Refined Literature*, with Li Shan's com-

mentaries and further interpretations). 4 vols. Beijing: Zhonghua shuju, 1985. 文選. 蕭統. 高步瀛. 文選李注義疏. 中華書局.

WXTK: Wenxian tongkao (A comprehensive examination of texts), by Ma Duanlin. Taibei: Taiwan shangwu yinshuguan, 1983. 文獻通考. 馬端臨. 台灣商務印書館.

Xie Mincong. 1979. *Zhongguo lidai diling kaolüe* (A brief investigation of the imperial mausoleums of China's dynasties). Taipei: Zhongzheng shuju. 謝敏聰. 中國歷代帝陵考略. 正中書局.

Xin Lixiang. 1982. "Han huaxiangshi de fenqu he fenqi" (A periodization and regionalization of Han pictorial stone carvings). M.A. thesis, Beijing University. 信立祥. 漢畫像石的分區和分期. 北京大學.

Xin xu (A new compilation of historical anecdotes), by Liu Xiang. References are to Lu Yuanjun, *Xin xu jinzhu jinyi* (An annotated edition of *A New Compilation of Historical Anecdotes*, with modern Chinese translations). Tianjin: Tianjin guji chubanshe, 1987. 新序. 劉向. 盧元駿. 新序今注今釋. 天津古籍出版社.

Xin yu (New dialogues), by Lu Jia. References are to Wang Liqi, *Xin yu jiaozhu* (An annotated and collated edition of the *New Dialogues*). Beijing: Zhonghua shuju, 1986. 新語. 陸賈. 王利器. 新語校注. 中華書局.

Xi-Qing xujian jiabian (A supplement to the Xi-Qing antique catalogue, first series), by Wang Jie et al. Beijing, 1910. 西清續鑑甲編. 王杰等.

Xu Daolin and Liu Zhiping. 1959. "Guanyu Xi'an xijiao faxian de Handai jianzhu yizhi shi Mingtang huo Biyong de taolun" (A discussion of the identity of the architectural remains found in the western suburbs of Xi'an as Mingtang or Biyong). *KG* 4: 193–96. 許道麟. 劉致平. 關於西安西郊發現的漢代建築遺址是明堂或辟雍的討論. 考古.

Xu Xusheng. 1960. *Zhongguo gushi de chuanshuo shidai* (The legendary era in ancient China). Beijing: Kexue chubanshe. 徐旭生. 中國古史的傳說時代. 科學出版社.

Xu Zhongshu. 1978. "Xi-Zhou Qiang pan mingwen qianshi" (An annotation and interpretation of the Qiang *pan* inscription of the Western Zhou). *KGXB* 2: 139–48. 徐仲舒. 西周牆盤銘文箋釋.

Xuanhe bogu tulu (An illustrated catalogue of antiquities from the Xuanhe era), by Wang Fu et al. 1603 ed. Harvard-Yenching Library, Harvard University. 宣和博古圖錄. 王黻.

Xunzi (Writings of Xunzi). References are to Wang Xian-

qian, *Xunzi jijie* (*Xunzi*, with collected commentaries). ZZJC, no. 2. 荀子. 王先謙. 荀子集解.

Xuzhou Museum. 1984. "Xuzhou Shiqiao Han mu qingli baogao" (Report on cleaning the Han tombs at Shiqiao in Xuzhou). *WW* 11: 22–40. 徐州博物館. 徐州石橋漢墓清理報告.

Xuzhou Museum et al. 1988. "Xuzhou Beidongshan Xi-Han mu fajue jianbao" (Brief report on the excavation of the Western Han tomb at Beidongshan in Xuzhou). *WW* 2: 2–18. 徐州博物館等. 徐州北洞山西漢墓發掘簡報.

Yan fanlu (Manifestations of luxuriant gems), by Cheng Dachang. Shanghai: Shangwu yinshuguan, 1936. 演繁露. 程大昌. 商務印書館.

Yan Ruoju et al. 1967. *Duli congchao* (A comprehensive examination of ancient ritual canons). Taipei: Wenhai chubanshe, 1967. 閻若璩. 讀禮叢鈔. 文海出版社.

Yang Dianxun. 1940. *Shike tiba suoyin* (An index of stone inscriptions). Reprinted–Shanghai: Shangwu yinshuguan, 1990. 楊殿珣. 石刻題跋索引. 上海商務印書館.

Yang Hongxun (Tao Fu). 1976a. "Cong Panlongcheng Shangdai gongdian yizhi tan Zhongguo gongting jianzhu de jige wenti" (Problems in the development of Chinese palatial architecture introduced by the remains of the Shang palace at Panlongcheng). *WW* 2: 16–25. Reprinted in idem 1987: 81–93. 楊鴻勛(陶復). 從盤龍城商代宮殿遺址談中國宮廷建築的幾個問題.

———. 1976b. "Qin Xianyang gong diyihao yizhi fuyuan wenti de chubu tantao" (An preliminary reconstruction of Site no. 1 of the Qin dynasty Xianyang Palace). *WW* 11: 31–41. Reprinted in idem 1987: 153–68. 秦咸陽宮第一號遺址復原問題的初步探討.

———. 1980. "Zhanguo Zhongshan wangling ji Zhaoyutu yanjiu" (A study of the "Diagram of the Funerary District" from the Zhongshan royal mausoleum). *KGXB* 1: 119–37. Reprinted in idem 1987: 120–42. 戰國中山王陵及兆域圖研究.

———. 1981. "Xi-Zhou Qiyi jianzhu yizhi chubu kaocha" (A preliminary investigation of the architectural site at Western Zhou Qiyi). *WW* 3: 23–33. Reprinted in idem 1987: 94–109. 西周歧邑建築遺址初步考察.

———. 1982. "Guanyu Qindai yiqian mushang jianzhu de wenti" (Problems of aboveground architecture before the Qin dynasty). *KG* 4: 402–6. Reprinted in idem 1987: 143–49. 關於秦代以前墓上建築的問題.

———. 1987. *Jianzhu kaoguxue lunwen ji* (Collected papers on architectural archaeology). Beijing: Wenwu chubanshe. 建築考古學論文集. 文物出版社.

Yang Kuan. 1965. *Gushi xintan* (New explorations of ancient history). Beijing: Zhonghua shuju. 楊寬. 古史新探. 中華書局.

———. 1982. "Xian-Qin mushang jianzhu he lingqin zhidu" (Aboveground funerary structures and the regulations of mausoleums during the pre-Qin period). *WW* 1: 31–37. 先秦墓上建築和陵寢制度.

———. 1983. "Xian-Qin mushang jianzhu wenti de zai-tantao" (A further investigation of the problem concerning aboveground funerary structures during the pre-Qin period). *KG* 7: 636–40. Reprinted in idem 1985: 211–18. 先秦墓上建築問題的再探討.

———. 1985. *Zhongguo gudai lingqin zhidu yanjiu* (A study of ancient Chinese regulations on funerary parks). Shanghai: Shanghai guji chubanshe. 中國古代陵寢制度研究. 上海古籍出版社.

Yang Shuda. 1933. *Handai hunsang lisu kao* (A study of the Han customs for marriage and funeral rituals). Shanghai: Shangwu yinshuguan. 楊樹達. 漢代婚喪禮俗考. 上海: 商務印書館.

Yantie lun (The debate on salt and iron), by Huan Kuan. SBCK no. 14. Shanghai: Shangwu yinshuguan. 鹽鐵論. 桓寬. 四部叢刊. 商務印書館.

Yao Qian and Gu Bing. 1981. *Liuchao yishu* (Art of the Six Dynasties). Beijing: Wenwu chubanshe. 姚遷. 古兵. 六朝藝術. 文物出版社.

Ye Xiaojun. 1988. *Zhongguo ducheng fazhan shi* (A history of Chinese capitals). Xi'an: Shaanxi renmin chubanshe. 葉驍軍. 中國都城發展史. 陝西人民出版社.

Yi jing (Book of changes). References are to Kong Yingda, *Zhou Yi zhengyi* (The correct interpretation of the *Book of Changes*). In *SSJZS*, 5–108. 易經. 孔穎達. 周易正義.

Yinxu qingtongqi (Bronzes from the Ruins of Yin). Beijing: Wenwu chubanshe. 殷墟青銅器. 文物出版社.

Yi Zhou shu (Leftover documents from the Zhou). References are to Zhu Youzeng, *Yi Zhou shu jixun jiaoshi* (The *Leftover Documents from the Zhou*, annotated and collated). Guoxue jiben congshu series. Changsha: Shangwu yinshuguan, 1940. 逸周書. 見朱右曾. 逸周書集訓校釋. 國學基本叢書. 商務印書館.

YL: *Yi li* (Ceremonies and Rites). References are to Jia Gongyan, *Yi li shu* (Annotated *Ceremonies and Rites*). In *SSJZS*, 941–1220. 儀禮. 賈公彥. 儀禮疏.

Yongle dadian (The great encyclopedia of the Yongle era), by Xie Jin et al. Shanghai: Zhonghua shuju, 1960. 永樂大典. 解縉等. 中華書局重印本.

Yong lu (Records of the Yong area), by Cheng Dachang. In

Wu Guan, *Gujin yishi* (Scattered historical writings of the past and present). Shanghai: Hanfenlou, 1937, vols. 22–26. 雍錄. 程大昌. 吳琯. 古今逸史. 涵芬樓.

Yongcheng Archaeological Team of Shaanxi Province. 1985. "Fengxiang Majiazhuang yihao jianzhuqun yizhi fajue jianbao" (Brief report on the excavations of Architectual Site no. 1 at Majiazhuang in Fengxiang). *WW* 2: 1–29. 陝西省雍城考古隊. 鳳翔馬家莊一號建築羣遺址發掘簡報.

Yu Weichao. 1985. *Xian-Qin Liang-Han kaoguxue lunji* (A collection of archaeological treatises on the pre-Qin and Han dynasties). Beijing: Wenwu chubanshe. 俞偉超. 先秦兩漢考古學論集. 文物出版社.

Yu Weichao and Gao Ming. 1978–79. "Zhoudai yongding zhidu yanjiu" (A study of the regulations for using *ding* tripods during the Zhou). *Beijing daxue xuebao (renwen kexue)* (Journal of Beijing University [social sciences]) 1978.1/2: 84–98; 1979, 1: 83–96. For a revised version, see Yu Weichao 1985: 62–114. 俞偉超. 高明. 周代用鼎制度研究. 北京大學學報(人文科學).

Yu Xingwu. 1957. "Cong jiaguwen kan Shangdai nuli shehui xingzhi" (The nature of the Shang slave society based on oracle bone inscriptions). *Jilin daxue renwen kexue xuebao* (Journal of humanistic sciences, Jilin University) 2/3: 97–136. 于省吾. 從甲骨文看商代奴隸社會性質. 吉林大學人文科學學報.

———. 1958. "Chi Tang Lan xiansheng 'Guanyu Shangdai shehui xingzhi de taolun'" (A criticism of Mr. Tang Lan's article "On the Nature of Shang Society"). *Lishi yanjiu* 8: 59–71. 斥唐蘭先生「關於商代社會性質的討論」. 歷史研究.

Yu Zhonghang. 1976. "Dawenkou wenhua he yuanshi shehui de jieti" (Dawenkou culture and the collapse of primitive society). *WW* 5: 64–73. 于中航. 大汶口文化和原始社會的解體.

Yuanshi shehui zhi Nanbeichao huihua (Painting from the primitive age to the Northern and Southern Dynasties). In *ZGMSQJ*. Beijing: Renmin meishu chubanshe, 1986. 原始社會至南北朝繪畫. 人民美術出版社.

Yuejue shu (The distinction of the Yue), by Yuan Kang. SBCK no. 64. 越絕書. 袁康. 四部叢刊.

YWLJ: *Yiwen leiju* (A literary anthology arranged by categories), by Ouyang Xun. Shanghai: Shanghai guji chubanshe, 1965. 歐陽詢. 藝文類聚. 上海古籍出版社.

Zeng Zhaoyue et al. 1956. *Yi'nan guhuaxiang shimu fajue baogao* (Excavation report on an ancient carved stone tomb at Yi'nan). Shanghai: Wenhua guanliju. 曾昭燏. 沂南古畫像石墓發掘報告. 文化管理局.

ZGMSQJ: *Zhongguo meishu quanji* (The treasury of Chinese art). 60 vols. Various publishers, 1985–89. 中國美術全集.

Zhan Li et al. 1977. "Shitan Yangjiawan Han mu qibing-yong" (On the clay horsemen from a Han tomb at Yangjiawan). *WW* 10: 22–26. 展力等. 試談楊家灣漢墓騎兵俑.

Zhanguo ce (Intrigues of the Warring States), by Liu Xiang. SBCK. 戰國策. 劉向. 四部叢刊.

Zhang Guangyu. 1979. "Jinwen zhong ceming zhi dian" (The investiture in Western Zhou bronze inscriptions). *Xianggang Zhongwen daxue Zhongguo wenhua yanjiusuo xuebao* (Journal of the Institute of Chinese Culture, Chinese University), 10b. 張光裕. 金文中冊命之典. 香港中文大學中國文化研究所學報.

Zhang Longhai and Zhu Yude. 1988. "Linzi Qi guo gucheng de paishui xitong" (The drainage system at the old Qi city near Linzi). *KG* 9: 784–87. 張龍海. 朱玉德. 臨淄齊國古城的排水系統.

Zhang Minghua. 1990. "Liangzhu yufu shitan" (A tentative interpretation of jade talismans of the Liangzhu culture). *WW* 12: 32–36. 張明華. 良渚玉符試探.

Zhang Wanfu. 1984. *Han hua xuan* (Selected examples of Han pictorial art). Tianjin: Tianjin renmin meishu chubanshe. 張萬夫. 漢畫選. 天津人民美術出版社.

Zhao Kangmin. 1979. "Qinshihuang lingbei er, san, si hao jianzhu yizhi" (The remains of structures nos. 2, 3, and 4 north of the mausoleum of the First Emperor of the Qin). *WW* 12: 13–16. 趙康民. 秦始皇陵北二、三、四號建築遺址.

———. 1980. "Qinshihuang ling yuanming Lishan" (The original name of the mausoleum of the First Emperor of the Qin is Lishan). *KW* 3: 34–38. 秦始皇陵原名驪山.

Zhao Ruzhen. 1984. *Guwan zhinan* (A guide to antiques). Beijing: Zhongguo shudian. 趙汝珍. 古玩指南. 中國書店.

Zhao Tiehan. 1975. "Shuo jiuding" (On the Nine Tripods). In *Gushi kaoshu* (Examining and reconstructing ancient history). Taipei: Zhengzhong shuju, 120–40. 趙鐵寒. 說九鼎. 古史考述. 正中書局.

Zhao Yi. 1960. *Gaiyu congkao* (Mesollenium). Taipei: Shijie shuju, 1960. 趙翼. 陔餘叢考. 世界書局.

Zhao Zhiquan. 1989. "Erlitou yizhi yu Yanshi Shang cheng" (The Erlitou site and the Shang city at Yanshi). *KW* 2: 76–83. 趙芝荃. 二里頭遺址與偃師商城.

Zhejiang Provincial Institute of Archaeology. 1989. *Liangzhu wenhua yuqi* (Jades from the Liangzhu culture). Beijing: Wenwu chubanshe. 浙江考古研究所. 良渚文化玉器. 文物出版社.

Zhejiang Provincial Institute of Archaeology and Cultural Relics. 1988. "Yuhang Yaoshan Liangzhu wenhua jitan yizhi fajue jianbao" (Preliminary excavation report on the remains of a Liangzhu altar at Yaoshan in Yuhang). *WW* 1: 32–51. 浙江省文物考古研究所. 余杭瑤山良渚文化祭壇遺址發掘簡報.

Zheng Zhenxiang and Chen Zhida. 1985. "Yinxu qingtongqi de fenqi yu niandai" (The periodization and chronology of bronzes from the Ruins of Yin). In Institute of Archaeology, CASS, *Yinxu qingtongqi* (Bronze vessels from the Ruins of Yin). Beijing: Wenwu chubanshe, 27–75. 鄭振香. 陳志達. 殷墟青銅器的分期與年代. 中國社會科學院考古研究所. 殷墟青銅器. 文物出版社.

Zhengzhou Erligang (Archaeological excavations at Erligang in Zhengzhou). Beijing: Kexue chubanshe, 1959. 鄭州二里崗. 科學出版社.

Zhengzhou Museum. 1981. "Henan Rongyang Xishicun yizhi shijue jianbao" (Report on the test excavation of the Xishicun site at Rongyang in Henan). *Wenwu ziliao congkan* 5: 84–102. 鄭州市博物館. 河南滎陽西史村遺址試掘簡報. 文物資料叢刊.

Zhongguo meishujia renming cidian (Dictionary of Chinese artists). Shanghai: Renmin meishu chubanshe, 1981. 中國美術家人名辭典. 人民美術出版社.

Zhongguo wenwu bao (Chinese cultural relics weekly). Beijing: Cultural Relics Bureau. 中國文物報. 文物局.

Zhongguo wenwu jinghua (Gems of China's cultural relics). Beijing: Wenwu chubanshe, 1992. 中國文物精華. 文物出版社.

Zhongguo yuqi quanji, yi (A treasury of Chinese jades, 1). Shijiazhuang: Hebei meishu chubanshe, 1992. 中國玉器全集, 一. 石家莊. 河北美術出版社.

Zhonghua renmin gongheguo chutu wenwu zhanlan zhanpin xuanji (Selected items from the Exhibition of Archaeological Finds of the People's Republic of China). Beijing: Wenwu chubanshe, 1973. 中華人民共和國出土文物展覽展品選集. 文物出版社.

Zhouyuan Archaeological Team. 1978. "Shaanxi Fufeng Zhuangbai yihao Xi-Zhou qingtongqi jiaocang fajue jianbao" (Brief excavation report on Zhuangbai bronze hoard no. 1 at Fufeng in Shaanxi). *WW* 3: 1–18. 陝西周原考古隊. 陝西扶風莊白一號西周青銅器窖藏發掘簡報.

Zhu Jianxin. 1940. *Jinshi xue* (The study of bronzes and stone carvings). Shanghai: Shangwu yinshuguan. 朱劍心. 金石學. 商務印書館.

Zhu Kongyang. 1937. *Lidai lingqin beikao* (A comprehensive examination of mausoleums throughout the Chinese dynasties). Shanghai: Shenbao guan. 朱孔陽. 歷代陵寢備考. 申報館.

Zhu Xie. 1936. *Jiankang Lanling Liuchao lingmu tukao* (An illustrated examination of Six Dynasties tombs at Nanjing). Shanghai: Shangwu yinshuguan. 朱偰. 建康蘭陵六朝陵墓圖考. 商務印書館.

—————. 1957. "Xiufu Nanjing Liuchao lingmu guji zhong zhongyao de faxian" (Important findings during renovation and reconstruction of the ancient Six Dynasties mausoleums in Nanjing). *Wenwu cankao ziliao* 3: 44–45. 修復南京六朝陵墓古跡中重要的發現. 文物參考資料.

Zhu Xizu et al. 1935. *Liu chao lingmu diaocha baogao* (Investigation report on Six Dynasties mausoleums). Nanjing: Zhongyang guwu baoguan weiyuanhui. 朱希祖等. 六朝陵墓調察報告. 南京: 中央古物保管委員會.

Zhuangzi (Writings of Zhuangzi). References are to Guo Qingfan, *Zhuangzi jishi* (*Zhuangzi*, with collected commentaries). ZZJC 3. 莊子. 郭慶藩. 莊子集釋. 諸子集成.

ZL: *Zhou li* (Rites of Zhou). References are to Jia Gongyan, *Zhou li zhushu* (Annotated *Rites of Zhou*). In *SSJZS*, 631–940. 周禮. 賈公彥. 周禮註疏.

Zong mulu (General index). In *ZGMSQJ*. Beijing: Renmin meishu chubanshe, 1989. 總目錄. 人民美術出版社.

Zou Heng, 1979. *Shang Zhou kaogu* (Shang and Zhou archaeology). Beijing: Wenwu chubanshe. 鄒衡. 商周考古. 文物出版社.

ZZ: *Chunqiu Zuo zhuan* (Master Zuo's commentaries on the *Spring and Autumn Annals*). References are to Kong Yingda, *Chunqiu Zuo zhuan zhengyi* (The correct interpretation of *Master Zuo's Commentary on the Spring and Autumn Annals*). In *SSJZS*, 1697–2188. 春秋左傳. 孔穎達. 春秋左傳正義.

ZZJC: *Zhuzi jicheng* (A complete collection of writings of ancient Chinese philosophers). 8 vols. Beijing: Zhonghua shuju, 1986. 諸子集成. 中華書局.

Character List

Entries are alphabetized letter by letter, ignoring word divisions and syllable breaks, with the exception of personal names, which are alphabetized first under the surname and then by the given name.

Adachi Kiroku 足立喜六
"Ai Jiangnan fu" 哀江南賦
An (gate) 安
An Guo 安國
An Shigao 安世高
An ling 安陵
Anqi 安溪
Anqi Sheng 安期生
Anxi (An-hsi) 安息
Anyang 安陽

ba (hegemony) 霸
Ba (river) 灞
Bacheng 灞城
Baigong Fu 白公父
"Baiguan zhi" 百官志
Baihu tong 白虎通
Baijiazhuang 白家莊
Bailiang tai 柏梁台

Bailu guan 白鹿觀
Baimiao 白廟
Baiqin tai 柏寝台
Baixian 白鮮
Bajun 八俊
Ba ling 霸陵
Ban 班
Ban Biao 班彪
Ban Gu 班固
Ban jieyu 班捷妤
Ban Zhao 班昭
"Baofu" 保傅
Baoji 寶雞
baoyu 寶玉
Baozhaishan 鮑宅山
Beidongshan 北洞山
Bei gong 北宮
Beihai 北海
Beimang 北邙

Beixiang 北鄉
Beixianghou 北鄉侯
Beixianghu 北鄉戶
Beizhai 北寨
"Benji" 本記
bi 璧
Bi Shi 弢師
Bi Yuan 畢沅
biandian 便殿
bin 儐
Bin 豳
bing 丙
bingwu 丙午
bingxu 丙戌
bingyin 丙寅
Biyong 辟雍
bo 薄
Bo (empress dowager) 薄
Bo (place) 亳
Bo Xian Fu 伯先父
Bo Yu 伯瑜
Bohai 渤海
boshu 薄疏

Boshuang 伯爽
Bowu zhi 博物志
Boxiao 伯孝
bu (coin) 布
bu (jar) 瓿
bu (register) 簿
"Buchu ximen xing" 步出西
　門行

Cai 采
Cai Yong 蔡邕
Cangshan 蒼山
cangwu 藏物
Cangwu 蒼梧
Cao Can 曹參
Cao Cao 曹操
Cao Pi 曹丕
Cao Yi 操義
Cao Zhi 曹植
caoshu 草書
Caotangsi 草堂寺
ce 冊
ceming 冊命

chang 常
Chang'an 長安
Chang'an cheng 長安城
Chang'an gongcheng 長安宮城
Chang'an ji 長安記
Changhe 閶闔
Changle gong 長樂宮
Chang ling 長陵
Chang Ling Yi 長陵邑
changman cang 長滿倉
Changming 長名
Changqing 長清
Changsha 長沙
Changshao 長勺
Changyang 長楊
Changzhi 長治
Chaoxian 朝鮮
Che Qianqiu 車千秋
Chen Can 陳參
Chen Hanping 陳漢平
Chen Ji 陳紀
Chen Mengjia 陳夢家
Chen Shi 陳寔
Chen Tang 陳湯
cheng (accomplishment) 成
cheng (receive) 丞
Cheng (Han emperor) 成
Cheng (Zhou king) 成
Cheng Dachang 程大昌
Chengdu 成都
Chengming 承明
chengqing 丞卿
Chengzhou 成周
chi 尺
Chong Shang 充尚
Chonghua tai 重華台
chongming 重命
Chongqing 重慶
Chongwu 重屋
Chu 楚
Chunhua 淳化
Chunqiu Zuo zhuan 春秋左傳
Chuxue ji 初學記
cong 琮
cun 寸

Da Dai liji 大戴禮記
Dafeng *gui* 大豐簋
Dai (surname) 戴
Dai De 戴德
Dai Mu (Kongdao) 戴目（孔道）
Dai Sheng 代盛
Dai Zhen 戴震
damen 大門
Dan 旦
danggu 黨錮
Danshui 丹水
Danyang 丹陽
Danyangxian zhi 丹陽縣志
daoshu 倒書
daoyin 導引
Daoyin tu 導引圖
"Daren fu" 大人賦
dashi 大市
Dashi 大室
Dasikong 大司空
Da tai 大台
Datong 大同
Dawenkou 大汶口
Daxia 大夏
"Daya" 大雅
Dayangzhou 大洋州
Dayuan 大宛
"Dazhuan" 大傳
Dazhucun 大朱村
Dengfeng 登封
Deyang 德陽
Di 狄
Di Xin 帝辛
Di Yi 帝乙
"Dian lun" 典論
diehuang 絰皇
ding (settle) 定
Ding (star) 定
ding (stem) 丁
ding (tripod) 鼎
Ding (Zhou lord) 丁
Ding Lan 丁蘭
dingding 定鼎
Dingjiao guan 鼎郊觀
dingmao 丁卯

ding qian yu Shang 鼎遷於商
ding qian yu Zhou 鼎遷於周
Dingxian 定縣
Dingxiang 定祥
dingzi 丁子
dizi 弟子
Dong 東
Dong Zhongshu 董仲舒
Dong'a 東阿
Dongdu Zhuren 東都主人
Dongfang Shuo 東方朔
Dongguan Han ji 東觀漢記
dou 豆
Dou 竇
Dou Wan 竇綰
du 都
Du Mi 杜密
Du Yu 杜預
Duan Ying 段穎
Duan Yucai 段玉裁
Duchang 都昌
dudu 都督
Du ling 杜陵
"Du yi" 都邑
"Duxing" 獨行

e 惡
Efang 阿房
Erligang 二里崗
Erlitou 二里頭
Erqilu 二七路
Er ya 爾雅
Er Yang que 二楊闕

fan 反
fang 方
Fang Pengjun 方鵬鈞
Fangruo 方若
fangshi 方士
Fanshan 反山
fanzuoshu 反左書
feili 非禮
Fen 汾
feng 諷
Feng (maker of Zhou bronzes) 豐

Feng (river) 灃
Feng (surname) 馮
Feng (town in Shandong) 豐
Feng (Zhou capital) 豐
Feng Huan que 馮煥闕
Feng Yan 馮衍
fengchang 奉常
Fengchu 鳳雛
Fengfu 風父
fengjian 封建
"Fengshan shu" 封禪書
Fengxiang 鳳翔
Fenshuiling 分水嶺
Fenyin 汾陰
fu (rhapsody) 賦
fu (sacrifice) 復
fu (vessel) 簠
Fu Hao 婦好
Fu Wuji 伏無忌
Fu Xi 伏犧
Fu Yi 傅毅
Fufeng 扶風
Fugou 扶溝
Fuli gong 扶荔宮
Fuquanshan 福泉山
fuxin 腹心
Fuyang (gate) 覆盎

gaiming 改命
gan 干
Gan 庁
Gan Bao 干寶
Ganquan 甘泉
Ganquan gong 甘泉宮
Gao Yi 高頤
Gao miao 高廟
Gao Yi que 高頤闕
Gaoping 高平
Gaoxing 高行
Gaozu (Kao-tsu, Han emperor) 高祖
Gao Zu (original ancestor) 高祖
Geng Ying 庚嬴
gengxu 庚戌
gengzi 庚子

Genqi 根耆
gong (palace) 宮
gong (vessel) 觥
Gong (Zhou king) 恭
Gong Fang 𢀰方
"Gong Liu" 公劉
Gong Shi 公氏
Gong Zizhen 龔自珍
Gongcao 功曹
gongdianqu 宮殿區
gongfu 功夫
Gonggong 共工
Gongsun Chen 公孫臣
Gongsun Ju 公孫舉
Gongsun Qing 公孫卿
Gongyang 公羊
gong yi 公義
Gongyu Dai 公玉帶
gongzi 公子
Gou 緱
Gouyi 鉤弋
gu (vessel) 瓠
Gu Jiegang 顧頡剛
Gu Kaizhi 顧愷之
Gu Yanwu 顧炎武
guan (architectural type) 觀
guan (to view) 觀
Guanfu guyu 關輔古語
Guanghe 廣和
Guangwu 光武
guanli 冠禮
Guanxiang guan 觀象觀
Guanzhang 關中
Guanzhong ji 關中記
Gudong zhinan 古董指南
gui (container) 簋
gui (cooking vessel) 𣪘
gui (ghost) 鬼
gui (jade tablet) 圭
gui (stem) 癸
Gui gong 桂宮
guiqin 貴親
guisi 癸巳
Gujin zhu 古今註
guli 故吏
gumin 故民

guo 國
Guo Baojun 郭寶鈞
Guo Jie 郭解
Guo Moruo 郭沫若
guobao 郭芭
Guozi Gao 國子高
Guwan zhinan 古玩指南
Guweicun 固圍村
Guyuan 固原
Guyu tukao 古玉圖考

Han (dynasty) 漢
Han (state) 韓
Han Boyu 韓伯瑜
Han Rong 韓融
Han Shao 韓韶
Han Xin 韓信
Han gongque shu 漢宮闕疏
Hangu 函谷
Hangzhou 杭州
Hanhuangfu 函皇父
Han jiuyi 漢舊儀
Han shi 韓詩
Han shu 漢書
Han Wu gushi 漢武故事
Hanzi 韓子
Hao 鎬
he 盉
He (maker of a zun vessel) 何
He Jin 何進
He Jingming 何景明
Hejiashan 何家山
Helingeer 和林格爾
He-Luo 河洛
Hemudu 河姆渡
Heshui 合水
Hong 閎
Hong Guo 洪适
Hong Ru 閎孺
Honglou 洪樓
Hongshan 紅山
Hongtai 鴻台
Hou Ji 后稷
Hougang 後岡
Hou Han ji 後漢記
Houshen 候神

hu 壺
Hu Shi 胡適
Hu Yinglin 胡應麟
huaguan 畫觀
Huai 淮
huai gu 懷古
Huainan zi 淮南子
Huan (Han emperor) 桓
Huan (Qi lord) 桓
Huan Kuan 桓寬
Huan Sangzhong 桓桑終
huang (stone, pendent) 璜
Huang Minglan 黃明蘭
Huang Shengzhang 黃盛璋
Huangdi neijing 黃帝內經
Huangdi neijing suwen 黃帝內
　經素問
Huangjin tai 黃金台
Huang-lao 黃老
Huangong tai 桓公台
Huangpi 黃陂
Huang shengqing que 皇聖
　卿闕
huangzhong 黃鐘
Huating 花庭
Huayangguo zhi 華陽國志
hui 槥
Hui (Han emperor) 惠
Huiwen 惠文
Huixian 輝縣
hun 魂
Huo Guang 霍光
Huo Qubing 霍去病
Huoming 壑明

ji (illness) 疾
ji (sacrifice) 祭
ji (stem) 己
Ji (ancestral name) 己
Ji (surname) 籍
Ji (Zhou royal clan) 姬
Ji Ru 籍儒
Ji Zhong 祭仲
jia (family) 家
jia (stem) 甲
jia (to flank) 夾

jia (vessel) 斝
Jia (ancestral name) 甲
jiachen (family retainer) 家臣
jiachen (year date) 甲辰
Jiang Hu 江胡
Jiang Yingju 蔣英矩
Jiang Yuan 姜嫄
Jiang Zhangxun (Yuanqing)
　蔣章訓 (原卿)
jiangren 匠人
Jian ling 建陵
Jianning 建寧
Jian tai 漸台
Jianwen 簡文
Jianwu 建武
Jianzhang 建章
jiao (vessel) 角
Jiaorao 嶕嶢
jiaqin 家親
Jiaru 郟鄏
Jiashan 郟山
jiashi 夾室
Jiaxiang 嘉祥
jiaxin 甲辛
Jiaxu ding 甲戌鼎
jiayin 甲寅
Jie 桀
"Ji fa" 祭法
jijiu 祭酒
jili 吉禮
Jimiao 極廟
jin 金
Jin (state) 晋
Jin Midi 金日磾
Jin Yong 金庸
Jin Zhuo 晋灼
jing (Classics) 經
Jing (Eastern Zhou city) 京
Jing (hall) 京
Jing (Han emperor) 景
Jing (Han prince) 靖
Jing (place) 荆
Jing (Qi lord) 景
Jing (river) 涇
Jing (surname) 景
Jing Ke 荆軻

Jing Lu 景盧　　　　　　Kong Yingda 孔穎達　　　　Li Yuan 李淵　　　　　　Liu Qingzhu 劉慶柱

Jinggong 京宮　　　　　Kong Zhou (Jijiang) 孔宙　Li Yufang 李毓芳　　　　Liu Sheng 劉勝

jingtian 井田　　　　　　（季將）　　　　　　　Liang (state) 梁　　　　Liu Xiang 劉向

Jingzong 京宗　　　　　Kongzi turen huafa 孔子徒人　Liang (surname) 梁　　　Liu Xiaobiao 劉孝摽

jinqin 近親　　　　　　畫法　　　　　　　　Liang Ji 梁冀　　　　　Liu Xin 劉歆

jinshi xue 金石學　　　　Ku 嚳　　　　　　　　Liang jiegujie 梁節姑姐　　Liu Xiu 劉秀

Jinshui 金水　　　　　　Ku-she (Gushe) 姑射　　　Liang Qichao 梁啓超　　　Liu Ying (Infant Liu) 劉嬰

"Jintong xianren ci Han ge"　Kunlun 崑崙　　　　　Liangcheng 兩城　　　　Liu Ying (Han prince) 劉英

金銅仙人辭漢歌　　　　Kunming 昆明　　　　　Liangchengzhen 兩城鎮　　Liu Yunyong 劉運勇

Jinxiang 金鄉　　　　　Kunwu 昆吾　　　　　　Liangqi 梁其　　　　　Liuguo gongdian 六國宮殿

jinzu 近祖　　　　　　Kunxie 昆邪　　　　　　Liangzhu 良渚　　　　　liuji 六紀

jiqi 祭器　　　　　　　Kuodi ji 括地記　　　　Lianyungang 連雲港　　　Liulige 琉璃閣

Ji que 冀闕　　　　　　　　　　　　　　Liaodong 遼東　　　　　Liyang 酈陽

"Ji tong" 祭統　　　　la 臘　　　　　　　　lieding 列鼎　　　　　lizheng 立政

Jiuceng tai 九層台　　　Lai 萊　　　　　　　　Lienü zhuan 列女傳　　　Longshan 龍山

Jiulongshan 九龍山　　　Laizi 萊子　　　　　　Lieshi zhuan 列士傳　　　Lou Jing 婁敬

Jiuzong 九嵕　　　　　langzhong 郎中　　　　　Liexian zhuan 列仙傳　　　Loujiaoshan 婁角山

jiwei 即位　　　　　　Laolao tai 老姥台　　　　"Liezhuan" 列傳　　　　lu (musical intrument) 蘆

jiwen 祭文　　　　　　Laozi 老子　　　　　　Lie zu 烈祖　　　　　　Lu (state) 魯

"Ji yi" 祭義　　　　　Lean 樂安　　　　　　ligong 離宮　　　　　　Lü (Han empress) 呂

jiyu 吉語　　　　　　lei (vessel) 罍　　　　　Lihuo lun 理惑論　　　　Lu gong 路公

Jizha 季扎　　　　　　Lei Haizong 雷海宗　　　Li ji 禮記　　　　　　Lu Ji 陸機

jue (chüeh) 爵　　　　　Leigudun 擂鼓墩　　　　Lilou 李樓　　　　　　Lu Jia 陸賈

jun 君　　　　　　　leiwen 雷紋　　　　　　Lin Xiangru 藺相如　　　Lü Shang 呂尚

Jun 俊　　　　　　　Leshan 樂山　　　　　　Ling (Han emperor) 靈　　Lu Tanwei 陸探微

jun ji 俊疾　　　　　　li (length measurement) 里　Ling (Jin lord) 靈　　　Lu yigujie 魯義姑姐

junzi 君子　　　　　　li (ritual) 禮　　　　　Ling (Wei lord) 靈　　　Lü Zheng 呂微

Jurong 句容　　　　　li (trigram) 離　　　　　Lingshan 靈山　　　　　Luan Da 欒大

Juxian 莒縣　　　　　　li (tripod type) 鬲　　　lingshi 凌室　　　　　　"Lu Lingguang Dian fu"

　　　　　　　　　Li (river) 黎　　　　　　Ling tai 靈台　　　　　魯靈光殿賦

Kaifeng 開封　　　　　Li (tribe) 黎　　　　　　Lingyanghe 凌陽河　　　lun 論

Kang (K'ang, Zhou king) 康　Li (Zhou king) 厲　　　lingyi 陵邑　　　　　　Luo (river) 洛

"Kang gao" 康誥　　　　Li (Zhou person) 利　　　Linru 臨汝　　　　　　Luo (writing) 洛

Kangjiacun 康家村　　　Li Cang 利倉　　　　　Lintao 臨洮　　　　　　Luo Fuyi 羅福頤

Kangju 康居　　　　　Li Daoyuan 酈道元　　　Lintong 臨潼　　　　　Luo Xizhang 羅西章

Kangshu 康叔　　　　　Li Falin 李發林　　　　Linxian 林縣　　　　　"Luo gao" 洛誥

Kangxi zidian 康熙字典　　Li Gang 李剛　　　　　Linyi 臨沂　　　　　　Luoyang 洛陽

"Kaogong ji" 考工記　　　Li Haowen 李好文　　　Linzi 臨淄　　　　　　Lüshi chunqiu 呂氏春秋

ke 克　　　　　　　　Li He (Li Ho) 李賀　　　liqi 禮器　　　　　　Luyang (princess) 魯陽

Keng 庚　　　　　　　Li Ji 利幾　　　　　　Lishan 驪山

kewei 客位　　　　　　Li Jin'e 李進娥　　　　Lishan shiguan 驪山食官　　Ma 馬

"Ke Yin" 克殷　　　　　Li Shan 李善　　　　　Lishanyuan 驪山園　　　Ma Rong 馬融

Kezuo 喀左　　　　　　Li Shaojun 李少君　　　Liu (marquis) 留　　　　Ma Xianxing 馬先醒

Kong Dan 孔耽　　　　　Li Xueqin 李學勤　　　　Liu (surname) 劉　　　　Mahao 麻壕

Kong Guang 孔光　　　　Li Ye 李鄴　　　　　　Liu Bin 劉斌　　　　　Majiazhuang 馬家莊

Kong Jingtong 孔敬通　　　Li Yi 驪邑　　　　　　Liu Jie 劉節　　　　　Man (tribe) 蠻

Kong Rong 孔融　　　　Li Ying 李膺　　　　　Liu Jing 劉敬　　　　　Mancheng 滿城

Mao 毛
Mao Heng 毛亨
Maogong *ding* 毛公鼎
Mao ling 茂陵
maoshen 卯申
maozi 卯子
Mawangdui 馬王堆
mei 美
Meng Fu 孟孚
Meng Mao 孟卯
mensheng 門生
mentong 門童
"Mian" 絲
Mianyang 綿陽
miao 廟
miaohao 廟號
Miao ji 廟記
Miao Xi 繆襲
miaozhi 廟制
min 民
Min Sun (Ziqian) 閔損
　(子騫)
ming (coin) 明
ming (inscription) 銘
ming (name) 名
ming (order) 命
Ming (dynasty) 明
Ming (Han emperor) 明
Ming (Wei emperor) 明
Minggonglu 銘功路
Mingguang gong 明光宮
minglei 銘耒
Mingtang 明堂
"Mingtang wei" 明堂位
"Mingtang yinyang" 明堂
　陰陽
"Mingtang yueling lun"
　明堂月令論
Miu 繆
Miu Ji 謬忌
Mo Youzhi 莫友芝
Mo zi 墨子
Mouzi 牟子
mu (lineage division) 穆
Mu (field) 牧
Mu (Qin lord) 穆
Mu (Zhou king) 穆

Mu Wu 母戊
muji 墓祭

Nan 南
Nanjing 南京
Nanyang 南陽
neigong 內宮
Ning Mao 寧懋
Ningxiang 寧鄉
Niu Hong 牛弘
nongqi 弄器
"Nüshizhen tu" 女史箴圖
Nü Wa 女媧

pan 盤
Panlongcheng 盤龍城
Pao 庖
Pei 沛
peiling 陪陵
Peng Fei 彭非
Pengcheng 彭城
Penglai 蓬萊
Pengli 彭蠡
Pengshan 彭山
ping (female chariot) 輧
Ping 平
Ping Di Jiangjun 平狄將軍
Ping ling 平陵
Pingshan 平山
Pingyang Fujun que 平陽府
　君闕
Pingyi 平邑
po 魄

qi (ch'i, ether) 氣
qi (vessel) 器
Qi (mountains) 歧
Qi (state) 齊
Qi yijimu 齊義繼母
qian (move) 遷
Qian (river) 汧
Qiandian 前殿
Qiang (An Guo's brother) 強
Qiang (Zhou archivist) 牆
Qiangzhong 羌中
qianshou 黔首
Qianxi tai 乾谿台
Qianzhai 前寨

Qiao 橋
Qilian 祁連
qilin 麒麟
Qilin ge 麒麟閣
Qimu 啟母
qin (musical instrument) 琴
qin (retiring hall) 寢
Qin 秦
Qin Shi Huang 秦始皇
qing 卿
Qing 清
Qing Ji 慶忌
Qingbaixiang 清白鄉
Qingmiao 清廟
Qingpu 青浦
Qingyang 青陽
Qiong 邛
Qishan 岐山
Qishi 漆室
Qiu Qiong 邱瓊
qiyun shengdong 氣韻生動
Qu 屈
Quanrong 犬戎
que 闕
Qufu 曲阜
Qutai 曲台
Quxian 渠縣

ren 仞
Ren Fang 人方
Renjiacun 任家村
rensi 壬巳
renxu 壬戌
renzi 壬子
ri 日
Rizhao 日照
Rong 戎
Rong Bao 榮保
Rong Qiqi 榮啟期
Ru 鄏
Rujiazhuang 茹家莊
Ruitu 瑞圖
Runde 潤德
Ruzi Ying 孺子嬰

sanchu 三出
Sanfu gushi 三輔故事
Sanfu jiulu 三輔舊錄

Sanfu jiushi 三輔舊事
Sanfu juelu 三輔決錄
Sang Hongyang 桑弘羊
san'gang 三綱
sangli 喪禮
Sanhuang 三皇
San li 三禮
Sanpanshan 三盤山
Sanque guan 三雀觀
Santai 三台
Sanwang 三王
sanwu 三巫
Shaan 陝
Shang 商
Shang Yang 商鞅
Shanglin 上林
shangling 上陵
shanglingli 上陵禮
"Shang shi" 商誓
Shangyao 上窯
Shangyongzhang que 上庸
　長闕
Shanhai jing 山海經
shanrang 禪讓
Shanyang 山陽
Shao 召
Shao Qiangsheng 邵強生
Shao Weng 少翁
"Shao gao" 召誥
Shaogou 燒溝
Shaohao 少皞
Shaoshi 少室
Shapingba 沙坪壩
She 社
shen (spirit) 神
Shen (state) 申
Shen Fujun que 沈府君闕
Shen Nong 神農
shendao 神道
sheng (headdress) 勝
sheng (musical instrument) 笙
sheng (sage) 聖
Shenming tai 神明台
shi (archivist) 史
shi (historical writing) 史
shi (origin) 始
shi (poetry) 詩

shi (radical) 示
shi (rank, officer) 士
shi (room) 室
shi (stone) 石
Shi Huang Di 始皇帝
Shi Jueshou 師覺授
Shi Qiang pan 史牆盤
shidian 石殿
shier jinren 十二金人
"Shi fu" 世俘
"Shijia" 世家
Shijiazhuang 石家莊
Shiji dashiji 史記大事記
shijie 尸解
Shi ming 釋名
shiming 始命
shishangyang 室上栙
Shishi 世室
Shixianggou 尸鄉溝
Shiyin 濕陰
Shizhai ciyuan 食齋祠園
shizhong 侍中
Shizhou ji 十洲記
shou 收
shoushi fanting 收視反聽
shu (letter) 書
shu (to list) 疏
"Shu" 書
Shu 蜀
Shu Si Zi 叔嗣子
Shuijing zhu 水經註
Shun (archaic ruler) 舜
Shun (Han emperor) 順
Shuo wen 說文
Shuo yuan 說苑
"Shuo zongyi" 說宗彝
Shusun Tong (Shu-sun T'ung) 叔孫通
Shuxiang 叔向
si 祀
Si (river) 泗
Si Mu Wu 司母戊
Si Mu Xin 司母辛
Si Tu Mu 司彔母
si ai 私愛
Sidun 寺墩
Si *gui* 秭簋

Sima Biao 司馬彪
Sima Jinlong 司馬金龍
Sima Qian 司馬遷
Sima Xiangru 司馬相如
Sima Zhen 司馬貞
sishi 四始
Sishier zhang jing 四十二章經
song 送
Song 宋
Song Wuji 宋母忌
Songshan 宋山
Soushen ji 搜神記
suidao 隧道
Suining 睢寧
suitou 隧頭
Suixian 隨縣
Sun Song 孫嵩
Sun Yan 孫炎
Sun Yirang 孫詒讓
Sun Zong 孫宗
Sunqitun 孫旗屯
Suo 索
Su wen 素問

Ta 它
tai 台
Tai Bo 太伯
taicang 太倉
Taichu 太初
Taidang 駘蕩
Taihao 太皞
taimen 台門
Tai miao 太廟
Taiping huanyu ji 太平寰宇記
Taiqiu 太邱
Taishan (Mt. Tai) 泰山
Taishanghuang 太上皇
Taishanghuang miao 太上皇廟
Taishi 太室
"Taishigong zixu" 太史公自叙
Taiwei (grand commandant) 太尉
Taiwei (star) 太微
Taixue 太學
Taiye 太液

Tan Fu 亶父
tang 堂
Tang (Shang king) 湯
Tang (T'ang, dynasty) 唐
Tang Lan 唐蘭
Tangshu 唐叔
Tao Qian 陶潛
taotie 饕餮
Tengxian 滕縣
Ti 帝
Tian 田
Tian Fen 田蚡
Tianfeng 天鳳
tiangan 天干
"Tianguan shu" 天官書
Tianlu ge 天祿閣
Tianshan 天山
Tianshi 天室
tiao 祧
Tiao 條
Tiaozhi (T'iao-chih) 條支
Tietoushan 鐵頭山
ting 亭
tingzhang 亭長
tong 童
"Tong ke" 童科
Tongshan 銅山
tongshi 通史
Tongtian 通天
Tongtian Wu 通天屋
tongzi 童子
tongzi lang 童子郎
Toshio Nagahiro 長廣敏雄
Tu Fang 土方
Tung Cho (Dong Zhuo) 董卓

wang 王
Wang Chong 王充
Wang He 王和
Wang Ci 王慈
Wang Hui 王暉
Wang Ji 王季
Wang Jian 王堅
Wang Lin 王琳
Wang Ling 王陵
Wang Mang 王莽

Wang Shimin 王世民
Wang Shiren 王世仁
Wang Shu 王叔
Wang Shucun 王樹村
Wang Su 王肅
Wang Wei (5th-century art critic) 王微
Wang Wei (modern archaeologist) 王巍
Wang Xueli 王學理
Wang Yanshou 王延壽
Wang Zhengjun 王政君
Wang Zhizi 王稚子
Wang Zhongshu 王仲舒
Wang Ziya 王子雅
Wang Ziya que 王子雅闕
Wangcheng 王城
Wangshi Gong 亡是公
Wangsun Man 王孫滿
Wangxian 望仙
"Wang zhi" 王制
Wannian ling 萬年陵
Wannian xian 萬年縣
Wannian Yi 萬年邑
Wei (dynasty) 魏
Wei (river) 渭
Wei (state) 魏
Wei (Zhou clan) 微
Wei Bo 微伯
Wei Gai 衛改
Wei Qing 衛青
Wei Tingsheng 衛挺生
Wei Xiang 魏相
Wei Xuancheng 韋玄成
Weifang 濰坊
Wei lüe 魏略
Weishan 微山
Weishao 尾勺
Weiyang 未央
Weiyang gong 未央宮
wen (refinement) 文
Wen (Han emperor) 文
Wen (Liang emperor) 文
Wen (Wei emperor) 文
Wen (Zhou king) 文
Wen Shuyang 文叔陽
wencheng jiangjun 文成將軍

Wengnan Yi 翁難乙
Wenshang 汶上
Wenshi 溫室
"Wen Wang you sheng" 文王有聲
wu (dance) 舞
wu (stem) 戊
wu (thing) 物
wu (zodiacal position) 戊
Wu (Han emperor) 武
Wu (Liang emperor) 武
Wu (surname) 武
Wu (Zhou king) 武
Wu Dacheng 吳大澂
Wu Ding 武丁
Wu Jingxing 武景興
Wu Kaiming 武開明
Wu Liang (Suizong) 武梁（綏宗）
Wu Ruzu 吳汝祚
Wu Shigong 武始公
Wu Wenqi 吳文琪
Wu Yi 武乙
Wu Zhu (Chengchao) 伍著（承超）
wuchen 戊辰
Wudi 五帝
Wuhan 武漢
Wuhuang 五潢
Wujin 武進
wuku 武庫
Wuling 武靈
wuwu 戊午
Wuyang 武陽
wuyin 戊寅
wuyou 烏有
wuzi 五子
Wuzuo 五柞

Xi 嘗
Xia 夏
Xiadu 下都
Xi'an (gate) 西安
xian (immortal) 仙
xian (vessel) 甗
Xian 獻
Xian-Qin guqi ji 先秦古器記

xiang (large village) 鄉
Xiang (surname) 蒍
Xiang Kai 襄楷
Xiang Tajun 蒍它君
Xiang Tuo 項橐
Xiang Wuhuan 蒍無患
Xiang Yu 項羽
xiangong 先公
xiangwei 象魏
Xiangyang 襄陽
Xian jing 仙經
Xianmen Gao 羨門高
xianwang 先王
Xianyang 咸陽
Xianyang gong 咸陽宮
xiao 孝
Xiao (Han emperor) 孝
Xiao (surname) 蕭
Xiao (Zhou king) 孝
Xiao Chongzhi 蕭崇之
Xiao Dan 蕭憺
Xiao Daoci 蕭道賜
Xiao Gang 蕭綱
Xiao He 蕭何
Xiao Hong 蕭宏
Xiao Hui 蕭恢
Xiao Ji 蕭績
Xiao Jing 蕭景
Xiao Shunzhi 蕭順之
Xiao Xiu 蕭秀
Xiao Yan 蕭衍
Xiao Ying 蕭映
Xiao Zhengli 蕭正立
Xiao Ziliang 蕭子良
xiaochen Yi 小臣邑
Xiao jing 孝經
Xiaolongnü 小龍女
Xiaotang Shan 孝堂山
Xiaotun 小屯
Xiaowen 孝文
xiaozi 小子
xiaozi Yu 小子舷
Xiaozi zhuan 孝子傳
Xiaqiu 瑕丘
Xiazhuang 下莊
Xibeigang 西北崗
"Xi ci" 系詞

Xidu Bin 西都賓
"Xidu fu" 西都賦
Xi'e 西鄂
xie 魯
Xie He 謝赫
"Xie lu" 薤露
Xiji 西極
"Xijing fu" 西京賦
ximing 系命
xin 信
Xin (ancestral name) 辛
Xin (dynasty) 新
Xin shixue 新史學
Xin Yuanping 新垣平
Xin'an 新安
xinchou 辛丑
Xinfan 新繁
Xinfeng 新豐
xinfu 新婦
xing 刑
Xing 瘷
Xin'gan 新干
Xingle gong 興樂宮
Xingping 興平
Xinjin 新津
xinmao 辛卯
Xin xu 新序
Xinyi 新邑
Xin yu 新語
Xinzheng 新鄭
Xiong Ya 鯢亞
xiongli 凶禮
Xishanqiao 西善橋
xishi 系世
Xishi 西市
Xiu ling 修陵
Xiutu 休屠
Xiwangmu 西王母
Xiyu 西域
xizun 犀尊
xu (vessel) 盨
Xu (clan) 徐
Xu (district) 許
Xu (Li Xu) 李續
Xu Aqu 許阿瞿
Xu Han 徐悍
Xu Qianxue 徐乾學

Xu Shen 許慎
Xu Wan 許綰
Xu Xusheng 徐旭生
Xu You 許由
Xuan (Han emperor) 宣
Xuan (Qi King) 宣
Xuan (Zhou king) 宣
Xuanhe bogu tulu 宣和博古圖錄
"Xuan ju" 選舉
Xuanshi 宣室
Xuantang 玄堂
xue 學
Xu Han shu 續漢書
Xun Shu 荀淑
Xun Yu 荀昱
Xunzi 荀子
Xuzhou 徐州

Ya Yi 亞吳
Ya Zu 亞祖
Ya'an 雅安
Yan 燕
Yan Ruoju 閻若璩
Yan Shigu 顏師古
Yan Shuai 顏率
Yan Wu 顏烏
Yan Ying 晏嬰
Yan Zhitui 顏之推
Yancun 閻村
yang (male principle) 陽
Yang (surname) 泱
Yang (surname) 楊
Yang Chengyan 陽成延
Yang Hongxun 楊鴻勛
Yang Kuan 楊寬
Yang sanlao 楊三老
Yang Shoujing 楊守敬
Yang Xun (Bieqing) 陽勛（別卿）
Yangjiawan 楊家灣
yangniao 陽鳥
yangqi 養器
Yangshan 陽山
Yangshao 仰韶
Yangzhou 楊州
Yanping 延平

Yanshi 偃師
Yanshi chunqiu 顏氏春秋
Yanshi jiaxun 顏氏家訓
Yanshou 延壽
Yanzhou 兗州
Yanxi 延熹
Yao 堯
Yao Li 要離
Yaoguanzhuang 姚官莊
Yaoshan 瑤山
Ye 鄴
yeting 掖廷
yi (discussion) 議
yi (ritual vessels) 彝
yi (stem) 乙
Yi (ancestral name) 乙
Yi (archivist) 乙
Yi (marquis) 乙
Yi (people) 夷
Yi (Zhou king) 夷
Yi Feng 翼奉
Yi Fu 夷父
Yi Gong (Li's ancestor) 益公
Yi Gong (member of the Wei clan) 乙公
Yi Kao 邑考
Yi Yin 伊尹
Yi Zu 乙祖
Yidu 益都
yiguandao 衣冠道
Yi jing 易經
Yi li 儀禮
Yili 逸禮
yimao 乙卯
yin (female principle) 陰
Yin (dynasty) 殷
Yin (mountains) 陰
Yin Jian 尹儉
Yi'nan 沂南
Ying (An Guo's brother) 嬰
Ying (city) 郢
Ying (county) 潁
Ying (Han prince) 英
Ying (place) 嬴
Ying Shao 應劭
Ying Zheng 嬴政
Yingchuan 潁川

Yingshi 營室
Yinshan 陰山
yinwu xiangxing 因物象形
Yinxu 殷墟
Yishou 益壽
yisi 乙巳
yiwei 乙未
Yixian 易縣
Yi Zhou shu 逸周書
yong (sacrificial cycle) 彤
Yong (Qin capital) 雍
Yongcheng 永城
Yongchu 永初
Yong da ji 雍大記
Yongjia 永嘉
Yongjian (era name) 永建
Yongmen 雍門
yongqi 用器
Yongshou 永壽
Yongxing 永興
Yongyuan 永元
you (child) 幼
you (vessel) 卣
You (Zhou king) 幽
Youjiao 遊徼
yu (jade) 玉
yu (musical instrument) 竽
yu (vessel) 盂
Yu (founder of the Xia) 禹
Yu (maker of bronze vessel) 魚
Yu (Shang courtier) 餘
Yu (Yao) 虞
Yu Bo 強伯
Yu Huan 魚豢
Yu Xin 庾信
Yu Xingwu 于省吾
Yu Yuanwei 庾元威
Yu Zhong 虞仲
Yuan (Han emperor) 元
Yuan (Lady) 元
Yuan (Li Yuan) 元
Yuan (surname) 爰
Yuan Ang 袁盎
Yuan Gu 原穀
Yuan Guangmin 袁廣民
Yuan Kang 袁康

Yuancheng 元城
Yuanhe 元和
Yuanjia 元嘉
Yuan ling (mausoleum) 原陵
Yuanshou 元狩
Yuantang 元堂
yuanyi 園邑
yuanzu 遠祖
Yudi zhi 輿地誌
Yue 越
yuefu 樂府
Yue jue shu 越絕書
"Yueling" 月令
Yueshang 越裳
Yuezhi 月氏
"Yu gong" 禹貢
Yuhang 余杭
yulianzang 玉殮葬
Yunmeng 雲夢
Yutai 魚台
Yutang 玉堂

Zai Wo 宰我
zan 贊
ze 則
zeicao 賊曹
Zeng 曾
Zeng Shen (Zengzi) 曾參 (曾子)
zengming 增命
Zha Rong 乍融
Zhaizishan 寨子山
"Zhan chengnan" 戰城南
zhang 丈
Zhang Ao 張敖
Zhang Bo 張勃
Zhang Cang 張蒼
Zhang Cheng 張成
Zhang Chun 張純
Zhang Er 張耳
Zhang Heng 張衡
Zhang Hua 張華
Zhang Liang 張良
Zhang Minghua 張明華
Zhang Nian 張年
Zhang Qian (Eastern Han) 張遷

Zhang Qian (Western Han) 張騫
Zhang Rang 張讓
Zhang Shizhi 張釋之
Zhang Shoujie 張守節
Zhang Wu 張武
Zhang Xunliao 張勛燎
Zhang Yi 張儀
Zhang Zhong 張仲
Zhangcheng (gate) 章城
Zhanghua tai 章華台
Zhangjiawan 張家灣
Zhanguo ce 戰國策
Zhangzhai 張寨
zhao 昭
Zhao (clan) 昭
Zhan (Han emperor) 昭
Zhao (Lu duke) 昭
Zhao (Qin king) 昭
Zhao (state) 趙
Zhao (Yan king) 昭
Zhao (Zhou king) 昭
Zhao Mai 趙買
Zhao Qi (Zhao Jia, Taiqing) 趙岐 (趙嘉, 太卿)
Zhao Ruzhen 趙汝珍
Zhao Shoujing 趙守敬
Zhao Xun 趙徇
Zhao Yang 趙鞅
Zhao Yi 趙翼
Zhao Yuanfu 趙元父
Zhaoxiang 昭襄
Zhaoyu tu 兆域圖
Zhe 折
Zheng 鄭
Zheng Xuan 鄭玄
Zheng Zhenxiang 鄭振香
Zhengbo Qiao 正伯僑
zhengfanshu 正反書
Zhengzhou 鄭州
zhi 質
Zhi (family surname) 摯
Zhi (legendary sovereign) 鷙
zhiguai 志怪
Zhiyuan 至元
Zhong 仲
zhongliu 中霤

zhongren 眾人
Zhongshan 中山
Zhongtian tai 中天台
zhongtu 冢土
Zhou (dynasty) 周
Zhou (Shang king) 紂
Zhou Bo 周勃
Zhou Gong (Duke of Zhou) 周公
Zhou Yafu 周亞夫
Zhougong miao 周公廟
Zhou guan 周官

Zhou li 周禮
Zhouyuan 周原

Zhu Rong 祝融
Zhu Wei 朱鮪
Zhuang (Lu duke) 莊
Zhuangbai 莊白
Zhuang ling 莊陵
Zhuangxiang 莊襄
Zhuangzi 莊子
Zhuanxu 顓頊
zhubu 主簿
zhucangjun 主藏君
zhucang langzhong 主藏郎中
Zhucheng 諸城
zhuiming 追命
"Zhulin qixian" 竹林七賢
zhuwei 主位

Zi 子
Zichan 子產
ziming 自名
Zitong 梓潼
Ziweiyuan 紫微垣
Ziyuan 紫淵
zong 宗
zongbo 宗伯
zongfa 宗法
zongjiao 總角
zongmiao 宗廟
Zongzhang 總章
Zongzhou 宗周
zou 奏
Zou Yan 鄒衍

Zouxian 鄒縣
zu (clan) 族
zu (stand) 俎
Zu Xin 祖辛
Zui Hou 最後
zun 尊
zuo 作
Zuoce Ban xian 作冊般甗
"Zuo Luo" 作洛
"Zuo Luo jie" 作雒解
zuoshu 左書
zuoyoushu 左右書
Zuxing 祖邢

Index

In this index an "f" after a number indicates a separate reference on the next page, and an "ff" indicates separate references on the next two pages. A continuous discussion over two or more pages is indicated by a span of page numbers, e.g., "57–59." *Passim* is used for a cluster of references in close but not consecutive sequence. Entries are alphabetized letter by letter, ignoring word breaks, hyphens, and accents.

Library of Congress Cataloging-in-Publication Data
Wu, Hung, 1945–
 Monumentality in early Chinese art and architecture /
Wu Hung.
 p. cm.
 Includes bibliographical references and index.
 ISBN 0-8047-2428-8 (cl.) : ISBN 0-8047-2626-4 (pbk)
 1. Public art—China. 2. Art and state—China.
3. Symbolism in art—China. 4. Art, Chinese—To 221 B.C.
5. Art, Chinese—Ch'in-Han dynasties, 221 B.C.–
220 A.D. 6. Art, Chinese—Three kingdoms-Sui dynasty,
220–618. I. Title.
N7343.2.W8 1995
709'.31—DC20 94-18434 CIP

Typeset in 11/13½ Bembo by G&S Typesetters, Inc.,
and ASCO Trade Typesetting, Ltd.